Art Doine's
CAMERA WORKSHOP

To Art Doine
with the compliments of the author
William W. Craig
4-8-78

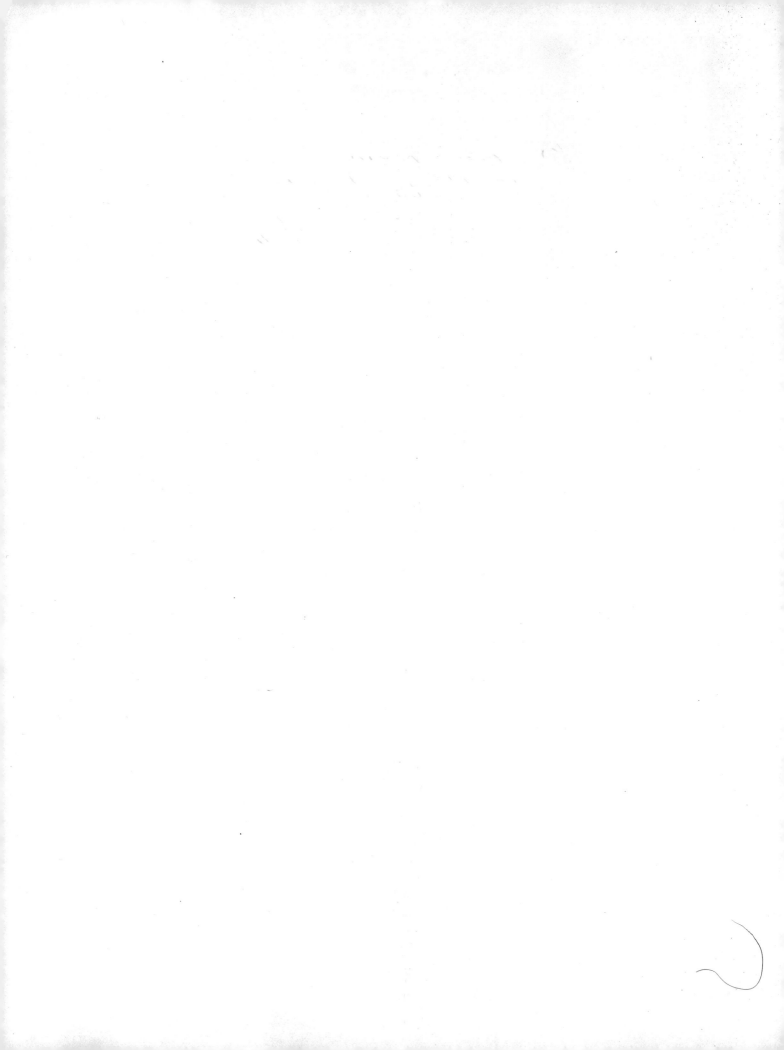

Photography
in America

View of Broadway from Tenth Street, New York, showing the northern side of the building, right, which housed Mathew Brady's photographic gallery from 1860 to 1873.

Photography in America

THE FORMATIVE YEARS
1839–1900

William Welling

THOMAS Y. CROWELL COMPANY

Established 1834 New York

Designed by Abigail Moseley

Manufactured in the United States of America

Library of Congress Cataloging in Publication Data

Welling, William B
 Photography in America.

 Bibliography: p.
 Includes index.
 1. Photography—United States—History. I. Title.
TR23.W44 770'.973 77-1983

ISBN 0-690-01451-1

1 2 3 4 5 6 7 8 9 10

ACKNOWLEDGEMENTS

To Marian Carson for her consummate energy and interest in helping me research the most extensive private collections of early photographs and photographic literature covering Philadelphia's pioneering role in the birth and early development of American photography, and for her gracious help in opening other doors in Philadelphia and Baltimore to prime sources of rare photographic material.

To George R. Rinhart, who has once again provided invaluable assistance in drawing upon the contents of his enormous photographic collection, and who readily put at my disposal his entire library of nineteenth-century photographic journals and books, which I believe to be now the largest such privately held collection in the United States.

To Gene Collerd, for his abiding help in unearthing antique cameras and rare, unpublished photographs from a fabulous collection, and in appreciation, too, of his craftsmanship in reproducing most of the illustrations loaned for reproduction.

To Allan and Hilary Weiner, R. Bruce Duncan, J. Randall Plummer, Samuel Wagstaff, Bradford Bachrach, Richard Russack, Pearl Korn, Paul F. Walter, Janet and Lewis Lehr, David Steinmann, Lou Marcus, and Robert Lansdale, each of whom undertook to copy images from their personal collections for use in these pages; and to Timothy Beard, Arnold Crane, Mrs. Roy Douglass, William Kaland, Fred Lightfoot, Jerome Sprung, and Harvey Zucker, who kindly made key items from their collections available for reproduction; and to Howard Bendix and Philip Kaplan for providing leads to other important sources of information or illustrations.

To these dedicated men and women at more than a dozen libraries and institutions, who have assisted me with original research or provided valued materials on a timely basis: Mrs. Helen Reid, manuscript librarian for the McKeldin Library at the University of Maryland, College Park, who with Dr. Robert L. Beare, the assistant director for collections at McKeldin, initiated a chain reaction of referrals which proved to be the most important of this entire undertaking; Dr. Michael McMahon and Harvey S. S. Miller at the Franklin Institute, who gave freely of their time and made it possible for me to photograph key items among the Institute's archives; Edda Schwartz of the Institute's research staff, whose original research was extremely beneficial; Barbara Bond, executive director, and Dr. Josephine Chapin at the Dyer-Yorke Library and Museum in Saco, Maine; Dean John C. Sprille and Anne Van Camp at the University of Cincinnati; Dr. John Patton at the Cincinnati Historical Society; Mrs. Susan Childress and Sarah M. Lowery at the Cincinnati Art Museum; John B. Griggs, librarian at the Lloyd Library and Museum in Cincinnati; Anthony Raimo, director of the library at the University of Maryland, Baltimore County; David Haberstich at the Smithsonian Institution Museum of History and Technology; Richard Wright of the Onondaga (New York) Historical Association; Suzanne H. Gallup at the University of California Bancroft Library; Thomas Greenslade at Kenyon College; Mrs. Hildegarde L. Watson, director of the Rochester Historical Society; Chuck Kelly at the Library of Congress Prints and Photographs Division; and the librarians at the Library of Congress, New York Public Library, and International Museum of Photography at George Eastman House.

To Hugh Rawson, the "captain" of this W.W. literary voyage and a prime motivator of what Winthrop Knowlton has justly termed "the lively and distinguished program which characterizes the Crowell imprint"; and to Cynthia Kirk, for her able assistance in editing.

To my brother, Lindsay H. Welling, Jr., finally, an "amateur" photographer with a distinctly professional touch and a helping hand in moments of need; and to those stalwarts—Richard W. Strehle, James W. Bowers, and Annette Sorrentino—whose personal help in compiling documentation has been of incalculable value.

PREFACE

Photography's formative years in America followed a pattern very similar to the American experience in art. Many who took up photography after 1839 had been house, sign, or carriage painters, or practitioners of another craft. Some, like their contemporaries in folk artistry, traveled the backroads of America as itinerant photographers; and even those in the big cities tended to work in isolation until well after the Civil War. Employees of metropolitan galleries were customarily enjoined to secrecy about their work, and as one of them said later, "the darkroom was as exclusive as a Free Mason's Lodge." Not surprisingly, they were slow in establishing fraternal organizations, which were organized first in Paris and London. Even the editors of American photographic journals had difficulty obtaining contributions, while those who did submit articles usually hid their identities, simply giving their initials or writing as a "friend."

Early American photographers, like early American painters, excelled in portraiture. During the 1840s, no photographic portraits abroad surpassed those made in New York by Mathew Brady, Jeremiah Gurney, and others, or in Boston by Albert Southworth and Josiah Hawes. In the 1850s, two Philadelphia photographers, John J. Mayall and Warren Thompson, established notable reputations as portrait photographers in London and Paris, respectively. At the great Crystal Palace Exhibition held in London in 1851, three Americans (Brady among them) captured top awards in photography, principally for portraiture.

American landscape photography developed slowly, just as landscape painting in America lagged behind oil portraiture. England and Europe boasted numerous distinguished landscape photographers in the 1840s and 1850s, but there were no counterparts in the United States. Not until after the flourishing of the Hudson River art school did an American landscape photography school emerge, its cameras focusing on the scenic wonders of California and other western states. In 1873, a gold medal for landscape photography was finally awarded, for the first time, to an American entry at an international exposition in Vienna.

Until the 1880s, the major new photographic processes, picture styles, and even equipment continued to originate in England, or on the continent. There were, of course, exceptions, such as the merchandising (in Philadelphia) of the Magic Lantern as an early slide projector; and the invention (in Baltimore) of the solar camera, which could make the first practical enlargements. But even in the realm of color photography, the extent of scientific research conducted in the United States never matched that performed in London, Paris, and Berlin. Except for the pioneering work of the New York optician Charles C. Harrison, the fineries of lens manufacture also remained strictly within the province of Europeans. But the dawn of photography's modern era near the turn of the century found the United States in a better position for technical innovation, or for exploiting what might be invented elsewhere. American ingenuity was becoming translated into vast new business enterprises, and under the auspices of one such duke of American capitalism—George Eastman—the long-sought dry negative process, perfected in England, was applied to rollable celluloid film, boxed in a hand camera (which no longer required a tripod), and made available—cheaply—to an entire new generation of amateur photographers. Once the domain of professionals, photography quickly became a handmaiden for *all* people.

During the nineteenth century, only one attempt was made to publish a history of photography in America. This was *The Camera and the Pencil,* by M. A. Root (Philadelphia, 1864; reprinted by the Helios Press, Putney, Vt., 1971). In the present century, only one attempt, again, has been made prior to this to provide a comprehensive history of the medium's formative years in America. This was *Photography and the American Scene,* by Robert Taft (New York, Macmillan, 1938; reprinted by Dover Publications, New York, 1964). The problem has been that not only are there few museums devoted to photography, but that no single library or institution has managed to acquire a fully comprehensive collection of nineteenth-century photographic journals, private papers, biographical material, and other literature pertaining to the medium. Talk with any scholar or curator in the photography field and he or she will tell you how much there is still to be learned, unraveled, or pieced together from additional isolated data—much of

it still in private hands, or otherwise still to be unearthed by researchers at public libraries, historical societies, and the like.

In these pages I have endeavored to give a new perspective on photography's formative years, particularly on the early workings with negative processes, photoengraving, the origins of amateur practice, motion picture camera development, and the birth of American art photography. In these pages, too, will be found a number of names which have not heretofore figured prominently in historical studies, but whose careers and accomplishments merit the attention which they are given here. The names include: John Locke, John Johnson, Victor Piard, J. DeWitt Brinckerhoff, Ezekiel Hawkins, J. Milton Sanders, Charles Seely, David Woodward, Charles Ehrmann, Frank Rowell, George B. Coale, Jex Bardwell, Arthur H. Elliott, Henry J. Newton, Thomas C. Roche, David Bachrach, Jr., Ernest Edwards, John Calvin Moss, Alfred Clements, Charles Francis Jenkins, Louis A. A. Le Prince, John Lawrence Breese, and George Bain.

Photography's formative years—in America as well as elsewhere—will continue to provide an exciting challenge for researchers for years to come. Occasionally, one hears that the private papers or photographs of a particular pioneer survive in private hands, unseen by scholars. While I have been privileged to be given access to a number of major private collections in preparing this book, I hope that its publication will encourage the making available of other unpublished information or photographs, or the donation of such valued material to the Library of Congress, or to such other institutions as will, in future, place only a modest premium on its use or reproduction by serious students and writers.

William Welling

CONTENTS

Contents

x

Photography in America

PROLOGUE

THE FOUNDING FATHERS

As early as the sixteenth century, scientists had constructed a primitive form of "darkroom" which contained a small hole in one wall through which the sun's rays projected the inverted image of the view outside onto the opposite wall of the room. This "room" was the first version of what came to be known over the next several centuries as the *camera obscura*. The smaller the hole, the sharper was the image projected on the opposite wall. Various forms of lenses were inserted in the aperture, which served to brighten the reflected image. Knowledge of the optical principle involved in this phenomenon dates back to the times of Aristotle, and the camera obscura was first used as an aid in drawing by Giovanni Batista (1538–1615).

In the eighteenth century, the portable reflex camera obscura was developed. This was the precursor of the box camera, and was placed on the market principally for sale to artists. The device (shown right) threw an observed image (of a person, object, or view) onto an internal mirror at a 45-degree angle, and the mirror, in turn, projected the image onto a piece of ground glass at the top of the box where it could be conveniently viewed. This enabled the artist to study an image which he desired to paint at close range; or, if he preferred, he could trace the image for later use by placing a piece of translucent paper over the glass. In time, these camera obscuras were equipped with achromatic lenses, which bring the visual and nonvisible light rays (possessing radiant energy) to the same point of focus. With an achromatic lens, camera obscura viewers could visually focus the lens on the intended image, and the image observed on the viewing glass would appear equally sharp.

Thus, by the 1700s, an early form of camera was in wide use, but its images could only be observed while the device was being used, and were never "trapped."

In 1725, scientists learned that the sun's rays could be utilized to darken silver salts (a procedure upon which photography would later depend). They found, too, that the darkening was caused not by the heat from the sun, but by the light. Silhouettes of objects, or of a person's head, placed directly between the sun's rays and a screen or other surface "sensitized" with silver nitrate could be "captured" on the sensitized surface as soon as the rays darkened the surface around the reflected image. But then the silhouette itself would darken upon exposure to light.

By the end of the eighteenth century, experiments were begun to find a means not only of securing but "fixing" the images of the camera obscura on paper, or on other surfaces coated with light-sensitive nitrate of silver, chloride of silver, or other substances. The ultimate success of these efforts can be credited principally to the separate undertakings of these five men:

THOMAS WEDGEWOOD (1771–1805) Fourth son of the noted English potter Josiah Wedgewood, Thomas Wedgewood experimented first with a camera obscura, then by directly superimposing leaves, wings of insects, paintings-on-

A portable camera obscura. The mirror reflects the image to the viewing glass.

glass, etc., on sensitized paper on white leather, and exposing them to light. He also obtained silhouettes by casting the shadow of a figure upon his treated surfaces—but the result was always the same; all of his copied images had to be kept in a dark place to prevent their fading and ultimate complete disappearance from exposure to light. Sir Humphrey Davy, a close friend of Wedgewood's and professor of chemistry at the Royal Institution, concluded in a report published in 1802: "Nothing but a method of preventing the unshaded parts of the delineation from being coloured [darkened] by exposure to the day is wanting, to render the process as useful as it is elegant." [1] Three years later, Wedgewood—who suffered from an illness his doctors could never identify—was dead at age thirty-four. Today, he is remembered as the first to secure photographic images, albeit temporarily.

JOSEPH NICEPHORE NIÉPCE (1765–1833) Niépce was a country gentleman who managed to save a portion of the family fortune after the French Revolution, and experimented at his estate near Châlon-sur-Sâone. He secured images on paper, partially "fixed" with nitric acid, which could be viewed in daylight, but evidently only for a short time.

His first success resulted from spreading a thin layer of light-sensitive bitumen of Judea (an asphalt used in engraving and lithography) on a glass plate, and exposing the plate, together with an engraving superimposed on it, to light for several hours. The bitumen beneath the white parts of the engraving hardened, while that beneath the dark lines remained soluble, and could be washed away with a solvent. The result was a permanently copied image, and technically the world's first photo-engraving (a specimen which, unfortunately, was later dropped and broken by a clumsy admirer).

In 1826, Niépce produced a series of photo-engraving

plates on pewter, and in 1826 or 1827 exposed a pewter plate of size 8 inches by 6½ inches (sensitized with bitumen) in a camera obscura and after an eight-hour exposure secured what is now recognized to be the world's first photograph obtained with a camera. The picture is of a pigeon house and barn adjacent to the Niépce home. Niépce called his pictures "heliographs," and prints from some of his photo-engraving plates were pulled as late as 1864 and 1869. In 1829, Niépce formed a partnership with Louis Jacques Mande Daguerre to continue photography experiments jointly, but in 1833 he died of a stroke.[2]

LOUIS JACQUES MANDE DAGUERRE (1787–1851) Painter, scenic designer, and proprietor of the Diorama (a theater without actors in Paris, where enormous paintings were exhibited under changing light effects to paying audiences), this Frenchman lacked a knowledge of physics or chemistry, yet was actively engaged in trying to secure permanent images with a camera obscura before entering into partnership in 1829 with Niépce. The latter had experimented with iodized plates (both pewter and silver-coated metal plates) before his death in 1833, but Daguerre alone perfected the finally adopted method of sensitizing the silver plates with the fumes of iodine. This was accomplished by placing the silvered side of the plate over a box containing particles of iodine. The iodine fumes, after heating, produced light-sensitive silver iodide when they came into contact with the silver.

In 1835, he also found a means of bringing out, or "developing" the unseen, or latent images secured on his plates by subjecting the plates after exposure to mercury vapor. The "fixing" of his secured images was accomplished with common salt. For a description of an early American Daguerre-type camera, see page 12.

In 1837 and 1838, Daguerre attempted to sell, or interest subscribers in his "daguerreotype" invention, but then the director of the Paris Observatory, Francois Arago, stepped into the picture. Recognizing its immense potential, Arago decided to use his influence to have France purchase Daguerre's invention and make it available to the entire world. This he accomplished by shepherding a bill through the French Chamber of Deputies which provided a pension both for Daguerre and Niépce's son, Isadore Niépce. Arago also appeared before the French Academy of Sciences (on January 7, 1839) and, after the passage of his bill, before a joint session of the Sciences Academy and the French Institute of Fine Arts (on August 19), to announce the details of the daguerreotype process. In his first talk, he was careful to point out that Daguerre's process could not produce pictures in color. "There are only white, black and grey tones representing light, shade and half-tones," he explained. "In M. Daguerre's camera obscura, light itself reproduces the forms and properties of external objects with almost mathematical precision; but while the photometric proportions of the various white, black and grey tones are exactly preserved, red, yellow, green, etc. are represented by half-tones, for the method produces drawings and not pictures in colour." Within a year, manuals covering the daguerreotype process were published in eight languages, and in thirty-two separate editions. The process was a no-negative one, but for nearly two decades it was to serve as the world's principal mode of photography.[3]

W. H. FOX TALBOT (1800–1877) Unaware of Daguerre's activities, this member of the English landed gentry, and Fellow of the Royal Society, experimented with photography at his country estate near Bath, and by 1835 had succeeded in securing images (in reverse) on ordinary writing paper, which he sensitized with silver chloride. Next, he put a reversed image in contact with another sensitized sheet and found he could obtain a re-reversed image on the second sheet (providing a picture the way it would be seen by the naked eye). The sheet with the reversed image was a form of negative, since it had served the purpose of making the re-reversed image, a second positive. In this way, Talbot in effect was the first to use a negative-positive mode in making a photograph. But because he was preoccupied with research in other scientific fields, he had made no formal report of his discoveries before word of Daguerre's discovery came from Paris.

Word of the new French process spread quickly to other countries. Immediately upon hearing it, Talbot put together specimens of his work—items which he called "photogenic drawings"—and both his own formal announcement and that of Daguerre's were made at an evening meeting of the Royal Institution on January 25, 1839. Six days later, a detailed description of Talbot's experiments was read to members of the Royal Society by the Society's secretary. But like Daguerre, Talbot had really not found a solution to the permanent "fixing" of pictures obtained with a camera. He bathed his images in a strong solution of sodium chlo-

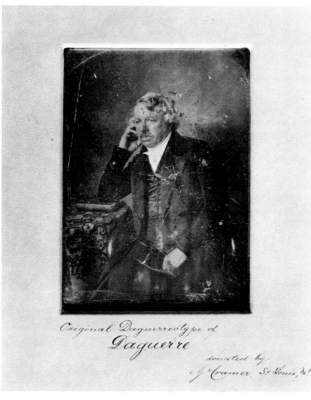

Original Daguerreotype of Daguerre

donated by
J Cramer St Louis Mo

Louis J. M. Daguerre (1787–1851), inventor of the daguerreotype process, from a daguerreotype by Charles Meade of Albany, New York, taken in 1849. After 1852, brothers Charles and Henry Meade operated a photography studio in New York City.

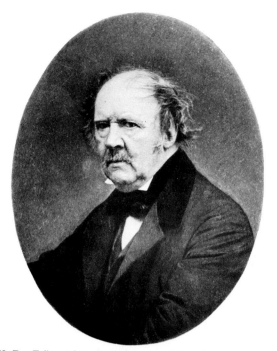

W. H. Fox Talbot (1800–1877), inventor of the calotype process.

of photography, and devoted much of his time to the study of the effects of light on organic and inorganic substances. In 1819, he had discovered a new acid from which a group of salts could be derived, and when word of Daguerre's announcement reached him, he went to work in his laboratory 19 miles west of London and a week later (January 29, 1839) perfected a method of using one of the new salts—hyposulphite of soda—as an improved means of "fixing" a daguerreotype image on a silver-coated metal plate. Thus, Herschel is given the credit for discovering the "hypo" used to the present day in every photographic darkroom.[5]

HIPPOLYTE BAYARD (1801–1887) Holder of a modest position in the French government, Bayard began experiments somewhat different from Talbot's as early as 1837. In May 1839, he exhibited pictures secured on paper to the physicist Jean Baptiste Biot and to Arago, who considered Bayard's work a threat to the government's negotiations with Daguerre, and arranged for a subsidy to prolong Bayard's experiments for a period of another year.[6] The historian W. Jerome Harrison, a Fellow of the Royal Geological Society and an officer of the Birmingham Photographic Society, gave this description of Bayard's process in 1895:

> Bayard's process was that he prepared a surface of chloride of silver on paper by means of a 2 per cent solution of chloride of ammonium, with subsequent drying followed by sensitizing upon a bath of a 10 per cent solution of nitrate of silver. The paper was then exposed to light until it became black all over, after which it was washed in several changes of water, and preserved in a portfolio until required for use. To sensitize it, a 4 per cent solution of iodide of potassium was applied, and the paper exposed in the camera. Iodine was liberated wherever the light acted, and, entering into combination with the silver, formed an image in iodide of silver; this was dissolved in the fixing solution, which consisted of diluted ammonia. In this way a positive on paper, with its sides reversed, was produced in the camera.[7]

ride, which made the unexposed, or imaged portion of the sensitized paper, relatively insensitive to light, but this was "stabilizing" rather than "fixing" the pictures permanently.[4]

SIR JOHN HERSCHEL (1792–1871) A renowned mathematician, chemist, astronomer, and past president of the Royal Society in 1839, Herschel appears to have been more interested in photochemistry than in inventing a practical process

THE CLIMATE FOR TECHNOLOGY IN AMERICA: 1800–1839

There were few attempts, as we shall see, to experiment with some primitive form of photography in America prior to 1839, principally because there were few men of science in the classical sense to be found in the new country. While American inventiveness became a recognized national trait after the turn of the century, it was directed primarily at solving problems of transportation, and in bringing the Industrial Revolution to the American scene. Such purely scientific research as there was in this period concerned itself less with adding to the body of technical knowledge than with merely keeping up with rapid scientific advances taking place across the Atlantic.

America had produced two outstanding men of science prior to the American Revolution, the foremost among them being Benjamin Franklin. But Franklin lived in England or France much of the time after he passed the age of fifty. The other early technical giant was Massachusetts-born Benjamin Thompson (later Count Rumford), who became a Tory in 1776 (at age twenty-three) and thereafter lived an illustrious life abroad. Thompson became a Bavarian diplomat, military strategist (greatly admired by Napoleon), Royal Scientist to King George III, founder of Britain's Royal Institution, and, in 1791, a count of the Holy Roman Empire. He not only exhibited Yankee ingenuity in numerous inventions (a drip coffeepot; the basic design for the modern fireplace and flue) but also contributed substantially to the fundamental knowledge on which his own and later technical advances of others were based.

The first American scientific society was organized in 1743 as the American Philosophical Society, with Franklin as secretary. College chairs in chemistry were not established until after the Revolution, the earliest being professorships at Harvard and Princeton. Institutional instruction in chemistry, at the outset of the nineteenth century, was almost exclusively confined to medical schools. The traditional college curriculum, at most colleges and universities, was heavily weighted toward literary pursuits and the study of classical languages. In 1828, the president of Union College in Schenectady, Eliphalet Nott, "cut loose" from this rigid curriculum structure and organized a "scien-

tific course" which he said was designed to fit young men for "practical life." One of Nott's students, Charles A. Seely, an 1847 graduate, founded (in 1855) the *American Journal of Photography,* and went on to obtain nineteen United States patents for improvements in photographic processes.

The first chair in chemistry at Yale was established in 1802 and filled by Benjamin Silliman (1779–1864), who founded the *American Journal of Science and the Arts* sixteen years later. Although the Franklin Institute had been established at Philadelphia in 1823, the American Association for the Advancement of Science and the Smithsonian Institution were not established until 1846. Even as late as 1850, when Josiah Parsons Cooke, Jr., assumed the chair of Erving Professor of Chemistry at Harvard, he found the Chemical Department of the college to be nearly extinct, and his first years have been described as "a constant struggle to re-establish the chemical teaching . . . and to raise chemistry to a position of equality with the so-called humanities, which up to that time had held undisputed possession of the college course." [8]

America had a number of technical giants early in the nineteenth century, among them Silliman and Thomas Cooper (chemistry), Joseph Henry (electricity), Nathaniel Bowditch (navigation), James Dwight Dana (geology), Gotthilf Muhlenberg (botany), and William Redfield (meteorology). But many, like Cooke, achieved their positions of prominence with only fragmentary schooling. The noted Philadelphia chemist and inventor Dr. Robert Hare (1781–1858), for example, learned chemistry by independent study and helped run his family's brewery while functioning at the same time as professor of natural philosophy at the University of Pennsylvania Medical School. In 1818, Hare was named professor of chemistry at the medical school, where his lecture hall was considered "perhaps the best equipped in the United States" at that time. [9]

One of Hare's students, and evidently the man whose experiments most closely paralleled those of photography's founding fathers in Europe, was John William Draper. Born in England, Draper studied chemistry at the University of London for several years, then came to America in 1832. He was graduated from the University of Pennsylvania Medical School in 1836, and the same year took a position as professor of chemistry and natural philosophy at Hampden-Sidney College in Virginia. His experiments in photochemistry and photography during the period 1836–1839 are recounted in this (excerpted) reminiscence, published in 1858:

For years before either Daguerre or Talbot had published anything on the subject, I had been in the habit of using sensitive paper for investigations of this kind. It was thus as you will find by looking into the Journal of the Franklin Institute for 1837, that I had examined the impressions of the solar spectrum, proved the interference of the chemical rays, investigated the action of moonlight and of flames, either common or colored, red or green, and also the effects of yellow and blue solutions, and other absorbing media. You will notice that in these experiments I was using the preparations of bromine, about which so much of has of late been said. The difficulty at this time was to fix the impressions. I had long known what had been done in the copying of objects by Wedgewood and Davy, had amused myself with repeating some of their experiments, and had even unsuccessfully tried the use of hyposulphite of soda, having learnt its properties in relation to the chloride of silver from

Herschel's experiments, but abandoned it because I found it removed the black as well as the white parts. This want of success was probably owing to my having used too strong a solution, and kept the paper in it too long. . . When Mr. Talbot's experiments appeared in the spring of 1839, they, of course, interested me greatly, as having been at work on the action of light for so many years. I repeated what he published and varied it. This was whilst I was professor at Hampden Sidney College in Virginia, and before anything had been published by Daguerre. . .

It was during my repetitions of Mr. Talbot's experiments that I recognized the practical value of the experiments I had made in 1835, and published in 1837 respecting the chemical focus of a non achromatic lens, and saw that the camera must be shortened in order to obtain a sharp picture. It is the experiment of passing a cone of light through a known aperture on sensitive paper. It was from considering the difficulty of getting an impression from colored surfaces as red or green, that I saw the necessity of enlarging the aperture of the lens, and diminishing its focus, so as to have the image as bright as possible ; for it was plain that in no other way landscapes could be taken or silhouettes replaced by portraits. And when I had failed altogether in these particulars, I knew it was owing to insufficient sensitiveness in the bromine paper, and waited anxiously for the divulging of Daguerre's process, respecting which statements were beginning to be made in the newspapers. [10]

A report that an Indiana youth experimented with photography as early as 1828 is contained in the first chapter of *The History and Practice of the Art of Photography,* by Henry Hunt Snelling, published in 1849. The youth, James M. Wattles, was using a camera obscura while studying under the Parisian artist Charles Le Seur at the New Harmony School in Indiana, according to Snelling. The latter also states in his book that Wattles' parents "laughed at him" and "bade him attend to his studies and let such moonshine thoughts alone." Snelling gives this account of the experiments in Wattles' own words:

"I first dipped a quarter sheet of thin white writing paper in a weak solution of caustic (as I then called it) and dried it in an empty box, to keep it in the dark ; when dry, I placed it in the camera and watched it with great patience for nearly half an hour, without producing any visible result ; evidently from the solution being to weak. I then soaked the same piece of paper in a solution of common potash, and then again in caustic water a little stronger than the first, and when dry placed it in the camera. In about forty-five minutes I plainly percieved the effect, in the gradual darkening of various parts of the view, which was the old stone fort in the rear of the school garden, with the trees, fence, &c. I then became convinced of the practicability of producing beautiful solar pictures in this way ; but, alas ! my picture vanished and with it, all—no not *all*—my hopes. With renewed determination I began again by studying the nature of the preparation, and came to the conclusion, that if I could destroy the part not acted upon by the light without injuring that which was so acted upon, I could save my pictures. I then made a strong solution of sal. soda I had in the house, and soaked my paper in it, and then washed it off in hot water, which perfectly fixed the view upon the paper. This paper was very poor with thick spots, more absorbent than other parts, and consequently made dark shades in the picture where they should not have been ; but it was enough to convince me that I had succeeded, and that at some future time, when I had the means and a more extensive knowledge of chemistry, I could apply myself to it again. I have done so since, at various times, with perfect success ; but in every instance laboring under adverse circumstances." [11]

SOLITARY BEGINNINGS

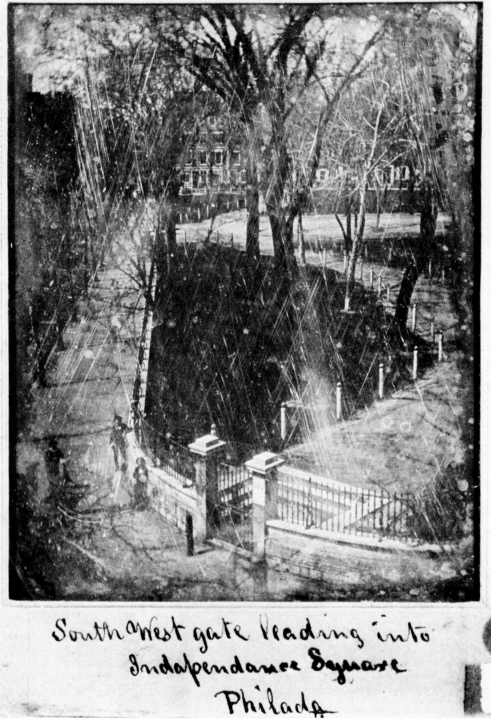

South West gate leading into Independance Square Philada

Philadelphia, New York, and Boston were the prime centers where the first practice of daguerreotype photography took place in the United States. Outdoor daguerreotype views were made in New York in 1839, but the specimens are not known to be extant. Although the date of the early daguerreotype made of Independence Square (above) is not known, the image was acquired by its present owner from descendants of the Philadelphia naturalist and artist Titian Ramsey Peale (1799–1885). Titian Peale was named an official of the Philadelphia Museum in 1821, but during the years 1838–1842 he accompanied the American naval officer Charles Wilkes on the latter's historic scientific exploration of the South Seas and Antarctic Ocean. Scratch marks which appear on the image surface are probably the result of a mistaken attempt made in subsequent years to clean the surface of silvered metal plate with a cloth.

1839

THE YOUNG DAGUERREANS
1839

It is probable that news of Daguerre's invention was published in American as well as European newspapers and journals in the first three months of 1839, but the earliest limited description of the process was sent by S. F. B. Morse to his brothers in New York after Morse had met with Daguerre in Paris on March 7 and 8. Morse's brothers were publishers of the *New York Observer,* a religious weekly with wide readership, and Morse's letter appeared in the May 18 issue.

> A few days ago I addressed a note to M. Daguerre requesting, as a stranger, the favor to see his results, and inviting him in turn to see my Telegraph. I was politely invited to see them under these circumstances, for he had determined not to show them again, until the Chambers had passed definitely on a proposition for the Government to purchase the secret of the discovery, and make it public. The day before yesterday, the 7th, I called on M. Daguerre, at his rooms in the Diorama, to see these admirable results. They are produced on a metallic surface, the principal pieces about 7 inches by 5, and they resemble aquatint engravings, for they are in simple chiaro-oscuro, and not in colors. But the exquisite minuteness of the delineation cannot be conceived. No painting or engraving ever approached it. For example: In a view up the street, a distant sign would be perceived, and the eye could just discern that there were lines of letters upon it, but so minute as not to be read with the naked eye. By the assistance of a powerful lens, which magnified 50 times, applied to the delineation, every letter was clearly and distinctly legible, and so also were the minutest breaks and lines in the walls of the buildings, and the pavements of the street. The effect of the lens upon the picture was in great degree like that of the telescope in nature.
>
> Objects moving are not impressed. The Boulevard, so constantly filled with a moving throng of pedestrians and carriages, was perfectly solitary, except for an individual who was having his boots shined. His feet were compelled, of course, to be stationary for some time, one being on the box of the boot-black and the other on the ground. Consequently, his boots and legs are well defined, but he is without body or head because these were in motion.[12]

Talbot, meanwhile, having been spurred to action by Daguerre's first announcement in January, disclosed the details of his primitive paper process immediately, and these were published in American journals as early as April.[13] The American academic community appears to have been first to respond. At some point in the spring of 1839, two Harvard students, Edward Everett Hale (later a noted clergyman and author) and Samuel Longfellow (brother of the poet) "repeated Talbot's experiments at once," using a small camera obscura and a common lens to secure a photographic image of a bust of Apollo, which reposed in a window of Harvard Hall.[14] In Cincinnati, John Locke, professor of chemistry and pharmacy at the Medical College of Ohio, exhibited specimens of photogenic drawings in a bookstore. The *Observer* picked up the story from a local Cincinnati newspaper and published it in the same issue in which Morse's letter appeared:

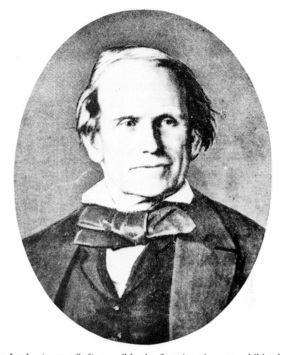

John Locke (1792–1856), possibly the first American to exhibit photographs to the public, which he made with Talbot's primitive "photogenic drawing" method. The son of the founder of Locke Mills, Maine, Locke left home in 1815 when his father opposed further scientific education. He attended Benjamin Silliman's lectures at Yale and became his laboratory assistant for a year. From 1816 to 1818 he studied medicine with doctors at Keene, New Hampshire, and in 1819 published his *Outlines of Botany* containing over two hundred illustrations, all drawn and engraved by himself. Because he felt that New England was dominated by religious intolerance, he moved west to Cincinnati where in 1822 he founded an academy for women. In 1835, he was appointed professor of chemistry and pharmacy at the Medical College of Ohio, a position he held until three years before his death.

> Some experiments on the subject of photogenic drawing have been made by Prof. Locke of the Medical College of Ohio, and with entire success. He prepared paper chemically for this purpose, and placed it under some astronomical diagrams, which were then exposed to the sun's rays. The new picture was in a few minutes formed and removed, and a process used by which the figures were permanently fixed. The specimens which the Doctor has left in our hands are in every respect satisfactory. They look as though they had been carefully engraven. The difficulty or mystery connected with the matter is to retain the picture which the light has formed on the paper. This has been overcome, and the curious may satisfy themselves with what success, by examining a few small specimens which we have left at Mr. Flash's book store.[15]

The *Observer* article reporting on Locke's experiments appeared under the heading "American Daguerroscope," which was indicative of the confusion in the public mind at this time between the French and British inventions. With the benefit of hindsight, it is now easy to see why photog-

SOME INITIAL THOUGHTS ON THE EFFECTS OF THE DAGUERREOTYPE ON ART

Thomas Cole wrote a friend in 1840: "You would be led to suppose that the poor craft of painting was knocked in the head by this new machinery for making Nature take her own likeness, and we [artists] nothing to do but give up the ghost." But he said he felt that "the art of painting is creative, as well as an imitative art, and is in no danger of being superseded by any mechanical contrivance." One might have thought he "ghosted" this (excerpted) commentary, published in *The Corsair* on April 13, 1839:

Here, in truth, is a discovery launched upon the world, that must make a revolution in art. It is impossible, at first view, not to be amused at the sundry whimsical views the coming changes present. But, to speak more seriously, in what way, in what degree, will art be affected by by it ! Art is of two kinds, or more properly speaking, has two walks, the imaginative and the imitative ; the latter may, indeed, greatly assist the former, but, in the *strictly* imitative, imagination may not enter but to do mischief. They may be considered therefore, as the two only proper walks. It must be evident that the higher, the imaginative, cannot immediately be affected by the new discovery—it is not tangible to its power—the poetry of the mind cannot be submitted to this material process ; but there is a point of view in which it may be highly detrimental to genius, which, being but a power over materials, must collect with pains and labor, and acquire a *facility* of drawing. Now, it is manifest that, if the artist can lay up a store of objects without the (at first very tedious) process of correct drawing, both his mind and his hand will fail him ; the mind will not readily supply what it does not know practically and familiarly, and the hand must be crippled when brought to execute what it has not previously supplied as a sketch. Who will make elaborate drawings from statues or from life, if he can be supplied in a more perfect, a more true manner, and in the space of a few minutes, either with the most simple or the most complicated forms ? How very few will apply themselves to a drudgery, the benefits of which are to be so remote, as an ultimate improvement, and will forego for that hope, which genius may be most inclined to doubt, immediate possession ! But if genius could really be schooled to severe discipline, the new discovery, by new and most accurate forms, might greatly aid conception. If this view be correct, we may have fewer artists ; but those few, who will " spurn delights and live laborious days," will arrive at an eminence which no modern, and possibly no ancient master has reached.

But, in the merely imitative walk, and that chiefly for scientific purposes, draughts of machinery and objects of natural history, the practice of art, as it now exists, will be nearly annihilated—it will be chiefly confined to the coloring representations made by the new instruments—for it is not presumed that color will be produced by the new process.

Ye animal painters, go no more to the Zoologicals to stare the lions out of countenance—they do not want your countenace any more. The day is come for every beast to be his own portrait painter. " None but himself shall be his parallel." Every garden will publish its own *Botanical Magazine*. The true " Forget me not" will banish all others from the earth. Talk no more of " holding the mirror up to nature"—she will hold it up to herself, and present you with a copy of her countenance for a penny. What would you say to looking in a mirror and having the image fastened ! ! As one looks sometimes, it is really quite frightful to think of it ; but such a thing is possible—nay, it is probable—no, it is certain. What will become of the poor thieves, when they shall see handed in as evidence against them their own portraits, taken by the room in which they stole, and in the very act of stealing ! What wonderful discoveries is this wonderful discovery destined to discover ! The telescope is rather an unfair tell-tale ; but now every thing and every body may have to encounter his double every where, most inconveniently, and thus every one become his own caricaturist. Any one may walk about with his patent sketch-book—set it to work—and see in a few moments what is doing behind his back ! Poor Murphy outdone !—the weather must be its own almanack—the waters keep their own tide-tables. What confusion will there be in autograph signs manual ! How difficult to prove the representation a forgery, if nobody has a hand in it ! ! [16]

1839

8

raphy took off in the direction of Daguerre's rather than Talbot's invention. The British government never took the same action as did the French to purchase Talbot's rights and donate them, freely, to the world at large. Immediately, manuals on Daguerre's process were published in eight languages, while no detailed information of schematic drawings covering the workings of Talbot's method appeared in either scientific or general news publications. Suitable chemical means for developing the latent image of a "photogenic drawing" were also not forthcoming until the fall of 1840, and Talbot's improved calotype process (also known as the Talbotype process) was not perfected and patented until February 8, 1841. (See page 31.) No promoter of Talbot's invention traveled the American lecture circuit either, as did Daguerre's agent, Francois Gouraud, who came to New York in November 1839 to hold exhibits and lectures first in New York City and soon thereafter in Boston.

Thus, while Talbot worked in seclusion at his English country estate endeavoring to further perfect his paper process, the "new art" of daguerreotyping spread like the wave of a new fashion on the continent, and to the United States. Daguerre, meanwhile, also took out a patent in England for the daguerreotype just prior to his government's purchase of the rights to the process. Perhaps because of his new friendship with Morse (or because there wasn't time), he made no attempt to patent the daguerreotype in America. This meant that there were no restrictions on its practice or further development in the United States, while at the same time the patent secured in Great Britain retarded its early practice there. A Frenchman, Antoine Claudet, who lived in London but had learned the daguerreotype process directly from Daguerre, purchased the English rights, and for a short time was the sole practitioner in the United Kingdom.

From the evidence which presently exists, New York, Philadelphia, and Boston were the principal scenes of action during the first year of the daguerreotype practice in the United States. Having been the first to provide American readers with a personal report on Daguerre's invention, Morse was among the first to take up its practice upon his return to New York. But as late as November 19, he dispatched a letter to Daguerre stating that he had been experimenting "with indifferent success," and promising the Frenchman that he would be favored with the first specimen that was "in any degree perfect." [17]

Morse's first camera was made by George W. Prosch, a manufacturer of scientific instruments who later was among the first to advertise commercially available cameras (his first advertisement appeared March 28, 1840). Forty-three years after the event, Prosch's brother, A. Prosch, published a reminiscence (see right) describing how the Morse camera was made, and how a Daguerre manual was brought to Morse by D. W. Seager, and was translated and used by Morse to aid in the equipment construction. One of Morse's first pictures, according to Prosch's account, was a daguerreotype of the New York City Hall.

A year after A. Prosch's reminiscence was published (in 1882), another reminiscence appeared looking back forty-four years to these same events. This was written by a Brooklyn, New York, resident, George E. West,[18] who recalled that in 1839 he represented the Rutgers Female Institute located at the time in the same building with George

Prosch (No. 142 Nassau Street), and that he, too, recalled Seager's having brought a Daguerre manual to Morse. "I was in his [George Prosch's] shop almost every day," West stated in his account. West also said Morse's City Hall daguerreotype was "the first daguerreotype of still life taken in this country," adding that it was taken in October 1839. But, as we shall see, this statement was in error, Seager having publicly exhibited a daguerreotype view earlier.

To further confuse the issue, Morse himself recollected later in life (in 1855) that his first successful daguerreotype was not of City Hall, but of the Unitarian Church adjacent to what is now New York University. Whenever it was taken, *The Corsair* reported on February 22, 1840, that a daguerreotype view of City Hall taken by Morse was on exhibit "in Chamber Street," adding: "We never saw anything in the shape of an engraving so beautiful."

Morse did not remember Seager's correct name in 1855; however, it was Seager who was first to publicly exhibit a daguerreotype. The *New York Morning Herald,* on September 30, 1839, reported viewing a daguerreotype taken three days earlier by Seager of St. Paul's Church (the edifice which stands to the present day at Broadway and Fulton streets). Although it subsequently disappeared, along with its maker (Morse indicated in 1855 that Seager had gone to Mexico), the Seager daguerreotype is generally regarded as the earliest produced and exhibited in the United States, for which documentation exists.

Having exhibited his daguerreotype, Seager announced in the press that he would hold a lecture on the daguerreotype process on Saturday evening, October 5, at the Stuyvesant Institute in New York City. It is quite possible that a twenty-six-year-old man of scientific bent, John Johnson, a native of Saco, Maine, attended this lecture. For, on the following day, or on Monday, October 7, Johnson brought a description of the process to his business partner, Alexander S. Wolcott, thirty-five, a manufacturer of instruments and dental equipment at 52 First Street. While Wolcott set about sketching a design he had in mind for a camera different from Daguerre's, Johnson went out and purchased the necessary materials for its construction and use (see next page). Quietly, the pair then proceeded on that same day to build the prototype of America's first patented camera. It was thereupon used by Wolcott, after several trials, to secure a daguerreotype profile of Johnson on a plate only ⅜th-inch square. This was, in all probability, the first successful photograph of a human being secured in the United States, although it, too, appears to have been lost. However, Samuel D. Humphrey, editor of *Humphrey's Journal,* disclosed to his readers on July 15, 1855, that the daguerreotype was then in his possession, and that he planned to send it to Europe, "that some of our friends as well as admirers of the art, may see it for themselves." [19]

Despite his letter to Daguerre of November 19, saying he was experimenting "with indifferent success," Morse claimed in 1855 that he had taken daguerreotypes of his daughter, both singly and in groups of her friends in September or early October 1839. [20] One of these specimens he sent to Marcus A. Root, who reproduced it as an engraving in *The Camera and the Pencil,* published in 1864. Root said he found the eyes of the sitters (in this case two) "tolerably

A DAGUERRE MANUAL THROWN ABOARD SHIP FOR NEW YORK

This reminiscence was published in 1882 by A. Prosch, whose brother, in 1839, made the first daguerreotype camera used by Samuel F. B. Morse.

EARLY in the fall of 1839 a gentleman by the name of Seger, and by birth an Englishman, but a resident of this city, had been on a visit to Europe, and returning to this country in one of our London packets just prior to the successful establishment of steam navigation, had the good fortune to make a quick voyage.

On leaving the London dock a friend of his having just received from Paris one of the French pamphlets giving a complete description of the process of making pictures known as daguerreotypes threw the pamphlet from the dock to the ship, as the ship had already cast off. Upon Mr. Seger's arrival in New York, having a personal acquaintance with him, he at once sought Professor Morse. As the Professor was an artist by profession at that time, and also President of the Academy of Design, and naturally one who would not alone be interested in any new method of picture taking but also to receive early information of such process, therefore pamphlet in hand Mr. Seger sought him.

At the corner of Nassau and Beekman streets, in the structure known as the Morse buildings, Prof. Morse was lodging, and experimenting, also, with his telegraph. My brother, George W. Prosch, also had a workshop in the basement of the same building, he being a skilled mechanic in scientific instruments. Prof. Morse, much excited, one day came to my brother with the pamphlet spoken of, wishing him to quit other work at once and give immediate attention to this new discovery. My brother being equally interested in all new scientific discoveries did not require much urging, and the result was, Prof. Morse acting as translator, the first apparatus was completed in a very few days, made exactly after the French description. I think not a week elapsed after the reception of th' pamphlet in this country before the first picture was made by my brother, with the assistance of Prof. Morse, Dr. James R. Chilton supplying the chemicals. One of the first pictures made was the City Hall, direct from the shop door at that time. There was an iron fence around the park, and hacks lined the curb stone waiting for custom. There upon the picture was the coachman sleeping on his box on the carriage, horses and carriage complete with view of City Hall, the horses standing so quietly that they, too, appeared almost like coachmen asleep This was the first picture of a living object taken, without doubt. It attracted a great deal of attention, and was hung with some others out by the door so that the passers-by could see them. [21]

DAGUERREOTYPE PORTRAIT

John Johnson's account (published in 1846) of the taking of his daguerreotype likeness by A. S. Wolcott, his business partner, on October 6, 1839.

On the morning of the 6th day of October, 1839, I took to A. Wolcott's residence a full description of Daguerre's discovery, he being at the time engaged in the department of Mechanical Dentistry on some work requiring his immediate attention, the work being promised at 2, P. M., that day; having, therefore, no opportunity to read the description for himself, (a thing he was accustomed to do at all times, when investigating any subject,) I read to him the paper, and proposed to him that if he would plan for a Camera, (a matter he was fully acquainted with, both theoretically and practically,) I would obtain the materials as specified by Daguerre. This being agreed to, I departed for the purpose, and on my return to his shop, he handed me the sketch of a Camera box, without at all explaining in what manner the lens was to be mounted. This I also undertook to procure. After 2, P. M., he had more leisure, when he proceeded to complete the Camera, introducing for that purpose a reflector in the back of the box, and also to affix a plate holder on the inside, with a slide to obtain the focus on the plate, prepared after the manner of Daguerre. While Mr. Wolcott was engaged with the Camera, I busied myself in polishing the silver plate, or rather silver plated copper, but ere reaching the end preparatory to iodizing, I found I had nearly, or quite removed the silver surface from off the plate, and that being the best piece of silver plated copper to be found, the first remedy at hand, that suggested itself, was a burnisher, and a *few* strips were quickly burnished and polished. Meantime, the Camera being finished, Mr. Wolcott, after reading for himself Daguerre's method of iodizing, prepared two plates, and placing them in the Camera, guessed at the required time they should remain exposed to the action of the light; after mercurializing each in turn, and removing the iodized surface with a solution of common salt, two successful impressions were obtained, each *unlike the other!* Considerable surprise was excited by this result, for each plate was managed precisely like the other. On referring to Daguerre, no explanation was found for this strange result; time, however, revealed to us that one picture was positive, and the other negative. On this subject I shall have much to say during the progress of the work. Investigating the cause of this difference, occupied the remainder of that day. However, another attempt was resolved upon, and the instruments, plates, etc., prepared, and taken up into an attic room, in a position most favorable for light. Having duly arranged the Camera, I *sat* for five minutes, and the result was a profile miniature, (a miniature in reality,) on a plate not quite three-eighths of an inch square. Thus, with much deliberation and study, passed the *first* day in Daguerreotype— little dreaming or knowing into what a labyrinth such a beginning was hastening us. [22]

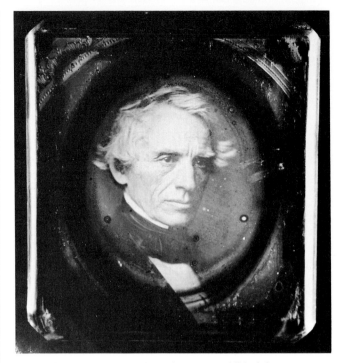

Samuel F. B. Morse (1791–1872), from an unpublished daguerreotype.

well defined'' on the original plate, even though he ''presumed'' that the eyes of the two girls had been both opened and closed during what Morse said had been a 10- to 20-minute exposure. It seems likely that if Morse had failed to exhibit daguerreotype specimens at the same time as Seager (the end of September), this and other portraits of his daughter and her friends were taken sometime later.

Prof. John W. Draper, meanwhile, had left Hampton-Sidney to assume a professorship at New York City University (now New York University) on September 28, 1838. In 1839, he, too, took up the ''new art,'' recalling in later years that he succeeded ''with no other difficulty than the imperfection of the silver plating in copying brick buildings, a church, and other objects seen from my laboratory window.'' None of these specimens, however, is extant. Draper afterwards tried portraiture, at first using a lens of 5 inches diameter (and a 7-inch focal length) and dusting the faces of his sitters with flour. But he soon found that the makeup was unnecessary. He also experimented for a time with lenses of other size. ''The first portrait I obtained last December,'' he wrote in an article published in July 1840, ''was with a common spectacle glass, only an inch in diameter, arranged at the end of a cigar box.'' Draper is also on record as saying that it was ''about this time'' (when he experimented with the spectacle glass) that he became acquainted with Morse, after which the pair took portraits on the rooftop of the University. [23]

The problem, in 1839, was that Daguerre's process was ''still an undeveloped mystery,'' according to Montgomery P. Simons, later a prominent Virginia photographer. ''For some cause or other,'' he said, ''the published accounts of it received were not clear nor definite, and as a matter of course, those who took hold of it in its early stages had a good deal to contend with, being obliged to fill in and work

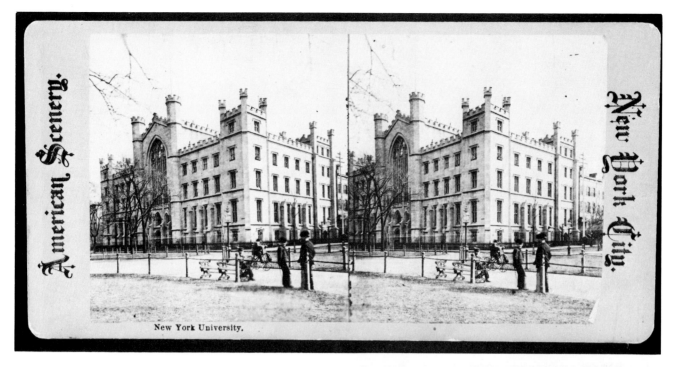

American Scenery. New York University. New York City.

up a picture (so to speak) from indistinct outlines."[24] Morse, Draper, and Wolcott all made different cameras, or had them constructed under their personal supervision. Others who did the same were Joseph Saxton, a curator at the United States Mint; Robert Cornelius, inventor, metalworker, and son of the founder of Cornelius & Sons of Philadelphia, largest American manufacturer (in the 1870s) of gas fixtures; and Prof. Paul Beck Goddard, an associate of Dr. Robert Hare at the University of Pennsylvania. Saxton was first, in Philadelphia, to experiment with the daguerreotype process. He fixed an ordinary sunglass in a cigar box, perfected a makeshift coating box and mercury bath, and on October 16, 1839, from a window in the Mint, secured a view of the Philadelphia Arsenal and cupola of the Central High School. This somewhat indistinct photograph, taken on a burnished piece of silver 1¼ x 2 inches, is the earliest known American-made daguerreotype image to survive to modern times. Saxton also secured a second image from the Mint.[25]

Robert Cornelius, in later years, recounted in these words how he began a brief career in the daguerreotype art (1839–1842), which started with a request for assistance from Saxton:

He [Saxton] was anxious to continue the experiment, and called upon me, and showed his experiment [the daguerreotype made on October 16], and explained to me the manner of doing it, and desired me to prepare some plated metal (copper coated with silver). Very soon afterwards I made in the factory a tin box (and boxes according to Saxton's description), and bought from McAllister . . . a lens about two inches in diameter, such as was used for opera purposes (called achromatic). With these instruments I made the first likeness of myself, and another one of some of my children, in the open yard of my dwelling, sunlight bright upon us."[26]

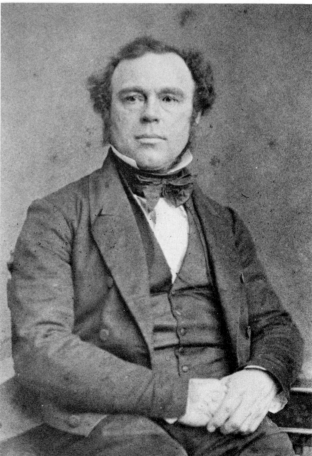

Prof. John W. Draper, shown above in an early paper photograph made by J. DeWitt Brinckerhoff, opened a daguerreotype portrait studio with Samuel F. B. Morse in 1840 atop the New York University building (also shown above) which then stood at Washington Square East and Waverly Place.

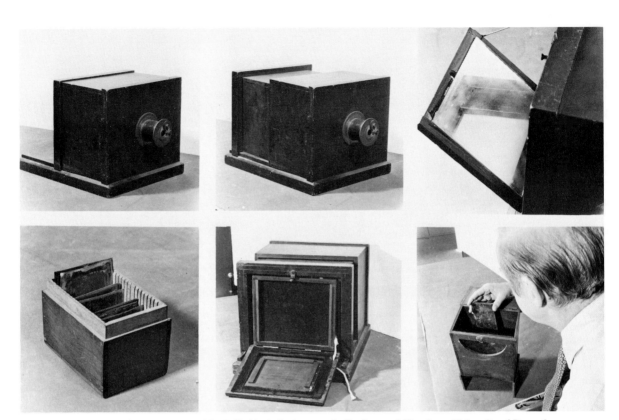

Apparatus owned by Dr. Paul Beck Goddard, Assistant to the Professor of Chemistry, University of Pennsylvania (now part of the permanent collection of the Franklin Institute).

AN EARLY AMERICAN-MADE DAGUERREOTYPE CAMERA

CAMERA, shown in Figures 1 and 2, is of the sliding-box variety (for portability), and is made of white pine blackened within and without. Its dimensions are 10 inches high by 12 inches wide. Interior measures 14 inches when camera is fully extended. Sliding tube protrudes from front of camera, and is protected by a brass cap having an orifice of $^9/_{16}$ inches (controlled by a brass shutter). Achromatic lens, 2 inches in diameter, is set in back of tube.

REAR VIEW MIRROR, shown extended, 3, on a hinged chain at a 45-degree angle from back of camera, is removable and allows easy checking of focus. Image seen on mirror is reflected by camera's ground glass, which is of same size as the mirror (4½ x 6 inches). Mirror is unhooked and removed after focusing.

PLATES used in camera are shown in portable box, 4. Each measures 4¼ x 6¼ inches. Although the exact nature of plates first used by Goddard (and manufactured at the Cornelius & Sons factory) is not recorded, standard daguerreotype plates were soon used with the camera. Plates were made of copper, silvered on one side. Silvered side was first cleaned with rotton stone, then brought to a high polish with a buffer. Great care was exercised to avoid the appearance of lines on the silvered surface.

EXPOSURE was made by removing mirror and ground glass from the back of camera, 5, and substituting a plateholder containing the sensitized image plate. Early exposures with daguerreotype cameras lasted as long as 10 to 20 minutes. Goddard's first portrait was taken in sunshine, reportedly in three minutes with this camera. Exposures by early 1840, achieved by "accelerating" imaging action on plates with the aid of bromine, were down to as little as from 10 to 60 seconds.

FUMING of exposed plate with mercury vapor, after its removal from camera, was accomplished by inserting plate in a special fuming box, 6. Spirit lamp placed beneath box heated mercury. Glass covering on side of box allowed viewing of plates during fuming, and their subsequent removal at the desired moment in "development" process. Iodine, bromine, and mercury used with apparatus were kept in glass-stoppered bottles which could be fitted into the fuming box for convenience of storage.[27]

1839

12

The Cornelius self-portrait (see next page) was in all probability made in November, or just before December 6, 1839, when the director of the United States Mint, Dr. Robert M. Patterson, exhibited a daguerreotype made by Cornelius at a meeting of the American Philosophical Society (unfortunately, the minutes of the meeting do not identify the subject of the image exhibited).[28]

These specimens by Saxton and Cornelius attracted widespread interest in Philadelphia scientific circles, and among the first to become interested in the daguerreotype process was Dr. Goddard. He and Cornelius soon became close working partners, although no formal business association was then established. Both soon ordered similar cameras of unique design (see illustration, left), which were constructed by Joachim Bishop, an assistant to Dr. Hare and the maker of the latter's research and demonstration apparatus. By December, too, Goddard had secured his first successful daguerreotype likeness—of Aaron D. Chaloner, a university student who reportedly posed in the sunshine for three minutes.[29]

By December, too, Goddard had also found the chemical means of treating a sensitized daguerreotype plate just before use in such a way as to substantially shorten the length of time required for an exposure. In this discovery, he was assisted both by Dr. Hare and Dr. Martin Boyé, another associate at the University of Pennsylvania.[30] As long as it

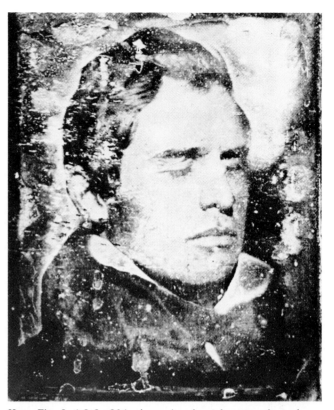

Henry Fitz, Jr. (1808–1863), pioneer American telescope maker and a co-worker with Alexander Wolcott and John Johnson in launching the first American photography studio in New York City. Image, with eyes closed because of the need for several minutes' exposure time, is on a daguerreotype plate of size 1½ x 1¾ inches, and may have been made in November 1839, when Fitz is reported by his son to have made his first daguerreotype portrait, and when an improved reflector was provided by Fitz for Wolcott's first patented American camera. Experiments by the trio were suspended in December 1839, hence the Fitz likeness may have been made in January 1840, or thereafter. Fitz died in his New York home twenty-three years later after being struck by a falling chandelier.

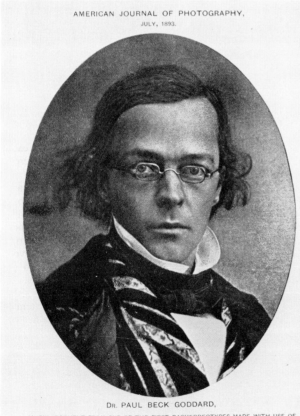

AMERICAN JOURNAL OF PHOTOGRAPHY,
JULY, 1893.

DR. PAUL BECK GODDARD,
AN ENLARGEMENT FROM ONE OF THE FIRST DAGUERREOTYPES MADE WITH USE OF
BROMINE, DECEMBER, 1839.

Dr. Paul Beck Goddard, an associate of the noted Philadelphia chemist and inventor Prof. Robert Hare of the University of Pennsylvania.

was necessary to count minutes instead of seconds for every camera exposure, it was difficult to view the "new art" as applicable to portraiture. When he took the additional step of subjecting a plate already sensitized with iodine to the vapor of bromine (Daguerre's process only called for sensitizing with the slow-acting iodine), Goddard found he could accelerate the securing of an image during plate exposure in the camera. The use of bromine as an "accelerator" in daguerreotype practice evidently remained a Philadelphia secret for a year or more, although John Johnson and a British technician, John F. Goddard (no relation to the Philadelphia chemist), experimented with it in 1840, and a Wolcott "quickstuff" accelerating formula was on the market by 1841. Additional chemical techniques and other methods cutting exposure time were also put into practice by gifted practitioners in the 1850s.

The team of Wolcott and Johnson in New York, meanwhile, continued with their efforts to perfect a patentable "mirror" camera—one that would use a reflector rather than a lens. They felt, with some justification at this early stage in photography, that a reflector could focus more light on the image plate than a lens of any type then available.

1839

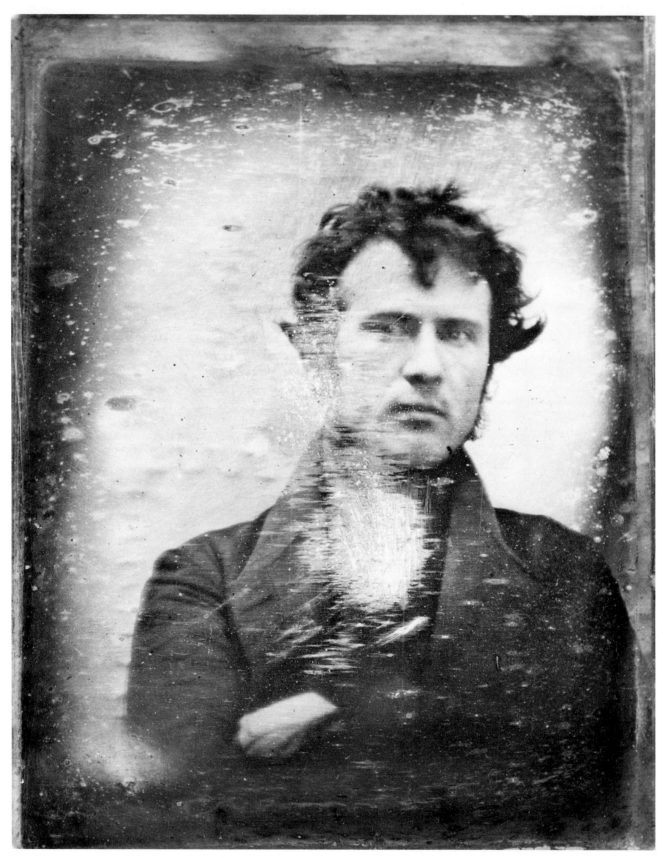

1839

14

Robert Cornelius self-portrait made by jumping in front of a daguerreotype camera in the yard of his Philadelphia home, probably in November 1839. Daguerreotype, from which this illustration has been copied, measures 2¾ x 3¼ inches, and is believed to be the earliest surviving photograph of a human being.

The decision was made to utilize a telescope reflector of 8 inches diameter, whose inner concave surface could reflect and focus light at a point (the focal point) eight inches away. By grinding the reflector's curved surface, the focal length (the distance between the reflector and the focal point) could be increased to 12 inches, which would make it possible to use image plates 2 x 2½ inches in size—still small, but larger than the tiny ⅜th-inch plate used for the first Johnson portrait. The grinding of the reflector was a time-consuming process, and one which Prof. Draper, at the time, didn't think could be done. At this point (late October or early November), Henry Fitz, Jr., thirty-one, a locksmith and later a world-renowned telescope maker (who had previously been associated in business with Wolcott), showed up on the scene. The trio thereupon divided their work—Wolcott attended to his mechanical dentistry business; Johnson set about trying to procure and properly finish good image plates; and Fitz completed the job of grinding and polishing the new reflector (later he said he also constructed the camera). Trials were begun with the camera and new reflector in November, when Fitz possibly made the self-portrait, left (for an illustration of the Wolcott studio and camera system, see page 13). But then Johnson became ill, and further trials were suspended for nearly four weeks, or until January 1840.[31]

Prof. Morse misspelled Daguerre's process when he dispatched his letter from Paris to the *New York Observer* in March 1839. The public, too, evidently found it a tongue twister. Abraham Bogardus, an early practitioner and later first president of a national photographic association, recalled the matter at a dinner meeting late in the nineteenth century:

I remember when the newspapers first announced that a French chemist named Daguerre had, after long experimenting, succeeded in fixing the image shown in the camera obscura on a chemically prepared plate. I remember some of the comments made on the great discovery. One writer said it would probably do away with oil painting. I remember the difficulty the public had in spelling and pronouncing that hard name Daguerreotype—Da-gu-erreotype, Dag-u-erreotype, and the vulgar Daugre-o-type, and finally the Dog-type. I remember the public estimate of the "dark room;" they thought the operator conducted some hocus-pocus affair in there. "Say, now, Bogardus, what do you do in there, do you say something over it?" I remember when a prominent merchant who had had a daguerreotype taken was asked how it was done. He said you sat and looked in the glass (lens) until you "grinned yourself on the plate."[32]

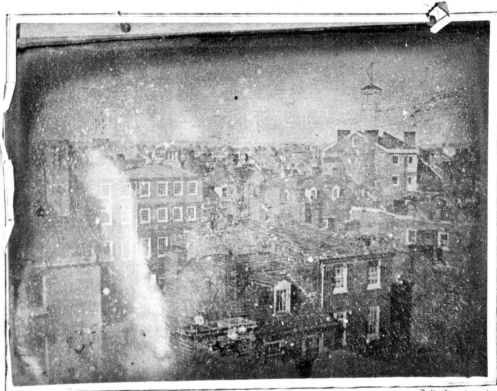

Heliograph *...* *P. B. Goddard*

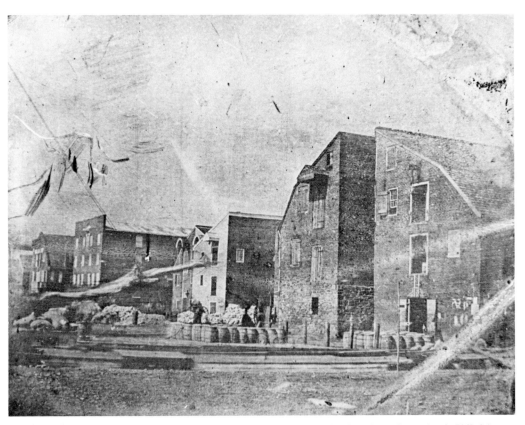

1840

16

Although daguerreotype views were taken by experimenters in New York in 1839, these views taken in Philadelphia are among the earliest extant in the United States. Top view, taken by Dr. Paul B. Goddard, is now in the Franklin Institute. Bottom view is a photographic print copied later in the nineteenth century of a daguerreotype view, now lost, made around 1840 by a Philadelphia dentist, Dr. J. E. Parker.

The United States entered its third year of a severe economic depression in 1840, and both the novelty of the "new art" and the fact that only a small outlay of money was required to begin its practice attracted many people to the new daguerreotype invention. In New York, the team of Alexander S. Wolcott and John Johnson lost no time in exploiting their opportunities. Men such as George W. Prosch, maker of S. F. B. Morse's first camera, placed a line of American-made cameras on the market in March which were somewhat improved from Daguerre's original equipment. But Wolcott and Johnson worked diligently, and secretly, to perfect their camera of different design, which became the first to be patented in the United States (on May 8) and in Great Britain (on June 13).

In their trials the previous October, Wolcott had decided to substitute a concave reflecting mirror (inside the camera) for the refracting lens called for in a standard Daguerre camera. The mirror was positioned such that it reflected a greater amount of light on the image plate than was brought to bear by a Daguerre camera lens. While this resulted in accelerating an exposure, the area of focus was small, restricting plate size to 2 x 2½ inches. If larger pictures were wanted, Wolcott maintained, photographers could always copy the originals on plates of larger size.

Americans were not scenery conscious at this time (as they became later), and perhaps for this reason—and also because most early daguerreotypes were small—daguerreotype cameras were little used to take city, landscape, or architectural views. In Europe it was otherwise; cameras of the Daguerre variety were employed immediately to secure daguerreotype views in many lands. The most notable example was the taking of views by various photographers in France, Italy, Spain, Greece, Egypt, Nubia, Palestine, and Syria under the direction of a Parisian optician, Noël M. P. Lerebours. Although some 1,200 daguerreotypes were secured by Lerebours, only a small portion were used to make copperplate engravings for illustrations of *Excursions Daguerriennes*, a two-volume work published during the years 1841–43. Books illustrated with lithographs made from daguerreotypes were also published in Paris, and in Poland, in 1840.

The earliest American daguerreotype views extant (other than Saxton's view from the U.S. Mint) appear to be those made in Philadelphia in 1839, or early 1840, by Dr. Paul B. Goddard and Dr. J. E. Parker, a dental surgeon. Parker, as well as Goddard, is said to have used bromine as an accelerator for plate exposure.[33] Views made in Boston and New England in April 1840 by Dr. Samuel Bemis, another dentist, have also survived. In addition to Bemis, Edward Everett Hale also is known to have made daguerreotype views early in 1840 in Boston (of a church which he later headed). Both men evidently purchased their cameras from Daguerre's agent, Francois Gouraud, who held a private viewing of daguerreotypes brought with him from France at the Masonic Temple in Boston on March 6. Bemis bought his camera on April 15, and four days later secured a view of King's Chapel in Boston. The view was taken late in the afternoon when the air was dry and it was unseasonably cold. It took Bemis 25 minutes to iodize his plate (he was not privy to Goddard's bromine discovery) and 40 minutes to make the exposure. After that, he later made a series of additional views in Boston and New Hampshire, all of which have survived to modern times. Bemis was fifty-one when he secured these images, and ninety-two when he died in Boston in 1881.[34] The safe-keeping of these pioneer American landscapes can be attributed to his longevity and the precise manner in which he kept records. Bemis' success, in 1840, was also clearly a case of the student outperforming his teacher. For of Gouraud's first Boston lecture on the daguerreotype process, another student, Albert H. Southworth, had this to say:

> His illustrative experiment resulted in his producing a dimmed and foggy plate instead of the architectural details of buildings, and the definite lines and forms of street objects. It happened to be a misty day attended with both snow and rain. The Professor appeared highly elated, and exhibited his picture with great apparent satisfaction, that he had it in his power to copy the very mist and smoke of the atmosphere in a stormy day. Many a photographer has often wished for some natural phenomenon that might serve as a pretext for attributing to some apparent cause the faults of imperfectly understood chemical combinations, or partially polished plates.[35]

In New York, John Johnson had recovered from his "illness" by January (possibly the injurious effects of daguerreotype chemicals on his health, which caused him to abandon daguerreotyping in 1843), and the trio—Wolcott, Johnson, and Fitz—again resumed their experiments. From a historical standpoint, one of the most telling comments Johnson makes in this subsequent (1846) account of this period in their activity (January–March) is the statement that most of the portraits secured—like the first one of Johnson himself—were profiles:

> Up to January 1st, 1840, all experiments had been tried on an economical scale, and the apparatus then made was unfit for public exhibition; we resolved to make the instruments as perfect as possible while they were in progress of manufacture. Experiments were made upon mediums for protecting the eyes from the direct light of the sun, and also upon the best form and material for a background to the likenesses. The length of time required for a "sitting" even with the reflecting apparatus was such as to render the operation any thing but pleasant. Expedients were ever ready in the hands of Wolcott: blue glass was tried, and abandoned in consequence of being at that time unable to procure a piece of uniform density and surface; afterwards a series of thin muslin screens secured to wire frames were prepared as a substitute for blue glass. The objections

to these screens, however, were serious, inasmuch as a multiplication of them became necessary to lessen the intensity of the light sufficiently for due protection to the eyes, without which, the likenesses other than profiles were very unpleasant to look upon.—Most of the portraits, then, of necessity were profiles, formed upon backgrounds, the lighter parts relieved upon black, and the darker parts upon light ground; the background proper being of light colored material with black velvet so disposed upon the light

A PRIMITIVE TABLE OF RULES FOR CAMERA EXPOSURES

This table, published by D. W. Seager in March 1840, suggests that he took numerous daguerreotypes before disappearing into oblivion. But the "rule of thumb" for timing exposures persisted throughout the daguerrean era. Later tables were published from time to time, and crude devices were developed to measure the actinic, or invisible radiant energy of light. But daguerreotypes were normally developed on the spot, and a bad picture was simply taken over again. The publishing, in 1857, of accurate data on the amount of sunlight received at various earth latitudes every hour of every day provided the first scientific basis for the design of exposure meters.[36]

TABLE OF GENERAL RULES FOR EXPOSURE OF THE PLATE IN THE CAMERA, IN TAKING EXTERIOR VIEWS

The following table is compiled partly from observation, and partly from analogy, and applies only to the period from the month of October to February. The observations were made upon ordinary city views.

State of the Weather	Hours of the Day						
	8	9	10	11 to 1	1 to 2	2 to 3	3 and after
	MINUTES	MINUTES	MINUTES	MINUTES	MINUTES	MINUTES	MINUTES
Very brilliant and clear, wind steady from W. or N.W., very deep blue sky, and absence of red rays at sunrise or sunset. Time employed	15	8	6	5	6	7	12 to 30
Clear, wind from S.W., moderately cold, but a slight perceptible vapor in comparison with above. Time employed	16	12	7	6	7	8	15 to 40
Sunshine, but rather hazy, shadows not hard, nor clearly defined. Time employed ...	25	18	14	12	14	16	25 to 40
Sun always obscured by light clouds, but lower atmosphere, clear from haze and vapor. Time employed	30	20	18	16	15	20	35 to 50
Quite cloudy, but lower atmosphere, free from vapors. Time employed	50	30	25	20	20	30	50 to 70

ground, this being placed *sufficiently* far from the sitter, to produce harmony of effect when viewed in the field of the camera. Other difficulties presented themselves seriously to the working of the Discovery of Daguerre, to portrait taking—one of which was the necessity for a constant and nearly horizontal light, that the shaded portions of the portrait should not be too hard, and yet at the same time be sufficiently well developed without the "high light" of the picture becoming overdone, solarized or destroyed. In almost all the early specimens of the Daguerreotype, extremes of light and shade presented themselves much to the annoyance of the early operators, and seriously objectionable were such portraits. To overcome this difficulty, Mr. Wolcott mounted with suitable joints upon the top of his camera a large looking-glass or plane reflector, in such a manner that the light of the sun, (as a strong light, was absolutely necessary,) when falling upon the glass could be directed upon the person in an almost horizontal direction.[37]

Before New York was aware of what they were up to, Wolcott and Johnson sent Johnson's father, William S. Johnson, to London on February 3 to try to arrange for the patenting of the mirror camera in England. Johnson, Sr., arrived at the end of the month "with a few likenesses," according to one British writer, and was put in touch with an English coal merchant and patent speculator, Richard Beard. The pair immediately entered into an agreement looking to an English patent, but, according to John Johnson, the move was opposed by Daguerre's agent in London, who threatened suit. This opposition was withdrawn, however, upon agreement to pay Daguerre 120 pounds annually for the right to employ the mirror camera and to use "all pertaining to the daguerrean art, chemically" in the United Kingdom. As for the financial arrangement with Beard, he paid the Americans 200 pounds and expenses for one half of the invention, and a year after issuance of the British patent (on June 13) paid another 7,000 pounds for the other half.[38]

From John Johnson, meanwhile, we have confirmation (hard to find elsewhere) that a number of now-prominent names, principally in New York and Philadelphia, were engaged in taking daguerreotype portraits and views in the early months of 1840:

From time to time reports reached us from various sources of the success of others, and specimens of landscapes, etc., were exhibited at Dr. James R. Chilton's Laboratory, in Broadway, much to the gratification of the numerous visitors and anxious expectants for this most wonderful discovery. Dr. Chilton, Professor J. J. Mapes, Professor J. W. Draper, Professor S. F. B. Morse, all of this city. Mr. Cornelius, Dr. Goddard and others of Philadelphia. Mr. Southworth, Professor Plumbe, and numerous others were early in the field; all, however, using the same description of camera as that of Daguerre, with modification for light, either by enlargment of lens and aperture for light, or by shortening the focal distance.[39]

Among the first to learn the daguerreotype practice from Morse was Joseph Pennell (not known to be a kin of the famous etcher), who graduated from Bowdoin College on

September 4, 1839. His former schoolmate, Albert S. South-worth, joined Pennell in New York, probably in January 1840. In 1870, Southworth recalled the event:

Thirty years ago last winter I found Mr. Joseph Pennell, of Brunswick, Maine, assisting Professor Morse in the Professor's own building on Nassau street. Mr. Pennell had a few months previously graduated at Bowdoin College in his native town. He had gone to New York for the purpose of procuring pecuniary assistance by some employment of his leisure hours. He had been my former school and room-mate, and had written to me to visit New York and learn respecting the new art. He invited me also to join him as an associate in business for the purpose of making likenesses. He introduced me to Professor Morse, and from him we received all the information and instruction he was able to give upon the subject. Little was then known except that a polished silver surface of plate, coated with the vapor of iodine in the dark, and exposed in the camera obscura for a certain time, and then played over fumes of mercury, would develop a picture in light and shade, the shaded parts being the black polished surface of the plate, and the lights made out by the mercury chalked upon and adhering to it. I do not remember that Professor Morse had then made any likenesses. Very clear, distinct views of Brooklyn in the distance and the roofs in the foreground, taken from the top of the buildings in Nassau street, were upon his table. I do remember the coil of telegraph wire, miles in length, wound upon a cylinder, with which he was experimenting, and which he had prepared to carry over to the New Jersey side, and extend for the purpose of testing the practicability of communicating between distant points by electricity, and the use of his alphabet of dots and marks.[40]

Only a few friends were apprised of Wolcott's and Johnson's progress prior to February, and one of these, a Mr. Kells (a mystery man in the partners' operation) was the first to divulge the news at a meeting of the Mechanics' Institute in which he drew on a blackboard "the whole as contrived by Mr. Wolcott." This gave publicity to the invention, and led immediately to sittings by Morse, Mapes, Dr. Chilton, and others. Morse, according to Johnson, proposed at this time that Wolcott join with him in a daguerreotype business (an invitation which Wolcott evidently declined).[41]

On March 4, the New York *Sun* announced that Wolcott was securing likenesses in sittings lasting 3 to 5 minutes, and said that the miniatures produced were being packaged in cases and sold for $3 apiece. Shortly thereafter, Wolcott moved his operation to the Granite Building at Broadway and Chambers Street, devising a unique studio lighting system (see illustration right) which soon became a showplace. Robert Cornelius reportedly came up from Philadelphia to see it in April, and George Prosch and others, according to Johnson, adopted its reflecting arrangement for their own practice.

While the successful use of bromine as an accelerator for plate exposure appears to have remained a Philadelphia secret during most, or all, of 1840, Johnson said (in 1846) that Morse "and others" were "acquainted with the use of bromine" in 1840, and that Wolcott had even asked Dr. Chilton to prepare a small quantity for his own experimental use. But he "did not succeed very well with it," having "invariably used too much in combination with iodine" for successful results.[42]

Cornelius, aided by the technical expertise of his silent partner (Dr. Goddard), fared somewhat better. According

FIRST PATENTED AMERICAN CAMERA AND STUDIO LIGHTING SYSTEM

Alexander S. Wolcott's "mirror" camera, shown here, is now in the Smithsonian Institution. No lens was in front. Light entered the opening at the front of the box and was reflected by an 8-inch diameter concave mirror onto an image plate measuring 2 x 2½ inches. Studio window sashes were removed and two reflecting mirrors were extended outside the building to deflect sunlight directly at the sitter. The light passed through a plate-glass contrivance (on easel) containing a liquid blue vitriol solution, which muted its intensity. A headrest and background screen are shown behind sitter.[43]

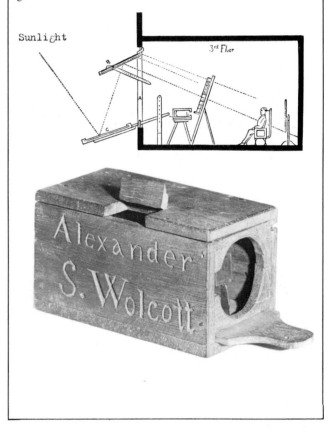

to historian Marcus A. Root, who learned the trade from Cornelius, the latter soon began procuring (indoors) "fair impressions, even without reflectors, in from 10 to 60 seconds."[44]

Another of what Johnson termed the "innumerable obstacles" to the rapid advance of the daguerreotype art was an inability to procure good image plates. Manufacturers at that time were reluctant to prepare silver-plated copper with *pure* silver—with the result that when one attempted to polish such plated metal as could be obtained, the plate would become cloudy or colored in spots (caused by the surface exhibiting more or less alloy, depending on whether more or less silver was removed in the polishing). Johnson stated the problem more fully in these words:

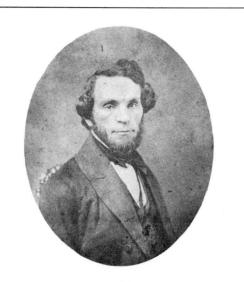

ENTER EDWARD ANTHONY

An 1838 graduate of Columbia (in a class of twenty), Edward Anthony learned photography from Samuel F. B. Morse, but gave up the practice in 1847 to found a supplies business whose name, E. & H. T. Anthony & Co., became world famous after the Civil War. The following remarks, excerpted from an 1883 speech at a photography dinner, relate all that is known of his early years:

> My first acquaintance with photography was by the announcement of the discovery by Daguerre, and on seeing the samples brought from Paris by M. Gouraud, which were exhibited in the building on the cor. of Chambers St. and B'way, N.Y. City.
>
> I immediately became an enthusiastic amateur, and set about manufacturing an apparatus to take daguerreotypes. This I did at large expense, the camera, lens and all costing a sum total of twenty five cents. This will show one point of contrast between the old and new, when we consider that lenses are now constructed for the apparatus costing $500 and $600, and cameras worth over $100. With this crude instrument I amused myself by taking pictures out of the back windows.
>
> In the following season I joined my brother as civil engineer in the construction of the Croton Aqueduct. We there got up a better camera, using the front lens of the levelling instrument. We not only took landscapes, but tried our hand at portraits. We had our axeman sit on a chair against the side of the white house in the bright sun with his eyes closed, and in thirty minutes got a portrait which was considered a great wonder. [45]

Croton Aqueduct, spanning New York's East River, about 1865.

To explain more clearly, it was the practice of most silver platers to use an alloy for silver-plating. In the reduction of the ingot, to sheet metal, annealing has to be resorted to, and acid pickles to remove oxides, &c. The number of times the plated metal is exposed to heat and acid in its reduction to the required thickness, produces a *surface of pure silver*. The most of this surface is, however, so rough as to be with difficulty polished, without in *places* removing entirely this pellicle of pure metal, and exposing a polished surface of the alloy used in plating. Whenever such metal was used, very unsightly stains or spots frequently disfigured the portraits. The portrait or portion of it, developed upon the *pure* silver, being much lighter or whiter than that developed upon the alloy; it therefore appeared that the purer the silver the more sensitive the plate became. [46]

Morse and Draper, once in partnership together, ordered French-made plates; and Prosch, in his first advertisement for commercially available cameras, specified Corduan, Perkins & Co. as his supplier. Not content with these sources, Johnson contacted the Scovill Manufacturing Company in Waterbury, Connecticut, and asked them to provide a roll of silver-plated metal capped with pure silver. This marked Scovill's entry into the photography field, the company in later years becoming a supplier second only to the house of Anthony. But on this initial project, Scovill provided an item which, while "a good article," nevertheless was too costly, according to Johnson. "Soon after this," he said, "some samples of English-plated metal of very superior quality came into our possession, and relieved us from the toil of making and plating one plate at a time." [47]

Southworth and Pennell, meanwhile, at some point in the spring or summer of 1840, established a daguerreotype business at Cabotville, near Boston. "We had the sympathy and substantial assistance of the Messrs. Ames, Chase [probably the pioneer Boston photographer, Lorenzo P. Chase], and Bemis," Southworth recalled later, "and began our business of daguerreotyping on a capital of less than fifty dollars." To obtain "more rapid action by increased light" (for their exposures), the pair fabricated a large lens weighing 55 pounds, which had a diameter of 13 inches and a focal length of 30 inches. But their efforts proved unsuccessful, and by the spring of 1841 they were "deeply in debt," and "often unable to take our letters from the Post Office." Their entire expenses for a week were sometimes as low as 75 cents! [48]

John Plumbe, the first man to advocate building a railroad linking the East with the West, also opened a Boston daguerreotype studio in 1840—the first of a chain of galleries he was soon to establish in other major cities.

As soon as the Wolcott camera patent was awarded (on May 8), Henry Fitz, Jr., headed for Baltimore to establish that city's first daguerreotype business, and Wolcott went to Washington, D.C., where he was evidently instrumental in helping John G. Stevenson open a gallery there on June 30

in "Mrs. Cummings' rooms" on Pennsylvania Avenue, a short distance from the U.S. Capitol building. Five days prior to this, he sent a letter to Johnson in New York, which is among few Wolcott letters or other documents extant. In it he imparts a small insight into the workings of the Wolcott-Johnson business just prior to concentration (in 1841) of their principal attention on the London operation:

> Washington, June 25 1840.
> Friend John— 1 forgot in my last to mention how you should direct your letters—you must send them by Harnden's Express Line to Baltimore, directed to *John G. Stevenson, care of William Hawkins, Baltimore,* and send the receipt you get for the package to Wm. Hawkins at Harrison & Co., requesting him to get the package and forward it to John G. Stevenson at Washington Send me a lot of the gilt frames; Mr. Stevenson has only about five dozen of the cases so if you have any to spare *send;* no glasses on hand but those I brought with me. If you have bought another lot of thermometers send two or three, we have none at present, but will have to buy at a high price; send a few sheets of filtering paper to manufacture distilled water with. How shall I direct my letters to you? I am busy *busy* BUSY, don't think I can be ready before Monday. How many customers has your advertisement brought to your rooms, and how many V's have they left with you? When Mr. Kells finishes the two lens he has on hand, he may, if you think proper, make two more of the same curves and of as large diameter as ¾ glass will allow. Mr. Stevenson intends when he leaves here to go to Baltimore, where he cannot use the reflector.
>
> Yours &c.,
> A. S. WOLCOTT [49]

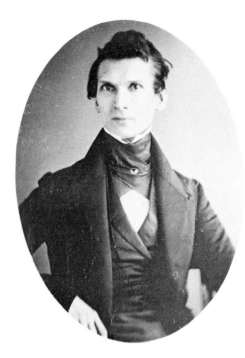

According to a seemingly reliable account published many years later, Morse and Draper opened what was described as a "primitive gallery" atop the New York City University building in April—not the previous December, as Draper has indicated. Morse, according to this account, "supplied the artistic element, whilst Draper attended to the scientific manipulation." The "gallery" consisted of an old room, used as a workshop, and a hastily constructed shed with a glass roof for operating quarters. But it appears to have been an instant success, and during the summer vacation period, the pair evidently made portraits of New York's political and social elite (while Johnson, as we have just seen, resorted to advertising for customers). The portraits were taken only on bright, sunshiny days, however, the darker days being used to teach the art to others. Exposures required 5 to 7 minutes, even in the sunshine.[50]

In August, Morse went to his thirtieth class reunion at Yale, taking his daguerreotype apparatus with him. The assembling of graduates for class reunions that far advanced from the original date of graduation was considered unusual, and the *New York Observer* gave prominent notice to the August 18 event, concluding in its article:

> This meeting was perpetuated in a manner altogether unprecedented by Prof. Morse of the University of this city, who took a *daguerreotype view* of the whole class. Arranging them side by side, he has, by the power of this wonderful art, transferred the perfect likeness of each individual to his plate, so that he has now in his possession the invaluable treasure of the image of his classmates, from whom he has been separated thirty years, and who will probably never be assembled in this world again. The likenesses are so natural that individuals not connected with the class recognize their acquaintances on the plate, without the least hesitation. How valuable would such a memento of early friendship be to every class, on leaving college for the busy scenes of life.[51]

A prominent gathering of men (totaling eighteen) it was, too. Besides Morse (who must have stepped into position during the exposure), the group included Connecticut gov-

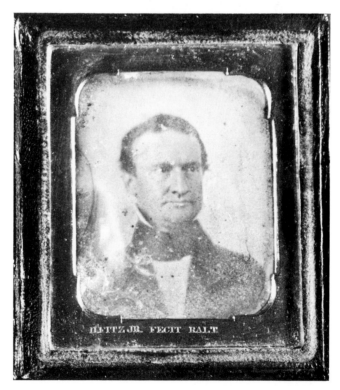

The use of bromine as an accelerator for daguerreotype plate exposures may account for the greater sharpness and quality of the portrait (top) of J. H. F. Sachse, who was the first to pose for Robert Cornelius when the latter opened his Philadelphia gallery in 1840. Discovery of the importance of the bromine accelerator is credited to Dr. Paul B. Goddard, a silent partner in Cornelius' gallery. Portrait of an unidentified man, bottom, was made by Henry Fitz, Jr., on a piece of solid silver. He did not use bromine prior to May 1840, and is not known to have used the accelerator when he opened a gallery of his own in Baltimore shortly thereafter (which he operated until 1844).

AN AMERICAN PHOTOGENIC DRAWING

Possibly the earliest surviving American photographs on paper are a set contained in a personal album at the Franklin Institute, from which the example above has been selected. The photographs are primitive forms of the calotype process, and were made of plants and shells by seventeen-year-old M. Carey Lea before being exhibited by his father, Isaac Lea, at a meeting of the American Philosophical Society in Philadelphia on February 6, 1840.[52]

ernor William Wolcott Ellsworth; his brother, Henry Leavitt Ellsworth, U.S. Commissioner of Patents; Abraham B. Hasbrouck, newly elected president of Rutgers College; Prof. Chauncey Goodrich, of Yale; and Ethan Allen Andrews, a renowned Latin scholar and former professor of ancient languages at the University of North Carolina.

And where has this, and all of the other daguerreotypes, taken by Morse, Draper, Wolcott, Seager, et al., gone? One explanation lies in the fact that the first specimens were inordinately delicate, being composed of an amalgam of silver and mercury, which could be removed from the surface of the plate by the merest touch. Not until the latter part of 1840 was a toning of gold applied to daguerreotypes (a process invented in France which came to be known as "gilding," and which was subsequently adopted univer-

sally). The toning not only improved the appearance of an image but it also rendered it less fragile. Another explanation may be that glass covers were not early adopted as protectors, allowing images to be easily damaged or destroyed. Morse, too, sent at least one plate to Root for use in making an engraving, and may have disposed of others in like fashion (the images ultimately becoming lost, or destroyed). The minutes of a meeting of the American Photographical Society in New York, on February 10, 1862, reveal interestingly enough that John Johnson had in his possession at that late date "about one thousand" daguerreotypes made prior to introduction of the gilding process. "Of these a majority are in perfect preservation," Prof. Draper, president of the society, stated in his annual address read at the meeting. "Where change has occurred it appears as a film of deposited matter, which commonly commences to form at the mat," Draper said. "It has been observed that ungilded daguerreotypes fade sooner if kept in a warm place, this being perhaps due to the vaporization of the mercury of the amalgam constituting the lights."[53]

Some early plates were also simply discarded as not worth keeping at the time. One man who said he posed for eight minutes at Wolcott's studio in February 1840 furnished his own solid silver plate, which was used to make his likeness. "After plates became plenty and cheap," he told the *American Journal of Photography* in 1861, "I considered the metal worth more than the portrait and sold it. I regret very much that I did not preserve it."[54]

The state of the art in daguerreotype portraiture, as of December 1840, was best summarized by W. H. Goode, a former assistant to Draper who by then had transferred to the Medical College in New Haven. His principal findings were these:

- Pictures of the largest size—eight inches by six—are taken with the French achromatic lenses, perfect throughout; the parts within the shade are brought into view, distant objects are perfectly delineated. A common spectacle lens, an inch in diameter, of fourteen inches focal length, adjusted by means of a sliding tube, into one end of a cigar box, answers very well to take small pictures . . . this apparatus . . . recommends itself by its cheapness—costing about 25 cents.
- Plates for daguerreotype purposes are either of American manufacture, or they are imported from France. American plates are exceedingly imperfect. The silver abounds with perforations, which appear as black dots in the pictures; it also assumes a yellow instead of a white coat in burning.
- The possibility of obtaining impressions on an iodized surface in any kind of weather has been amply demonstrated. Generally, however, to obtain proofs successfully, a dry atmosphere, a pure white light, and a clear blue sky, are required. Attempts made to obtain them the day after one of rain—when snow is melting rapidly—or when the sun's light is of a yellowish tint, will generally be fruitless. The proofs taken with the light of a yellowish cast are frequently black.
- The camera operation is usually completed in from 1 minute to 2½ minutes; portraits, however, have been obtained in 10 seconds.[55]

1841

In October 1840, John Johnson left New York to join his father at the Beard studio in London. There was a considerable delay before the studio's official opening, due to the continued experimentation with chemical techniques for accelerating camera exposures. Beard had hired an assistant in midsummer, John Frederick Goddard (no kin of the Philadelphia chemist), who had been serving as a lecturer on optics and natural philosophy (a nineteenth-century term for scientific pursuits) at the Adelaide Gallery. After John Johnson's arrival, both he and Goddard devoted a great part of their time to these experiments. Both used the same mirror camera—Johnson at first continuing experiments begun in New York with nitro-muriatic acid (a solution which he found "reacted and formed a peculiar chloride of iodine . . . preferable to simple iodine"), then experimenting with chloride of iodine directly. John Goddard, on his part, discovered "a rather valuable combination of chemicals," according to Johnson, which consisted of a mixture of iodine, bromine, iodus, and iodic acid. A proper combination of these solutions "gave an action (on the daguerreotype plate) somewhat more sensitive than chloride of iodine." [56]

On February 12, 1841, John Goddard used his new formula to take a daguerreotype of Johnson's father, which was accomplished on a rainy day in a matter of 2 minutes and a few seconds. The same day, Goddard also took a self-portrait, and on the sixteenth, a portrait of his own father. On the eighteenth, he exhibited these specimens at a meeting of the Royal Society (among those present being Sir Charles Wheatstone, who the previous year had appeared before the same body to demonstrate the principle of binocular vision and a primitive stereoscope illustrating the new principle). Because bromine was to become such an essential factor in daguerreotype portraiture, Goddard's description of the chemical reaction resulting from a combination of bromine and iodine (published two months before the Royal Society meeting) is informative:

> If iodine and bromine are placed together in equal porportions, they instantly combine and form a new compound, the bright, scaly crystals of the former dissolving, and the new substance crystallizing in dark microscopic crystals of a beautiful arborescent appearance. These are exceedingly volatile, more so than iodine alone, the vapor attacking the silver surface in a similar manner, and so delicately sensitive are the plates, when properly prepared, that the faintest light acts readily on them, even in the dull, cloudy days of November, with a London atmosphere, if not too foggy. [57]

In keeping with a policy of the Royal Society to acquire deposits of sealed packets covering data on technical advances, Goddard submitted a packet covering the results of his experiments on March 2, 1841 (a report which, when opened twenty-three years later, revealed that he had used a more elaborate formula than the one published in December 1840). But Johnson still felt that the "high lights" in Goddard's specimens would become "solarized, or overdone" more frequently than was the case with portraits secured

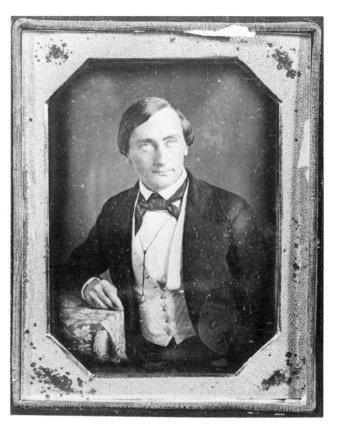

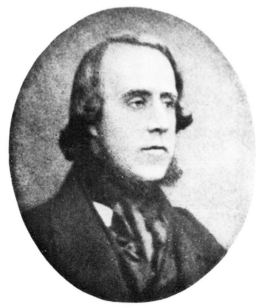

Prof. Martin Boyé (top) of the University of Pennsylvania is credited with first suggesting to his colleague, Dr. Paul B. Goddard, the possible value of using bromine to accelerate daguerreotype plate exposures, which Goddard thereupon adopted and perfected chemically in December 1839. In February 1841, John F. Goddard (bottom), no kin of the Philadelphian, perfected a similar method independently at the Richard Beard Gallery in London. Bromine was used by daguerreotype photographers universally thereafter.

2ND U.S. PATENT IN PHOTOGRAPHY

Patent was assigned to John Johnson on December 14, 1841, for a method of polishing the silvered metal plates on which exposures were made in daguerreotype cameras. He described his pioneering work in this 1846 statement:

> Having it now in our power to obtain good plated metal, a more rapid mode of polishing than that recommended by Daguerre, was attempted as follows:—
>
> This metal was cut to the desired size, and having a pair of "hand rolls" at hand, each plate with its silvered side placed next to the highly polished surface of a steel die, were passed and re-passed through the rolls many times, by which process a very smooth perfect surface was obtained. The plates were then annealed, and a number of plates thus prepared were fastened to the bottom of a box a few inches deep, a foot wide, and eighteen inches long; this box was placed upon a table, and attached to a rod, connected to the face plate of a lathe, a few inches from its centre, so as to give the box a reciprocating motion. A quantity of emery was now strewn over the plates, and the lathe set in motion. The action produced was a friction or rubbing of the emery over the surface of the plates. When continued for some time, a grayish polish was the result. Linseed when used in the same manner gave us better hope of success, and the next step resorted to, was to build a wheel and suspend it after the manner of a grindstone. The plates being secured to the inner side of the wheel or case, and as this case revolved, the seeds would constantly keep to the lower level, and their sliding over the surface of the plates, would polish or burnish their surfaces. This, with the former was soon abandoned; rounded shots of silver placed in the same wheel were found not to perform the polishing so well as linseed. Buff-wheels of leather with rotten stone and oil proved to be far superior to all other contrivances; and subsequently, at the suggestion of Professor Draper, velvet was used in lieu of buff leather, and soon superceded all other substances, both for lathe and hand buffs, and I would add for the benefit of new beginners, that those who are familiar with its use, prefer cotton velvet. The only requisite necessary, is that the buffs made of cotton velvet should be kept *dry* and *warm*.[61]

with chloride of iodine "applied as one coating" to a daguerreotype plate. In July, Wolcott arrived from New York. According to Johnson, he proceeded to experiment with a combination of iodine, bromine, and chlorine, achieving "more or less success." But the difficulty of exactly combining the three elements—such as "to produce a certainty of result with harmony of effect"—was the work of many months, "the slightest modification requiring a long series of practical experiments, a single change consuming, frequently, an entire day in instituting comparisons, etc., etc."[59]

However extensive these experiments may have been, it was still necessary to count minutes instead of seconds in making a camera exposure. By March 23, the date of the Beard studio's official opening, it was still not possible to secure a daguerreotype portrait in the 10 to 60 seconds reportedly accomplished by Robert Cornelius a year earlier in Philadelphia. Cornelius' success was due to the efforts of the University of Pennsylvania chemist Dr. Paul B. Goddard, aided by a number of colleagues. It appears that one of these, Prof. Martin Boyé, proposed a combination of bromine and iodine in definite proportions, and that the successful "Philadelphia method" for plate acceleration was ultimately worked out by an "interchange of ideas" between Goddard, Joseph Saxton (of the U.S. Mint), and Prof. William G. Mason, an accomplished engraver.[60] The exact formula was said to have been published later, but one of the best recorded descriptions of what was involved—a so-called third step in sensitization, presumably introduced by the Philadelphia experimenters—is to be found in this excerpt from an article published in Philadelphia around the time of photography's centennial in 1939:

> Sensitization was effected by first placing the polished (daguerreotype) plate, in a holder, inside a box filled with iodine vapor. From this box the plate was transferred to another, similar in construction, containing the vapor of bromine. The plate was then returned to the iodine box to complete the sensitization. This last step was necessary to prevent the finished daguerreotype from having a bluish tone in the whites. Some of the earliest daguerreotypes made with the use of bromine, and before this third step in sensitization was discovered, are in the collection of the Historical Society of Pennsylvania. These were undoubtedly made by either Professor Goddard or Professor Boyé of the University of Pennsylvania. . . . Shortening the time in the first insertion in the iodine box increased the sensitivity, but made for thinness which was not adapted for portraiture, although suited to views.[61]

John Johnson was awarded the second American patent in the field of photography (see description, left) for a method of polishing daguerreotype plates before use. While at the Beard studio in London, he also supervised the manufacture and polishing of plates at a factory in Birmingham. On his part, Wolcott attended to the manufacture of mirror cameras at a factory in London. Branch portrait galleries were established by Beard in Liverpool (September), Southampton (October), Brighton (November), and Manchester (also in November). Johnson evidently handled the Liverpool and Southampton openings, but returned to the United States in October prior to the openings in Brighton and Manchester in order to marry a boyhood sweetheart in his native Saco, Maine.[62]

By September, Beard's chief rival, Antoine Claudet, was making daguerreotype portraits at the Adelaide Gallery, using a Daguerre style rather than a mirror-type camera. *The Spectator,* after viewing both operations, decided London's best portrait photographs were being made at the Beard studio (see next page). But this acclaim was to be short-lived. Cameras without lenses (i.e. the mirror camera) were not the real answer to photography's needs. This was to come in the form of the first true camera lens, which had been designed and constructed in Austria during 1840. Strangely, this all-important invention was ready by the time the Beard-Claudet rivalry first began, but was not properly brought to the world's attention until 1843 (see page 39).

When Wolcott went to London in July, M. D. Van Loan took over his New York studio, and on July 19 placed an advertisement in the New York *Tribune* in which he stated that likenesses could be taken "from 7 A.M. till sundown, in any kind of weather—clear, cloudy or rainy." Other ads in a similar vein soon began to appear. A. Page advertised that he could take likenesses in any kind of weather "in a few seconds."[63] Despite these claims, reality was usually a different story. The noted Rochester daguerreotypist of the 1850s, Edward T. Whitney, recalled in later years this opinion of the first specimen he ever saw:

I was visiting a friend in Newark who showed me a daguerreotype case with what looked like a plate of polished steel in it, and stating at the time that it was his likeness. I looked and looked. Finally, by many turns and twists, I caught the shadow. The likeness was good but perfectly black. It was taken by Seth Boyden, the great inventor. I afterward sat for him in his observatory at Newark; the time of the sitting was 15 minutes; results—some black dots on a white vest, but no likeness.[64]

Montgomery P. Simons, another veteran looking back to his early daguerreotype days, summed it up this way:

Ah! those were the days of trials and many tryings of contingencies, of slow iodine, slow cameras and consequently long sittings, when an artist might very easily have taken his dinner whilst his sitter was sweating out a picture in the sun. This, then, should have been called *long* as well as *"high"* art." Few were able to sit long enough to be "taken off" quietly, and fewer still could go through the mysterious operation without receiving a bunged eye or having some other feature knocked into a condition not the most flattering to be handed down as one's facsimile.[65]

The story is told that a young assistant working with Robert Cornelius in Philadelphia was bribed to tell his employer's method of using bromine as an accelerator in 1841, and that he subsequently worked for several weeks in New York divulging the entire secret. Just when this took place is not recorded, but in all probability during or before the summer. For as early as October 2, George Prosch, the first to supply cameras in New York, began advertising the commercial availability of a French brand of bromine to the trade. This suggests that bromine was by then generally accepted as a principal chemical, along with iodine, for successful daguerreotype portraiture. Yet the record also shows that in the latter part of 1841, Prof. Draper, working with Frederick Augustus Porter Barnard, later president of Co-

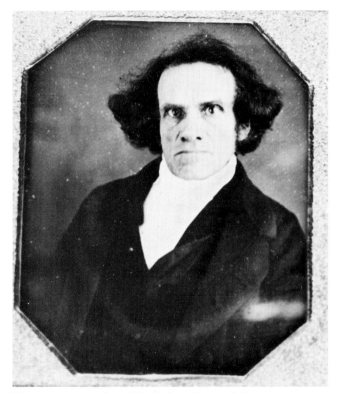

This daguerreotype of an unidentified man is typical of many an icy stare adopted by sitters during long camera exposures in the early daguerreotype years.

lumbia College, was conducting experiments with chlorine for plate acceleration use.[66]

George Prosch's "warranted good" French bromine may have attracted many customers in 1841, but this is how E. T. Whitney characterized its early general use:

Bromine at first caused much trouble by flashing over the plate and fogging the image. To overcome this we constructed a glass box with a glass fan in it, the place under the coating box having a hole in the bottom, covered by a slide. When the bromine was wanted, the slide was drawn, and the fan was then used to draw up a small portion of the vapors into the coating box. By closing the slide we had just enough stored to coat one plate. But this troublesome and uncertain remedy was overcome when it was found that lime would hold the bromine and give off the fumes slowly. Before this we experimented with "closed doors" each morning before admitting sitters, and often after admitting them, thinking all was right, would discover that we had to dismiss them with excuses about the weather, etc. Thus, through much tribulation, we at last emerged under a clear sky; but complete success was not attained until we galvanized the plates with pure silver before buffing.[67]

Galvanizing—a method of electrically charging a plate before exposure—was tested as early as the summer of 1841 by Daguerre in Paris, but without success. Whitney's cousin in St. Louis, T. R. Whitney, began experiments of a similar nature after observing the effects of thunderstorms on camera exposures:

In the year 1841, while practicing the art in St. Louis, Mo., I was at times, during the summer, much troubled with the electric influence of the atmosphere, especially

MIRROR CAMERA SHINES IN LONDON DAGUERREOTYPE RIVALRY

Richard Beard's portrait gallery atop the Polytechnic Institute and Antoine Claudet's studio at the Adelaide Gallery were the only two photographic portrait galleries in London when this article in *The Spectator* appeared on September 4, 1841:

PHOTOGRAPHIC MINIATURES.

INVITED lately by M. CLAUDET to witness his method of taking Photographic Miniatures, in operation at the Adelaide Gallery, we had an opportunity of ascertaining in what consists the difference between it and that of Mr. BEARD at the Polytechnic Institution, and of comparing the results of each. As the sun-limned portraits are become very popular, on account of the quickness and cheapness of the process and the force and minute fidelity of the resemblances, though they are unflattering to disagreeableness, an explanation of the two methods may be interesting.

To render the Daguerreotype applicable to the purpose of portraiture, it was necessary to accelerate the action of light on the plate; for rapid as was the formation of the image, even five minutes was too long for any sitter to remain perfectly still. This has been accomplished by various modifications of the chemical preparation of the plate, which it is needless to specify: suffice it to say, that the diminution of time required to form the image is in the ratio of seconds to minutes. The process of Mr. BEARD is the quicker of the two; but as M. CLAUDET takes two different views of the face at once in two cameras, and Mr. BEARD two in succession in the same, the time required to produce a couple of miniatures is about equal in both cases.

The principal difference, and that which affects the likeness, is the means of transmitting the image formed by the pencils of light on to the plate. M. CLAUDET accomplishes this by refraction, Mr. BEARD by reflection,—that is, M. CLAUDET, following the practice of DAGUERRE, transmits the rays of light radiating from the face of the sitter through a plano-convex lens; while Mr. BEARD avails himself of the improvement of an American optician, of which he has purchased the patent, and reflects the image on to the plate by a concave mirror. The distortion of the image in the refracting medium is less in amount than that of the reflector, and of the opposite kind,—that is, the image transmitted by the convex lens is larger in the centre and smaller at the circumference; while that of the concave reflector is smaller in the centre and larger at the circumference: though the deviation in either case is so slight, owing to the smallness of the surface affected by the rays of light, that it is almost incalculable. But the image transmitted through the lens is reversed laterally,—that is, the left side of the face appears to be the right in the miniature, and *vice versa;* so that if a sitter had the right eye closed the left would be closed in the miniature, and a person taken in the act of writing would appear to be left-handed. This reversal of the lineaments has an injurious effect on the likeness; much more so than the slight deviation from actual proportion in those taken by the reflector. M. CLAUDET has a process of fixing the portrait which is peculiar to himself; but that adopted by Mr. BEARD has not been known to fail, as far as we can learn, though we have seen miniatures exposed to the light for several months without changing: the process of gilding them, however, effectually secures the plate from the influence of climate, and any but violent injury.

On an attentive comparison of the two, we are bound to say that the Photographic Miniatures taken at the Polytechnic Institution by Mr. BEARD's process are superior to those taken by M. CLAUDET at the Adelaide Gallery, in fidelity of resemblance, delicacy of marking, and clearness of effect; in a word, they are more pleasing and artistical: the shadows are denser and the lineaments less defined in those produced by M. CLAUDET; though these objections are less important than the reversal of the countenance and figure.

At the Adelaide Gallery we saw two or three cancelled miniatures of persons who had very red faces, which looked black and heavy; from which we infer that the redness of the lips contributes to give to the mouth the dark tint that, added to the strong shadow between and below the lips, makes this feature look larger and coarser than in life, at least in the instance of persons with full and prominent lips. The

Cruikshank's *Omnibus* published this illustration of Richard Beard's London daguerreotype studio some years after it was opened on March 23, 1841. Two of Alexander Wolcott's American-made mirror cameras can be seen on the shelf pointed at the sitter. An assistant on the stepladder times an exposure, while another, right, appears to be burnishing the silvered surface of a daguerreotype plate prior to its use in the camera for another portrait. The laboratory can be seen through the opened door.

grave look and formal attitude commonly assumed by the sitters, being faithfully reflected in the miniature portrait, the sombre effect of the strong shadows and colourless lights of the photograph is increased to an unpleasing degree of sternness, occasionally amounting to a repulsiveness, and sometimes even falsifying the likeness: an animated expression, therefore, is essential to the production of a pleasing portrait, and the most vivacious countenances appear to the best advantage. In every case, however, the want of brilliancy in the eyes, and the strong shadows beneath the nose and about the mouth, cause the physical peculiarities of form to predominate in an exaggerated degree. The apparatus used to steady the head gives a fixed and constrained air to the sitter; and it would be well if this could be dispensed with, that persons might assume their habitual posture and be at ease. The great pains taken to place the sitter and to satisfy the parties with the likeness, by taking fresh ones if the first is defective, indicates a praiseworthy willingness to please. The photographs may best be copied through a powerful lens, not only for the sake of enlarging their size, but for bringing out the details of form and lightening the intense shadows: the mere addition of colour to the copy will effect a marvellous improvement, and may, perhaps, render a fresh portrait painted from the sitter unnecessary: the photograph alone will satisfy but in few instances.

QUICKSTUFF

By the end of 1841, ready-made chemicals, called "quick-stuff" in the trade, were placed on the market for use in accelerating camera exposures. Among the best known, both in the United States and in England, was a formula bearing Alexander S. Wolcott's name. Eleven years after its introduction, *Humphrey's Journal* termed it "one of the first and most valuable sensitives introduced to facilitate the operator in forming an image by the camera," adding that "probably no chemical before the Daguerreotype public has so often been counterfeited as this." The *Journal'* s further comments and publication of the formula follows:

WOLCOTT'S MIXTURE

Woolcott's Mixture was one of the first and most valuable sensitive introduced to facilitate the operator of forming an image by the camera. This compound has been known to our operators under different names, as *Van Loan's* Quick, and *Mayall's* Quick, probably no chemical before the Daguerreotype public has been so often counterfeited as this.

Through the kindness of Mr. J. JOHNSON, the former partner of Mr. Woolcott, we are enabled to give the *true* receipt for preparing the mixture known and used as *Woolcott's*.

> One part of Bromine,
> Eight parts of Nitric Acid,
> Sixteen parts of Muriatic Acid,
> About 100 parts of Water.

The above should be allowed to stand several days, and a few *drops* can be put into the coating box, containing, if a half size box about three ounces of pure water, the strength of the mixture is soon gone, and it requires frequent renewal.

The impressions successfully produced by this combination are exceedingly brilliant, but it requires an operator of certainty and much skill to use it, from the fact of the volatile agents employed.

We have a half ounce bottle hermetically sealed, which is filled with Woolcott's mixture, made in 1841. [68]

A FATHER PHOTOGRAPHS HIS SON

Horace Finley, age four, posed outdoors for 4 minutes while his father, Marshall Finley, a teacher, made this daguerreotype in 1841. Marshall Finley had never seen a camera or a lens when he decided to construct his own camera and his own lens arrangement, purchasing all materials locally. His first daguerreotype was of the family barn, but the first "good" image was of Horace. In 1842, the Finleys moved to Canandaigua, New York, where Marshall Finley co-authored, with Samuel D. Humphrey (in 1849) *A System of Photography,* one of the first books on photography published in the United States. The book was printed on the press of the local newspaper. Until his death in 1893, Marshall Finley was among the most prominent of upstate New York photographers, and was named president of the town of Canandaigua in 1872 and 1873. Horace Finley also became a noted photographer, the Finley gallery name carrying on well into the twentieth century. [69]

on the approach of a thunder-storm. At such times I found the coating of my plates much more sensitive than when the atmosphere was comparatively free from the electric fluid, and the effect was so irregular that no calculation could counteract the difficulty. This satisfied me that electricity was in some measure an important agent in the chemical process, and it occurred to me that the element might be turned to advantage. I determined, therefore, to enter on a series of experiments to test my theory. Finding it impossible to obtain an electric machine, and unwilling to abandon the examination, it occurred to me, that the galvanic influence might answer the same purpose. I therefore proceeded to make a galvanic battery in the following simple manner. I obtained a piece of zinc about two inches long, one inch wide, and an eighth of an inch thick. On this I soldered a narrow strip of copper, about six inches long, the soldered end laid on one side of the zinc, and extending its whole length. The battery was completed by placing the zinc in a glass tumbler, two-thirds full of dilute sulphuric acid, strong enough to produce a free action of the metals. The upper end of the copper slip extending

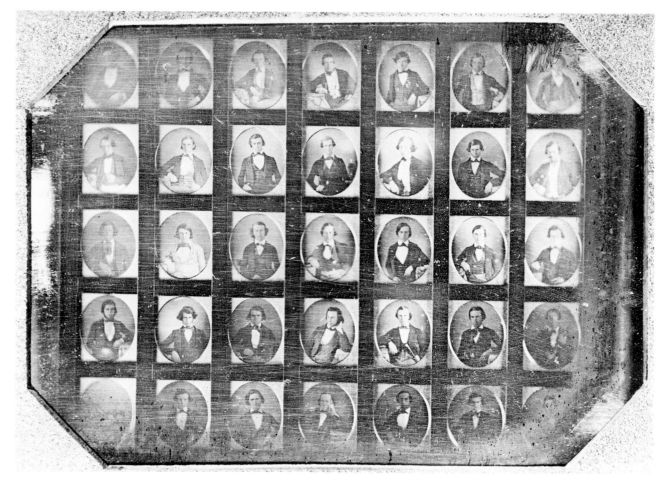

Prof. Samuel F. B. Morse made what is believed to be the first photograph of a group of graduates when he daguerreotyped the Yale class of 1810 at its thirtieth reunion in New Haven, Connecticut, on August 18, 1840. The illustration above is an enlargement of a group of thirty-five daguerreotype images, each only one-half-inch square, presumably of students whose names and institution remain unknown. Images could be tiny originals (possibly made with a Wolcott mirror camera) or tiny copies of larger daguerreotype portraits made to fit the actual frame size of 3¼ x 4¼ inches.

above the tumbler was sharpened to a point, and bent a little over the glass.

The method of using, was thus :—After preparing the plate in the usual manner and placing it in the camera, in such manner as to expose the back of the plate to view, the battery was prepared by placing the zinc in the acid, and as soon as the galvanic fluid began to traverse (as could be known by the effervessence of the acid, operating on the zinc and copper) the cap of the camera was removed, and the plate exposed to the sitter ; at the same instant the point of the battery was brought quickly against the back of the plate, and the cap replaced instantly. If the plate is exposed more than an instant after the contact, the picture will generally be found solarized. By this process I have taken pictures of persons in the act of walking, and in taking the pictures of infants and young children I found it very useful. [69]

Prof. Draper's duties at New York City University prevented him from continuing to work with Morse, probably after the conclusion of the summer vacation period, and the latter, in his own words, "was left to pursue the artistic results of the process, as more in accordance with my profession." Actually, Morse was in a state of near poverty—waiting for congressional action (which came in 1843 with some lobbying by his classmate, Henry Ellsworth, the Commissioner of Patents), funding an experimental telegraphic line between Baltimore and Washington. David Hunter Strother, the noted magazine illustrator of the 1850s and a breveted brigadier general and consul general in Mexico after the Civil War, recalls Morse's plight in a reminiscence published in Morse's official biography. "I engaged to become Morse's pupil and, subsequently, went down to New York and found him in a room in University Place. He had three other pupils, and I soon found that our Professor had very little patronage. I paid my fifty dollars; that settled for one quarter's instruction. Morse was a faithful teacher, and he took as much interest in our progress as—more, indeed, than—we did ourselves. But he was very poor. I remember that when my second quarter's pay was due, my remittance from home did not come as expected, and one

day the Professor came in and said, very courteously, 'Well, Strother, my boy, how are we off for money?'

" 'Why, Professor,' I answered, 'I am sorry to say I have been disappointed, but expect a remittance next week.'

" 'Next week!' he repeated sadly, 'I shall be dead by that time.'

" 'Dead, sir?'

" 'Yes, dead by starvation!'

"I was distressed and astonished. I said hurriedly, 'Would ten dollars be of any service?'

" 'Ten dollars would save my life; that is all it would do.'

"I paid the money, all that I had, and we dined together. It was a modest meal but good, and after he had finished, he said, 'This is my first meal in 24 hours. Strother, don't be an artist. It means beggary. Your life depends upon people who know nothing of your art and care nothing for you. A house dog lives better, and the very sensitiveness that stimulates an artist to work, keeps him alive to suffering.' " [71]

Morse's influence on American daguerreotype portraiture was nevertheless sizeable. From him, many of the most illustrious early photographers not only learned their trade but more importantly were given the rudiments of the traditional art form as it applies—in oil as well as photographic portraiture—to lighting, proportions, subject posing, facial expression, and the like.

But at the same time, the concurrent advent of the traveling salesman, whose wagons meandered over the highways and byways of the land, provided an unschooled medium for the spread of the ''new art'' to rural as well as urban communities. Advertisements by itinerant daguerreans began to appear in contemporary newspapers of this period, in many cases short-lived—due, usually, to an unfavorable response to their ''art'' by local citizenry. A Mr. Salisbury, for example, placed an ad in a Chicago newspaper in March 1842, making him possibly the first photographer to operate in that city; but within two weeks the advertising ceased, and Mr. Salisbury disappeared into oblivion. [72]

AN EARLY CALOTYPE VIEW MADE IN BOSTON

The earliest surviving American photographs made by the calotype process patented in 1841 by inventor W. H. F. Talbot may be a set of views made in Boston in 1842 by fifteen-year-old Josiah Parsons Cooke, later head of the chemistry department at Harvard. The view above from this collection shows a portion of the Boston Museum, left, and the Old Merchants Building, center. It is possible that Cooke made the photograph after reading of a further technical improvement in Talbot's process published in February 1842 by a fellow Bostonian, twenty-two-year-old William F. Channing.

1842

Methods of coloring daguerreotypes were introduced in 1842, and the public evidently responded to the novelty with much the same enthusiasm which greeted the arrival of genuine color photography in the present century.

The first coloring patent (the third patent awarded in the photographic field) was awarded March 28, 1842, to two Lowell, Massachusetts, operators, Benjamin R. Stevens and Lemuel Morse. It specified application of a transparent protective varnish over the image, after which the plate could be hand-colored with paints. A second patent, awarded the following October 22 to Daniel Davis, Jr., of Boston, called for gilding the plate by fixing deposits of transparent colors (applied to selected areas of the image) with the aid of a galvanic battery. Both methods were probably widely used, but in the case of the Davis patent, many photographers used a spirit lamp instead of a battery to heat the rear of the plate in those portions where evaporation of a gilding solution (applied to the face of the plate) was wanted. The Davis patent was assigned to John Plumbe, Jr., shortly after its award, and by 1843 Plumbe was advertising the capability of producing colored daguerreotypes at a chain of galleries he had established by then in Boston, Albany, Saratoga Springs, New York, Philadelphia, and Baltimore.[73]

An apparently momentary interest in paper photography occurred at this time in Boston. The previous year (on February 8, 1841) Talbot patented an improved paper photography process in England, which came to be known, interchangeably, as the "calotype" or "Talbotype" process. In his original invention, that of making photogenic drawings, the paper negative was left exposed in the camera until the image became visible on it. In the calotype process, the negative paper was exposed in the camera, then removed while still blank, the image being developed chemically thereafter.

As early as February 1842, William F. Channing, twenty-two, son of the noted Boston clergyman and author, published a method of simplifying the preparation and treatment of the paper both before and after its exposure in the camera. The English responded admirably, one authority citing Channing as "the first to publish any method by which the calotype process could be simplified." Channing, on his part, felt that "there is no science which is now advancing so rapidly as photography," and modestly stated that he expected "these processes" which he had proposed "will soon undoubtedly be superseded."

Possibly Channing collaborated with, or served as an inspiration for, another young Bostonian, Josiah Parsons Cooke, fifteen, who produced in 1842 the first of a series of calotypes which today are the earliest such American specimens extant. Cooke was obsessed with chemistry and was an early version of the proverbial American youth puttering at home with a chemistry set (which of course did not exist at that time). As a boy, he even attended a series of Lowell Lectures by the elder Benjamin Silliman. In 1850, he began an illustrious career as head of the chemistry department at Harvard. But in 1842–44, he made a series of calotype views in Boston, the first being a view taking in portions of the Boston City Hall and the Boston Museum, then adjacent to it. Photography was not to become his vocation, hence these photographs merely exemplify one phase of his scientific endeavors during his younger years.

The Channing and Cooke exploits appear to have been nothing more than two straws in the wind.[74] Talbot's patent, as we shall see, exerted a restrictive influence on the practice of the calotype at the very moment when practice of the daguerreotype was beginning to assume sizeable proportions. The most outstanding calotypes produced anywhere in the 1840s were those made in Scotland (where the patent did not apply) by David O. Hill and Robert Adamson. But a full appreciation of the Hill-Adamson works did not capture the world's attention until their "rediscovery" in the 1890s. An American patent for Talbot's process was secured in 1847, but to no avail. American photographers showed no real interest in its practice until the 1850s when all attempts by Talbot to patent his own and other paper photography processes were voided, and a French modification of his process was adopted by a number of American photographers.

Despite the problems of lengthy exposures and poor lenses, the camera was taken into the field on at least three American exploratory missions in this early period. There is some confusion as to its application on two excursions to the Yucatan made in the fall of 1839, and again in the autumn of 1841 by John Lloyd Stephens, the noted travel writer, and Frederick Catherwood, archaeologist, surveyor, architect, and illustrator. Stephens was a sponsor of D. W. Seager's lecture on the daguerreotype process held in New York on October 5, 1839, but was not present for the occasion, having departed for the Yucatan with Catherwood just two days previously. In his first book on the 1839–40 explorations of lost Mayan stone cities on the Mexican peninsula, Stephens implied that a daguerreotype camera had *not* been taken along. On the second trip, which lasted from the autumn of 1841 to June 17, 1842, Stephens and Catherwood (accompanied this time by Dr. Samuel Cabot of Boston) *did* take a daguerreotype apparatus with them, although Stephens reported in his second book that Catherwood was dissatisfied with the results obtained with the camera.[75]

But these reports by Stephens are at variance with a reminiscence published much later in the nineteenth century by the distinguished photojournalist Henry Hunt Snelling. Snelling was admittedly seventy-one years old and blind when his account was published, but it is nevertheless a straightforward, rather factual report of his evidently successful efforts to help Catherwood make his camera more effective for operation in the intense heat, and "yellow atmosphere" prevalent in the Yucatan. To begin with, before meeting Catherwood, Snelling said he had been experimenting with blue glass for camera nozzles (which were the tubes containing camera lenses) at "Mathew Brady's gallery" in New York—which is equally evocative, since

LABNAH

GATEWAY AT LABNA

Edward Anthony reportedly made successful daguerreotype photographs on a government survey in 1841, but John Lloyd Stephens, Frederick Catherwood, and Dr. Samuel Cabot reportedly had little success trying to make daguerreotypes of the ruins of the stone Mayan cities on the Yucatán peninsula in 1842. A pyramidal mound, top, among the ruins of Labná, which Stephens described as the most interesting of all ruins encountered, was drawn by Catherwood while Stephens and Cabot spent an entire day trying to photograph it with their daguerreotype apparatus. "Our best view," Stephens said, "was obtained in the afternoon, when the edifice was in shade, but so broken and confused were the ornaments that a distinct representation could not be made even with the Daguerreotype, and the only way to make out all the details was near approach by means of a ladder." An arched gateway (bottom illustration) was situated a few hundred feet from the mound.[76]

Brady is not known to have operated a "gallery" prior to 1843. Then Snelling recalled Catherwood's entry into the picture in these words:

> It was just after these experiments that Mr. Catherwood, who had been to Central America with Mr. Stephens, the traveler and author, to obtain views of the ancient ruins in that country, returned to New York unsuccessful with his camera. He said the heat was so great, and the atmosphere so yellow, that he could not make the chemicals work, and every attempt at a picture was a failure. We told him that we thought we could remedy the evil. As he was going to return to Yucatan with his artist's materials immediately, we induced him to bring his camera to us and have it fitted with blue glass. On his return from this second trip, he informed us that it was effectual, and he brought home many daguerreotypes.[77]

Even more strange is Stephens' statement in his first book (covering the 1839–40 expedition) that daguerreotype instruments "had not reached this country at the time of embarkation." But if Stephens was a sponsor of the Seager lecture, he must have been familiar with the early experiments of the other sponsors, namely Morse and Dr. Chilton, all having begun before the first departure to the Yucatan. Then, too, why would a blind seventy-one-year-old man, in looking back to his more impressionable years (Snelling was between twenty and twenty-four at that time), recall that a celebrity (Catherwood) had come to see him *twice,* the first time to complain about his camera on one trip to the Yucatan, and the second time to report that all had gone well on a second trip? Unfortunately, we shall probably never know the answer to this particular riddle. For if Catherwood did in fact return with "many daguerreotypes," they were subsequently lost and may have perished along with Catherwood when he was lost at sea with all his belongings in the sinking of the S.S. *Arctic* on September 27, 1854.[78]

The great American "Pathfinder," John Charles Frémont, evidently was unsuccessful with a daguerreotype apparatus which he took with him on *his* first western expedition, begun in 1842. Having failed to obtain results, he neglected to mention in his official report of the trip that he had taken the equipment with him in the first place. The world had to wait an entire century before learning of Frémont's abortive photography exploits from the diary of the German illustrator and cartographer Charles Preuss, who accompanied him. Preuss's diary remained in the Preuss family through successive generations down to 1954, when it was translated and published in the United States. Preuss was highly critical of Frémont, and gave these unflattering accounts of the progress of the expedition, thirteen and sixteen days, respectively, after leaving Fort Laramie:

> *August 2:* Yesterday afternoon and this morning Frémont set up his daguerreotype to photograph the rocks; he spoiled five plates that way. Not a thing was to be seen on them. That's the way it often is with these Americans. They know everything, they can do everything, and when they are put to the test, they fail miserably. Last night a few horses became restless. When we walked up with a lantern, we were told that Indians are nearby. Frémont wasted the morning with his machine. Now, after we have ridden about ten miles and pitched camp, we see smoke rising in the mountains opposite us, about six miles dis-

Col. John C. Fremont

tant. Here that can mean nothing else but Indians. We shall therefore have to be on guard again. We shall probably not be at ease again until we see the Missouri before our eyes.

> *August 5:* . . . Frémont is roaming through the mountains collecting rocks and keeping us waiting for lunch. I am hungry as a wolf. That fellow knows nothing about mineralogy or botany. Yet he collects every trifle in order to have it interpreted later in Washington and to brag about it in his report. . . . Today he said the air up here is too thin; that is the reason his daguerreotype was a failure. Old boy, you don't understand the thing, that is it.[79]

The most successful early operator in the field was clearly Edward Anthony. Following his first trials at the Croton Aqueduct, Anthony took lessons in daguerreotyping from Morse during his spare hours. Before the aqueduct was completed, Anthony's former instructor at Columbia, Prof. James Renwick, invited him to obtain a complete daguerreotype apparatus and accompany him on a government mission to survey the northeast boundary of the United States, the exact location of which had become a matter of dispute between the United States and Great Britain. Few records exist profiling Anthony's career and activities, but at an 1883 field-day excursion by members of the Photographic Section of the American Institute to Brighton Beach, he gave this brief account of the trip with Renwick:

> In the year 1841 I went as a surveyor on the Northeastern boundary survey, about the location of which there was then a dispute with Great Britain. The boundary was described as running along the *highlands* between the rivers emptying into the

7.—VICTOR PIARD, ESQ.

Negative by Rudnicki—H. H. Snelling, Print.

THE STORY OF A FAMOUS ENGRAVING

Victor Piard, shown left in a photograph which he took of himself in 1857, served as principal operator for Anthony, Edwards & Co. when the latter firm set up business in Washington, D.C., in 1842. Among his first assignments was the taking of daguerreotype portraits of members of Congress which were later used to compose the celebrated engraving of the United States Senate chamber, shown above, commemorating Henry Clay's farewell address on March 31, 1842. Although the plates in this instance may have been destroyed after use by the engravers (a common occurrence at the time), all of the daguerreotype portraits made and retained by the Anthony firm in Washington were included in Anthony's National Daguerreotype Miniature Gallery in New York City, which was destroyed by fire in 1852. Piard's role in early Washington portraiture is little known, and appears only to have been recorded once in contemporary photographic literature. He remained with Anthony until the latter gave up photography for the supplies business in 1847, after which he became associated with Alexander Beckers in New York City. In the 1850s, Piard went into the grocery business for a while, but returned to photography when, in his own words, he accepted "a more agreeable position before the nitrate bath in the establishment of C. D. Fredericks."[80]

Atlantic Ocean and those emptying into the St. Lawrence. On the land claimed by the United States, Great Britain asserted there were no highlands. Professor Renwick requested me to take a daguerreotype apparatus on the survey, and take views of the highlands, which would place their existence beyond dispute. I did so, and though the facilities for making views in the wilderness were very poor at that time, yet I succeeded in taking a number of the objects required, which were copied in water colors, and deposited in the archives of the State Department at Washington.[81]

The "dispute" between England and the United States, which stemmed from the provisions of a 1783 treaty, were resolved by the Webster-Asburton Treaty signed by the foreign ministers of both countries (Daniel Webster and Lord Asburton) on August 9, 1842. Anthony's daguerreotypes evidently settled the question as to the existence of the "highlands," for the agreement refers to them in Article I of the treaty.

The financial depression then in full swing in the United States made it difficult for a young civil engineer to obtain work, and this was probably a factor in Anthony's decision, after the boundary survey, to establish a daguerreotype business, Anthony, Edwards & Co., with a partner, J. M. Edwards. Also, it is possible that Anthony's services may have been called upon in the discussions held in Washington by Webster and Asburton from June 13 to the signing of the treaty on August 9. In any event, something determined Anthony to establish his business in Washington at some point in 1842, and for a base of operation he was given use of the Senate Military Affairs committee room—interestingly enough, a committee headed by Missouri senator Thomas Hart Benton, the principal Senate opponent of the Webster-Asburton Treaty.[82]

Although he later returned to the United States Senate in 1849, Henry Clay gave his famous farewell address there on March 31, 1842, and it appears that one of the first things

Rooftop daguerreotype sittings were common in the early daguerreotype years, because of good exposure to sunlight, but such daguerreotypes today are extremely rare. Illustration above is from a daguerreotype of the Philadelphian, John McAllister, Jr.

1842

Anthony, Edwards & Co. set out to accomplish was the taking of daguerreotype likenesses of all the members of Congress present on that occasion, the purpose being to have the plates copied by engravers and composed into a single large mezzotint engraving depicting the historic scene (see page 34). What is less known about this undertaking is that Anthony brought with him to Washington as his "principal operator" a young daguerrean by the name of Victor Piard, who assisted in taking the portraits for the Clay speech engraving, and remained with the Anthony firm, in total obscurity, until Anthony entered the supplies business some five years later. In 1852, the vast majority of Anthony's personal collection of daguerreotypes made in Washington at this time were destroyed in a fire. Nevertheless, the Chicago Historical Society, which owns a sizeable collection of daguerreotypes of men prominent in Washington in the 1840s, believes that some of the specimens in the society's collection, including possibly one of Anthony's patron, Sen. Thomas Benton, are copies made by the Anthony firm for their sitters. But such attribution can only apply to plates which it can be accurately determined were secured in the period 1842–47 (Anthony gave up his daguerreotype business to enter the supplies business in 1847). Perhaps the only daguerreotype ever positively attributed to the Anthony firm was a portrait made by Anthony's partner, J. M. Edwards, of Secretary of the Navy Thomas W. Gilmer just a few days before Gilmer was killed (on February 28, 1844) in an explosion aboard the USS *Princeton*.[83]

Things continued to go well, meanwhile, for the Americans in London—A. S. Wolcott and John Johnson. During the first year of operation, the Beard studio was heavily patronized. "In the waiting rooms," according to an account published years later, "you would see, awaiting their turn to enter the blue glass roofed room, the nobility and beauty of England, accommodating each other as well as the limited space would allow, during hours of tedious delay." In 1842, Beard opened two additional studios in London. He also established the practice of selling the rights to his businesses in the counties outside London, and on November 9, 1842, he assigned to Johnson the exclusive rights to all daguerreotype business in the counties of Lancashire, Cheshire, and Derbyshire. A biographical sketch of Johnson published in 1896 states that while in England (Johnson was in Manchester at least in the early part of 1843), he took pictures of the Royal Family, including the Prince of Wales (later King Edward VII, born in 1841). But a more recent record reveals that the first picture of the Prince was taken March 6, 1842, by William Constable, proprietor of Beard's Brighton gallery. Nevertheless, it is probable that Johnson photographed a number of England's nobility. A daguerreotype of Lady Byron, according to Johnson's biographical sketch, was still in the hands of his survivors twenty-five years after his death.[84]

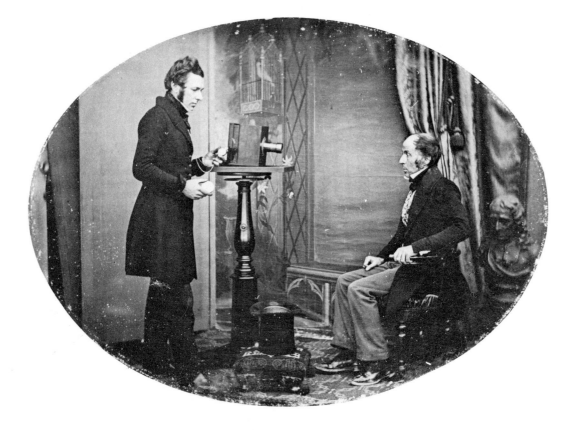

At Richard Beard's Westminster gallery (opened March 29, 1842), Jabez Hogg uses a new sliding-box daguerreotype camera to photograph "Mr. Johnson" (probably William S. Johnson, father of John Johnson). Possibly the earliest surviving photograph of a photographer at work, the image was reproduced as an engraving in the *Illustrated London News* on August 19, 1843.

1843

Many early advances in photography emanated from the researches of Sir John Herschel, who freely published his findings without any apparent desire to claim or to patent this or that discovery from his rather large bag of tricks. First, he had given the photographic world its "hypo" universally used to "fix" prints in a darkroom; in February 1840, he disclosed that bromide of silver was far more light-sensitive than any other silver salt, and this provided the basis for bottling various formulas of "quickstuff" used throughout the daguerrean era. Herschel also disclosed, in 1840, that he had been experimenting with photography on glass, and that he had even made positive prints from glass negatives.

No doubt this set a number of minds working, among the first of whom was Alexander Wolcott. Wolcott was still in London in the early part of 1843, where he and Johnson patented (in March) an apparatus intended for use in making enlargements from the mirror camera's small images—producing the enlargements on larger daguerreotype plates, or on sensitized paper. But at the same time, Wolcott began experimenting with a camera which was designed to secure an image on a hemispherical piece of transparent glass. If this could be done, the glass plate could be used in a magic lantern to project the image on a screen. Johnson, meanwhile, was in Manchester, presiding over his three-county domain for daguerreotype operation. The pair evidently conducted experiments separately, but corresponded frequently by mail. Then, unfortunately, at some point in 1843, Wolcott became ill with a terminal disease. He returned to the United States the same year and died on November 10, 1844, at Stamford, Connecticut, in his fortieth year.[85]

Much of the Wolcott-Johnson correspondence in this period was given to Prof. Charles A. Seely, editor of the *American Journal of Photography,* in 1860. Seely said at that time that he intended organizing and publishing the material, but never did. He did, however, publish two of Wolcott's letters which, unfortunately, were written in a somewhat rambling manner, making the precise nature of his experiments unclear. For his part, Johnson never published or shed any further light on the pair's work. However, in a letter to Johnson dated February 20, 1843, Wolcott made the following statement:

> The easiest plan that occurred to me was to follow some known process, Talbot's for instance (which was the one I tried); previously, however, coating the glass with some substance which, like paper, would absorb the fluids; the thing that first occurred to me was the white of egg, and that by heating it after it was spread on the glass, it would coagulate and thereby become insoluble. The difficulty seems to be that although it is insoluble, it is mechanically disturbed by the fluids, and that therefore it is exceedingly difficult, if not impossible, to preserve an even coating throughout the operation.[86]

The white of an egg is known as albumen. In experimenting with this substance, Wolcott anticipated, by seven years, its use as a sensitizer for photography's first glass

negative process. He also indicated, in his February 20 letter, that he had been studying Herschel's published reports, but his remark to Johnson that "for some reason or other I cannot do anything by Herschel's plan, with the ammonia citrate of iron," gives us no clue as to precisely how he was endeavoring to benefit from Herschel's research. Wolcott also told Johnson that he had gone to the "Enrolment Office" in order to "see Talbot's claim," and followed this with a jumbled series of "extracts" from the claim which he said he hoped "might suggest something useful to your mind."

In November 1861, Johnson donated the camera used by Wolcott in 1843 to the Photographical Section of the American Institute. Prof. Seely, who was present on the occasion, is recorded in the minutes as having stated that Wolcott and Johnson had "nearly succeeded in perfecting the albumen process," and added: "Had the letters of Mr. Wolcott been published at the time they were written, Messrs. Wolcott and Johnson would have been everywhere recognized as the inventors of many devices which are used at the present day."[87] Prof. Draper, in his annual report as president of the society in 1861, concurred: "It appears," he said, "that evidence is in existence that Messrs. Wolcott and Johnson had at that time nearly succeeded in perfecting the albumen process."[88]

Wolcott's obituary states that "the disease which terminated his life was contracted by too close application to some extremely valuable improvements in the manufacture of cotton." In the biographical sketch of Johnson published in 1896, the statement is made that Johnson "invented several improvements in cotton machinery" while in England, "for which he received medals." Johnson never discussed or published anything on these experiments in later years, but one is left wondering why they became involved with cotton. In 1846, gun-cotton (an explosive substance consisting of cotton mixed with nitric and sulphuric acids) was mixed with ether and alcohol to make collodion. In the late 1840s, collodion was used to treat wounds, but then, in the 1850s, it was adopted universally as a sensitizer for preparing photographic negatives.

Despite Wolcott's patented means of enlarging the small daguerreotypes made with the mirror camera, the impending demise of this type of equipment became evident, if it had not done so earlier, in May 1843, when Claudet exhibited daguerreotypes of large size produced with a new camera and a new type of lens. This was the Petzval lens—the first true camera lens—which had been perfected two years earlier, but was slow in reaching the market. Initially, all lenses used in daguerreotype cameras were single lenses, constructed originally for telescopes or microscopes—or were ordinary spectacle lenses of the type used by Prof. Draper in a cigar box. Achromatic lenses were adopted early (making the focus seen with the eye coincident with the focusing on the plate of the sun's invisible or "actinic" rays), but the angle of these lenses was small (at most a few degrees), and did not insure a sharp image over the entire

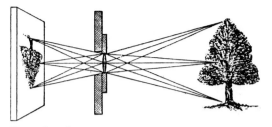

Fig. 1. Lens Image

Fig. 2. Chromatic Aberration

Fig. 3. Achromatic Lens

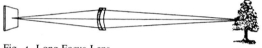

Fig. 4. Long Focus Lens

Fig. 5. Short Focus Lens

THE FUNDAMENTALS OF EARLY LENS DESIGN

Beginning with the Petzval lens, camera lenses quickly took on a variety of design configurations. Basically, the glass of a lens bends the rays of light, which proceed from a point in the object being photographed until they reach the lens, after which they are bent by the lens until they meet once again in a point (called the focal point) on the focusing glass or image plate. Fig. 1 illustrates how this is true of all points of a subject tree. The distance from the lens to the place where the rays come again to a point depends on the strength of the lens in bending the rays, and this distance is called the focal length.

The focal point at which the visible rays of light come together on the viewing glass or image plate is not the same for the actinic or nonvisible light rays. Thus, the rays of visible and actinic light proceeding from point D in Fig. 2 are brought to differing focal points (d and d¹) unless this chromatic aberration is corrected by the lens itself. This is accomplished in the achromatic lens (Fig. 3), wherein two pieces of glass of differing refractive powers (once having been ground "positive," or thicker in the middle than at the edges, the other having been ground "negative," or thinner in the middle) are united. Two of the surfaces of each of the two glasses are given a similar curvature, making it possible to cement the glasses together. In the achromatic lens, the visual and actinic rays are thus brought to the same point when the camera is focused.

Lenses having a longer focal length rely upon the back lens cell only for bending light rays and bringing them into focus (as in Fig. 4). A shorter focus lens (Fig. 5) utilizes both front and back lens cells, bending the rays to a much greater extent and bringing them into focus in a much shorter distance.[89]

1843

38

plate. Straight lines would appear curved; circles when seen at the edge of the plate would appear oval and ill-defined. Achromatic lenses also could not focus enough light on the plate fast enough to achieve the wanted reduction in exposure time.[90]

Immediately after the daguerreotype invention, a Viennese optician, Josef Max Petzval, began the tedious work of designing a photographic doublet some twenty times faster-acting than the lenses used in Daguerre's camera, and having an aperture corresponding in today's nomenclature to f/3.6. First, Petzval (who had flunked mathematics as a student, but kept up studies on his own) made use of optical data on all known kinds of glass tabulated in 1811 by Friedrich Voigtlander, son of the founder (in 1756) of the Voigtlander optical firm, also in Vienna. On the basis of this data, he calculated the curvatures and internal distances

A VIENNESE CONNECTION

The early arrival in the United States of this novel, spyglasslike camera, containing the new Petzval portrait lens, resulted from a close family tie between the manufacturer, Voigtlander & Sons in Vienna, and the bothers William and Frederick Langenheim in Philadelphia. The all-metal camera was easily taken apart for traveling, but square daguerreotype plates had to be cut to fit its cylindrical frame. Low temperature of metal also necessitated longer exposures.

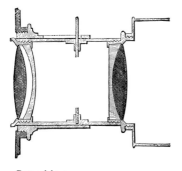

Petzval lens

required to make a doublet of low achromatism and spherical aberration. The task was an enormous one, and such calculations today are handled by a computer; in Petzval's case, the Archduke Ludwig came to his rescue with two officers and eight soldiers of the Austrian Bombadier Corps, all skilled in mathematical computation. Petzval's lens consisted of an achromatic cemented pair backed by an achromatic air-spaced pair. Voigtlander produced a wooden camera of conventional design to house the new lens, together with a spyglass style, all-metal camera of unconventional design. The spyglass camera was not widely adopted, but the Petzval lens became the standard for most cameras and was exported all over the world. By 1862, Voigtlander had produced the ten thousandth Petzval lens, and it continued its popularity throughout the nineteenth century.[91]

The first Voigtlander cameras were available in the United States as early as January 1843. This resulted from the fact that Peter Friedrich Voigtlander, third son of a founder of the firm, had been a classmate of the eldest of the two Philadelphia photography pioneers, William and his brother Frederick Langenheim (both natives of Brunswick, Germany), and had married one of the brothers' two sisters. Alexander Beckers, later a prominent New York photographer and builder of stereoscopes, recalled that one of the spyglass instruments "and a kind of hiding-place for a darkroom" greeted him when he joined the brothers as an assistant in 1843 in their first rooms in the Merchants' Exchange in Philadelphia. Beckers said the camera had been sent to William Langenheim by young Voigtlander "as a present,

with supplies and instructions, but also the warning not to try daguerreotyping unless he had courage enough to try five hundred times more after failing with the first hundred pictures. William Langenheim, a lawyer, did not have the courage," Beckers added, "but his brother Fred had, and succeeded so well that he was offered six hundred dollars for that odd camera."[92]

M. P. Simons felt that the exclusive agentry for the Voigtlander cameras gave Frederick Langenheim "quite a start and a decided advantage over his contemporaries. I at once saw that he was getting ahead of me fast, much faster than suited my youthful aspirations; so one day I took it into my head to make him a professional visit to ascertain if possible the cause of his great success, for up to that time, I must admit, I was not aware of there being any difference whatever in the quality of lenses. I found Mr. L. quite busy making better pictures, and in much shorter sittings, with his quarter-size Voigtlander than I was able to do with my half-size Plumbe." This referred, in all probability, to a camera manufactured by J. H. Plumbe. On a second visit, Simons found Langenheim "without sitters, though as busy as ever in that mysterious 'No admissions' room, finishing up his day's work and preparing for the next. This suited me very well, as it gave me a fine opportunity to scrutinize more carefully his little lens without being in anybody's way. There were quite a large number of these tubes and lenses of the different sizes, as they are usually gotten up, lying about on shelves and tables waiting for lucky purchasers. But the one Mr. L. himself used interested me the

most of all; it was a tube lens and camera-box combined, done up in brass and reminded one of a small telescope—the only one of this description I have ever seen—and, although it appears, not a *success,* it was to my notion a perfect beauty from head to foot, and I fell dead in love with it at first sight. No child ever looked with more covetous eyes at toys in the shop windows than I did at this unique, brass-clad camera."[93]

Although it is not known how widely the spyglass camera was used after its introduction by the Langenheims, M. P. Simons was one operator who dug up the money and bought one. But "necessity soon introduced a square camera, with square plates and holders" at the Langenheim gallery, according to Beckers. "In the summer of 1843 the first dozen of small Voigtlander objectives . . . were imported. Soon after, four larger ones, for 6 x 8 pictures, arrived."

When the first daguerreotype was exhibited in New York in September 1839, it was contained in an expensive moroccan leather case of the type which was used previously to house miniature paintings. While many of the first specimens made at the Beard and Claudet galleries were placed in pinchbeck cases, or in black papier-mâché frames similar to those used for silhouettes, the custom quickly began, both in the United States and in England, of adopting the

GHOSTLY PIONEERS

The directories of major United States cities contained few names of daguerreotype photographers in 1843, yet reports like those opposite reveal that there may have been more activity in this early period than has been fully recorded. The unknown daguerreotypist, above, could have operated for only a fleeting moment, or this could be an early likeness of numerous later photographers of note, of whom no early likeness—and in some cases no likeness at all—is known to exist. No identified daguerreotype likeness of any of photography's early "big names," with few exceptions, is known to be extant. Only the Boston firm, Southworth & Hawes, left a record of their work in sizeable form. No collections by Morse, Draper, Anthony, Brady, Gurney, the Langenheims, Plumbe, and numerous others who maintained large operations have survived—all having disappeared with their sitters, or, as in the case of the Anthony collection, been destroyed in fires.

COMPETITION FOR ANTHONY IN WASHINGTON, D.C.

A photographer who appears to have escaped notice up until the present time placed the following advertisement in a Washington, D.C., daily on June 23, 1843, and repeated it in same or shortened form twenty-one times in 1843 and twice in 1844. The ad appeared on the front page on December 4, 1843, the day of the opening of the 28th Congress.

DAGUERREOTYPE: Daguerreotype Portraits and Miniatures, copies of paintings and statuary, views of buildings, landscapes, etc. by L. T. WARNER at the Washington Photographic Rooms, corner of Pennsylvania Avenue and C Street, a few doors west of Brown's Hotel.

Likenesses taken on plates, from breastpin size to 8 inches square, and full length groups from 2 to 20 persons.

The natural colors given to pictures by various processes, including those of Thsenring, Lechi, Lerebour, and Dr. Page; also Electrotype copies of Daguerreotype pictures.

Instructions in the above; also in Magneto electric and Galvanic gilding and silvering, according to the processes of Elkington, Roulz and Fitzeau.

Daguerreotype apparatus of the first quality for sale, at prices varying from $25 to $100. Also Electro-magnetic, Magneto-electric, Thermo-electric, Galvanic and Electrotype apparatus of the most approved construction.

Chemicals and all materials of the best quality for Daguerreotyping, Electrotyping and gilding and silvering constantly on hand.

Rooms open from 8 o'clock till 7 o'clock P.M. The public are respectfully invited to call and examine specimens and witness the manner of taking pictures.

L. T. Warner[94]

moroccan leather case for framing daguerreotype images. Then, in 1843, a Boston case maker, William Shew, conceived the idea of producing wooden cases of cheaper design which could be covered with embossed paper. This marked the beginning of a sizeable new industry wherein millions of cases were produced in a variety of materials and shapes.

There were an estimated 500 to 600 different embossed designs applied to wooden cases, and some 800 motifs to the plastic cases introduced in 1854. Cases were also made of papier-mâché, papier-mâché inlaid with mother-of-pearl, tortoise shell, and silk. The vast majority of the cases were manufactured in New York, Philadelphia, Boston, and half a dozen cities and towns in Connecticut. The reason for this proliferation of manufacturers lies in the fact that neither Shew nor the largest of the manufacturers, the Scovill Manufacturing Company in Waterbury, Connecticut, obtained patents for their designs. Nature motifs predominated in the early case designs, following the widespread artistic interest in nature created during the period 1827–38 by publication of John J. Audubon's monumental *Birds of America,* which contained a thousand life-size figures of some 500 different species.

Although it went unrecognized at the time, the manufacture of plastic cases for daguerreotypes marked the beginning of thermoplastic molding in the United States. The cases were made of a plastic material consisting of shellac and excelsior, ground wood or sawdust, and a black or brown coloring—all of which was hot-pressed in dies or molds of the chosen design. Thick image cases made to resemble a book were produced, the edges of the case usually gilt-painted to resemble the pages of a book. Among the embossed and plastic case design motifs are two of Washington monuments, one in Washington, D.C. (a design later abandoned when the monument was reconfigured prior to completion of the structure in 1884), and one in Richmond. Strangely, no case design of the first Washington monument, built in Baltimore in 1824, is known to exist.[95]

At this early stage of photography the daguerreotype camera was not used for social documentation purposes, as cameras in the hands of Jacob Riis and Lewis Hine were

DAGUERREOTYPISTS AND BEGGARS ARE MONEYMAKERS IN NEW YORK

This humorous item appeared on February 24, 1843, in a Washington, D.C., newspaper. It was sent by a New York correspondent four days earlier:

I presume you would like to know who makes money in New York in these Jeremiad times. I can hear but two classes—the *beggars* and the *takers of likenesses by daguerreotype.* It's an old contradiction in human nature (very likely the basis of the parable of the camel and the needle's eye) that we give more as we have less to give; and with the late twin increase of poverty and pity, the beggars of New York have correspondingly increased. . . . *Daguerreotyping,* which is now done for a dollar and a half, is the next most profitable vocation. It will soon be difficult to find man or woman who has not his likeness done by the sun (Apollo fecit) as it was, before the *rain* of portrait painters, to find one without a profile cut in black. A Frenchman has opened a shop in Fulton street for the sale of apparatuses for daguerreotyping, so that any pedlar can take up the trade. Some beginnings have been made in copying in colors, and one man has altered his sign to *"photographer."* Should an improvement be made hereafter by which an artist could correct the variations made by the imperfectness of the perspective and the convexity of the lens (for these daguerreotypes are very incorrect after all), the immortality of this generation is as sure, at least, as the duration of the metallic plate.[96]

later in the century. In 1841, Dorothea Dix, for example, began visiting jails and almshouses in Massachusetts, and delivered a scathing report to the Massachusetts Legislature in January 1843, which produced a profound sensation and call for reforms. This was an early instance in which the exposure of inhuman social conditions prompted official remedial action. But no cameras recorded what Miss Dix witnessed.[97]

THE ELEMENTS OF A DAGUERREOTYPE PORTRAIT

Looking every bit like the original, this copy daguerreotype of Daniel Webster (probably made after his death in 1852 from a daguerreotype made in the 1840s) is secured on a silvered copper plate (1), which was exposed in the camera without the use of a negative. A sheet-brass mat (2) and glass cover of same size (not shown) are placed over the image and secured in a thin, pliable gold-plated protective border (3) which wraps around these elements (4). The completed daguerreotype is then placed in the right-hand side of a paper-covered plastic miniature case (5), the interior left-hand side of which is lined with velvet-covered cardboard. Many cases made after 1855 were of plastic.

Louis J. M. Daguerre made many of his daguerreotypes on plates measuring approximately 6½ x 8½ inches, which was larger than the 2¾ x 3¼ size which became the most prevalent for the millions of daguerreotypes made after a general standardization of plate holder sizes. The daguerreotype plate of Webster, above, measures 1½ x 1¾ inches, which was a size frequently used in making copy daguerreotypes. The nomenclature adopted for the various plate sizes was as follows:

Ninth plate	1½ x 1¾ inches	Half plate	4½ x 5½ inches
Sixth plate	2 x 2½ inches	Whole plate	6½ x 8½ inches
Quarter plate	2¾ x 3¼ inches	Double whole plate	8½ x 13 inches

1844

Experiments with glass as a negative base for photography were begun in 1844 in Boston. John A. Whipple, twenty-two, a supplier of chemicals for daguerreotype use, gave up his business at this time because of the ill effects of the chemicals on his health, and formed a partnership in a daguerrean studio with Albert Litch. Strangely, Whipple did not experiment with Litch (who became associated with Jeremiah Gurney in New York after 1846, then went to England in 1853), but chose to work, instead, with another friend, William B. Jones, during the pair's leisure hours. At first, they began "trying the different processes then published (principally Talbot's calotype process), devising means to improve upon them." But when they made positive prints from a paper negative, they found that they could not prevent the fibers of the negative paper from being copied in the prints, which Whipple felt marred their beauty (there would be later schools of thought in photography which thought quite the contrary).

"Knowing that the basis of the whole thing was the connection of nitrate, and iodide of silver with organic matter, the idea naturally suggested itself, why could not an even film of some kind be laid upon mica and glass, and the negative impression be taken upon that, thus avoiding the great evil of copying the texture of the paper," Whipple thought. Having come to this conclusion, the pair tried their first "film"—milk. But this proved unsuccessful. "Not being able to operate to our mind with the milk, various other substances of a gelatinouus and albuminous nature were tried: but none operated so well as albumen from the hen's egg," according to Whipple. "It would hold the desired quantity of iodide of silver, and dry smooth, and would withstand the action of the hyposulphite of soda solution—two very important points gained—but in pictures made with it, there was a want of harmony, of light and shade; the deep shades and high lights coming in masses, the half tints being most wholly wanting, so that for practical purposes it was very difficult." Whipple and Jones nevertheless continued experimenting with albumen, evidently for quite an extended period of time, unaware that similar experiments begun about the same time, or shortly afterwards, would catch them napping in another four years, much as Daguerre's invention had caught Talbot by surprise in January 1839.[98]

Talbot, meanwhile, endeavored to make up for lost time in promoting the calotype process. First, he established his Reading Talbotype Establishment outside of London, where a large number of "Talbotype Photogenic Drawings" were

The cased miniature oil portrait, such as the one (above) of Ann Bolton by Edward Greene Malbone (1777–1807), the noted artist from Newport, Rhode Island, provided the style copied by daguerreans for casing their photographic portraits.

produced, but sold with only moderate success. Then, in June 1844, he commenced publishing (in six installments) *The Pencil of Nature,* the world's first book illustrated with original photographs (of architecture, sculpture, botanical specimens, and other assorted themes). "It must be understood," he explained in the prospectus, "that the plates of the work offered to the public are the pictures themselves, obtained by the action of light, and no engravings in imitation of them . . ." A thousand prints—two hundred each from five negatives—were supplied for the first installment of the book, which was issued in a limited edition of about two hundred. Ultimately, a total of twenty-four negatives were used to make the thousands of prints required to complete the six installments, the last of which came off the press in April 1846. All prints were exposed to sunlight in racks in the back yard of the Reading establishment. Exposures in each case took from minutes to hours, depending upon the intensity of sunlight at a given time. Patrons for this monumental work were solicited in the United States, as well as in England and on the continent. The *Living Age* reprinted in New York a review published by *The Spectator* in London, which said in part:

> The images of the calotype are only inferior to those of the daguerreotype in this respect—the definition of form is not so sharp, nor are the shadows so pure and transparent. By looking through a magnifying glass at a daguerreotype plate, details imperceptible to the naked eye become visible in the shaded parts; not so with the calotype drawings—they do not bear looking

into. This arises chiefly from the rough texture and unequal substance of the paper; which cannot, of course, present such a delicate image as the finely polished surface of a silvered plate.

In 1845, Talbot undertook a second publishing venture, *Sun Pictures in Scotland.* This was a book without text, sold in a limited edition of only 118 copies. Twenty-three negatives of scenes connected with the life and writings of Sir Walter Scott were used to print a total of 2,714 photographs at the Reading factory. But the prices for these publishing ventures were high, and delays developed in deliveries. In addition, the stability of the prints was considered unsatisfactory in many instances. Talbot also had high hopes that his process would be adopted (under license) for portraiture, but a studio opened in London in 1847 proved a failure. Only in Scotland was the calotype a resounding success in portraiture. There the process was practiced in all its forms by Hill and Adamson from 1843 to 1847, and their works can still be found today at auctions or in the hands of dealers.[99]

By 1844, daguerreotype portrait galleries were becoming more plentiful in New York. Doggett's New York City Directory for 1843–44 lists Mathew Brady as a jewel case maker, then in 1844–45 as a jewel, surgical, and miniature case maker at 187 Broadway; and as a daguerrean operator at 207 Broadway, with an entrance at 162 Fulton Street. Before opening his first gallery, Brady worked as a clerk at the A. T. Stewart dry goods firm. But upon becoming a photographer, his notoriety was immediate. He captured

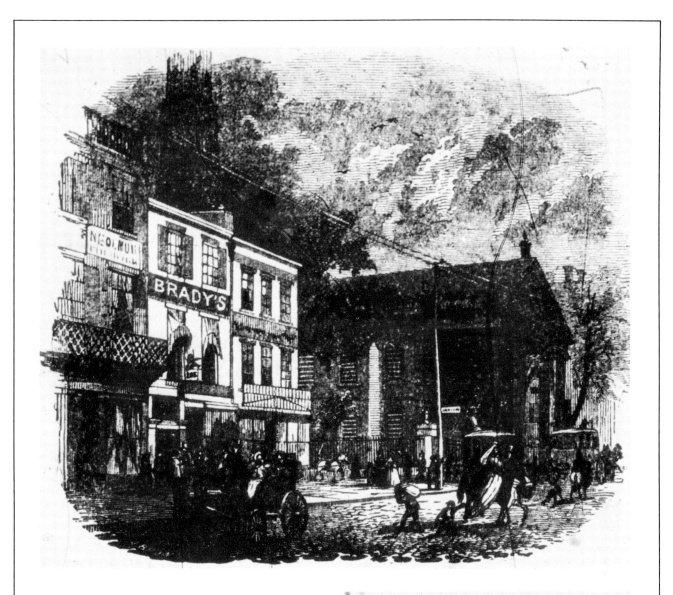

THE FIRST BRADY GALLERY

From 1844 to 1853, Mathew Brady operated his first photo-graphic gallery (top) in New York at this Broadway and Fulton Street location, opposite St. Paul's Chapel where Washington had worshiped half a century earlier. The Brady gallery is not visible in this view (bottom) taken from a similar vantage point. The Low footbridge in the foreground was built in 1866 at the request of merchants on one side of Broadway, then torn down in 1868 after protests from those on the *opposite* side.

1844

45

Daguerreotypes were placed in oval silver frames of the type used for miniature portraits in oil (top), and were applied to all forms of jewelry. Depicted above are likenesses in a watch case (center) and breast brooch (bottom), which also contains decoration of strands of hair on the exterior.

first honors for daguerreotype portraiture at the annual fair of the American Institute in 1844 (the Institute's first industrial fair was in 1828), while his principal rival, Jeremiah Gurney, and the Boston operator John Plumbe, Jr., were awarded other prizes.

Although he was officially in the photography business by 1844, it is still questionable as to when the famous Civil War photographer actually began to take daguerreotypes commercially. H. H. Snelling, as we have already seen, recalled experimenting in "Brady's Gallery" at the time of the two Yucatan expeditions by Stephens and Catherwood. Possibly, this could have been an early studio of the celebrated portrait painter, William Page (1811–1885), who befriended Brady in the late 1830s and introduced him to Morse in 1839 or 1840. Page maintained a gallery in New York from about 1833 to 1843 (when Brady was possibly his roommate), then relocated in Boston during the years 1843–47. Brady's birthdate (1823 or 1824) and place of birth (Wales or upstate New York) have never been determined precisely, and one Brady historian has termed the years 1841–43 in Brady's life as "shadowy." Still another source puts Brady and a water-colorist, James S. Brown (who became a photographer with his own gallery after first working for Brady), as working together as early as 1842 in New York, combining their respective talents.[100]

1844

46

·When another New York photographer and plate maker, Edward White, bought a large Voigtlander camera from the Langenheims in Philadelphia in the spring of 1844, Alexander Beckers was evidently induced to leave the Langenheims' employ in order to join White in New York. But by December, he went into business for himself "when it became impossible to make a picture in his [White's] operating room on account of the extreme cold" [White would not allow a fire to burn in his gallery overnight]. Beckers recalled that besides Brady, Gurney, and Plumbe, the other principal daguerreans in New York at this time were Edward Anthony, J. M. Edwards, Howard Chilton, Augustus Morand, Samuel Van Loan, Nathan G. Burgess, Henry Insley, and others he identified only as Brush, Weston, and Artho. Two others also then in business in New York were Martin M. Lawrence and George Prosch. Beckers later said he had made "the first large daguerreotypes" in New York while associated with White, and had made a view of the Croton Aqueduct in the spring of 1845, before the construction scaffolding was removed. "By taking out-of-doors views I discovered that the plates increased in sensitiveness with the time between preparation and exposure," Beckers said of these early daguerreotype views. By 1848, he had succeeded in obtaining a "sharp picture of a procession in motion."[101]

1845

It was in 1845 that the term "manifest destiny," which presumed a divine sanction for American growth across the continent, first appeared in an expansionist magazine edited by John L. O'Sullivan.[102] Prompted by foreign opposition to the annexation of Texas, the phrase applied equally well to the 1845 dispute with Great Britain over the joint occupation (since 1818) of Oregon, which President Polk flatly declared was United States territory in his first annual message to Congress on December 2.

The feeling that a Divine Providence had great things in store for the "free development" of the nation's "yearly multiplying millions" evidently had its effect on young Mathew Brady. "From the first," he said of his goal in life, "I regarded myself as under obligation to my country to preserve the faces of its historic men and mothers." He "loved men of achievment," and he set out to make daguerreotype likenesses of all the great and famous—first at his New York gallery, then at a second gallery opened in Washington in 1847. Brady has been described as shy and a tireless worker whose poor eyesight grew weaker in this period when the lenses in his glasses grew thicker and thicker.

Reportedly, he took "thousands" of daguerreotypes in the first few years of his business. Possibly, many of the gallery's early daguerreotypes were finished in colors, since an 1893 profile of the water-colorist James S. Brown, who was Brady's helper prior to 1848, makes the statement in looking back to the Brady years that "Brown's eye for color in the coating process made fine, strong, vigorous daguerreotypes." By the 1850s, Brady was to become the principal source for supplying daguerreotype portraits copied as engravings and published in *Harper's, Leslie's,* and other illustrated weeklies. During all of the nineteenth century, the term "Photograph by Brady" was never matched in the public's eye by the works of any other American photographer.[103]

Aside from isolated undertakings (such as Lerebours' feat in securing daguerreotype views of various European architectural and scenic wonders), cameras were little used in the 1840s to record scenic views anywhere. No photographs are known to have been taken, for example, of the first wave of migrations across the American continent to Oregon and the Far West. One exception occurred, however, when Frederick Langenheim journeyed to Niagara Falls in the spring or summer of 1845 and made a primitive form of a panoramic view of the falls by securing five daguerreotypes which he mounted side by side in a single frame. Returning to Philadelphia, he copied these views in eight sets, and in December he sent one set each to President Polk; Queen Victoria; Daguerre; the kings of Prussia, Saxon, and Württemberg; and the Duke of Brunswig. The five views taken of Niagara Falls did not exactly coincide with one another; however, this was accomplished in a similar feat the following year by Friedrich von Martens, who secured a panoramic view of Paris with a camera of unique design in which the lens was moved horizontally through an angle of more than 150 degrees, the picture being secured on a curved daguerreotype plate.[104]

Daguerreotype portraiture, meanwhile, was not practiced with any marked success at all in Daguerre's homeland prior to this time. Historian Marcus Root tells the story of Nathan G. Burgess' visit to Paris in 1840, where he met one of the "artisans" who had constructed Daguerre's first apparatus (presumably Michel Chevreul or Alphonse Giroux). Burgess, the "artisan," and another unidentified man tried making daguerreotype portraits and views in Paris, but without success. As strange as it sounds, a nineteenth-century version of "an American in Paris" was among the first to produce noteworthy daguerreotype portraits in Paris. This was Warren Thompson of Philadelphia—another pioneer American photographer who leaves a tantalizingly illustrious but elusive trail in the recorded pages of photographic history. Thompson is said by Root to have been the second Philadelphian (after Cornelius) to successfully take daguerreotype portraits—presumably with a mastery of plate acceleration techniques learned from Dr. Paul God-

The westward migration of covered wagons across the American continent began in the early 1840s, increasing from a thousand vehicles a year heading for Oregon in 1843 to three thousand by 1845.

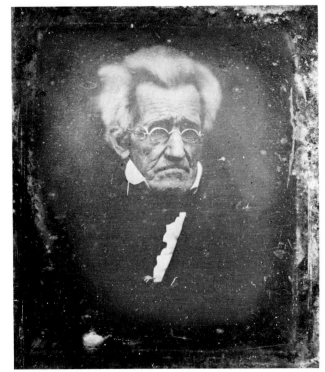

Fig. 1

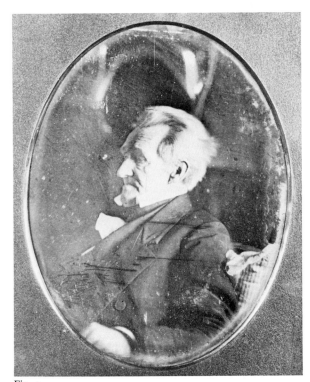

Fig. 2

PHOTOGRAPHERS PAY HOMAGE TO A NATIONAL PATRIOT

As the spirit of "manifest destiny" spread throughout the land, so it seemed an appropriate time to pay homage to one of America's most venerable patriots, who had helped to make it all possible. Thus, one of the great photographic undertakings of 1845 was the effort by a number of daguerreans—possibly including Brady—to procure a likeness of former President Andrew Jackson, who was by this time approaching the end of his life in failing health at The Hermitage, his planation home outside of Nashville.

Although all of the portraits above were made of Old Hickory in the spring of 1845, the photographer of only one can be determined with assurance. This is Fig. 2, reproduced from a half-plate daguerreotype profile in a private collection which is still secured in its original case, on the back of which is written in a contemporary hand: "Daguerreotype of Genl. Andrew Jackson in possession of the late Judge John K. Kane. Taken by Langenheim at The Hermitage a short time before the death of the General." The photographer was therefore either Frederick or William Langenheim of Philadelphia. Fig. 1, which has been reproduced from a sixth-plate daguerreotype donated by A. Conger Goodyear to the International Museum of Photography at George Eastman House, is attributed by museum officials to a Nashville photographer, Dan Adams. Figures 3 and 4 are clearly similar to one another, but Fig. 4 gives the appearance of being a retouched version of Fig. 3. The latter has been reproduced from an 1897 article in *McClure's* in which Charles H. Hart, an authority at that time on historical portraiture, describes the original as a daguerreotype of only size 1⅛ x ¾ inches, made by Dan Adams and owned at that time (1897) by Col. Andrew Jackson of Cincinnati. Fig. 4 is from a wet-plate negative at the National Archives attributed to Brady, and said to have been made from a daguerreotype. But the daguerreotype itself is not in the Archives and remains unidentified. It would seem that the daguerreotype represented in Fig. 3 (or another copy of the same image) served as the original from which the retouched wet-plate negative by Brady (Fig. 4)

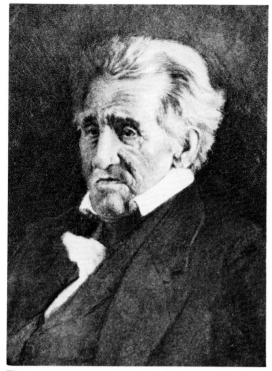

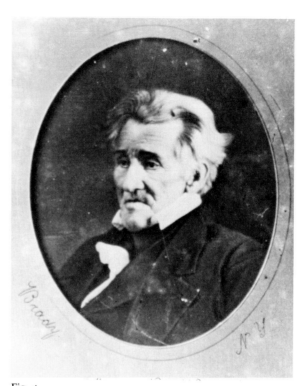

Fig. 3 Fig. 4

was made in later years. The question therefore remains: Who made the original daguerreotype attributed by Hart to Dan Adams, and represented in Fig. 3? The late Prof. Robert Taft, in his *Photography and the American Scene,* is of the opinion that the *McClure's* image attributed to Adams was actually a copy of an original, since small copies of this nature were frequently made of larger daguerreotype portraits. The *McClure's* image could therefore be attributed to Adams, or to another photographer, such as Brady or Edward Anthony. There is considerable likelihood that the original was, in fact, made by Anthony, who is reported to have journeyed from New York to The Hermitage in 1845 for the express purpose of daguerreotyping Jackson. Two issues of the *Democratic Review* in 1845, and another in 1846, carried engravings of a Jackson likeness similar to the daguerreotype in Fig. 3, and these engravings were said to have been made from a daguerreotype by Anthony, Edwards & Co. In the *McClure's* article, Hart quotes Jackson's granddaughter, Mrs. Rachel Jackson, as having "a vivid recollection of the arrangement for taking this likeness," but she does not state that it was Adams who came to The Hermitage for this important sitting. She does, however, refer to "old plates of some earlier daguerreotypes [of Jackson], but they are entirely faded out." As for Mathew Brady, we have only the statement he made to a reporter in 1891: "I sent to The Hermitage and had Andrew Jackson taken barely in time to save his aged lineaments to posterity." Brady was, of course, unaware of the existence of the Langenheim portrait, and whom he "sent" or whether he went to Nashville himself remains unknown. But Brady and Anthony frequently collaborated in daguerreotype undertakings, and possibly it was Anthony whom he "sent." If the Fig. 3 daguerreotype attributed to Adams was copied from an Anthony original, it is possible that the original was lost in the 1852 fire which destroyed Anthony's National Daguerreotype Miniature Gallery in New York City after it had been sold to D. E. Gavit. Only one daguerreotype, a portrait of former President John Quincy Adams, was retrieved from the rubble of that holocaust.[105]

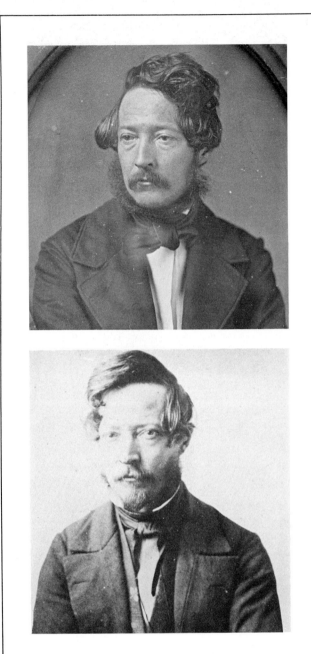

THE LANGENHEIM BROTHERS

Frederick (top) and William Langenheim came separately to the United States from Germany in the 1830s, and later rendezvoused in Philadelphia. But before that, William fought in the Texas war of independence and helped recapture the Alamo after the massacre of 1836. The brothers are credited with being first to introduce German-made cameras equipped with Petzval portrait lenses in the United States, and their Philadelphia gallery became one of the nation's foremost after 1843. After 1850, they would become the principal American pioneers both in the new field of stereophotography and in the application of photography to audience slide viewing with magic lanterns. Their attempts to license American photographers in the use of Fox Talbot's calotype process in 1848–49, however, would prove unsuccessful.

dard. On May 12, 1843, he was awarded the fifth patent in American photography for a daguerreotype coloring process—a patent which he sold the same year to Montgomery P. Simons. His subsequent distinguished career in Paris began modestly in 1845:

> Thompson came to Paris without being able to speak a single word of French. He merely had a letter of introduction from the Russian Consul in New York to the Vice-Consul, Iwanow, in Paris. The latter turned the American over to Levitzky,* who received him cavalierly, supposing him to be a mere amateur. He was soon disabused when Thompson produced his specimens. They proved far better than anything which had so far been seen in Europe. Neither Paris, Vienna, nor Rome could produce such results. Levitzky, then one of the leading daguerreotype artists in Paris, writes: "They were not mere daguerreotypes, they were works of art." Here was strength, relief, artistic lighting, softness of shadows, with a wealth of halftones. All specimens were half-plates. This in itself was a revelation, as thus far in Paris nothing larger than quarter-plates had been used. Thompson at once opened a studio in a large building in Boulevard Poissonier, Maison du pont de fer. The studio contained two stories, with three large rooms, having large windows. So superior were Thompson's results, that, notwithstanding the competition of native operators, his sitters averaged 30–40 a day.[106]

Contrasting with this tour de force in Paris, we find that an Ohio blacksmith-turned-daguerrean was successfully playing Yankee tricks on Yankees in Boston at this same time. John W. Bear was called the "Buckeye Blacksmith" (for his native state, Ohio) all during his life, which included much politiking on behalf of various national political campaigns (and an occasional political appointment when his candidates won). According to his autobiography, which he published privately, in 1873, his on-again-off-again career in photography began after the defeat of Henry Clay in the presidential election of 1844:

> As soon as the election was over and I had got a little rested, I concluded to leave the West and go East where I thought there was a better chance to get a start in life than in the West; I therefore went to Philadelphia where some of my old Whig friends assisted me with funds to learn and start the daguerreotype business. I started my business in Philadelphia, but owing to its being a new thing I did not succeed as well as I expected, so I packed up in the Spring of 1845 and went to Boston, believing that if ever I got a start in life again it must be among the Yankees; accordingly I opened up in Boston where I had but one or two oppositions to contend with; I hung out my sign and at the end of the first month I found I had made a failure; I could not get the people to
>
> come into my place; I saw plainly that I must burst up or use some other plan to attract the attention of the people; we were charging three dollars for a small picture in a morocco case which was considered very high. So I concluded to reduce the price, and in order to attract attention to the price, I concluded to play a Yankee trick on the Yankees. I got up a large placard on each side of a frame that I fixed on the top of a pole ten feet high and hired a boy to stand at the corner of Court and Hanover Sts., the most popular corner in the city, and hold this pole so that all the passers-by could see it, (from five to seven in the evening when thousands passed on their way home from work.) The people of the country had just

1845

50

began to talk about a war with Mexico; this subject was in everybody's mouth, I took advantage of this and had my placard headed in large letters: "War with Mexico, (then under that) or not (in small letters) J. W. Bear will furnish beautiful daguerrotypes at No. 17 Hanover street, colored, true to life, in fine morocco cases for one dollar and a half, with a premium to the first setter every morning." This was all that I had on my large placard.

I stood a short distance off to see the effect it would have; it had the desired effect, for the people came running from every direction to see what that war news meant; after reading the whole bill they would go away laughing, saying, "that it was the best dodge of the season."

The bait took like hot pancakes, for next morning early when I got to my rooms I found a score or more waiting ready to enlist as they said for one of my cheap pictures. I gave a premium of fifty cents to the first one that came every morning, (this hurried them up.)

The result of my experiment was: that rich and poor, high and low, all flocked around me, and many of them said that I must be a Yankee for none but a Yankee could ever have got up such a good dodge as I had to get custom, and many of them offered to assist me with means to increase my business, and I have no doubt had I have stayed there that I should have been a rich man to-day, for the Yankees are the best people I have ever seen to help a stranger along in business who is willing to help himself, and I would here advise every young man who wishes to make a good start in the world to make that start among the Yankees.[107]

With all these activities—in New York, Nashville, Paris, and Boston—the daguerreotype process was still "very difficult and uncertain" in the eyes of the London photographer Antoine Claudet. "So many conditions are requisite to a successful operation that, indeed, it might be said that failure is the rule, and success the exception," he said in a progress report on the state of the art, published in the summer of 1845 in the *Journal of the Franklin Institute*. First, there was the problem of light itself:

This renders the task most delicate and arduous. The operator has constantly to overcome new difficulties, and the greatest is, perhaps, the want of power to appreciate the amount of operating rays existing at every moment. No photometer can be constructed; for the acting rays are not always in the same ratio to the intensity of light. It is true that, if it were possible to measure the comparative quantity of blue, yellow, and red lights, at all times, then it would be of considerable assistance in judging of the amount of photogenic light. But even this test would not be sufficient, for the acting rays are not strictly identical with the blue rays. Still, to be able to ascertain that there were no yellow or red vapors in the atmosphere, making, as it were, screens of those colors between the sun and the object, would be, no doubt, an important assistance.

It is to the influence of these vapors that the difference found by operators in various climates is due, which difference seemed at first irrational, but which can now easily be explained.

When the daguerreotype was first discovered, it was expected that southern climates would be more favorable than northern for the process, and that, in countries, where the sun constantly shines, the operation would be considerably shorter. This has not been proved to be the fact, and the following reason may be given for such an apparent anomaly. Light is more intense in the northern latitudes up to a certain degree, on account of its being reflected in all directions by the clouds disseminated in the atmosphere; whilst in the drier climates the open sky, instead of reflecting light, absorbs a great quantity of it. Of course, in speaking of clouds, it cannot be meant that a completely covered sky is more favorable than a sky without any clouds, for in this case the sun is entirely obscured. But still there are days when, although the disk of the sun is not seen from

Antoine Claudet (1797–1867), circa 1865.

any part of the horizon, the thin clouds allow a much more considerable quantity of photogenic rays to be diffused and retained in the lower strata of the atmosphere than when there are no clouds, and that by some imperceptible vapors the light has a yellow or red tint.

Today, our cameras are equipped with devices which automatically cope with differentials in lighting, as it is cast upon each and every subject of a camera exposure. It is difficult to realize that different atmospheres and even the response of different prople to long exposure to light had an important effect on the success or failure of daguerreotype portraiture. Claudet explained the matter in these words:

There is a curious fact which would seem to corroborate the argument in favor of greater intensity of light in northern climates. It is known that, by a provision of nature, all races of men are constitutionally adapted to the climates in which they are destined to live, that the inhabitants of the tropics can bear a much higher temperature than the inhabitants of the north. May it not be the same for light? The eyes of the inhabitants of the cloudy and snowy countries are adapted to bear a stronger light than those living in the south. In the course of my daguerreotype experience, I have observed that there is a comparatively greater number of Englishmen than of Frenchmen, Spaniards, and Indians, capable of sitting for their portraits in a strong light, without being much incommoded. If this fact is correct, such a provision of nature would prove that generally light is more intense in the northern climates, and that it decreases gradually towards the equator.

It was first expected that the climate of England, and countries similarly situated, would be unsuitable to the daguerreotype operation; nevertheless, it has turned out that this is one of the most favorable climates for the practice of the process.[108]

* Sergej L. Levitzky (1819–1898).

1845

WASHINGTON IN THE POLK ADMINISTRATION

1846

52

These half-plate daguerreotypes (each 4½ x 5½ inches) are two of the earliest-known photographs of Washington, D.C., found with several others at a California flea market in 1972. The views of the U.S. Capitol building (top) and the White House (bottom) are attributed to John Plumbe, Jr., and are believed to be examples from a series which Plumbe advertised for sale in 1846.

With the new availability of improved cameras and lenses, the practice of photographing the great and famous became more commonplace. The *Christian Watchman* observed that "already, the daguerreotypes of the most important public characters adorn the saloons of noted artists." John K. Plumbe, Jr., became the third photographer—along with the Anthony firm and L. T. Warner—to establish a major gallery in Washington, and by March 1846, President Polk and former President John Quincy Adams had posed before his cameras. Perhaps because Edward Anthony was given the use of a congressional committee room to conduct his private photographic business, Plumbe also endeavored, before locating in Washington, to secure a committee room for himself through a political connection of his brother's; but whether or not he managed that is not known. His gallery, in any event, was established on Pennsylvania Avenue.

On January 29, a Washington newspaper reported that Plumbe was setting out to take daguerreotype views of "all the public buildings" in the city, something no one else before him is known to have attempted. The account also stated that Plumbe intended to dispose of copies of these photographs "either in sets, or singly." Twenty-two days later, another Washington newspaper reported that views of the U.S. Capitol, Patent Office, and other buildings "embellish" the walls of the Plumbe gallery, and were the subject of "universal commendation."[109] But like the daguerreotype views known to have been taken by various photographers in New York and elsewhere, Plumbe's daguerreotypes of Washington buildings were soon heard of no more. If there were sets made and sold, they were subsequently discarded or lost by their owners, or by successive generations—until, one hundred and twenty-six years later, a set turned up (in 1972) at a flea market in Alameda, California. When photographic copies of these specimens were sent to the Library of Congress for confirmation of their identification, "excitement ran high in the [Prints and Photographs] division, for, after an examination of the images," according to a division official, "it was felt that five of the views undoubtedly were those referred to in the 1846 newspaper story and would, therefore, have the distinction of being the earliest surviving photographic record of the nation's capitol."[110] A sixth daguerreotype found at the 1972 flea market is of the Battle Monument in Baltimore (constructed in 1815). This indicates that if it was taken by Plumbe, as presumed, he evidently made an attempt to secure daguerreotype views in other cities.

Plumbe appeared to be doing well at his New York gallery (at Broadway and Murray streets) as in Washington. A New York newspaper reported being shown a daguerreotype early in March of former president Martin Van Buren, which was described as being "nearly twice the size of the usual miniatures."[111] Nevertheless, within a year, for reasons none of his biographers has made clear, Plumbe found himself in financial difficulty and sold *all* of his photographic establishments (in Washington, New York, Boston,

THE FURTHER EXPLOITS OF THE "BUCKEYE BLACKSMITH"

I stayed in Boston until the winter set in, and then concluded that the climate was too cold for me and that I had better go South.

The first place I stopped at was Wilmington, Del., where I stayed a few weeks, but done but little business, owing, I suppose, to its being a new thing it did not take with the people there. I very soon saw that it was no go at that place, so I pulled up stakes and went to Annapolis, Md., where I opened up in the Court House with an excellent light for the business. I had no sooner hung out my sign than the people began to crowd around me, and for five or six weeks I done a most excellent business; I took in over five hundred dollars in less than two months, then when all that wished pictures had been supplied I packed up and went to Alexandria, Va.

I opened up in a fine room and went to the printer to get some bills printed, when he frankly told me, that he would charge me five dollars for them and that I would never get it back for pictures in that city, for said he, "daguerreotypes are played out here, there are three men at it here already that can't make their rent, and they are citizens, so it is no use for a stranger to try it." All right, said I, "print my bills, I will try it a few days and see what I can do."

I changed my bills from what I had intended to put up; in place of putting the price at two dollars I concluded to play a Yankee trick on them, so I got up the following bill:

Only $1.50 for the best daguerreotype ever seen in Alexandria, put up in fine morocco cases; colored true to life and warranted not to fade at —— Washington street, (adding below,) how many have lost a father, a mother, a sister, a brother, or an innocent little prattling child, and have not even a shadow to look upon after the separation; some little toy or trifling article are often kept for years and cherished as a token of remembrance. How more valuable would be one of the Buckeye Blacksmith's beautiful pictures of the loved and lost.

Reader you could not do a better thing now, while your mind is on the subject, than to take a stroll to the Buckeye's Place, you may have reason in future years to feel thankful for these gentle hints from a stranger:

For think not these Portraits by the sunlight made,
Though shades they are, will like a shadow fade;
No when this lip of flesh in dust shall lie,
And death's gray film o'erspreads the beaming eyes,
These life like pictures mocking at decay,
Will still be fresh and vivid as to day.

A call is respectfully solicited. I hung out my sign at 12 o'clock, went to my dinner and returned at 1, and found a dozen or more looking at my pictures. "Are you the gentleman that makes these pictures," said a pretty young lady to me. I told her I was. "Will you make me as pretty a picture as this (pointing to one in my frame) for a dollar and a half?" "oh, yes, and prettier too, for you are a better looking young lady than the one that set for that picture," said I. This raised a great laugh among the crowd; we went in, and I not only took her picture but nine others, thus before night I had taken in fifteen dollars. I went to the printer that night and told him what I had done, "that I had taken fifteen dollars the first day and intended to take in fifteen hundred before I left," he said, he hoped that I would but doubted it. The next day I was full from morning till night with the fashion and beauty of the city, and so I continued from day to day, until finally the families of all three of the other operators came to me to get pictures, for none of these operators knew how to take good pictures and had quit the business as soon as I got under way.[112]

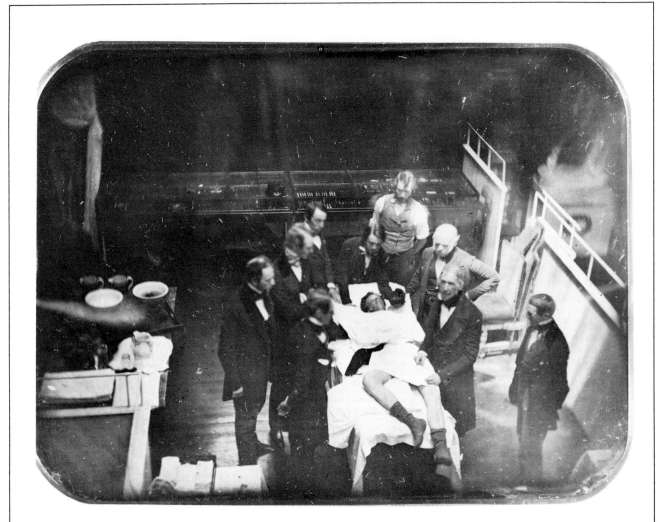

PHOTOGRAPHY DOCUMENTS FIRST SURGERY UNDER ETHER

Of all medical advances, none was more revolutionary than the discovery of anesthetics; without a way of preventing pain no real advances in surgery would ever have been possible. On October 16, 1846, in the first such experiment, surgeon John C. Warren operated on a patient's neck tumor while Dr. William T. G. Morton applied ether as an anesthetic at Massachusetts General Hospital. The half-plate daguerreotype, above, is a reenactment of this historic scene. Dr. Warren was again present (facing camera with hands on the patient's thigh), but Dr. Morton was not. In his place, Freeman J. Bumpstead, acting as a stand-in, holds ether cloth. A substitute was also used for this photograph to play the role of the patient, Gilbert Abbott, on whom the operation was originally performed. Although the date of this reenactment of the 1846 operation is not known, it may have been as early as November 1847, when Dr. Warren and ten other prominent Bostonians—among them Oliver Wendell Holmes and Nathaniel Bowditch—petitioned Congress to reward Dr. Morton for the ether anesthesia discovery. Or the reenactment photograph may have been taken as late as the fall of 1856, when Boston and New York hospitals took up a collection for the financially troubled Morton, aided by the poet Longfellow. This daguerreotype is believed to be the original taken of the reenactment, and at least one copy daguerreotype is known to be extant. The scene is possibly the earliest documentary photograph taken in the United States.[113]

EMERSON AND CARLYLE EXCHANGE DAGUERREOTYPES

Ralph Waldo Emerson was eminently happy with a daguerreotype sent to him by his friend, Thomas Carlyle, in 1846, but neither Emerson nor Carlyle were happy with Emerson's results secured in Boston. On May 14, the latter wrote Carlyle:

> I was in Boston the other day, and went to the best daguerreotypist, but though I brought home three transcripts of my face, the housemates voted them rueful, supremely ridiculous. I must sit again; or, as true Elizabeth Hoar said, I must not sit again, not being of the right complexion which Daguerre and iodine delight in.

On May 31, Emerson again wrote Carlyle that he had brought home "three shadows not agreeable to my own eyes," which his wife dubbed "slanderous." But he decided to send one to Carlyle anyway. The latter responded thus on July 17:

> . . . the photograph after some days of loitering at the Liverpool Custom-House, came safe to hand. Many thanks to you for this punctuality: this poor shadow, it is all you could do at present in that matter! But it must not rest there, no. This image is altogether unsatisfying, illusive, and even in some measure tragical to me! First of all, it is a bad photograph, no eyes discernable, at least one of the

eyes not, except in rare favorable lights: then, alas, Time itself and Oblivion must have been busy. I could not at first, nor can I yet with perfect decisiveness bring out any feature completely recalling to me the old Emerson, that lighted us from the Blue, at Craigenputtock, long ago—eheu! Here is a genial, smiling, energetic face, full of sunny strenth, intelligence, integrity, good humor; but it lies imprisoned in baleful shades, as of the Valley of Death; seems smiling on me as if in mockery. Doesn't know me, friend? I am dead, thou seeist, and distant, and forever hidden from thee; I belong already to the Eternities, and thou recognizest me not! On the whole, it is the strangest feeling that I have:—and practically the thing will be, that you get us by the earliest opportunity some living pictorial sketch, chalk-drawing or the like, from a trustworthy hand; and send it hither to represent you. Out of the two I shall compile for myself a likeness by degrees: but as for the present, we cannot put up with it at all; my wife and me, and to sundry other parties far and near that have interest in it, there is no satisfaction in this.[114]

During the last dozen years of his life, Emerson suffered from a failing mind and loss of memory. But near the end when he saw a picture of Carlyle, he is reported to have whispered: "That is that man, my man."

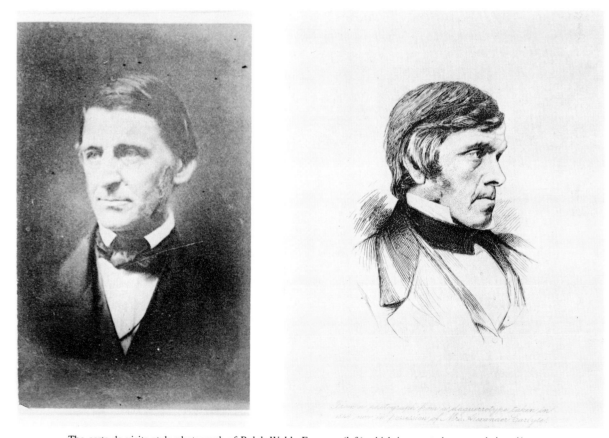

The carte-de-visite-style photograph of Ralph Waldo Emerson (left) which is mounted on a card size 2½ x 4 inches, was made in the early 1860s. The photograph of Carlyle (right) was copied from an 1846 daguerreotype of the English essayist and historian. No daguerreotype of Emerson made in 1846, or a copy photograph made from such a specimen, is known to have survived to modern times.

Baltimore, Philadelphia, Saratoga, Louisville, New Orleans, Dubuque, and St. Louis) to employees. After this his activities became as "shadowy" as had been those of Brady four years earlier. He returned first to his former home in Dubuque, then in 1849 went to California where he again endeavored to promote his scheme for an east-west railroad which would follow a southern route across the continent. But the government decided on a northern route. At some point after 1854, Plumbe returned once again to Dubuque where, in 1857, he committed suicide. He was only forty-eight years old.[115]

A more happy tale is to be found in the life of Plumbe's contemporary, John J. E. Mayall, of Philadelphia. Mayall, who may have been born in England, decided in 1846 (at age thirty-six) to sell his photographic gallery to Marcus Root, and in the summer he left the United States to join Antoine Claudet in London. Within a year, he established his own business there, known as the "American Daguerreotype Institution," which flourished immediately. Mayall had studied under Professors Goddard and Boyé at the University of Pennsylvania, and this training served him well. He became noted for making unusually large daguerreotypes admired for their superior polish and clarity. As the years passed, he became recognized as one of England's foremost Victorian photographers, and his photographs of Queen Victoria after 1860 are now ranked as the finest.

Mayall lived to the age of ninety-one, serving at one time as mayor of Brighton.[116]

The lot of the rural or small-city photographer was still a difficult one for most, although the novel approach to his businesses in various cities continued to be beneficial to the "Buckeye Blacksmith" (see page 53). There were two photographers in Elmira, New York, during the period 1846–47, for example, but neither lasted more than a matter of weeks—their "shadow pictures" having been not well received by the local citizenry. An itinerant woman photographer, Sarah Holcomb (who had been a student of Albert Southworth's in Boston) lacked the "Buckeye Blacksmith's" competitive nature, and when she journeyed to Manchester, New Hampshire, in the winter of 1846, she did not stay when she found that there was already another photographer there. A combination of bad weather and the absence of any competition at Claremont, New Hampshire, made her decide to stop there, but then she found her chemicals had frozen. She wrote Southworth that her bottle of bromide had burst and that "I can do nothing till I get more."[117]

Abraham Bogardus, twenty-four, a farmer's son from Dutchess County, New York, decided at this time to become a photographer and spent two weeks in September learning the trade from George Prosch in New York. In later years he recalled:

The page of daguerreotype advertisements (above left) is from the *Mercantile Directory* of Philadelphia for 1846. John J. E. Mayall (above right) sold his gallery to Marcus A. Root the same year and went to England to become an assistant to Antoine Claudet. Within a year he established an "American Daguerreotype Institution," and soon became one of England's most prominent portrait photographers of the Victorian era. After becoming mayor of Brighton, he died there in 1901 at the age of ninety-one.

William C. Bouck (left), governor of New York from 1843 to 1845, exhibits what the *Christian Watchman* considered a "literary weakness" by posing for this daguerreotype surrounded by his books. An unidentified man, (right), posing with his musical instrument, exhibits what the *Watchman* considered a "musical weakness."

"THERE IS A PECULIAR AND IRRESISTIBLE CONNECTION BETWEEN ONE'S WEAKNESSES AND HIS DAGUERREOTYPE . . ."

The *Christian Watchman*, in the spring of 1846, foresaw unlimited possibilities for the daguerrean art, and expressed the belief that it was "slowly accomplishing a great revolution in the morals of portrait painting." The problem had simply been, the magazine contended, that the flattery of portrait painters was "notorious." But now, these "abuses of the brush" could "happily" be corrected by the new photographic art:

Daguerreotypes properly regarded, are the indices of human character. Lavater judged of men by their physiognomies; and in a voluminous treatise has developed the principles by which he was guided. The photograph, we consider to be the grand climacteric of the science. Lord Chesterfield assures his son that everybody has a weak point, which if you are fortunate enough to touch or irritate delivers him into your power at once. It has been said that the inhalation of exhilarating gas is a powerful artificial agent for disclosing these weaknesses of human nature. In reality, however, the sitting for a daguerreotype, far surpasses all other expedients. There is a peculiar and irresistible connection between one's weaknesses and his daguerreotype; and the latter as naturally attracts the former as the magnet the needle, or toasted cheese, the rat.

There is a *literary weakness*. Persons afflicted with this mania are usually taken with a pile of books around them—or with the fore-finger gracefully interposed between the leaves of a half-closed volume, as if they consented to the interruption of their studies solely to gratify posterity with a view of their scholarlike countenances—or in a student's cap and morning robe, with the head resting on the hand, profoundly meditating on—nothing. Thus a young woman whose leisure hours are exclusively devoted to the restoration of dilapidated male habiliments, appears in her daguerreotype to be intensely absorbed in the perusal of a large octavo. What renders the phenomenon the more remarkable is, that the book was upside down, which necessarily implies the possession of a peculiar mental power.—There is the *musical* weakness which forces a great variety of suffering, inoffensive flutes, guitars, and pianos, to be brought forward in the company of their cruel and persecuting masters and mistresses. One young lady, whose ear had been pronounced utterly incapable of detecting discords, sat with a sheet of Beethoven's most difficult compositions, in her delicate dexter hand. Some amusing caricatures are produced by those who attempt to assume a look which they have not. Timid men, at the critical juncture, summon up a look of stern fierceness, and savage natures borrow an expression of gentle meekness. People appear dignified, haughty, mild, condescending, humorous, and grave, in their daguerreotypes, who manifestly never appeared so anywhere else. Jewelry is generally deemed indispensable to a good likeness. Extraordinarily broad rings—gold chains of ponderous weight and magnitude, sustaining dropsical headed gold pencils, or very yellow-faced gold watches, with a very small segment of their circumference concealed under the belt—bracelets, clasps, and brooches—all of these, in their respective places, attract attention, and impress the spectator with a dazzling conception of the immense and untold riches of those favored beings whose duplicate daguerreotypes he is permitted to behold.[118]

I paid fifty dollars for instructions and a complete set of apparatus, consisting of a quarter-size camera and stand with three legs, two coating boxes, a mercury bath, a hand buff, a clamp head-rest to attach to a chair, and a clasp to hold the plate while being buffed. With this outfit I commenced business.

To have a daguerreotype taken was the ambition of every aspiring man. It was a great event to most sitters. A black suit, a white vest and thumb in the armhole of the vest, the other hand holding an open book—an attitude of spirit and importance—was considered just the thing.

A sitting required from *forty seconds* to *four minutes*. At that date we all worked by side lights; there was but one skylight in the city, and that was in the granite building on the corner of Broadway and Chambers Street. The light was some six or seven flights up stairs from the street, and was made to revolve, so as to keep the back of the sitter towards the sun. Soon after this most of the fraternity built skylights; then the work improved, sittings being made in much shorter time, and much better effects of light and shade were produced. [119]

The fall of 1846 was a "trying and discouraging" period for Bogardus, and sometimes he managed to take only two pictures in an entire week. But sixteen years later he was still operating at the same location (Barclay and Greenwich streets), and he continued to expand his business with marked success. In 1871, he was named first president of the National Photographic Association of the United States.

One of the things which evidently caused John A. Whipple to delay, or to temporarily abandon his experimentation with glass negatives, was his early (and evidently successful) efforts to obtain daguerreotypes of images seen through a microscope. His experiments, which were presumably the earliest in microphotography, were described in an undated letter which he addressed to H. H. Snelling:

"Friend Snelling * * * * * * * In 1846, it was suggested to me by the Rev. S. Adams, of this city, that it might be possible to daguerreotype the image of the microscope; he was in possession of a fine 'Oberhausen,' which he loaned me for the trial. By removing the lenses from the camera and substituting the microscope in its place and adjusting the object properly for seeing with the naked eye, a clear but very faint image was found projected on the ground glass, the light being so weak that it was hardly possible to focus it. But doing that as well as I could, and submitting a plate to its action, giving it an exposure of one and a half hours, then marvelously long, great was my astonishment and delight when lifting the plate to take a peep, I saw a clear and distinct image there, thus demonstrating the possibility of indelibly fixing the forms of nature now invisible by our unaided vision. The object tried was the mandible of a small spider, so small that it could only be discerned as a mere speck by the naked eye; it was magnified on the plate to cover three-fourths of an inch surface, and every part was reproduced in bold relief, showing its little comb-like appurtenances to perfection, equally as well as represented to the eye in the instrument; the only defect in this first proof was a small light spot exactly in the middle of the plate, which we found was caused by a prism used in the microscope to reflect the image at right angles. On removing that the next proof was without a blemish. My next experience was with test object scales of the tepizum; and truly they were a test for daguerreotyping. I could do every part well enough but the cross-strings, which are only brought out with instruments of the very best manufacture; when so high a power is used as is here necessary a great loss of light is experienced, requiring an exposure of many hours, which every one acquainted with daguerreotyping knows is not favorable to fine results. I succeeded in doing them with the finest instrument as well as a second rate one would show them to the eye. I find a much better way for ordinary purposes, instead of a microscope with eye pieces, is to use simply a double or treble achromatic of a combined focus, of from one-fourth to one inch in length, according to the character of the object, and the extent desirable to magnify; a section of woody fibre, for making an eighth of an inch in diameter, an image of which it would be desirable to impress on a plate five inches in diameter, I should use a lens of about half an inch focus, and all that is to be done to it is to have these little lenses set in the brass plate, which will screw into the camera when the daguerreotype lenses unscrews, then support the slip of wood to be magnified half an inch before the lens on a little slide prepared to hold it, that can be made to move backwards and forwards a quarter of an inch or so, thereby pointing the camera towards the rim, and having the wood just in the focus of the small lens, a beautiful distinct magnified image of it will be seen on the ground glass of the camera, in size just in proportion as the camera box is lengthened or shortened, and the wood supports on the stand moved nearer to or farther from the lens.

"The brilliancy is greatly increased if the sunlight is condensed upon the object by means of a lens, one about two inches in diameter, and three or four inches focus answers the purpose well, always being careful not to exactly focus the sunlight upon the object; if so it would be singed by the heat. [120]

1846

1847

A Cincinnati daguerrean scooped the world in the summer of 1847 by making a positive photograph on a piece of glass, using collodion as his sensitizer—but nobody talked about it until nearly a dozen years later. The photographer was Ezekiel Hawkins, one of three artist sons of a minister of the Gospel. A privately printed book on Ohio taverns (published in 1937) now appears to be the only source of information on the Hawkins family, but it gives no indication as to the three brothers' place of birth. Ezekiel (''Zeke'') was said to be working as a window-shade painter in Baltimore in 1806; Steubenville, Ohio, in 1811; Wheeling, Virginia (now West Virginia), in 1829; and Cincinnati in 1843. He also tried landscape and portrait painting, and ''indulged'' in Shakespearean drama before ''becoming famous for his perfecting of the daguerrean art.''[121]

The historian Marcus Root says that the daguerreotype practice was introduced in Cincinnati by Thomas Faris in 1841, and that Faris was the first to use bromine as a plate accelerator there. But a Cincinnati newspaper stated in 1852 that Ezekiel Hawkins was first to introduce the daguerreotype art in that city. Hawkins is listed for the first time in a Cincinnati directory in 1844, and the listing given reads ''H. & Faris'' after Hawkins' name.[122]

Like many of photography's ''firsts,'' the invention of the glass negative process using collodion has been contested. An English sculptor, Frederick Scott Archer (1813–1857) is generally credited with the invention, and he published his method in a British chemical journal in March 1851. The noted French calotypist Gustave Le Gray (1820–1862) has also been credited with suggesting collodion for photography use, but he did not propose or publish a method for its adoption before Archer did. A third claim was made twenty years after Archer's premature death in 1857. Robert J. Bingham, who had been a laboratory assistant at the Royal Institution prior to 1850, and partner of Warren Thompson in Paris after 1859, claimed on his deathbed (in 1870) that he had assisted Archer in the latter's darkroom, and that he, not Archer, was the one who actually perfected the method published by Archer. Bingham is not known to have contested Archer's publication or subsequent recognition for the invention prior to the deathbed statement, which he made to the English photographer and author Thomas Sutton. Then Sutton waited another five years before he published Bingham's claim.[123]

Ezekiel Hawkins seems never to have tried to perfect a workable collodion method based on the one he used to produce his pioneering photograph, nor did he publish anything concerning this endeavor, or assert any claim when he later achieved notoriety in the photography world (in 1852) for being one of the first in the United States to make paper photographic prints from glass negatives. The first word of Hawkins' 1847 feat was contained in what the theatrical world would label a ''throwaway line'' at the end of an article which appeared in the fourth American edition of a standard English chemistry textbook published in 1857. The editor of the American edition was Dr. J. Milton Sanders, who was no slouch in the world of chemistry. Sanders experimented in Dr. Michael Faraday's laboratory at the Royal Institution, and served for a time as professor of chemistry at the London Adelaide Gallery. He was twice professor of chemistry at the Eclectic Medical Institute in Cincinnati (from 1851–52, and again from 1856–58), and held similar posts at eclectic medical institutes in New York and Philadelphia. Sanders was evidently acquainted with Hawkins, and by his own account had proposed to Hawkins that he try using collodion in his photographic work, which Hawkins thereupon proceeded to do. Ten years later, Sanders mentioned Hawkins' successful experiment in a two-sentence attribution in his chemistry textbook, and this caught the eye of Charles A. Seely, editor of *The American Journal of Photography,* who at the time was also a manufacturer of photographic chemicals. Seely queried Sanders on the matter, and the latter responded with the only recorded description of Hawkins' feat (see correspondence, next page). Sanders never provided the additional details promised, but became after that an infrequent contributor to Seely's journal.[124]

Collodion, when it came into use in the 1850s, could be used to make a glass negative (from which positive prints could be made on paper or another surface), or to make a positive image on glass or other surface (from which no prints could be made). Different chemical conditions were called for to produce either one or the other result. In Hawkins' case, he produced a positive image on glass—technically an ambrotype, which may well have been the first ambrotype produced anywhere. The image would appear to be a negative when the glass was examined by itself, but became a positive photograph when Hawkins painted the back of the glass with black paint. The identical set of circumstances can be observed by examining the elements of any ambrotype (see page 110). No Cincinnati institutions today appear to possess any records or photographs by, or pertaining to, Hawkins, and the whereabouts of his 1847 ambrotype is unknown. It may have been lost in an 1851 fire which started next door at the Cincinnati museum building and destroyed Hawkins' gallery.[125]

It appears that the thought of using collodion for photography may have occurred to a number of people at the time. Dr. Charles S. Rand, of Philadelphia, for example, reportedly suggested the use of collodion to the Langenheims in 1848, and the Langenheims reportedly conducted experiments with it, but were unsuccessful. The Langenheims were more interested in calotype photography at this point, and in 1849 William Langenheim met with Talbot in England to secure (for the price of $6,000) the exclusive American rights to the calotype process, which had been given an American patent on June 26, 1847.[126] American photographers, however, showed no interest at this time in making photographs with paper negatives. There were, in fact, few practitioners of the calotype process anywhere, although increased interest was shown in Europe after 1847 when a Frenchman, Louis Blanquart-Evrard, perfected an

COLLODION IS USED TO MAKE A PHOTOGRAPH
ON GLASS IN CINCINNATI

Just as the first recorded American photograph on paper appears to have been made in Cincinnati in May 1839 by Prof. John Locke at the Medical College of Ohio, so it appears that the first recorded American photograph on glass was made there in the summer of 1847 by Ezekiel Hawkins. The correspondence below indicates that Hawkins was assisted by Prof. Joseph Locke, which in all likelihood was the same Prof. John Locke who in 1847 was still in his post at the Medical College.

New York, August 26th, 1858.

Dr. J. Milton Sanders—Dear Sir,—In your American edition of Gregory's Chemistry, on page 59 I find the following: "The first collodion picture that we have any account of, was taken at Cincinnati, in 1847, by Mr. E. C. Hawkins, assisted by the writer. If others were taken previous to that time, we have no knowledge of it." This is the first intimation to myself that the origin of the present beautiful methods of the photographic art may be claimed for America. Is it not justice to Mr. Hawkins and yourself, that the facts regarding that early experiment should be known by the photographic public?

Will you have the goodness to furnish for publication in the American Journal of Photography a history of the picture alluded to, with as much detail as convenient.

I am with great respect,

Yours truly,

J. Milton Sanders, M.D., L.L.D Charls A. Seeely.

New York, August 27th, 1858.

Mr. Charles A. Seely—Dear Sir,—Your letter of the 26th inst. is received, in which you request a detailed account of the discovery of collodion as an article for pictures mentioned in my edition of Gregory's Chemistry.

After a lapse of eleven years, it cannot be expected that the mind could retain all the details you desire; still I remember the principal incidents connected with the discovery. They may interest you, and perhaps substantiate the fact, that the first collodion picture was taken in this country. It was while in a conversation in the Summer of 1847, with Mr. E. C. Hawkins of Cincinnati that the first idea of using collodion was suggested. Mr. Hawkins had been experimenting upon paper pictures, (the colotype I believe) but could not get paper fine and thin enough for the purpose. He remarked that if a paper could be got sufficiently fine and thin, that paper negatives could be made which would print positives that would rival the finest engravings. I had that day, in Dr. Kent's drug store, been experimenting upon the preparation of collodion for medicinal purposes, and this previous occupation suggested collodion to my mind. Collodion after all, I thought, was nothing else than paper held in solution, and I suggested its use. Glass was then naturally suggested for the purpose of retaining the paper, and Mr. Hawkins, with

Dr. J. Milton Sanders (above) was probably serving as head of the chemistry department of the Eclectic Medical Institute in New York at the time of this correspondence. His American edition of *Gregory's Chemistry*, published in Britain, was a standard American college textbook.

his characteristic zeal and perseverance, commenced his work. If I am not mistaken, Prof. Joseph Locke assisted him in the preparation of the first picture. Their surprise was great when besides a negative picture, as they anticipated, they got a positive one, which was painted upon the back with black paint, and mounted. That picture still exists, or did a short time ago, and even in these days of beautiful ambrotypes, is a pretty picture. I would here state that I do not claim any of the credit of producing the first collodion picture, but to Ezekiel C. Hawkins of Cincinati, belongs the credit of having made the first picture upon collodion. In a future communication, either by Mr. Hawkins (if I can prevail upon him to forego his usual modesty,) or by myself, you will get more details upon this interesting subject.

Respectfully,

J. Milton Sanders.[127]

improved means of preparing the paper negative. The greatest impetus to calotype practice—both in the United States as well as in Europe—proved to be yet another improvement in negative preparation published by Gustave Le Gray in December 1851 (see page 91).

At this time, meanwhile, the number of daguerreotype photographers—at least in the New York area—began to increase ''somewhat faster than the demand'' for their photographs, according to H. H. Snelling. These operators depended heavily on apparatus and appliances imported from France, and the prices for these items were high because the French, as Snelling expressed it, ''were not disposed to calculate on very large sales or rapid increase'' in business in the American market. The Messrs. William and William H. Lewis (father and son), formerly machinists in New York, had begun operating a retail establishment for daguerreotype materials in Chatham Square around 1843, and by 1847 had become a prime New York source for cameras and other supplies. In the summer of 1846, too, the Scovill Manufacturing Company had opened a New York retail outlet, serving as a major supplier of daguerreotype plates, mats, and cases.[128] Then, at some point in 1847, Edward Anthony, at age twenty-nine, gave up his daguerreotype business and also entered the supplies field. Snelling, who became his general manager, recalled the effect on his competitors:

Up to this time the manufacture and sale of daguerreotype apparatus and appliances was confined to two or three firms, who considered themselves, quite justly to all appearances, to supply the demand, and when Mr. Edward Anthony . . . joined their ranks, many doubts were expressed as to the wisdom of the act; ''there were too many in the business already.'' It proved, however, to be a ''new departure'' in the right direction, and added an impetus to the entire business of making daguerreotypes that photography has not yet got over, and, probably never will, judging by the events as they pass. Like all such business apprehensions, the fears of the other stock dealers were groundless. Mr. Anthony's methods of doing business not only built up his own but materially improved theirs. At first he was not disposed to become a manufacturer, but it was soon evident that nothing less would suit the daguerreans. One branch of manufacture after another was added to his business until it assumed the largest proportions, and his goods were sought after wherever the daguerreotype was made.[129]

One of Anthony's first moves was to import French-made daguerreotype plates in such vast quantities as to be able to substantially reduce the prices he could quote to his customers. By this time, Scovill had gone heavily into plate manufacture, having been unable to produce such articles at low price only seven years earlier. Albert Southworth's former partner, Joseph Pennell, had joined Scovill and wrote Southworth in the winter of 1848 that Scovill was then producing daguerreotype plates at the rate of 1,000 a day.[130] But the French plates continued to be in large demand. They were high-quality items, and daguerreans appreciated the fact that this quality was reflected in most instances by the appearance, on the edges of the plate, of an officially stamped hallmark indicating the numerical ratio of the thickness of the silver plating to that of the (copper) base metal.

Daguerrean operators—particularly itinerant photog-

"WE WERE NOW MASTERS OF THE CHEMICALS"
From a reminiscence by Abraham Bogardus

The years 1847 and 1848 saw some elegant pictures made. Gurney, Lawrence, Anthony, Edwards & Clark, Brady, Inslee, Becker, Prosch, Plumb, Whitehurst, Lewis, the speaker, and others, made work that beat the *world*. The daguerreotypes made in Europe did not compare with the *Yankee work !*

We were now masters of the chemicals, and produced pictures with certainty, and the time of sitting was reduced to *ten* and *twenty seconds*. One of our greatest difficulties was to get the plate clean enough to be sensitive in damp weather—the buff used in polishing being filled with rouge, this would attract the dampness; and if the buff was damp a good impression could not be obtained. Many dryers were made and patented to keep the buff dry in any weather. One introduced by Mr. Lewis I found effective.

Thousands of the pictures made at this time are still in existence and are as good as ever. I have some now in my possession that are as good as the day they were made. Sometimes they were covered by a film from the action of the air. This could be removed by the application of hyposulphite of soda or cyanide of potash; one or both properly used will clean them instantly.

In making the daguerreotype we went from the wet to the dry process. At first the bromine was used in liquid form; afterwards, we used it dry, being absorbed by dry lime. And also the iodine was at first covered with water to prevent its evaporating too fast; afterwards we used it dry.

The smell of turpentine in the building rendered it impossible to get an impression. I remember while the building I occupied was being painted outside, the windows being open, I was compelled to stop work until the odor of the turpentine was gone.

I shall always remember with pleasure the good old daguerreotype. No glass to clean and albumenize; no black fingers; few or no re-sittings; no re-touching; no proofs to show for his grandmother, and his sisters, and his cousins, and his aunts to find fault with; no waiting for sunshine to print with; no paper to blister, and no promising of the pictures next week if the weather was good. The picture was gilded, finished and cased while the lady was putting on her bonnet; delivered, put in her pocket, and you had the money in your pocket.

I have yet to see the picture made with a camera equal to the daguerreotype. Yet that process, like the photograph now, required great care in manipulation, and only by experience could you make good work.

It was a rarity to hear any person say, "It does not look like me." It was a known certainty that the impression on the plate was a copy of the sitter. There was no disputing the fact. Yet I remember a man saying to me one day, "my picture looks like the *Devil.*" I told him I had never seen that personage and could not say as to the resemblance, but sometimes a likeness ran all through families.[131]

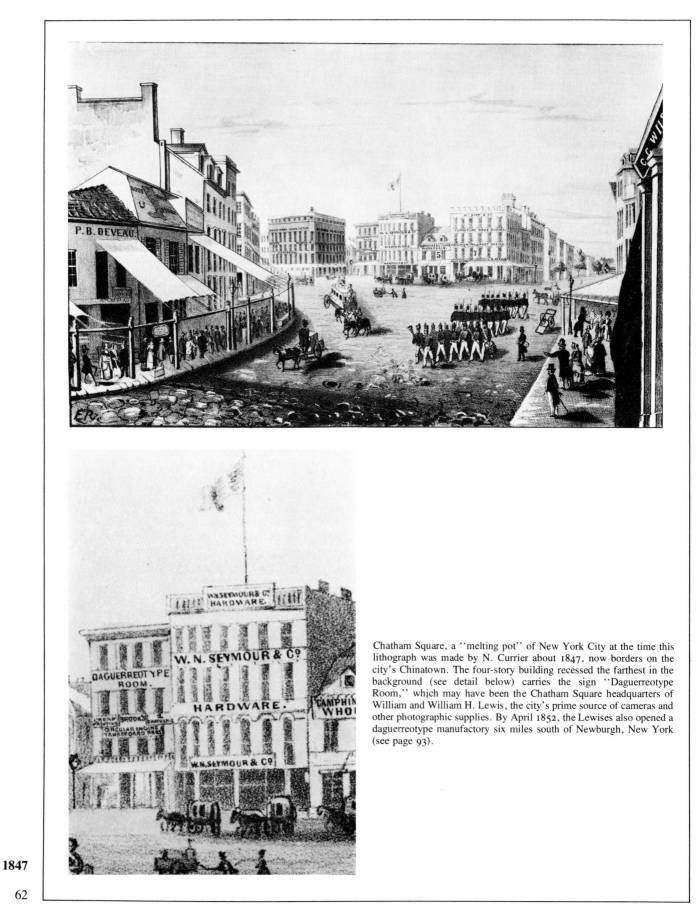

Chatham Square, a ''melting pot'' of New York City at the time this lithograph was made by N. Currier about 1847, now borders on the city's Chinatown. The four-story building recessed the farthest in the background (see detail below) carries the sign ''Daguerreotype Room,'' which may have been the Chatham Square headquarters of William and William H. Lewis, the city's prime source of cameras and other photographic supplies. By April 1852, the Lewises also opened a daguerreotype manufactory six miles south of Newburgh, New York (see page 93).

raphers or those operating in smaller communities—began at this time to style themselves as "professors." One of the most colorful descriptions of what a "professor" was like is to be found in the autobiography of the noted nineteenth-century Cleveland photographer James F. Ryder, whose career began in 1847 in Ithaca, New York:

The new business of likeness-taking was admitted to be a genteel calling, enveloped in a haze of mystery and a smattering of science. The dark room where the plates were prepared was dignified by some of the more pretentious as the laboratory. A "No Admittance" door, always carefully closed by "the professor" on entering or emerging, naturally impressed the uninitiated as something out of the usual, and when he came out carrying a little holder to his sitter and from it drawing a thin slide, revealing from under it the likeness just taken, it was no unreasonable stretch of credulity to recognize in the man something of a scientist and a professor.

In the fall of 1847 I met the professor who was to lead me into the mysteries of daguerreotypy. I had been three years the boy behind the press, pushing the inking roller over the pages of "forms" in a book printing office, with a vague idea of following the Ben Franklin route, when I met Professor Brightly, a newcomer to our village, a daguerreotype man. He encouraged my visits to his rooms, and I naturally became interested in the new and mysterious work. Professor Brightly was a tall man of rather striking appearance. His silk hat had been much brushed and was shiny. He wore glasses, his hair was heavy, stiff, and, especially in front, stood straight up. At the sides it was trained behind his ears, at the back it covered his coat collar. His eyes were gray and keen, which evidently pleased him. He had a big forehead, bigger up and down than across. He wore a large gray shawl, heavily folded, such as was worn by men fifty years ago as a shoulder covering and as a substitute for an overcoat. His trousers bagged at the knees and were too short by a couple of inches. He always wore rubbers.

He had taught cross-roads school in the country, had a smattering knowledge of, and lectured upon, phrenology and biology. The new art of daguerreotypy attracted his attention and had been gathered in as another force with which to do battle in the struggle for fame and dollars. His habit of brushing with his hand the already stiff front hair in an upward direction rather emphasized its standing and his dignity. . . .

The professor was anxious for my progress and helped me all he could. He encouraged me, praised my work as promising and satisfactory, assured me I was surprisingly good for a beginner, and told me it would be greatly helpful for me to work out the difficulties alone, rather than depend upon him. The fact was, I asked too many questions, many of which he could not answer.

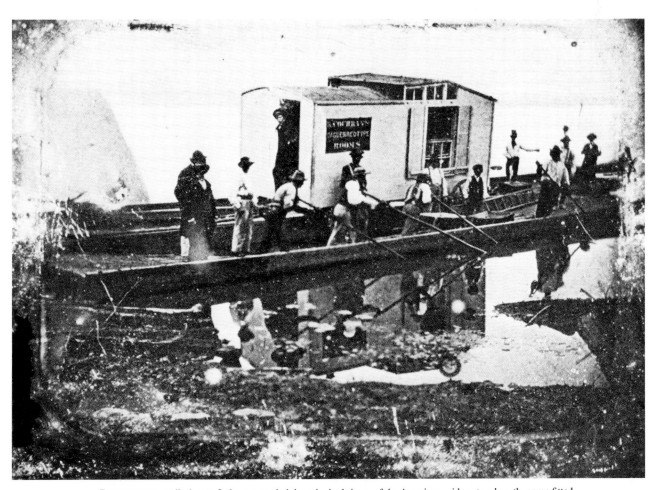

Daguerreotype galleries on flatboats traveled the principal rivers of the American midwest and south, some fitted with skylights and reception rooms. This daguerreotype, made about 1847, is of a small gallery which traveled a tributary of the Ohio River.[132]

In the first few years most practitioners were plodding in the dark, something like "the blind leading the blind." There was no literature bearing upon the subject beyond the mere statement of routine description, no sure road yet opened to successful work. "Professors" were more plentiful than intelligent teachers. In our work repeated trial was the rule—we would try and try again without knowing the cause of failure. Many a day did I work blindly and almost hopelessly, pitying my outraged sitters, and pitying myself in my despair and helplessness. The weak excuses and explanations I made to cover my ignorance were many. The lies I told, if recorded, would make a big book which I would dislike to see opened. *"You moved!"* headed the list. "You looked too serious!" "You did not keep still!" "You winked too often!" These and other fabrications to show the necessity for another sitting were made with great efforts at cheerfulness, but the communings with my inner self in the dark room while preparing the next plate would hardly bear the light, and were best left in the dark. After three months practice I had gained confidence and some skill. The professor could and did trust me with his business when on occasion he went out to arrange for and deliver lectures in the neighboring villages. These lecture outings were productive of advantage to the business in daguerreotypes. He made acquaintances who came in for likenesses and in turn the picture business played into the hands of the lecture field. We were not accused of driving "a trust" or "a combine," but photography, phrenology, and biology were all handled from our headquarters at 137 Owego street, over J. M. Heggies' harness store, Ithaca, New York. It was no uncommon thing to find watch repairers, dentists, and other styles of business folk to carry daguerreotypy "on the side." I have known blacksmiths and cobblers to double up with it, so it was possible to have a horse shod, your boots tapped, a tooth pulled or a likeness taken by the same man; verily, a man—a daguerreotype man, in his time, played many parts.[133]

1848

In 1848, just before reaching the age of seventy-one, Henry Clay made a final try for the presidency, but was bypassed for the Whig party nomination by the Mexican War hero Gen. Zachary Taylor. Clay's preconvention tour took him to Baltimore, Philadelphia, and New York, and according to one of his biographers, "there was no end to the hand-shaking and cheers."[134] In New York, the festivities lasted several days. Marcus Root photographed Clay after his arrival in Philadelphia, and the mayor, the sheriff of the county, and a party of well-wishers accompanied Clay to Root's studio for the picture-taking event. Root evidently made daguerreotypes of the statesman while engaged in conversation, and he later recalled the visit in these words:

"The mayor, turning to Mr. Clay, said, 'Mr. Root desires us to continue talking, as he wishes to daguerreotype your *thoughts;* to catch, if possible, your very smiles.'

" 'Smiles!' exclaimed Mr. Clay,—'I can give him *frowns, if he wants them'*; upon which he smiled, while his face was radiant with intelligence as well. And in twenty seconds three good portraits were taken at once; the plates were removed from the instruments and four fresh ones got ready. In a few seconds more, Mr. Clay the while conversing pleasantly with his friends, all else was prepared, and then his likeness again was daguerreotyped by four cameras at once; all representing him, as we *then* saw him engaged in conversation, mentally aroused, and wearing a cheerful, intellectual and noble expression of countenance. Thus

eleven portraits were taken in but thirteen minutes—with such success, too, that Mr. Clay remarked, after inspecting them: 'Mr. Root, I consider these as decidedly the best and most satisfactory likenesses that I have ever had taken, and I have had many.' These words as he left in my register with his autograph."[135]

If Clay was photographed in Philadelphia in this precampaign period, he was presumably daguerreotyped in New York and possibly in other cities visited. It was becoming commonplace for daguerreans to produce daguerreotype copies of their own, or others' specimens, and today there are four identical daguerreotypes of Clay in museum collections which are attributable to at least three different makers—Southworth and Hawes, Brady, and Martin M. Lawrence. One Philadelphia photographer, Frederick De-Bourg Richards, offered copy daguerreotypes of the Swedish singer Jenny Lind, in 1851, which were available in a variety of sizes. But the vast majority of copy daguerrotypes made of particular celebrities in the daguerrean era have not survived; the existence of the four identical Clay plates is the exception rather than the rule.[136]

In Boston, John A. Whipple had become dissatisfied with the amount of labor expended in mechanical operations at his gallery, so he decided to buy a steam engine and apply its power to plate polishing and other branches of his business (see advertisement, reproduced on pg. 67). The engine was particularly helpful in preparing large plates, according

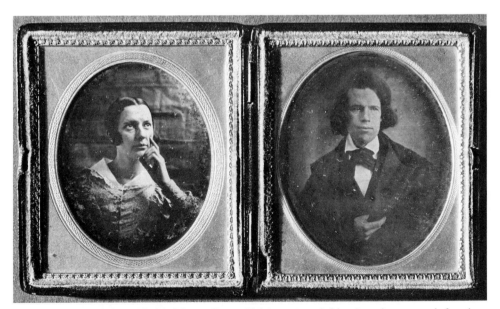

Nancy Southworth (left) and Josiah Johnson Hawes (right) were married in 1849, about a year before these daguerreotypes were made, presumably by her brother, Albert Sands Southworth, Hawes's partner from 1843 to 1861. The firm of Southworth & Hawes daguerreotyped all of the major figures during New England's great flowering in literature, statesmanship, and the arts. After 1861, Hawes alone made the principal surviving record of buildings and urban living in Boston during the 1860s and 1870s. Active to the end of his life, Hawes died in 1901 at age ninety-four. His wife preceded him by six years.[137]

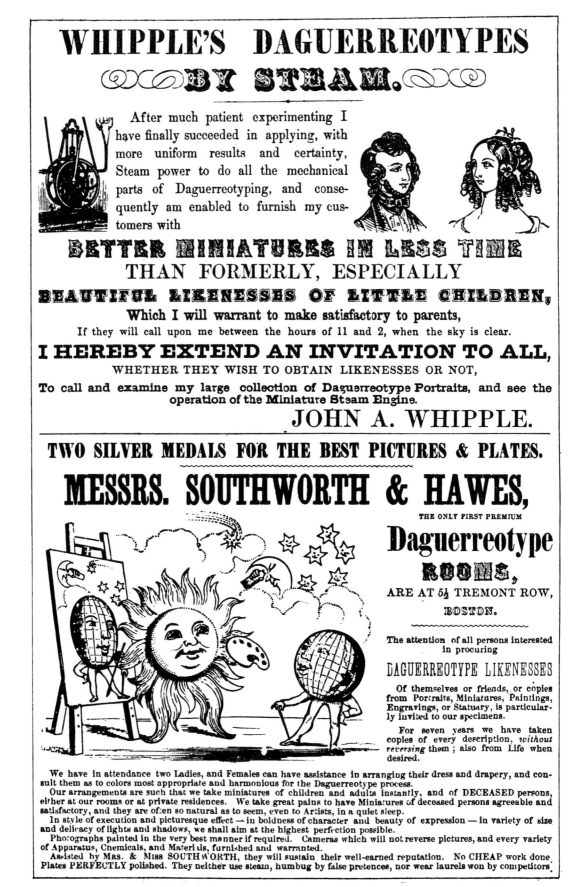

WHIPPLE'S DAGUERREOTYPES
BY STEAM.

After much patient experimenting I have finally succeeded in applying, with more uniform results and certainty, Steam power to do all the mechanical parts of Daguerreotyping, and consequently am enabled to furnish my customers with

BETTER MINIATURES IN LESS TIME
THAN FORMERLY, ESPECIALLY
BEAUTIFUL LIKENESSES OF LITTLE CHILDREN,
Which I will warrant to make satisfactory to parents,
If they will call upon me between the hours of 11 and 2, when the sky is clear.

I HEREBY EXTEND AN INVITATION TO ALL,
WHETHER THEY WISH TO OBTAIN LIKENESSES OR NOT,
To call and examine my large collection of Daguerreotype Portraits, and see the operation of the Miniature Steam Engine.

JOHN A. WHIPPLE.

TWO SILVER MEDALS FOR THE BEST PICTURES & PLATES.

MESSRS. SOUTHWORTH & HAWES,

THE ONLY FIRST PREMIUM

Daguerreotype
ROOMS,

ARE AT 5½ TREMONT ROW, BOSTON.

The attention of all persons interested in procuring

DAGUERREOTYPE LIKENESSES

Of themselves or friends, or copies from Portraits, Miniatures, Paintings, Engravings, or Statuary, is particularly invited to our specimens.

For seven years we have taken copies of every description, *without reversing* them ; also from Life when desired.

We have in attendance two Ladies, and Females can have assistance in arranging their dress and drapery, and consult them as to colors most appropriate and harmonious for the Daguerreotype process.

Our arrangements are such that we take miniatures of children and adults instantly, and of DECEASED persons, either at our rooms or at private residences. We take great pains to have Miniatures of deceased persons agreeable and satisfactory, and they are often so natural as to seem, even to Artists, in a quiet sleep.

In style of execution and picturesque effect — in boldness of character and beauty of expression — in variety of size and delicacy of lights and shadows, we shall aim at the highest perfection possible.

Photographs painted in the very best manner if required. Cameras which will not reverse pictures, and every variety of Apparatus, Chemicals, and Materials, furnished and warranted.

Assisted by MRS. & MISS SOUTHWORTH, they will sustain their well-earned reputation. No CHEAP work done. Plates PERFECTLY polished. They neither use steam, humbug by false pretences, nor wear laurels won by competitors.

1848

PHOTOGRAPHING THE DEAD: A PECULIARLY AMERICAN CUSTOM

Soon after daguerreotype photographers appeared in rural towns and cities, the custom began of taking daguerreotypes of the dead, particularly of children. It was strictly an American phenomenon, and became a lucrative source of income for those who specialized in its practice. In the 1850s, photographic supply houses offered framing mats in black, and cases of sentimental design as regular stock items. This experience of James F. Ryder occurred before he settled in Cleveland in 1850:

AWAY back in '48 I found myself in a little village in Central New York, where a camera had never been seen or used before, and to the citizens of that quiet place it was as good as a brass band.

The prominent lady of the place, whose husband was merchant and post-master, welcomed me to her house, gave me her parlor (the finest in the village), for operating room, rent free, and glad to have me at that—board, two dollars per week, payable in daguerreotypes,

My little frame of specimens was hung upon the picket fence beside the gate, my clip headrest screwed to the back of a common chair, and the business of "securing the shadow ere the substance fade" (see handbills), was declared opened.

The people came in throngs, the dollars rolled in right merrily; no business in town equalled mine.

The good lady of the house was the possessor of a large cluster breastpin, which was kindly loaned to every female sitter that came, to the mutual satisfaction of lady owner and lady sitter; a great help to me as well, proving a capital point for aiming my focus.

After the day's work was done a saunter across the bridge and through the narrow path of the meadow, where was the pleasant odor of clover and the glad ripple of the brook, was my pleasure and my habit. The home-coming farmer gave me friendly greeting. The boy with torn hat and trousers rolled half way to the knee, as he fetches the cows from pasture, hails me with: "Take my likeness, mister?" The country lasses, shy and sweet, give a modest bow as they meet the "likeness man."

I was regarded with respect and supposed to be a prosperous young fellow. All were friendly and genial—save one.

The blacksmith, a heavy, burly man, the muscular terror of the village, disapproved of me. Said I was a lazy dog, too lazy to do honest hard work and was humbugging and swindling the people of their hard earnings. He, for one, was ready to help drive me out of the village.

The greater my success the more bitter his spleen, and in the abundance of his candor denounced me to my face as a humbug too lazy to earn an honest living. He said he wouldn't allow me to take his dog; that I ought to be ashamed of robbing poor people. Other uncomplimentary things, he said, which were hard to bear, but in view of his heavy muscle and my tender years, I did not attempt to resent.

Well, I left that quiet town and brawny blacksmith one day and moved to another town a few miles distant.

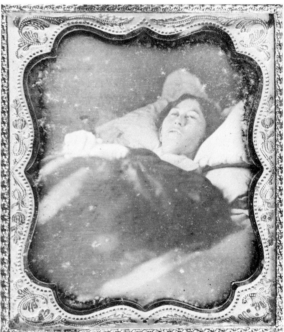

Example of a sixth-plate size daguerreotype of a dead person.

A week later I was surprised at a visit from him. He had driven over to the new place to find me. He had a crazed manner which I did not understand and which filled me with terror.

He demanded that I put my machine in his wagon and go with him straight at once. I asked why he desired it and what was the matter. Then the powerful man, with heaving chest, burst into a passion of weeping quite uncontrollable. When he subsided sufficiently to speak he grasped my hands, and through heavy weeping, broken out afresh, told me his little boy had been drowned in the mill race and I must go and take his likness.

"A fellow-feeling makes us wondrous kind." My sympathy for the poor fellow developed a tenderness for him in his wild bereavement which seemed to bring me closer to him than any friend I had made in the village.

To describe his gratitude and kindness to me after that is beyond my ability to do. [138]

"BUCKEYE BLACKSMITH"
CONSTRUCTS
A MOBILE DAGUERREOTYPE "SALOON"

After the campaign of '48 was over I concluded to go to work again at my business, but by this time every little town in the country had a daguerrotype saloon in it and the large places had two or more men running opposition in them. Every fellow who could raise a few dollars would get up a small outfit, mostly almost worthless, and put out into some country town and stick up his cards and pretend he knew more about the business than any man living, when at the same time all that he knew and his tools in the bargain were not worth ten dollars. Almost every town I went to I found one or two and sometimes more of these fellows blowing their own trumpets, and as soon as I would open up and commence business they would generally put the price of their pictures down to about half what I charged in order to burst me up, but I generally made them leave, and that very soon after I got under way.

The greatest difficulty I had to encounter with these men, was the want of a suitable room with the right kind of light to make good pictures with, they being there before me, would generally get the best places to be had, and I would have to take an inferior place to compete with them, but having more knowledge of the business than they had, and the best instruments in the country, I could always put them to flight.

I saw very plainly, that there was something wanting. I knew what kind of light I required to do good work with, and this light I could not get in country towns. There being a little Yankee in me, I set to work to build me a house adapted exactly to the business, with a large, splendid sky-light, made in such a manner, that I could, by taking off a few screws, take it all apart in small compartments and load it on a car or big wagon and move it to any place I might wish to, where, with the aid of two men, in three hours I could put it up, ready for work. It was three times as large as those saloons which were built on wheels years after that, and far superior; those saloons were too small and were never adapted to the business, consequently I never had one.

As soon as I got my house done I had no more trouble with opposition. My sky-light made such fine even shades over the face, everybody said they were just the thing they wanted, and everybody admired my enterprise in getting up such a novel plan of doing good work, and they fully rewarded me for my outlay and skill. I would go into a town, get a vacant lot wherever I could, get two or three men to help me, and have my house all ready for business before any person knew what was going on. The first thing they would know about my being there would be when they read my bill, which I would have thrown into every house as well as all over the country around. I put up my bills thus:

The great crowd you see moving from morning till twilight
Are enquiring the way to the Buckeye's great sky-light,
To have a daguerrotype view of their faces
Put up for a dollar, in the very best cases.

A call is respectfully solicited—saloon on——lot —— &c.

This saloon as I called it was a decided success, for in it I did the best work I had ever done, and wherever I went, I did a very nice business. I continued to travel about through Pennsylvania, from town to town, from the time of Taylors election until the Spring of 1852, when another political campaign was about to open, but as yet nobody knew who were to be the candidates. [139]

to a contemporary account, and "with the steam he brings out his pictures, heats his rooms in winter, and cools them in summer by means of an ingeniously constructed fan." Whipple's action may have been prompted by the adoption of steam power by lithographers. P. S. Duval of Philadelphia, for example, installed steam power to run most of his presses, thereby making it possible to produce lithographs more cheaply, and at a faster rate. But Whipple's competitors, Southworth and Hawes, stated in their advertisements on the same pages with Whipple that they "neither use steam, humbug by false pretenses, nor wear laurels won by competitors." [140]

But with all his experimenting with glass negatives, microphotography, and steam power, Whipple and his partner on the side, Jones, failed to get on with the job of perfecting an albumen negative process, and were caught napping when Abel Niépce de Saint-Victor, a cousin of Daguerre's former partner, published a method in Paris (on June 12, 1848). The experiments by Whipple and Jones had been carried on, in Whipple's own words, "with the greatest secrecy, known to only a few of our most intimate friends, which I am now convinced [he was speaking in 1853] was very bad policy." Niépce de Saint-Victor's discovery, he said, "dashed all our hopes to the ground for foreign countries." The pair immediately filed a caveat with the U.S. Patent Office, conducted further experiments during the time period allowed by this filing, then applied for a patent which was granted in 1850 after a long delay. [141]

Niépce de Saint-Victor's process called for coating a glass plate with albumen containing a few drops of a solution of iodide of potassium. The plate was sensitized in a silver nitrate bath and could be exposed in the camera while moist (for quicker exposures), or after drying. The process had built-in drawbacks, since exposures with moist plates were irksome, and those made with a dried plate required from five to fifteen minutes' time. [142] Whipple's process was similar, but included addition of pure liquid honey to the albumen coating. Neither process ultimately was considered suitable for portraiture, but both were used by photographers on both sides of the Atlantic to make architectural and landscape views.

Strangely, the revolutions which swept Europe in 1848 had a direct effect on the early development of both the French and American albumen processes. In France, rioters who brought an end to King Louis Philippe's eighteen-year reign, entered Niépce de Saint-Victor's laboratory and destroyed all his valuables, leaving no trace of the work he had accomplished. This put an end to further progress for the time being, and delayed the adoption of the French process. [143] The revolutions in Germany the same year caused a wave of immigration to the United States by many well-educated Germans, who settled principally in New York, Baltimore, Cincinnati, St. Louis, and Milwaukee. One such immigrant was twenty-six-year-old Carl August Theodor Ehrmann, who as a student at the University of Berlin, had participated in guerilla warfare in Schleswig-Holstein, in the revolt of Silesian weavers, and in street warfare in Dresden. When Ehrmann settled in Philadelphia around 1850, he contributed immeasurably to the improvement and widespread adoption of the American process (see page 98). [144]

1849

The gold rush years gave photography a shot in the arm. Business increased to such an extent, particularly at eastern galleries, that operators were able to reduce prices to a lower level of about $2.50, which was thereafter maintained by most of the better galleries to the end of the daguerrean era.

Photographers in 1849 suddenly found themselves busy taking daguerreotypes of prospective miners about to leave for California, and also of their loved ones who would be left behind. "On steamer days," Abraham Bogardus recalled, "the gallery would be filled with miners in rough suits carrying their mining tools and a pair of pistols in the belt. We made several sittings before he left the chair and usually sold them all." The number of miners who made the journey by steamer or sailing vessel via the Isthmus of Panama (a 60-mile, malaria-ridden strip of land and waterways) totaled 6,489 in 1849, rising to 24,231 in 1852. The steamers also made the journey to San Francisco via Cape Horn, a route which took from six to nine months' travel time under crowded shipboard conditions.[145]

The cameras in most general use in the United States at this time, according to Henry Hunt Snelling, were Voigtlander models of the box, as opposed to the telescope variety. Because of the absence of photography manuals or books on photography practice during the 1840s, it is not now possible to determine with any degree of assuredness just how long the original Daguerre-style daguerreotype camera (as copied by the Goddard camera) or Alexander Wolcott's mirror style camera remained in widespread use. Beginning in 1843, Voigtlander began supplying the American market with a new box-style daguerreotype camera, as well as the Petzval portrait lens. By 1849, Edward Anthony was supplying cameras which Snelling said were "fully equal to the German, and for which Voigtlander instruments have been refused in exchange by the purchaser." But Snelling functioned as Edward Anthony's general manager, as well as the first chronicler of American photography, and the presumption must be made that other American manufacturers besides Anthony supplied cameras similar to the new Voigtlander design. The illustration on page 69 is of what Snelling characterized as "the ordinary camera box" in vogue in 1849. Whether it was a Voigtlander camera or an American version of the same style, is not known. But by 1849 there were several other firms—newly formed, in most cases—which could have been the manufacturer, including W. and W. H. Lewis, and Charles C. Harrison, all of New York City.

In 1849, Snelling published *The History and Practice of the Art of Photography*, which he characterized as the "first bound book on photography issued from the press in this country." The book had a rapid sale and passed through four editions of 1,000 copies each.[146] "The extensive manufacture of the most approved cameras, both in Europe and this country, obviates all necessity for any one attempting to construct one for their own use," Snelling stated in this publication. "Lenses are now made so perfect by some ar-

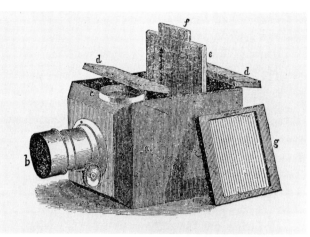

AN ORDINARY CIRCA 1849 DAGUERREOTYPE CAMERA

The camera was a dark box (*a*) having a tube with an achromatic lens (*b*) which formed the image seen (inverted laterally) upon a ground glass spectrum (*g*). Within the camera, a slide was used to regulate focusing, and the ground glass was inserted at one end of the slide. The cap (*c*) covered the lens until the silvered copper plate was placed in holder (*e*), covered with a dark slide (*f*) and inserted in the camera, taking the place of the ground glass spectrum, which was withdrawn. Lids (*d,d*) were closed after removing the slide (*f*). Camera boxes varied in size to suit the tube, and were termed medium, half, or whole, depending on the plate size intended for use.[147]

tisans that what is called the 'quick working camera' will take a picture in one second, while the ordinary cameras require from eight to sixty." Snelling also had some recommendations to make with respect to lenses used:

The diameter and focal length of a lens must depend in a great measure on the distance of the object, and also on the superficies of the plate or paper to be covered. For portraits one of 1½ inches diameter, and from 4½ to 5½ inches for focus may be used; but for distant views, one from 2 inches to 3 inches diameter, and from 8 to 12 inches focal length will answer much better. For single lenses, the aperture in front should be placed at a distance from it, corresponding to the diameter, and of a size not more than one third of the same. A variety of moveable diaphragms or caps, to cover the aperture in front, are very useful, as the intensity of the light may be modified by them and more or less distinctness and clearness of delineation obtained. These caps always come with Voigtlander instruments and should be secured by the purchaser.[148]

By the time his book was published, there were about nine dealers in the supply of photographic apparatus and materials. They were: Edward Anthony, Scovill Manufacturing Company, and William and W. H. Lewis all in New York; Benjamin French and John Sawyer in Boston; Myron Shew, and Dobbs and Birmingham in Philadelphia; and Peter Smith in Cincinnati. In 1851, Smith offered a line of cameras made by Charles C. Harrison, of New York, for taking quarter, half, whole, and Mammoth plate daguerreotypes. He also offered "quick-working" cameras of the type described by Snelling. Mammoth plates used in the

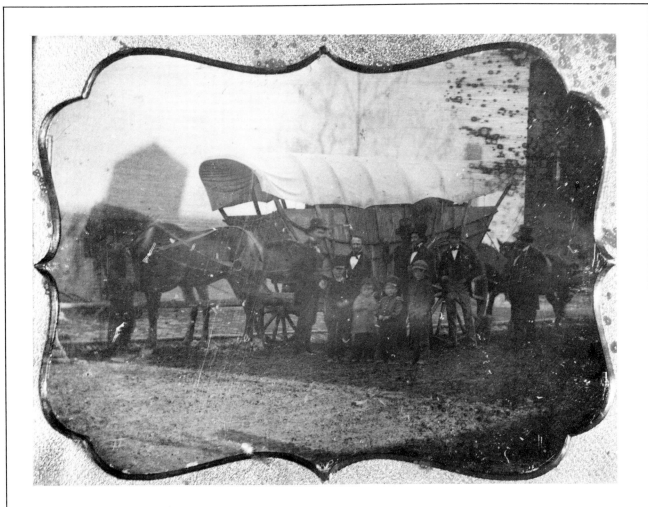

GOLD RUSH

Few daguerreotypes exist today of the covered wagons which traversed the American prairies during the 1840s. This half-plate specimen of an unidentified group was made about 1849, when an estimated thirty thousand wagons took the northern route from St. Louis through the Rocky Mountains to California. A southern route, also marked out before the gold rush, went via Sante Fe and the Arizona desert to southern California. Caravans averaged twenty-six wagons, each drawn by five yoke of oxen, or a span of ten mules. The 2,000-mile trek (over either route) could be covered in a hundred days, although delays were not infrequent. Eastern daguerreotype galleries, meanwhile, were crowded with prospective miners at this time having their pictures taken to leave behind with their kin. But these daguerreotypes are also now extremely rare. The man in the sixth-plate size daguerreotype (left) is unidentified. Few of those who flocked to California were experienced miners, but some of those who were first to arrive averaged between $300 and $500 a day for weeks on end, while there were reports of a few lucky diggers who made as much as $5,000 in a single day.[149]

"THE MOST HOMELY FACES MAKE THE HANDSOMEST PICTURES"

In a revised edition of his 1849 book *The History and Practice of the Art of Photography,* Henry Hunt Snelling used the above two illustrations of President Zachary Taylor as evidence that "there are many points to be observed in placing the head in a position to be the most effective." The pose of Taylor at the left, he maintained, "represents him in a very unfavorable position," while the one at the right "shows him as he really is, when animated and graceful."

Snelling carefully refrained from drawing any analogies, but said: "I have noticed that in a majority of instances, the most homely faces make the handsomest pictures; this is a fact that will be duly appreciated by all, and will undoutedly lead to the query why it is so?, and I answer that it is mainly owing to the fact that ugly faces have more strongly marked outlines than those that are beautiful; the image produced therefore by the camera possesses greater contrast in light and shade, which while they give a greater depth of tone and a more pleasing effect, do not betray the defects." Stating that he was "not aware that any one else had made these observations," Snelling offered the following suggestions in posing:

In Daguerreotyping, I should, as a general thing, adopt the following rules, although in some instances I should possibly have to deviate.

A full round face, with large mouth, small eyes and nose, I should make what is called a half face, that is, where the whole of one side, and a *very small* portion of the other is seen, being but a slight remove from the profile likeness.

Of a moderately full face, with aquiline nose and handsome mouth and eyes, I would make a three-quarter picture, wherein all the features of one portion of the face would be visible, and about one-fourth of the other.

A face in which the features were a little more prominent, a three-quarter view would be preferable.

And one in which the lines are very strongly marked, and bordering upon projecting angles, I should decidedly make a full front view.

Always endeavor to throw life into the expression of your sitter's face by animate conversation, or a pleasant and polished witticism, avoiding all approach to the broad grin.

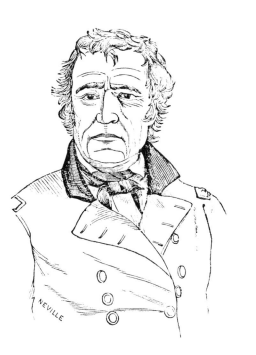

CHOLERA VICTIM
GEN. WILLIAM JENKINS WORTH
(1794–1849)

Cameras were evidently too busy recording the faces of miners to be focused on the streets, or in dingy rooms of tenements in such cities as New York, Cincinnati, and St. Louis where the worst effects of an epidemic of blue cholera broke out in 1849. One who succumbed was the Mexican War hero Gen. William Jenkins Worth, whose unpublished daguerreotype likeness, left, was made shortly before his death on May 7, 1849, while commanding United States troops in Texas. At one point, the death rate in New York reached between two hundred and three hundred persons *daily,* while the epidemic was also particularly severe in many infant cities of the West, which were crowded with transients. There were no American illustrated weeklies in 1849, and the plague appears not to have been recorded visually in the daily press, where the use of illustrations was decreasing rather than increasing at the time.

Gen. Worth's death removed what some observers considered a potential contender for the American presidency. Worth was known as the Murat of the American army, because his dashing manner and dress conjured up memories of Joachim Murat, king of Naples and a brother-in-law of Napoleon Bonaparte. Worth's Mexican War superiors, Zachary Taylor and Winfield Scott, figured prominently in later political history, as did such other generals and junior officers in the Mexican War as Franklin Pierce, Ulysses Grant, and George McClellan.[153]

larger cameras ranged in size up to as much as 13½ x 17½ inches. Such specimens sold for $50, the plates alone costing nearly $10 before use.[151]

And who were the big names in photography at the end of the medium's first decade as later recalled by Snelling? Mathew Brady, Jeremiah Gurney, J. R. Clark (Anthony's partner after J. M. Edwards), Augustus H. Morand, Abraham Bogardus, Gabriel Harrison, Alexander Beckers, Martin M. Lawrence, Jesse M. Whitehurst—all of New York; Frederick DeBourg Richards, of Philadelphia; James F. Ryder, of Cleveland; George S. Cook, of Charleston, South Carolina; John Fitzgibbons, of St. Louis; Alexander Hesler, of Galena, Illinois; George Barnard, of Syracuse; D. D. T. Davie, of Utica, New York; and James Landy, of Cincinnati. If Snelling had thought about the matter at greater length, he would presumably have included: John A. Whipple, Albert Southworth, and Josiah Hawes, of Boston; Marcus and Samuel Root, and A. A. Turner, in New York; Edward T. Whitney, in Rochester; Thomas Faris, Ezekiel C. Hawkins and Charles Fontayne, in Cincinnati.[152]

This was the year the Langenheims attempted to interest the American photographic community in Talbot's process, after William Langenheim returned from a visit with Talbot in England where he had concluded an agreement for exclusive rights to Talbot's American calotype patent on May 11.

But, as indicated earlier, there were no takers. At the same time, the Langenheims also developed a modification of Niépce de Saint-Victor's albumen negative process, which the brothers managed to patent on November 19, 1850.[154] Precisely when they began their experiments with glass negatives—paralleling Whipple's experiments in Boston—does not appear to be recorded. The Langenheim patent applied to positive pictures on glass obtained with albumenized glass negatives, and to these positives they gave the name "Hyalotypes." Whipple's 1850 patent applied to positive pictures secured on paper from glass negatives sensitized with a different albumenizing formula, containing pure liquid honey. These prints were termed "Crystalotypes." The Langenheims exhibited both their Hyalotypes and Talbotypes at the annual fair of the Franklin Institute in Philadelphia in 1849, but the top photographic award went to the Cincinnati photographers Charles Fontayne and William Porter for a daguerreotype panorama of the Cincinnati waterfront, taken the previous September. Porter had learned the daguerreotype business in Philadelphia and had secured a panorama of that city (consisting of seven plates framed together) on May 28, 1848. The Cincinnati panorama, which he took with Fontayne, consisted of eight wholeplates framed in a custom-made mahogany display case. The panorama was also displayed in 1849 at the Maryland Institute, where it again took top honors.[155]

1850

The first rumblings of civil disunion were heard in 1850 as three ailing elder statesmen—Clay, Webster, and Calhoun—debated for eight months in the United States Senate over antislavery legislation, and the role which slavery was to play in the creation or admittance to the Union of several new western states, among them California. While this drama was taking place in Washington, the great El Dorado in California began to take on sizeable proportions. San Francisco had grown from a town of 812 people (in March 1848) to a city of 25,000 by 1850, and along with the incessant influx of gold diggers and adventurers, there came, individually, a small band of photographers. Their names were: S. S. McIntyre (from where, unknown); William J. Shew (the Boston daguerreotype case maker); Isaiah W. Taber (from New Bedford, Massachusetts); J. Wesley Jones (from where, also unknown); Fred Coombs (from Chicago); Henry W. Bradley (from Wilmington, South Carolina); William H. Rulofson (from Newfoundland); and Robert Vance (from New York City). In the hands of these daguerreans, the outdoor use of the daguerreotype camera flourished—if only for a period of a few years—as it never did elsewhere in the country.

Robert Vance and J. Wesley Jones were the most prolific of the group, but unfortunately their photographs have been lost. Vance was among the earliest to arrive, and appears to have begun making dagurreotypes as early as 1849. Only because a record exists of more than three hundred photographs he took and exhibited in New York in the fall of 1851 is it possible to surmise the extent of his activities, and where he was and when.[156]

Among the Vance collection was a daguerreotype panorama of Panama, and daguerreotypes made in Acapulco (Vance called it Acupulco), one showing the hills in back of the city with the steamers *Panama* and *Sea Bird* at anchor in the bay. These would seem to suggest that Vance had traveled to California via the Isthmus of Panama, as William Shew had done. (Shew took the steamer *Tennessee* via the Isthmus route, and sent his daguerreotype wagon on a clipper ship via Cape Horn.) Vance may have made the trip on either the *Panama* or *Sea Bird,* photographing the two vessels during a stopover at Acapulco. But the collection also includes daguerreotype views made in the Chilean seaport of Valparaiso, and a daguerreotype of a cathedral in Cuzco, the former capital of the Inca empire in southern Peru. If these photographs were made by Vance on his initial trip to California, it would suggest that he traveled via Cape Horn.

Still another possible explanation seems more plausible. In August 1849, Isaiah Taber journeyed to San Francisco from his native New Bedford, Massachusetts, on the clipper *Friendship* via Cape Horn. In April 1850, with a group of friends, he chartered a bark, the *Hebe,* on which the party sailed to Valparaiso on a unique seafaring venture. The voyagers purchased flintlock muskets at Valparaiso, then sailed to the island of Marquesas (south of what is now Hawaii) to exchange the muskets for a thousand hogs. By November 1850, the *Hebe* was back in San Francisco, the

hogs being offered in a market where pork was selling for as much as a dollar a pound.[157] It is likely that Vance had become acquainted with Taber in San Francisco, and quite possible that he made his South American daguerreotypes on the *Hebe* voyage.

That Vance began making daguerreotypes in the San Francisco area as early as 1849 is suggested by the fact that two of the identified views in his collection were made in Hangtown, the early mining community which derived its name from a hanging which took place there in 1849. A number of daguerreotypes were also made in Placerville, the name to which Hangtown was later changed.

None of his photographs, however, can be said definitely to have been made between April and October, or November 1850 (when the *Hebe* was away on its voyage), but a major series was made in San Francisco before and after what Vance described only as the "May" and "June" fires. San Francisco was ravaged by fires in December 1849, and again in May, June and September 1850, but the most disastrous of its early conflagrations occurred on May 4, 1851. Since Vance's exhibition of his photographs took place in New York only four months later, it seems logical to conclude that his designations "May" and "June" applied to 1851, as opposed to 1850 fires in San Francisco.

Six of the daguerreotypes were made in Portsmouth Square before and after the "May" and "June" fires, and while another was made of Kearney Street on election day (the date being unspecified), Vance appears not to have recorded the celebration in Portsmouth Square which took place on October 18, 1850, when news reached San Francisco of California's admission to the Union. This is further indication that he may have been away at that time.

The catalog of Vance's daguerreotypes (page 77), which is all that remains, establishes him as among the first to use the camera for a large-scale documentary undertaking. He made plates of John Sutter at his famous mill; views of miners and mining activities in all of the principal towns—Coloma, Sonora, Yuba City, Makelame, Nevada City, Marysville, etc.—and of the principal supply centers, Stockton to the north, Sacramento to the south; views along the Stanislaus and Feather rivers; and views of streamers and waterfront scenes. His numerous views of a Spanish mission three miles south of San Francisco were strictly documentary in purpose. "This mission, Dolores, now time-worn and crumbling to ruins, was a proud and influential religious establishment of the days of the Jesuits, founded more than a century ago," he said. He also photographed in Benicia, possibly including the two-story building then in mud flats (now a museum) which housed the first meetings of the California Legislature in 1853–54. When he made his photographs in Benicia and Martinez, which today are connected by a freeway and toll bridge spanning Carquinez Strait, he remarked: "This place is a port of entry, and [is] destined to be a place of first importance as a commercial city."

Vance left California for New York, possibly as early as

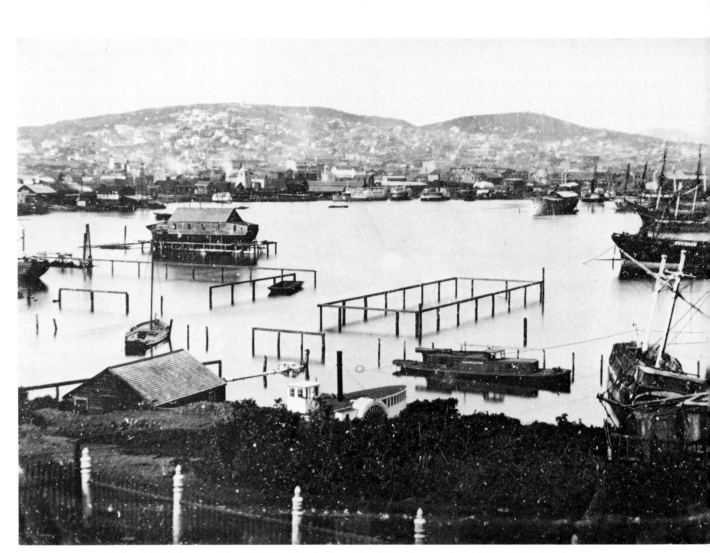

As the multitude began arriving in San Francisco for the gold rush, frigates soon clogged the city's inner harbor. The scene above is from only two plates of a panorama of five whole-plate daguerreotypes taken about 1852 by William Shew, a Boston daguerreotype case maker who was among those who headed west in 1851. An estimated thirty-six thousand immigrants landed in these and other ships in 1850, and the harbor had become a forest of masts when six hundred abandoned vessels were counted a year before Shew's panorama was taken.

June 1851. He secured space on the second floor of 349 Broadway (above the gallery of Jesse Whitehurst, newly arrived from Washington), opened a formal exhibition of his works at the end of September and put together a finely printed catalogue to announce the event. H. H. Snelling gave him a rave review in a photographic journal which he had just recently established, but there is no evidence that it was duplicated in the general press. In any event, the exhibition was a total failure, and in January or February 1852, Vance returned to San Francisco to reestablish his daguerreotype business there. For about a year, the California photographs were exhibited at Jeremiah Gurney's gallery, then Snelling, in February 1853, announced that he was authorized to sell the collection at a greatly reduced price: It had cost Vance $3,000 to make his photographs, and another $700 to frame them in gilded rosewood. Snelling offered to sell the collection for $1,500, or in smaller increments at a price of about $7.50 a daguerreotype.[158]

It is difficult to think of another occasion when such a large, timely, and interesting collection of photographs (in keeping with the popular tastes and interests of the period) was ever presented at a public exhibition. Snelling was also incredulous at the lack of interest in the daguerreotypes. The attention which the world was giving California, he said, was "never before equalled in the annals of history. To such a pitch has public curiosity been excited," he added, "that the smallest item of news in regard to this newly discovered El Dorado is eagerly seized upon." Perhaps so, but no eagerness was evidenced to *purchase* the California views. The collection was finally bought in July 1853 by John H. Fitzgibbons, the last recorded owner. Fitzgibbons twice sold his St. Louis gallery, the first time in 1861 when he moved to Mississippi (where he was captured by Union troops and sent to a prisoner of war camp in Cuba), and again in 1877 when he retired. Vance's collection could have been acquired at either time, and could,

therefore—like the previously lost Plumbe daguerreotypes of Washington—still be found.[159]

Also missing are the 1,500 daguerreotypes which J. Wesley Jones claimed he had taken, beginning in the summer of 1851, in California and on the prairies and Rocky Mountains. Jones also came east to New York, but to lecture and exhibit sketches and paintings made from his daguerreotypes. This he did in New York and in other eastern cities in the winter of 1853–54. Then, in March 1854, his paintings were sold in a lottery. Jones reportedly lived in Melrose, Massachusetts, after coming east from California, but today there appears to be no record of what became of his daguerreotypes or his paintings. Some of his sketches, and the notes for his lectures, however, were acquired by the California Historical Society.[160]

Daguerreotype views of San Francisco and mining activities exist in small numbers in institutional and private hands, but the photographer, in most instances, is un-

Isaiah W. Taber

1850

75

Some gold rush vessels abandoned in San Francisco's harbor were salvaged for other purposes, as this 1849 N. Currier lithograph reveals. But as building lots become more costly at the bay's edge downtown, room was made for more lots simply by dumping landfill around the remainder of the abandoned armada.

known. Six daguerreotype panoramas of San Francisco are extant, for example, but only the five whole-plates panorama taken about 1852 by William Shew (see previous pages) is identified as to maker. The International Museum of Photography in Rochester possesses a daguerreotype view of Montgomery Street in San Francisco, said to have been taken in 1850 by Fred Coombs. In July 1851, Samuel D. Humphrey, editor of the then newly founded *Daguerreian Journal* (later *Humphrey's Journal*), disclosed to his readers that S. S. McIntyre had sent him a panorama of San Francisco consisting of five half-plates. Humphrey also said that McIntyre had been burned out of his gallery (presumably the May 1851 fire), and that he (Humphrey) was prepared to supply copies of McIntyre's original at no charge for his services. William Shew's daguerreotype wagon was scorched in a San Francisco fire, and he was later burned out of a gallery which he had established after civic authori-

ties banned his use of the wagon in Portsmouth Square.[161]

With the national focus centered on gold-digging in California and the great Senate debates in Washington, little attention was given to the birth of the world's first photographic journal in New York, or the perfection in Philadelphia of the first photographic slides which could be projected on a screen by a magic lantern.

Samuel D. Humphrey, about whom virtually nothing is now known, started the *Daguerreian Journal* (the title being spelled differently from the term "daguerrean" used at the same time) on November 1, 1850. Humphrey was probably a native of Canandaigua, New York, where he was active as a daguerrean in 1849 and printed, on the local newspaper press, his first photography book in conjunction with Marshall Finley.

In the first issue of the *Daguerreian Journal,* Humphrey prepared photography's first "Who's Who" listing (right),

CATALOGUE

OF

DAGUERREOTYPE PANORAMIC

VIEWS IN CALIFORNIA.

By R. H. VANCE.

ON EXHIBITION AT

No. 349 BROADWAY,

(OPPOSITE THE CARLETON HOUSE.)

NEW-YORK:
BAKER, GODWIN & COMPANY, PRINTERS,
TRIBUNE BUILDINGS.
1851.

Unless or until they are someday found, this catalog is all that remains, giving us a partial listing of some three hundred daguerreotypes by Robert Vance which documented the people, activities, towns, and numerous fires in the bay area during the early gold rush years.

which omitted a number of operators such as Southworth and Hawes, the Langenheim brothers, Abraham Bogardus, Alexander Beckers, Victor Piard, Edward T. Whitney and Alexander Hesler whose names today are prominent in the annals of photographic history. Humphrey also mispelled Mathew Brady's first name, a common error to the present day. In his first issue, Humphrey also counted seventy-one daguerreotype rooms in New York City which were run by 127 people (proprietors, operators, eleven ladies and forty-six boys). The fact that the 1850 national census tabulated only 938 males over the age of fifteen as daguerreotype practitioners can be attributed to the variety of occupations which a daguerrean then followed. If a man or woman did not give daguerreotyping as a principal occupation, that person was tabulated under a different heading.

In Philadelphia, the Langenheims found little interest in their Hyalotypes, when offered simply in the form of posi-

PHOTOGRAPHY'S FIRST "WHO'S WHO"

An incomplete listing published in the first issue of the first photographic journal, the *Daguerreian Journal*.

DAGUERREIAN ARTISTS' REGISTER.

Adams, George, Worcester, Mass.
Brady, Matthew B., No. 205 Broadway, N. Y.
Burges, Nathan G., No. 187 Broadway, New York.
Baker, F. S., Baltimore, Md.
Broadbent, Samuel, Wilmington, Md.
Barnes, C., Mobile, Ala.
Brown, H. S., Milwaukie, Wis.
Collins, David, Chesnut Street, Philadelphia, Pa.
Cooley, O. H. Springfield, Mass.
Clark Brothers, No. 551 Broadway, N. Y. 128 Genesee Street, Utica, Franklin Building, Syracuse, New York, and Tremont Row, Boston, Mass.
Cook, George S., Charleston, S. C.
Coombs, F., San Francisco, Cal.
Cary, P. M., Savannah, Ga.
Dodge, E. S., Augusta, Ga.
Davie, D. D. T., Utica, N. Y.
Dobyns, T. J., New Orleans, La and Vicksburg, Miss., and Louisville, Ky.
Evans, O. B. Main Street, Buffalo, New York.
Finley, M., Canandaigua, Ontario Co., N. Y.
Fitzgibbon, J. H., St. Louis, Mo.
Faris, ——— Corner Fourth and Walnut Street, Cincinnati, Ohio.
Gurney, Jeremiah, No. 189 Broadway, N. Y.
Gavit, Daniel E., 480 Broadway, Albany, N. Y.
Gay, C H., New London, Ct.
Hough & Anthony, Pittsburg, Alleghany Co., Pa.
Hale, L. H., 109 Washington street, Boston, Mass.
Hawkins, E. C., Corner of Fifth and Walnut Street, Cincinnatti, Ohio.
Johnson, Charles E, Cleaveland, Ohio.
Jacobs, ——— New Orleans, La.
Johnston, D. B., Utica, N. Y.
Johnson, George H., Sacramento, Cal.
Kelsey, C. C., Chicago, Ill.
Lawrence, Martin M., No. 203 Broadway, N. Y.
Lewis, W. and W. H., No. 142 Chatham Street, New York.
Long, H. H., St. Louis, Mo.
Long, D., St. Louis, Mo.
L'Homdieu, Charles, Charleston, S. C.
Meade Brother, No. 233 Broadway, New York, and Exchange Albany, N. Y.
Martin, J. H., Detroit, Mich.
Moissenet, F., New Orleans, La.
Moulthroup, M., New Haven, Ct.
Manchester & Brother, Providence, and Newport, R. I.
Mc Donald, D., Main Street, Buffalo, New York.
Peck, Samuel, New Haven, Ct.
Root, M. A. & S., No. 363 Broadway, New York, and 140 Chesnut Street, Philadelphia, Pa.
Sissons, N. E., No. 496 Broadway, Albany, N. Y.
Shew, Jacob, Chesnut Street, Philadelphia, Pa.
Thompson, S. J., No. 57 State Street, Albany New York.
Tomlinson, William A., Troy, New York.
Van Alsten, A., Worcester, Mass.
Walker, Samuel L., Poughkeepsie, N. Y.
Westcott, C P., Watertown, Jefferson Co., N. Y.
Wood, R. L., Macon, Ga.
Whipple, John A., Washington Street, Boston, Mass.
Whitehurst, J. H., Norfolk and Richmond, Va., and Baltimore, Md. 162

1850

The "Hyalotype" glass slide of the U.S. Mint at Philadelphia (above) is from Frederick and William Langenheim's first series of 126 different slides prepared in 1850 for magic lantern viewing. Series included portraits of celebrities and views taken in Philadelphia, Washington, and New York.

tive pictures on glass, and they turned their attention to manufacturing Hyalotypes in the form of glass slides suitable for use with the magic lantern. Previously, this device was used to project hand-painted slides only, which were prepared by applying transparent oil colors to the slides. The method used by the Langenheims to make their first slides (see example above) involved use of a thick piece of glass bearing the image, which was covered by a second piece of glass, the two plates being bound together with the same gummed paper used to bind daguerreotype plates together with their covers. Thus assembled, the bound plates were placed in a wooden frame, the front of which had a circular opening while the back was hollowed out in rectangular shape to hold the slide in much the same fashion as any modern picture frame holds a picture (with nails secured on the back side). The slides were toned a golden brown, a distinguishing characteristic of the few such Langenheim slides which are to be found today anywhere.

To launch this latest of a number of ventures begun by the

Langenheims in this period (1848–1850), they made a series of 126 slides of prominent personages (President Zachary Taylor, ex-President Martin Van Buren, Henry Clay, and John J. Audubon among others) and views taken in Philadelphia, New York, and Washington, which could be sold individually or as an entire group for magic lantern viewing. The brothers also prepared a circular and sent collections to various people for promotional purposes. One recipient was Robert Hunt, editor of the *Art-Journal* in London and author of an early book on photography, *Researches on Light*. Hunt expressed himself as greatly "excited" with the Hyalotype slides sent to him, and published portions of the Langenheim circular, few, if any, copies of which are to be found today:

The new magic lantern pictures on glass, being produced by the action of light alone on a prepared glass plate, by means of the camera obscura, must throw the old style of magic lantern slides into the shade, and supersede them at once, on account of the greater accuracy of the smallest details which are drawn and

1850

78

fixed on glass from nature, by the camera obscura, with a fidelity truly astonishing. By magnifying these new slides through the magic lantern, the representation is nature itself again, omitting all defects and incorrectness in the drawing which can never be avoided in painting a picture on the small scale required for the old slides. To be able to perceive fully the great accuracy with which nature is copied in these small pictures, it is absolutely necessary that they should be examined through a magnifying glass. In minuteness of detail, as well as in general effect, they surpass even the daguerreotype impression, as the light passing through the picture gives a better effect in the deep, yet transparent shadows.''[163]

The Langenheims exhibited their Hyalotypes—both the lantern slides and the glass positives—at the London Crystal Palace Exhibition, the first international exhibit of technology by the industries of all nations, where they were received as ''a pleasing application'' of the photographic art.

They were not, of course, recognized immediately for what they were—the forerunners of lecture slides for business, educational, and home use, and an important first step toward motion picture projection.

In 1850, Richard Beard was declared bankrupt in London after a protracted series of litigations against infringers of his rights to the British daguerreotype patent. While this did not prevent him from continued prominence in the British photographic world, his litigation problems had repercussions on his former American partner, John Johnson. After 1843, Johnson took up plumbing and gas fitting in New York because of the ill effects on his health from continued working with daguerreotype chemicals. At the same time, he also became for a time a correspondent for the *Scientific American*. He evidently also continued to derive revenue from the rights to daguerreotype practice which had been assigned to him by Beard (in 1842) for the counties of Lan-

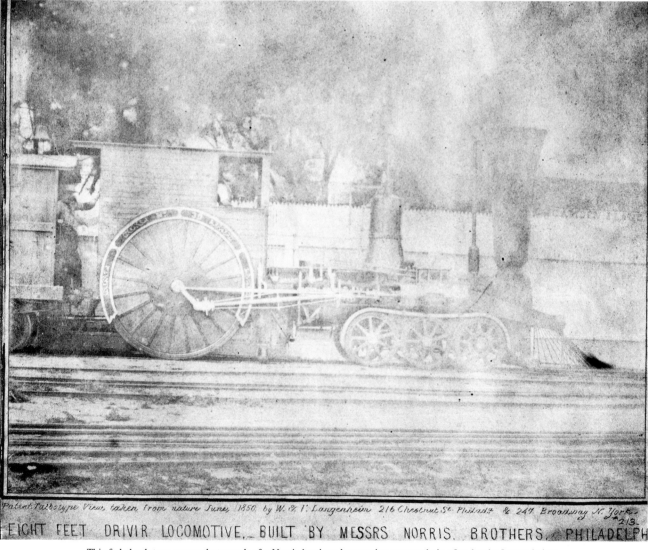

Patent Talbotype View, taken from nature June, 1850 by W. & F. Langenheim 216 Chestnut St. Philad.a & 247 Broadway N. York.

EIGHT FEET DRIVER LOCOMOTIVE, BUILT BY MESSRS NORRIS BROTHERS, PHILADELPH

This faded calotype paper photograph of a Norris brothers locomotive was made in 1850 by the Langenheims, who were unsuccessful in trying to introduce Talbot's process in the United States. Gustave Le Gray's improved calotype process, introduced in the United States in 1851, would attract greater interest.

Although uncommon, daguerreotype cameras were made in large size after 1850 to accommodate large plates (and occasionally small children!). In 1851, S. D. Humphrey reported having seen Southworth & Hawes daguerreotypes in size 13½ x 16½ inches.

cashire, Cheshire, and Derbyshire. Just how long this source of revenue continued is not recorded; however on June 29, 1850, Johnson inserted the following notice in the *Manchester Guardian:*

CAUTION—PHOTOGRAPHY. Whereas several persons in the counties of Lancashire, Cheshire and Derbyshire, have been and are infringing upon the patent rights granted in and by certain letters patent, bearing date the 14th day of March 1842, Assigned and Granted unto RICHARD BEARD, Esquire, of the city of London, by whom the sole and exclusive right and privilege of using and exercising the Daguerreotype invention in the taking of likenesses, or other representations, in the said counties of Lancashire, Cheshire and Derbyshire, was on the 9th day of November, 1842, Granted and Assigned unto JOHN JOHNSON, Esquire, of the city of New York in America. Notice is hereby given, that the validity of the said letters patent has been fully established by the Judgment of the Court of Common Pleas at Westminster, and that the proceedings will be taken against all persons in the said counties now or hereafter infringing upon the said several letters patent, by using the said invention without having a license and authority for that purpose. And notice is also given, that the only establishment licensed to practice photography under such letters patent in the borough of Manchester and its vicinity, is the Photographic and Daguerreotype Portrait Gallery, in the Exchange Arcade, Manchester. Persons desirous of obtaining licenses to use and exercise the said Daguerreotype inventions in the said counties, may learn the terms upon which licenses can be obtained upon application to MR. NEILD, 5 Marsden Street, Manchester, solicitor for the said John Johnson. Manchester, June 1850.[164]

1851

American photographers took top honors at the world's first exhibition of the industry of all nations, held in 1851 at the newly constructed Crystal Palace in London. Looking back to this time from the vantage point of later years, the English photographer and writer John Werge felt there was a definite reason for American superiority in daguerreotype practice: "All employed the best mechanical means for cleaning and polishing their plates, and it was this that enabled the Americans to produce more brilliant pictures than we did. Many people used to say that it was the climate, but it was nothing of the kind." American-made daguerreotypes, Werge said, "were all of fine quality and free from the 'buff lines' so noticeable in English work of that period."[165]

But both European and American daguerreans were by this time demonstrating an ability to prepare their chemicals and to use the daguerreotype camera in such a way as to obtain early examples of "instantaneous" photographs—the term used throughout the nineteenth century for results which today would be called "candid" photographs. Through a combination of unique plate preparation techniques, favorable weather, and lighting conditions, certain photographers managed to reduce exposures to one second—the time it would take a facile operator to remove and replace a lens cap—and, with small, fast-acting cameras, to a fraction of a second. Most early instantaneous results were novelties, and many were small pictures made from a high vantage point to minimize whatever movement was "stopped" and recorded in the image. Hippolyte Macaire, of Le Havre, could get as much as 100 francs apiece for daguerreotypes he made in 1851 of people, horses, and carriages in motion, and of seascapes with waves, and steamships with smoke coming out of their funnels. But few instantaneous daguerreotypes of this period are to be found today, and in most cases the movement recorded was probably coming towards, or going away from, the camera, as opposed to taking place laterally.[166]

Alexander Beckers and Alexander Hesler appear to have arrived at a similar conclusion about the same time with respect to a means of enhancing the sensitiveness of a daguerreotype plate, but it was many years before either of them talked about it, or published any details of their experiments (which, in fact, Beckers never did). All Beckers ever said (recorded in 1889) was that "by taking outdoor views I discovered that the plates increased in sensitivity with the time between the preparation and exposure." He evidently put this discovery to good use, for in 1864 Marcus Root said Beckers had made instantaneous views in Broadway in 1851 "wherein all moving objects were clearly and beautifully delineated on a silver plate." Hesler waited thirty-eight years before revealing his "secret," which also involved use of a primitive camera shutter mechanism:

In the early summer of 1851 I made a series of views for "Harpers' Traveler's Guide" of all the towns between Galena and St. Paul that were then

NEW YORK.

Copy of Instantaneous Daguerreotype, 1854.

The English photographer-historian John Werge visited the United States for the first time between June 1853 and October 1854. His second visit lasted from April 1860 to August 1861. This daguerreotype was either made by himself or by an American photographer, and taken with him back to England. Reproduced some thirty-six years later in Werge's *Evolution of Photography*, the illustration ranks as possibly the earliest surviving photograph of a New York harbor scene. Werge abandoned the daguerreotype process in 1857.[167]

settled on the Mississippi, from the pilot-house of the steamer "Nominee" while under full headway, that were just as sharp as if taken from a fixed point. The pictures were taken on what we then called a half Daguerreotype plate.

I had constructed a drop-shutter, the first and only one I had ever seen or heard of—had it made at a tin-shop—and practically the same as is now in use. In the drop I made a slit half an inch wide, and extending entirely across the diameter of the lens. The drop was accelerated in its fall by a stout rubber spring. The lens was a " C C Harrison" single view. When the boat was far enough away so that all the village was embraced in the plate it was at once put in place and the shutter released, the plate put away in a light-tight box, and not developed until I got back to Galena.

How did I get the rapidity? Simply by having a pure silver surface exposed to the right proportion of the fumes of iodine and bromine. And here was the secret. *Coating the plates two or three weeks* beforehand and keeping in light and air-tight boxes! The longer they were kept the more rapid they became! When properly prepared, the time was reduced from minutes to seconds!

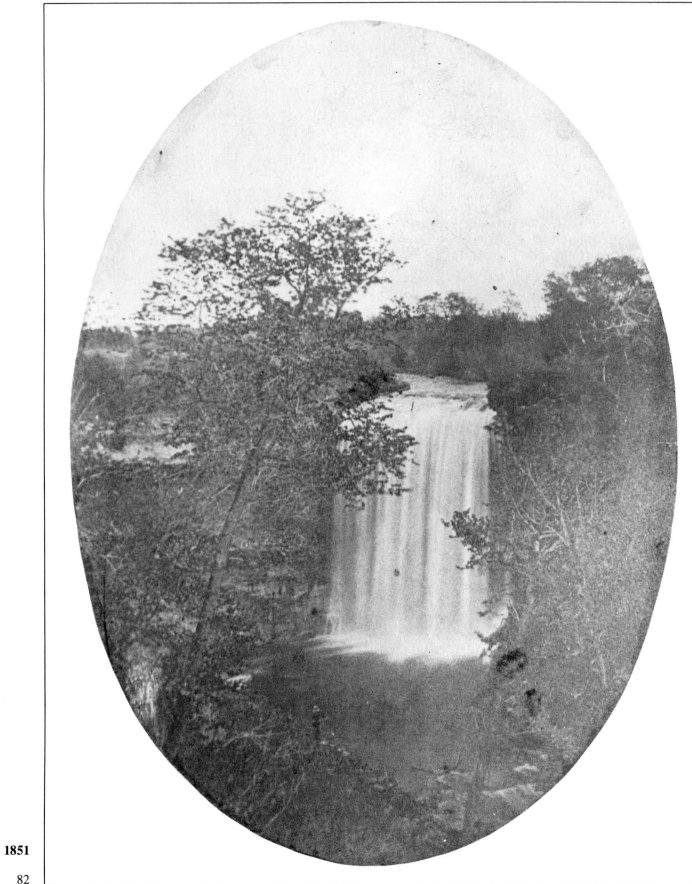

HESLER DAGUERREOTYPE INSPIRES "HIAWATHA"

About the same time that Robert Vance was making his dageurreotype views of gold mining activities and urban life in the San Francisco area, Alexander Hesler, of Galena, Illinois, was photographing the upper Mississippi River, Fort Snelling, and the falls of St. Anthony. Later, when glass negative processes came into general use, Hesler copied many of his daguerreotypes, making what are classed as "salt prints"—the earliest form of photograph on plain salted paper, similar in appearance to a calotype, but made with a glass, as opposed to a paper negative. The original from which the photograph (left) has been reproduced is a Hesler salt print copied from an 1851 daguerreotype of the falls of Minnehaha. Another daguerreotype made at the same time by Hesler was given to Henry Wadsworth Longfellow, inspiring "Hiawatha," the idealized love story based upon the poetic legends of the Indians which Longfellow wrote in 1855.

Later a photographer of Lincoln, Hesler was feted shortly before his death in 1895, and on that occasion this description was given of the role played by his daguerreotype in the writing of "Hiawatha":

Alexander Hesler, from an 1858 salt print.

'It has been made the subject of much comment among artists and poets that it was Mr. Hesler who was principally responsible for the inspiration which induced Henry W. Longfellow to write 'Hiawatha.' The incident became known at a dinner in this city, attended by old-time photographers at which anecdotes were discussed, as well as choice morsels and cigars.

"It seems that Mr. Hesler, armed with his picture-taking paraphernalia, wandered into the northwest in search of Nature's beautiful retreats. This was in 1851, and in August of that year, he tramped over the present site of Minneapolis. There was no sign of a city at that time. Coming upon the falls of Minnehaha, he took several views of the 'natural poem.' While arranging his pictures, he was accosted by a man who said his name was George Sumner. The latter purchased two pictures of Minnehaha to take to his home in the East, remarking that he would retain one and give the other to his brother Charles.

"The incident had nearly been forgotten by Mr. Hesler when it was revived in a startling manner. He received an elegantly bound volume of a work by Longfellow, and the principal poem was 'Hiawatha.' On the flyleaf was the poet's signature and the legend, 'With the author's compliments.' Hesler was puzzled to account for the poet's solicitude, and almost a year after the receipt of the book he met George Sumner, who explained the mystery.

"It seems that the daguerreotype had got into Longfellow's possession and taking it with him into the woods, he got his inspiration, as he said, from the pretty view, and wrote 'Hiawatha.' Mr. Sumner said that it was a good thing for the poet that it was the counterfeit of Minnehaha Falls, not the real article, that the poet gazed upon for his inspiration, otherwise there would have been no 'Hiawatha' written." 168

Romanticized painting of Minnehaha and her Indian lover, Hiawatha, showing falls in the rear.

The plates could be exposed and developed at any future time. Many, both in and out of the profession, wondered at the soft and delicate detail both in shadow and high light, and roundness of the portraits I exhibited at the Crystal Palace in 1853, and tried in vain to equal.

None of the pictures had received over five seconds' exposure! Hence their lifelike pose and expression.

Rapid or short exposures were also obtained by charging the plates with electricity generated by giving the plate for the last finish a brisk rubbing on a white silk-plush buff; but this was only effectual in a dry, warm atmosphere. When thus treated I could get rapid plates about one-sixth the usual time, but unless the temperature and atmosphere was right the exposure was only retarded, so I had to abandon that as very uncertain.[169]

Other experimenters resorted to other methods or devices. F. A. P. Barnard, while professor of mathematics at the University of Alabama in the early 1840s reportedly had made instantaneous daguerreotypes with chlorine even before the advent of bromine and the various "quickstuff" formulas. Still another experimenter was James Cady, of New York. This account of his instantaneous experiments, about 1851–52, was given at a meeting of the New York Mechanics' Club in 1858:

> Mr. J. Cady had made daguerreotypes of the ferry boats in motion, so that all parts were as distinct as if taken at rest. The paddles of the wheel, and even drops of water in the air were faithfully depicted. He had frequently made good pictures of stages in motion on Broadway, and men in the act of walking. The pictures were made with what was called Cyrus' Magic Buff. He was one of the very few who succeeded with it. The greatest difficulty at first was in shutting off the light quick enough.[170]

Separate attempts at fraternal organization were initiated this year, but they were not destined to be successful. The first was the New York State Daguerrean Association (organized initially as the New York State Photographic Asso-

THE ABORTIVE FIRST STEPS TOWARD FRATERNAL ORGANIZATION

DATE	NEW YORK STATE DAGUERREAN ASSOCIATION Organized initially as the New York State Photographic Assoc.	AMERICAN DAGUERRE ASSOCIATION Organized initially as the American Heliographic Assoc.
July 12 1851 Syracuse	Edward T. Whitney of Rochester named chairman; preamble and resolutions adopted calling for the burying forever of "all feelings of envy and jealousy which has heretofore existed"; "fair compensation" for the "best miniatures" not made by the "many imposters (which) are flooding our country with caricatures" at low price; call for a national convention at Utica November 20.	
July 15 1851 New York		Jeremiah Gurney named chairman, Samuel D. Humphrey secretary of meeting to form an association and prepare a constitution.
July 17 1851 New York		Augustus Morand, Martin M. Lawrence, Alexander Beckers, and others named to draft bylaws; M. M. Lawrence elected president; vice presidents named included: Gurney, John H. Fitzgibbons (St. Louis), Albert Southworth (Boston), Samuel Van Loan (Philadelphia), T. J. Dobyns (New Orleans), Thomas Faris (Cincinnati); constitution adopted calling for "a higher standard of taste" in photography, and "more friendly intimacy" among photographers. Association boasted 131 *elected* members.
August 5 1851 New York		Committee appointed to contact Daguerre's widow expressing sympathy at Daguerre's death July 10.
August 20 1851 Utica	Augustus Morand appointed chairman of convention, then president of the association. A new constitution adopted, prescribed membership only for those "who will agree not to take pictures at a disreputably low price"; confirmation of new members to be by two-thirds vote of members; call for another convention in New York in November, with invitation to members of American Daguerre Association to join.	

ciation), which was composed of photographers from New York City and environs, whose names for the most part are not well known today. The setting of a floor for daguerreotype prices was a principal factor in leading to the establishment of this group, which held an organizational meeting on July 12 in Syracuse.

A second organization, the American Daguerre Association (initially called the American Heliographic Association), was founded three days later by a group of prominent New York, Boston, Philadelphia, Cincinnati, St. Louis, and New Orleans photographers. The A.D.A. reported at a second meeting (July 17) that it had an *elected* membership of 131. A higher standard of "taste" in photography was the principal stated purpose of this group. Martin M. Lawrence, one of the three Americans who were to take top honors in photography at the Crystal Palace exhibition, was chosen president of the A.D.A.

There was an immediate antipathy to the A.D.A., and the first man to express his misgivings was none other than Gabriel Harrison, Lawrence's chief operator. Perhaps there was bad blood between the two, for Harrison was operating his own gallery in Brooklyn by 1852, and in 1853 said that he—not Lawrence—had taken all of the daguerreotypes which Lawrence exhibited at the Crystal Palace exhibition. Harrison's attack against the A.D.A. was delivered at a meeting of New York and Brooklyn photographers which gathered at Brady's gallery to "respond" to the Daguerrean association's call for a convention at Utica just twelve days later (on November 20). Brady was not present, having sailed for Europe with his wife the previous month. Harrison did not specifically name the A.D.A. in his speech at this gathering, but it was the A.D.A. to which he eluded when he delivered these remarks:

> Now, gentlemen, I come not here for the purpose of finding fault with any particular individual in the profession; but, certain it is, that lately, a *Secret Society* has been formed in this city, I must call it a Secret Society, from the notorious fact, that not more than a dozen or two knotted and gendered for it in a corner, elected its President, and even appointed its foreign Plenipotentiaries, and most inapplicably christened it a National Institution. Three out of the dozen originators, are not practical Daguerreotypists, and one of the three holds the high and responsible office of Secretary. I respectfully ask if this is not unprecedented in the history of the formation of National Institutions. All this was done without a single notice through the medium of the press calling together even the Daguerreans of the city, let alone from all parts of the Union, and at this moment, after they have had some eight or ten meetings, there is in this city some of the brightest stars the profession can boast of still uninvited, and even operators, the first that took up the art after the immortal Daguerre's discovery, the men who have been scorched over the furnace of the art, the identical men, too, that have by their *taste*, their

WHO'S WHO AT FIRST CONVENTION OF AMERICAN PHOTOGRAPHERS

Officers and delegates in attendance at the first convention of the New York State Daguerrean Association, Utica, New York, August 20, 1851.

From the minutes of the meeting:

> Mr. Morand—after expressing his desire that the Convention would select some other gentleman to fill the honorable position of president, and his unwillingness to assume the responsibility, and being overruled by the unanimous voice of the assembly—then retired.
>
> The Convention then proceeded, after signing the constitution and paying the initiation fee, to an election for president, which resulted in the unanimous election of Augustus Morand of New York city.
>
> *For Vice Presidents:*—D. McDonald, of Buffalo; C. P. Westcott, of Watertown; P. Haas, of New York city.
>
> *For Corresponding Secretary:*—C. B. Denny, of Rochester.
>
> *Recording Secretary:*—L. V. Parsons, of Auburn.
>
> *Treasurer:*—N. E. Sissons, of Albany.
>
> *Trustees:*—O. B. Evans, of Buffalo; E. T. Whitney, of Rochester; B. L. Higgins, of Syracuse; F. J. Clark, of Utica; P. H. Benedict, of Syracuse; W. A. Tomlinson, of Troy; S. J. Walker of Troy; J. S. Myers, of Po'keepsie; J. M. Clark, G. Harrison, J. P. Weston, of New York; D. B. Johnson, of Utica.
>
> Delegates then reported as follows.—
>
> P. Haas, J. M. Clark, S. D. Humphrey, from the American Heliographic Association.‡ of New York city. S. Selleck, W. Metcalf, G. R. Turner, A. Morand, H. H. Snelling, honorary delegate of New York city, from the meeting of the Daguerreotypists of the cities of New York and Brooklyn, held at Brady's gallery on the 8th inst.; P. H. Benedict, B. L. Higgins, Mary S. Hoyt, of Syracuse; G. N. Barnard, of Oswego; L. V. Parsons, C. B. De Reimer, of Auburn; A. C. Nichols, of Fulton; D. V. Frost, of Augusta, Erie Co.; N. E. Sissons, of Albany; C. P. Westcott, of Watertown; D. D. T. Davie, J. Davie, F. J. Clark, U. Dunning, D. B. Johnson, R. Everett Jr., of Utica; H. N. Manchester, Providence, R. I.; W. P. Beech, of Homer; P. C. Huntley, of Paris, Oneida Co.; W. P. Davis, of Union Springs; C. N. Johnson, of Batavia; M. J. Goddard, of Lyons; C. B. Whitney, C. B. Denny, of Rochester; G. S. Ragg, of Denmark, Lewis Co.; Jane P. Martin, of Paterson, N. J.; J. P. Merritt, of St. Catherine's, Canada; D. McDonald, A. McDonald, R. McDonald, of Buffalo; A. Fairchild, of Deriter. [172]

Gabriel Harrison (1818–1902) was more prominent in acting and literary circles than in the world of photography. Having learned daguerreotyping from John Plumbe, Jr., he worked alone and as a chief operator for other daguerreans, including Martin M. Lawrence during 1849–52, when Lawrence won top awards at the London 1851 Crystal Palace Exhibition for daguerreotype portraits made at his New York gallery. Harrison opened a second gallery of his own in Brooklyn, New York, in 1852.

patience, and their *genius,* elevated these men in the eyes of the public, and placed their mysterious art on the high and proud pinacles it now rests upon.

Gentlemen, I must be emphatic, and tell these partialists I cannot, *will not sanction* any such *work* as this. If we are to have a society for the good of *all,* why not invite all to come in? Why not invite the fifty cent man as well as the dollar or two dollar man? Let the corner stone of the institution be democratic. With such we will have union! Union is strength! and with strength we must prosper. Therefore let us here to night respond to these men of *Syracuse,* who were the first to move in the matter, and who have, in a noble and democratic manner invited every Daguerrean to come to their Convention at Utica on the 20th day of August, and there, in a proper manner, form a National Institution.[173]

Despite Harrison's misgivings, there were men whose feet could be found in both camps. Augustus Morand, a New York photographer of some note, served as a member of the committee which drafted the bylaws of the A.D.A., then was elected president of the Daguerrean association. S. D. Humphrey was named secretary of the A.D.A., then an honorary member of the Daguerrean body. Whatever his sentiments before attending the August 20 convention in Utica, Harrison along with J. P. Weston, another photographer from the New York-Brooklyn group, were elected trustees of the Daguerrean association. Snelling also joined Humphrey as an honorary member. The association held several meetings in New York in November, first at Brady's gallery then at Anthony's headquarters, but the principal action centered on the reputed discovery of a color daguerreotype process claimed by an upstate New York photographer, Levi Hill. The Daguerrean group named a committee to look into the matter, which consisted of Harrison, Morand, D. D. T. Davie, J. M. Clark (Anthony's former daguerrean partner), and W. A. Tomlinson. This committee spent the night of November 13 in Westkill, New York (where Hill resided), and most of the following day, after which it issued a devastating report, stating that it had "found no evidence to satisfy them that any person had seen any picture colored by any process, new to the scientific world, at the hands of Mr. Hill. On the contrary, they are of the opinion that the pictures in colors which have been exhibited by Mr. Hill are mere transfers of colored prints, and that they have been in no case transfers of copies from nature." The whole thing, the committee concluded, was a "delusion." But this was not the end of the affair. Samuel F. B. Morse, Jeremiah Gurney, Marcus Root, John A. Whipple, and a number of other men of equal prominence in the photography world visited Hill in 1852—all attesting to the apparent achievement by Hill of securing daguerreotypes in color. Even a Senate committee, after looking into the matter in 1853, produced a report which, although inconclusive, nevertheless tended to be favorably inclined towards Hill's claims.[174]

While the first signs of a fraternal spirit had emerged, both the Daguerrean Association and the A.D.A. were gone from the scene within another year. The "fraternity" was, in effect, still factionalized; the signs on the darkroom doors still read "no admittance." It would be another twenty years, for example, before such a book could be published as *Secrets of the Dark Chambers,*[175] revealing the practices and methods of operating in the galleries of such prominent men as Gurney, Bogardus, and Charles deForest Fredericks. In an October issue of his *Photographic Art-Journal,* Snelling drew attention to yet a third new fraternal group. He was critical of the "selfish and demeaning sentiments" which had given birth to the A.D.A., but, in this short essay, he put the problems and challenges of fraternal organization in proper perspective:

Our Daguerrean artists have truly awakened to the necessity of forming protective and mutual benefit associations. Besides the New York State Daguerrean Association, and the American Daguerre Association, another has been organized in

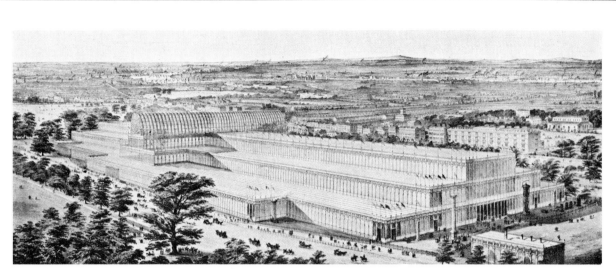

Exterior of the London Crystal Palace, scene of the first great world's fair.

AMERICANS TAKE ALL DAGUERREOTYPE AWARDS
AT CRYSTAL PALACE EXHIBITION

"In daguerreotypes we beat the world!" So exclaimed Horace Greely after a jury awarded the three prizes for daguerreotypes exhibited to Martin M. Lawrence, Mathew Brady, and John A. Whipple. Lawrence received the top award for a series of portraits termed "remarkable for clear definition." The jury noted that the two large portraits of size 12½ x 10½ inches were "throughout, pefectly in focus." Brady received a prize medal for forty-eight uncolored daguerreotypes, but the jury also said: "The artist, having placed implicit reliance upon his knowledge of photographic science, has neglected to avail himself of the resources of art" (apparently a reference to the custom, introduced by Claudet, of placing painted backgrounds behind the sitter). Whipple also was awarded a prize medal for a daguerreotype of the moon taken through a telescope at Harvard University. The *Illustrated London News* felt that the American display was "super-excellent," and that it atoned for "the disrespect with which they have treated all other nations, in having applied for so large a space, and yet at last having left their space comparatively unfilled."[176]

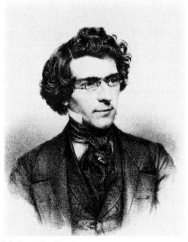

Mathew B. Brady

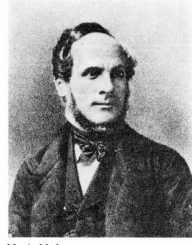

Martin M. Lawrence

John A. Whipple

1851

A PHOTOGRAPHIC SUPPLIES BUSINESS TAKES SHAPE

In his fourth year of business, Edward Anthony placed an advertisement (below) in the *Daguerreian Journal*. The Anthony name was now without a peer in photographic supplies, and long after his death a merger between the Anthony firm and the Scovill Manufacturing Company would create a new trademark, "Ansco," which survives to the present day. H. H. Snelling, Anthony's manager, began publishing a competitive journal, the *Photographic Art-Journal*, in January 1851 and in its second issue Snelling touted certain foreign-made chemicals such as German bromine and English iodine (see listings below) as being superior to American-made counterparts. The best "golds", he said, were those made by Dr. James R. Chilton, Nathan G. Burgess (both of New York), and D. D. T. Davie of Utica.

ANTHONY'S

NATIONAL DAGUERREIAN DEPOT,

203 & 205 BROADWAY, NEW YORK.

DAGUERREOTYPE GOODS ONLY.

The attention of Dealers and Daguerreotypists is respectfully requested to my assortments of Apparatus and Materials, which will be found to be very extensive and complete.

DAGUERREOTYPE PLATES.

The celebrated Crescent Brand Plate, exclusively of my own importation, stamped with my name, and warranted. The Sun 40th Plate, (guaranteed to be 40th.) Star 40th Plate. French Plates, 20th and 30th. (quality guaranteed.) Scovill Plates, of all sizes and qualities. French Galvanized Plates. *All the plates of my importation are carefully examined in Paris by an EXPERIENCED agent, practically acquainted with the manufacture of plates, and all that are VISIBLY imperfect, are rejected and returned to the manufacturer. The great number I import, enables me to sell a GENUINE ARTICLE at a low rate.*

CASES.

[Exclusively of my own manufacture.] 1-15 size, 1-9 size, 1-6 size, 1-4 size, 1-2 size, 2-3 size, 4-4 size, of every style and quality. Papier Mache or Pearl Inlaid Cases of every size and style. *My Papier Mache work will be found to be superior to any in the market.* Turkey Morocco Bookcases. Snap Cases of various styles. *Cases manufactured to suit the taste of any customer*, or adapted to any particular Gallery, the name being beautifully embossed on the cushion without extra charge, except for the die.

CASEMAKERS' MATERIALS.

Heavy leather for embossing. Thin leather for binding. Crimson silk for cushions. Silk velvet, ruby and maroon, of different qualities. Cotton velvet, crimson. Patent velvet, silk finished, crimson., Satin, maroon. Varnish, of superior quality. Hooks. Clasps, for book-cases, &c., &c. Embossing done at moderate rates.

PLATE GLASS

Of the very best quality, cut to order, of any size, for cases or show frames, and furnished by the quantity to dealers, in original packages as imported. Also, Half white German Glass, in original packages or cut. Green English Glass, by the gross.

METALLIC MATTINGS,

Burnished and fire gilt, of all sizes and styles, for cases or frames, all of my own manufacture, and superior in color and beauty of finish to any in the market.

ROSEWOOD AND BLACK WALNUT FRAMES

Of all sizes, made in a durable manner, and fitted in a style to do justice to a good specimen of Daguerreian art.

Fancy Frames, of various styles, of French manufacture.

PRESERVERS.

1-9 size, 1-6 size, 1-4 size, 1-2 size, of a new and beautiful style of chasing.

APPARATUS.

Cameras of Voightlander, Harrison, Roach, and Lewis' make; also Coating Boxes, Mercury Baths, Plate Vices, &c., &c., comprising every thing required for the successful prosecution of the art.

HARRISON'S PATENT BUFFING WHEEL.

LEWIS' BUFFING WHEELS.

NEW STYLE PLATE BENDER.

Neat simple, and effectual, Price, $1,50.

CHEMICALS.

Iodine, best English resublimed. Chloride o Iodine. Bromine, pure German; do. American Chloride of Gold, of the best makers. Salt of Gold or Hyposulphite of Gold. Distilled Mercury. Rotton Stone, of all the various makers. Rouge, best French; do. American. Photogine. Hyposulphite of Soda, best French; do. do. American. Cyanide of Potassium. Dry Quickstuff, Anthony's Anhydrous. Roach's Triple Compound of Bromine. Chloride of Bromine. Fluoride of Bromine. Oxide of Silver. Gallic Acid. Crystallizable Acetic Acid. Bromide of Potassium. Nitrate of Silver. Muriate of Potash. Chloride of Calcium. Succinic Acid. Hydrofluoric Acid. Drying Powder. Pure liquid Ammonia. Iodide of Lime, a new and valuable preparation for iodizing the plate.

Those desiring to commence the practice of Daguerreotyping, fitted out with everything necessary for their success at moderate cost. LOCKETS, Gold or Gilt, of all sizes and styles, oval, round, single or double, open or hunting.

GOODS CAN BE FORWARDED to any town in the United States or Canada (provided said town have connection by Express with New York) and the money collected on delivery of the goods. Persons will do well, when in places that have no such connection, to have what they order forwarded to the nearest express town.

TERMS—Cash. No allowance for breakage after goods have left the City.

I have been compelled to adopt the rule of not sending lists of prices, because it only injures such country dealers as buy of me. But all who send *orders for goods* may depend upon getting them at my regular New York prices.

E. ANTHONY,

Importer and Manufacturer of Daguerreian Materials.

308 Broadway, New York.

N.B.—Good journeymen Case-Makers wanted to whom steady employment will be given.

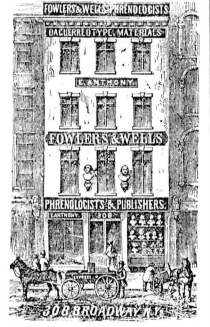

This building, which once stood at 308 Broadway in New York, was not only Edward Anthony's first headquarters but that of the American Phrenology movement, the pseudoscience which divided the human brain into separate sections of differing mental faculties, holding that the development of each faculty could be judged by the shape of the skull over it. During the 1850s, phrenology took on all the aspects of a religion as well as a science. Karl Marx reportedly judged the mental qualities of others from the shape of their heads. Walt Whitman published his phrenology chart five times, including it in an 1855 edition of *The Leaves of Grass* published at the Fowlers & Wells headquarters depicted in this illustration. But Mark Twain remained skeptical, satirizing the "bumpologists" in his literary works after a phrenology "reading" given him when he appeared under an assumed name held that he lacked a sense of humor. Phrenology "readings" were even provided by mail (at a cost of $4), provided the customer sent in a "good" daguerreotype—a "three-quarter pose" being preferred.[177]

the city of New York, essentially different from the two named, under the title of the American Photographic Institute. This society is in principle, both a protective and collegiate institution. It already numbers thirty-seven members, with Mr. J. M. Clark, of the city of New York, for its president, and Mr. Dorat and Mr. Harrison, for recording and corresponding secretaries. It has a fine chemical apparatus, and an embryo library. Several lectures have already been given to its members by Dr. Dorat and Mr. Holt, upon the combination of chemicals used in the art. This institution is certainly deserving the attention of Daguerreans throughout the country, and we sincerely wish it all the prosperity its members can desire.

The American Daguerre Association still holds its weekly meetings, we believe, but its proceedings are so studiously kept a profound secret from us, that we are deprived of the pleasure of speaking of it as we wish. Since its organization, we understand that several important changes have been made in the constitution, by-laws, and officers, making it less objectionable than at first. We trust to see it soon completely eradicated of the most unwarrantable selfish and demeaning sentiments which gave it birth ; and we have every reason to trust so from the more elevated minds which have attached themselves to it since its first organization. We have no reason to fear for the result at present.

There is, however, we think, too much stress and importance put upon the pecuniary measures of this movement, both in the State and City Society, to the exclusion of more important considerations. Instead of the improvement of the mind, and the practical manipulary processes being discussed as of paramount importance, the question of " what shall be the price of pictures ?" is most eagerly and persever-ingly discussed by nine-tenths of the members of the art. . . .

There is too great a disposition on the part of the most influential operators to lose sight of the fact that others besides Daguerre are equally entitled to lasting honors as discoverers of the beautiful art of Heliography, as well as to exclude every branch of the art except the Daguerreotype, from consideration. Under the present organizations, none can be admitted who do not practice the daguerreotype, consequently all those connected with the other branches, such as the calotype and the photogenic, are forcibly excluded. It is also unjust to the other great minds, Niepce of France, and Talbot of England, to imply by such proceedings that to Daguerre alone are we indebted for the great discovery. We have no objection that the latter gentleman's name should be given to some of the Heliographic societies formed, but to assert, in so doing, that to him alone is due the honor, is decidedly wrong. He was undoubtedly the first to practically perfect the art, but sufficient data is given to prove conclusively that its first principles were the discovery of M. Niepce. He should, therefore, receive a due portion of the honor at the hands of Americans. Our principal objection, however, to Daguerre's name being exclusively given to our Photographic societies, is that it makes them too exclusive and isolated.

We trust that the National Convention, to be held in New York city on the 12th of November, will take these facts into serious consideration, and before they fix upon a name for the National Society, debate the subject well. . . .

The paper photographists are now increasing almost as rapidly as the Daguerreotypists, and they are equally entitled to the benefits of these societies. They should not, therefore, be excluded.[178]

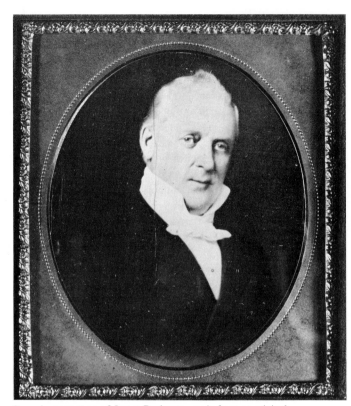

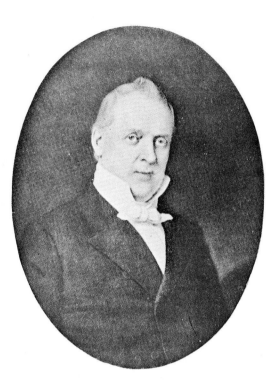

Copy daguerreotype of James Buchanan, made from an original taken circa 1851.

Miniature painting of Buchanan made by J. Henry Brown in March 1851.

A DAGUERREOTYPE SERVES AS "SITTER" FOR
PORTRAIT OF A FUTURE PRESIDENT

Copy daguerreotypes were used quite extensively by artists in the 1840s and 1850s for portraiture, particularly in painting portraits of the famous. The copy daguerreotype of James Buchanan (left), found at an antiques show in the early 1970s, is the youngest known likeness taken from life of the fifteenth president, and is similar to, or the one actually used by artist J. Henry Brown to paint the miniature portrait (right), completed in 1851 when Buchanan was between stints as Secretary of State and Ambassador to Great Britain.

"Copying pictures," the Owego, New York, photographer George N. Barnard said in 1852, "has become a large share of the daguerrean business." But there were tricks to this trade, as in others, which Barnard described in these words: "The chief dificulties in making copies has been that the copy is produced in a much lower tone—that is, the lights and shades are much weaker—and that, in the copy, the lines are not so sharp and distinct as in the original. The freshness and brilliancy of a fine tone daguerreotype I fear can never be imparted to the copy, but we can produce one as clear, distinct and strong as the original; further than this cannot be expected of us. In my process I use a whole size camera with an aperture in the diaphragm about the size of a dime, and I place the picture to be copied directly in the sunshine, by which all the reflections will certainly be avoided—because the direct light is stronger than the reflected lights. Reducing the size of the aperture in the diaphragm produces the sharpness and distinctness of the original, and in aid to this, and to obtain the same strength of light and shade, I use a smaller quantity of bromine in the preparation of the plates. Others may have adopted this process, but I believe that it is not generally known."[179]

PERFECTING NEGATIVE PROCESSES
1852

This was photography's watershed year. The profession was now dividing itself three ways—between continued use of silvered metal plates to make daguerreotypes; the never widespread use of paper negatives to make calotypes; and the adoption of glass negatives (prepared with albumen or collodion) to make newer forms of photographic prints. S. D. Humphrey felt that the daguerreotype would continue to be the dominant medium "while the patent right of Mr. Talbot exists." He also said that Talbot's process was, "comparatively speaking, almost neglected." He also felt that "many objections might be argued" against universal adoption of glass negatives, because "the nature of the material will always be an insuperable obstacle to its general use."[180] Snelling, too, thought (in July 1852) that it "might be many months, perhaps years" before the daguerreotype was superseded, but by the end of the year he had changed his tune:

> Hitherto the photographists of this country have confined themselves exclusively to the practice of their art upon the silvered plate, but, if we are to judge from the constantly increasing demand for photogenic paper and paper chemicals—it will not be long before photography upon paper will be as extensively practiced as the daguerrean art. The beautiful results obtained by the Messrs. Whipple and Black, of Boston, have undoubtedly contributed to enhance the interest in the paper processes. These gentlemen have produced proofs upon paper far excelling any of those coming from either English or French manipulators. We consider them superior, because they come from their hands in a finished state, fine in tone and softness, excellent in color, and almost perfect in outline, soundness and perspective, without the aid of the brush, which cannot be said of the European photographs, they being more or less retouched.[181]

Snelling also drew attention this year to the improvements on paper processes made in France by such men as Louis Blanquart-Evrard, Gustave Le Gray, and others. As a result, he said that many French operators "have thrown entirely aside the metallic plate," and that the same could be said of England, "notwithstanding the shackles thrown around the art by Talbot's patents."

Helmut Gernsheim has termed the years 1852–57 "the golden period of the paper negative" in Europe.[182] So, too, there was a mild flourishing of the calotype practice in the United States, utilizing principally the newer French mode introduced in 1851 by Le Gray. Among the earliest practitioners was a Frenchman, Victor Prevost, who had studied art with Le Gray and Roger Fenton in the studio of Paul Delaroche in Paris, then came to the United States in 1848. There is no record of his work in the period 1848–51, but in the latter year Prevost made at least one recorded calotype view in New York, the first of a series made by the Le Gray method in the period 1853–54. But in 1853, Prevost returned to Paris, possibly to master the new process which his friend Le Gray had published after Prevost had gone to the United States. The *Daguerreian Journal,* meanwhile, commented on a number of occasions during 1851 on calotype activities by others in New York. One notice cited C. J. Muller, who used a method he had originated while living in India, and which the *Journal* said "resembles somewhat the Talbotype." Another notice described prints made by J. P. Weston, a trustee of the New York State Daguerrean Association, as "some of the best calotypes we have seen." A lady by the name of Madam Weinert Beckman exhibited such a fine collection of calotypes made with waxed paper negatives that J. DeWitt Brinckerhoff decided, after viewing her prints, to quit his association of several years with camera maker Charles C. Harrison and establish a photography business of his own. This was probably as early as 1852, as Brinckerhoff was one of the first American photographers to take up the collodion process after his friend, John J. E. Mayall, sent him Archer's formula before it was published in the United States. In Chicago, Polycarpus von Schneidau, a Swedish immigrant who learned the daguerreotype process from Brady in 1848, also practiced Talbot's calotype method, and in 1854 made a Talbotype of Abraham Lincoln which is the second earliest known photograph of Lincoln.[184]

But the calotype lost out in competition with the daguerreotype when John Charles Frémont, the noted American explorer, made a decision between the two methods for

LE GRAY PROCESS

Gustave Le Gray (1820–1862), a French painter, took up Talbot's process in 1848, then modified the process in 1851. By using thinner paper impregnated with wax, he could achieve paper negatives of almost glasslike transparency, yet sturdy enough for in-camera use. Talbot's paper was thicker; it had to be, to withstand the many and frequent washings required in print making. One British writer said of the Le Gray process: "It imparts a horny character to the paper, making the thinnest very strong, without increasing its thickness; it may even be washed, soaked, and re-washed for several days if required without the slightest fear of injury. And secondly, the paper so prepared can be kept after it is made sensitive and ready for the camera, without deterioration for from ten to fourteen days; while that prepared by the Talbot process can only be kept for about as many hours." Waxing was accomplished with a moderately hot iron passed with one hand over the unprepared paper, the other hand following with a block of pure wax. As the iron heated the paper, it absorbed the wax and became saturated with it. The Le Gray process could obtain sharper positive images on paper than could be obtained with the thicker, more fibrous paper negatives of the Talbot method. For exposures, Prof. John Towler, in his *Silver Sunbeam,* said that the time would vary according to temperature and brilliancy of light, but that "2–3 minutes in a good light will in general be sufficient; in ordinary light on an average from 10 to 15 minutes will be required." Photographs printed from finely prepared wax paper negatives are hard to distinguish, in terms of clarity, from prints made from glass negatives of the same period.[183]

Only the faded photograph (top) of Victor Prevost and the 1881 photograph (below) of J. DeWitt Brinckerhoff survive to tell us what two of America's pioneers in the making of paper photographic prints looked like. Prevost made the earliest known American calotype photographs, using Gustave Le Gray's waxed paper negatives. Brinckerhoff was possibly the first professional American photographer to take up the practice of the collodion glass negative process. Both operated in New York City.

field work on an expedition begun in the fall of 1853 to survey a southern route for the proposed transcontinental railroad. Frémont first engaged S. N. Carvalho, an artist and daguerreotypist then residing in Baltimore, to accompany him, then asked a second photographer known only as "Mr. Bomar," who worked Le Gray's method, to join the expedition in St. Louis. After getting as far as Westport, Missouri, Frémont asked both men to prepare specimens of their work so that he could choose between them. Carvalho's later report of the contest stated: "In half an hour from the time the word was given, my daguerreotype was made; but the photograph [Carvalho's term for Bomar's calotype] could not be seen until next day, as it had to remain in water all night, which was absolutely necessary to develop it." Bomar naturally lost out, but it would appear that he engaged in an unnecessary amount of washing—required, perhaps for Talbotypes, but not for the Le Gray process.[185]

While the Langenheim brothers endeavored, unsuccessfully, to promote the practice of Talbot's process in the American fraternity, several other men took the lead in adopting other means of making photographs on paper, using either Le Gray's process or glass negatives. Among the first of these was Dr. Charles M. Cresson of Philadelphia. According to Marcus Root, who supplied the cotton Cresson used to prepare collodion negatives, Cresson mixed "iodine, bromine and sundry other substances"—all suggested by James (probably John) Price Wetherill of the family of noted scientists—to make his negatives. Cresson himself later said that he used bromine to make collodion negatives in the period spanning April 15 to May 20, 1852, and that he made pictures thereafter of "the most eminent business men and members of the bar of Philadelphia." A chemist, Dr. Cresson had practiced photography —principally as an amateur—since 1845. While he did not go into the business of making collodion photographs, and there is some question as to just how good his photographs were, nevertheless he did one very important thing at this time: he communicated the nature of his experiments —principally the way he used bromine—to James A. Cutting of Boston, who was then preparing to apply for an American patent for the collodion process. Cresson's action was in response to queries from Cutting, who may have read of Cresson's exploits in the May 20 issue of the *Journal of the Franklin Institute*. Sixteen years later, this brief communication between Cresson and Cutting would be spotlighted as the highlight of testimony gathered by American photographers to support their claims in the greatest of their nineteenth-century patent wars.[186]

Other early leaders in perfecting methods of securing photographs on paper were: John A. Whipple, inventor of "crystalotype" photographic prints (made initially by his patented albumen negative process; later by the collodion method); Victor Prevost, whose calotype views of New York City and environs made in 1853–54 are today the earliest surviving photographs of the city; Ezekiel Hawkins, inventor of "solograph" photographic prints (which won awards in Cincinnati before Whipple's crystalotypes did at the American Institute Fair of 1853); and J. DeWitt Brinckerhoff, who adopted, and was among the first to teach, the collodion process.

Ezekiel Hawkins, the pioneer American experimenter with collodion pho-
tography, was making his solograph photographs on paper at least by Octo-
ber 1852. The advertisement (above), which appeared in the 1851–52 *Cin-
cinnati Directory,* gives no hint as to the style or nature of his solographs,
however. Available evidence suggests that they were made with al-
bumenized glass negatives in the early 1850s, and with collodion negatives
thereafter. Although Hawkins' colored solograph portraits as well as his
daguerreotype portraits and glass portraits having an enameled appearance
were universally admired, none are known to survive in institutional
hands.

Records do not seem to exist which will tell us precisely
when Whipple abandoned and sold the rights to the albumen
negative process which he had invented and patented in
1850, but we do know that the Whipple and Black studio
was using the collodion method to make crystalotypes as
early as the summer of 1853.[187] Whipple's process did not,
however, die with his abandonment of it; on the contrary,
there is evidence that it was practiced fairly extensively in
the United States and spread to England and the continent
through the efforts of the Philadelphia firm McClees and
Germon (see page 98). It is unfortunate, too, that records
do not appear to exist on Hawkins' methods. The Cincinnati
Directory for 1850–51 carries a Hawkins advertisement for
his ''Apollo'' daguerreotype rooms (which were destroyed
by a fire in August or September 1851), while that of
1851–52 lists him at a new address with the title of his
gallery changed to read: ''Daguerreotype and Solograph
Gallery.'' A Cincinnati newspaper, on October 6, described
his solographs only as ''taken on paper instead of the silver
plate.''

In 1852, Hawkins was awarded a silver medal for the
solographs he exhibited at the twelfth annual exhibition of
the Ohio Mechanics' Institute. In 1854, he exhibited paper
prints at the American Institute fair in New York which a
critic, writing in Snelling's *Photographic Art-Journal,* said
were ''not to be compared to Whipple's; the process is en-
tirely different and do not show them to the same advan-
tage.'' The critic also gave Hawkins (by then in his fifties) a
pat on the head: ''We hope that Mr. Hawkins will persevere
and try and do better the next time.'' One clue as to Haw-
kins' methods is to be found in an isolated statement made
in a communication from a Col. John R. Johnson to Snell-
ing's journal, which appeared in November 1857. It said
that Hawkins was ''one of the first in the Union to use the
albumen process—now he uses the collodion.'' Possibly
Hawkins used the French, as opposed to Whipple's al-
bumen process for his early solographs; possibly, too, he
used the collodion method he had first tried in 1847.[188]
Whatever his methods were, Hawkins was, in Humphrey's
view, every bit the pioneer that Whipple was. On December
1, 1852, Humphrey proposed that the two get together for
the benefit of the entire profession:

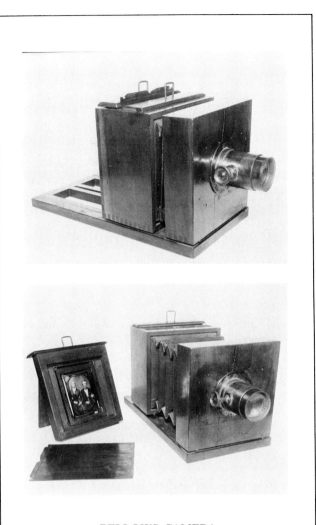

BELLOWS CAMERA

On November 11, 1851, William Lewis and two sons, William
H. and Henry J. Lewis, were awarded a patent for the first
commercially produced camera having an accordionlike bel-
lows, which made the camera collapsible and at the same time
helpful for copying work. A later version of the camera (simi-
lar to the original) is shown in closed condition (top) and
opened (bottom). The box was held opened at any desired dis-
tance with the aid of a thumbscrew. Although the patent speci-
fications show the plate holder as loading from the side, most
known models (including the camera above) loaded the plate
holder through a panel on the top of the rear (sliding) camera
section. The Lewis firm was located in Chatham Square in New
York in the late 1840s and evidently remained there at least
until the 1870s. But by April 1852, the firm had also es-
tablished a manufactory at New Windsor, New York (near
Newburgh), which became known as ''Daguerreville.''
Humphrey's Journal described the company at that time as
''the largest manufacturers of daguerreotype apparatus in the
world.'' The business included the manufacture of cameras,
camera stands, chemical boxes, chemical baths, headrests,
etc., all of which were stocked in what the *Journal* described as
the firm's ''extensive warehouse'' in New York (presumably at
the Chatham Square location).[189]

1852

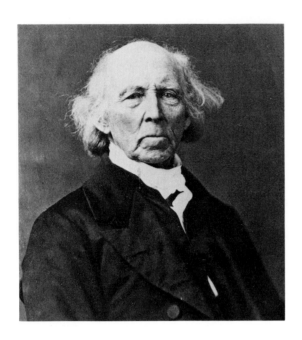

DAGUERREAN ASSOCIATION
GETS SCIENTIFIC FLAVOR

At its December 7, 1852, meeting, the New York State Daguerrean Association elected several scientific men to honorary membership, among them Prof. Chester Dewey (1784–1867) (above), who had been named first professor of chemistry and natural sciences at the founding of the University of Rochester in 1850. Dewey, a nationally known botanist, had previously served as principal of the high school in Rochester (afterwards known as the Collegiate Institute), where for several years his laboratory assistant was Charles A. Seely, founder (in 1852) of the *American Journal of Photography*. In 1839, when he was thirteen, Seely borrowed apparatus from Dewey to conduct his first experiments in photography.[190]

Whipple of Boston is still progressing in his paper and glass experimenting. Probably no two daguerreotypists do a greater amount of valuable service for the profession than this gentleman and Mr. Hawkins of Cincinnati. We are sorry to learn from one of these gentlemen, that he is not in correspondence with the other, for by their united exertions, good would result. Mr. Whipple—Mr. Hawkins—now you are acquainted, go on. You are both liberal minded men, and in union there is strength.[191]

1852 Three years later, Snelling sounded equally impressed, but he could not find Hawkins when he called on him in October 1855:

We called twice on Mr. Hawkins but did not see him, and as he had recently removed into his present establishment and appeared to be still unsettled, we had little opportunity of judging of his work. With the exception of a few daguerreotypes we saw nothing of which we can give a decidedly favorable opinion. We are sorry we did not see him, for he appears to stand high in public estimates, and we should have been pleased to have seen those results upon which his fame rests.[192]

P. C. Duchochois, another of Prevost's Parisian acquaintances who came to the United States in 1853, formed a partnership with Prevost in a gallery on Broadway north of Houston Street. There, according to Duchochois, Prevost "introduced the wax paper process in this country, and he and I together the albumen and collodion processes."[193] Presumably the albumen process was Niépce de Saint-Victor's. But it is questionable whether their practice of the collodion process preceded Brinckerhoff's, whose receipt of Archer's formula from Mayall in London must have occurred prior to Duchochois' arrival in New York in 1853. The two photographs by Brinckerhoff used as illustrations in this book (pages 11 and 108) can be dated approximately 1851–53, based on the known ages of the two subjects at the time the photographs were made. A profile of Brinckerhoff, published in 1881, said he was "among the first to exhibit, along with his daguerreotypes, proofs of photographs on paper made from collodion negatives, which led to his being employed in giving instructions to many daguerreotypists, who were flocking to the city for the purpose of acquiring a knowledge of the new art."[194]

Chemicals used in daguerreotyping, meanwhile, were taking their toll. Claudet warned of the "deleterious effects" of mercury vapors, and on May 1, 1852, this announcement appeared in *Humphrey's Journal:*

☞ A WARNING TO ALL.—Mr. GURNEY, of this city, has been confined to his bed by his system being charged with *mercury*—he has suffered the most accute pain, and been unable to move his limbs; his legs and arms have been swollen to nearly double the ordinary size, and his situation has been of the most perilous nature. We have known several instances of effects produced by mercury, but never before to such an extent. No operator can observe too much caution in being exposed to the vapors of this metal.

Frequently the question is asked "if there is not danger in operating in the Daguerreotype." We must say that the chief, if not the only danger, is in being so much exposed to the *mercury*. Many will say that its effect can be avoided by placing a flange with pipe conducting the vapor off, this plan is not complete in itself, as the metal in contact with the colder air is condensed and falls back, falling about the bath, and the consequence is, particularly in a close room, the atmosphere is charged, it is inhaled and in other ways penetrates the system. Few indeed are the instances where any marked influences have been given, but is it better not to have a *mercury room* very close.[195]

"For some time past," Claudet said almost a year later, "several operators have, to my knowledge, been obliged by advice of their physicians, to abandon daguerreotyping at least until they should become completely restored." [197]

Polycarpus von Schneidau, the Chicago daguerreotypist who is best remembered for taking the second earliest known likeness of Abraham Lincoln in 1854, became poisoned from his chemicals shortly thereafter and engaged in a long but losing war with death, which led him to return to Europe with his daughter in 1856 to seek medical help there. But in 1859 he gave up hope and returned to Chicago, a paralyzed man, where he died a few months later. [197]

Tantalizing evidence that the daguerreotype camera may have been used more extensively in landscape photography than is generally acknowledged today is to be found in a book which was published in 1852 in London (with an American edition) by the English authority Robert Hunt. Hunt's *Photography* gives this brief mention of what must have been a vast exploratory undertaking with a daguerreotype camera:

H. Whittemore, a gentleman who has traveled over most of the South, as well as North America, has probably made the most valuable collection of views ever produced in this country. His collection presents a map of paramount interest. I saw a single view of the falls of Niagara, which surpassed anything of the kind that has ever been presented before me; the harmony of the tone, the exquisite mellowness and faithful delineations, were unsurpassed, while the whole effect presented a charm rarely attending a daguerreotype view. Mr. W. produced his views with a common mirror reflector. [198]

Whittemore's camera suggests an enlarged variation of Wolcott's earlier mirror camera, which was confined to small images. Hunt said he was familiar with Robert Vance's large collection of views, but as they were of a single state only, he felt they were of less "general interest" than Whittemore's. And who was H. Whittemore? Evidently another "ghost" in American photographic history. His photographs are not known to have survived, and information about him is meager. In the same issue of *Humphrey's Journal* that told of Gurney's illness, we learn that "H. Whittemore [is] doing a fine business in South America." Seven months later, we learn he is in New York "much engaged in the stereoscope line." Humphrey then added this rejoinder: "Mr. W. is heartily welcome, but we fear that the great difference in customers of the two countries will not tend to increase his happiness with us." [199]

A move was afoot in the spring of 1852 to organize a national photographic society in the United States (such an organization was formed in England in January 1853), but the only brief mention of it appears at the end of an article by Snelling on a similar theme in which he expressed regret "that those who have the subject in charge are so dilatory in their movements." Snelling identified those in charge as a "committee" consisting of the two presidents of the two existing fraternal organizations, Augustus Morand and Martin M. Lawrence, and Henry Meade. Nothing further, however, was heard from this committee. Snelling's voice, as was so frequently the case during his journalistic career, was a lone cry in the wilderness where it concerned the need for true fraternal association among American photographers. It would not happen while he remained actively on

A COSTLY FIRE

On February 7, 1852, a fire destroyed the National Daguerrean Gallery in New York which had housed the collection of daguerreotypes made by Edward Anthony's firm in Washington in the early 1840s. Only a daguerreotype of ex-President John Quincy Adams was saved from the rubble. *Humphrey's Journal* gave this description of the tragedy:

There is not such another collection of the likenesses of our old Statesmen and distinguished individuals; and numbers of the subjects have long since departed from this world leaving no duplicate Daguerreotypes of themselves. At a time this was the most flourishing establishment of the kind in America. It was established about the first of the year 1843, under the management of Messrs. Anthony, Edwards & Chilton. Mr. Chilton, however, remained in the concern but a short time, and it was Anthony, Edwards & Co. Another change, it was Anthony, Clark & Co. Up to this time the greatest endeavors were made to obtain likenesses of the most distinguished citizens of America. We give one, as a single instance, of the exertions made by the enterprising proprietors to gather in this collection the great men of the world.—Mr. Anthony went from this city to the residence of *Gen. Andrew Jackson*, for the purpose of securing a likeness of the old hero before his death. Thus we see no expense of time or money was spared to accomplish the grand object. After the establishment had flourished for some time under the care of Anthony, Clark & Co., Mr. J. R. Clark, assumed the responsibility of the concern. Mr. Clarke remained here but a short time after, disposed of his interest to Mr. E. White; and although we feel that the gallery did not improve to any great extent under Mr. W., yet we cannot say that it depreciated in interest. This gentleman remained here two years and sold to W. & F. Langenheims, who made some valuable additions to the collection by their fine *Talbotypes, Hyaliotypes, or Pictures on Plate Glass*, and a number of well executed *pictures on ivory*.

We have followed the progress of the successive changes in this establishment up to about a year since, when Mr. Gavit purchased the entire gallery, and it has been his misfortune to loose it as before stated. There was no insurance, consequently the loss fell heavily upon the proprietor. [200]

the scene, but at no time did anyone hit the nail so squarely on the head as he did in this analysis of the drawbacks to new improvements or inventions caused by the secretiveness of individual operators, and the vast "humbug" mentality which seemed to pervade the ranks:

None dispute the superiority of American daguerreotypes over those of all other countries, but all are astonished that among so many excellent practical daguerreotypists as we possess in this country, none have made themselves a name as the discoverers of some improvement worthy of more than a passing notice.

There is not an improvement now in use among our artists at the present day, that enables them thus to excel, that did not first eminate from some European daguerrean, and that European a scientific man. The process of gilding, the use of chloride of iodine, bromine, and even the dry quick were first applied to the art either in France or England.

The various methods of making the latter pursued by our daguerreans cannot be called inventions ; they are mere modifications of the invention and are actually better only so far as they enable the lime to hold more permanently the bromine which it absorbs, for the same difficulties occur in their use which were prevalent before their adoption.

And why is it that Americans do not add to their reputation as inventors as well as manipulators in the art ? The answer is given in the remarks made to us a very short time since by one of our most succesful artists.

"Daguerreans in this country are not a scientific set of men ; they are merely imitators not researches."

This is, unfortunately too true. So many take it up only to use and abuse it that our really scientific men are actually ashamed to attempt experiments in it, or have it known that they are in any way engaged in it, for fear of being considered daguerreotypists.

There are, notwithstanding, many more engaged in the art who are its ornaments, and who command the respect of all classes ; but these too are deterred from making researches into its secret principles, or when they do and are successful, are deterred from making their discoveries public—to use the language of one of them—" because there are so many knaves who are constantly practising upon the credulity of the more simple that an announcement of a discovery by any connected with the art in this country is synonymous with " *humbug*" and that it is as much as a daguerreans reputation is worth to father an invention." In short it appears to be considered, now, by the daguerrean community, that discoveries and rascality go together.

Now, what is the remedy for this state of affairs ? We answer, well organized Photographic Associations, both National and State. From these associations can emanate all inventions and discoveries impressed with the seal of truth, and the designing men who suck so assiduously at the bunghole of credulity—to use a homely expression—will be deprived of their occupation, while the talented and simple minded but honest artists will be protected in their inventions, and secured against imposition.

We, therefore, beseech our artists to foster and sustain the NEW YORK STATE DAGUERREAN ASSOCIATION, as the only means through which to elevate the character of, and beget respect for, the art. [201]

Until 1853, American photography remained free of any major attempts to control or license the various facets of its practice. The Langenheim brothers, busy with experimentation in stereophotography and perfection of their "Hyalotypes" for magic lantern slides, made no attempt, for example, to assert broader claims for Talbot's patent in the United States, such as Talbot himself was proceeding to do in England. In Boston, John A. Whipple initiated then abandoned a controversial scheme to channel the production of crystalotype photographs through a "joint stock company" which was to consist of a limited number of dues-paying subscribers—a plan which was sanctioned by S. F. B. Morse and Edward Anthony, but was attacked as "worse than the Talbot monopoly" by *Humphrey's Journal*. "Now what would be the result of such a company?" Humphrey asked. "Would it not have a tendency to build up a monopoly, and drive our worthy and enterprising operators from the field of honorable competition, by presenting a barrier to intimidate many from taking hold of *any process?*"

But worried as he was about a monopoly, Humphrey had no idea what was in store for the profession when he published this brief notice on October 1:

Cutting and Rehn are giving instruction in taking paper pictures in this city. Of their process we know nothing.[202]

The item referred to James A. Cutting of Boston, and Isaac Rehn of Philadelphia. Within a year, Cutting and Rehn would be awarded a United States patent which would give them, in effect, a monopoly on the entire practice of collodion photography in the United States. Talbot endeavored to do the same through extension of his calotype patent in Britain. But within two years, his battle would be lost; while in America, the war with Cutting and his agents would drag on for fourteen years.

There appears to have been a general confusion at this time as to what processes were being tried in the various paper photography experiments at a number of galleries. The previous year, Humphrey, for example, had made the comment that a Dr. Canfield of Pennsylvania, Whipple in Boston, and a Mr. Holt of New York were making "very fine calotypes." In Whipple's case, of course, he was making crystalotypes, not calotypes. Again, when Jeremiah Gurney referred to his paper prints as "Mezzographs," Humphrey remarked: "How much easier it would be to say calotypes." For a time, the word *calotype* was probably applied by many others to any and all methods of securing a photograph on paper—whether from a paper negative (i.e. the calotype method) or from a glass negative (albumen or collodion).

Humphrey's attack on the joint stock company plan was made in April. On June 15 he reported in his journal that Whipple "disclaims all connection with the great scheme of the *paper monopoly concern*," and said Whipple planned to dispose of his crystalotype process "at such prices as to be within the reach of almost everyone." Actually, Whipple

JOINT STOCK COMPANY PROPOSAL

H. H. Snelling published this description of Whipple's proposal for channeling production of crystalotypes through an organization having a limited number of dues-paying subscribers, and said "we cordially recommend his plan to our readers."

The Stock of the Company will be represented by 100 shares at $250 each—it will go into operation as a Manufacturing, rather than a Patent Right Company; that is, its object will be to manufacture pictures, and dispose of the same by means of Agents, rather than to sell rights to individuals to manufacture their own. The object of this is, to control the manufacture in order that the character and prices of the pictures issued may be sustained, and also enable the Company to make exclusive contracts with parties for special purposes; it is also intended that no parties shall be engaged in the manufacture or sale of Crystalotypes except Stockholders.

The holding of one share by a Photographer will entitle him to the dividends on the same—the agency for the Public Pictures of the Company, and the privilege of having his customer's daguerreotype copied—but a knowledge of the process, instruction in the same, and the right to practise the art, will involve the purchase and holding of a second share by the same person, together with the giving of bonds neither to teach the Art or impart the secret to others,—in other words, the charge to any one party, for the right to execute pictures for their retail customers, will be $500.

As the company will provide, upon an extensive scale, everything necessary to produce good pictures at the lowest possible cost, it must, as a general rule, be for the interest of all photographists to send their daguerreotype to the company's manufactory to be copied in preference to being at the expense of a full right—the sale of the published pictures of the company (public men, views, &c.) and of their customer's crystalotypes will give a good business of itself, while the dividends upon the shares held will in time pay for them.

The number of shares will be but one hundred; and it is proposed that the operatives, Trustees, &c., shall all be stockholders, and there is already a call for crystalotypists to go abroad on account of pictorial magazines; and as there is a large extent of territory to cover, the sale of rights must necessarily be limited to one in each place, immediate application should be made by those who desire to secure them.

The following gentlemen have been named as Trustees:—

CALEB S. WOODHULL,)
S. F. B. MORSE, } Trustees.
ED'W. ANTHONY.) [203]

WHIPPLE'S PROCESS

During the 1850s, the collodion "wet-plate" photography process, then in its infancy, was given more competition than has perhaps been recognized by the albumen negative process patented in 1850 by John A. Whipple and his partner, W. B. Jones. Although numerous collodion process methods were published, Whipple's never was, and about 1853 he sold the rights to James E. McClees for Philadelphia for $250. The process was further perfected by the McClees firm (McClees & Germon), principally through the efforts of an employee, Charles Ehrmann (who later headed the Chautauqua University School of Photography at Chautauqua, New York). In 1855, McClees won a premium at a photography exhibition in Paris for a panoramic view of Niagara Falls made by Whipple's process on five plates, each 16 x 22 inches; and after that, through the McClees firm, the process spread to Europe as well as the United States. In 1856, a Liverpool photographic journal observed: "Whipple's process seems to be in great favor with the Liverpool photographers." In 1858, the first full-scale photography manual published in the United States for amateurs devoted itself principally to the merits of Whipple's process for outdoor use. In 1885, Ehrmann gave what may be the only recorded description in a lecture to members of the photographic section of the American Institute:

> The process is similar to Nièpce's, but greatly modified and improved. I will describe it to you in all its details as far as my memory serves me:
>
> | Iodide of potassium | 3 drams |
> | Bromide of potassium | 30 grains |
> | Chloride of sodium | 10 grains |
>
> were dissolved in 2 ounces of water and added to a mixture of 8 ounces of albumen, from which the germ had been carefully removed, and 7 ounces of pure liquid honey.
>
> Crystallized honey never answered as well when directly taken from the comb. In course of time the proportion of bromide was increased, by which a more rapid action was believed to take place. The addition of the chloride served to give better details in foliage when taking landscapes. . . .
>
> The mixture is beaten into a stiff froth, allowed to settle, and strained through flannel. The plates are coated in a similar manner as with collodion, but as with albumen a sudden evaporation does not take place; by returning the liquid from edge to edge repeatedly, or by spinning the plate around, a perfectly even coating can be effected. The plate is then laid down flat, another one coated, and so forth, until the required number is on hand. The plates having been coated have first become sticky in the meantime and are ready to be dried.
>
> We used to dry over an alcohol lamp, repeating the operation three to four times, or until the film, when still warm, did not adhere to the finger when touched.
>
> The most difficult and also the most important part was silvering the plate, so that the film comes from the bath without having been injured. The bath:
>
> | Nitrate of silver | 6 ounces |
> | Acetic acid No. 8 | from 6 to 8 ounces |
> | Water | 60 ounces |
>
> previously iodized, as we do with a bath for collodion plates. The dried plate, yet warm, somewhat higher than the temperature of the bath, is now dipped for about one minute, during which time it is constantly moved about. After the plate is taken from the bath it is slightly washed if to be used immediately; if to be kept for future use (the plates keep well for six or eight weeks), a more perfect washing is necessary, in fact, all the silver should be washed away. Many difficulties arose at times when plates were sensitized; the film washed off in flakes; not acid enough in the bath; the plate too cold, or the glass not clean. The film cracked all over the plate in forms of lines of different thicknesses when the plate is too hot, or blistered and puckered when a crystalline honey is used, *or the glass is not*

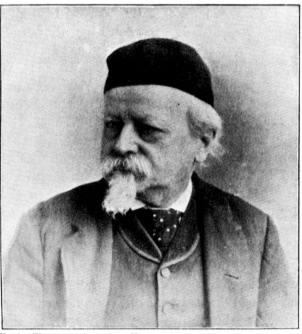

Charles Ehrmann, circa 1890. He was given a salary raise and a new suit of clothes after perfecting improvements in Whipple's process at the McClees firm in Philadelphia, about 1853.

> *clean.* Air bubbles made comet-like spots; dust on the plate, pinholes; in fact, troubles arose as we have seen in all processes afterwards. After the plate had been washed it was ready for exposure; when still wet it worked much quicker than when dry. At the time the process was in use daguerreotypy was at its height, and a daguerreotype could be made much more rapid than an albumen negative. When a paper photograph was wanted we made a daguerreotype first, and copied it, reversing the original. For reproductions, for out-door work, for photographing inanimate objects, the process, although slow, worked well.
>
> The developing of crystallotype plates is not easier or more difficult than with other processes. Gallic acid in saturated solution, occasionally increasing the strength with an alcoholic solution and a trace of nitrate of silver, developed a correctly exposed plate in a short time. With over or under exposures, however, a careful watching of the development for two hours and more was often necessary. We regulated the process then by weakening or strengthening the gallic acid solution and adding more or less silver to it. As we developed upon those level stands used for gilding daguerreotypes, we often applied the flames of an alcoholic lamp to accelerate the process in parts holding back. We fixed in hypo. With our little knowledge, and less experience, and from the fact that these plates do not resemble in appearance either emulsion or collodion plates, being semi-transparent, we actually at first did not know whether a plate was fixed or not. We took it for granted that five minutes were sufficient.
>
> The greatest blunders were committed with washing the plates; had we done so properly no doubt our negatives would have kept for thirty years, which, however, they did not. Although it does not properly belong here, let me describe how we printed them. We salted the plain paper, silvered with ammonia nitrate, and fixed with plain hypo, saturated with chloride of silver, gold, and before that chloride of platinum came later. Washing the prints left a great deal to desire.
>
> In course of time the process was improved and we made pictures quite rapidly, fluorides, even cyanides were added, and the proportions altered, till finally it had to succumb to collodion.[204]

told Snelling a week later that a Mr. Brigham had been trying to make arrangements to form the stock company, but that he had "failed to comply with my terms within the time specified." Four months later, Whipple issued the following announcement, which appeared in *Humphrey's Journal:*

Having now so far perfected my crystalotype process as to render it eminently practical for a great variety of purposes, I am now prepared to dispose of it to Daguerreotypists and others who may wish to practice (with the exception of New England and Philadelphia) for the sum of fifty dollars for a right, and fifty more for instructions. In fixing upon a price for this I have wished to consult the interest of the art, and daguerreotypists generally, as well as my own, and I take this method of putting it before the public so as to remunerate myself in some measure for the large outlay of time and money it has cost me, and hope it will meet the wishes of all.[205]

The rights to the practice of the crystalotype in New England were sold to Marcus Ormsbee, and a year later Humphrey reported that Ormsbee "was in a strife with Whipple to excel him in producing the finest crystalotypes." Full rights to the practice in Philadelphia were sold to James E. McClees for $250.[206]

At this point, the young German immigrant, Carl, now "Charles," Ehrmann, who had arrived in Philadelphia sometime after fleeing Germany in 1848, came into the picture. Having acquired the rights to Whipple's process, McClees and his partner, W. L. Germon, immediately experienced difficulty in making crystalotypes, and evidently imparted this fact to Ehrmann, who was a prescription clerk in their local drugstore. Years later Ehrmann recounted his introduction to McClees, the nature of the problems the firm was having, and what he did to help solve them:

"I met McClees, was introduced to him, and he asked me if I knew anything about chemistry. I answered modestly, yes, to some extent. Then Mr. McClees spoke to me about coming to his photographic department to undertake to make pictures by the Whipple process. The greatest difficulty that all my predecessors and my employers had in the preparation of albumen plates was, that they could not coat the glass plate uniformly, and here came to my rescue an experience that I had gained with working in a pharmaceutical laboratory, viz.: In order to prepare for the market citrate of iron and ammonia, we coated large glass plates with a solution of the substance reduced to a certain concentration, and when dried scraped that off. The coating of a plate with albumen mixture appeared to me at once to be analogous to that of coating a glass plate with the iron solution, and when I first took hold of the matter I was perfectly successful. We had clean plates, uniformly coated, and they developed evenly all over. The albumen plates did not work with sufficient rapidity to take portraits directly, but in order to circumvent this difficulty, we took daguerreotypes first, of the person that wanted a talbotype, or a photograph, and copied that afterward upon an albumen plate. At one time there came a big order for six quarter size

The crystalotype rated equal billing with the daguerreotype among photographic processes used at the McClees & Germon firm in Philadelphia, as this circa 1854 advertising leaflet reveals. Lesser known today (because of the scarcity of their identified works), James E. McClees and Washington L. Germon enjoyed a prominence in Philadelphia equal to that of their Boston contemporaries, Albert S. Southworth and Josiah J. Hawes.

daguerreotypes to be enlarged to 11 x 14 size, to be colored and framed, which amounted to several hundred dollars. The following Sunday I went to the atelier and undertook the job on my own responsibility. I was successful with my first attempt, with the second, with the third, and up to the last. I printed from my negatives good prints in our estimation then, and Mr. McClees, when he saw my work, was so highly delighted with the result, that he raised my salary—which was originally $5 a week—to $15, and gave me a new suit of clothes and a hat.

"The albumen honey process was not accepted as readily as might have been expected, although extremely fine work had been done upon plates of that description. As the photographic business proper was not extensive

THE SAGA OF THE NEW YORK CRYSTAL PALACE, 1853–1858

Inspired by the Crystal Palace in London, the New York Crystal Palace was built for America's first World's Fair in 1853, and was officially opened by President Franklin Pierce on July 14 of that year. It stood in what is now Bryant Park, adjacent to the massive Croton Reservoir (partially shown in background) which was replaced after 1900 by the present New York Public Library. Daguerreotypes predominated in the photography competi-

enough to employ one man constantly, I was often relegated to the daguerreotype room. I learned daguerreotyping so that I was able to make a good daguerreotype, and if I had the opportunity to do so, could do it at the present day.[207]

Whipple's sale of crystalotype rights to McClees probably took place in the summer of 1853 (based on the fact that Whipple's offer to sell the process to others outside of Philadelphia and New England was made in September). Ehrmann's improvements were presumably made in the fall, as the McClees & Germon firm was awarded a premium for both the colored crystalotypes and Talbotypes which they exhibited at the annual fair of the Franklin Institute, held in December.[208]

It appears, too, that Whipple took up the collodion process probably at the time he determined to abandon organizing the joint stock company (May or June). Whipple's activities were not recorded in American photographic literature; however, the English photographer and writer

1853

100

John Werge visited Boston in June 1853 and left this account which reveals that by that time the crystalotype had gone collodion:

At Mr. Whipple's gallery, in Washington Street, a dual photography was carried on, for he made both Daguerreotypes and what he called "crystallotypes," which were simply plain silver prints obtained from collodion negatives. Mr. Whipple was the first American photographer who saw the great commercial advantages of the collodion process over the Daguerreotype, and he grafted it on the elder branch of photography almost as soon as it was introduced. Indeed, Mr. Whipple's establishment may be considered the very cradle of American photography as far as collodion negatives and silver prints are concerned, for he was the very first to take hold of it with spirit, and as early as 1853 he was doing a large business in photographs, and teaching the art to others. Although I had taken collodion negatives in England with Mawson's collodion in 1852, I paid Mr. Whipple fifty dollars to be shown how he made his collodion, silver bath, developer, printing, &c., &c., for which purpose he handed me over to his active and intelligent assistant and newly-made partner, Mr. Black.[209]

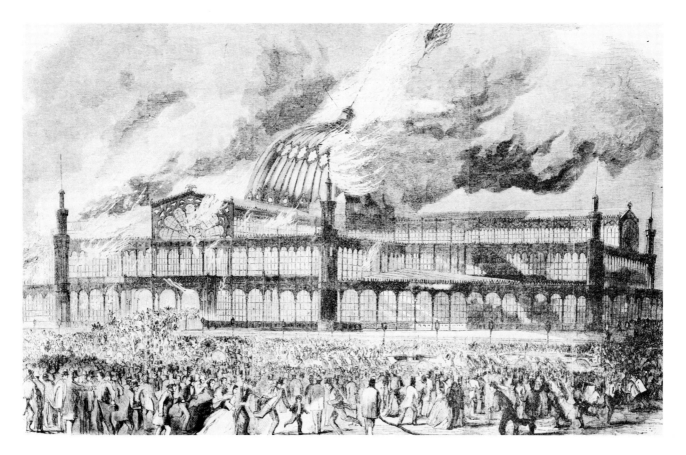

tion at the 1853 fair, as in previous years, but for the first time the top award was captured for photographs made on paper from glass negatives. These were crystalotype prints made from albumen glass negatives by the patentee of the process John A. Whipple, of Boston. Reputedly fireproof, the New York Palace was constructed of glass and iron, but contained wood and other combustible materials in the interior. On October 5, 1858, it caught fire and was destroyed in fifteen minutes' time, burying in its ruins the rich collection of the American Institute Fair of that year. No photographs of the Palace are known to exist.

Despite all of the new activity in paper photography, the daguerreotype continued to be "the fashion" in portraiture. During the summer of 1853, the New York *Tribune* counted "upward of a hundred daguerrean establishments" in New York and Brooklyn, "giving direct employment to about 250 men, women and boys." With respect to the country as a whole, the paper said "it is estimated that there cannot be less than three million daguerreotypes taken annually."[210] Probably for about the last time, the daguerreotype camera was used to record views in New York City which were then copied as engravings and used to illustrate an article, "New York Daguerreotyped," published in *Putnam's Monthly Magazine* in February. Once again the question can be asked, What happened to the daguerreotypes? The answer, probably, was that they were left with the engravers to be later destroyed or discarded. Up until this time, lithography served as the principal medium for recording city and landscape views sold to the public, or used for book or magazine illustration. But competition was on the way; in 1855, for example, McClees and Germon made large photo-

graphic prints of a whole series of Philadelphia's most prominent buildings and favorite scenes, which were made available commercially.[211]

Frederick DeBourg Richards, in a review of the December Franklin Institute fair, said he was "sorry to say" that "a couple of the 25-cent fraternity" had placed exhibits at the event. This was the first year, apparently, that these "cheap workers," as Bogardus termed them, appeared on the scene in force. Probably as the size of their number grew, there was a corresponding decline in attempts to counteract their commercial viability. The New York State Daguerrean Association, which had been organized principally by photographers interested in maintaining a higher price level, had a membership of only sixty by the summer of 1853, only a quarter of which had paid their dues. Marcelia Barnes, of Salem, New York, was the sole person who showed up at a Daguerrean association meeting set at Utica in October. Bogardus evidently took "the 25-cent fraternity," as Richards called them, in his stride:

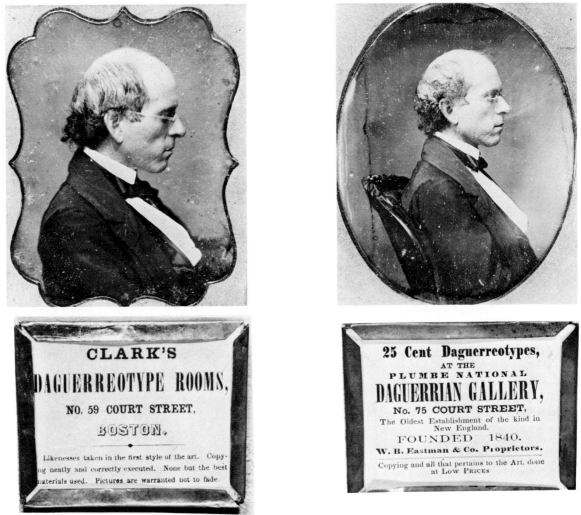

DAGUERREOTYPE SHOPPING

The unidentified man above appears to have patronized two Boston studios on the same day, paying 25 cents for one ninth-plate likeness, and presumably 25 cents for the other. Both were kept with the respective photographer's card behind each image.

I once had a hearty laugh in visiting a 25-cent gallery. The ninth size picture was made and inserted in a cheap case for that sum. Sitters paid their money at the desk and received a numbered check. In the skylights the operator and assistant stood one at the camera and the other at the head rest; and that interesting accessory was jammed against the head of No. 13 as soon as he touched the chair, the plate exposed, and he was ordered to step out and number 14 called. The so-called picture was delivered to him in the next room, and if he had any complaints to make he was told to buy another ticket and go through again. [212]

But Alexander Hesler felt there was more to low-price pictures than just quackery; in fact, he thought it was a good thing for the future of photography:

1853

102

As I look upon it, there is a great responsibility resting upon the leading members of the art, and if they would see the art improve, they must put their shoulders to the work. But, some will say, "I do work to sell all the pictures I can, and make all the money I can, and this is my duty. I paid for learning what I know and if others get it they must pay me, and besides, if I give all my experience and research to others, they will stand an equal chance with me and may get some of my business." Ah!, this is the sticking point, and the very feeling that keeps the art down, and that has brought so much shame and reproach upon it.

It is not the dollar, or fifty-cent, or 25-cent pictures that have done it, for there will be quacks in all professions, do what you may, and, I think in this case, the low-price pictures have done much good in many ways. It has brought the art and its influence within the reach of all classes, and thousands and tens of thousands have had daguerreotypes taken at the low prices that would never have thought of it at higher prices, and what has been the result? When a person has got a low price picture and worth only the first price of the material used in its manufacture, this person compares with others better and worth something. Now, will he be satisfied with the poor one, when he can get a better at a higher price? Certainly not, his taste for the beautiful is aroused and he will not be satisfied until he has the best the art will give him, cost what it may . . .[213]

1854

"Stereoscopic pictures are sold in Paris and London by the thousands, and it is time they were better appreciated in America." So wrote Henry Meade to H. H. Snelling, while traveling in Europe in the summer of 1854.[214] Photography's great nineteenth-century bonanza had begun in Europe, but it would be another four years before the double-image picture craze would strike the United States.

A small lenticular stereoscope for convenient viewing of stereoscopic pictures had been invented as early as 1849 by Sir David Brewster. It was a small box in which two similar photographs, mounted side by side, could be viewed (magnified) through a pair of eye pieces. The device attracted considerable attention at the 1851 Crystal Palace exhibition, and largely as a result of Queen Victoria's interest in it, nearly a quarter of a million of the stereoscopes were sold in the ensuing months. At this time, too, patented daguerreotype miniature cases were on the market—one manufactured in Philadelphia by John F. Mascher, another produced in London by Antoine Claudet—which contained folding eyepieces for viewing two similar images placed opposite one another in the two folds of the case.

There are few records which give any indication of the extent to which stereoscopic photographs were produced in the United States during the period 1850–54. One man who appears to have played a major role was Otis T. Peters, about whom little is now known. According to Snelling, Peters introduced the stereoscope in New York just prior to October 1852, after which Brady, Gurney, and Beckers & Piard followed by offering the same or similar type of product three to four weeks later. Peters died February 10, 1862, at the age of fifty-two, and from an obituary by Prof. Charles Seely, published in his *American Journal of Photography,* we are given this additional, albeit small, bit of information:

> As soon as the stereoscope was brought to this country, Mr. Peters took it up as a specialty. His gallery at 394 Broadway, previous to 1856, was the headquarters of the business for many years; it was the only place where stereoscopic portraits were correctly made. Mr. Peters also made most of the stereo-daguerreotypes which were sold by opticians about the country or exhibited as philosophical curiosities.

Peters lacked "business tact and ambition," according to Seely, and but for the want of these "might have been eminently successful." He retired from his photographic business about 1856, and thereafter engaged in a variety of manufacturing "speculations" in which he was "only moderately successful." At the time of his death he was manufacturing hoop skirts.[215]

When a Detroit newspaper editor examined paired daguerreotype images through a stereoscope in George P. Henson's gallery in January 1853, he thought that "this curious instrument" was so great that Congress should appropriate funds for a national gallery of some sort where people could view portraits of American heroes and statesmen by stereoscopic means.[216] But it was "the great en-couragement this special kind of pictures had found in Europe" that prompted the Langenheim brothers to be the first to undertake large-scale production of stereoscopic photographs. In a letter to Snelling dated September 19, Frederick Langenheim said he was "confident that the American public will patronize this branch of the Photographic Art, in a similar degree as the European public, as soon as the results are brought before them in a presentable shape, and at reasonable prices." Langenheim also said he thought American photographers "have not paid the attention to the subject it richly deserves."[217] By the end of the year, the Langenheims were making both glass stereographs (another version of their hyalotype glass photographs) and card stereographs.

Prior to this time, all stereoscopic pictures on glass had been imported from Europe, principally from France. But over the next several years the Langenheims enjoyed moderate success with their American-made glass specimens. What form of stereoscope was adopted for viewing them does not appear to be recorded, but presumably it was of the lenticular variety. That the means of viewing may have been a drawback to sales of the glass slides can be surmised from the experience encountered by Beckers and Piard when exhibiting the first three dozen slides sent by the Langenheims to their New York gallery. Twelve were broken at the exhibit, causing Beckers to toy with ideas for the design of a new type of stereoscope which would "show and secure the pictures against breakage." Within four years he secured a patent for a revolving stereoscope design, and in 1858 he abandoned his photography business in order to manufacture stereoscopes exclusively.[218]

In 1854, the London Stereoscopic Company was established to market Sir David Brewster's lenticular stereoscope and card stereographs (mostly of views secured by company photographers, not only in England but in other European countries and, after 1858, in the United States). This marked the real beginning of the stereophotography revolution. By 1858, when the card stereograph "took on" in the United States, the British concern had already compiled a stock of over 100,000 different views of famous buildings and scenic points of interest all over Great Britain, on the continent, and in the Middle East.

Up until this time, stereoscopic pictures could be secured either with two single-lens cameras positioned a few feet apart from one another, and both pointed in the direction of the object (or person) being photographed, or with one single-lens camera equipped with a rear sliding plate holder which allowed the subject to be photographed twice, the resultant images appearing side by side. During the period 1854–60, the single-lens camera was gradually replaced by the binocular, or twin-lens, camera, which made it possible to take two pictures of the same object simultaneously. The distance between the double lenses of these new cameras was about the same as that between the pupils of the eyes (or about 2½ inches). The lenses were of short focus, which

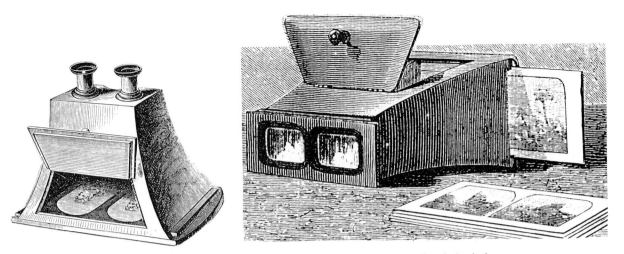

In 1849, Sir David Brewster (1781–1868), the English scientist and inventor, developed a lenticular stereoscope for viewing magnified images of two similar illustrations side by side. At first unsuccessful, the Brewster device was modified by a Parisian optician to include a lid which could be opened for improved lighting of the images. This model (above left) was placed on the market in 1851 and sold rapidly. A simplified Brewster stereoscope, minus the eyepieces (above right), was introduced later after the market for card stereographs took on sizeable proportions.[219]

gave sharp pictures at almost open aperture, and this, combined with the use of faster-acting collodion negatives, made it possible to make exposures in as little as half a second. Thus, the world's first truly "instantaneous," or candid, photographs soon began to appear in card stereograph form.[220]

The first binocular camera appeared in Great Britain in 1852, but its developer, John Benjamin Dancer, did not place it in full production for several years. A French model, developed by A. Quinet of Paris, appeared in 1853, and in 1854, Silas A. Holmes, of New York, patented a double camera which could make simultaneous exposures on two separate plate holders. Holmes's patent specified use of the camera for stereophotography and "other purposes," but it was used principally for the latter.

Talbot's endeavors to extend his calotype patent to the practice of collodion photography, meanwhile, delayed widespread adoption of paper photography not only in England but to some extent in the United States as well. In May, Brewster and Herschel signed affidavits in Talbot's behalf, and after these were printed in full in *Humphrey's Journal,* Humphrey disclosed that there was "some little excitement among our photographers in regard to the Talbot patent," adding: "We may not look for a full advancement of photography in America while things are in this state." But while the storm clouds of a long American patent war gathered on the horizon, Talbot's claims were challenged in the British press, then were rebuffed entirely by a British court in December. "The decision settles the question in this country as well as in England," Snelling said after the court victory, "and we hope our readers will no longer pay attention to the threats of speculators, but enter boldly and energetically into the photographic processes. No court in this country will attempt to enforce the patent here (it still had several months to run) after the decision we now record, and we expect to see a very decided progress made

in all the paper and glass processes during the present [1855] year."[221]

One of the myriad problems encountered in adopting a paper photography process was the simple determination of what paper, among the variety offered, was most suitable for a photographer's particular purpose. Photographic paper was supplied principally by four English manufacturers (Turner, Whatman, Nash, and Towgood), and three French suppliers (Canson Brothers, Marion, and Lacroix). For waxed-paper process work, for example, Gustave Le Gray recommended thin Whatman paper (slightly glazed) for portraiture, but a thicker version for use in making views of landscapes and monuments.[222] Humphrey was particularly unhappy with Turner's paper, but at the same time said he felt that none of the manufacturers was giving photography the attention it deserved:

There is great difficulty in procuring good paper of Turner's make; he having lately undertaken a contract for Government in making paper for the new stamps, the manufacture of paper for photographic purposes has been to him of little importance. In fact, this observation—of the little importance of photographic compared to other papers—applies to all our great paper makers, who have it in their power to make a suitable article. . . . All manufacturers, in order to please the eye, use bleaching materials, which deteriorate the paper chemically. They should be thoroughly impressed with the truth, that color is of little consequence. A bad colored paper is of no importance; it is the extraneous substances in the paper itself which do the mischief.[223]

A British correspondent expressed himself as equally disenchanted with the Turner paper two months later: "For every sheet that has turned out well," he said, "at least half a dozen have proved useless from spottiness, and some sheets do not take the iodizing solution evenly, from an apparent want of uniformity in the texture of the paper."[224]

Philip Henry Delamotte, a London Stereoscopic Company photographer and author, whose book, *The Practice of*

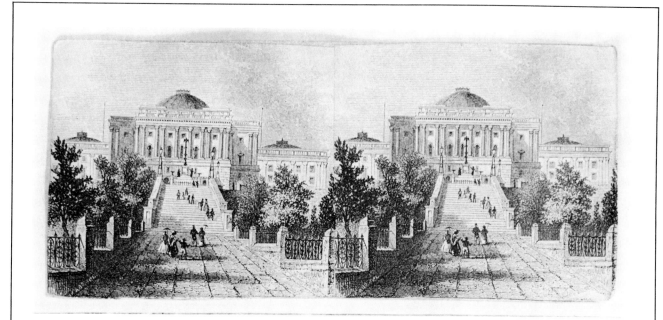

CARD STEREOGRAPHS

The first stereoscopes, such as Sir David Brewster's lenticular model (left), were used for viewing artist renderings, engravings, etc., before actual photographic prints were substituted on the card mounts. The stereoview (above) was probably prepared by cutting out two similar illustrations from two of the same issues of a newspaper or journal (cira 1850–54). These were pasted side by side on the same mount for viewing stereoscopically. In 1854, Frederick and William Langenheim introduced the first major American card stereograph series with copyrighted photographs, entitled "American Stereoscopic Views," taken on a journey from Philadelphia along the southern route of the Reading, Catawissa, Williamsport, and Elmira Railroad to Niagara Falls. More than twenty subscribers backed the photographic venture, then signed an advertisement published in the Philadelphia *Public Ledger* (in December 1855) certifying as to their complete satisfaction with the results. The example (below) from the Langenheim series is of the interior of a covered bridge which traversed the Niagara River at the time.

Entered according to Act of Congress in the year 1854 by F. Langenheim in the Clerks office of the district Court for the Eastern district of Pennsylvania

1854

This view of the Columbia College building, which stood from 1790 to 1857 in lower Manhattan, has been reproduced from one of several calotypes of the building made by Victor Prevost in the period 1854–55. Prevost used waxed paper negatives (the Le Gray calotype process) to make photographs in New York, and today his are the earliest known photographs of the city to survive.

Photography (Humphrey defined ''Photography'' as meaning paper and glass processes), was published in an American edition in 1854, identified these differences between the quality of the English and French papers:

> The difference in their quality appears to consist in this—the English papers are hard and dense, owing to their being sized with gelatine, or resin soap, consequently the sensitive preparation does not so readily penetrate its substance, but remains more on the surface; they are, therefore, best fitted for positive proofs. The French papers on the contrary are generally sized with starch, with which iodine enters eagerly into combination; they are usually thinner and lighter, and consequently better adapted for negatives; but both English and French papers are prepared for positives and negatives; and the photographer can select either without any reserve; only with this precaution, let him avoid using different papers as much as possible, for the difference in their manufacture causes them to be equally affected under the same treatment. If bought of an honorable dealer in apparatus, etc., there is little fear of an unsuitable material being offered for sale. All the success of manipulation may rest upon the quality of the paper.[225]

1854

106 Snelling thought ''the superiority of paper photographs as illustrations, the rapidity with which they can be multiplied, their distinctness, and the great number of purposes to which they are applicable must cause them, in a great measure, to supersede the daguerreotype; and not only daguerreotypes, but lithographs.''

Seventeen years later, when he reread these remarks, he considered them so much hogwash. Paper photographs made in 1854 were ''a poor, miserable, deformed infant,'' he said. He characterized them further in these unflattering words:

> Take the landscape—not a negative could be shown that was not faulty in every particular. The defects of the lenses produced aberration in every part of the picture; not a line nor an object true to nature or art, and everything that had life was marred by a want of distinctness in outline, while the foliage was more or less characterized by fuzziness, more resembling tufts of cottonwood than leaves.
>
> The print, of course, partook of all these defects and exhibited many more peculiar to itself; its general characteristics being want of clearness, no uniformity of detail, no softness, no delicate contrasts of light and shade. It reminded one of the first attempts at lithography, or mezzotint engraving, and the crude drawings of the savage.
>
> Portraiture was still worse—masses of muddy shadows and dusky middle tints, and chalky highlights—the eyes looking like two whortleberries in a bowl of milk.[226]

Snelling was referring, of course, to American-made photographic prints of this period; but as early as 1850, a new photographic paper became available in Europe which, although slow in being adopted by American photographers, gave prints of greater luster and life. This was albumen paper, introduced in France by Blanquart-Evrard. Once again egg white was used as a coating for paper, as it was already being used as a coating for glass negatives. The albumen (mixed with the conventional "salting" solution) filled the pores of the paper, causing pictures printed on it to appear more *on* the surface, as opposed to *sunken into* the paper, which was a characteristic of prints secured on plain paper. The photographic literature of this period does not record to what extent albumen paper was adopted by American photographers in the 1850s, but few American-made prints of this period will be found today on albumen paper; and at least one authority, John Werge, has asserted that up to 1860, American photographic prints "were all on plain paper." There were problems enough, it seems, in working the new albumen or collodion negative processes—each man separately perfecting his own particular methods and procedures—without taking on the additional complications (and costs) involved in preparing albumenized paper. Few modes for preparing albumen paper were published in American journals at all, and those that were were taken from foreign publications.[227]

In such a time of secrecy and "no admittance" signs on photographers' darkrooms, it was perhaps easier for James A. Cutting to obtain the several patents he did in July 1854, covering, first, a *particular* method of making ambrotype photographs, but more importantly the use of bromide of potassium *in combination with collodion* to prepare collodion negatives. The use of bromine was a technique previously known and used on both sides of the Atlantic, but documenting the proof was another matter. The Commissioner of Patents found certain early references, but Cutting—benefiting from the total absence of any other protesting voices—convinced him otherwise. Fourteen years later, another Commissioner of Patents would admit that the patent should never have been granted in the first place. When the full text of the patent was published in *Humphrey's Journal*, there were no voices of protest raised—probably because there had never been a patent problem in the United States before and the fragmented nature of the photographic profession caused few to take the matter very seriously. The protests would come later, but in the meantime, Humphrey candidly sized up the situation—and even named names—in this essay criticizing both the "secrecy" of American operators, and the propensity for some to "appropriate" foreign processes for domestic license:

> We do not mean to be understood as being opposed to a strife for the greatest perfection in practice, for we look upon a desire to excel as a most worthy ambition. What we would complain of is, a number of our American photographers are in the habit of taking European experiments and appropriating their results to their own personal benefit, and not even giving in return an acknowledgment. There is no wonder that the foreigner looks upon us as being "a selfish, grasping people."

ALBUMEN PAPER

Invented in 1850, albumen paper was little used in the United States prior to 1860. This procedure for making it, suggested by a British photographer, George Shadbolt, was published in Snelling's journal in New York in December 1853:

To prepare the Albumen —Take the white of *one egg*; this dissolve in one ounce of distilled water, two grains of chloride of sodium (common salt,) and two grains of *grape* sugar; mix with the egg, whip the whole to a froth, and allow it to stand until it again liquifies. The object of this operation is to thoroughly incorporate the ingredients, and render the whole as homogeneous as possible.

A variety in the resulting tone is produced by using ten grains of sugar of milk instead of the grape sugar.

The albumen mixture is then laid on to the paper by means of a flat camel's hair brush, about three inches broad, the mixture being first poured into a cheese plate, or other flat vessel, and all froth and bubbles carefully removed from the surface. Four longitudinal strokes with such a brush, if properly done, will cover the whole half-sheet of paper with an even thin film; but in case there are any lines formed, the brush may be passed very lightly over it again in a direction at right angles to the preceding. The papers should then be allowed to remain on a perfectly level surface until nearly dry, when they may be suspended for a few minutes before the fire, to complete the operation. In this condition the glass is but moderate, and as is generally used; but if, after the first drying before the fire, the papers are again subjected to precisely the same process, the negative paper will shine like polished glass. That is coated again with the albumenizing mixture, and dried as before.

One egg, with the ounce of water, &c., is enough to cover five half-sheets with two layers, or five whole sheets with one.

I rarely iron my papers, I do not find any advantage therein, because the moment the silver solution is applied the albumen becomes coagulated, and I cannot discover the slightest difference in the final result, except that when the papers are ironed I sometimes find flaws and spots occur from some carelessness in the ironing process.

If the albumenized paper is intended to be kept for any *long* time before use, the ironing may be useful as a protection against moisture, provided the *iron be sufficiently hot;* but the temperature ought to be considerable.[228]

1854

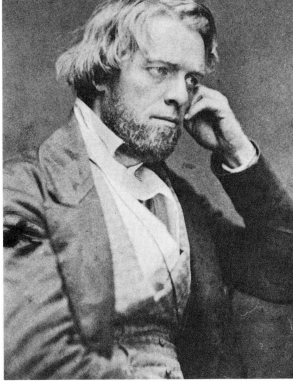

Charles C. Harrison, circa 1852. From an early collodion photograph by J. DeWitt Brinckerhoff.

NEW YORK RAILROAD DEPOT AND PHOTOGRAPHIC SUPPLIES CENTER

This massive railroad depot and manufacturing center stood until at least the 1880s in what is now the complex of city, state, and federal court buildings in lower Manhattan. Edward Anthony's manufacturing operations were housed in the section to the left, while those of Charles C. Harrison, shown left, occupied one of the upper stories to the right. Harrison "commenced in a small way," according to S. D. Humphrey, "being limited in means and convenience, and having to plod his course through—to him—an unexplored field." But by 1854, he was America's foremost camera manufacturer. His role as the country's most noted early photographic optician also began at this time. In 1855, H. H. Snelling said Harrison had devised a means "to test the achromalicity of each lens, separately or in combination, so that the chemical and visual foci are rendered coincident to a certainty. He is also engaged on, and will shortly perfect, a new View Camera of short focus and enlarged field, which is something all have wished for but none has been able to obtain." A new addition to the New York camera manufacturing scene in 1854 was the firm of brass manufacturers, Holmes, Booth and Hayden, headed by John C. Booth, Israel Holmes, and Henry Hayden. Humphrey said the firm could be "justly considered as vieing for the palm of superiority" with Harrison's manufactory.[229]

Every person has a just right to expect the credit of a process which originated in his own hands; and it is not in the least surprising, that specimens produced by mere practitioners, and sent forth to the world, should be held in disrepute, particularly when from those who have never published the process employed in their production.

We are well aware that it is said "We are compelled to keep *our process* a secret, or every one else would benefit by it: or, "We have paid for a *right*, and it will not do to let any one know how we work." Now, this is speaking highly for the honor of the profession at large. You plainly imply that it is composed of scamps, and admit a great inefficiency in our country's laws. You have a process which is patented, and have *bought* a *right*, and yet the rascality of the profession of which *you* are a member, prevents you from giving publicity to the very article you may legally control. Poor, deluded mortals! divest yourselves of fear, and describe to the world the manipulations you employ, and even though they may bear close resemblance to, or exactly correspond with those of another, you, by your liberality, will be entitled to credit, at least for an honorable frankness; and those European experimentalists to whom *you* owe the very first hint for your process, will look upon you with respect, and not cast aside your productions as the result of *their studies*, which have been pirated from themselves and appropriated solely to purposes of satisfying a morbid propensity for gain.

Let a Daguerreotype operator visit WHIPPLE's, GURNEY's, McCLEES & GERMON's, or LAWRENCE's establishment, and tell either of these gentlemen that *he* has "something new," and can do so and so, by which "*he* has done such great things, in the village in which *he* has operated," yet show nothing better than they or their neighbors are every day producing—would they not consider this boaster a conceited mountebank? We greatly dislike these secret processes, consequently we do not hold in deep reverence those who proclaim they have great improvements, and at the same time withhold them.

We cannot possibly see what objection our friends WHIPPLE and CUTTING can have to giving their process, since they are willing to guarantee its *security* to others, by right of a patent. Come, gentlemen, don't be incredulous! First try the profession, before you fear.

There is a gentleman in Cincinnati (Ohio), who has promised us some hints upon the paper process. Come, friend HAWKINS, you are just the man, and only need the start. No one can say more of the difficulties of the process than you, who have battled your way to eminence, through every variety of mishap. [230]

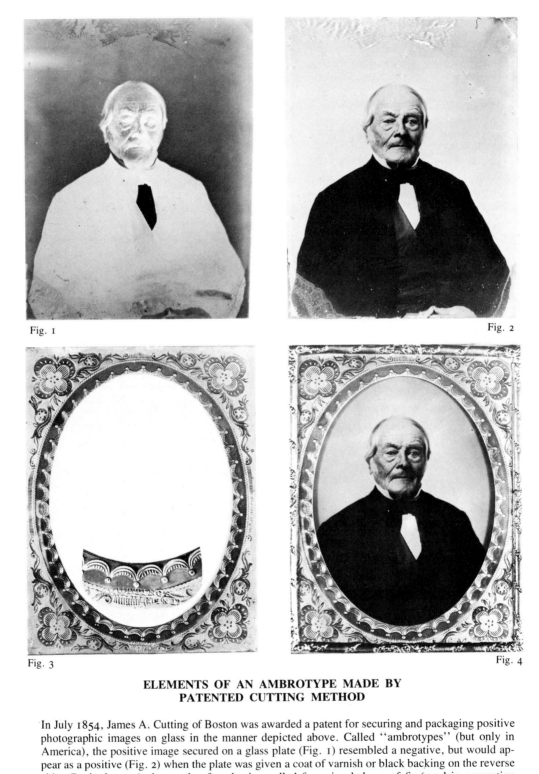

Fig. 1

Fig. 2

Fig. 3

Fig. 4

ELEMENTS OF AN AMBROTYPE MADE BY
PATENTED CUTTING METHOD

In July 1854, James A. Cutting of Boston was awarded a patent for securing and packaging positive photographic images on glass in the manner depicted above. Called "ambrotypes" (but only in America), the positive image secured on a glass plate (Fig. 1) resembled a negative, but would appear as a positive (Fig. 2) when the plate was given a coat of varnish or black backing on the reverse side. Cutting's *particular* mode of packaging called for using balsam of fir (used in cementing lenses together) to seal a second piece of glass of the same size to the rear of the image plate, thus protecting the image thereafter against infiltration of air or moisture, or against damage in handling. An oval brass mat (Fig. 3) contains Cutting patent identification at bottom (magnified in insert). Completed ambrotype, with ornate protector rim (Fig. 4), is ready for placement in a miniature case of wooden or plastic design.[231]

1855

Because the daguerreotype remained in vogue for portraiture, and this constituted a large portion of gallery business everywhere, many photographers turned to what might be called a detour at this stage of collodion photography. This was the ambrotype, frequently referred to today as a daguerreotype on glass. Ambrotypes looked like daguerreotypes, but they were made by a slight variation of the collodion process. Above all, they were less costly to make than a daguerreotype. Ezekiel Hawkins had made an ambrotype in 1847, when he first experimented with the collodion process and produced a photograph on glass. The word "ambrotype" had not been coined at that time, nor was it used by James A. Cutting when he secured a patent for a *particular* mode of making an ambrotype in July 1854. The first ambrotypes exhibited in the United States (in December 1854) were actually described as daguerreotypes on glass. The term was coined early in 1855 by Marcus A. Root, who derived the name from a Greek word signifying "imperishable." [232] But in England, where this type of photograph had been made by Archer at the same time he introduced the collodion process, the term "collodion positive" remained in use. This, in effect, was how an ambrotype was made; a weaker solution of collodion was used, and after the plate was exposed in the camera it could not be used as a negative after that to make prints on paper or other surfaces. Like the daguerreotype, it remained as a one-of-a-kind image—on a glass plate, instead of on a silvered copper plate.

Cutting's patent came to be known fairly quickly, however, as the "ambrotype patent," and it might have become the object of a second prolonged patent war on the American photographic scene were it not for the fact that the ambrotype was short-lived, suffering a similar fate as the daguerreotype when a combination of events (the stereophotography revolution; the invention of the carte de visite form of portrait photograph; multitube cameras; etc.) signaled a mass exodus just before the Civil War to the collodion method of paper photography.

Ambrotypes were fitted into the same miniature cases used for daguerreotypes. Images resembled glass negatives until the plates were given a backing of some form (black or dark varnish; black paper or cardboard). Then they would assume the appearance of a positive picture (see illustration opposite). Probably because of the existence of the Cutting patent (and his subsequent court actions taken against certain photographers), ambrotypes were made in a variety of ways. Cutting's method was among the best, in that it called for hermetically sealing together the image plate (image side) and a second piece of glass of the same size, which would serve as a permanent cover. The ambrotype of an elderly man (opposite page) was made by the Cutting method. Many ambrotypes were made more simply, using just one piece of glass with the image side painted over with a varnish or paint. The specimen shown on page 112 serves as an example, but since the varnish has deteriorated the photograph requires additional backing (the black piece of paper shown in the center) in order for it to exhibit some semblance of its original appearance. Some ambrotypes were also made without any suitable protective coating, or covering for the image, and in the case of such specimens the image can literally be wiped off the glass with a finger or cloth.

Cutting's basis for pricing, as of July 1855, was $100 a license for one photographer to make ambrotypes by the Cutting method in an area of approximately five thousand inhabitants. "Of course, some modification is necessary in large cities and among people who do not appreciate the fine arts," Cutting's agent, W. R. Howes, of Mattapoisett, Massachusetts, declared in a letter to George N. Barnard in Syracuse. "The disposal of your county is in my hands at present," he told Barnard, adding: "From what we have been able to learn of Onondaga County, we think it worth $800." Whether Barnard purchased a license on these terms is not known. [233]

Cutting's patent specified balsam of fir as the sealing compound for the two glass plates, but Montgomery P. Simons, operating in Richmond, found a way to get around this which he communicated to Snelling on November 11:

> . . . if you will get Mr. Cutting's claim from the patent office reports, 1854 (I have one before me), you will find that *two glasses can be used,* and cemented together with *any varnish* except balsam of fir; I use two glasses and cement them together with a varnish which I think has many advantages over the patented balsam; it is not so sticky and unpleasant to use, it dries quicker and the tone which it imparts to the picture is quite as good. [234]

Ambrotypes reportedly were not widely made by the more prominent photographic galleries, but they were made to some extent by most—even in whole-plate size at Brady's gallery. The better made specimens were greatly admired, as witness these comments by Marcus A. Root after visiting the Whipple and Black gallery in Boston:

> The ambrotype patent being reserved exclusively by J. A. Cutting & Co. of Boston, others have had little encouragement to experiment in this beautiful style of heliographic portraiture. Yet I saw, taken by Mr. Black, a specimen likeness of a gentleman, which in delicacy and beauty, was not only vastly superior to the finest daguerreotypes, but was what an enthusiastic virtuoso would pronounce "a miracle of art." In truth, all enthusiastic daguerrotypists who succeed in producing good photographic ambrotype portraits by the collodion process, will probably loose—for a time at least—much of their attachment to the daguerreotype process: so much more pleasing, and easily handled by the skillful artist is the former than the latter. And here I would earnestly urge on Messrs. Cutting & Co. the propriety of rendering to all *located* daguerreotypists who may desire to make these pictures, the *right* of so doing, at rates so moderate as to inflict upon them no injustice—offering the same to *all,* and permitting the most skillful to "lead the field." [235]

But most of the major galleries were beginning by this time to concentrate heavily on using the collodion process to make photographs on paper. Brady, Gurney, Lawrence, and others in New York were now using it commercially, prompting the New York *Tribune* to declare in March that the process was "coming into vogue as a means for taking

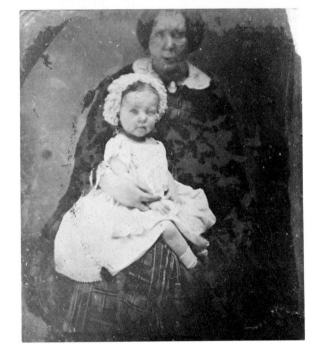

INFERIOR GRADE AMBROTYPE

Photographers made ambrotypes in a number of different ways to get around paying Cutting a license to use his process. Here, the image secured to the rear of the glass plate (above left) has flaked away, but with the backing of black paper (above) appears more positively, as at left. Varnish or black paint backing on the original was inferior, and no second glass of the same size for added backing and sturdiness was used.

1855

portraits." Hesler adopted it in Chicago in 1855, as did I. B. Webster in Louisville and John H. Fitzgibbons in St. Louis. Root was particularly laudatory of collodion portraits, both small and life size, which A. A. Turner from Brady's gallery exhibited at a Franklin Institute fair early in 1855.

Root also praised the collodion prints exhibited at the same fair by McClees & Germon, but once again Charles Ehrmann recorded how difficult it was to work the collodion method at the start. According to Ehrmann, a Philadelphia acquaintance, Ed Thilgman, had visited Archer in Edinburgh in 1852 and had returned with a six-ounce bottle of collodion and a twelve-ounce bottle of developer, containing pyrogallic acid and hyposulphite of soda. As Ehrmann then recalled:

> Mr. Thilgman handed these new materials to me. I tried them; my associate John C. Parke did the same; Mr. McClees, Mr. Germon, my old chum William Bell, and many others, and we all came to the one conclusion—that this stuff called collodion could not be possibly used for making pictures. We went back to our albumen and practiced it as much as possible. At last a man from Boston, James Cutting, took out a patent for bromized collodion. He sold his patent right and left in every direction, and photographic pictures upon collodion were then made. I give him the credit of having made the collodion process practical, but more credit belongs to Isaac Rehn of Philadelphia.[236]

Ehrmann also said a collodion operator became "a big man" at this time. The pay ranged from $40 to $70 a week, "with a percentage attached each year, and we all lived in clover." According to Ehrmann, McClees & Germon printed their collodion pictures principally on plain silvered Rives or Steinbach paper.

While the process had come into use as the "collodion process," a new term gradually became synonymous in usage, and is perhaps better known today. This is the term "wet-plate process," which evolved quite naturally from the photographer's need to keep his collodion glass negatives continuously moist (with wet collodion) from the moment the plate was sensitized in its bath through exposure in the camera, and subsequent negative development. As Humphrey would later say: "In taking collodion pictures it is always advisable for the sitter to be arranged before the glass is taken from the bath; this will save time and there will be less liability of the collodion drying." While this was not an undue hindrance to gallery practice, this requirement made it necessary for a photographer to transport to the field with him all of the chemicals and paraphernalia required to sensitize, expose, and develop a plate when taking photographs out-of-doors. Understandably this led to continuing efforts—achieved in the 1880s—to perfect a dry-plate method equally suitable for *all* forms of photography, such as only the collodion process was during its lifetime.

As early as 1852, cameras had been given the capability of moveable focus with the introduction of the accordionlike bellows camera that year, and in 1854 the noted French photographer Eugene Disderi devised a way of repositioning the plate inside a camera in order to allow multiple exposures to be made on the one plate. Either with or without the knowledge of Disderi's invention, Albert S. Southworth, in April 1855, patented a sliding plate-holder device

Plastic "union" cases for housing daguerreotype and ambrotype photographs were introduced in 1854, marking the beginning of thermoplastic molding in the United States (a feat which went unheralded at the time). Approximately eight hundred different design motifs on plastic cases are said to have been made, featuring scenes derived from classical paintings and etchings, or reflecting the popular taste for themes of nature, history, patriotism, and religion. The scenes of a clipper ship and fort (top) and a seated Liberty (bottom) were made between 1858 and 1860 at Northampton, Massachusetts, by Littlefield, Parsons & Co. The case with the nautical motif (middle) is by an unknown maker.

1855

113

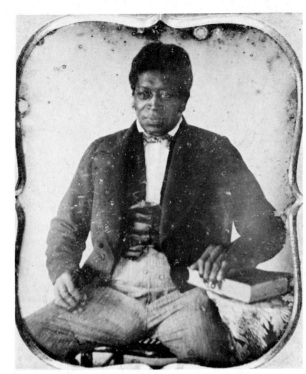

Robert Morris, from a daguerreotype, circa 1855.

Mrs. Robert Morris, from a daguerreotype, circa 1855.

Morris home, circa 1870s.

Morris home, 1976.

FROM SLAVERY TO LANDOWNER

The illustrations on this page tell the success story of a New Jersey slave, Robert Morris (1790–1878), who was freed in 1828, the year Andrew Jackson became president, and the year the minstrel character "Jim Crow" was introduced in Louisville, Kentucky. Morris was freed by a landowner, Simon van Duyne, whose modest stone house still stands in what is now Pine Brook, New Jersey. From his meager savings, Morris began purchasing lots from other members of the van Duyne family, and records which have been handed down through several generations reveal the following purchases:

Seller	Acres	Year	Price
John van Duyne	2 +	1829	$35
James van Duyne	5 +	1851	$26.70
Daniel van Duyne	4	1853	$120

After winning his freedom, Morris continued to till the land for the van Duyne family and built a home not far from the Simon van Duyne homestead. Here, his wife engaged in weaving, and many of her embroideries will still be found in the van Duyne house. Like the latter, the Morris house still stands today. A granddaughter is shown standing in front of the house (at left, center) and the house as it looks today is pictured beneath. After Morris' death in 1878, the house was later willed back into the van Duyne family.[237]

which was designed to accomplish the same purpose. Like Silas Holmes's "double camera" patented the previous year, the Southworth invention was also intended to be applicable to taking stereoscopic pictures "upon the same or different plates with one camera." But neither the Holmes nor the Southworth inventions are known to have been applied to any great extent to stereophotography. Instead, these mechanisms served immediately to increase the number of daguerreotype or collodion photographs which a photographer could obtain with a single exposure at one sitting. Describing his invention, Southworth said it "consists of a peculiarly arranged frame in which the plate-holder is permitted to slide, by which means I am enabled to take four daguerreotypes on one plate and at one sitting, different portions of the plate being brought successively opposite an opening in the frame, the opening remaining stationary in the axis of the camera while the plate-holder and plate are moved." By the same token, four images could be secured on a single collodion negative plate, after which the plate was developed in the usual manner and the four [similar] images on the paper print were cut apart and mounted separately. No doubt, the Southworth invention made a significant contribution to the tabulated 403,626 daguerreotypes taken throughout the state of Massachusetts this year.[238]

Silas Holmes, whose negatives today comprise an important element of the nineteenth-century photographs owned by the New York Historical Society, was dubbed the "machine daguerreotypist" by Snelling because of the number of daguerreotypes he could produce with his own particular invention. Humphrey noted in January that six hundred of Holmes's "two-at-once" daguerreotypes could be turned out daily at his "picture factory" for prices ranging from twenty-five cents to $5 a dozen. A month later, Humphrey said Holmes had further enlarged his gallery with the addition of a wholesale department, and was advertising the taking of daguerreotype portraits at $20 a hundred. When the gallery was put up for sale at the end of the year, Snelling said Holmes had "made a fortune there in four years," and had even won a medal for "machine pictures" at the annual fair of the American Institute in 1855.[239]

Daguerreotyping continued to be a $50,000-a-year business at this time in such cities as Philadelphia and St. Louis. But in the case of St. Louis, volume appears to have been heavier at only sixteen galleries there, as compared to the reported seventy galleries in Philadelphia.

Two Boston photographers, George Silsbee and Samuel Masury, tried making daguerreotypes by artificial light, but their experiments ended in a mishap. While attempting to make a daguerreotype by gaslight, the chemicals exploded, shattering the front of their building on busy Washington Street, and causing Silsbee to lose an eye. Masury suffered a broken leg.

In 1855, Buffalo was the scene of possibly the first recorded use of the daguerreotype for law enforcement. The police there were looking for a "rogue" by the name of Lewis Fredel, and sent a daguerreotype likeness of Fredel to Boston where they evidently thought he had gone. But *Ballou's* magazine, which reported the incident, did not state whether the image was helpful in apprehending the fugitive.[240]

THE FIRST "BOHEMIANS"

Although the camera did not capture the group of young rebels known as "the Bohemians" which scandalized polite society in New York in the late 1850s, their unconventional dress, irreverent literary fervor, and "seductive ways" (*The New York Times*'s description for what it considered their moral menace) could be observed at the far end of Charlie Pfaff's cellar restaurant beneath Broadway a few doors north of Bleeker Street. Walt Whitman was a member of the group, and the photograph of him above, made from a circa 1855 daguerreotype (probably by Gabriel Harrison), reveals the Jovian-looking man with the steel-blue eyes as he appeared at the time of publication of his *Leaves of Grass*. His companions at Pfaff's were the poets Ada Clare, Edmund Clarence Stedman, and Thomas Bailey Aldrich, and literary figures such as Fitz-James O'Brien and the editors of the notorious *Saturday Press*. But by the end of the Civil War, all were gone, or departed to other, and for the most part, more "respectable" walks of life.[241]

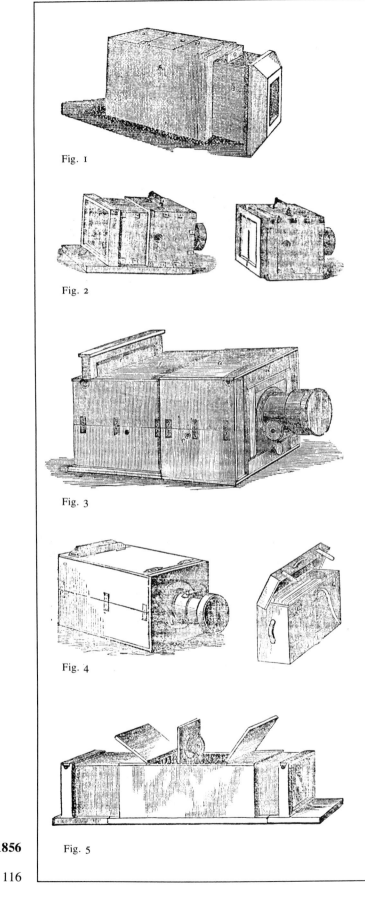

Fig. 1

Fig. 2

Fig. 3

Fig. 4

CAMERA STYLES, CIRCA 1856

Catalogues or other literature on American-made cameras available in the 1850s are today nonexistent. In the summer of 1856, *Humphrey's Journal* published these drawings of cameras offered by a British concern:

EXPANDING CAMERAS: The larger of two versions (Fig. 1) came in two portions, one sliding within the other. It allowed use of either a portrait or view lens, and the back portion held a plate holder on which could be placed a sensitized daguerreotype or glass plate, or paper negative. Figure 2 illustrates a similar but smaller and more portable expanding camera. The tail board was hinged so it could be turned up to give added protection to the plate holder.

FOLDING CAMERAS: The larger of two versions (Fig. 3) included the facilities of adjustment possessed by an expanding camera, but could be dismantled by folding the sides and back flat on the camera's base for packing in a compact manner with separate plate holders, lens, and interior dividers. Figure 4 illustrates a folding camera whose front and sides could be lifted from their grooves and the body of the camera folded together by hinges for packing with plate holders, lens, etc., in a traveler's leather case.

COPYING CAMERA: Daguerreotypes or photographs on paper or other opaque surfaces could be placed in a good light a short distance from the open end (left) of the camera shown in Fig. 5 for copying. A slide holding the lens was placed in a center-section groove, and a focusing glass was placed in the plate holder (right). Focusing was accomplished by moving the right-hand (expanding) body of camera inwards or outwards from center portion. When focusing was completed, a sensitized plate was substituted in the plate holder, after which the copy photograph could be secured. The nearer the lens was placed to the plate holder, the further the camera itself had to be removed from the original, and the smaller the copy photograph would be. The reverse was the case in making larger copies.

STEREOSCOPIC CAMERA: Figure 6 shows an ordinary view camera equipped with a rear sliding plate holder, which gave it the ability to make two images of the same scene on the one plate. After making the first picture, the camera was moved to a second location, two, four, or six feet to the right or left, depending on the distance of the camera from the scene.[242]

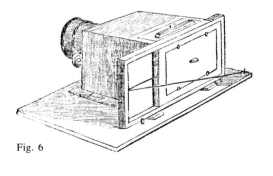

Fig. 5

Fig. 6

1856

An obscure professor of chemistry and natural philosophy (physics) at Kenyon College in Ohio patented the great American tintype on February 19, 1856, apologizing afterwards for the necessity to extract a small fee ($20) for its practice. This was Hamilton L. Smith, who graduated from Yale in 1839, the year the daguerreotype process was introduced, and who for a time shared directorship of the Yale Observatory before becoming (in 1853) one of a faculty of seven for a student body of sixty-five at Kenyon College. At first the new pictures were called "melainotypes," then "ferrotypes" (by a rival manufacturer of the iron plates used), but the world knows them as tintypes.

The tintype is an offshoot, in a sense, of both the daguerreotype and the ambrotype. Like the former, a tintype image was secured on a metal plate exposed in the camera, but the metal used was iron instead of copper, and the iron plate was lacquered with a black japan varnish instead of coated with silver. The tintype plate, like the ambrotype glass plate, was sensitized with collodion. With the new sliding-plate camera mechanisms just introduced by Southworth and Holmes, it was possible to expose four images on a plate which, after the plate's development, could be cut apart with a pair of tin shears. Later, when multilens cameras came into use, up to a dozen, or even thirty-six tiny "gem" tintype images could be secured on a single plate.

As soon as it was granted, Smith assigned the rights to his patent to an associate at Kenyon, Peter Neff (then calling himself Peter Neff, Jr.), and Neff's father, William Neff. The younger Neff had worked with Smith on his invention and had persuaded Smith to apply for the patent, which, by his own account, he prosecuted before the Commissioner of Patents. The patent covered the production of tintype photographs, but not the manufacture of materials for them (which left room for the rival manufacture of "ferrotype" plates). William Neff died in November 1856, leaving his rights and all the manufacturing responsibilities to his son. As this account by Peter Neff reveals, it was no easy matter to produce sheets of iron that would be thin enough for commercial use:

My first experiments toward making it of commercial value were made in rooms over my father's stable, on West Sixth Street, near Cutter Street, Cincinnati, Ohio. The many difficulties in obtaining sheet iron thin enough to suit for my plates were insurmountable, and plainishing them did not remove its roughness, but in the summer of 1856, with my father's security, Phelphs, Dodge & Co., imported for me several tons of Tagers Iron. This was among the earliest if not the first importation of these sheets. I built a factory for japanning plates at 239 West Third Street, Cincinnati, with rooms for operating and teaching their manipulation and uses, and the preparation by compounding chemicals. It was slow and difficult work introducing this new process, being everywhere met with opposition from daguerreotype dealers, but succeeded by sending out teachers to instruct daguerreotype operators. My factory was destroyed by fire in the summer of 1857, and I then built at Middletown, Conn., and James O. Smith had charge of them and the work. My office was with James O. Smith in Fulton Street, New York.[243]

A tintype portrait of a youth in uniform. Photographs of youths or military personnel in uniform, taken prior to 1860, are uncommon today.

In the midst of building his first manufactory, Neff prepared and distributed—gratuituously—some four thousand copies of a fifty-three-page pamphlet, *The Melainotype Process, Complete*. But having originated in the Midwest, instead of in New York or in Europe where most new photographic processes had previously originated, the tintype was not adopted across the country as soon as it might otherwise have been. The ambrotype eclipsed the daguerreotype in the years 1856–57, but the tintype never eclipsed either. It did, however, outlast them both, and also outlasted the wet-plate process itself, accommodating itself equally well to dry-plate photography after the 1880s. It never achieved social status, but the simplicity and novelty of the process—and the low cost of its pictures—assured it a long life.

A variety of camera styles (see illustration, left) were now to be had on the market, but to the brothers A. S. and A. H. Heath, manufacturers of chemicals in New York, there was still no "perfect" camera in their eyes which had yet been devised. In reality, cameras in the emerging wet-plate era would become both larger and smaller, and would be produced to meet narrower demands. The Heaths nevertheless drew attention to the drawbacks of the existing equipment of the period, and were among the first to call for a breed of camera that, in their words, would "give large-size pictures distinct in all parts; command a most intense light; and be equally adaptable for portraits or for landscape and architectural work:"

Up to the present time, the problem of fulfilling all these conditions equally has not been solved; indeed one excludes the other. If the picture is to be large, or of equal clearness and distinctness in all parts, even to the border, and equally so for near objects as for those farther off, the focal distance must be proportionately longer, and the aperture through which the luminous rays enter must be smaller. The necessary consequence of this mode of construction is that the apparatus does not command a sufficiently intense light to answer the purpose of taking portraits with it. On the other hand, if the focal distance is less-

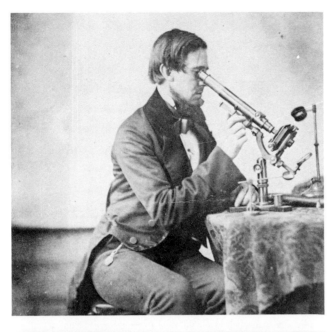

Tintype inventor Hamilton L. Smith (top) shared directorship of the Yale Observatory in the 1840s before being named professor of chemistry and natural philosophy (physics) at Kenyon College, Gambier, Ohio, in 1853. His co-worker at the time of the tintype patent award (1856) was Peter Neff (bottom), who attended Yale for a year in 1845 and later transferred to Kenyon, where he graduated in 1849. Neff was studying for the ministry while working with Smith in 1853–54, and continued the association after assuming the ministry of Christ Church, Yellow Springs, Ohio, in 1855.

ened, and the aperture enlarged (with the best suited to the purpose), the apparatus will then command a greater amount of light, and will accordingly be better adapted for the taking of portraits. But it will be found that this has been achieved only at the expense of the size of the picture, and of the desired correct delineation, and equal clearness and distinctness in all parts. An apparatus so constructed is therefore but imperfectly adapted for taking views of landscapes or of architectural objects; and although small views may, if need be, be taken with it, by placing screens before it to reduce the aperture, the productions so obtained are very inferior to the views taken with an apparatus of greater focal distance and smaller aperture. This applies more especially to pictures taken on paper; since from the unequal texture of that material, the minute details of the object delineated will necessarily grow indistinct and confined, or even vanish altogether if the surface acted upon is too restricted to reflect these details on a sufficiently large scale.[244]

Although Prof. Smith found it personally "galling" to have to exact a fee for the practice of tintyping (to reimburse his expenses over several years), James A. Cutting suffered from no such qualms and began a prolonged series of litigations in January 1856, aimed at curbing the practice of those whom he felt violated the dictates of his ambrotype and bromide patents. His first thrust was against M. P. Simons in Richmond, but to no avail, as Simons explained in this letter to Snelling:

"I wrote you some time ago that I was making ambrotypes and cementing them between two glasses, and at the same time told you that I had not been foolish enough to pay for a patent right. Since then I received a notice from Gibbs, one of Mr. Cutting's victims, informing me that he would, through his lawyer, apply for an injunction on the following Tuesday. I heeded him not, but continued to make ambrotypes, as usual. Tuesday came, and Mr. Gibbs was not ready, and, for the same reasons, it was put off again and again, until I was not willing to have it delayed any farther, and last Thursday it was argued at length before the Judge of the U.S. Court. His bill desired to restrain me from making ambrotypes and cementing them between two glasses. My answer was, that there was nothing new or novel in the patent, and, if the patent was good, that I did not use balsam, and, therefore, did not infringe his rights. You will be pleased to learn that the judge, after having it in consideration for several days, decided in my favor, by refusing to grant the injunction. What will these patent men say to this? It is laughable to read their advertisements—"Rights for sale to respectable operators"—meaning any one who would be willing to pay through the nose for them."[245]

Other litigations commenced in 1857, including a suit (handled by Cutting's New York agent, W. A. Tomlinson) against a group of New Yorkers, among them Abraham Bogardus, Nathan G. Burgess, Battelle & Grey, and Lewis & Hall. This case was also thrown out of court, however, on the grounds that the name "ambrotype" was not included in the Cutting patent. Robert Vance purchased the ambrotype rights for the state of California, and in October he placed an advertisement in a San Francisco newspaper which stated: "I hereby denounce all Pictures taken on Glass in this city or state, and called Ambrotypes, as BOGUS, and a fraud upon the public, being a miserable imitation of the genuine article." A rival photographer, J. M. Ford, placed an advertisement on the same day in the same newspaper in which he said the "Patent Ambrotypes" were "worthless trash." He gave these reasons:

Proprietor Vance stands in center, third from the right, surrounded by, left to right: Ira G. French, gallery operator; Milton M. Miller, photographer; George H. Foster, clerk (seated); P. A. Davis, bookkeeper; and John Hammersmith, operator.

THE ROBERT H. VANCE "PREMIUM DAGUERREOTYPE GALLERY" IN SAN FRANCISCO

Having left his celebrated daguerreotype views of California behind in New York, Vance opened a gallery in San Francisco in 1852. After winning the First Premium for his photographs at the state fair in 1854, he opened an enlarged "Premium Gallery," followed by other branches in Sacramento and San Jose. The San Francisco gallery boasted fourteen rooms, a billiard parlor, a ladies' boudoir, and a skylight containing 500 feet of glass. Vance made "many threats of prosecution . . . against his brother artists for alleged infringements" on his rights to the Cutting ambrotype patent, but is not known to have filed any suits. He sold his business in 1861, drifted into oblivion, and died in New York in 1876.[246]

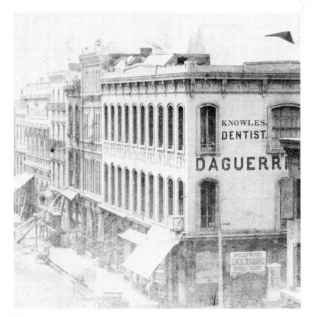

This 1859 view of Vance's "Premium Gallery" was among the first series of card stereographs published by Edward Anthony.

1856

119

LAST SEEN AT THE ENGRAVERS

Commodore Matthew Perry took an artist, William Heine, and a daguerreotypist, E. Brown, with him on his 1852–53 expedition to Japan. Heine's lithograph (above) from Perry's three-volume *Narrative of Expedition of American Squadron to China Seas and Japan* (Washington, D.C., 1856) depicts Brown at work with his camera on an island in Okinawa. Several scores of the illustrations in Perry's report were based on Brown's daguerreotypes, but the photographs may have perished in a fire at the P. S. Duval lithographic firm in Philadelphia on April 11, 1856, which destroyed the government-supplied lithographic stones and illustrations made from the stones at the Duval plant.

The daguerreotypes made by S. N. Carvalho on the 1853 Frémont western expedition, together with copy photographic prints made by Brady in the winter of 1855–56 in New York also have been lost. The photographs were used to make oil paintings and engravings on wood in a special studio set up near a large bay window in the Frémont home. These were passed on to other "artist-engravers of the best school," and a book on the expedition was scheduled to be published (then was later cancelled) by George Childs of Philadelphia. The materials for the book survived an 1881 warehouse fire, according to Mrs Frémont.[247]

In the so-called Patent Ambrotypes the pictures are sealed with Balsam, which constantly oozes out, and soon leaves the pictures covered with blisters. . . . By the improved method of putting up Ambrotypes, the cement is entirely done away with, and the picture is covered with an enamel which instantly dries and becomes as hard as the glass itself. This is the improvement, and the pictures are called IMPROVED AMBROTYPES throughout the United States and honest operators make no others.[248]

Were daguerreotypes subject to fading? Prof. Draper said he thought they would if they were left in a warm place, such as on the top of a mantlepiece. He had seen specimens "almost obliterated" in this manner. But Humphrey argued that the daguerreotype was the only type of photograph that could be "finished" on the basis of "scientific principles," and the only type that could be "secured from the oxydizing influence of adulterated atmosphere." But the problem of fading photographic prints was another matter, and in 1855 a committee of photographers was formed in London to determine if the problem could be remedied. Its report, published in *Humphrey's Journal* on January 1, listed the principal causes (enumerated at right), but concluded that no set of procedures adopted for making prints would insure their "permanency." For the remainder of the nineteenth century efforts would be made by the best technical minds—principally in England and on the continent—to devise so-called permanent modes of photographic printing. But as there would never be a universally accepted "perfect" camera able to do all things for all users, so there would be advantages and drawbacks to every "permanant" process devised for making photographic prints.[249]

The collodion process provided the first stimulus for amateur photography, which flourished for a time in England and in Europe, then subsided somewhat as "the stains of inky darkness upon the hands and clothes soon earned for the infant science the appellation of the 'black art.'"[250]

A "second birth of photography" in England began as soon as Talbot's patent claims were thrown out of court, according to the *Art-Journal* in London. "Since then our opticians have found no rest for mind or body, our camera makers have been inundated with orders—and Photographic chemists have sprung up one after another and continue to increase, till the unconscious public wonder and are amazed. The *Illustrated London News* gives learned criticism as incomprehensible as they are long . . ."[251]

On October 28, 1856, a Baltimore businessman, George B. Coale, addressed a letter to *Humphrey's Journal* which may be characterized today as the first sound of the trumpet for amateur practice in the United States.

Dear Sir,—I desire, through you and your Journal, to urge upon the professional Photographists throughout the country, and especially upon the Manufacturers and Dealers in Stock and instruments, to make some exertion to encourage the *amateur* practice of the Art in this country. In Europe, the Amateurs far outnumber the Professors; and there is no exaggeration in saying, that the perfections attained in many branches of the Art are more than half attributable to the animated enthusiasm with which the former class have devoted to it leisure, wealth and chemical science. Here the Art has been exclusively left in the hands of the takers of likenesses—and what has America contributed to it beyond some mere mechanical improvements and perhaps some simplifications in manipulation? Mr. Whipple's Albumen Process is all, or nearly all, that can be claimed for us. I would not be understood as implying by these remarks any *reproach* to the body of Professors. It is not to be expected that they should abstract from their active business, time and means, which it wholly needs to make it a profitable calling. But I would suggest to each one who takes the trouble to read this communication, that there is doubtless within the circle of his acquaintance more than one person whom he can stimulate to take up the practice of the Art as an accomplishment and amusement of his leisure; and such a one, if gifted with taste, will be led by the fascinations of the Art into paths of experiment and

PRINT FADING

A committee of London photographers examined Talbotypes and plain paper prints up to ten years old; also albumen paper prints, and prints colored with a salt of gold, or fixed with "old hypo." The report, published on January 1, 1856, listed these causes of fading:

Causes of Fading.

The most common cause of fading has been the presence of hyposulphite of soda, left in the paper from imperfect washing after fixing.

The committee think it right to state, that they have been unable to find any test to be relied upon, which can be used to detect a minute portion of hyposulphite of soda, in the presence of the other substances which are obtained by boiling photographs in distilled water and evaporating to dryness; yet they have no doubt of the truth of the above statement, from the history given of the mode of washing adopted.

The continued action of sulphureted hydrogen and water will rapidly destroy every kind of photograph; and as there are traces of this gas at all times present in the atmosphere, and occasionally in a London atmosphere very evident traces, it appears reasonable to suppose that what is effected rapidly in the laboratory with a strong solution of the gas, will take place also slowly but surely in the presence of moisture, by the action of the very minute portion in the atmosphere.

The committee find that there is no known method of producing pictures which will remain unaltered under the continued action of moisture and the atmosphere in London.

They find that pictures may be exposed to dry sulphureted hydrogen gas for some time with comparatively little alteration, and that pictures in the coloration of which gold has been used, are acted upon by the gas, whether dry or in solution, less rapidly than any others.

They also find that some pictures which have remained unaltered for years, kept in dry places, have rapidly faded when exposed to a moist atmosphere. Hence it appears that the most ordinary cause of fading, may be traced to the presence of sulphur, the source of which may be intrinsic from hyposulphite left in the print, or extrinsic from the atmosphere, and in either case the action is much more rapid in the presence of moisture.[252]

investigation, in which he will gather what will more than repay his professional friend for setting him in the way.

The Manufacturers and Dealers in Photographic Stock have more in their power; and from establishments that boast of selling to the amount of a million a year, surely something may reasonably be asked. At present *no one facility* exists for the Amateur. He must find out by costly experiments what he really needs, and then, at unreasonable cost, have specially made articles adapted to his purposes, or, at great risk of mistakes, undertake to import them from England or France. In your large New York establishments, not an article is to be found except such as are needed for likenesses—not even a cheap stand that could *be brought to a level:* and, I am sorry to add, not the least disposition to go one step in advance of the present state of the market to supply articles that might and surely would *create* a demand. I searched in vain for a portable field camera and stand, and finally had to have one made after a design furnished by my friend and neighbor Mr. D——, who has been working his way through the same difficulties that I have experienced, and who, with myself, constitute our "Photographic Society" thus far. This camera is compact and light; all bellows except the front and bottom, and could be furnished at as low a price (according to Mr. Townsend) as the common "Bellows Box," *if made in any number.* To make a single one cost about 30 per cent. more. I cite this single fact as illustration of the difficulty an Amateur has to contend with at every step.

Now, as the readiest means of advancing the end I wish to see attained, will not one of your large Manufacturing Companies, or if not they, then some Importing house connected with the Arts—Williams & Stephens or Goupil for example—import a judicious selection from the full English or French catalogues of apparatus? I note, in Thornthwaite's list, complete outfits for the Photographic Excursionist, at prices ranging from $15 to $250 and upwards; "packed in a convenient case," &c., &c. I do not think that one of these cases would be exhibited here a long time without a purchaser. The very examination of such an arrangement of apparatus is as good as a Manual of Instruction.

It is about two months since I commenced the practice of Whipple's albumen process, (undoubtedly the branch for Amateurs), and already, with the application of only such leisure as a pretty active business affords, I have obtained a facility that yields me the greatest delight; and at every step of progress the fascinations of the Art increase. I can prepare half a dozen plates in an hour after tea—carry out three of these in the early morning before business hours, with the certainty of returning with three good pictures; a short time after tea suffices to develope them. I can prepare a few sheets of paper any morning before breakfast and let my negatives print themselves in my office window while I am attending to my business; I then carry them home carefully wrapped up and give them to my fixing and coloring bath in the afternoon or evening.[253]

1856

121

Fig. 1. David Woodward's enlarger.

Fig. 2. Alphonse Liébert's enlarger.

SOLAR CAMERAS

In the early 1850s, photographers began making enlargements with cameras which used reflectors and a copying lens to pass the sun's rays through a negative onto larger sheets of sensitized paper. In 1857, David A. Woodward, a professor of fine arts at the Maryland Institute in Baltimore, patented the first "solar camera" (Fig. 1), which used a plano-convex lens, B, to condense and focus the sun's rays from an inclined mirror, A, through a negative, C, to the copying lens, E. The focus was made to coincide exactly with the optical center of the copying lens, with the result that an enlargement could be made totally from powerfully focused sunlight, and not by any other points of the copying lens subject to spherical aberration. The English photographer and editor Thomas Sutton, after seeing an enlarged print of a Baltimore civic building made with a Woodward camera, said the definition was as good as if the print had been made directly from a same-size negative. A solar camera which could be operated unattended in the open air (principally on rooftops) was patented by David Shrive of Philadelphia in 1859, and another of similar design (Fig. 2) was exhibited by Alphonse Liébert at an 1864 Vienna photographic fair. The Liébert camera, which was manufactured in Philadelphia after that, could make photographs of size 17¾ x 23¼ inches from a carte-de-visite-size negative in from 45 to 70 minutes. It passed sunlight through a condenser at the camera's top to a copying lens, which projected the image with the required degree of amplification onto sensitized photographic paper at the camera's bottom.[254]

1857

The year 1857 appears to have been a milestone year for photographers in making large-size photographs. Henry Hunt Snelling in New York and the Whipple and Black studio in Boston gained notoriety at the outset of the year for making prints as large as 18 x 22 inches without resort to enlargement. In Paris, the Philadelphian Warren Thompson fitted his studio with a 12-foot-long, bellows-style camera which could be moved backwards or forwards on a pair of railroad tracks to bring the subject to be copied into the proper focus of a lens 3 feet long and 13 inches in diameter.[255] But the year's most important invention (patented on February 24) was a new "solar camera" developed by David A. Woodward, a professor of fine arts at the Maryland Institute in Baltimore. This device collected the sun's rays with the aid of a reflector and focused them powerfully through a condenser and copying lens onto a conventional-size negative, amplifying and projecting the negative after that onto a large sensitized sheet of photographic paper. But since it was impossible to use a solar camera in the absence of sunshine (and because the enlarging process itself was time consuming), the instrument never became an adjunct of every photographer's studio. Instead, the process of making enlargements with solar cameras became in time the province of a specialized new breed of "solar printers" (see page 192).

Prof. Woodward is not known to have experimented in photography previously, and said the idea for his camera originated from his desire to make enlarged copies of photographs on canvas in order to be able to paint portraits over them. He had his detractors, however, among them Charles Seely, who co-invented a "Megascopic" solar camera which did not use a condenser. Stating that he considered the Woodward patent "of little moment," Seely contended that, "with a lens of nine inches diameter [the Woodward camera was supplied with condensers of either nine or five inches diameter], refractory metals may be melted, and ordinary combustibles readily ignited." Further, he asked: "Who has not heard of solar camera boxes being set on fire and other damage done? Who would long trust a valuable camera tube in such a heat? Accidents from fire may be prevented, but the injury to the tube is certain."[256]

But while the *Scientific American* praised Seely's camera design, Woodward obtained a continuing series of patent renewals for his camera in the 1860s and 1870s, and his invention sparked development of other new cameras with condensers which could be operated unattended on rooftops. In 1859 he traveled to Europe to promote his camera, and after giving a demonstration to Antoine Claudet in London, the latter termed Woodward's camera "one of the most important improvements introduced into the art of photography." The Austrian court photographer came to London to see what it was all about, and subsequently adopted the use of the camera himself. Woodward also visited Thompson and his partner, Robert Bingham, in Paris, selling them the rights to his patent for France and Belgium for 5,000 francs. Woodward followed one of the customs of the time in providing only his customers with information as to his suggested mode of solar printing, with the predictable result that others published their particular methods of operating a Woodward camera—methods which did not always meet with the inventor's approval. In June 1859, however, Woodward wrote to Snelling giving this scant bit of information:

> I am constantly using one of the large size Solar Cameras, with plain salted paper, or with that which is albumenized. The longest period of time consumed seldom exceeds one hour of good sunlight, and often not more than 45 minutes for a life-size print, and much less for a cabinet. It must be understood that this is in the production of prints not to be retouched or afterwards painted. By a much more sensitive process the time of exposure can be reduced to from 3 to 5 minutes. The latter process is intended generally for pictures that are afterwards to be painted.[257]

The first American photography manuals covering the practice of the collodion "wet-plate" process appeared this year. These included Humphrey's *Practical Manual of the Collodion Process,* published in New York, and the Charles Waldack and P. Neff manual, *Treatise of Photography on Collodion,* published in Cincinnati. Snelling also published two American eidtions of T. F. Hardwich's *Manual of Photographic Chemistry* (originally published in London), which included the collodion process. Wet-plate photography allowed of many formulas for preparing the collodion, most of them mixing an iodide (of potassium or cadmium) with the viscous collodion; others, a combination of bromide with the iodide. A method using iodide of potassium is described in the brief excerpt (see page 130) which relates the steps a photographer afterwards took to prepare a collodion negative. No committee of American experts appears ever to have been formed to sanction a particular mode or series of modes for collodion practice; however, in 1859 such a committee was appointed by the Royal Society in London. This committee thereafter gave its approval to Hardwich's methods among several other modes favorably reported by individual committee members.[258]

Negatives prepared with collodion were more sensitive and more stable than those prepared with albumen (requiring seconds instead of minutes for an exposure), and this proved to be a boon for making large-size photogrphs. Snelling, for example, in offering a size 18 x 22 salt print of the Equestrian Washington Monument in New York's Union Square to his readers free of charge, asserted: "This offer has never before been made in the publishing line. A year ago it would have been considered a piece of madness." Another who began making large-size photographs at this time was James Landy of New York, later prominent in Cincinnati. His first series were views of size 14 x 17 of all the points of interest on the Hudson River made historic by Washington Irving and Nathaniel Parker Willis. He followed these with views of similar size of Niagara Falls and Washington, D.C. England's largest publisher of English and foreign views, Francis Frith, did some of his finest early

This view of the Equestrian Washington Monument in New York's Union Square has been reproduced from a salt print which was bought at a New York auction in 1952. It was probably made by H. H. Snelling, who offered similar photographs of the monument and Union Square scene in size 18 x 22 inches to the readers of his *Photographic & Fine Arts Journal* in January 1857, free of charge. The palatial homes depicted to the right and the building in the rear have long since been torn down, and the monument itself has been relocated in the park to the left. At the time the view was made, the Vanderbilts were building new mansions ''uptown'' at Thirty-fourth Street (twenty blocks north), and the Astors maintained a country estate near what is now East Eighty-eighth Street and the East River. The year 1857 was something of a turning point in photography from the standpoint of the ability of photographers to make large prints. Mathew Brady and Jeremiah Gurney, for example, entered into their first competition to make enlarged prints with the aid of solar cameras for display at the 1857 American Institute Fair in New York. New cameras were also becoming available, able to handle mammoth-size negative plates. John Whipple and J. W. Black sent photographic portraits of size 18 x 22 inches to Snelling in January 1857, which were said to have been made from life by a camera. At about the same time, James Landy made a series of views of size 14 x 17 inches of scenes along the Hudson River which had been popularized in the writings of Washington Irving and M. P. Willis.

1857

124

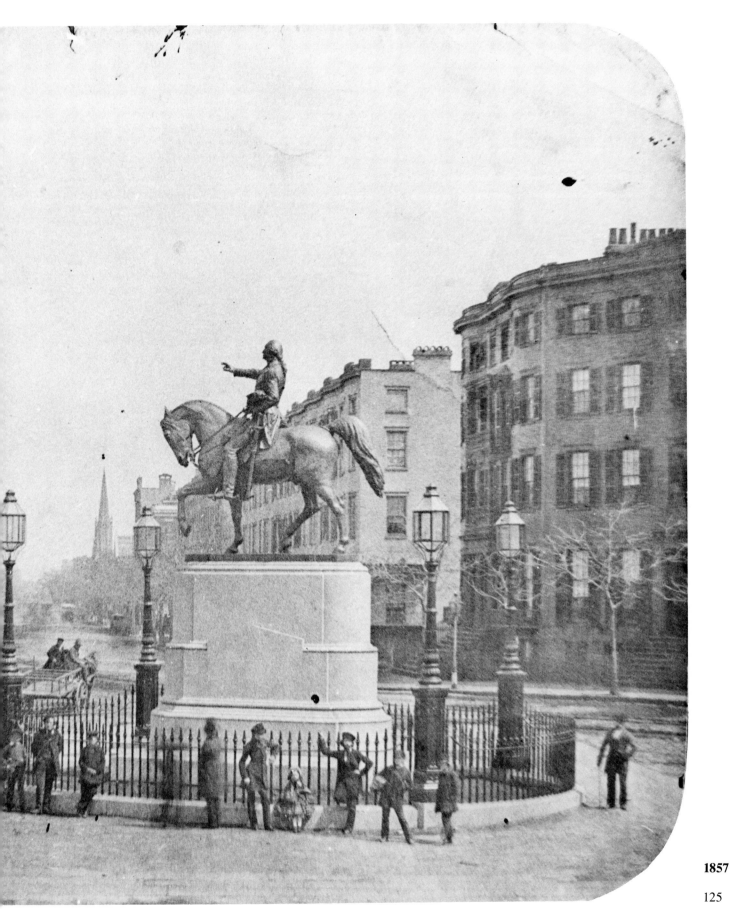

1857

125

COLLODION PROCESS

This capsule explanation has been taken from one of the first American manuals on collodion photography, published in 1857. Exposures by this time ranged from three to thirty seconds, depending on light conditions. Good judgment in timing would prevent grayish pictures (from too long an exposure), or overly positive pictures (from too short an exposure).

What is generally known as "Iodized Collodion," is a gun cotton solution, in which has been dissolved a certain quantity of an iodide or a bromide: the iodide of potassium for instance. If a glass or melainotype plate be coated with this iodized Collodion, and after being "set" by the evaporation of the greater part of the ether, be then dipped into a solution of nitrate of silver, the iodide of potassium and nitrate of silver will decompose each other and produce *iodide of silver*, which will be retained on the plate by the fibers of the collodion. In this state, the film will present a blue, white, or creamy opaque appearance, according to the quantity of iodide of potassium dissolved in the plain collodion. This operation must be done in a dark room by the light of a candle. If we now expose this plate in the camera, the iodide of silver will be impressed by the rays of light, strongly in the clear parts, to a smaller extent in the darker. If we examine the plate at this moment, we find it to have the same appearance as before, presenting no trace of an image. To bring the image out, we have to submit the plate to the action of certain compounds called developers. In the Daguerreotype process, the developer is the vapor of mercury; in the collodion process, it is a solution of protosulphate of iron or of pyrogallic acid in water. If, then, we pour one of these developers on the plate, the image will make its appearance in a short time, presenting the most intensity in those places where the light was the strongest. This image is formed by metallic silver in fine powder retained on the plate by the film of collodion. At this period of the operation, we have thus on the plate metallic silver, and iodide of silver that has not been reduced by the subsequent action of the light and the developer. That which remains to be done is to take away this iodide of silver by dissolving it in a solution of cyanide of potassium, or of hyposulphite of soda.[259]

work in Egypt, Nubia, Palestine, and Syria in the latter half of the 1850s, and this description of his handling of the large negatives at his Reigate printing establishment, recalled later by Hardwich, is indicative of the "dexterity" which collodion operators had to develop in working with large negatives at this time:

> Frith had at that time a photographic omnibus replete with every convenience. His plates were so large that when I first saw him developing a negative it looked to me like a man balancing the top of a small table on his fingers and pouring a jug of water over it. I was anxious to see whether he would ever get the developer back again into the vessel without spilling; but this feat he accomplished with much dexterity.

In New York, Mathew Brady and Jeremiah Gurney were first to enter into a competition to make large-size prints by the collodion process for exhibition at the 1857 annual fair of the American Institute. The prints were costly to make, and each man went about making them by a different mode, as this excerpt from a later reminiscence by E. T. Whitney reveals:

> The first year that the solar camera was introduced there was great rivalry between Brady and Gurney as to who should make the largest and best solar print for the American Institute fair. Unknown to each other, both were working in different ways to accomplish the object. Fortunately, I happened to be in New York at this time, and went from one gallery to the other to witness the operation at the same time keeping the secret. Brady prepared his paper for a life-size group of three. He floated his paper in an immense tank of gutta percha, 7 feet long by 5 feet wide, on a "silver wave" that cost $100.00. Gurney spread his silver on the paper with wads of cotton. His subject was a life-size figure of a lady. Brady's group took the prize.[260]

H. H. Snelling severed his association with Edward Anthony in January 1857 and began devoting full time to publishing the *Photographic and Fine Art Journal* (the new name for his journal adopted in January 1854). He also commenced making, himself, all of the prints (usually from negatives supplied by others) which were prepared in quantity and inserted by hand in all copies of each issue mailed to his subscribers. He soon found that "different papers require different treatment even with the same formulae. The same degree of intensity in printing on Marion and Canson papers," he observed, for example, "produce entirely different results. In the latter, the shadows dissolve out—in the toning bath—more readily and require closer watching; while in the former they are slow in changing, and are rather inclined to become milky and opaque instead of clear and transparent in the same length of time." These problems possibly account for the difference in sharpness or luster of individual prints to be found in the relatively small number of copies of the *Photographic and Fine Art Journal* which have survived to modern times.

Another bugaboo was the varnish applied to the glass negative after it was "fixed" in its hypo, washed, and dried. Snelling found that it would wear off, and the collodion would sometimes blister. J. W. Black encountered similar problems in Boston, and wrote Snelling that he found that this happened when the glass was not perfectly clear. He also observed that the negative film would sometimes detach itself from the glass, even before varnishing,

Photographic services at tourist resorts in the United States probably date from 1853 when a man known today only as "Mr. Babbitt" was granted a monopoly to take daguerreotypes of tourists visiting Niagara Falls. By 1857, the ambrotype was widely adopted as a cheaper mode of taking photographs of tourists, and while the specimen shown above may be an ambrotype taken by Babbitt, it is similar to an ambrotype by S. Davis owned by the International Museum at Rochester, New York, which shows tourists posing in the same or a similar carriage at Niagara Falls.

"in the dark parts of the picture where the light has had but *little* accession." This allowed portions of the picture to contract and expand, and when the negative was used to make prints under varying weather conditions—hot, cold, damp, or dry—the picture would actually split off from the glass. Black said he had found that "some varieties of collodion are much more liable to this kind of accident than others," but he did not specify the varieties to which he alluded. He did, however, specify a homemade recipe for making a tough varnish which was not susceptible to scratching, and when applied to a "good" collodion film on the glass, would adhere permanently. "I have never had a single picture crack up or darken by exposure," he said, adding that he had used some negatives to make as many as five hundred prints, and that many were at least three to four years old.[261]

Ellicott's Mills, Md.

THE CARD STEREOGRAPH COMES INTO VOGUE

A series of "American Stereoscopic Views," issued in 1858 by the Philadelphia photographers Frederick and William Langenheim, signaled the beginning of the card stereograph bonanza in the United States. The Langenheims began importing foreign-made views, and were joined in competition by Edward Anthony, D. Appleton & Company, and George Stacey, all of New York. The view of Ellicott's Mills (above) bears the Langenheim name on the face of the card, which is characteristic of this early series. Ellicott's Mills was the principal industry in what is now Ellicott City, located four miles west of Baltimore. An unknown number of other photographers sold small numbers of card stereographs at this time, and such views are now quite rare. The Beckel brothers of Lockport, New York, secured the view of New York's City Hall (below) before a fire, which was touched off at the ceremonies of the Atlantic cable laying in 1858, destroyed both the clock tower and the circular cupola behind it. In the rebuilt tower, as it stands today, the clocks are no longer contained in the dome, but will be found in the windows beneath the dome.

BECKEL BROS.

1858

On August 1, 1858, the following notice appeared in the "Editorial Miscellany" columns of Seely's *American Journal of Photography:*

> Stereoscopes are at last coming into vogue with us, and we are actually getting up a taste for them. This may be somewhat owing to the price, since they can be bought for $1.50 a dozen. It were strange indeed if many parlors were without them; what is better adapted to enlarge the attention of a visitor whilst temporarily delayed, waiting for the appearance of the lady of the house? What a better interlude during an evening party than to fill up a pause with a glance at a fine steroscopic view? Certainly, nothing better displays the beauties and marvels of the Photographic Art. . . . It is a good sign that the taste has commenced in the right direction—Landscapes, Architecture and Composition.[262]

The start of photography's great nineteenth-century bonanza was at hand. Never before had pictures been taken on such a vast scale to be sold commercially by the number. Paired photographs made by the daguerreotype, ambrotype, and calotype processes had enjoyed only limited sales up to this time, and even the card-mounted stereoviews of Pennsylvania and upstate New York scenery sold by the Langenhiems in 1854 are now extremely rare items. But the series of "American Stereoscopic Views" (see illustration, left) which the Langenheims issued in 1858 started the ball rolling. Within a year, Edward Anthony placed a set of 175 different stock views on the market, and was joined in competition by two other New York publishers, D. Appleton & Company and George Stacey. In 1859, too, the English photographer William England made a series, "America in the Stereoscope," for the London Stereoscopic Company, which were the first views of American scenery and architecture to be published abroad commercially. Among the first card stereographs placed on the market were such items as a Langenheim stereoview of the construction of the dome on the U.S. Capitol building in Washington, D.C.; an Anthony series of the yacht regatta in New York on July 4, 1859; a series of views of the steamship *Great Eastern* by Stacey; a train crossing the bridge over the Niagara River, and Blondin walking a tightrope over the Niagara Falls by William England.

The card stereograph revolution was by this time farther advanced across the Atlantic. The London Stereoscopic Company already boasted a stock of one hundred thousand commercially available titles. In 1857, Francis Frith had made two series of a hundred stereoscopic views in Egypt and the Holy Land, which, after they were published by Negretti and Zambra, prompted the London *Times* to comment editorially that the views were "the first serious and worthy effort that has been made to develop the educational uses of the stereoscope in an artistic, geographical and historic point of view."[263] By 1858, card views of many of the architectural gems of Paris had been recorded for stereoscopic viewing by Theodorine d'Harcourt.

Although it is not known how many, there were other photographers besides the Langenheims and the New York

Alexander Beckers patented a stereoscope in 1857 which allowed hand rotation and viewing of card stereographs in sequence, and the device shown above is a later version of this basic design. Stereoscopes soon became available in a variety of configurations as the card stereograph boom increased. Table-model versions of the type above could hold up to three hundred cards mounted in blades, which could be viewed through the eyepiece by rotating a knob or handle on the side of the device. Beckers gave up his photography business in order to become a manufacturer of stereoscopes.

publishers who began making stereoscopic views in this early period. The Beckel brothers of Lockport, New York, for example, secured what may be one of the earliest surviving photographs of New York's City Hall (see illustration, left). The stereoview was taken at some point prior to 1858 when the original clock tower (now replaced) was destroyed by fire. In September 1858, Seely's journal gave this brief report on P. C. Duchochois' stereophotography activity:

> Our correspondent Mr. P. C. Duchochois has returned from a very successful photographic tour in New Jersey and Staten Island. His stereoscopic pictures as photographs are among the most perfect we have ever seen. . . . Few are aware of the beautiful natural scenery we have almost in our midst. We believe American views will soon be in demand, and that people will be convinced that every branch of photography is as thoroughly understood here as abroad.[264]

Many of the earliest American card stereographs which have survived are of a quality equal to those which came later; yet H. H. Snelling, writing in December 1858, said the majority of American-made cards, as well as those im-

ported from France, "are perfect failures—abortions—and if continued on sale to the public must eventually produce for them disgust in the public mind. They indicate that the makers of them consider it only necessary to plant their camera stand, point their double tube box at an object, secure two pictures on the same glass or paper slide, and put them into market, and all necessary work is done." Snelling said he felt that "no true artist" would use a double tube or stereoscopic camera because he considered the results from a single camera positioned twice for the same view "more perfect in every respect." He also doubted that it would be possible to produce a pair of lenses for a stereoscopic camera "so completely identical as to give pictures precisely alike and at the proper angle."

N. G. Burgess, author of *The Photograph Manual* (originally published as *The Photograph and Ambrotype Manual* in 1855), felt that a camera with a single lens was better for still life, statutory, or architectural photographs, but that a stereoscopic camera was needed for "instantaneous" views capturing people or objects in motion. Otherwise, the peo-

ple or objects in motion would appear differently on the two slides obtained, or might even be out of the picture entirely in one case or the other.[265]

Having called attention to the needs of people who wanted to take up photography as an amateur practice, George B. Coale published a *Manual of Photography* in 1858 through the firm of J. B. Lippincott & Company in Philadelphia. This appears to be the earliest manual prepared in the United States for the amateur market. In it, Coale devoted a considerable number of pages to Whipple's albumen process, which he said "appears to surpass Collodion in the capability of rendering depth and transparency of shadow, and details in shadow contrasted with high light." He said further:

> It is, under the names of "Whipple's Process," and "The American Process," largely practiced in England, and affords, perhaps, above all others, the greatest attractions to the amateur. No other is more capable of being practiced in hours of leisure occurring at uncertain periods. Plates properly prepared retain their virtue for a long time unimpaired; the tourist is encumbered with only his camera, a box of plates, and exposure frame, and a dark bag in which the plates may be adjusted to the frame, and afterwards returned to the box; the development after exposure is the work of leisure hours that may be waited for without hazard to the result of the labor undergone. For landscape Photography it is especially adapted; extreme distance and all the gradations of distance being rendered with wonderful fidelity and beauty.

The best plates for amateur practice, Coale maintained, were the "French full" size measuring 8½ x 6½ inches, which he said were almost universally used by English and French amateurs, and were easy to manipulate and more portable than plates only a few inches larger. French and German window glass was preferable to American window glass, he said, because the latter was "too brittle to be always relied on." Coale still regretted, as he did when he wrote to *Humphrey's Journal* in 1856, "that so little of the apparatus adopted peculiarly to the amateur practice of Photography is supplied, as yet, by the manufacturers of the United States," but he recommended Anthony's portable field camera and Harrison's landscape lenses. With regard to the advisability of using either plain or albumenized paper for print making, he offered these comments:

> The first point upon which judgment and taste are to be exercised is in the choice between plain and Albumenized papers. Landscapes upon plain paper possess more of the characteristics of fine drawings in India Ink or Neutral Tint. They appear to be preferred by the English amateurs, who regard them as more artistic and expressive. Prints upon paper which has received a fine coating of Albumen surpass them in sharpness of details, and in brilliancy of color. They present a highly glazed surface, and are ascertained to be more permanent than prints on plain paper. The Photographers of France and Italy appear to use it almost exclusively. Of all the various kinds of paper offered for sale in this country, the Saxony Paper (papier Saxe) will be found the most invariably good in quality and free from defects. It gives the best results when used plain, and is also excellent for Albumenizing. It is procured in sheets measuring 17½ x 22½ inches, cutting into six pieces of the size adapted for our negatives, with a small margin. The papers of Marion and Canson are good in quality, but the writer has never seen in the Photographic Depots a sheet of either plain or Albumenized French

Published in 1858 by J. P. Lippincott of Philadelphia, this manual by Baltimorean George B. Coale is possibly the first American photography manual aimed at the amateur, as opposed to the professional photographer.

paper, which was *entirely* free from belmish. All that comes to this country seems to have been picked over. Occasionally a small lot of Albumenized paper of superior quality is specially imported.

As an alternative to the use of Whipple's process, Coale said Le Gray's waxed-paper process also "offers great attractions to the amateur," although it was "inferior to Whipple's process in sharpness of detail and in rendering of distant objects," and required "a tedious length of exposure." But he cited these advantages:

> It is admirably adapted to large masses. Buildings, Rocks, Trees without foliage, with details of foreground. It also has the advantage of greater portability; a portfolio of paper being substituted for the box of plates, and an adjustment to the camera for the exposure frame. With the exception of waxing the paper, an operation which requires care with some skill and experience, the details of the manipulation are so simple and mechanical, as scarcely to admit of failure, except through carelessness and uncleanliness. It requires also a smaller amount of chemicals and laboratory apparatus than any of the previously named methods.[266]

D. D. T. Davie was another advocate of Whipple's process. He was one of the few American photographers to publish his thoughts and methods of operating during the 1850s, and he authored several copyrighted articles which appeared in Snelling's journal in 1857. With respect to the albumen negative process, Davie said its advantages lay in the fact that any number of negative plates could be prepared at one time and then developed after use at the photographer's convenience; that the views secured by the process were unquestionably sharper and exhibited "well defined outlines"; and that because of the hardness of the albumen film on the glass plate, it could scarcely be scratched even with the point of a knife.[267]

Coale's statement that the developing agent "most commonly used" in bringing out the image of a glass negative in the darkroom was photosulphate of iron is at variance with one made by Edwin Musgrave some eight years later in Seely's journal. In 1858, according to Musgrave, "pyrogallic acid was considered to be the only correct developer for negatives, the iron developer being only considered suitable for glass positives." The reason for the switch to the iron developer, he said, was that pyrogallic acid had a tendency to produce excessive hardness and a loss of delicate detail in pictures so developed unless it was very skillfully used. But in the 1850s, intensity was what was wanted, according to Musgrave. "Unless the sky in a landscape negative was as black as your hat, the negative was considered to be inferior; and various plans, such as painting out with black varnish, were resorted to, to produce white paper skies, without which no landscape photograph was considered perfect." In any event, when John Werge went looking for some pyrogallic acid during his visit to the United States in 1860–61, the only place he could find any was in Anthony's store stowed away with a "Not Wanted" sign on it.[268]

Coale also maintained in his manual that cyanide of potassium was as universally used as hyposulphite of soda in the final darkroom operation in which an image was rendered permanent. But the cyanide of potassium was evidently injurious to the photographer's health, as this report by Franklin B. Gage in December 1858 reveals:

JEREMIAH GURNEY

For years, Jeremiah Gurney (above) and Mathew Brady vied with each other for top honors at photographic contests, and in their promotional feats. When Gurney moved further uptown in the fall of 1858, Seely published a description of the new gallery, from which this has been excerpted:

> Photography has become so great an institution in this City that it builds "marble halls" for itself. GURNEY has just opened, at No. 707 Broadway, a sort of Photographic palace which he has erected for the purposes of his business, and with a special view to its requirements. Discarding the practice of sending customers up three or four flights of stairs to an operating room which the sun can get at, he receives them in the ground-floor—shows them his pictures, cases and so forth, takes their orders and passes them forward to his main gallery, on the floor above, from which they enter upon a ladies dressing room on one side, and an operating room on the other. This latter apartment is provided with side-lights and roof-lights, so that in the event of his having a customer more "wrinkly" than usual—in which case the roof-lights, are insufficient—GURNEY usually smoothes down the creases with the side-light, and somewhat rejuvenates him by the process. When the operating rooms below are full, which would seem to be a common occurrence at this establishment, there are others on the next floor, which are, however, mainly devoted to the artists, who are there, in great force, to finish the photographs. These are taken of all sizes, from the "locket minature" to the "life," sometimes containing only the face, at others giving the bust also, and not uncommonly the whole form, of the size of life.
>
> Of the various "types" which are more or less advertised, GURNEY confines his operations to the Daguerreotype and the Photograph. He objects to the Ambrotype on the ground that it is not durable, which is another proof of the way in which even Doctors will disagree, since BRADY declares the Ambrotype to be the most durable picture made.[269]

URBAN PHOTOGRAPHY

In 1855, James McClees began making large photographs of historic and new buildings in Philadelphia, which he then sold to the general public in competition with prints made by lithographers or engravers. But the practice was little repeated elsewhere in the 1850s, and the size 16¾ x 14¾-inch albumen print made probably the same year (1855) of the Maryland Steam Sugar Refinery in Baltimore (right) was probably secured not for public sale,

Having had my attention called to this matter by sudden and unaccountable inflammation of the throat and mouth, accompanied with dizziness and great difficulty of breathing, I instituted a series of experiments and inquiries to ascertain if the sickness was caused by this chemical. After my recovery I laid the potassium aside for four weeks, using hyposulphite of soda instead. Having occasion to make a picture extremely white, I tried the cyanide of potassium for fixing the impression. Although not exposed more than one minute of time to the weak fumes, I felt an immediate return to the symptoms of the dizziness and inflammation. One subsequent trial, three weeks after, produced the same effect; and I have since fully resolved not to use it at all in future. I then commenced making inquiries of other operators; and, out of twenty, I found five who had been extremely sick with the same description of disease. Ten more, of the twenty, had felt the symptoms I describe; the other five did not know whether they had experienced any bad effects from its use, as they had not been long in the business, and never had thought about it.

On one occasion a lady accidentally got a silver stain on her finger, and I gave her a lump of the potassium to remove it with. The fumes produced such instantaneous and extreme prostration that she had to be carried from the room. I have been accustomed to fix my pictures where my customers could watch the operation as a matter of curiosity, and I recollect many instances where they spoke of *feeling queer* from the effect of the fumes. 270

1858

132

Despite earlier experimentation by others, James A. Cutting and his Boston partner, Lodwick H. Bradford, were the first to secure a U.S. patent for a photolithography process on March 16, 1858. Joseph Dixon, a perennial inventor in many fields, had been somewhat successful as early as 1840 when he coated a stone with bichromate of potash, exposed the stone in a camera (as he was then doing with daguerreotype plates), and secured a rudimentary form of photolithographic printing plate. He did not continue with these experiments, however, and waited until 1854 to publish an article concerning them in *Scientific American*. The Duval lithographic printing company in Philadelphia had also conducted photolithography experiments in 1857, indicating "probabilities of success" in future.

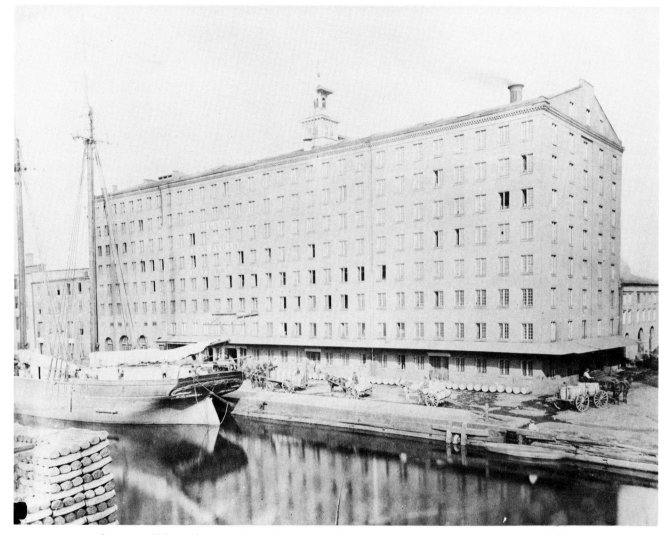

but as an aid in making engravings of the refinery. Several engravings have survived, and the one left is reproduced in an 1873 history of Baltimore. The photograph of the refinery, which was found in a Cockeysville, Maryland, antiques store in 1972, is probably one of several made from different vantage points, since the engraving was drawn from a different angle. To a public used to colorful lithographs or doctored engravings of their buildings and monuments, the somewhat duller appearance of a photograph (whether a salt print or a glossier albumen print) caused them to be valued less highly, with the result that few pictorial records exist today of American metropolitan centers prior to the Civil War.[271]

Humphrey was ecstatic over the new discovery, but failed to describe it very clearly. Snelling described it in these words:

> This particular process for transferring the photograph to stone is the joint invention of Messrs. Cutting and Bradford. The impressions here given are taken direct from the stone, without any retouching, the transfer to the stone being made from a glass negative in the same way as other positive prints. The impression so obtained is afterwards prepared so as to take the lithographic ink, and the prints are taken off the press in the same manner as any other lithograph. The advantages, both to art and business, of this method of executing pictures, are very numerous. . . . Specimens of photo-lithography have been occasionally shown, which were very fair; but the processes were not sufficiently developed to produce the perfection required by

art. This process . . . may be considered a decided step forward in this branch of art.[272]

Only the *American Journal of Photography* reacted negatively to the invention. Henry Garbanati, writing in the journal, described it as "scarcely an improvement, but by being more generally known by being patented, than Mr. Dixon's mode, simply answers the purpose of placing this branch of the art in exclusive hands." Garbanati also indicated that the patent award was as much a reflection of the inadequacies of the U.S. Patent Office as it would be a new bone of contention for the photographic community:

> The practice of the Commissioners granting to almost all who apply, patents for the products of other mens' brains, because of some trifling, and perhaps, valueless variation, is

1858

HOBNOBBING WITH THE FACES OF CELEBRITIES—AT BRADY'S GALLERY

Noting that "no feeling is more common everywhere than a desire to see great or famous people," a *New York Times* reporter went to study their faces at a photographic gallery.

It is not, however, always possible to see many great men together, but as it is quite easy to see their portraits, which answer the purpose almost as well as the originals, we went to Brady's gallery in Broadway a few days ago, expressly to pass an hour in an inspection of the features of the numerous people of note whom Brady keeps "hung up" in photograph. We found the amusement agreeable. It is pleasant, after reading what Senator [John P.] Hale [of New Hampshire] said, to look at the features of the man who said it. When we hear that Senator [James M.] Mason [of Virginia] has been pitching into Senator [William] Seward [of New York], it is agreeable to inspect the features, in a state of placidity, of the two belligerents. So also, when we learn that the President [James Buchanan] has been doing something tricky and evasive, it is not bad to have one's surprise immediately removed by a glance at the corresponding expression of features in the portrait of that venerable man. For the President is there—at Brady's—and almost opposite to the master stands the man, in the person of James Gordon Bennett, whose pleasant features excite in the portrait, the same sensations of doubt suggested by the inspection of the original, as to the actual direction of his visual orbs. Our affectionate Brother [Horace] Greeley is also there, the malicious photographer having placed him side by side with his affectionate Brother Bennett, just mentioned. Brother [Henry J.] Raymond [publisher of the *New York Times*] is also in the collection, and faithfully rendered to the last hair of his moustache. We sought in vain for Brother [James W.] Webb [publisher of the New York *Enquirer*], who begins to appear in plaster with great frequency as a sign for image makers in the side streets; he shines not at Brady's. The most striking picture now in the gallery is that of John C. Calhoun, a half-length portrait, photographed, life-size, from a daguerreotype miniature, and finished in oil. It is a beautiful piece of work, and wonderfully life-like. The ragged, wiry character of the face, marking nervous energy—the overhanging brow and broad intellectual development,—all mark Calhoun at a glance. We found, also, Mr. Speaker [James L.] Orr—a right proper, staid sort of gentleman, with an expression of countenance speaking loudly of red tape. Then we have the high and mighty General Lewis Cass, Secretary of State, etc., etc., with that peculiar "shut-up" case of countenance, which belongs to the high and mighty diplomatist. Mr. [John C.] Breckinridge, the Vice President, occupies a prominent place in the gallery—a gentlemanly but rather disputive face, with a nose somewhat of the Edwin Forrest [the actor] pattern. . . . Gov. [Henry] Wise [of Virginia] is also present in photography, with the decidedly *prononcé* face belonging to the Calhoun class—and near him is our beloved President, sunk into his chair—James Buchanan, with the "buck" forehead thrust forward, and his eyes a long way behind, peering at you from ambush as though it is not a delight to the old gentleman to look anybody in the face—the features expressing a strange mixture of obtuse stolidity and sharp cunning. . . . The great financiers are represented by Erastus Corning, two of the Messrs. Brown, of Wall Street, and Cornelius Vanderbilt—commonly called by persons who desire to impress you with their intimacy with the great, "Kurnele Vanderbilt"—whose portrait, by the way, is one of the best-looking in the gallery; there is an air of aristocracy about the face which does not altogether accord with the "Kurnele's" beginnings, but there is also a shrewdness which is quite in keeping with the little trifle of $50,000 a month which the Commodore is said to receive as a bonus for not running his Nicaragua steamers.[273]

James A. Cutting of Boston, the great adversary of American photographers in the period from 1854 to a year following his death in an insane asylum in 1867, is pictured above in the five-hundredth impression of a photolithograph made in 1858 at the time he received the first U.S. patent with co-inventor Lodwick H. Bradford for an American photolithography process. Photolithography was little used after this, however, for reproduction of human likenesses in books, magazines, or newspapers.

becoming of so serious a matter, that it almost necessitates a "Vigilance Committee" to examine into the various claims No branch of industry has suffered more than the photographic, and it is really worthy of consideration whether its members should not subscribe to a general fund for mutual protection in keeping open all the various channels of improvement in the art.

Messrs. Cutting and Bradford, in applying for a patent for the simple use of sugar and soap in photo-lithography, either must have carefully eschewed all publications detailing the progress of their art, not to have known that the same results were obtained both here and in Europe before their claims; or, anxious to originate something themselves, have plodded over the well beaten track, and taken a vast deal of trouble to arrive at the point they might have started from; nevertheless as they have claimed, on the use of the sugar and soap alone, it would appear as if they were cognizant of the previous success of photo lithography.[274]

It appears that there may have been some connection between Cutting and the Duval firm in Philadelphia. The five-hundredth impression of the lithographic likeness of Cutting (shown above) turned up in the estate of James F. Queen, who served as Duval's chief artist. But an exhaustive study of lithography in Philadelphia in the nineteenth century has failed to uncover evidence that Duval engaged in photolithography to any extent. Nor is it known to what extent it was practiced by Cutting and Bradford. But in 1872, five years after Cutting's death, Bradford and Cutting's estate administrator obtained an extension of the 1858 patent.[275]

1859

In the spring of 1858, Edward Anthony told a meeting of the Mechanics' Club in New York that he doubted the practicability of forming a photographic society, then being talked about, because the "practical operators," he felt, had tried on several occasions to unite, but "there was no harmony." Amateurs, he said, could not spare the time.[276] Nevertheless, on February 22, 1859, about forty invitations were sent out to a list of "photographic amateurs" to participate in the organizational meeting of such a society which would be held four days later at the American Institute. The invitations were signed by eight men: Charles A. Seely, Henry H. Snelling, Joseph Dixon, P. C. Duchochois, Lewis M. Rutherford (the noted astrophysicist and early experimenter in astronomical photography), Alex H. Everett, John Campbell, and Benjamin T. Hedrick.

The organizational meeting was held, as scheduled, and a number of speeches were delivered citing the existence of a growing number of European societies and the need to make the American society "popular"; the importance of encouraging and making more popular the study of chemistry; and the opportunity to enlist membership among amateur photographers "of education and leisure," who seek further knowledge and instruction in the photographic art. A. W. Whipple of Brooklyn was named chairman at the organizational meeting, and committees were appointed to draw up a constitution and a set of bylaws.

Two additional organizational meetings were held in March at the newly completed Cooper Institute, after arrangements were made with the inventor and philanthropist Peter Cooper to hold these and subsequent meetings there.

At a March 26 meeting the new society was formally constituted as the American Photographical Society, and a slate of officers was elected which included Prof. John W. Draper as president; Lewis M. Rutherford, Dr. Robert Ogden Doremus and Henry H. Shieffelin as vice presidents; John Johnson as treasurer; and A. W. Whipple and Isaiah Deck, respectively, corresponding and recording secretaries.

How it all happened is not recorded, but for the first time an interest in the practice and furtherance of photography had brought together some of the medium's earliest pioneers—men such as Draper, Johnson, Snelling, and Dixon; scientific men, such as Rutherford, Samuel D. Tillman (professor of science and mechanics at the American Institute), Amasa G. Holcomb and Henry Fitz, Jr. (foremost American manufacturers of telescopes), and Robert MacFarlane (editor of the *Scientific American*); and a group of men who could be characterized as some of the foremost business, professional, and social leaders of the day. Dr. Doremus was professor of chemistry and physics at the College of the City of New York (later a vice president of the institution until his retirement in 1903), and was later a founder of the New York Philharmonic. Among others who signed the constitution were Robert L. Pell, president of the American Institute; Mendes Cohen, superintendent of the Hudson River Railroad, and later a trustee of the Peabody

Institute in Baltimore and president of the American Society of Civil Engineers; James A. Roosevelt, founder of a New York banking firm, a director of the Delaware and Hudson Railroad, president of Roosevelt Hospital, and uncle of future President Theodore Roosevelt; Leopold Eidlitz, leading exponent of the "Gothic" revival style then popular in American architecture, and designer of such buildings as the Brooklyn Academy of Music and the State Capitol at Albany; and Cornelius Grinnell and Henry H. Shieffelin, the bearers of two of the oldest names in New York society. It is strange that the existence and activities of this society have remained so obscure, and that biographies of Prof. Draper, for example, fail to record that he was the founding president of the society, while recording his founding presidency of the American Chemical Society seventeen years later.

In Snelling's view, the existence of the new society would "prove to the world that we are not the mere mechanics in the business that we are deemed by many Europeans." Seely noted that "many scientific men were more or less engaged in Photography, and that it was only necessary for them to give expression to their views and labors through a society of this kind to place the art here in a position equally as elevated as in Europe." He also observed that not only were "the first scientific minds of the age" engaging in photography investigations in Europe but that "it had got to be quite fashionable, even the Queen of England devoting some of her leisure hours to its study and practice."[277]

The number of active photographers among the signees was not high. Those with distinguished careers (past or present) included Draper, James R. Chilton, Johnson, Fitz, Dixon, Burgess, Duchochois, Cady, Pike, and a newcomer, Napoleon Sarony. By June, membership in the society rose to a hundred, but in October, Seely noted in his journal that few other so-called practical photographers—just as Anthony, himself absent, had forecast a year earlier—had joined the body. In fact, Seely felt they would be "more out of place" in the society "than in any other spot they could find."[278]

The American Photographical Society not only survived but became the principal counterpart to similar bodies in a number of British and European cities. It continued to grow both in membership and stature, and in the 1870s it became the Photographic Section of the American Institute. Throughout its entire existence, it provided a major forum for the exchange of ideas, and the report of, or testing of, new discoveries in the photographic field.

The practice began at the society's first meeting on February 26, at which Duchochois presented a technical paper covering an entirely new mode of preparing more sensitive albumen glass negatives. At the society's third meeting, Samuel Wallin disclosed that another signer, Charles B. Boyle, had developed a commercially acceptable method of making photographs in wood, and that he (Wallin) had successfully applied the method to engraving. Two other pho-

IVORYTYPES

In 1855, John J. E. Mayall patented a method in England for printing photographic images on artificial ivory sensitized either with albumen or collodion (after which the photograph was hand-colored). F. A. Wenderoth, of Philadelphia, invented a method described later by Marcus Root as a photograph which was colored and sealed upon plate glass. Wenderoth gave no description of his process at the time he exhibited specimens at a fair of the Franklin Insitute, but in a letter to H. H. Snelling, dated May 3, 1859, he said he had sold the process for $250 each to Jeremiah Gurney and C. D. Fredericks in New York.

Other modes of making an ivorytype followed the "Grecian printing" process whereby the hand coloring was applied to the backs of pictures secured on transparent paper or glass. A popular version was one using two superimposed prints on paper. The front print was made on transparent paper, and coloring was applied to the back of this print. The second, or back-side print, was made on ordinary photographic paper and coloring was applied to its face. The two prints were then sealed together.

In the ivorytype specimen shown on this page the portrait has been secured on the back of a piece of thin oval glass (top left) to which coloring was applied to the eyes, cheeks, and tie. A second piece of oval glass of the same size (top right) was placed behind the first, allowing skin coloring applied to the back of the rear glass to flesh out the otherwise transparent facial features on the front glass. Black coloring on the rear glass also darkened the subject's hair and clothing. At right, you see the result when the two pieces of glass are sealed together.[279]

tographers who had earlier developed methods of using photography to make woodcuts were J. DeWitt Brinckerhoff and George N. Barnard (who exhibited pictures on boxwood at the 1857 American Institute fair). Most of the society's ninth meeting (on October 11) was devoted to a wide-ranging discussion of the problem and causes of faded photographs (a discussion which also alluded to evidence of daguerreotype fading, and possible methods of restoring faded daguerreotypes). Members used their new forum during 1859 to exhibit new advances in photolithography, improved enlarging and focusing apparatus, and even a French-made photograph on varnished cloth procured in France by Mendes Cohen.

The society elected to honorary membership such men as Nathaniel F. Moore, ex-president of Columbia University and an early amateur photographer; and T. Frederick Hardwich, the noted British photographer and professor of photographic chemistry at King's College, London. Dr. J. Milton Sanders joined the society in August, and George B. Coale became a corresponding member from Baltimore in July. There was much talk of establishing a museum of photography under the auspices of the society, and a committee composed of Johnson, Deck, and Hedrick was named to consult with Peter Cooper on the possibility of its establishment at the Cooper Institute. This scheme came to naught, however, when Cooper made the proviso that any museum established at the Institute would have to remain at the Institute thereafter. Proposals would continue to be made over the coming years, but no such museum would be established in New York for over a hundred years.

Among the more interesting demonstrations was a preview of a new electrical technique for instantly lighting a series of gas burners. The event took place on August 8, 1859, in the main hall of the Cooper Institute where there were 156 gas burners by Humphrey's count, and 168 by Seely's. Humphrey gave this description of the feat:

> After this [previous discussion] the members received an invitation from Mr. Wilson to examine an arrangement he had in the large hall of the Institute to light the 156 gas burners at once by means of an electric spark. After finding their way with some trouble along the dark stairs to the darker hall, the company was agreeably surprised with a sudden brilliant illumination of all the lights; a thin copper wire is conducted from one burner to the other, and so arranged that a little spark, one-sixteenth of an inch long, will fly over to the orifice of each burner, as soon as the gas is turned on. The electricity used is the secondary current of Ruhmkort's induction apparatus, with the improvement of Ritchie of Boston.[280]

The electric current and sparks were of particular interest to photographers, Humphrey said, "as their light is one of the best to obtain impressions from in the night." Several years earlier, he said, Brady had made some large negatives in the Academy of Music at midnight, using the light of electric sparks. Six months after this demonstration, Abraham Lincoln came to the same hall to deliver his famous Cooper Institute speech which he later said was a major factor in his election to the presidency in 1860. On the occasion of his speech, it was said that in the quiet of some moments, the only sound competing with Lincoln's voice was the steady sizzle of the burning gaslights.

THE SIGNERS

The sixty-two names affixed to the constitution of the American Photographical Society, adopted March 26, 1859.[281]

PETER COOPER,
JOHN CAMPBELL,
WILLIAM CAMPBELL,
HENRY FITZ,
ISAAC FITZ,
ISAIAH DECK,
CHARLES A. SEELY,
A. W. WHIPPLE,
P. H. VANDERWEYDE,
HENRY GARBANATI,
B. S. HEDRICK,
THOMAS D. STETSON,
LEWIS M. RUTHERFORD,
P. C. DUCHOCHOIS,
ALEX. BENJAMIN,
M. HASKELL,
O. J WALLIS,
JOHN JOHNSON,
SAMUEL D. TILLMAN,
H. H. SNELLING,
JOHN C. LORD,
PHILIP BOILEAU JONES,
JOHN W. HADFIELD,
N. GRIFFING,
ROBT. L. PELL,
N. G. BURGESS,
GEO. A. JONES,
WM. H. BUTLER,
CHAS. WAGER HULL,
F. W. GEISSENHAINER, JR.,
NICHOLAS PIKE,

JNO. W. DRAPER,
A. G. HOLCOMB,
LEVI REUBEN,
HENRY DRAPER,
CHARLES HADFIELD,
R. OGDEN DOREMUS,
BERN L. BUDD,
HENRY H. SHIEFFELIN,
CHARLES A. JOY,
A. H. EVERETT,
AUGS. WETMORE, JR.,
EDWD. PRIME, JR.,
CORNELIUS GRINNELL,
J. A. ROOSEVELT,
H. MEIGS,
LEOP. EIDLITZ,
JAMES R. CHILTON,
J. B. WANDESFORDE,
JOSEPH P. PIRSSON,
WILLIAM CHURTON,
JOSEPH DIXON,
ALFRED PELL, JR.,
ROBERT MACFARLANE,
WILLIAM GIBSON,
F. H. HARDCASTLE,
MENDES COHEN,
N. SARONY,
SAML. WALLIN,
CYRUS MASON,
JAMES CADY,
CHARLES B. BOYLE.

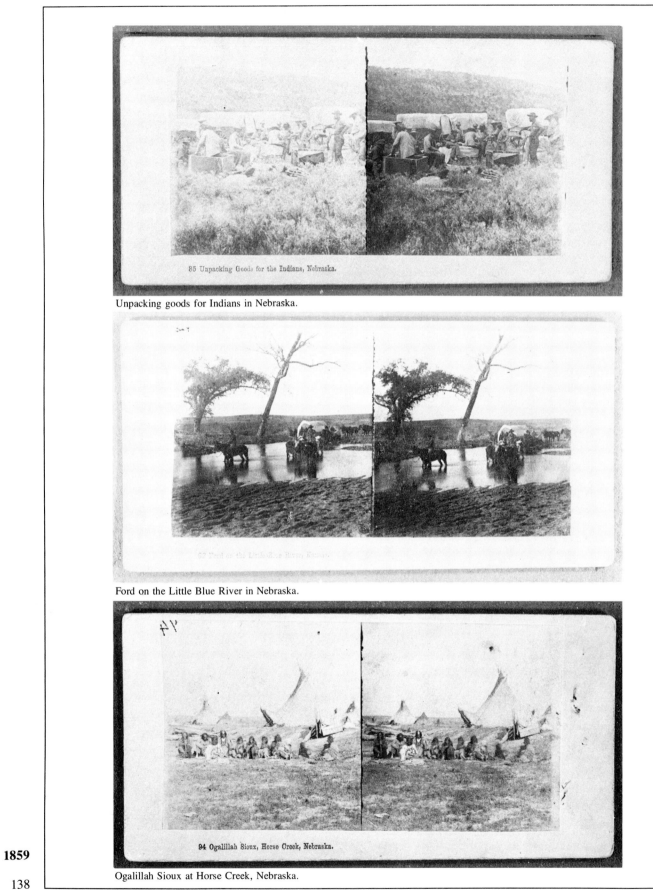

85 Unpacking Goods for the Indians, Nebraska.

Unpacking goods for Indians in Nebraska.

Ford on the Little Blue River in Nebraska.

94 Ogalillah Sioux, Horse Creek, Nebraska.

Ogalillah Sioux at Horse Creek, Nebraska.

ALBERT BIERSTADT SKETCHES,
MAKES STEREOVIEWS IN THE FAR WEST

A few daguerreotypes survive of the earliest government expeditions in the West, but the three illustrations (left) are from the first series of stereoviews made on an expedition in the summer of 1859 by Col. Frederick W. Lander, which had the purpose of relocating certain portions of a wagon route to the Pacific. The views are by Albert Bierstadt, earliest of the ''Rocky Mountain School'' of picturesque genre painters of the Far West.

Albert Bierstadt and his two brothers, Charles and Edward, were born near Düsseldorf in Germany, but grew up in New Bedford, Massachusetts. Albert early exhibited an avocation for painting, and in 1853 (at age twenty-three) he returned to Europe and studied art in Düsseldorf and Rome. During his stay in Europe, it is probable that he learned stereophotography from other artists who were then beginning its practice. In 1857, after his return to America, he explored the White Mountains in New Hampshire with a camera. Then, with S. F. Frost of Boston, he joined the Lander expedition to make sketches and photographs at his own expense. From somewhere in the Rocky Mountains, on July 10, he sent a letter to *The Crayon* which told briefly of his photographic exploits:

> We have taken many stereoscopic views, but not so many of mountain scenery as I could wish, owing to various obstacles attached to the process, but still a goodly number. We have a great many Indian subjects. We were quite fortunate in getting them, the natives not being very willing to have the brass tube of the camera pointed at them. Of course they were astonished when we showed them pictures they did not sit for; and the best we have taken have been obtained without the knowledge of the parties, which is, in fact, the best way to take any portrait. When I am making studies in color, the Indians seem much pleased to look on and see me work; they have an idea that I am some strange medicine-man. They behave very well, never crowding upon me or standing in my way, for many of them do not like to be painted, and fancy that if they stand before me their likenesses will be secured.

Bierstadt presumably traveled in his own wagon, heavily laden with glass negatives, darkroom materials, at least one camera, and artist's supplies. He went only as far as what is now Wyoming, then returned to New Bedford with an estimated one hundred to two hundred stereoscopic negatives to make paintings from his sketches by a method he had mastered in Germany. All three brothers thereupon formed a photography business, and in 1860 issued a sales catalogue offering fifty-two western views in glass and card stereograph form. The views were numbered, with gaps, from 53 to 136, suggesting that the negatives of missing photographs were not up to commercial standards. But it is possible that these were later published separately. In 1861, for example, *The Crayon* drew

Albert Bierstadt, circa 1870.

attention to publication by the Bierstadts of Albert's earlier views taken in the White Mountains.

In 1866, the Bierstadts sold their business, and during the 1870s, a castle-studio with thirty-five rooms which Albert built overlooking the Hudson River at Irvington, New York, became an American showplace, and he himself became a national celebrity. But then the castle burned in 1882, and in 1889 Bierstadt's work was passed over for the first time for an exhibit that year in Paris. After that he became a has-been, and at his death in 1902 he was all but bankrupt.[282]

"INSTANTANEOUS" STEREOVIEWS

Until 1857, when George Washington Wilson made card stereographs of people and carriages in motion on Princess Street in Edinburgh, views of city streets were customarily barren of human activity, as in the view of Broadway (left) printed by Snelling from a negative by L. E. Walker. Early in the summer of 1859, Edward Anthony issued his first series of "instantaneous" card stereographs, and sent several specimens to the editor of the *Photographic Notes* in London. "One of these views," Anthony said, "was taken as you will perceive when it was *raining,* and the *drenched* appearance of the sidewalks and carriage way is admirably developed in the stereoscope [reproduced below]. The sharpness of the moving figures is sufficient evidence of the quickness with which it was taken. The development occupied but one or two minutes."

In response to Anthony's request to know how his pictures compared with "instantaneous" views taken in Europe, the editor of the *Notes* printed this reply:

> The noble street is represented thronged with carriages and foot passengers. All is life and motion. The trotting omnibus horses are caught with two feet off the ground,—boys are running,—men walking, driving, riding, carrying weights,—ladies sweeping the dirty pavement with their long dresses, or brailing up their crinoline and displaying their pretty ankles as they trip over the crossings, exactly as they do in Europe. . . . There is very little snow upon the tops of the omnibuses . . . and a little black sticking plaster in places, but at the same time a great deal of good halftone. In particular, the picture taken in the rain has a charming effect . . . we can only say we know of no pictures, save two or three of Mr. Wilson's best, which could be put in comparison . . .[283]

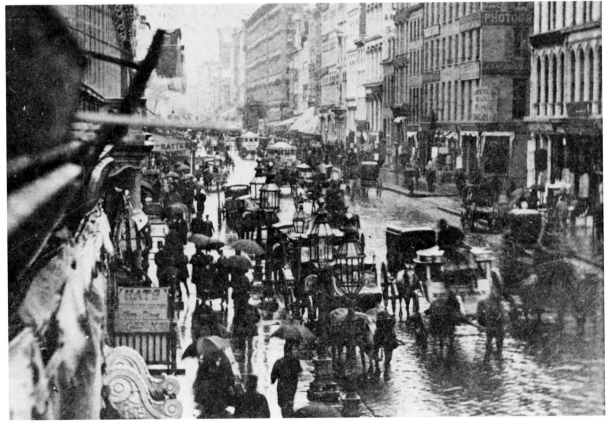

THE "WET-PLATE" ERA

JAMES F. MAGEE & CO.

MANUFACTURERS OF

Pure Photographic Chemicals,

No. 108 NORTH FIFTH STREET,

PHILADELPHIA.

1860

142

The revolution in portrait photography, brought on by the carte de visite, together with the bonanza already underway in stereophotography, enhanced the supplies business for ready-made chemicals to fulfill the needs of photographers less schooled in chemistry and more concerned with speed of output.

CARD PHOTOGRAPHY REVOLUTION
<u>1860</u>

The *carte de visite,* or "visiting card," style of photograph was universally adopted for photographic portraiture in 1860. As its nomenclature suggests, the style originated in Paris, then spread to London and New York. Like the card stereograph, it could be made cheaply in small or large numbers, and for the first time, likenesses of the world's celebrities could be reproduced and sold commercially on a vast scale. The style was never used to any great extent for making outdoor views, but more full-length portraits were made by this method than had been previously attempted with either the daguerreotype or ambrotype processes. Carte de visite photographs customarily measured 2½ x 4 inches and were mounted on cards providing a small border around the sides and top of the picture, leaving room beneath the print for the photographer's logo. To N. G. Burgess, cartes de visite were a consequence of stereoscopic photographs, not an original conception. "They are in reality stereoscopes, only not viewed in pairs—for every card picture can be so arranged as to produce the stereoscopic effect, as most of them are taken with two sets of lenses."[284]

Silas Holmes, inventor of the "double camera," was, naturally enough, among the first to adopt the new style. As early as January 7, 1860, he began advertising that he could make "the London style" portraits for as little as $1 for twenty-five copies. But this was evidently unrealistic, and the going price soon established itself at a higher level of $1 for four copies, which occurred after the introduction of a new breed of cameras with four or more tubes, each able to take its own picture at the same time on one negative plate in the camera. One exposure would produce four separate but similar images on the one plate (or up to eight if the camera was equipped with a moveable plate holder). When printed, the images could be separated and mounted individually, providing a set of similar card photographs (see illustration, page 144).

The arrival of the carte de visite vogue was timely, and probably had more than a little to do with boosting the candidacy, and ultimately the election, of Lincoln in the 1860 presidential campaign. On the morning of his Cooper Union speech, February 27, 1860, Mathew Brady took an ordinary collodion negative of Lincoln which was later reproduced in carte de visite form, helping make the Illinois rail splitter known throughout the country. Once he was nominated, Lincoln was photographed in Chicago by Alexander Hesler on June 3, and more than one hundred thousand copies of four poses from this sitting were distributed in the campaign.

As Lincoln was being nominated in Chicago, Queen Victoria began the custom of putting cartes de visite taken of herself and the royal family (by John J. E. Mayall) into a new style of photograph album designed specifically to house card photographs. This immediately sparked yet another new vogue; people everywhere began putting cartes de visite not only of their family and friends but also of celebrities into what became known as the "family album." Fifteen U.S. patents were issued for designs of carte de

This example of a carte de visite photograph, reproduced in actual size, was made by C. D. Fredericks of his adversary, W. A. Tomlinson, the New York photographer and agent of James A. Cutting, holder of the "bromide" patent for collodion practice. In January 1860, Tomlinson brought suit against Fredericks to compel him to obtain a Cutting license for collodion practice. But the case was later taken out of Tomlinson's hands and was never fully prosecuted.

visite albums in the period 1861–65, most of them featuring recessed pockets in each leaf into which the card photographs could be inserted.[285]

While photography began to take massive new strides through the mediums of the carte de visite and card stereograph, legal skirmishes were stepped up by the forces of James A. Cutting against the New York photographic community. Cutting's agent for New York City and environs, William A. Tomlinson, had lost the first of these skirmishes

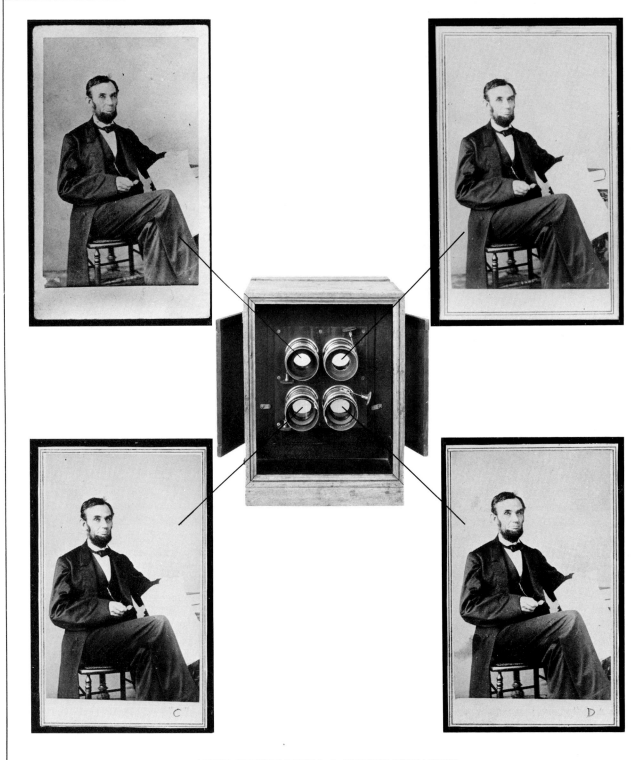

FOUR PRINTS FROM A SINGLE NEGATIVE

The carte de visite revolution brought with it a new style camera equipped with four or more tubes, each able to take its own picture on a portion of one glass negative plate. A contact print from one negative in a four-lens camera yielded four pictures on a single sheet of photographic paper. These were then cut apart and mounted individually to provide four similar but slightly varied carte de visite poses. This 1863 series by Alexander Gardner of Abraham Lincoln has been reassembled by Lincoln historian Lloyd Ostendorff.

in 1857 when a suit brought against Abraham Bogardus for violation of Cutting's ambrotype patent was thrown out of court (see page 118). Next, Tomlinson instituted a suit against Bogardus over the bromide patent, this time obtaining a judgment against Bogardus which the latter, under the press of business, settled out of court early in 1859.

The rumblings of discontent among photographers over the Cutting matter continued, fanned by the editorial fires of both Seely and Snelling. Humphrey chose to retire at this time (with good riddance, in Seely's view), and was never heard from again. In March 1859, Seely printed a sampling of letters received from various photographers—most of them opposing the Cutting patents—and three months later Snelling printed a factual review of discoveries and events prior to 1854 which indicated quite clearly that the patents had been wrongfully granted.

After the Bogardus settlement, Tomlinson moved again—against C. D. Fredericks—and for the first time, on February 3, 1860, a large group of photographers convened at the Cooper Institute to determine a course of resistance to Tomlinson and aid to Fredericks. Committees were appointed to solicit a subscription of funds to aid Fredericks' cause, and to contact photographers in other cities. Interestingly enough, men such as Bogardus, Charles C. Harrison, and Henry T. Anthony (brother of Edward, and partner in the newly renamed firm E. & H. T. Anthony & Company), who took no active part in the American Photographic Society, felt strongly enough about this issue to participate in the meetings at the Cooper Institute.

Successive meetings were held on the Fredericks case, and on February 24 a fund of about $500 had been raised. But the Fredericks case was never resolved. It became expensive for the Cutting forces, and its prosecution was passed from the hands of Tomlinson to those of Thomas H. Hubbard, who "knew how things were done in Yankee Land," as one observer later expressed it. "He approached the enemy; found it weak in pocket; made an offer, and the case, upon settlement, was very mysteriously allowed . . . to go by default." Thus, as the guns of the Civil War began firing, the skirmishes in the Cutting patent war were, for the time being, halted.[286]

There was a widespread interest at this time in instantaneous photography, as witness the card stereograph series issued by Anthony, and other series made across the Atlantic. On May 14, the subject became a matter of prolonged discussion at a monthly meeting of the Photographical Society when George Barnard appeared before the body with a series of waterfront views taken in Havana. The light was stronger than usual, and the collodion he had used was a little more sensitive; but that little difference, Barnard said, was very important in obtaining the results which he exhibited. W. S. Kuhns marveled at the Barnes prints because, while he could achieve "whites and blacks" in instantaneous photographs with any collodion, he could never achieve the "intermediate shadows" wanted. In the Barnard specimens, he noted, the stones on Moreau Castle could be distinguished even in the shade. Barnard estimated that his exposures had been made in as little as a fortieth of a second, but this was challenged by Lewis M. Rutherford. On the basis of his experiments with astronomical clocks and chronometers, as well as in estimating time by the

Mathew Brady's February 27, 1860, portrait of Lincoln was reproduced in tintype form to serve as a campaign medal measuring a half-inch in diameter (top) in the 1860 presidential election. A similar medal was made of a likeness of vice presidential candidate Hannibal Hamlin (bottom), a Maine Democrat turned Republican who was defeated for renomination four years later by Andrew Johnson.

chronograph, Rutherford said he doubted that the exposures could have been made in less than a fifth of a second.

Seely, who was also present at the discussion, referred to the many so-called instantaneous collodion mixtures being offered, but said these were not reliable because there were so many "little conditions" that determined a particular formula's sensitiveness. "Ether and alcohol today might be very different from what they were last week. A man however skillful he might be could not make gun cotton twice the same. There might be uniformity in the iodides and bromides, but there were complications when you tried to mix them with the unknown ether and the unknown gun cotton, and tried to put them in the ever-changing bath."

The discussion touched on two other important aspects of instantaneous photography, namely, the choice of camera used and, as Rutherford expressed it, "a good process of making the picture strong after you had got it." A year previously, Thomas Sutton had stated that "it is impossible in the present state of the photographic process to take in-

EARLY VIEWS OF THE FIRST MONUMENT TO GEORGE WASHINGTON

On July 4, 1815, in the presence of an estimated twenty thousand people, the cornerstone of the first monument to George Washington was laid in a cleared woodland area in front of the Baltimore home of Charles Howard, son of the Revolutionary war patriot John Eager Howard. The monument's architect, Robert Carey Long, sketched the scene (above) after the monument was finally completed, following construction delays, in 1829. The earliest known photograph of the monument taken from the same vantage point is the quarter-plate ambrotype (left) made about 1860, and found in an antiques store in 1972. By 1860, the monument had become the focal point of Baltimore's Mount Vernon Square. The chimneys of the Howard home can still be seen above the treetops to the rear of the monument, while at the extreme right is a corner of the famed

Peabody Institute, whose walls were standing in 1860, although the Institute did not open its doors until several years later. Francis Scott Key, who composed the United States' national anthem in 1814, died in the Howard home in 1843. The Howard home was demolished in 1870 to make way for a Methodist church, and the railings shown ringing the park area in front of the monument were removed in 1877. Of the three wagons shown in the foreground of the photograph, possibly one contained the photographer's nitrate bath and other developing chemicals; for, as N. G. Burgess pointed out in his *Ambrotype Manual* (published in 1855), it was necessary to have the bath nearby when making outdoor views, since "as little time as possible should intervene after the impression is given before the developer is applied."[287]

GEORGE N. BARNARD

Barnard's was among the longest but now least-known careers in early American photography. He began in Oswego, New York, in 1847, then moved to Syracuse. In 1853 he served as secretary of the New York State Daguerrean Association, and in 1857 perfected a method of using photography to make woodcuts, for which he was awarded a prize at the American Institute. In February 1861, he joined Mathew Brady's Washington, D.C., gallery where he helped photograph Lincoln's inauguration and made many of the earliest carte de visite photographs of the nation's political leaders and military personnel. When Gen. Sherman left Nashville in 1864, Barnard went along as official photographer for the Military Division of Mississippi, and his large photographs made on this campaign are among the rarest and most famous of the Civil War period. In the 1870s he worked in Chicago and in South Carolina, then returned to New York State where he helped George Eastman get started in business. Barnard and Eastman were elected members of the Rochester Photographic Association on the same evening in 1884. There are no details of his last eighteen years. He died in Onondaga, New York, on February 4, 1902.[288]

stantaneous pictures with a view lens and small stop.'' Sutton also said that the use of a portrait lens with full aperture presented yet another ''optical difficulty,'' in that it was not possible to get the sides of a picture into the same focus with that of the center of the picture. Rutherford echoed these sentiments at the Photographical Society meeting. It was important ''to have a camera which, with a large aperture gave a reasonable degree of distinctness in the different parts of the field,'' but that ''here was required a reconciliation of contradictions, because depth of focus really meant no focus at all. A camera which was microscopically sharp on any one point could not be so in regard to objects on any other plane. It was then by sacrificing a little of the sharpness in all parts of the picture, yet still retaining sharpness enough on the whole, that the best results were obtained.''

Instantaneous pictures, Rutherford also pointed out, were ''scarcely more than positives at first and required to be brought up.'' With this Seely was in total agreement. Earlier, he had expressed the matter in his journal in these words:

> The practice of short exposures has brought out the various methods of strengthening negatives by redeveloping and otherwise. The necessary opacity required for a negative is obtained with difficulty, after a short exposure, without recourse to reinforcement. Many photographers will be surprised to find with what a short exposure they can make a good negative, by carefully managing the development and strengthening.

One aspect of the subject not specifically covered at the Photographical Society meeting was the effect of a certain chemical which photographers used at this time in their nitrate baths, Edwin Musgrave touched on this matter some six years later in Seely's journal:

> In 1858, empirical mixtures and secret processes for the purpose of taking instantaneous pictures by the wet process were abundant. Experience has taught us, since that time, that the conditions requisite to produce pictures instantaneously are—absolute purity of chemicals and a condition of perfect balance between the collodion, bath, and developer, combined with tact and dexterious manipulation. The view as to the condition of the nitrate bath were also unsatisfactory at that time, acetic acid being recommended in preference to nitric acid for acidifying the nitrate solution; and there is no doubt that most of the excessive chalkiness of a great number of pictures taken at that period was due to the formation of acetates in the nitrate bath, as well as the accumulation of organic matter.[289]

Along with the carte de visite and four lens cameras used to make them, the so-called multiplying camera came into vogue at this time. There were several versions of this type of camera, evidently, but the most famous was a camera developed by Simon Wing of Waterville, Maine, which Wing, together with Marcus Ormsbee of Boston, sold as the "Ormsbee & Wing Tri-Patent Multiplying Camera," beginning in the summer of 1861.

The four-tube device was equipped with a plate holder which could accept 616 negative images, each a half-inch square, on an area measuring 11 x 14 inches. To secure these images, the operator made a single half-second exposure (using all four tubes) on a corner of the plate, then sequenced the plate in one direction or the other by half an inch and made another half-second exposure, repeating the operation until the entire 11 x 14-inch area was fully covered. All 616 images could be obtained on the one plate in about five minutes, according to Wing, and a single print from the 11 x 14 negative could be made in a matter of about two minutes. By exposing ten plates in this manner at one sitting, Wing said, it was possible to obtain as many as 184,800 half-inch-square photographs in one hour.[290]

Today, we have only Wing's word that his camera could, in practice, produce this many pictures in one hour; however, within a year, the camera was reported to be making a considerable stir both in New York and Boston. *Humphrey's Journal* reported in August 1862, for example, that Ormsbee had opened rooms at 411 Broadway where the camera was being used to make daguerreotypes, ambrotypes, and tintypes, as well as cartes de visite. This account by the editor (presumably Prof. John Towler, who had taken over the magazine's editorship the previous month) suggests that the invention had an explosive effect on photographic portraiture, much as Silas Holmes's double camera had had a decade earlier:

We are told that some operators, with only one small room, have netted sixty and seventy dollars per day, or eight hundred dollars per month, by using this new Camera. The second size of the Patent Camera will copy and make from the face more than thirty different styles of pictures. We hear of parties who have recently started in business having leased rooms and hired apparatus, and commenced receiving ten, fifteen, and twenty dollars per day.. . . . With his wonderful multiplying camera he is now executing the vignette carte de visite photographs at the low price of one dollar and fifty cents per dozen, mounted on the finest quality of cards. He sells one card vignette of three dozen, without mounting, at two dollars; for another size, sixty-four on card, his price is only one dollar and fifty cents; duplicate cards, one dollar. Houses of Representatives, schools, churches, choirs, military companies, or assemblies of any kind, can obtain likenesses of a superior quality, by this new process, at as low a price as two dollars per hundred, each person, or ten dollars per thousand. He defies all competition as to price and quality unless by the use of the tri-patent camera.

At Boston Mr. Ormsbee one day made sixty-four photographs of the Chaplain of the House of Representatives on one plate; the next day his rooms were full of Representatives, and the next following a committee called to arrange for 30,000 pictures. He has some of these card prints on exhibition at 411 Broadway, where all are invited to call and examine. [291]

One August Semmendinger, of 144 Elizabeth Street, New York City, appears to have secured an earlier patent for a multiplying camera, but this was not recorded in any

The first product-style photograph of a camera to be published in an American photographic journal appears to have been this illustration of the front (left), side (center), and rear (right) views of Simon Wing's four-tube camera, which could accept 616 negative images, each a half-inch square, within an area measuring 11 x 14 inches on a negative plate of size 12 x 15 inches. The illustration is an enlargement of an actual photograph of size 1¾ x ⅝ inches which was pasted into all copies of the July 1, 1861, issue of the *American Journal of Photography*. In the lower part of all three views is a drawer for storage of articles or materials used with the camera.

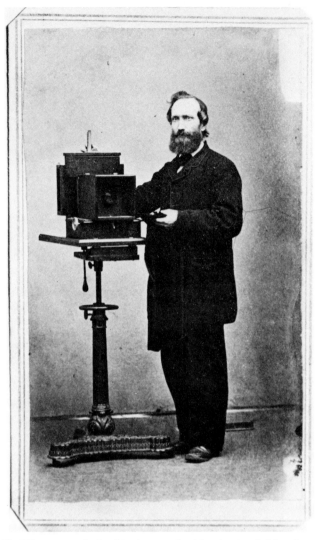

The Wing camera depicted in the carte de visite photograph (above) exhibits a protruding plate holder, which would be sequenced in one direction or the other for purposes of securing multiple exposures on a single 11 x 14-inch image plate. The patent for the moveable plate holder was assigned to Simon Wing by inventor Albert S. Southworth (see page 113).

defend my right. . . . My right to make and sell these boxes is a clear one, and I shall make and sell these boxes hereafter and shall warrant their use without a license. If you think that you are in a position to nullify my patent, commence your proceedings at once. I would prefer to see action on your part rather than your idle threats, as I shall then have an opportunity of showing to what extent you are an infringer on my patent, and also who was the real original inventor of shifting or sliding a plain plateholder on a camera-box.[292]

During or after the Civil War, Ormsbee moved his New York studio to 350 Bowery, south of the Cooper Institute, where his greatest volume of business appears to have been in making limited numbers of tintypes and cartes de visite for individual customers at low cost. Among his more popular orders were those calling for eight ferrotypes (tintypes) in carte de visite size for fifty cents; and eighteen vignetted cartes de visite in medallion size (1½ x 2⅚ inches), also for fifty cents. "His box," *Humphrey's Journal* contended in the winter of 1867, "is an institution, and make no mistake."

By February 1, 1861, Seely could report in his journal that "card photographs in New York are now in the height of fashion. In several of the leading galleries it makes the chief business, and in one so great is the demand that the actual work is at least a week behind the orders; the patrons make their applications and appointments a week in advance. Each photograph is multiplied by the dozen, so that it appears that photographs may soon become as common as newspapers, and we trust as useful." As to the manufacturers of cases, mats, and preservers for daguerreotypes and ambrotypes, Seely reported on January 1, 1862, "Their occupation is gone."[293]

While phasing out this supplies business, E. & H. T. Anthony & Co. received a boost in the carte de visite business from two major sources. First, because business came virtually to a standstill in the South, the Charleston photographer (and former manager of Brady's gallery in 1851) George Cook sold a large amount of carte de visite negatives to the Anthonys, who thereupon made prints from them at the rate of a thousand a day. Secondly, because business at Brady's Washington, D.C., gallery was booming with sittings of Washington officialdom and soldiers (particularly following Lincoln's call for troops), Alexander Gardner, the gallery manager, approached the Anthonys with a plan to supply the firm with carte de visite negatives which the Anthonys could mass-produce and distribute from New York—the Brady and Anthony establishments both sharing in the profits from sales.[294]

There were only four photographers in the federal government at this time—one each in the Navy and Treasury departments; and at the Capitol Extension and Patent offices—and on June 10 Charles Seely proposed at a meeting of the American Photographical Society in New York that the society contact the War Department to discuss "the application of photography to military purposes." This was agreed to and a committee comprised of Seely, John Johnson, and a Mr. Babcock was named to follow through on the proposal. But nothing came of this effort, and later in the year Mathew Brady took steps on his own to organize a war photography operation for which he would receive lasting fame.[295]

of the journals until eight years later. Evidently Semmendinger's camera afforded enough competition to prompt Ormsbee to try to halt his sales. In response, Semmendinger sent Ormsbee a blistering letter, which was published in *Humphrey's Journal*:

Mr. Marcus Ormsbee: Sir: In the month of July, 1861, you and Mr. Wing from Boston called on me and informed me about a re-issue of a patent for multiplying pictures, stating at the same time that it would not interfere with my patent. I told you that I had procured a patent for the same purpose, February 21, 1860, and that before that time no Multiplying Camera-Box was known or used except those made by myself. Ever since (now over eight years) I have openly and publicly made and sold the boxes thus patented by me. Now some weeks ago, you requested me to stop making said boxes, a request which I of course utterly disregarded, and I then declared that I would

PRIMITIVE DEVICE MAKES MOTION PICTURES, USING CARD STEREOGRAPHS

On February 5, 1861, Coleman Sellers, thirty-four (above, right), professor of mechanics at the Franklin Institute School and supervisor of drafting at his father's machine tool factory in Philadelphia, patented the *Kinematoscope* device shown in both pictures above. Sellers was an avid amateur photographer, but his interests lay principally in mechanical engineering. The object of his patent, he said, was simply "to exhibit stereoscopic pictures as to make them represent objects in motion, such as the revolving wheels of machinery." He harbored no thoughts of becoming the inventor of motion pictures. To prepare pictures for his rotating wheel device, he posed his two sons, Coleman, Jr., and Horace, and photographed related stages of action with a stereoscopic camera in a series of timed exposures (shown at left). These captured Coleman, Jr., in the throes of hammering a nail into a box, and Horace rocking gently in a small rocking chair beside him. Next, he made card stereographs and placed these on the surfaces of the series of paddle wheels comprising the drum of the *Kinematoscope.* Each photograph could be secured in a slot in the steel rim around the drum. By turning a knob (as in the photograph at top, left, showing the device as it appears today in the archives of the Franklin Institute), the viewer sequences the pictures and captures the illusion of motion, the one boy hammering and the other rocking. Because the stereographs are secured in their respective slots, the viewer receives only an instantaneous glimpse of each photograph before the appearance of the next one to follow. This provides movement which is intermittent rather than continuous, and prevents the appearance of blurring (a principle which became basic to all motion picture cameras developed in later years). Sellers made no effort to commercialize the *Kinematoscope,* and concentrated most of his energies on new machine tool inventions. In later years, he managed an organization which for the first time transmitted electrical power from Niagara Falls.[296]

1861

FIRST AMATEUR CLUB

Henry T. Anthony, aided by two New Yorkers, F. F. Thompson and Charles Wagner Hull, organized an Amateur Photographic Exchange Club with headquarters in New York in November 1861. The club functioned until September 1863, when both Anthony and Hull were drafted into the Union forces. Membership was purposefully kept small, and each member was required to send every other member at least one stereoscopic photographic print six times a year at prescribed intervals. Members of the club included:

H. T. Anthony, New York
C. W. Hull, New York
L. M. Rutherford, New York
August Wetmore, New York
F. F. Thompson, New York
J. H. Haight and Mr. Masterton, of the Anthony firm, New York
E. L. Cottenet, Dobbs' Ferry, New York
George B. Coale, Baltimore
Robert Shriver, Cumberland, Maryland
Constant Guillou, Philadelphia
S. Fisher Corlies, Philadelphia
Prof. Fairman Rogers, Philadelphia
Coleman Sellers, Philadelphia
Dickerson Sargent, Philadelphia
Frederick Graff, Philadelphia
F. T. Fassitt, Philadelphia
E. Borda, Schuylkill County, Pennsylvania
Prof. E. Emerson, Troy University, Troy, New York
Charles F. Himes, Troy, New York
Henry Bedlow, Newport, Rhode Island
Titian R. Peale, U.S. Patent Office, Washington, D.C.

The club reportedly issued seven issues of *The Amateur Photographic Print,* which was prepared by Thompson with contributions from members. Oliver Wendell Holmes declined membership in the club, but in later years Coleman Sellers reported that he had sent pictures to Holmes on April 2, 1862, and that the latter had sent him at that time "a fine stereoscopic picture of a large ball of rock crystal from Japan, in and on the surface of which can be seen the reflection of the objects in the room."[297]

THE GLOBE LENS

The crowning achievement of Charles C. Harrison's career was his development of the wide-angle *Globe* camera lens about four years before his premature death in 1864. It was imitated in Europe, and Prof. John Towler described it in the *Silver Sunbeam* as "all that can be desired for field work; it comprehends a larger angle than almost any other lens, and produces an irreproachable picture." Lewis Rutherford described it in these words at an American Photographical Society meeting on January 14, 1861:

Mr. C. C. Harrison has for a considerable time been engaged in perfecting a lens which appears to be a novelty in construction and its properties. He has already completed three grades: first, for stereo views with a focal length of 2½ inches and a flat field 5 inches in diameter; second, a view lens with 5½ inches focal length and a field 10 inches in diameter; third, a 12-inch focus and a field of 24 inches. Thus the angular aperture is double what has hitherto been achieved. The plan of the lens is this: the two lenses of the combination are symmetrical and are so mounted in the tube that their outer surface shall form a part of the surface of the opposite segments of the same sphere. These outside curves subtend an angle of about 180 degrees, and thus the combination is brought within a convenient length. A small stop is placed midway between the two lenses, and at the center of the sphere. The lenses being symmetrical, either end of the tube may be turned to the view. The trials with these lenses show that they give a flat field and a more perfect rendering of straight lines than any other lens.[298]

Up to this time, the principal camera lenses made for landscape and architectural use had originated in Europe. These included a Voigtlander lens whose mathematical design calculations had been completed by Petzval as early as 1840; the first aplanat (a lens free from spherical aberration, a defect caused by a lens's curved surface) introduced in 1857; a panoramic lens introduced by Thomas Sutton in 1860, which could cover a field of 120 degrees (but only on a curved plate); and a triple achromatic lens introduced in 1861 by John H. Dallmeyer.

At some point in (or before) 1860, Charles C. Harrison,

the self-trained optician and New York camera manufacturer, together with a partner, J. Schnitzer, introduced the *Globe* lens, which became one of the most famous nineteenth-century American-made camera lenses. The lens covered a field of 90 degrees with an aperture which, in today's nomenclature, would be defined as f/30. At a meeting of the American Photographical Society held on January 14, 1861, Rutherford said the *Globe* gave a more perfect rendering of straight lines than previous view lenses, adding that Petzval "does not claim as much for his *Orthoscopic* lens, although he professes in that to have exhausted the subject." Seely was skeptical of the configuration chosen for the *Globe* design (see illustration, above), and pointed out

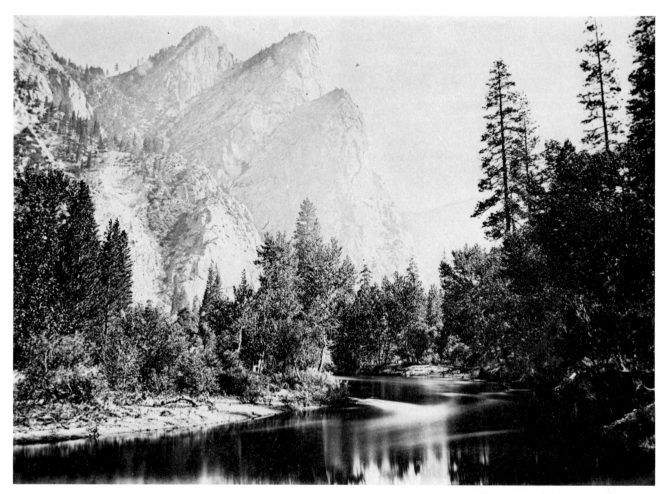

An American western landscape photography school was unobtrusively launched in 1861 when Carlton E. Watkins, a photographer in San Francisco, employed the first "mammoth-plate" camera (able to make photographs as large as 22 x 25 inches) on a trip to the Yosemite Valley. The unattributed photograph (above), was probably made at Yosemite by Watkins, since it is strikingly similar to one he is known to have made there in 1861.[299] Watkins came to San Francisco from Oneonta, New York, in 1851, then worked for Robert Vance before opening a gallery of his own in 1857. The camera he used in 1861 was probably made to order by a skilled cabinetmaker. Only about twenty-five mammoth-size photographs made by Watkins in 1861 are known to survive. The first photographer to make views in Yosemite was another Vance protégé, Charles L. Weed, but his photographs, made in 1859, were of the glass stereograph variety.

1861

EXIT HENRY HUNT SNELLING

For all of photography's first two decades, the name of Henry Hunt Snelling stands foremost as a chronicler of the American era of isolated practice. During the 1850s he endeavored to ride two horses—the one, his photographic journal, founded in 1851; the other his position as general manager of Edward Anthony's photographic supplies business. To handle these responsibilities he frequently worked as many as 16 hours a day. In 1857 he severed his association with Edward Anthony and engaged more heavily on his own in photography, while continuing at the same time to edit his *Photographic & Fine Arts Journal*. Reportedly, he suffered from nervous prostration at this time. In 1860, he was forced to relinquish control of his journal, and its management passed temporarily to William Campbell and Joseph Dixon of Jersey City. Then, in November 1860, it was absorbed by Charles Seely's *American Journal of Photography*. For Snelling there were no laurels or banquets proffered by a fraternity he so diligently supported—and lectured; and when Seely acquired his records he found there was enough in unpaid dues from subscribers "to make him [Snelling] a competency for his lifetime." Seely asked Snelling to write a small *adieu,* and the latter responded: "The photographic operators of the United States will, therefore, please consider my cap doffed, and with a low bow, I will say good-bye! and good riddance to bad rubbish!"

The son of a military officer, Snelling spent his boyhood on army posts on northern and northwestern frontiers. In 1837, he married the sister of publishing magnate George Palmer Putnam, whose son, George Haven Putnam, later described Snelling as "a good natured 'Skimpole' kind of a man, who was always in need of help from his brother-in-law."

Snelling's *History and Practice of the Art of Photography,* published in 1849, was considered the first American book on photography until attacked in 1973 as having been largely plagiarized from an early work by George T. Fisher, Jr. (an infrequent contributor to Snelling's journal in the early 1850s). But plagiarism among journals was more common in the nineteenth century, and Snelling was never attacked by others in his own time as were such other editors as Samuel D. Humphrey and Edward L. Wilson.

After giving up his journal, Snelling continued for a year to participate actively in meetings of the American Photographical Society, and during the 1860s he worked for several government agencies. During this period he reportedly suffered a breakdown, and in the 1870s assumed editorship of a Cornwall, New York, weekly newspaper. He became blind in 1887, and after the death of his wife he was forced to spend his last years in a home for the aged in St. Louis, where he died in 1897.[300]

H. H. Snelling in 1855—negative by Brady.

that Sutton's panoramic lens "appreciated the advantage of the curvature of great angle."

Rutherford, who produced negatives and prints made with a *Globe* lens at the January 14 meeting, inquired of Seely:

"Have you seen the work of the panoramic lens?"

"Yes," Seely replied, but admitted that "it is not comparable to what is here exhibited. The field of the panoramic is curved, a fact which is a serious objection to it."

The Photographical Society appointed a committee to determine if the society should issue an official commendation of the *Globe,* but before the members could contact Harrison, he became ill for an extended period. Then, because of what Seely termed Harrison's subsequent "withdrawal," the committee was unable to prepare its report. On August 29, Seely called on Harrison's agent, but "was politely informed that the lens was not ready for exhibition, and that no information about it would be given at present." Seely was annoyed. "There is a good deal of unpleasantness hanging about this matter," he said. "We think also we perceive a slight odor of humbug . . ." He promised the readers of his journal that he would try to "blow away some

of the fog," but two years would pass before the lens would be accorded universal technical acclaim on both sides of the Atlantic.[301]

Prior to this time, the world had not engaged in any extensive debate as to whether photography should be considered one of the fine arts, although the matter would become an increasingly important topic over the next several decades. As early as 1856, it was suggested that photographs be included in exhibitions of the French Academy of Fine Arts, but in 1861 agents of Queen Victoria excluded photography from an exhibition of fine arts, setting off what Coleman Sellers described as a "war" between Her Majesty's commissioners and British photographic societies. Sellers chose this opportunity to author one of the earliest American essays on the subject, from which the following has been excerpted:

> The exclusion of photography from the ranks of the fine arts seems to me very unjust. That art or employment which confers the greatest amount of good on the greatest amount of people, and at the same time calls for the exercise of the highest mental attainments on the part of the artist or operator, is the one entitled to the greatest respect in its class.
>
> The engraving or etching claimed among the "modern fine arts" is not the work of an artist, it is the work of a printer, who may be a very uneducated man with no artistic taste.
>
> The copper plate which produced the print is the work of the artist, and in the print we see the proof of the perfection of the artist's work. This artist, however, has but the one mental faculty called into play. He has acquired great skill in cutting certain lines, all according to certain fixed rules and much—very much of his work has perhaps been performed by ruling machines and lathes of the construction of which he is ignorant. If now an ingenious mechanic should arrange machinery that an oil painting could by the machine be copied on a plate of copper, each shade and form reproduced by certain combination of lines and stipple, the print from this mechanical engraving would take its place among the works of great masters and enjoy the select society of the fine arts.

> We know that a medal or other bas relief can be engraved by a ruling machine in a much more perfect manner than can be done by hand, yet the product is a picture produced by a machine; that machine is then the artist, or the workman who turned the crank is, for the product of the machine is an engraving and can be admitted into Section 4 (fine arts category) of the great exhibition. If now we take a step above engravings and into the domain of painting, let me not be charged with disrespect if I assert that it is more of a mechanical operation than photography. A grandson of Charles Wilson Peale, I claim as the descendant of a painter, a right to speak of painters, many of whom I am moved to say have been my dearest friends.
>
> In old times before the making of colors became a trade, the pupil of a great master was first put to grinding paints; he was through a long course of apprenticeship taught to mix and compound from earths, metals, and vegetables all the brilliant colors that were the special charm of his master's work. That the works of the great masters have in some cases been more permanent than that of others, was due to their greater skill in preparing their pigments. Here there was required a practical knowledge of the chemistry of the substances used and scientific skill outside of painting. Now, however, the artist furnishing stores have put up in such neat little metal tubes, all kinds of tints and shades of color, that the modern artist is almost ignorant of the slab and muller.[302]

The problem, Sellers felt, was that "photographers are looked upon as men who without any scientific skill slop a plate with collodion, dash over it sundry liquids, and lo! and behold! a picture is made, in far too easy a way to be genteel." But in truth, he said, the success of the photographer depended upon his being well versed in chemistry, composition of the picture, and the delicate study and mastery of light and shade. He must also be a student of nature with a keen perception of the beautiful, and in the case of portraiture able to see character, notice peculiarities, and immediately highlight or compensate for these in making his finished product.

The zoetrope device, above, was invented before photography and was sold in toy stores for many years. When spun, illustrations painted inside appeared animated, but at the same time blurred, through viewing slots on the side. In his *Kinematoscope* (page 151), Coleman Sellers provided a mechanism for holding each image momentarily stationary during viewing, eliminating blurring.

INSTANTANEOUS STUDIO PHOTOGRAPHY

"Instantaneous photographs are always highly admired, and yet photographers rarely take them," S. D. Humphrey lamented in 1858. With the adoption by photographers of multi-tube cameras able to secure a series of portraits on one negative plate, infrequent attempts were made in the 1860s by some portrait photographers to obtain instantaneous ("candid," in modern terms) photographs of their sitters. The series above, probably made in 1861–62 by H. Skinner of Fulton, New York, is among the earliest examples in American photography of a storytelling sequence acted out before the camera. Although four of the scenes appear posed, the scene at bottom (left) has caught the movement of the youth's arm raising the bottle over his head in a gesture of reckless abandon.

1862

Most nineteenth-century photographs encountered today—whether a standard-size card portrait or a mounted print of larger or irregular size—will be found printed on extremely thin paper (which curls easily, if separated from its mount), having a glossy and brownish appearance. This indicates the extent to which albumen paper came to be used by photographers everywhere in making their photographic prints. By February 1, 1862, *Humphrey's Journal* announced that the use of albumen paper "is now the rage, and our country operators must learn this process very thoroughly if they wish to keep up with the times." Albumen paper had been adopted more extensively in Europe during the 1850s than in the United States, but by this time it became the American standard as well, lasting until nearly the turn of the century.

D. D. T. Davie, the veteran Utica photographer long prominent in the ranks of the so-called practical photographers in New York state, appears to have been a principal early proponent of its use, and was among the first to publish a series of articles (which he copyrighted) covering the workings of the process. The paper was "much preferable," he said, for use in landscape and architectural photography, and for photographing objects where detail was an important factor. Davie was also among the first to point out that the collodion negatives used for making albumen prints "must be made with collodion from very intense cotton iodized principally with potassium," which he said gave greater intensity than either cadmium or ammonium. Photographers, he said, should also abandon use of pyroxylene and other materials generally used in making negatives for printing on plain paper, because negatives made with these materials printed too feebly on the albumen paper, causing red tones "of which we hear so many complaints from all parts of the country."[303]

In this early period, improperly made papers added to the photographers' problems in adopting use of the albumen paper. "The New York market is constantly flooded by irresponsible parties with worthless trash at low rates," Davie cautioned one distraught photographer, "which proves as disastrous to country photographers as it is disgraceful to these money-seeking Abrahams who sell them." Davie also said, "if you would use the albumen paper and chemicals manufactured by the Daguerre Manufacturing Company and sold by dealers generally throughout the country, you would find immediate relief from those metallic tints and nearly all of your other troubles." The problem of print yellowing, he added, "may arise from two causes: for instance, there may be traces of hyposulphite of soda in your dishes, but it is more probable that your paper is coated with *rotten* eggs."[304]

About the same time, the writer of a communication to Seely's journal, identifying himself only by the single initial "L," complained that as far as the dealers in albumen paper which he had encountered, "not one of them knows whether it is salted with five or fifteen grains of salt, so that the purchaser can tell how to silver it only by experiments,

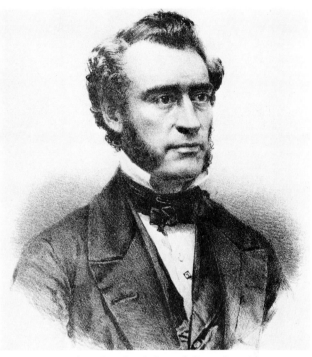

D. D. T. Davie, from *Humphrey's Journal,* September 1851.

which must be repeated every time a new purchase of paper is made." Every batch of paper, "L" said, should come marked on the margin with the salting. In response to this, Seely commented editorially: "Purchasers of albumenized paper should insist on knowing the strength of salting; a little agitation of the subject will bring about the much needed reform."[305]

The undertones of discontent evidently persisted, and in July 1863, *Humphrey's Journal* reported:

The demand for albumen paper has fallen off tremendously of late, and nothing at all is doing in it. It is one of the worst articles in the trade to have anything to do with, there is such a want of uniformity in it, and each make seems to require a different formula for toning. If an operator now-a-days has anything the matter with his picture, he will be sure to lay the fault to the "albumen paper." We have seen some of the finest results we ever saw produced on albumen paper returned by country operators as "not good," "can't work it," etc. The different dealers in town we know sell tip-top paper and yet all have more or less complaints.[306]

With the benefit of hindsight it is not too difficult to see why *good* photography remained an elusive goal sought by many, but achieved only by a few. Davie had said that "very intense cotton" iodized with potassium was wanted to give deep shadows and clear highlights in albumen prints, but for the photographer this meant that if ready-prepared gun cotton of the required "intensity" was not available commercially, he must make his own. But the manufacture of gun cotton, N. G. Burgess pointed out in

PHOTOGRAPHY AND THE CIVIL WAR

"A spirit in my feet said 'Go,' and I went." This was how Mathew Brady, shown above with Maj. Gen. Ambrose E. Burnside before the confrontation with Confederate troops at Fredericksburg in December 1862, described the personal motivation which led him to organize his own photographic coverage of the Civil War—putting men, as he said, "in all parts of the Army, like a rich newspaper." The undertaking cost him $100,000, and it placed him in debt for the rest of his life. He did not himself become a prominent field photographer, but he covered the route of the Army of the Potomac at the first battle at Bull Run in July 1861, the abortive sieges at Antietam (September 1862) and Fredericksburg (December 1862), the Union defeat at Chancellorsville (May 1863), the battle at Gettsyburg (July 1863) and the nine-month siege of Petersburg (June 1864–April 1865).[307]

At the wooded photographer's studio (top right), a mammoth-plate camera is used to make large negatives and prints of hand-drawn maps, which could then be distributed to Union field commanders. Government agencies, following Brady's lead, also put photographers in the field during the war, and the "camp-following photographer" was to be found everywhere, principally making tintype or ambrotype portraits of soldiers to be sent home to loved ones. The ambrotype tent (bottom right) was set up at Cloud's Mill, Virginia. Because the collodion process could not easily cope with movement, only four views are of actual battle scenes among the thousands of Civil War photographs in the Library of Congress.

1862

158

Oliver Wendell Holmes (1809–1894) was a proponent of stereophotography. He advocated libraries of card stereographs for all major cities, and invented the hand-held stereoscope with hooded pair of lenses which became the most popular and widely used card stereograph viewing device in the nineteenth century.

ALBUMEN PAPER MANUFACTURE REQUIRES COOPERATION OF 10,000 YANKEE HENS

Oliver Wendell Holmes, the author and physician, visited E. & H. T. Anthony & Co. late in 1862, where he found that the eggs from some 10,000 Yankee hens were required to coat the large stock of paper which the Anthonys had on hand for making albumen photographic paper.

The paper was sold dry to the trade, and had to be floated (albumen side down) in trays of silver nitrate solution for sensitizing before use. Photographers sensitized their paper daily, as the paper would not keep in its sensitized state. After exposure of a glass negative in the camera, the sensitized paper was placed in a printer's frame against the collodion film of the negative and development took place under exposure to sunlight, usually on the rooftops of buildings housing photographic galleries. In the case of the larger establishments, long racks were used providing room for as many as a hundred frames. The action of the sunlight was allowed to continue until a print obtained what the printer considered to be its suitable contrasts. No chemicals were used in the development process, and printing could not be accomplished on dull or rainy days. Developed prints were subsequently washed in a darkroom, toned with a solution of gold chloride, and fixed, as they are today, in hypo.[308]

his *Photography Manual,* first published in 1862, "is usually attended with many difficulties, and liable in all cases to result in failure from the slightest variation of the process, and withal is quite detrimental to health. It is therefore recommended," he said, "to purchase the gun-cotton, when possible, thereby saving all the perplexity and uncertainty attending its preparation."

When the subject of making collodion negatives came up in a discussion at the Photographical Society at this time, Lewis Rutherford said he felt that when all was said and done, the making of the best negatives was a matter of compromises:

> To get the minutest detail, thin collodion must be used; but the print from such a negative is without any life. If a thick collodion, or a strengthener be used to secure the vigor, it is at the expense of detail. We cannot have strength and fineness of definition at the same time. The subject of the picture, our tastes, etc., must determine in what proportion we shall have these combined. I think it is better to get the negative desirable without recourse to strengtheners. A negative which owes its intensity only to strengtheners is harsher than when it is obtained by the simple development. Yet as we have not the skill to control the conditions of developed intensity, we must occasionally resort to strengtheners, and hence their peculiarities of behavior are worth study.[309]

Small wonder, too, that the ranks of amateur photographers did not become substantially larger, even though the carte de visite and card stereograph were bringing photography into every home to an extent never before known. One of the most illustrious amateurs of this time, Henry J. Newton (later president of the American Photographical Society), recounted his early experience in these words:

> To succeed then meant hard work and study. You were required to know how to make almost everything connected with the production of a photographic print. You must know how to make collodion; how to coat a plate and how to sensitize and develop it; how to construct the silver bath in which the plate was sensitized; how to make the developer; how to clean the plate; how to prepare the nitrate of silver bath for sensitizing the albumen paper; to fume, print, tone and fix the prints; how to make paste, and how to mount the prints. The amateur of those times was further required to make himself familiar with the chemistry involved in all this work: first, in order that what he did he might do intelligently and successfully; and, second, to be qualified to determine with a degree of certainty what was the matter when his chemicals gave unsatisfactory results. The negative bath was one of his most treacherous friends; he could not predict, with any degree of certainty, what would happen to the next plate by the result on the one immediately preceding it.[310]

Tricks of the trade were legion. Today, some of the earliest card stereographs to be found in the archives of the Library of Congress are a series donated to the library in the period 1858–61 by Franklin and Luther White, of Lancaster, New Hampshire. The views are principally of the White Mountains, and at a meeting of the American Photographical Society on December 8, 1862, Franklin White said the trick used by the brothers to keep their collodion plates moist while hiking in the mountains was to wrap them in wet towels and carry them in a "close-fitting box." This procedure, White said, kept the plates moist for at least three to four hours.[311]

SNELLING—OUT OF STEP—ARGUES AGAINST USE OF ALBUMEN PAPER

The deterioration or fading of photographs made on albumen paper remained a much-talked-about subject throughout the nineteenth century, suggesting a certain prophecy in these remarks by H. H. Snelling at a meeting of the American Photographical Society:

> Notwithstanding the brilliancy and strength given to the picture by albumen, I am decidedly adverse to its use, as from its very nature, and the necessary preparation of it for photographic purposes, it must be considered the least calculated to ensure permanency. I repudiate the idea, that, because its present results are so fine, and the people at large prefer it, photographers should use and recommend it. The ultimate results should alone be considered if we desire to perfect photography and give confidence in it to the public mind. The natural affinity between sulphurated hydrogen and albumen is increased by the various processes through which albumenized paper passes during photographic manipulation, and, although I have seen thousands of albumen prints from all parts of the world, and of every size, I have yet to see one, of more than a few months' existence, uninfluenced in a greater or less degree by the destructive agency of this sulphurated hydrogen. Pure albumen may be dried and hardened, cut and shaped so as to resemble amber, and so it will remain so long as it is kept perfectly dry, but let it become saturated with moisture, sulphurated hydrogen will attack and destroy it. In photographic printing on albumen the toning and hyposulphate baths render the albumen more disposed to absorb moisture and consequently it is more easily attacked by the sulphurated hydrogen of the atmosphere. Decomposition by this obnoxious gas often occurs in albumen paper before it gets into the photographer's hands, and hence arise some of the complaints constantly dinned into the dealers' ears.[312]

ENTER HENRY J. NEWTON

About 1858, Henry J. Newton, then thirty-five, had made a small fortune in the burgeoning field of American piano manufacture and decided to take up amateur photography. He joined the American Photographical Society in 1863, became its treasurer in 1864, and its president by 1874.

Newton was born in Pennsylvania, but grew up in Somers, Connecticut, and received his education at the Literary Institute in Suffield. In 1845, he began a four-year apprenticeship to learn "the art and mystery of piano-forte making." In those days, a grand piano (shown below) was simply "the most perfect and magnificent" of the three styles of square pianos sold under the name piano-forte.

In 1849, Newton established a business with C. F. Lighte. At that time, American-made pianos were a rarity, and European concert artists visiting the United States customarily traveled with their own instruments. Newton's name was gone from the business by 1869, when the name of the firm was listed as C. F. Lighte & Co., ninth after Steinway on a list of twenty-six of the most prominent United States manufacturers.

Newton bought his first supply of photographic apparatus and materials from Charles Seely, who operated a store on Canal Street in addition to publishing the *American Journal of Photography.*[313]

Accidents, too, were frequent. Louis M. Dornbach, a manufacturer of gun cotton in Brooklyn, New York, suffered the demolition of one three-story brick building in an explosion of the gun cotton, then was killed in yet another explosion on June 22, 1862, while packing a shipment for Connecticut at a second factory in a remote area of the Williamsburgh (now Williamsburg) section of Brooklyn. Dornbach, thirty, manufactured gun cotton at the rate of a hundred pounds daily, and was using a heavy stick to press down the cotton in 20-gallon waterproof casks made of stout oaken. A thrust, probably heavier than usual, ignited the mass, according to a later account.

When a photographer told of an explosion of a collodion bottle which he was endeavoring to clean with a bottle brush, water and alcohol, Coleman Sellers responded with a word of caution to all photographers against using wire brushes inside a glass tube. "It is a well known fact that if the inside of a glass tube be touched by a rough wire it will be scratched," Sellers explained, "and that scratch though ever so slight will be the starting point from which a [spontaneous] disintegration of the tube will radiate; and the fraction is always in rings and of a conchoidal form."

Mice "frolicking among a lot of matches," which *Humphrey's Journal* said had caused earlier fires, was the cause of a fire which destroyed D. D. T. Davie's gallery in Utica in August 1862.[314]

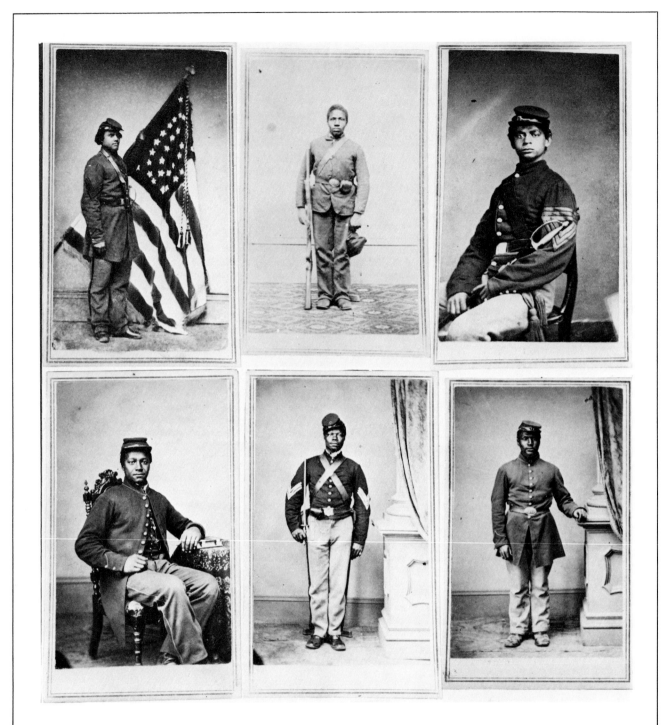

The blacks' role in the Civil War began when the fugitive slaves, who followed Union forces everywhere, were pressed into service in labor battalions, then were recruited for guard detachments and given castoff army uniforms. Early in 1863, the government authorized the organization of black regiments to be officered by whites, and to be available for combat duty. The pride which many of these men must have felt is reflected in these rare carte de visite photographs made by post photographers at barracks in Rock Island, Illinois, and neighboring Camp McClellan in Iowa. By the war's end, more than 150,000 black soldiers had been placed in uniform.[315]

1863

Having taken it upon himself to fund a large-scale photographic coverage of the Civil War, Mathew Brady evidently decided that other events demanded his personal attention, and he was therefore not present when Abraham Lincoln dedicated the battlefield cemetery at Gettysburg, Pennsylvania, on November 18, 1863. Brady was in New York, where a squadron of Russian naval vessels had arrived on October 1. After the admiral and his staff had posed for Brady's cameras, weeks of celebrations followed, ending just about the time of the Gettysburg dedication with a reception by the city of New York which Brady attended at the Astor Irving Hall.

Alexander Gardner and Timothy O'Sullivan, whose photographs of dead soldiers at Gettysburg had shocked Lincoln and the nation only a few months earlier, were also absent. While one or more photographers from Brady's staff, as well as other local photographers and several stringers were on hand, it appears that only one prominent nineteenth-century photographer was there. This was David Bachrach, Jr., then only eighteen, and later founder of the noted firm of chain portrait studios which still bears his name. Bachrach was serving as an apprentice to William H. Weaver, who was acting as a stringer for *Harper's Weekly*. His presence at Gettysburg went unnoted at the time, and would have remained so were it not for this brief description of his participation in the events of that historic day which were recorded in the *Photographic Journal of America* (formerly *Wilson's Photographic Magazine*) fifty-three years later:

> My employer was called on by a photographer sent by the Harpers to aid in photographing the dedication of the Hill cemetery at Gettysburg. I took the portable dark-room and drove over the hills by way of Westminster and Emmittsburg, a day and a half being consumed, and did the technical work of photographing the crowd, not with the best results with wet plates, while Mr. Everett was speaking. After this hour and a half of oratory, Mr. Lincoln got up (I was on a temporary stand about ninety feet away) and in about three minutes delivered his famous address, which drew no demonstration and was hardly even noticed by the current papers. . . . The negatives, 8 x 10, were of no real interest, I then thought, and the gentleman took them for the woodcut artists.[316]

It was customary in these times to give original photographs of public interest to engravers or woodcut artists for use in preparing magazine, newspaper, or book illustrations. Brady, for example, was doing precisely the same thing in New York with his photographs of the visiting Russian naval officers. Presumably, whatever photograph or photographs Bachrach secured of Lincoln and passed on to the woodcut artists were discarded by them, or became lost thereafter. This, too, was the customary fate of many important photographs, as we have already seen.

If Bachrach retained any negatives of the Gettysburg events, they were lost or sold. According to Bachrach family records, many of Bachrach's early negatives were destroyed in the great Baltimore fire of 1904, although the Bachrach studio, at Eutaw and Lexington streets, was several blocks west of the vast downtown district which burned. At some point in the early 1900s, Bachrach reportedly sold certain of his Civil War negatives to Charles Bender, of Philadelphia, who with his father made a business of buying photographers' glass negatives (at the rate, sometimes, of a million plates a year, according to Bender) in order to remove the negative emulsions and resell the clear plates again (in bulk form) to various customers, including photographers and gas meter manufacturers. Among the Bachrach negatives which Bender reports buying were those of the hanging of Mrs. Mary Surratt after the assassination of Abraham Lincoln, and of "those guilty in the [1901] assassination of President McKinley."[317]

By this time, several methods of making photographs with a *dry* collodion process had been introduced, but only five months prior to Lincoln's speech, the new editor of *Humphrey's Journal*, Prof. John Towler, was telling his readers that "it must be confessed that the same degree of sensitiveness in the dry process has not yet been attained as in the wet process; and instantaneous pictures," he added, "are the result only of the latter." A short time later (two months before the Lincoln speech), Towler claimed that it would be "absurd, because as yet impossible of success, to attempt by means of dry plates to photograph the vitality of Broadway, the mobility of old Ocean, the moving, undulatory masses of water at Niagara, or the onslaught of a Brigade on the field of battle." On the basis of these comments, the reported use of dry plates by one photographer at Gettysburg must have been something of a novelty.[318]

But a year prior to the Gettysburg battlefield dedication, a British journal observed that while the number of amateur photographers in the United States was "decidedly limited" (when compared with the number in Britain), nevertheless, "since dry photography has begun to be appreciated there, the number of amateurs has increased." With this, Towler was in agreement. "With amateur photographers, the wet collodion process," he said, "in a great measure is becoming gradually relinquished, and the various dry processes are taking its place; hence the great search after preservatives by which the sensitized collodion film can be maintained for a long time in a normal condition of sensitiveness even when the film of collodion is dry. Amonst the preservatives in vogue are found: tannin, gums, resins, milk, honey, syrups, malt, serum, etc. The best seems to be, without doubt, tannin; and the attention of photographers is directed mainly to the perfection of the tannin process."[319]

Although it is not usually considered in this light today, the albumen process—either Niépce's or Whipple's process—was considered a *dry* photography process at this time, as was, also, Le Gray's waxed-paper process. But the *collodion* dry processes introduced in the 1850s and 1860s all involved the use of a preservative coating of one kind or another (among them albumen) atop the wet collodion, which, when dried, allowed the plates to be kept for a matter of weeks, or up to six months before use. The preserva-

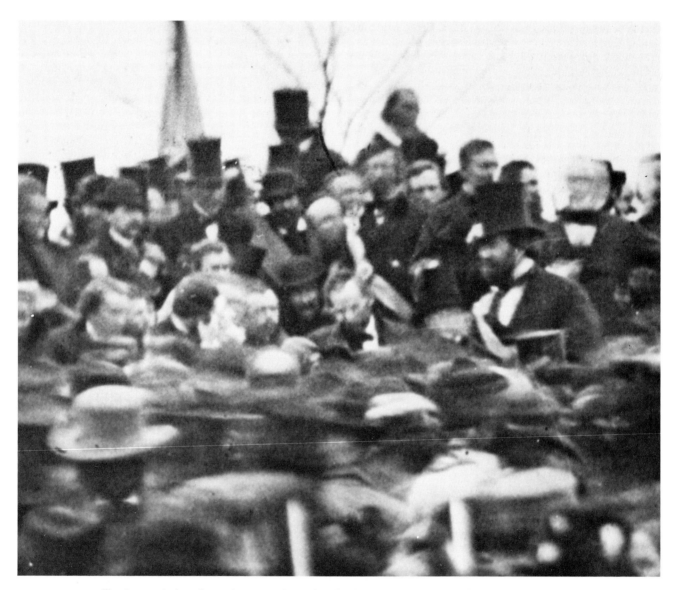

The photograph above is an enlargement of a portion of a view made of the crowd at Gettysburg when Lincoln dedicated the cemetery on November 18, 1863. Lincoln appears bareheaded in the center, his head inclined slightly forward, while white-haired Edward Everett, who gave the principal oration of the day, stands out second from the right at top. The photograph is said to have been taken by an assistant of Mathew Brady, who was in New York at the time. David Bachrach, Jr., who later founded the noted chain of Bachrach portrait studios, was ninety feet away, but it is unclear from statements he made fifty-three years later whether he photographed the President during or after his brief address.

1863

tive processes were all of English or French origin, and of all of them the tannin process, introduced by Maj. Charles Russell in 1861, did indeed become the most popular in the United States.

The process involved coating the wet collodion negative with tannic acid, which in addition to acting as a preservative also had a beneficial effect on negative development after the plate was exposed in the camera. As with most photographic processes, this one was also modified by users in one way or another. Prof. Edwin Emerson of Troy University, for example, found he could gain increased sensitiveness for his tannin plates by adding honey to the tannic acid.

Among the earliest users was A. F. Styles, a professional photographer in Vermont, who retired to Florida for health reasons at this time, taking his tannin plates with him. He took orders for pictures, then sent the negatives back to his Burlington, Vermont, gallery for processing and forwarding to his customers in the North. For three winters he did a large business, principally in card stereographs, securing a monopoly of the photographic business for himself in Florida. Then, having become enamored of life there, he sold his Vermont property entirely, bought a tract of land five miles south of Jacksonville, and began an orange grove.

Most collodion dry plates became articles of commerce after 1860, but in 1862 a British writer lamented that "dealers in photographic apparatus have never yet had the enterprise to establish a manufacture and sale of dry plates in such a way as to insure their popularity." The problem was that few plates could be depended upon. "Some will not keep long enough before exposure; some will not keep at all after exposure; some fail in sensitiveness; some spoil soon after they are opened; to say nothing of the constant liability of stains, irregularities, blisters, and all sorts of troublesome and annoying defects, which not only spoil the operator's work but—what is of more importance—destroy all reliance on his operations, and so discourage him from undertaking them." [320]

After a period of several years' silence, Charles C. Harrison's *Globe* lens received a full measure of laurels in the spring of 1863—both from technical leaders in the photographic community and from the United States government. In February, a long discussion on the attributes of the *Globe* was held by the Photographic Society of Philadelphia in which various members, among them Coleman Sellers, attested to the superiority of the lens after field trials. In May, Sellers published a lengthy tribute to the lens in the *American Journal of Science,* stating at the end of the article:

> Its advantages may be summed up in a few words. Short focus, clear definition, wide angle of included vision, absolute correctness of copy on a plane surface, and tolerably quick work. It takes the place entirely of the orthoscopic lens, giving absolute correctness to marginal lines, while the orthoscopic was only approximately correct. It fills all the requirements of a lens for landscape and architectural work, and is wanting only in the one thing of absolute instantaneity of action. [321]

The United States Coast Survey came to a similar conclusion after trials in which the *Globe* was used to make photographic copies of large maps without line distortion. In En-

225-746.C

THE APPRENTICESHIP OF A FAMOUS PHOTOGRAPHER

In 1858, Robert Vinton Lansdale (above) established a photography gallery in Baltimore where he reportedly took the first daguerreotype of Madam Jerome Bonaparte, the former Elizabeth Patterson of Baltimore, whose husband was King of Westphalia and a brother of Napoleon I. His first apprentice was David Bachrach, Jr., later founder of the Bachrach chain of portrait studios.

Lansdale, according to Bachrach, "was different from most of the leading artists, more intelligent and full of the experimental spirit, which suited me exactly, and further, he was a man of high moral character and free from the scandals connected with some of the leading photographers. He thoroughly understood the technique of the business and was fairly artistic. I kept up my friendship for him until he passed away."

In 1861, Bachrach was employed by William H. Weaver, an ornamental painter who had made a specialty of outdoor photography, and who was employed at times for special jobs by *Harper's Weekly.* "On account of the chemical and technical experiments made by the influence of Mr. Lansdale, to which I was naturally adapted," Bachrach recalled later, "I found myself knowing more about that part than the employers I was with, and, as a result, I had my own way and was hardly an employee at all." This applied particularly, he said, to Lansdale and Weaver, and later with William Chase for whom he worked from circa 1866–68. [322]

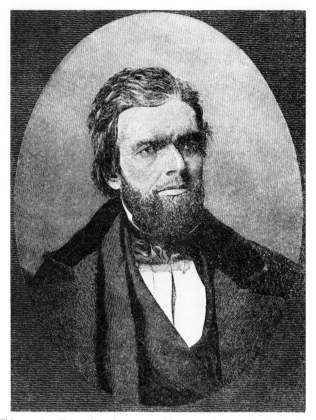

This woodcut illustration of camera and lens manufacturer Charles C. Harrison, which appeared in the February 1855 issue of the *Photographic & Fine Arts Journal,* was said by editor H. H. Snelling to have been the first American photograph secured from a glass negative on a wooden surface. The feat was accomplished by Harrison's former associate, J. DeWitt Brinckerhoff, and signaled the start of this direct mode of making woodcuts for book and magazine illustration. George Barnard developed a method for taking photographs on wood for engravers, and in 1857 he sold his gallery in Syracuse to devote full time to this branch of photography. The practice became commonplace after the Civil War.

DRY COLLODION PROCESSES

Between 1855 and 1861, various methods were introduced for coating wet collodion negatives with other preservative substances, after which the plates could be dried and kept for later use. In 1864, a workable process was developed for bottling a negative sensitizing emulsion (collodio-bromide of silver) which could be flowed on a glass plate when the photographer was ready to take a picture. But all dry collodion methods required long camera exposures, and none served to *supplant* the wet plate. The principal preservative methods were the following:

TAUPENOT PROCESS—Introduced by Dr. J. M. Taupenot, the wet collodion film was given a coating of iodized albumen. After drying, the plates could be kept several weeks.

NORRIS PROCESS—Introduced by Dr. Richard Hill Norris, of Birmingham, England, the wet collodion film was given a coating of liquid gelatin (which would soften in water during later negative development, allowing the developer to pass into the collodion base). These plates could be kept dry for six months, and were the first to be sold as articles of commerce.

FOTHERGILL PROCESS—Introduced by Thomas Fothergill, the wet collodion film was given a coating of albumen (as in Taupenot's process), but was washed off, leaving just enough in the pores of the collodion base to allow proper action of the developer during negative development. These plates were also sold commercially.

TANNIN PROCESS—Introduced by Maj. Charles Russell, the wet collodion film was given a coating of tannin, which was a further aid in negative development.[324]

gland, John Werge, having heard so much about the *Globe,* imported a 5 x 4-inch lens, which he found "embraced a much wider angle than any other lens known." C. Jabez Hughes used it to photograph a royal bridal suite in the Isle of Wight, after which Werge said, "I feel certain that no other lens could have done the work so well." Werge also showed the lens to John H. Dallmeyer. "He thought he could make a better one," Werge said, "and his wide-angle Rectilinear was the result."

Not only Dallmeyer but also Thomas Ross of Edinburgh, and Darlot in France, copied the *Globe* design, as evidenced in an article published in 1865 by M. Carey Lea (reproduced on page 167). As of May 15, 1863, Harrison had manufactured 307 of his *Globe* lenses, and some 8,817 portrait and other view lenses.

According to Snelling, Harrison was a large man, but not physically strong. Virtually nothing is known today of his life, and there appear to be no records of his successive achievements culminating in the *Globe* objective. On November 23, 1864, Harrison died of apoplexy, and we have only Snelling's word that he died "while still quite young." Several weeks after his death, D. D. T. Davie wrote in

Humphrey's Journal: "I did not know of the death of Mr. Harrison until I read the obituary notice in your journal. I have a desire to find his grave, to visit it as a mourner."[323]

The phenomenon known as "spirit photography" made its appearance at this time, and like the spiritual séance, it quickly gained its adherents and detractors. The photographic press took first notice of the movement in January 1863, reporting its origins in the hands of one William Mumler in Boston. "The subject is introduced with an apology," Seely commented in his journal, "for we are persuaded that in a short time spirit photographs will be generally looked upon as a low swindle." But he was wrong. Spirit photographs would continue to be a matter of discussion and debate for a dozen years. As early as the summer of 1862, carte de visite portraits depicting the appearance of a "spirit" behind and above the sitter were sold at five dollars a dozen to vast numbers of customers in Boston. Despite the fact that the trick could be easily performed by letting the "ghost" appear suitably draped in a white sheet for only a portion of a camera exposure, photographers, "out of curiosity to see how the spirit photographs are made," flocked to see them at their first New York showing

THE GLOBE LENS IN WORLD PERSPECTIVE

M. Carey Lea was one of the foremost authorities on photochemistry in the nineteenth century, and his Manual of Photography *published in 1868 was long considered a standard work among photographers. He served as American correspondent for the* British Journal of Photography, *and by 1875 was credited with publication of nearly fifty papers in American and British journals. The article below was published in June 1865.*

SOME REMARKS ON GLOBE LENSES.

BY M. CAREY LEA.

I HAVE several times already had occasion to speak of these lenses, moved thereto by what has seemed to me, extravagant praise. I now return to the subject, because I regret quite as much to see them made, in some quarters, the subject of unreasonable blame, and reproached with faults, with which, whatever be their real shortcomings, they are not chargeable.

The "Globe" principle, that is, the giving a great curvature to the posterior and anterior surfaces of the combination, has some advantages so evident that after having been once introduced by Messrs. C. C. Harrison and I. Schnitzer, of New York, the idea has been rapidly copied elsewhere. The new wide-angle lens of Mr. Ross, figured lately in the English journals, and in the Bulletin Belge, is extremely similar to the American Globe. And Darlot, of Paris, the successor of Jamin, has now produced a lens, the nature of which is admitted to partake largely of the same principle. *La Lumière* speaks of it in the following terms:

"The Americans were the first to construct objectives on this plan; but, in consequence of the exaggeration of the curve of the anterior glass, the vertical lines near the edge were bent to an intolerable extent.

"By an extended and attentive study of this new system of objectives, M. Darlot has succeeded in obtaining everywhere a perfect straightness of lines, and, for all his plates, a diameter which exceeds one-half more than the length of the focal distance, with a uniform sharpness from the centre to the edges, for the most distant objects. This is a magnificent result," &c.

I do not mean to say a word against M. Darlot's lenses, which are no doubt excellent. And no one will accuse me of any undue partiality for the Globe lens, whose faults I have frequently commented upon, but the charge that the "vertical lines near the edge were bent to an intolerable extent," is certainly amusing. It has led me to examine carefully a negative which I took a few days since with a Globe lens of Harrison's make.

The lens in question is one belonging to me. It is called a "3-inch focus" lens, and I find that its circle of light measures full seven and a half inches, or two and a half times the focal length.

This focal length is measured from the centre of the back lens to the focussing surface,—an incorrect mode of measurement, but one in general use, and probably that adopted also in measuring the focal length of the Darlot lens.* It will be seen, then, that while a diameter of one and a half times the focal length is, in the article referred to, insisted upon as an extraordinary achievement, in the American lens *two-thirds more* than this is accomplished.

The negative that I am speaking of, includes a building which occupies one-half of the circle of light, from the middle to the extreme edge. All the lines are perfectly straight, even those which are almost lost at the edge of the picture. Of course, the definition at the edge of the picture is not equal to the rest. I have yet to see a lens capable of accomplishing this, and if M. Darlot's will effect this, as its eulogist (I fear rather rashly) claims, he has accomplished something unparalleled in photographic optics. But this leads to another reflection.

The Globe lens of which I speak, gives with a 3-in. "back focus," a circle of light of seven and a half inches. M. Darlot's, of the same focal length, would give one of four and a half inches, viz., one and a half times the focal length. Now, as the areas of circles are as the squares of their diameters, the superficial sizes of the respective pictures produced by the American and French lenses of equal focal distances, will be as 225 : 81, that is, the American lens gives *nearly three times* as large a picture as the French of equal focal length.

Again, were I to cut off from my picture an annulus one and a half inches wide all round, the remaining central piece would be of the same size as that given by the French lens, viz., four and a half inches diameter, and would be excellently sharp all over. The advantage, therefore, will be with the American lens, in all those points which have been specially pressed as the peculiar strength of the French. It is possible that the French lens may not have the faults of the Globe, viz., want of atmospheric effect and exaggerated perspective, but it will probably be found that these faults are inseparable from an extremely short focus.

I must also, in strict fairness, observe that mine is a remarkably good Globe lens, and that the usual circle of light given by the three-inch focus size is six inches; occasionally, but rarely, less. I have seen another, however, which performed about

equally well as mine, and do not doubt that there are many such made. In fact, I do not see why the manufacturer cannot make all his lenses alike or very nearly so, in this respect. The construction is also ill-devised: too much of the tube is thrown inside the camera; this necessitates a longer camera, and the extreme inconvenience of having to unscrew the tube from the flange to alter the diaphragm. This difficulty is avoided in the French lens. The prices demanded for the Globe are also absurdly high; a competition of French lenses of large angle will probably lead to a reduction in the price of the American. The Globe principle cannot, so far as I see, be controlled by a patent. Lenses of which the posterior and anterior surfaces form parts of the surface of a sphere, with an intermediate stop, are very old. One form, in which the effect of a diaphragm is produced by grinding away the equatorial portions, will be found figured in *Brewster on Optics*. (American Edition, 1833, p. 282.) Wollaston had previously proposed something of a similar nature, but in separate pieces, with a metallic diaphragm.

I have here specially referred to the remarks in La Lumière, but others, very similar, and, to my mind, equally unjust to the Globe lens, were made at one of the meetings of the Photographic Society of Berlin some months back.

One thing is clear, that the increasing disposition of the best makers everywhere to give a much greater convexity to the posterior and anterior surfaces of their objective doublets, demonstrates that the Globe principle possesses certain incontestable advantages, and must be regarded as a valuable acquisition to the photographic repertory.

PHILADELPHIA, May 10, 1865.

———❦———

* The expression in the article quoted is simply "focal distance,"—not equivalent focus,—and the presumption is that the back focus is meant, because that is the commonest mode of measurement. And this presumption is heightened by the expression "exaggeration of the curve," used in reference to the Globe, from which it is probable that M. Darlot's lens is one of flatter curvature and less included angle. 325

Dr. Charles Rice of Bellevue Hospital, New York, poses for a "spirit" carte de visite portrait taken by O. G. Mason, the hospital's resident photographer and secretary of the American Photographical Society. Mason said the portrait was made "in illustration of the [William] Mumler method," referring to the Boston photographer who introduced the craze in January 1863. Various methods were used to make the trick photographs, which were considered by many to be the workings of true "spirits."

at A. J. Davis & Company. "The spiritual people at once endorse the new art, and defend it with a passion," Seely observed. "They throw down the gauntlet to all who are not 'progressed.'"

In April, the matter became a topic of discussion at a meeting of the Photographic Society of Philadelphia. Coleman Sellers introduced the subject by reading a letter from an acquaintance in Boston who had participated in an investigation of the Mumler photographs. "I agree with you perfectly," the correspondent reported, "in supposing that the plate in the bath is changed during the time that the darkroom is entirely without light, as is the case when the plate is removed from the bath." According to the minutes of the society's meeting, J. W. Hurne exhibited two card pictures with spirit accompaniment, which he said he had made himself. Hurne's remarks were then recorded as follows:

> He said that his acquaintance with the spirit world had been so recent that he had not been able to prepare as many of these specimens as he should have liked. The spirit pictures were exactly like the ones made by Mumler, but the photographs as a whole were far better than his; he had gone ahead of Mr. Mumler in one respect, inasmuch as one of his spirits was head downwards, showing conclusively that it must have been taken in the act of descending to the earth. After many amusing comments on them by himself and others, he said that the spirits were from positives, the impression being made by lamp light in one or two seconds, the portrait of the sitter being made afterwards with the usual exposure.[326]

Seely expressed his sentiments regarding spirit photographs in this brief editor's note: "What a shame that all these things should come to pass in the nineteenth century, and in America."

1864

The photography business generally remained good in the North during the Civil War, but as early as 1861 the southern artists were reported to have "nothing to work with, and nobody to work for, and, probably, are forced to go soldiering." Nitrate of silver, which was estimated to be a $6.5 million business on the international market in 1864, became increasingly in demand for treatment of the sick and wounded, and a certain amount of hoarding of this and other photographic materials took place, prompting *Humphrey's Journal* to warn in July 1864:

> Dealers who have goods now are not anxious to sell—not they; the goods are all the time rising on their hands, and they look at one another, and say: "Very well; they've got to have 'em by-and-by, and *then* they'll have to pay for 'em; I'd rather *not* sell now." This will all be very nice, provided Grant continues inactive around Richmond; but just let him achieve some splendid military success, and gold will drop, and prices will fall, and those who have small stocks *then* will be very glad of it.[327]

One photographer who elected to go south at the beginning of the war was J. H. Fitzgibbons, of St. Louis. In 1861, he sold his gallery and relocated in Vicksburg, Mississippi, then a bustling commercial center of 4,500 with strong economic ties to the North, and its citizenry predominantly opposed to secession. But the war was soon brought to its doorstep, and after the long winter siege in 1863, Fitzgibbons left the city, tried to run the blockade, but was captured and sent to New Orleans. From there he was able to travel directly to New York, where Seely gave this report of his trials and tribulations:

> He had at the beginning of the war one of the best appointed photographic establishments in the southwest, with materials for a protracted siege. But he was unable to stand the continued pressure. Finally with alcohol at $24.00 per gallon, and many other useful things not procurable at any price, and with no money among the people to pay for pictures if he could produce them, he very properly felt that he had a call for a cooler climate. He is thankful, we presume, to get away with a whole skin and a good suit of clothes. There has been little photography in Jeffdom for the past two years. It is only in Charleston and perhaps Richmond that any photographs at all are made. By favor of our British cousins who run the blockade with powder and guns, our friend Cook of Charleston has still a precarious stock of photographic materials and still makes a business in the shadows of the people.[328]

Aside from the war, *Humphrey's Journal* felt that the photographic art—principally through the carte de visite revolution—"has done a good deal to make people personally acquainted. Everybody keeps a photographic album, and it is a source of pride and emulation among some people to see how many cartes de visite they can accumulate from their friends and acquaintances. Young gentlemen who travel on their appearance, have their cartes printed off by the dozen, and distribute them under the impression that they are affording a gratification to their numerous friends and acquaintances. But the private supply of cartes de visite is nothing to the deluge of portraits of public

BOSTON STUDIOS

John A. Whipple (1822–1891) and James Wallace Black (1825–1896) operated as partners during the years 1856–59, then went their separate ways thereafter. Whipple's studio at 96 Washington Street is shown (top) where he operated until 1874 when he retired from photography. Black operated establishments at 163 and later 173 Washington Street, having as his business partner a Mr. Case during the 1860s and 1870s. Whipple and Black are ranked among the foremost American photographers of the nineteenth century.

characters which are thrown upon the market, piled up by the bushel in the print stores, offered by the gross at the book stands, and thrust upon our attention everywhere. These collections contain all sorts of people, eminent generals, ballet dancers, pugilists, members of Congress, Doctors of Divinity, politicians, pretty actresses, circus riders, and negro minstrels. To the theatrical profession photography is a good advertising medium. The protean actress adorns the doors of the theater at which she appears, with a highly colored photograph of herself as she appears in private life, surrounded with other pictures in character. The Ethiopian comedian, following suit, has himself taken in twenty-five different dresses and attitudes.''[329]

Photographers in Boston were generally getting higher prices at this time than in New York. Although the city seemed unable to support a photographic society (such as had been organized in Philadelphia, Cincinnati, and other major cities), there were approximately seventy galleries, most of them selling cartes de visite at $3 a dozen ($4 a dozen if vignetted). A demand for larger pictures was evidencing itself, prompting one observer to remark: "It is supposed that the albums are now full, and that the public now intend to fill their walls.''

Having dissolved their partnership in 1859, John A. Whipple and James Wallace Black now maintained separate studios on Washington Street, the celebrated photography row of Boston. Whipple was at No. 96, and Black at Nos. 163 and 173. Even by this time, Whipple continued to make

A MODEL SKYLIGHT

With the explosion in business brought on by the carte de visite, Abraham Bogardus bought the Root gallery at 363 Broadway and installed what the *American Journal of Photography* termed a "model sky-light":

The light fronts the south. This is the capital fact about it. Of course we know it is not the first light which has been made to face the south. But we believe it to be the first that was deliberately and designedly so constructed, a southern aspect being preferred to any other. The top light is 14 feet square; the bottom or side light, meeting the top light, is 10 feet high and 14 feet wide. The upper edge of the top light is 15 feet from the floor. The top light has a pitch of about 20 degrees. The glass of these lights is the ordinary white ground glass; but the glazing is double and we have only described the outside. Six inches within, and parallel to the ground glass, are sashes glazed with blue glass. There are four sashes for the bottom light, sliding lightly on rollers. The operation of the whole contrivance is this: the pure sunlight easily gets through the ground glass, but the rays are diffused and softened; these diffused rays meet the ground glass, and everything in them which is not wanted is held back and only the uncontaminated chemical force passes down into the room. Mr. E. M. Howell, late of Fredericks, the skillful manager of the camera, told us that he found it best to make his sitters face the sun, and accordingly the position of the background was constantly changed during the day to secure the desideratum. A wonderfully small stop on bright days is used on the camera, and 15 seconds are considered a long time for exposure. On such days with lens at full aperture, the sitting is less than one second.[330]

1864

more daguerreotypes than all the rest of the New England operators combined.

Although Black is not as well known today as he was in his own time, Marcus Root felt (in 1863) that Black's "success for the last five years in all branches of his profession is probably without a parallel in the United States." Black took on a business partner, a Mr. Case, about this time, who remained with him during the 1860s and 1870s. The Washington Street gallery was described in 1864 as "a wilderness of rooms, upstairs, downstairs and in the lady's chamber, evidently patterned after the style of Boston streets." The firm employed about sixty persons of both sexes, and although some forty thousand glass negatives were stored "seemingly here, there and everywhere," any desired one could apparently be readily found. In the handling of patrons, "Mr. Black himself attends to the positions, and another assistant develops."

Black and Case, at this time, introduced the porcelain photograph, which was given this notice in *American Artisan:*

The effect is quite pleasing, the picture being clear and distinct like a fine line engraving, and especially beautiful when suspended where the light can pass through the porcelain, which renders the shading soft and delicate, and brings out many effects which cannot be produced in an ordinary picture.[331]

The year 1864 may be said to mark the birth of a more flamboyant style of gallery photography, which was soon coupled with new techniques in lighting and posing to render more dramatic, and in many cases more artistic, photographic portraits. The prime innovator was Napoleon Sarony, who was born in Quebec in 1821, the year Napoleon I died, and was named for him because of his father's great admiration for the French emperor.

During the 1840s, Sarony worked for Currier & Ives, then operated his own lithographic business in New York during the 1850s under the name Sarony, Major and Knapp. He evidently operated a daguerreotype gallery for a year in Yonkers, New York, and was one of the founding members of the American Photographical Society.

In 1858, he decided to retire from his lithography business in order to study art in Europe. Sarony's brother, Oliver Sarony, was already established as a photographer of considerable note in England, and Napoleon Sarony operated a gallery of his own, for a short time, in Birmingham, England, while continuing to study art. In 1864, he returned to the United States and opened his first New York establishment on Broadway near Bond Street.

This short (5 feet, 1 inch in height), colorful man, sporting a beard, polished calvary boots, and a Turkish fez or astrakhan cap, soon became a familiar and evidently much-liked figure on the New York scene.

He was the first of New York's fashionable photographers to become a part of the American art world. He was a founder of the Salmagundi Club, and a member of the Tile Club on East Tenth Street, which was decorated by Stanford White, and where William Chase, Hopkinson Smith, Swain Gifford, and many others met to talk, drink beer, smoke, and criticize one another's work.

In addition to breaking new ground in the style for studio lighting, settings, and accessories, Sarony perfected what

America was still without an accomplished landscape photography school in the 1860s, and few American-made photographs will be found today to match the works of such English and European masters of this and earlier periods as Philip Delamotte, Francis Frith, Gustave Le Gray, Maxime Du Camp, or Charles Nègre. The *Philadelphia Photographer,* which commenced publishing in 1864, encouraged submission of landscape views such as this one by the Philadelphia photographer F. A. Wenderoth, which was printed in quantity and bound separately into each copy of the magazine's March 1864 issue.

1864

Napoleon Sarony, only just over 5 feet tall, always dressed colorfully in Turkish fez and trousers tucked into highly polished cavalry boots. He was among the first of New York's fashionable photographers to move in literary and art circles.

Edward L. Wilson, editor of the newly established *Philadelphia Photographer* described several years later as a "posing machine." A sitter's head, back, arms, sides, "and in fact the whole person were at perfect rest and repose" in the Sarony device. "We were comfortable and could keep still an hour in its pleasant embrace," Wilson said. "The sensation is almost indescribable. It must be experienced to be fully realized." Sarony customarily made eight poses on a single plate, which prompted Wilson to observe that "those who have four positions of the same person, will notice the changes in position that can be rapidly made in using Mr. Sarony's machine. With the old arrangement it would be almost impossible to secure eight positions before the film became dry and horny." Sarony made his prints "entirely in the shade," Wilson said, and the tone of the prints he characterized as "peculiar to Mr. Sarony's paper." [332]

The new American photographic journal, *Philadelphia Photographer,* begun by Edward L. Wilson and M. F. Benerman in January 1864 (using a combined capital of only $100, and working principally at night), soon became the principal journalistic medium for the photographic community. On the occasion of photography's fiftieth anniversary, it was given a new title, *Wilson's Photographic Magazine,* then, in 1915, was retitled the *Photographic Journal of America.* Wilson quickly acquired the mantle worn in pre-

vious years by Snelling, and functioned as a prime chronicler of photographic events throughout the rest of the nineteenth century.

Among the first steps taken by the magazine was that of giving greater exposure to landscape photography—both American and foreign. The photographs of John Moran, brother of the celebrated painter, and other Philadelphia photographers were printed separately and inserted as frontispieces for many issues in the period 1864–66. But only two or three photographers—among them Moran, John Carbutt of Chicago, and the Bierstadt brothers—were doing "really first class outdoor work," Wilson felt. Prof. Towler was of the same opinion, judging by these remarks in an article on lake scenery which he published in the December 1 issue of *Humphrey's Journal:*

Judging from the public exhibition of views and scenery by means of the stereopticon, the stereoscope and albums, a stranger would be inclined to conclude one of two things: either that this vast continent of ours was a flat country devoid of all interesting accidents, or that we Americans were behind the times in landscape photography. He is justified in this conclusion; for it is almost an impossibility to get a sight of any of our magnificent land and water formations reproduced by photography, whilst thousands of inspired views of bare walls and naked plains in Egypt, Palestine and Italy, without a single native living being to give vitality to the scenery, or a single native object, as a wheelbarrow, a wagon, or a toll-gate to characterize the country, may be seen and obtained at almost any of our photographic depots: an abundance of trash! [333]

America in the 1860s was without any counterparts to such professional landscape and architectural photographers across the Atlantic as Francis Frith, Gustave Le Gray, Maxime Du Camp, Henry Peach Robinson, Carlo Ponti, or the brothers Louis and Auguste Bisson. For most of the decade, this was an activity practiced principally by amateurs, or by photographers whose names would become more prominent in the 1870s. One American amateur much praised in his time, but whose works are today unknown, was Henry J. Newton.

Like Victor Prevost, Newton adopted a form of calotype practice, and both men on several occasions exhibited prints to members of the American Photographical Society. P. C. Duchochois said he had never seen "the paper negatives excelled in delicacy and finish," after viewing Newton's work. Newton first tried, but "became disgusted" with the tannin process. He began experimenting with paper negatives, and found he could make negatives in half the exposure time for the tannin method. "I made a great variety of experiments, and finally settled on a process which made beautiful work. Instead of using wax, I used paraffine. I think I was the original operator in that direction, and the paper prepared with paraffine was much more sensitive than that prepared with wax." Duchochois found Newton's prints "particularly admirable for the absence of granulation and mottlings of the paper." Outdoor views could be made with the paraffine paper in exposures of as little as 45 seconds. [335]

During the years 1856–63, Marcus A. Root was at work compiling the first history of photography to be published in the United States. Entitled *The Camera and the Pencil,* the book appeared in 1864 with apologies from Root that it con-

UNRECORDED PHOTOGRAPH OF LINCOLN APPEARS
REVEALED IN X-RAY OF OIL PORTRAIT

What is believed to be an unrecorded life-size photograph of Abraham Lincoln (right) has been found beneath the oil painting (left) which was acquired in 1973 by George R. Rinhart of New York City from heirs of the French-born landscape and portrait painter Alexander Francois, who died in Albany, New York, in 1912. The photographic likeness has been reproduced from one of a series of X-rays made of the portrait by Grace Galleries, Inc., of Englewood, New Jersey, a restorer of paintings. The twill-weave canvas, which measures approximately 50 x 40 inches, has been painted over several times, and because of an irregular shrinking on the part of the various layers of thick and thin paint, the canvas support has become buckled and warped. Test cleanings with different solvents applied locally to the painting's surface have indicated the presence of a photographic emulsion which appears to be sepia tone in color. According to Grace Galleries, the X-rays would pick up the presence of silver salts in a photographic emulsion, and this would account for the X-ray likeness exhibiting a stronger appearance than the emulsion probably would have appeared to the human eye at the time it was secured on the canvas. The highlights in Lincoln's face can be attributed to the presence of lead in the paint. The likeness in the X-ray can be dated to 1863–65, suggesting that it is from a negative made at that time either at the Brady or Alexander Gardner studios in Washington, D.C. The enlargement on the canvas would have been made with a solar camera, which both Brady and Gardner are known to have used. According to records accompanying the painting, it was first offered for sale by Francois in 1870. Besides the inventor, David Woodward, one photographer who used the solar camera regularly to make photographic portraits on artists' canvases was Woodward's fellow Baltimorean David Bachrach. In later years, Bachrach recalled in these words the method he used after opening his business in 1869:

Paintings on canvas over photo portraits were then largely used, and I think we made over two thousand of them with our solar cameras. They were as good as prints on paper. Various journals at the time published my method both in this country and Europe. It consisted in first cleaning the oil [Bachrach here probably refers to the painting's prepared base] partly with a solution of ammonia and then hardening the same with acetic acid No. 8. I then used gum mastic or gum benzoin in an alcoholic solution containing the chlorides, and this united perfectly with the surface, but citric acid was also used in the solution. It was then ready for silvering and printing.[334]

1864

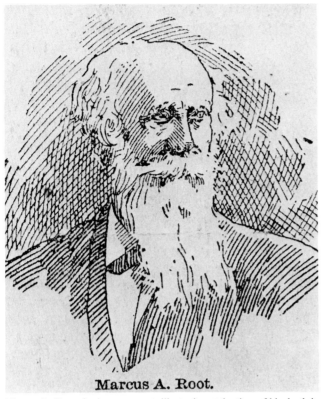

Marcus A. Root.

Marcus A. Root, from a newspaper illustration at the time of his death in 1888.

tained "not a little repetition" in subject matter. "One reason for this," he said, "is that I was specially anxious to impress these subjects on all within my reach; and another, that the book having been seven or eight years in hand, it was impossible to carry the whole in my mind, so as to avoid occasional reiteration." Another contributing factor was that one of Root's legs had been broken in two places (above the knee and at the ankle) in a freak railroad accident in 1856, and he was long in recovering from these injuries.

When his book was published in 1864, he described it as an attempt at "embracing the theoretic basis of the art," and promised a second volume which would delve into photography's "practical processes, formulae, etc." The first volume is long on the "theoretic basis," and tantalizingly brief on specific doings and achievements of American photographers prior to the Civil War.

The planned second volume, from a man so closely acquainted with all of the major personalities and events of the daguerrean era, would today be an invaluable reference source for those who still thirst for records of photography's formative years, but, unfortunately, it was never issued. A letter dated November 21, 1866, which was addressed to Prof. J. C. Booth in Philadelphia from A. Muckle, who had made "a number of contributions" to Root's second volume, informs us that Root was still "getting up" the second work. But after the second part had been stereotyped and placed on the press, the building in which the plant was housed was destroyed by a fire, and the manuscript as well as the plates were lost.[336]

1865

Faulty generalship by Maj. Gen. Benjamin Butler, who concentrated on digging a canal to straighten a loop in the James River, prevented Gen. Ulysses S. Grant's forces from taking Petersburg, Virginia in 1864, and helped prolong the Civil War into 1865. Petersburg and Richmond were abandoned by Gen. Robert E. Lee's forces two days before Lincoln's second inauguration on April 4, and Lee's surrender at Appomattox followed on the ninth. Five days later Lincoln was dead at the hands of an assassin, unleashing an era of political rivalry, bitter feelings, and social upheaval which continued unabated for several years.

Ten days after the assassination, Lincoln lay in state in New York's City Hall, where Mayor C. Godfrey Gunther allowed—or deliberately selected—Benjamin Gurney to take photographs of the dead president in his coffin. Gunther was a "peace Democrat," and like many New Yorkers (who provided the greatest amount of supplies and paid the most taxes to keep the war going), he was of a similar opinion as other "peace Democrats," whose slogan was: "Restoration of the Union as it was and the maintenance of the Union as it is." Other Democrats in New York were ardent supporters of the war, and had joined with Republicans to form the Union party. The two factions, in the frenzied state of affairs which followed the assassination, gave vent to their prejudices and anger over the photography which took place at City Hall.

Gurney, son of Mathew Brady's chief rival, was evidently opposed to the war, and was considered a "Copperhead" (a northern sympathizer with the southern cause) by others in the New York fraternity. Thus it was he, and he alone, who was allowed "uninterrupted possession of the premises for several hours" at City Hall, making photographs of Lincoln and of scenes in and around the hall. No other photographer was given similar privileges by city officials. A correspondent identified only as "Union," in a letter to *Humphrey's Journal,* decried the action, asserting:

> Where was the necessity of photographing the remains? Was there not already millions of good representations of the living man that they must desecrate the dead? And why should this privilege be granted to Mr. Gurney, to the exclusion of all other photographers. The reason is simply this. Mr. G. is a *Copperhead;* Mayor Gunther is another. Had not Mr. Gurney, during President Lincoln's four years administration, sufficiently exhausted his vial of wrath and venegeance against him, that he must now disturb the repose of the dead, and insult and injure the bereaved family and true friends of the departed? The whole scheme was a disgraceful outrage upon humanity, and deserves the execration of every American citizen.[337]

Secretary of War Stanton, on hearing of the City Hall photography, dispatched agents to the Gurney establishment in New York where they seized the negatives in the name of the United States government. Gurney followed the agents to Washington in the vain hope of retrieving them. But as "Union" stated in his letter to *Humphrey's Journal:* "Mr. G. did *not* recover these negatives, nor never will. In this case justice has been meted out to avarice; the negatives

were totally destroyed by order of Secretary Stanton, and thus ends Mr. Gurney's disgraceful speculation."

But "Union" was wrong. The photographs were *not* all destroyed. Stanton retained at least one for himself, and this was given by his son to John Nicolay, secretary to Abraham Lincoln, in later years. The photograph remained unnoticed among Nicolay's papers until 1952 when it was discovered among the papers at the Illinois State Historical Library by a fifteen-year-old student, Donald Rietveld, of Des Moines, Iowa.[338]

As early as 1859, it had been discovered that extreme brightness coupled with favorable actinic qualities could be achieved by burning magnesium wire, and photographic portraits using this method were made in England in 1864. A different mode of using magnesium for artificial light—namely, igniting it in powdered form—was proposed in 1865, but this was not put to practical use for nearly two decades. In the meantime, when the price of an ounce of magnesium fell to a little more than twice that for an ounce of silver (also in 1865), experimentation began more in earnest with the wire mode. Because of a higher exchange rate, New York prices were higher than in England. Charles Seely said some dealers charged 25 cents an inch for the wire, while others charged 50 cents a foot. He also estimated that the wire used by photographers burned at the rate of about one foot a minute.[339]

On the nights of October 26 and 27, 1865, a series of photographs was taken at the home of the Philadelphia amateur photographer John C. Browne, using magnesium lighting. Edward Wilson was present for the occasion (posing in at least one of the photographs taken), and the experiments were given prominent notice in the *Philadelphia Photographer.* Most of the negatives were made with a pair of Jamin stereoscopic lenses of 4½ inches' focal length. The length of exposures ranged from 15 to 30 seconds, and the number of tapers of magnesium wire used in the case of each exposure ranged from three to six (120 tapers being roughly equivalent to a pound of magnesium). In all cases, there were heavy shadows in the pictures, but Wilson felt that these might have been overcome if two instead of only one reflector had been placed near the camera. The problem of shadows in making photographs by the light of a burning magnesium wire was not one which would ever be fully overcome. As Professor Draper explained at a meeting of the American Photographical Society, all shadows would appear obscure "in consequence of the light emanating from a very minute point." Nor was the magnesium light used with any regularity in photographic galleries, because apart from the harshness of the illumination, the white smoke from the burning tapers lingered after an exposure, and could not be readily dissipated.[340]

While the experiments conducted at the home of John C. Browne were among the earliest with magnesium light, John A. Whipple had managed to secure several nighttime photographs with electric light in Boston Common as early as August 6, 1863. When these were exhibited at the Amer-

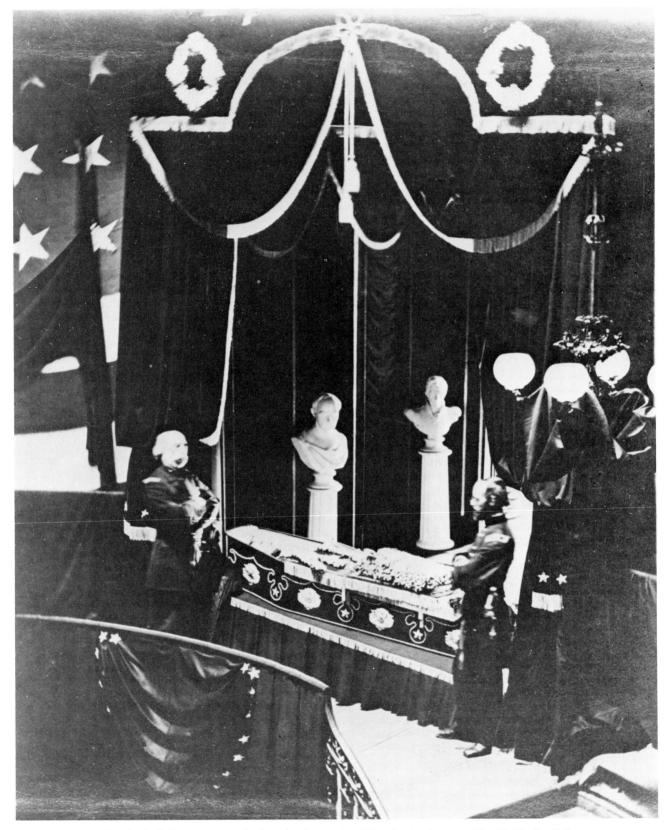

After Benjamin Gurney was permitted to take photographs of Lincoln lying in state at New York's City Hall, Secretary of War Edwin M. Stanton confiscated the plates and prints, but retained one print himself from which the illustration above has been reproduced. The print was given by Stanton, or his heirs, to John Nicolay, Lincoln's secretary, and remained in the latter's papers at the Illinois State Historical Library until discovered by a researcher in 1952.

Baron F. W. von Egloffstein

EXPERIMENTS ARE BEGUN WITH HALFTONE REPRODUCTION

Although the halftone process by which photographs today are printed in books, magazines, and newspapers wasn't perfected until the 1890s, Baron F. W. von Egloffstein began experimenting with a method of photomechanical printing (i.e., securing photographic images on a printing plate) in 1861. A halftone is made by putting the original photograph through a screening process which converts the images into fine dots of varying size. The dot images are then transferred to a metal plate where they are etched into relief for inking and printing along with the text.

Baron von Egloffstein has been called the "father of the halftone." He was a former member of the Prussian army who began his experiments in Philadelphia. In this he was assisted by the noted engraver Samuel Sartain, who prepared the screens (lines evenly ruled on a glass plate) through which von Egloffstein made photographs on a steel plate coated with asphaltum. But the baron ran out of bensole, a solvent which he considered essential to the experiments, and temporarily abandoned his work after trying in vain to obtain a new supply. He joined Gen. Burnside's forces in the Civil War, but was severely wounded in a battle near New Bern, North Carolina, in 1862. Recovered, he again resumed his experiments in New York and on November 21, 1865, was issued a patent for a primitive halftone method. But despite being given a large amount of financial backing by Jay Cooke & Co., von Egloffstein remained unsuccessful in his efforts to perfect the process and over the next thirty years his pioneering work was forgotten.

Baron von Egloffstein and Sartain had differed on the number of lines to the inch for the screen plates. "He wanted them made over 250 lines to the inch," Sartain said in later years, "which I told him could not be well printed with the ink then in common use." Sartain made screens with 220 lines to the inch, but these were also finer than those used when the halftone process was fully perfected in 1893 (see pages 362 and 369), leading experts to conclude that the extreme fineness of lines prevented von Egloffstein and Sartain from achieving ultimate success.[341]

ican Photographical Society, they were pronounced "very fine." The minutes of the meeting also reveal that the spray of a fountain depicted in the photographs was "well shown." Whipple used a 5-inch Voigtlander lens with a 16-inch focus, and made his exposures at full aperture in about 90 seconds. In a note accompanying the prints he stated:

The image came up immediately, strong without re-developing. A very curious effect is given to the trees; those leaves only are photographed which were in position to reflect the light directly into the instrument; their number is few, and the trees appear to be nearly bare of foliage. The effect of the electric light as compared with sunlight is about in the proportion of one to one hundred and eighty—ninety seconds exposure being required in the former case, while in sunlight, or slightly hazy daylight, about one-half a second is sufficient to produce the same effect.[342]

During the Civil War, the photographers' attempts to resist licensing of the collodion process under the provisions of the 1854 Cutting bromide patent had remained dormant. But by March 1865, T. H. Hubbard of Boston assumed the reins of the various suits, and in the face of a widespread collapse of opposition by individual operators (Brady and Bogardus among them), he began collecting $50 in arrears, and another $25 for each remaining year of the patent as licensing fees (which was good until 1868) from one and

ALEXANDER GARDNER'S
WASHINGTON D.C., GALLERY

Alexander Gardner, from a carte de visite made at Mathew Brady's Washington studio, circa 1861–62.

The photographer most active in Washington, D.C., photographing Lincoln's funeral, the assassination conspirators, and their hanging outside of the Washington penitentiary on July 7, 1865, was Scottish-born Alexander Gardner (1821–1882). Trained both as a jeweler and chemist, Gardner mastered collodion photography before emigrating in 1856 to New York, where he was employed by Mathew Brady. Gardner is credited with having introduced the Woodward solar camera at the Brady gallery, used in making Brady's "imperial" photographic portrait enlargements, and in 1858 he was named manager of Brady's gallery in Washington, a position he held until 1862 when he parted company with Brady after a dispute over copyrighting of photographs made at the gallery. Gardner's departure was Brady's loss, because not only had Gardner arranged for mass production of carte de visite photographs by E. & H. T. Anthony & Co., using negatives supplied by the Brady gallery, but he had introduced bookkeeping methods which, if adhered to, might have prevented or alleviated Brady's later financial woes.

After a brief stint as photographer to the Army of the Potomac, Gardner established his own gallery first at 332 Pennsylvania Avenue, then in 1863 at 511 Seventh Street, just around the corner from Brady. He was joined by his brother James, and by a number of Brady staffers, including Timothy O'Sullivan, George Barnard, D. G. Woodbury, and Egbert Guy Fox. Among Gardner's first sitters was President Lincoln, who posed on August 9, 1863, both alone and with his secretaries, John G. Nicolay and John Hay. Gardner's photographs of Lincoln made at the August 9 sitting, and again on November 15, are considered by many to be the best ever made of Lincoln. On the day of General Robert E. Lee's surrender at Appomattox (April 9, 1865), Lincoln again went to Gardner's studio with his son, "Tad," where the last photographs of the sixteenth president were made in a series of now-famous poses. In 1864, William A. Pinkerton, son of the celebrated detective, called Gardner "the best artist in the country," and today Gardner's two-volume *Photographic Sketchbook of the War* is considered the equal of any work executed during the Civil War by Brady or others. For a time after the war, the Gardner studio was the scene of many official group portraits. These included visiting delegations of Indians and the members of the U.S. Supreme Court which, with the appointment of Chief Justice Salmon P. Chase in December 1864, became known as the "Lincoln Court" (Lincoln was the first president after Washington to appoint a controlling number of sitting justices). In 1867, Gardner made card stereograph views together with larger photographs of scenes along the route of the Union Pacific Railroad, and the latter were much admired in 1868 at a meeting of the Philadelphia Photographic Society. He enjoyed a separate income from real estate interests, and in 1873 he set up the first Rogues' Gallery at Washington's Metropolitan Police headquarters.[343]

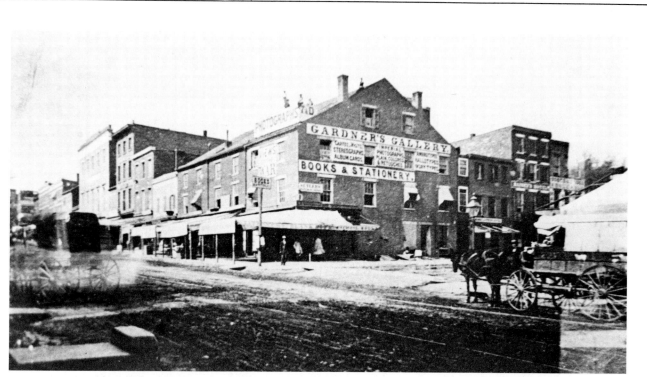

After working for Mathew Brady in New York and Washington, D.C., from 1856 to 1862, Alexander Gardner established a gallery of his own (shown above) at 511 Seventh Street, just around the corner from Brady's Washington studio. A number of the most famous photographs of Abraham Lincoln were taken at this gallery on August 9 and November 15, 1863, and again on April 9, 1865.

The justices of the U.S. Supreme Court posed for this photograph in Gardner's gallery possibly before Lincoln's assassination. They are, from left to right: Daniel W. Middleton, clerk; David Davis; Noah Swayne; Robert C. Grier; Chief Justice Salmon P. Chase; Samuel Nelson; Nathan Clifford; Samuel F. Miller; and Stephen J. Field. Lincoln appointed Chase, Davis, Swayne, Miller, and Field.

1865

SOURCES OF ARTIFICIAL LIGHT

From *American Artisan*

Light from common gas and candles is due not to the chief combustible, hydrogen, but to the heat it gives to particles of carbon suspended in the flame, and not yet burnt; if the combustion is so perfect as to burn the carbon promptly, there is little light. In the lime light, hydrogen gives heat to lime, which is incombustible, and makes it white hot, so that it gives more light than the orange or yellow flame from hot particles of carbon. So with the oxyhydrogen light, in which magnesia, an incombustible substance, is used. In the new light, magnesium, a metal extremely combustible, gives an intense heat, and at the same time forms an abundance of solid incombustible *white* particles of magnesia, which continue to give light until they become relatively cool; whereas the hot particles of carbon cease to give light as soon as they meet with oxygen, and are turned into gas. The light is not yet fit for common use; but may do well for signals, and for photography.[344]

STAMP NUISANCE

Photographs transported in the mail were subject to a stamp tax between September 1, 1864, and August 1, 1866. Following are the arguments of a petition to Congress sent by Albany and Troy, New York, photographers in December 1865, which led to removal of the tax:

1. Tax is greater than for other merchants such as retailers, apothecaries, confectioners, etc.

2. Tax on photographic supplies caused a rise in prices for the supplies, an additional burden.

3. Tax on small (card) photographs is amounting to 50 percent of their retail price.

4. Tax applies to proofs, many of which are returned by customers; a technical ruling by "some assessors" prevents the reuse of these stamps.

5. Tax severely effects business of ferrotype, ambrotype, and other photographers dealing in small photographs, gem miniatures, etc.

6. In establishments where as many as three to four hundred small pictures are made each day, it is necessary to employ an individual just to affix and cancel stamps.

7. Coloring on stamps frequently rubs off and stains, discolors, or otherwise spoils many photographs sent in the mail.

8. Despite the tax, and an estimated 40 percent increase in materials costs, photographers outside of New York, Boston, Philadelphia, and Washington have not increased their prices for photographs.

9. Photography is the "hand-maid of science and art," and should not, because of a tax burden, be confined to large operators in the large cities.[345]

all. On November 15, C. D. Fredericks announced that he had expended all of the funds provided in 1860 by the fraternity, plus a still larger sum of his own, and that he had made settlement with Hubbard. Similar announcements recommending acquiescence to licensing came from the principal supplies dealers: E. & H. T. Anthony & Co.; the Scovill Manufacturing Co.; Willard & Co.; O. S. Follett; and Wilcox & Graves.

Once again, as many as 150 photographers met at the Cooper Institute on December 3 for the first of three "adjourned" meetings of the Photographers' Protective Union of the United States. At the first meeting, a long list of names was given of men who pledged "their lives, their fortunes, and their sacred honors" to resistance of all patents (the Ormsbee & Wing patent for the multiplying camera included), but according to the minutes of the meeting, "no money was paid, and no treasurer [was] appointed" at adjournment time. At the successive meetings, Brady and Bogardus were named to positions as top officers of the association, but declined on the basis that the association was viewed by some, legally, as a "criminal conspiracy" against a lawfully granted government patent. During all of the sessions, Nathan G. Burgess, as the designated vice president of the association, presided, but was never formally elected president. At one meeting, both Marcus Ormsbee and W. A. Tomlinson, Hubbard's New York agent, applied for membership in the body, but were rebuffed. Even Hubbard himself was proposed for membership, making a speech in which he declined membership, but "recognized fully the right of anyone to determine the validity of any claim upon him," a statement which, according to the minutes, was received with "much applause." By the final meeting (December 19), there had been much discussion, but no actions taken.[346]

John C. Browne, long prominent in Philadelphia's early amateur photography circles, poses in his home for a photograph taken at night with the aid of magnesium light.

In October 1866, the directors of the Union Pacific Railroad posed for John Carbutt's camera at the 100th Meridian near what is now Cozad, Nebraska. The fund-raising ceremonies, covered by all major newspapers, may be said to mark the beginning of the flowering of American western photography, which centered principally at first on the building of the transcontinental rail lines, and in recording scenes at locales along the way.

1866

1866

With the Civil War ended, American photographers set out to catch up with their English and European colleagues in landscape and urban photography. Benjamin and Edward Kilburn established a photography business in Littleton, New Hampshire, in 1865 which soon mushroomed to the point where that quiet New England town became a world capital for card stereograph production. By 1866, the brothers were on a second issue of several hundred card views of the White Mountains and other New England scenery. Residences of the elite of Newport, Rhode Island, were photographed by J. W. Black and Case, and by the Bierstadt brothers (who also provided the *Philadelphia Photographer* with 120 views of the White Mountains, New England, New York, and New Jersey scenic meccas). In May, someone brought *Humphrey's Journal* an album containing twenty large (17 x 22-inch) prints of Yosemite and other western scenes by Carleton E. Watkins, who the following year copyrighted about 1,600 views taken by him in the West prior to that time.[347]

The greatest focal point for photographic coverage centered on the activities associated with the laying of tracks between Omaha and San Francisco by the Central Pacific and Union Pacific railroad companies. Things had gone slowly after passage of the Pacific Railroad Act of 1862, but now the Union Pacific was laying tracks at the rate of a mile a day.

Among the first to record views of the rail construction, and of the scenery and urban life on the plains, was the Chicago photographer John Carbutt. He began with the famous publicity and fund-raising stunt which the directors of the Union Pacific decided to stage in October.

The occasion was an excursion for about 250 distinguished Americans organized by the line's vice president, Thomas C. Durant, to travel the full length of the tracks then constructed (about 250 miles) to the one hundredth meridian near the present town of Cozad, Nebraska. Reporters from most major newspapers were taken along, as were two brass bands, a staff of chefs, a French marquis, an English earl, government commissioners, and, of course, the rail's directors. Carbutt made about three hundred card stereographs of scenes and life along the Union Pacific route during 1867.

From the fall of 1867 to well into 1868, Alexander Gardner followed the line, making about half as many stereoviews, and larger prints (up to size 11 x 14) which he exhibited at the Philadelphia Photographic Society in 1868. During the years 1868–69, Capt. Andrew J. Russell, formerly a Union photographer who had specialized in railroad photography, was employed as the line's official photographer.

The principal photographer who made views along the route of the Central Pacific line was Alfred A. Hart, of Sacramento. Hart's views numbered about three hundred, and were bought by C. E. Watkins in 1869 following Hart's early death.

On May 10, 1869, when the Central Pacific and Union

From Baltimore to Niagara Falls.

With the blossoming of card stereophotography, David Bachrach, Jr., made stereoviews on an extended trip from Baltimore to Niagara Falls in 1866–67, which were published by William M. Chase in Baltimore. The illustration, top, of the U.S. Custom House in Buffalo is from the right-hand portion of card number 1290 in the Chase series. The illustration, bottom, is of the back side of the full card, with 1290 underlined to indicate view on the reverse (picture) side.

A PRESIDENT PHOTOGRAPHED WHILE IN THE PROCESS OF COMMITTING POLITICAL SUICIDE

Card stereographs made locally of a celebrity or major event were seldom printed in large quantities, and those of this nature which have survived to modern times are extremely rare, and frequently of historical importance. This applies to the unpublished photograph (above) of President Andrew Johnson (right), Gen. Ulysses S. Grant (left), and Secretary of the Navy Gideon Welles. The illustration has been reproduced, enlarged, from one half of a card stereograph whose maker, as well as the place and date, are unknown. Presumably the trio were photographed during a self-defeating political tour which Johnson made through New England and midwestern states during the period August 28 to September 15, 1866. At the time, Johnson and the Radical Republican leaders of the 39th U.S. Congress were in open warfare over Constitutional amendments and legislation affecting reconstruction. To rally support for his cause in the upcoming congressional elections, Johnson took a "swing around the circuit," taking with him various members of his cabinet and the two Civil War heros, Grant and Adm. David Farragut. But everywhere he went he encountered hostile audiences, and his speeches became increasingly intemperate. Lampooned in the press by humorists and cartoonists, Johnson's tour led directly to sizeable gains by the Radicals in the November election. Worse, still, the president's intemperate speeches, in which he allowed himself to indulge in personal debates with persons in his audience, were later cited as grounds for his impeachment trial in 1868.[348]

Pacific lines were joined at Promontory, Utah, the most celebrated photograph of the ceremonies was taken by the Salt Lake City photographer Charles R. Savage.

Timothy O'Sullivan, the Civil War photographer better known for his western views of the 1870s, joined the first of the major geological surveys following the war, which was headed by the scientist Clarence King. This was the survey which the historian Henry Adams described as a feat that "paralleled the Continental Railway in Geology; a feat as yet unequalled by other governments which had as a rule no continents to survey."

The expedition began in July 1867, with a visit to the Nevada mining camps, then moved eastward along the 40th Parallel recording data and views of the land and its inhabitants. King had persuaded Congress to appropriate the necessary funds for the venture, and to Adams it amounted to inducing Congress "to adopt almost its first modern act of legislation."

Eadweard Muybridge, whose western views taken in the 1870s are among the best examples of early American scenic photography, also started out in 1867 making views in the Yosemite Valley. Under the name "Helios," he published seventy-two views in size 6 x 8 inches, and 114 card stereographs, which are today extremely rare items. A contemporary newspaper felt that Muybridge's views "surpass in artistic excellence anything that has yet been published in San Francisco," adding: "In some of the series, we have just such cloud effects as we see in nature or oil-painting, but almost never in a photograph."[349]

The year 1866 marked the first time that certain United States photographers began issuing various series of card stereographs separately from the larger publishers. In addition to Carbutt in Chicago, Hart in Sacramento, and the Bierstadt brothers (operating out of New Bedford, Massachusetts), others were John Soule and DeLoss Barnum in Boston; J. A. Williams in Providence; James Cremer and John Moran in Philadelphia; and William M. Chase in Baltimore. In the latter instance, Chase's work was done mostly by David Bachrach, Jr., who described his association with Chase some fifty-four years later in these words:

> About a year after the war I fell in with Mr. William M. Chase, a former Army officer of volunteers, afterward a sutler, from Massachusetts, who went into the publication of stereoscopic views, very popular at the time. I made the negatives for him for about two years, over 10,000 of them, and from the few copies I saved I must say I have never seen better results since. We went all over Maryland, the Cumberland and Shenandoah Valleys, in the Alleghenies, Washington, D.C., on the Hudson and Niagara Falls. At the latter place we were handicapped with lenses rather slow for real instantaneous views of the rapids, so I went back to an old experiment, and used the front lenses of a celebrated make of French field glasses, which required very little stopping down. With a home-made drop shutter, we made perfect views of the spray of the rapids.[350]

Like the New Hampshire photographers, Franklin and Luther White, who used wet towels to keep their collodion plates moist, Bachrach perfected his own unique techniques for working in a portable darkroom:

> We had many dodges for keeping plates wet, but the best plan, partly my own invention, was to have two silver baths, one with the usual solution, and another made up one-half with glycerin

Prof. John W. Draper (circa 1870); cabinet card portrait by Jose M. Mora.

THE NEW SIZE

In October 1866, Edward Wilson said that "something must be done to create a new and greater demand for photographs. Photographers in all directions are complaining that trade is dull. The carte de visite, once so popular and in so great demand, seems to have grown out of fashion. Everyone is surfeited with them. All the albums are full of them, and everybody has exchanged with everybody." Wilson also said: "We think we have noticed that there is an inclination on the part of the public to sit for larger and better pictures than the carte de visite, and that operators have found that the tide is turning in that direction, though nothing new has been adopted yet. The adoption of a new size is what is wanted. In our experience, we have found that fashion rules in photography as well as in mantua-making and millinery, and if photographers would thrive, they must come into some of the tricks of those whose continual study it is to create a fashion, and then cater to its tastes and demands." A new size, called the *cabinet card,* had just been adopted in England, the prints measuring approximately 4 x 5½ inches on cards of size 4¼ x 6½ inches. By November, Wilson reported that "the New York people have held a meeting, and adopted it." E. & H. T. Anthony & Co. began immediately to make albums for the new size, and Sherman & Co. began manufacturing the new card mounts.[351]

instead of water. This latter solution was exposed to sunlight to reduce the organic matter until the solution was clear, otherwise the plates would have been hopelessly fogged. I have thus carried plates for over an hour, and obtained perfectly good negatives. I had this to do one time on top of Maryland Heights, opposite Harper's Ferry, where we had no water to wash off the plates.[352]

Snelling's *The Photographic Art Journal,* in the 1850s, had been one of the first publications to publish original hand-printed photographs bound in with the text. This practice was later followed by the *Philadelphia Photographer.* But few books illustrated with original, separately bound-in photographs came off American presses prior to the 1870s.

PRE-1865 PHOTOGRAPHS ARE REMOVED FROM COPYRIGHT

A decision by Judge Shipman, in the United States Circuit Court, furnishes an interesting example of how the changes and advances in science compel changes in laws. In the year 1831, Congress amended the copyright laws, so as to extend their benefits to artists, giving to anyone who should "invent, design, etch, engrave, work, or cause to be engraved, etched, or worked from his own design, any print or engraving * * * the sole right and liberty of printing, reprinting, publishing and vending such print, cut or engraving, in whole or in part, for the term of twenty-eight years." A very useful and proper law was this; for there was no reason why the artist should not be able to derive advantage from the workings of his brain as well as the author. But since that law was passed, the art of photography has been invented and brought into general use; and this art, as was easy to be seen, brought with it possibly the entire destruction of the law, and the overthrow of the object for which it was passed. For photographic copies of engravings were as good for many purposes as printed ones, and their use would necessarily interfere with the profits of the artists, unless they could be brought within the terms of the law. There was so much doubt whether they could be so brought that Congress by an amendment, passed March 3, 1865, amended the act so as to include photographic copies as well as engravings. The decision to which we refer shows that this action of Congress was needed. The suit was brought to test the question, the plaintiff claiming that photography was covered by the word "print," inasmuch as in taking the copy from the negative on paper, the paper was pressed firmly against the plate by springs. But the judge holds that this is not so; that this process of procuring a picture upon sensitive paper by the action of light upon it, passing through the negative upon glass, is not printing, although it is so called; the art was not in existence at the time the act of 1831 was passed, and of course Congress could not have meant to include that idea in the language which they used. The effect of the decision is very manifest. It is to take out from the restrictions of the Copyright Act photographs of all pictures made before the act of 1865, and to throw them open to the public.

—*Humphrey's Journal,* July 1, 1866

"In England, books illustrated by photographs are quite common and obtainable at a reasonable price," Wilson told his readers in January 1866. "A few faint attempts at it have been made in this country, but we hope before another holiday season we shall have something really fine."[353]

All books published with original photographs bound in with the text enjoyed only limited editions, because of the high cost of printing the photographs separately and marrying them to the type pages at the binder—or in pasting them onto printed pages in spaces specifically reserved for them. Nevertheless, before embarking on his mission, beginning in October 1866, to photograph the activities and environs of the Union Pacific rail route, Carbutt made photographs of some of Chicago's leading citizens for purposes of preparing the first American biographical dictionary to be illustrated photographically. In February 1866, Wilson noted in his journal:

John Carbutt of Chicago has near completion the largest order for portraits we ever heard of. It numbers 45,000 to 50,000 of the new cabinet size of eighty to ninety of the most prominent citizens of Chicago, which are to illustrate a work shortly to be published there. And this is being done without in the least interfering with his regular portrait business, so great are the resources of his establishment.[354]

Twenty of Muybridge's 1867 views of Yosemite were used as illustrations for the first guidebook to the Valley, *Yosemite: Its Wonders and Its Beauties,* by John S. Hittell, published in 1868 in San Francisco by H. H. Bancroft. The Hittell book is now classed as a rare book, as are other recorded volumes published at this time with photographic illustrations. Occasionally, an unrecorded, privately published volume of this period will be found containing photographic illustrations, such as *Sketches of a Summer Tour* printed by William J. Read in 1866 at Brownson's Steam Job Printing Establishment at 45 Fulton Street, New York (see opposite page).

The so-called magic photograph became a popular craze this year. The technique for making such a photograph had been described by Sir John Herschel in 1840, but that was in a technical journal, and had not received much popular attention. The idea was to make a photograph disappear by immersing the print in a corrosive sublimate (Herschel suggested mercury bichloride) until the image literally disappeared. However, the "disappeared" picture, like invisible writing, had not been obliterated. Though invisible, it was merely dormant; and the paper on which it remained in this state appeared otherwise perfectly clear, and could be used for writing, drawing, etc. Evidently someone reread Herschel, or rediscovered the simple process again; for early in 1866, dealers began offering invisible pictures along with a piece of blotting paper which had been saturated with hyposulphite of soda and dried. All the customer had to do was to dip the latter in a tray of plain water, then lay it upon or against the former. This would immediately revive the image, and presto! A "magic photograph!"

In July, Wilson described the new craze in these words:

Quite an excitement has been prevailing since our last number was issued over the Magic Photographs. . . . We, with the rest, have been making them, and have had much pleasure in showing them to many. Prof. Towler has written a little book on

The Noerodalen (Norway.)

The City of Pesth (Hungary).

The Grand Canal (Venice).

SKETCHES

OF A

SUMMER TOUR.

NEW YORK.
PRINTED BY WILLIAM J. READ,
(AT BROWNSON'S STEAM JOB PRINTING ESTABLISHMENT.)
No. 45 Fulton Street.
1866

The Ponte Vecchio (Florence).

Throughout publishing history, individuals have privately printed books in limited editions for distribution to family, friends, libraries, etc. *Sketches of a Summer Tour* (above) is one of the earliest such American books published with original photographs bound-in separately from the text. The book consists of a series of letters to a friend (signed simply "J," in most instances) describing a voyage to the British Isles and Europe. Shown above are four of eleven albumen prints, each pasted on a separate page in the book. By this time, according to one authority, the wet-plate collodion process was being relinquished by amateur photographers in favor of a dry collodion or dry (albumen) glass negative or paper negative process more convenient for traveling. As can be seen from some of the illustrations, the author used a stereoscopic camera. Perhaps he had read an article in an 1862 issue of *Humphrey's Journal* (reprinted from a British magazine) in which the author recommended use of a stereoscopic camera for traveling, citing one portable camera that was no larger than "a good-sized octavo book." The purpose in taking pictures while traveling, the writer of the article pointed out, "is not to make large and valuable artistic pictures—that we must always leave to the professional man—but it is simply to preserve faithful representations; and this may be done as well on the small as on the large scale, and with infinitely less trouble."[355]

the subject. Wilson & Hood of our city, and Farris, of New York, are offering them for sale in neat packages, and are selling thousands of them. All sorts of advertisements are to be seen in the papers about them. Some call it *photoprestigiation*, others, *acquamirabilisographictrickography*, etc., etc. The dealers tell all sorts of stories about those who call upon them to see what the Magic Photographs are. Many expect that with a few drops of water they may make any photograph they desire.[356]

If the customer wanted to keep his magic photograph for any length of time, Wilson recommended that the revived print be washed for three or four hours in changing water. This, he said, "will secure prints as permanent as many that are sold now-a-days, and not of an unpleasant tone."

It appears that pending application (in 1868) for a renewal of the 1854 patent awarded to James Cutting to, in effect, license the collodion process, photographers across the country were generally "caving in," as *Humphrey's Journal* expressed it, to individual visitations or lawsuits pressed by T. H. Hubbard, the successor to the patent following Cutting's commitment to an insane asylum in 1862. In March, it was reported, too, that Hubbard had retained counsel to press a claim of infringement against the biggest of all users of the collodion process—the United States government. Wryly, *Humphrey's Journal* pointed out that the claim was "certainly a strong argument, if not in favor of the validity of the patent, at least in favor of the strong faith which its owners, and their legal advisers, have in its validity," adding that if the government had, indeed, derived all of the asserted benefits from the numerous photographers engaged during the Civil War, "we certainly can see no great and valid defense which the Government can set up against the covenant of its own deed, adjudged by its own courts to be valid and legal."

In June, the Chicago *Evening Journal,* under a heading "Interesting to Photographers," carried a statement by the president of the Northwestern Photographic Society, James R. Hayden, that that society had also decided to submit to Hubbard's demands. In a letter to *Humphrey's Journal,* Carbutt elaborated further on this development:

Mr. Hubbard respectfully invited me to a private conference, in order to show me certain documents that he averred would satisfy me as to the validity of the patent, and that it would be a waste of time and money to contest it. After a two hours' conference and examination of his papers, I could come to no other conclusion than to submit to his claims. A meeting was held by the photographers, Mr. Hubbard attending and explaining his position, and it was amusing to see the ignorance that prevailed among some of the photographers in relation to the evasion of payment of his claims. A committee was appointed, of which I was one, to wait on Mr. Hubbard, and get his best terms for the city of Chicago. We did so, and thirty-two of us bought the right for the city, and formed ourselves into an association to be known as the Cutting Bromide Association. We propose to charge the balance of the photographers a less sum than Mr. Hubbard would have charged them, and so everything has been settled with perfect good feeling. Mr. Hubbard has done a

wholesale business in selling territory today; three others and myself have bought the balance of the State of Illinois. Mr. G. B. Green has bought Wisconsin, Iowa and Minnesota, so that you see instead of Mr. Hubbard finding us prepared for war, he has been saved the expense of bringing suits, and his interest in the Northwestern States bought up . . . Mr. Hubbard met the members of the Northwestern Photographic Society on Friday evening, May 11, and expressed to them his great joy and surprise at the amiable manner in which Chicago had settled up his claims, and we, to show him we bore him no ill will, presented him with a gold-headed cane.

Humphrey's Journal was aghast, but could not help but express its admiration for Hubbard:

So it seems to be with Mr. Hubbard; as soon as he appears before a meeting of photographic doubters, he explains his claims, and answers satisfactorily every objection and all opposition at once vanishes; everybody caves; everybody thinks he is a capital fellow, and the Chicagoans even went so far as to give him a gold-headed cane, which cost, we are told, $150! Well, really this Mr. Hubbard must be a wonderful man; we think we could make money by hiring him to canvass for our Journal; we could well afford to give him $5,000 a year as salary.[358]

1867

Seventeen years after the birth of photography, the Duc de Luynes, a French archaeologist and member of the French Institute, placed 10,000 francs at the disposal of the Photographic Society of France to be offered to the inventor of some process which would produce photographic prints that could be considered *permanent,* and unsusceptible to fading. At the time of this gesture, the society's president, the French chemist Henri Regnault, suggested that inventors concentrate their attention on carbon, stating:

> Of all the substances with which chemistry has made us acquainted, the most permanent and the one which best resists all chemical reagents in the temperature of our atmosphere is carbon. . . . The present condition of ancient manuscripts shows us that carbon, in the form of lampblack on the paper, remains unchanged for centuries. If, therefore, it were possible to form photographic pictures in carbon, we should then have the same guarantee for their permanency that we now have for our printed books; and that is the best which we can hope or wish for.[359]

No one inventor received the full amount of the prize, but the Frenchman, Alphonse Poitevin, received the lion's share of the award in 1867 for having developed a basic method of printing photographs in carbon (in 1855) which was improved upon and patented in 1864 by Sir Joseph Wilson Swan. In the Swan process, photographic images could be secured on paper treated with pigments of powdered carbon in gelatin. But it was a process requiring expert hands, since the treated paper (sold as "carbon tissue") could not be worked on, and any desired manipulations or retouching had to be done on the negative before it was exposed in contact with the tissue.

Carbon printing was slow in being adopted—and then only by a limited number of dedicated practitioners and those fashionable photographers whose customers were willing to pay the higher cost for prints. Swan took two years to introduce his process commercially, then sold the rights in 1868 to the Autotype Printing and Publishing Company in London. In a short time, that company became the principal British licensee of the process to professional photographers, providing at the same time a printing service which enabled individual practitioners to free themselves from many of the complicated manipulations called for.[360]

In the United States, Charles Seely experimented with carbon printing in 1858, and gave brief but inconclusive reports on his progress in the *American Journal of Photography.* Prof. John Draper, like his French counterpart, Regnault, recognized the potential of the medium, and in an annual address to the American Photographical Society, he pointed to the "great changes" which carbon printing might bring to photography in the future.

At first, noted European photographers such as Adolph Braun sent portfolios of large carbon prints to America which were offered for sale by dealers such as Wilson and Hood in Philadelphia. In the case of the Braun photographs, E. L. Wilson described them in the pages of the *Philadel-*

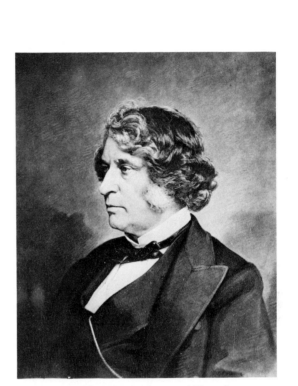

Carbon print of Sen. Charles Sumner of Massachusetts.

AMERICAN CARBON PROCESS

An American process for making carbon prints, which differed from the British method patented in 1864, was developed by a Boston photographer, Frank Rowell. After working in secrecy for six months, he sent his first specimens to E. L. Wilson, together with a letter, dated February 10, 1867, in which he announced that he would be ready "in a few days" to supply prepared paper ("carbon tissue") to the trade. Rowell triumphantly predicted that photographs "will hereafter be as permanent as the engravings which adorn the walls of our dwellings," and claimed that carbon prints could be made more cheaply than conventional photographic prints, and with greater ease and certainty. Rowell and a partner, E. L. Allen, continued to advocate and to practice the carbon process, but in 1877 Allen said "it has taken from that time (1867) to this to make it anything like a success financially." The Allen and Rowell print (above) made in quantity for an 1874 memorial to Sen. Charles Sumner, has retained its original strength and luster.[361]

PHOTOGRAPHY AND PHOTO-CHEMISTRY

By Prof. John W. Draper

Photography, interesting and extensive as it is, is only a department of a far higher subject, Photo-chemistry—the influences of light in producing chemical action. Within the last four years the attention of the chemical world has been strongly directed to that subject, particularly in the application of spectrum analysis, and it may now be said to have succeeded to the prominence accorded a few years ago to organic chemistry. There is a striking parallel between the condition of chemistry now and that as exhibited sixty years ago. At that time, every one was occupied with the influence of electricity in producing chemical charges, the Voltaic battery had been invented, the decomposition of water and other substances had been accomplished by its means, soon a great revolution was to occur in chemistry through the decomposition of the alkalies and earths by [Sir Humphrey] Davy, the production of metals light enough to swim on water, and even to accomplish the proverbial impossibility of setting it on fire. The nomenclature of the science had to be changed, discoveries crowded upon one another with such rapidity that in succession many subordinate but yet extensive and mathematical sciences, such as electro-magnetism, magneto-electricity, came into existence, the polarity of the needle was explained, and the practical application culminated in the great and inappreciably valuable invention of the electric telegraph.

Now it seems that Photo-chemistry is about to run through the same career as Electro-chemistry, but with the conspicuous superiority at its starting point. When the great development of the latter took place, there was no important, no master fact, foreshadowing the value of what was about to ensue, or indicating the direction that discovery would actually take. With Photo-chemistry how different! Long ago it was recognized that the sunlight is the cause of all vegetable organization. The myriads of plants that we see, from the moss upon the wall to the great palms of the tropics, are all children of the sun, the countless combinations they contain, their oils, their acids, their beautiful coloring materials, have all originated in the action of the solar rays. What a world of phenomena have we here, unrivalled in variety and importance! And we must also remember that, even the animal kingdom is affiliated to these facts, for animals find their nutrition in plants, and in turn render nutrition to them. The heat of the sunbeam is the source of the warmth that pervades our bodies, the blush of shame that suffuses our faces, the fever that consumes us in sickness. That heat was incorporated in plants, and is restored to the outer world again by animal life.

There is therefore a grand future in prospect for Photochemistry, and that not only as a science but as an art. Every advancement it makes in the scientific direction will be quickly made available for his purposes by the photographer. And hence there is every inducement to cultivate it in both these forms. It is not to be believed that we know at present the best photographic compounds that exist. The salts of silver were the first to be used, and it may be said that thus far they have preserved their pre-eminence. But they are not the substances employed by nature. It is, in the main, compounds of carbon with which she deals. I look for great changes in our art in this respect, both as regards more truly working material—in which the natural order of light and shade will be better preserved—and also more sensitive and more durable preparations.[362]

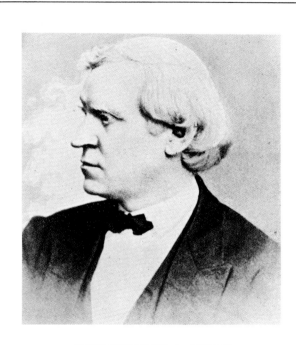

EXIT CHARLES A. SEELY

Charles A. Seely was a wearer of many hats during a career in which he was awarded nineteen patents in the field of photography (covering methods for manufacturing collodion; preparing a toning bath; designs for cameras; etc.). In 1838, at the age of thirteen, he became a laboratory assistant to Dr. Chester Dewey at the Collegiate Institute in Rochester, New York, and was graduated from Union College, Schenectady, New York, in 1847. After serving on the staff of the *Scientific American,* he founded the *American Journal of Photography* in 1855, and served as its publisher until 1867. During these years he also engaged separately in the manufacture of photographic chemicals, both alone and later in partnership with Henry Garbanati and others. In 1859, he became a charter member of the American Photographical Society, and an analytical and consulting chemist at the New York Medical College and the New York College of Dentistry. Although he did not obtain a doctorate until 1878, his identification in the minutes of meetings of the American Photographical Society changed from ''Mr.'' Seely to ''Professor'' Seely, beginning on October 8, 1861.

In 1867, the same year in which he ceased publication of the *American Journal of Photography,* Seely became an organizer of the American Electric Light Company, and removed himself thereafter from the American photographic scene. His departure appears to have been sudden and complete, for having carried the battle against James A. Cutting's endeavors to license all practice of collodion photography virtually to the finish line, he was absent at the time of the final showdown in the early months of 1868. Seely twice lost his papers and books, first in a fire at 26 Pine Street in 1874, and again in a fire at the World Building in Park Row in 1882. This led an editor of the *Photographic Times* to comment at the time of Seely's death in 1896: ''Perhaps to this double calamity is due the fact that of his *American Journal of Photography,* there is no complete file known to the writer.'' Today, there are no known copies of the first volumes published between 1855 and 1858; and no complete sets of issues for the years 1858–1867 are to be found at any single library or institution.[363]

phia Photographer as "probably the finest landscape photographs in the world."

In February 1867, Frank Rowell of Boston introduced an American carbon process which was basically similar to Swan's method, but used a carbon tissue which Rowell claimed was "entirely distinct" from Swan's. Among the first to take up the carbon process in New York was the firm of Huston & Kuhns (William Huston and W. J. Kuhns). In April 1868, when the partners exhibited carbon prints at an American Photographical Society meeting, Huston said that he and Kuhns felt that the stock of carbon tissue offered by Rowell, and another offered by Braun (whose home base was in Dornach, Alsace) were superior to Swan's (which they considered too soluble and troublesome to use), but that Swan's mode of printing was simpler and otherwise more preferable.[364]

No process for making photographs received greater attention in the photographic press throughout the remainder of the nineteenth century than the carbon process. Among the first to herald its arrival was the New York *World:*

> As far as pictorial beauty is concerned, we have never seen anything in silver that compares with the new prints. No consideration of simplicity, economy, or permanency would avail to popularize the new process, if the results were inferior to those attained by the old method. The advantage in this respect, however, lies with the carbon prints. The minutest details of the finest negative, each delicate gradation of light and shade, and every monochromatic tint possible in art, is reproduced with an accuracy that is truly remarkable. The albumen gloss so much objected to in silver prints is rendered unnecessary by the new process, and the lusterless surface adds greatly to the effect of the pictures. The permanency of this work, however, is its chief advantage. . . . The image is taken on a bed of India ink, carbon, or some other permanent pigment, and it may be easily demonstrated that the picture will last as long as the paper on which it is printed. We have seen variously tinted prints, resembling the most delicate drawings in India ink, sepia, India red, and other colors never before attained in photography. Some old paintings copied in this way are more beautiful than anything of the kind we have ever seen. . . .
>
> We welcome this discovery as the great desideratum so long sought by scientific photographers, and can only wish that an American had discovered it. As it is perfectly new and but little known, it has found but few who are willing to try it and demonstrate its superiority over the old process. The successful experiments in Boston and our own city will tend greatly to popularize it, and for both fancy pictures and portraits it must eventually supersede the silver prints.[365]

Seely, on the other hand, felt that carbon prints would never rival the conventional or "silver" prints either in fineness of detail or in general artistic effect. Further, he prophesied (accurately, as it would be proven in the future) that the general public would not sufficiently appreciate its good qualities to made its practice financially rewarding to a large number of photographers. In Philadelphia, F. A. Wenderoth gave a formal presentation on carbon printing to the Philadelphia Photographic Society, citing its greater cost ("We have tripled the cost of manual labor, as we have to employ three times the amount of help to finish, in a given time, the same amount of carbon prints as of silver prints"), the greater number of printing operations required (fourteen in the case of the carbon process, which had to be

POSED FOR THE EXODUS

The years 1868–78 have been termed those of "the grand flowering" in American stereophotography, when photographers such as the unidentified operator, posing (below) with his stereo camera, took to the field to record a civilization shedding its agrarian heritage and opting for a new industrial and urban way of life. They went individually, or as representatives of publishers bent on stocking card stereographs of people, places, and events everywhere. Many headed west, and scenes of Yosemite, other tourist meccas and shrines became stocked on display racks all across the country. Every railroad line and its surroundings was photographed, as was every bridge standing in 1860, or built thereafter. Views were made of statuary and of noted murals and other works of fine art. At the same time, the card stereograph was adopted by merchants for advertising, and by publishers for adding an entirely new dimension to education and entertainment.

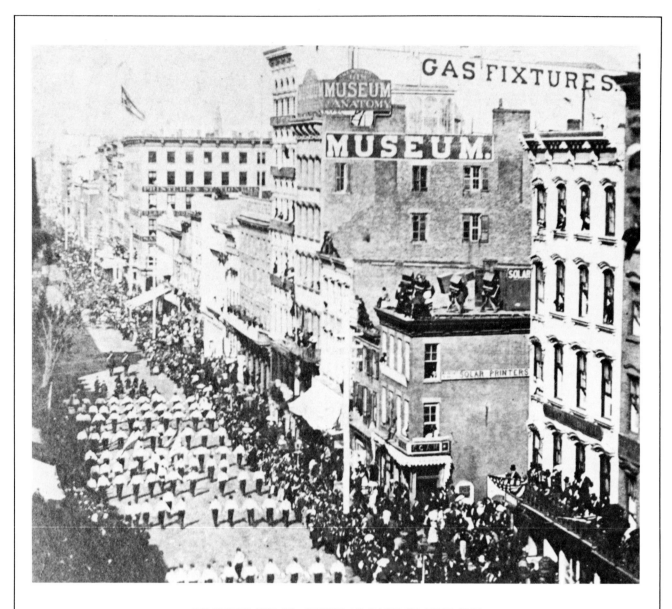

ROOFTOP SOLAR CAMERAS BASK IN THE SUN

In 1865, Prof. John Towler, editor of *Humphrey's Journal,* observed that solar cameras had become "the favorite mode" for making enlarged photographs. In midsummer, 1867, he noted that there were a "great number of solar cameras now visible on the roofs of photographic establishments, as well as in their windows and gardens." The view of a New York parade (above), made by E. & H. T. Anthony & Co. in 1871, is possibly the only surviving photograph depicting a solar printing establishment with a bank of solar cameras on the rooftop. Solar printing was a special art, and to those engaged in its practice, Towler gave these helpful suggestions:

Positioning the Camera. "When about to print, take out the camera upon the roof or elsewhere, if it is of the portable kind, and place it in a position where there will be no need of moving it from this position, until the printing operation is complete; place it, too, where it is not liable to be jarred or agitated by the wind."

Drying and Positioning the Enlargement Paper. "Albumen paper is sensitized in the usual way and hung up to dry. As soon as all excess of silver has drained off from the lowest corner, and the sheet is no longer wet on the surface, but simply embued and expanded with moisture, place the sheet on a large flat board and pin down the edges all around firmly to the board, and set it aside to dry *completely.* Whilst drying, the sheet contracts and becomes perfectly flat. When dry, the film may be formed, just as you are accustomed to operate in this respect. Be very careful that the sheet is *perfectly dry* before you substitute it for the focussing paper. Pin it well in place, turning the portable camera, of course, away from the sun during the operation. . . . If the sensitive sheet were not dry when the sun was turned on, the picture will be nowhere sharp; for, by contracting as it dries, the paper gradually recedes from the picture and makes the impression nowhere perfect. Frequently, the drying is irregular, or the pins give way more on one side than on another, in which case the contraction is sudden in a given direction. By this means, lines, points, leaves, etc., become doubled."[366]

accomplished over a period of from 14 to 24 hours; eight for silver printing, which required no more than 5½ hours time), and challenging the contention that the process was more "permanent." Carbon prints, he pointed out, consist of a more or less thick layer of gelatine, and some coloring matter, resting *on* the surface of the paper, whereas a silver print is not on, but *in* the paper to a larger extent. To his way of thinking, the silver print would be "safer from injury than one which rests only on the surface." Then there was the problem of retouching or coloring of carbon prints. The demand for colored prints was high in every photographic establishment, yet, according to Wenderoth, "a leatherified carbon print repels water colors even more than albumen silver prints, and makes retouching and coloring near impossible."[367]

John R. Clemons, the largest American manufacturer of albumen paper, recognized the problem of print coloring on the glossy surface of the albumen paper, and as early as 1863 he began concurrent manufacture of plain salted photographic paper which, he said, had been "kept on the shelf" during the first years of printing of card stereographs and cartes de visite on albumen paper. In 1867, Clemons introduced a matt-surface paper under the brand name of "Clemons Arrowroot Paper," and while he also continued to make the plain slated paper, the matt paper became, in time, a more popular article.[368]

Cooper's Institute, Junction 3d & 4th Avs, N. Y.

THE COOPER INSTITUTE CIRCA 1868

Peter Cooper was among the organizers of the American Photographical Society, and the society's first meetings were held at his Cooper Institute, situated then, as now, at the northern tip of the Bowery section of New York City. In 1860, Abraham Lincoln delivered one of his most famous campaign addresses there, and on the same day Mathew Brady took a picture of Lincoln which together with the speech Lincoln later said were most responsible for electing him to the presidency.

Erected at a cost of nearly half a million dollars, the brown stone building was constructed with steel beams manufactured at Cooper's own rolling mills in Trenton, New Jersey. The Institute's purpose was to provide gratuitous instruction for the "working classes" in science, art, telegraphy, English literature, and foreign languages. One department was a school of design for women. The operation was liberally endowed, and ground floor stores and offices elsewhere in the building were providing a recorded annual income of $30,000 in 1872. Of the Institute's neighborhood, it was said in 1872: "Respectable people avoid the Bowery as far as possible at night. Every species of crime and vice is abroad at this time watching for its victims."[369]

1868

194

THE FRATERNAL YEARS
<u>1868</u>

On April 7, 1868, the nation's photographers gathered for the first time in a National Photographic Convention, which was held for two days at Cooper Institute in New York. The purpose of the gathering, which had been advertised in the March and April issues of the *Philadelphia Photographer,* was to map a campaign of resistance to the imminent possible extension by the government of a patent which would, in effect, allow one man and his agents to license virtually all photographic practice. Ordinarily, this noteworthy event might have attracted considerable public attention, but the eyes of the country were focused elsewhere on the Congress of the United States, which for the first time in American history, had begun impeachment proceedings against a sitting president.

Many of photography's biggest names were on hand for the convention: Mathew Brady, Abraham Bogardus, D. D. T. Davie, John A. Whipple, James W. Black, Edward L. Wilson, Henry T. Anthony, James F. Ryder, Edward T. Whitney, J. E. Whitney, Alexander Hesler, John Carbutt, and James Cremer. Those from out of town came as delegates, their attendance funded in most cases by the treasuries of local societies or fraternal organizations. On the eve of the convention, *Humphrey's Journal* (which ceased publication a week later) ran this brief notice, which would make it appear that the delegates were meeting unnecessarily:

> We are informed by Mr. Tomlinson, the party owning the patent for New York and Brooklyn, that no measures whatever are being taken to renew it; that the thing is "dead" and will never again rear its head to trouble photographers. But it is best to be on the alert . . . Cutting is dead; he died in a mad-house and left no heirs. Was the ill success of his Patent the cause of his insanity? We are told that it was . . . as we are informed, no one has any legal right to speak for him or to claim a renewal of the Patent in his behalf . . .[370]

The article evidently went unnoticed, and failed to forecast the events to come. James A. Cutting, the original patent holder, was in fact committed to the Worcester Insane Asylum in Worcester, Massachusetts, in 1862, and died there in 1867. The patent assignee during the period of his confinement was Thomas H. Hubbard, whose legal standing now became a matter of dispute (Hubbard claimed rights to the patent extension, but to no avail). It was the administrator of the Cutting estate, Asa Oliver Butman, who made the official move for extension (which he did on April 11, 1868, the last day on which such action could be legally taken). Anticipating this move, meanwhile, the delegates set about establishing the necessary funding and battle plan which would take effect as soon as the expected patent extension application was made.

Henry T. Anthony was chosen temporary chairman at the outset of the convention, and the committee established to nominate a slate of officers and present guidelines for a *permanent* photographic organization consisted of G. H. Loomis, of Boston, Mathew Brady, of New York, and Alexander Hesler, of Chicago. The officers nominated and

PHOTOGRAPHERS' LEGAL COUNSEL

In applying for an extension of the so-called bromide patent awarded in 1854 to James A. Cutting, the administrator of the Cutting estate engaged a Boston lawyer, James B. Robb, and the Washington law firm of Holmean & Hollingsworth to prosecute the case. Delegates to the National Photographic Convention, meanwhile, had made provision for funds to engage legal counsel to fight the patent renewal if required. The convention empowered its secretary and treasurer, Edward L. Wilson, to take this action, which he did immediately after those above were chosen by the Cutting estate administrator. The men chosen by Wilson, shown above, were Henry Howson, standing, and Furman Sheppard, both Philadelphians, the former, a patent solicitor and the latter, in Wilson's words, "one of the most prominent patent lawyers in the country." He had not anticipated the need to employ two counsel, Wilson said later, "but, finding the other side so largely provided for in this direction, it was deemed expedient to employ the very best counsel that could be had." He described the pair as "well versed in patent law, and fully up to any game that might be played by our wily opponents."[371]

JEX BARDWELL

The Detroit photographer Jex Bardwell became one of the unsung heros of American photography in 1868 when he journeyed to New York with a private collection of old pamphlets and journals which proved invaluable as evidence in disputing the claims of attorneys for the heirs of James A. Cutting in their fight to renew the bromide patent. That one man's records should prove so crucial to this important litigation attests to the carelessness of other photographers in maintaining records of their own, as well as the wantonness with which photographic records were discarded. Bardwell made daguerreotypes of Indians in the 1850s, and adopted dry-plate photography for outdoor work after 1860. The photograph above was made after 1893, when he asked the photographic fraternity to come to his aid in a period of severe financial stress.

manent "National Photographic Union," the fourth read as follows:

> *Resolved,* That the present state of isolation among photographers leaves them exposed to the designs of any one who may prey upon them, to the mercy of the process-monger, the exactions of the patent-seeker and owner, and to suffer the degrading influence of the cheap and incompetent.

Most of the resolutions were at least discussed, and some were amended by the delegates; but the fourth resolution was adopted unanimously without any discussion. Symbolically, by this unanimous vote, photography's formative years of isolated practice were declared *finis*.

When, at the eleventh hour, Butman filed for the patent extension, he was represented by two lawyers, James B. Robb, from Boston, and another representing the prestigious Washington law firm, Holmean & Hollingsworth. Wilson had been empowered by the photographers' convention to engage legal counsel when and if such counsel was required, and he immediately engaged the Philadelphians Furman Sheppard and Henry Howson. "A few hours after our first consultation," Wilson recalled afterwards, "telegrams were flying here and there, and busy pens were at work initiating the movement against the extension of this odious patent."

On April 29, James Black served notice on Butman in Boston that the application would be contested; objections to the extension were subsequently filed with the Patent Office on May 11. Between May 23 and June 4, the official testimony in the case was presented by both parties in the presence of an alderman in the cities of Philadelphia and Boston. The greatest amount of factual information came from one source, cited by Wilson in this tribute, which he included in his report of the case:

> It is not out of place to say here that these books were mainly procured for us by Mr. J. J. Bardwell, of Detroit. We had been informed that it had been his habit, for many years, to purchase most of the works on photography that were published, and that he had used bromide of potassium in collodion in 1853. Considering this most valuable testimony, he was asked to come to Philadelphia, bringing his books with him. He replied at once, volunteering to close his gallery (having no assistant), and to give all the time necessary. On his arrival here, I found he had carefully read over his large number of books, and marked the pages useful to the case, so that they were ready to offer in evidence, as above, at once. He also had a list of other books, known to contain matter of value to our case, which were purchased and given to him to examine.

There were also a number of interesting revelations which emerged from the testimony taken in Philadelphia and Boston. First, it appears that the chain of events which led to Cutting's application for the original patent in 1854 began with an earlier visit he made to Whipple's gallery in Boston, ostensibly to purchase the rights to practice the collodion process Whipple was then using. Whipple's deposition follows:

> Q. State under what circumstances you first became acquainted with him.
> A. Mr. Black and myself owned a patent for taking negatives on glass; Mr. Cutting came to my place and wished to purchase a right to use it; he thought the price we asked for it exorbitant,

quickly elected were the following: Abraham Bogardus, president; six vice presidents, consisting of James W. Black, Boston; W. E. Bowman, Ottawa, Illinois; James Cremer, Philadelphia; David Bendann, Baltimore; James F. Ryder, Cleveland; and Edward T. Whitney, Norwalk, Connecticut. Edward L. Wilson was chosen secretary and treasurer. The agenda for the convention was prepared by a committee consisting of Loomis, John A. Whipple, B. Gurney (son of Jeremiah Gurney), Ryder, and Wilson. Among the five resolutions on the agenda, which called for resistance to the patent extension and the establishment of a per-

The U.S. Patent Office examiner who, in 1854, had recommended award of the so-called bromide patent to James A. Cutting, now stated, fourteen years later, that the patent was wrongfully granted, and that its extension to the administrator of Cutting's estate should be denied. His recommendation was officially adopted a month later.

EXAMINER'S REPORT.[372]

UNITED STATES PATENT OFFICE,
June 15th, 1868.

To A. M. STOUT, Esq.,
Acting Commissioner of Patents.

SIR: After a careful examination of the application of Asa Oliver Butman, administrator of the estate of James A. Cutting, deceased, for the extension of a patent for a composition for making photographic pictures, granted on the 11th of July, 1854, numbered 11,266, I have the honor to report: At the time Mr. Cutting applied for the above-named patent, there were a number of originators of the same invention in Europe and in this country. The only difficulty was, in getting proof of priority in the time of invention; within the meaning of the law, the composition claimed was not found definitely "described in any printed publication in this or any foreign country." (Act approved July 4th, 1836, Section 7.) But the application was rejected. Mr. Cutting was then allowed by the Commissioner of Patents, on personal appeal, to procure evidence anterior to his application, against the foreign printed evidence. He procured the testimony on file of Milo S. Torsey, fixing the 2d of April, 1853, and Isaac Rehn, 1st day of July, 1853. The earliest foreign evidence, although close by, did not mark so early a period of time. Dr. Cresson's notice of his discovery, in the Franklin Institute Journal, May 20th, 1852, although unknown at the time, is too indefinite to offer any serious opposition. Mr. Cutting's claim, as an original inventor, is not undisputed. See Giles Langdell's testimony, taken for the remonstrants.

Now, it fully appears that Dr. Charles M. Cresson, of Philadelphia, had the composition fully in use, as early as the month of April, 1852, one year before Mr. Cutting, a fact known to Mr. Cutting when he obtained the patent.

The invention "was not new, or patentable, when patented." (See Act approved May 27th, 1848, Section 1st.) That it is useful, is proved by simultaneous invention, and the fact of its use by all photographers in this and other countries.

That it is valuable and important to the public, is proved by the fact of its being in almost universal use: the patent to the contrary, notwithstanding.

As Mr. Cutting was not entitled to the patent when it was granted to him, I do not touch on the question of his adequate reward, for the invention, I believe he was fully rewarded, while others, with equal, if not superior claims, including Dr. Cresson, remained passive, and sought no monopoly.

Photography has arisen, now, to that state, in which the properties of materials used, and the modes of compounding them, are well understood. Bromine is one of the standard substances in use, in all countries, for photographic purposes, in its various compounds; and, although it may be shown that chlorine, with other compounds, may, in some cases, be substituted for bromine, the monopoly of so useful a substance,

would be an infringement on the liberty of the public, unless an inventor can clearly prove himself to be the original and first to propose and introduce his invention for public good, as well as individual profit.

James A. Cutting was not the original or first inventor of the compound of bromine for making photographic pictures, for which the patent was granted him on the 11th of July, 1854. This fact being clearly proved, I have only to suggest that the extension of the patent now sought by the petitioner, A. O. Butman, cannot be granted without great injustice to the public.

Respectfully submitted,

T. R. PEALE,
Examiner Fine Arts.

and angrily said he would be damned if he didn't find out some other way to do it; in about three weeks afterwards, he brought me a picture; said he made it from a negative taken as quick as a daguerreotype; that's all the conversation we had at that time that I now remember.

Q. Did Mr. Cutting ever travel for you, or any firm to which you belonged? If so, for what purpose?

A. He did; for the purpose of selling the rights to use our combined patents.

Q. When, and for what reason, did Cutting's services as a traveller on account of these patents cease?

A. I should say in 1855 or 1856; because I had no confidence in him as a business man or in his strict honesty; I never had any settlement with him, or could bring him to a settlement, of our affairs, and finally dissolved partnership with him, he giving me the free use of his patent, and I giving him the free use of my patent, as we considered them both worthless in a legal point of view; that was our talk together as we talked the matter over and passed the papers.

Secondly, the testimony in this case points strongly to the likelihood that Cutting derived the formula spelled out in his 1854 bromide patent from the experiments of two men—Dr. Giles Langdell, then of Boston, but later a resi-

dent of Philadelphia; and Dr. Charles M. Cresson, the Philadelphia chemist—after which (sometime in 1853) Cutting contacted a friend, Isaac Rehn, and prevailed upon Rehn to become his business partner.

The historian Marcus A. Root tells us that Langdell procured a published account of Scott Archer's collodion process in 1853, and after several experiments succeeded in making "very good" collodion portraits on paper. Langdell's own testimony at the patent renewal hearings not only substantiates this but reveals that he conducted his experiments jointly with Cutting. Langdell's deposition also asserts that it was he who first used bromide of potassium in these experiments:

Q. Please describe a little more fully the nature or general character of these experiments you were then making with collodion.

A. We commenced with experiments by using the collodion simply excited by the iodide of potassium; I should judge that we were experimenting with that alone for some two or three weeks, with various results, and I made a little alteration myself by introducing the bromide of potassium.

Q. Introducing it into what?

A. In combination with the iodide of potassium in collodion.

Q. What led you to introduce the bromide of potassium into collodion?

A. Well, from some hint in some publication, and I cannot state positively what that publication was; and from the fact that we were using it in the albumen process in connection with iodide of potassium also, as well as in the daguerreotype process.

Q. By whom, at that time to which you are referring, was the bromide of potassium in combination with the iodide of potassium introduced into the collodion?

A. By myself.

Q. Had such introduction been suggested, or taken place during these experiments, prior to the time when it was done by you?

A. No.

Q. Had Mr. Cutting, during those experiments, suggested, or made any use of the bromide of potassium, in combination with the collodion?

A. Not at all.

Q. After having made this alteration, by the introduction of the bromide of potassium, did you take any pictures by the altered process? And if so, with what result?

A. I made our usual experiment; that was pointing out and taking the steeple of one of our churches, I don't remember which; the result was very different from any previously made. I showed it—the picture—to Mr. Cutting, and he was astonished at the result, and wished to know how I proceeded to obtain it. I told him I had introduced bromide of potassium in combination with the iodide. Then we continued on experimenting and working with the bromide after that.

Further in his deposition, Langdell stated that Cutting suggested that the pair take out a patent for the use of bromide of potassium, but that he (Langdell) "remarked to him 'that the idea was absurd,' or something to that effect, and stated to him that I did not think there was novelty in it sufficient, for bromine had already been in use for years, both in the albumen process and the daguerreotype. That was about all that was said in regard to it. That was the last he ever said to me."

It is quite possible that the collodion pictures shown by Cutting to Whipple in 1853 were made after the Langdell experiments cited above. It also appears that Cutting became aware of Dr. Cresson's experiments in Philadelphia, possibly reading about them in the May 1852 issue of the *Journal of the Franklin Institute* (but which he could not have seen until after the Langdell experiments, Langdell possibly having read about them first).

Dr. Cresson also gave a deposition at the patent renewal hearings, stating that he had used bromine in combination with collodion to make collodion pictures between April 15 and May 20, 1852. He also produced a bottle at the hearings containing the ingredients of his 1852 formula (and still bearing its 1852 label). After the 1852 experiments, Cresson said, he was contacted by Cutting with respect to a patent which Cutting had applied for, or was then applying for:

Q. Please state what, if anything, he said, and all that took place between you on the subject.

A. Mr. Cutting asserted that he had been experimenting on the subject for some time, and had exhausted his means, and desired me to withdraw any claims which I might have, which would secure any patent right to myself, and, if I recollect clearly, I signed a disclaimer of some sort, the particulars of which I have now forgotten.

A deposition taken from Isaac Rehn at the hearings reveals that Cutting contacted Rehn in 1853 in York, Pennsylvania, and persuaded Rehn to join him in Philadelphia to take up the practice of collodion photography. Possibly this occurred after Cutting secured a disclaimer from Cresson. After that, according to Rehn, the pair "travelled here and there over the country, selling rights and teaching the process." But as we have already seen, their "teaching" began as early as 1853, or six months to a year prior to the award of the bromide patent to Cutting in July 1854. Rehn belittled all of the exhibits provided at the hearings in behalf of the photographic community. This applied to Dr. Cresson's bottle of ingredients used in 1852 to make collodion photographs (the bottle was of no avail because no proportions were given, Rehn said; in addition, the pictures made by Cresson with the formula were not "merchantable"), and it presumably applied to all of the books and articles provided by Bardwell. Rehn contended that the proportion of bromide used in iodized collodion must be such as to create bromo-iodide of silver in the film, and that this result could only be secured by the Cutting formula. Cutting, he contended, had been the first to succeed in making collodion photography workable, where all before him had failed.

After the filing of all official documents in the case, the same Patent Office examiner who, in 1854, had recommended to his superior that the Cutting patent be granted, now reversed himself, and on June 15 recommended against further extension of the patent. All parties appeared before the Acting Commissioner of Patents on July 7, and three days later the Commissioner issued a lengthy opinion upholding the Examiner's position, and denying the patent extension. Having thus banded together and successfully won their cause, the photographers of the nation now made plans to perpetuate their newly formed union in a National Photographic Association.

The fraternal years had begun.[373]

1869

Many factors converged to make 1869 a turning point in American photographic history. At long last a fraternity was born out of a necessity to wage a common war against a syndicate bent on licensing virtually all photography. The voices of Snelling, Humphrey, and Seely—as well as their journals—were now gone from the scene. Not until February 1870 would there be any competition for the *Philadelphia Photographer,* which would then come from the house of E. & H. T. Anthony & Co. Edward L. Wilson was now the predominant spokesman for American photography, and would remain so throughout the remainder of the century. In 1871, he began publishing a companion magazine, *Photographic World* (suspended in 1875), and began issuing a supplement to *Philadelphia Photographer,* entitled the *Photographic Times.* The latter publishing venture was at first sponsored by the Scovill Manufacturing Company, but after 1875 was published independently by Scovill until 1902.

This year also saw the final completion of the nation's first transcontinental rail line, which enhanced people's interest in the scenic wonders of the American west. This, in turn, sparked a widespread increase in the demand for stereoviews and for large landscape views (photographs of size 18 x 21 inches, or larger) which could only be made at this time with mammoth-plate cameras previously custom-made for only a handful of entrepreneurial photographers operating out of San Francisco. This year also saw a stirring of activity in Europe in the field of color photography, and in mechanical means of producing photographs from images secured on a printing plate.

When the members of the newly formed National Photographic Association gathered for their first annual convention in Boston on June 1, 1869, they were greeted with another revelation, marking an important turning point in photography. This was an exhibit of photographic portraits made from retouched negatives. Negative retouching had not heretofore been practiced in the United States, although it had made its appearance several years earlier in Europe. Previously, retouching had been limited to the doctoring of finished daguerreotype, ambrotype, or tintype images, or photographic prints; but now it was to be applied to the negative itself, in order to improve facial characteristics in portraiture, or to secure a greater variety of intermediate tones such as a collodion negative could not by itself record.

The exhibit at the NPA convention was staged by the Cleveland photographer James F. Ryder, who characterized negative retouching as "the most important and first real improvement to the portrait photographer after the advent of collodion." In later years Ryder recalled how it had been he, rather than "some prominent New York photographer," who was responsible for the innovation:

> Dr. Hermann Vogel sent examples of this work to Edward L. Wilson, and from him I secured a small collection. The pleasure I found in these little portraits which got their smooth, soft, and delicate finish from the retouched plate was most gratifying. The coarse skin texture, the pimple and freckle blemishes were converted into fine, soft complexions, most gratifying to the

Abraham Bogardus (top) and James F. Ryder (bottom) emerged as two of the guiding lights of American photography's early fraternal years. Bogardus was named president of the newly formed National Photographic Association, and Ryder, after displaying retouched photographic portraits at the Boston 1869 convention, was given the responsibility of hosting the 1870 convention in Cleveland. Both men began their respective practices modestly in the period 1846–47, and both survived to the early years of the present century. Ryder operated an extensive art gallery as well as a photography studio in Cleveland.

eye, and especially to the eye of the person represented in the picture. This was a phase of art wrought out by the patient German and but recently introduced by him, while in America it was unknown.

I expected it would be captured and introduced by some prominent New York photographer, as we look to that city to take the first bite at every pie coming from abroad. I was anxious it should so happen that I could take a later chance at securing it for my own practice. The metropolis was tardy; I was impatient. I concluded to take the liberty of giving Cleveland a chance, and set about it.

Mr. Cyrenius Hall, an artist skilled in water-colors and India-ink work, who had been some years in my employ as a finisher

of photographs, had gone to Germany to study more serious art. To him I wrote, telling him of my want, describing what I had seen, and asking him to secure for me a skilled artist in retouching. He was successful in finding an excellent man—Herr Karl Leutgib, of the Munich Academy, who was desirous of coming to America. Mr. Hall soon closed a contract with, and secured passage for him on the steamer *Schmidt* for New York.

I had a friend to meet him at the steamer's dock, with photograph in hand, held aloft, standing by the bridge as he came ashore and see him safely on board the train for Cleveland. For reasons, I did not want him to loiter about New York or visit any photographic establishment in that city.

On his arrival in Cleveland we made him very welcome and

SCOTTISH, FRENCH EXPERTS ESTABLISH FOUNDATIONS OF COLOR PHOTOGRAPHY

The human eye contains millions of color-sensitive cones which are believed to be blue-sensitive, green-sensitive, and red-sensitive. By being stimulated in varying degrees, they enable the eye to distinguish several million different colors. In 1861 this was demonstrated by the Scottish physicist, Sir James Clerk-Maxwell, by projecting three diapositives from three magic lanterns onto a screen through red, blue, and green filters, respectively. When the diapositives were superimposed in register, the audience saw a colored photograph, albeit one that was a far cry from the type of colored photograph one is used to seeing today. The principle involved in the Maxwell demonstration is depicted schematically right: where red and green mix, we get yellow; green and blue-violet give us a peacock blue; where blue-violet and red overlap, we obtain a purple; and in the center, where all three colors overlap, they give us white.

In 1869, the French experimenter Ducos du Hauron, proposed three different ways in which to reconstitute (i.e., obtain) colored images, either for viewing or in print form. In these experiments, he laid the basis of modern color photography:

First, du Hauron proposed a method based on the Maxwell concept which would allow superimposing filtered images in a chromoscope viewing instrument (an idea suggested independently at the same time by another Frenchman, Charles Cros). On this concept was based the most successful form of color photography achieved in the nineteenth century. But it was not a method of achieving colored photographic prints; only a method, best exemplified by the achievements of Frederic E. Ives in later years (see page 360), of achieving photographs in natural colors for momentary viewing.

Second, du Hauron noted that metallic pigments absorb or subtract from light all colors except their own. Thus he took three color separation negatives through separate color filters and made positives on thin layers of bichromated gelatine containing carbon pigments complementary in color to those of the negatives. After conventional treatment of the gelatine surfaces (i.e., washing away the portions upon which the hardening ef-

fect of light had not acted), it became possible to obtain superimposed colored photographs either on paper or on glass. Ducos du Hauron's earliest surviving photograph produced by this method appears to be one made in 1877, after further experimentation and progress was accomplished by Dr. Hermann Vogel, who used colored dyes to increase the color range (see page 233). Colored photographs obtained by this method, however, were weak and unbalanced by modern standards.

Third, du Hauron proposed performing Maxwell's triple operation through a glass screen ruled with colored lines (crosswise) that were so fine as to be indistinguishable to the naked eye. This concept, never perfected in the nineteenth century, provides the basis of modern screen-plate color photography.[374]

comfortable, sounding no trumpets in his honor or in our exaltation. Very quietly we prepared a creditable display of the new work, selecting well-known citizens among which were beautiful young ladies and children. These we exhibited with pride.

A decided impetus was given our business from the introduction of the new finish, and I soon imported two more artists. In the spring of 1869 was to be held in Boston the first convention exhibition of the newly organized National Photographers' Association. For that event I made special preparation and took a carefully prepared collection of the ''new finish'' work, the first exhibited in America by an American photographer. It was really the sensation of the exhibition, and created a very favorable impression. It caught like measles, and became an epidemic. Now came a craze for retouching and retouchers. Great was the demand and meagre the supply.[375]

Some important new names in American photography were also now appearing on the scene. After traveling around the country for William M. Chase, and then working part time for a tintype photographer in Baltimore, David Bachrach, Jr., age twenty-four, bought out the latter's business ''with a few hundred dollars,'' and, in October 1869, started the Bachrach firm which has continued among the most prestigious names in world photography to the present day. ''I had to acquire a little taste in posing and lighting, which took years to succeed with partially,'' Bachrach recalled later. ''But the advent of Sarony [Napoleon Sarony, of New York] with the occasional access I had to his studio, and his friendliness, helped me a lot.'' Bachrach also paid tribute to a man younger than himself in helping further his education as well; this was Benjamin J. Falk, also of New York, who opened his first gallery in 1877. In Bachrach's words, Falk was ''a splendid fellow'' who was ''always open and friendly, and I gained a good deal from him.'' Bachrach immediately discontinued tintype portraiture at his new Baltimore gallery, but it was a year's time before he could build up his business to a level of $150 a week in receipts, and two years before he could add a receptionist and farm out his retouching work.[376]

America also now had a major western school of landscape photography. Like the Hudson River school in painting, which encompassed artists with varied careers and began with the works of a single artist (Thomas Cole) a decade before gathering momentum, the new landscape photography school began with a series of mammoth-plate views taken by Carleton E. Watkins in the Yosemite Valley in 1861.

In 1865, the California Art Union was established in San Francisco for purposes of exhibiting works of local artists (as well as the works of the Hudson River school), and in the same year the San Francisco photography dealership, Lawrence and Houseworth, began offering mammoth-plate photographs made by the new landscape school. Although copyrighted by Lawrence and Houseworth, the landscape photographs were made by Watkins, Weed, Alfred A. Hart, and a newcomer, English-born Eadweard Muybridge. After the Civil War, the landscape school was joined by still other noted photographers, namely Timothy O'Sullivan (who made his views while traveling on the Clarence King geological survey of the 40th Parallel and Andrew J. Russell (who worked in the employ of the Union Pacific Railroad). In 1869, King exhibited O'Sullivan's views in Washington,

By 1869, America's western landscape photography school was in full bloom. Its two principal, early guiding lights were Carleton E. Watkins and Thomas Houseworth, sole proprietor (after 1867) of a dealership in western landscape photographs, which had been founded in 1865. Watkins' gallery and the Houseworth gallery, shown above (circa 1867), rivaled the California Art Union which had also been opened in 1865 to exhibit works of San Francisco artists, as well as artists of the celebrated Hudson River school.

New York, and Boston, where they were widely acclaimed. Watkins' photographs were also exhibited at this time in New York at the prestigious Goupil Gallery, and in 1869 the Union Pacific Railroad published *The Great West Illustrated,* each copy containing fifty large photographs by Russell bound in with the separately printed text.[377]

Another European innovation introduced in America at this time was the first of various photomechanical processes—techniques wherein a photographic image could be secured on a printing plate and produced on fine quality paper in considerable volume (although not on the same press used for printing type). There were a number of independent inventors of photomechanical processes, but Alphonse Poitevin (a French chemist and photographer) and Walter B. Woodbury (an English photographer) may be considered the fathers of the basic methods of photomechanical printing.

Poitevin was first to secure a patent in 1855 for what was essentially a forward step in photolithography. The patent covered a method of securing an inked gelatin printing surface on stone, which later inventors secured (as Poitevin had indicated would be possible) on metal, glass, wood, etc. All of these subsequent processes—each known by a particular name (usually that of its ''inventor'')—can be de-

PHOTOGRAPHY ILLUSTRATES
A BIOGRAPHICAL DICTIONARY

In February 1868, a notice appeared in the *Philadelphia Photographer* stating that John Carbutt was nearing completion "of the largest order of portraits we ever heard of." The order was for nearly fifty thousand cabinet-size portraits of about one hundred leading citizens of Chicago. These were used to illustrate *Biographical Sketches of the Leading Men of Chicago*, published by Carbutt in 1869. Biographical dictionaries of this type were illustrated prior to this with woodcuts, or engravings prepared from artist renderings, or (after 1840) copied from daguerreotypes. Carbutt's was the first to appear with actual photographic prints bound in separately with the text. The edition was limited to about five hundred copies, and many were lost two years later in the great Chicago fire. Similar biographical dictionaries were published with photographs of leading citizens during the 1870s in Baltimore, Cincinnati, Syracuse, and the state of Nebraska. A less comprehensive "gallery" of 311 photographic portraits of members of the 35th U.S. Congress published in 1856 by McClees & Beck was claimed at the time to be the "largest collection of perfectly authenticated photographic portraits ever published."[378]

scribed collectively as collotypes, since they are all of the same family and modern dictionaries include the word *collotype*, but not always the other "types" (most of which are described, individually, in later pages of this book).

Woodbury, in 1864, patented a method of embossing photographic images on paper with a metal mold containing the gelatin relief of a photographic negative. No ink was employed in printing; however, colored gelatin was used and was referred to as ink.

The Woodburytype process allowed the securing of photographs on glass as well as on paper, and both glass and paper Woodburytypes were exhibited by Wilson at a meeting of the Photographic Society of Philadelphia in December 1869. The minutes of the meeting record that "it was the general expression of opinion that they [the Woodburytypes] were the finest pictures ever exhibited before the society—perfect in light and shade, of exquisite tone and brilliancy, and leaving nothing desirable but color to make complete pictures."[379]

In 1868, the Bavarian court photographer Josef Albert perfected a collotype process in which inked gelatin printing surfaces were secured to finely ground glass plates. His "Albertype process" evidently appealed more quickly to American photographers than any of the other photomechanical modes—possibly because of the ready availability of glass for experimentation. David Bachrach said he thought he was the first American to make an Albertype in the winter of 1868 when he was still in the employ of Chase, making negatives in Washington, D.C.:

> I believe I am the first one who made an Albertype in this country. In the winter of 1868, I believe, I was employed by Mr. William M. Chase, the stereo publisher, in making a set of negatives of Washington. We received the *Philadelphia Photographer* on the second of the month containing a European letter, which gave the bare outlines of Albert's method, *just patented*. It being a rainy day, I at once prepared a plate, guessed at the proportions, exposed it next morning on a negative of Wallach's New School-house, and took it to a lithographer on Ninth Street, near the Avenue, to be printed. They were all surprised when it was inked up and a print was made from it; but, of course, not knowing how to put it in the press, the plate was smashed. Mr. Chase kept the print, and some others that I made, for a number of years as a curiosity.[380]

A large number of Albertypes made in Munich were exhibited at the December meeting of the Photographic Society of Philadelphia. Although they were deemed "very interesting and beautiful examples of the Albertype," nevertheless, a spokesman for the society complained that "the tone of almost all of the prints seemed cold, resembling the appearance of an over-toned silver picture." Edward Bierstadt made Albertypes in 1869 and exhibited them in January 1870 at a meeting of the Photographic Section of the American Institute (formerly the American Photographical Society, which had decided in May 1867 to merge with the Institute). One of Bierstadt's Albertypes was as large as 20 x 25 inches. According to the society's minutes, the pictures were "pronounced by all to be superb." The Albertype was patented in the United States in November 1869, and the American rights were thereafter acquired by Bierstadt, who became the foremost practitioner of this and other photomechanical printing processes.

1870

Motion pictures shown in theaters did not result from a single invention, but rather from three separate realms of development, viz., the camera, the film (after 1890), and the projector. The process was evolutionary in each instance.

Coleman Sellers' *Kinematoscope,* shown in 1861, was a first step toward camera development, in that the card stereographs used were fitted into slots in the machine's revolving drum, preventing blurring when the rotating cards were viewed through the eyepiece.

On February 5, 1870, a primitive motion picture projector was demonstrated publicly in Philadelphia which, for the first time, equated moving images projected on a screen with sound and music. The device, called the *Phasmatrope* by its inventor, Henry Heyl, was built around a conventional mercury oil lantern, on the front of which was mounted (vertically) a skeleton wheel holding sixteen thin glass photographs (each only ¾ of an inch in height) around the wheel's periphery. As the wheel was revolved in the rays of the lantern, the images were projected life-size and in sequence on the screen.

The event was a night to remember, although it was given little notice at the time. The program was billed, simply, as the "Ninth Entertainment of the Young Men's Society of St. Mark's Evangelical Lutheran Church, Philadelphia," but was held at the Academy of Music in the presence of an orchestra and an audience of 1,500 paying customers. There were three separate showings, and a separate skeleton wheel was used for each. The program was conducted by the photographer, O. H. Willard, and opened with a wheel of photographs depicting a speech by Brother Jonathan (as "Uncle Sam" was called at this time), which was projected while the voice of a reader supplied audible words coinciding with the pantomimic gestures and lip movements of Brother Jonathan. A second wheel of images depicted an acrobatic performance by a popular Japanese gymnast, "Little All Right." The most colorful of the showings involved projection of eighteen images of Heyl and his wife, appropriately costumed, dancing a waltz in perfect synchronism with the same music performed by the Academy's forty-piece orchestra.[381]

In retrospect, this was quite an undertaking for such an obscure man in photographic history, and it was repeated a month later at the Franklin Institute. Heyl has been described as "a little man, thin, wiry, with sandy hair and blue eyes," who "wore thick glasses and very often used a pocket magnifying-glass when looking at small objects." It has also been said of him that he was "quite nervous, and his brain was constantly working out some idea which he would burst out with when he was in the company of people. He was quite musical, was a good singer, and a devout Christian. He never missed attending the Lutheran Church wherever he was. He was very kind and had a gentle voice.

Born in Columbus, Ohio, in 1842, Heyl moved to Philadelphia in 1863. As a boy he is credited with having invented the paper collar, and later patented a folding paper-

Dr. Michael McMahon, director of historical programs at the Franklin Institute, examines the primitive *Phasmatrope* motion picture device demonstrated by Henry Heyl at the Philadelphia Academy of Music on the night of February 5, 1870. The skeleton wheel device holds sixteen small glass photographs, each depicting Heyl and his wife, appropriately costumed, in different stages of dancing a waltz. The wheel is mounted on a conventional magic lantern, of the type shown at right, and on the 1870 occasion the revolving images were projected on a screen in perfect synchronism with the same music as performed live by the Academy's forty-piece orchestra. An audience of 1,500 was present for the demonstration.

box machine and other machines for stitching and sewing books. In 1898, some three years after the first showing of motion pictures in public theaters, Heyl felt compelled to draw attention to his pioneering effort, and sent a letter to the *Journal of the Franklin Institute* recalling further details of the 1870 Academy of Music event:

At that day flexible films were not known in photography, nor had the art of rapid succession picture-making been developed; therefore, it was necessary to limit the views of subjects to those that could be taken by time exposures upon wet plates, which photos were afterwards reproduced as positives on very thin glass plates, in order that they might be light in weight. The waltzing figures, taken in six positions, corresponding to the six steps to complete a turn, were duplicated as often as necessary to fill eighteen picture-spaces of the instrument which was used in connection with the lantern to project the images upon the screen. [The pictures on the skeleton wheel were placed] in such relative position, that as the wheel was intermittently revolved, each picture would register exactly with the position just left by the proceeding one. . . . A shutter was then a necessary part of the apparatus to cut off the light rays during the time the pictures were changing places. This was accomplished by a vibrating shutter placed back of the picture wheel, that was

operated by the same drawbar that moved the wheel, only the shutter movement was so timed that it moved first and covered the picture before the latter moved, and completed the movement after the next picture was in place. This movement reduced to a great extent the flickering, and gave very natural and life-like representation of moving figures.[382]

According to his son, in later years Heyl (who died in 1913) always held to the belief that his *Phasmatrope* embodied the basic operating principles of the modern motion picture projector, but that he never obtained a patent because he regarded it as an amusement without commercial possibilities (a sentiment which Thomas Edison would also later reflect with respect to his own first motion picture projector). Heyl's (and perhaps Willard's) thoughts on the significance of the Academy of Music event were summarized in the speech which the audience heard from Brother Jonathan:

> We are here tonight to see for the first time, photographs of persons shown upon a screen by the aid of a magic lantern, the figures appearing to move in most lifelike ways. How this effect is produced we cannot briefly explain, but you will have the evidence of your own eyes to convince you that this new art will rapidly develop into one of the greatest merit for instruction and enjoyment. This beginning of greater things is not an imported product, but it was perfected right here in Philadelphia, where it adds one more to the list of first inventions of real merit that stand out to the credit of the City of Brotherly Love. The photographs were made at 1208 Chestnut Street in the studio of Mr. O. H. Willard, which place may now be well named "The Cradle of the Motion Picture."[384]

After it was all over, a Philadelphia newspaper columnist writing under the heading "Current Topics of the Town," quoted a proud Heyl as stating: "We came out of the entertainment with $350 in clean money. Pretty good for one picture show, wasn't it?"[385]

Because of the success of his exhibit of retouched photographs at the first N.P.A. convention the previous year, James F. Ryder was designated general chairman of the 1870 convention, which was held at his home city, Cleveland, with over five hundred photographers in attendance. Of these, some two hundred and fifty exhibited photographs, and the number of general visitors passing through the exhibits at a given time reportedly ran as high as two thousand. "The Bromide Patent extension man, with his visions of a yearly revenue of a million or more, did not start out with a view of calling into existence a powerful association with powerful prejudices against unjust patents," Ryder said of the gathering. "He *administered well* for us, and we owe him much. For the good of our young but rapidly growing art, nothing can be of more value to us than unity, that we may all pull together in the direction of improvement." Two appeals to Congress by the successors of the Cutting patent were made seeking the patent's reissue, but both were successfully fought by the N.P.A. counsel. Indeed, the success of the 1870 convention was such as to wipe out all past debts in the patent litigation, plus the cost of renewed resistance.[386]

The greatest attraction of the Cleveland convention, however, was the German scientist and photographic editor Dr. Hermann Vogel. A contributing editor to the *Philadelphia Photographer* since 1865, the thirty-six-year-old founder of the Imperial Technical High School of Photography in Berlin was just at this moment becoming a favorite with the American fraternity. Letters from Edward Anthony and E. L. Wilson and a cable from William Kurtz were dispatched to Berlin inviting him to attend the convention and to be the guest of photographers at their homes. His address to the convention paid marked tribute to his American hosts:

> We in Europe sometimes labor under the hallucination that American photography has not yet arrived at a high point of perfection, because but few good American pictures find

WOODBURYTYPE

The Chicago photographer John Carbutt was so favorably impressed with photographs he saw in England which were produced by Walter B. Woodbury's photomechanical process, that he sold his gallery, acquired the U.S. rights, and established the American Photo-Relief Printing Company in Philadelphia in 1870 to launch what he considered to be a major new bonanza for photography. While it is true that the process was the first commercially viable mode of reproducing photographic intermediate tones (i.e., halftones) repeatedly by machines, rather than by the photographer's hand, nevertheless the process had its drawbacks, and Carbutt's enterprise did not materialize into the bonanza envisioned. Woodburytype photographs were secured by embossing a photographic image on paper with a metal mold containing the gelatine relief of a photographic negative. Elaborate machinery was called for, including hydraulic molding presses able to exert a force of five tons per square inch in configuring the gelatine relief matrices; paper calenders to give a special surface to the nonabsorbent paper used; and hand-operated presses on which finished prints were produced from the matrices. The first French presses installed by Carbutt fractured, and it was well into 1871 before he could obtain newly designed replacements from the noted American manufacturer R. Hoe & Co. Also, Woodbury's claims for production efficiency proved unrealistic because of the delicacy of the molded gelatine relief images. While British and French operators further mechanized their production by installing rotating tables for the hand-embossing presses (thereafter claiming production figures of from 30,000 to 55,000 prints from a single matrix), Carbutt's output does not appear to be recorded.[383]

AMERICAN PHOTOGRAPHERS AT CLEVELAND

A photograph may have been taken of the delegates attending the first annual convention of the National Photographic Association held in Boston, Massachusetts, in 1869, but if so it was not recorded. The first appears to be the group picture above taken by T. T. Sweeny at the 1870 convention held in Cleveland, Ohio. To the convention chairman, James F. Ryder, looking back on it twenty-two years later, this was the greatest moment in American photography's fraternal years. "All was harmony. The man with a sore head was not there. No axes to grind; no wrangles; no jealousies; no smart Aleckism; no cheap Johnery. The abundance of good fellowship was marked; a happier lot of people would be hard to find." All the great lights of the profession were there, gathered at the foot of the Perry Monument. At the center was N.P.A. president Abraham Bogardus with permanent secretary

Edward L. Wilson and treasurer Albert Moore. Surrounding them were H. T. Anthony, W. Irving Adams, Col. V. M. Wilcox, Dr. Hermann W. Vogel, Gustave Cramer, John Carbutt, John A. Fitzgibbons, George G. Rockwood, James Wallace Black, Henry Rocher, William H. Jackson, William H. Rulofson, W. H. Rhoades, J. C. Elrod, C. W. Zimmermann, William G. North, W. E. Bowman, J. A. Scholten, A. J. Fox, David Bendann, and a host of others. As for the exhibition of photographs at the convention, Ryder considered it "the best and largest ever brought together up to that time. And what a display of apparatus and fine goods! It may have been surpassed since, but we don't remember when or where. Three happy days of cheerful work, and at the end the great building echoed with songs at parting. Who would not like to attend another such meeting?" [387]

PHOTOGRAPHERS WIN COPYRIGHT PROTECTION

Congress passed a new copyright law on July 8, 1870, which for the first time gave protection to photographers against what the *Philadelphia Photographer* termed the "piratical stealing" of negatives. Alexander Gardner headed a committee appointed by the newly established National Photographic Association to lobby for inclusion of the photographers' interests in the new law, and reportedly was responsible for "interpolations" made in the act even after it was printed. In addition to operating his gallery in Washington, Gardner made portraits of criminals for the Metropolitan Police and set up a rogues' gallery for the department in 1873. Following are the provisions of the 1870 law applicable to photography:[388]

SECTION 86. Any citizen of the United States, or resident therein, who shall be the author, inventor, designer, or proprietor of any photograph, or negative *thereof*, and his executors, administrators, or assigns, shall, upon complying with the provisions of this act, have the sole liberty of printing, reprinting, publishing, completing, copying, executing, finishing, and vending the same.

SECTION 87. Copyrights shall be granted for the term of twenty-eight years from the time of recording the title thereof, and they may also be extended and assigned the same as patents.

SECTION 90. No photographer shall be entitled to a copyright unless he shall, before publication, deposit in the mail a printed copy of the title of the photograph for which he desires a copyright, addressed to the librarian of Congress, and within ten days from the publication thereof, deposit in the mail two copies of such copyright photograph, to be addressed to said librarian of Congress, as hereinafter to be provided.

The titles aforesaid are recorded in due form in a book, by the said librarian of Congress, and he shall give a copy of the title under the seal of his office to said proprietor, whenever he shall require it.

SECTION 92. For recording the title of any photograph, the librarian of Congress shall receive from the person claiming the same, fifty cents, and for every copy under seal actually given to such person or his assigns, fifty cents.

SECTION 93. The proprietor of every copyright photograph or negative shall mail to the librarian of Congress, at Washington, within ten days after its publication, two complete copies or prints thereof of the best edition issued, and a copy of any subsequent edition where any substantial changes shall be made.

SECTION 94. In default of such deposit in the post-office, said proprietor shall be liable to a penalty of $25, to be collected by the librarian of Congress.

SECTION 95. Any such copyright photograph may be sent to the librarian of Congress by mail, *free of postage*, provided the words "*Copyright Matter*" are written or printed on the outside of the package containing the same.

SECTION 96. The postmaster to whom any such copyright photograph is delivered shall, if requested, give a receipt therefor, and when so delivered, he shall mail it to its destination, without cost to the proprietor.

SECTION 97. No person shall maintain an action for infringement of his copyright, unless he shall give notice thereof by inscribing upon some portion of the face or front thereof, *or on the face of the substance on which the same shall be mounted* the following words, viz.:

" Entered according to Act of Congress, in the year ——, by A. B., in the office of the librarian of Congress, at Washington."

SECTION 98. Any person impressing such notice upon any photograph for which he has not obtained a copyright, for so offending, shall forfeit and pay $100.

SECTION 99. Any person infringing a photograph copyright shall forfeit all copies to the proprietor, and also suffer suit for damages by said proprietor in any court of competent jurisdiction.

Interior view of the exhibition hall at the National Photographic Association convention in Cleveland, 1870. Note the display, in foreground, of mammoth-plate views of Yosemite Valley, possibly taken by C. E. Watkins, C. L. Weed, or Eadweard Muybridge.

their way to Europe. The actual observations, however, which I have made during my brief sojourn among you, have filled me with wonder and admiration.

He who would judge of the merits of American photography, must in person tread upon American soil.

The photographer in your country works under greater and more manifold difficulties than the photographer in our country. Time and labor being of but little value in Germany, the German artist can finish his work at leisure; while you in America must make the best possible use of every moment, giving you less time to devote to your study and experimenting. Yet the art, in America, has been much advanced by your readiness and willingness to grasp and bring into practice all that is new and good; while, on the con-

trary, in Germany, as our celebrated Professor Liebig says, "each new discovery must pass through three different periods before meeting with a general acknowledgment." At first, it is proven that the new discovery is worthless and impracticable; second, later it is asserted that it is nothing new—that a similar discovery was made perhaps a hundred years ago; and it is not until the third period that the discovery is acknowledged and put into practical employment.

Quite different is it with you. Whenever any new and useful discovery is made, the American people are the first to recognize the same according to its real merits or demerits; and for this reason I wish success and prosperity to American science, American art, and, above all, to American photography. [389]

PHILADELPHIA SUPPLIER CORNERS WORLD MARKET FOR PHOTOGRAPHIC CARDBOARD

Production figures are hard to come by covering photographs or the materials used in their making during the nineteenth century. Frequently, isolated news accounts, such as the following by Edward L. Wilson, provide the only known data on a particular subject—in this case the cardboard used for mounting stereographs, cartes de visite, cabinet, and other forms of photographic prints. Wilson's visit was made in August or September 1870, in the company of Dr. Hermann Vogel, who remained in the United States for several months following his attendance of the 1870 annual National Photographic Association convention in Cleveland: [390]

HOW CARDBOARD IS MADE.

OUR readers are probably not aware that the major portion of photographic cardboard used in this Western World is manufactured in Philadelphia, by Messrs. A. M. Collins, Son & Co. Such is the fact, however; for their machinery is so perfect and their facilities so great, that no one has been able to compete with them successfully either in quality or price. All the large and small dealers draw their supply from this great factory, which is four stories high, and 75 feet deep by 100 feet front.

We were never within its busy walls until a few days ago, when we visited it with our good friend, Dr. Vogel. Until that hour, we had hardly ever given a thought as to how all the cardboard used for mounting pictures upon is made. How seldom do any of us, by the way, think how much skill and tact, and brains and machinery are used in manufacturing what we daily consume.

The manufacture of cardboard is attended with a great deal of labor, and the thousands of reams and rolls of paper that are thrown from the paper-mill into this great hopper run through a great many manipulations, between many nimble fingers, and through sundry muscular machines, before they come out in the shape of pure, white, stiff, hard, calendered sheets, ready for our use.

Nearly all of the paper is received at the factory in huge "endless" rolls. When it is needed to be glazed or colored, the rolls are placed in the machine and passed over rollers and brushes, which lay on the color evenly and uniformly. The paper is then caught by automatic fingers, carried up to the ceiling, and hung up to dry, one length after another, as rapidly as the machine supplies it. After it is dry, it is again rolled up, and is ready for cutting into sheets for pasting.

The pasting-room is one entire floor, filled with benches, and busy girls, who paste the sheets together with astounding rapidity. When the sheets are pasted together, two, three, or four "ply," as the case may be, they are hung up by one edge in "clips" to dry thoroughly. When dry, the sheets are run between immense rollers, which calenders them to any extent desired. After this they are ready to be cut into shape, and printed with whatever the trade may require.

Then there are dozens of other machines used to cut the cards into shape, to round the corners, to print the lines, to cut out the mats, to count the cards as they are cut, to polish the colored sheets, and so on, all of which could only be described by means of diagrams, and matter enough to fill our entire issue. Over three million sheets were turned out here during the year past. Where does it go!

We would like to give more details, but our purpose is served in calling attention to this most important industry. The utmost care is taken to prevent all impurities in their cardboard by Messrs. A. M. Collins, Son & Co., and the variety they manufacture is endless. You all use their boards and know how they please you.

LANTERN EXPLOSION

James Wallace Black, the former partner of John A. Whipple, served in the vanguard of the Cutting patent fight, and became a noted authority on the use of magic lanterns as they came into wider use in the 1870s. He became the official photographer for the Boston police department, and a long-time member of the National Photographic Association executive committee. His assistant, who became involved with him in the mishap recounted below, was his brother-in-law (who recovered from his injuries and later accompanied the artist and explorer William Bradford to the polar regions):

SAD ACCIDENT: On the evening of February 4th while Mr. J. W. Black of Boston, and his worthy assistant, Mr. J. L. Dunmore, were about to commence a lantern exhibition in Lowell, one of the gas bags exploded with tremendous force, threw Mr. Dunmore high in the air and burned him sadly about the face and eyes, knocked Mr. Black senseless, drove a stick through the nose of the organist, and damaged the organ-loft, organ and church considerably. Mr. Dunmore at this writing still lies suffering much and very low, but, with great care, it is hoped, may recover his sight. Mr. Black, though much hurt and quite deaf, faithfully applied restoratives to Mr. Dunmore the whole night of the accident, or the poor sufferer's sight would have been gone. Mr. Dunmore's many friends will be grieved to learn this, and with us heartily sympathize with him and hope for his speedy recovery.

We have not yet learned the cause of the accident. When the explosion occurred, some old revolutionary female spirit innocently inquired of her neighbor if that was the signal to commence the exhibition! [391]

ALBERT SANDS SOUTHWORTH
1811–1894

Albert Southworth had been out of active photographic practice for eight years when he addressed the National Photographic Association's second annual convention at Cleveland in June 1870. Having established a partnership with Joseph Pennell in 1840, and with Josiah Johnson Hawes in 1843, he became a lecturer after 1862 and took up the study of photography as it might be applied to handwriting. Unlike the major daguerreotype collections of Edward Anthony and Robert Vance, which were destroyed or lost, nearly 1,500 priceless daguerreotype portraits by Southworth and Hawes passed from Hawes's heirs in the 1930s to the archives of such institutions as the Metropolitan Museum of Art, the Boston Museum of Fine Arts, and the International Museum of Photography at George Eastman House. The collection represents the largest and most complete body of extant portraits from a single daguerrean gallery.

The veteran Boston pioneer Albert S. Southworth also gave a major address at the Cleveland convention. Vogel had taken the position that the pressures of the American way of life gave photographers little time for study and experimentation. Southworth was less compassionate:

Unsparing efforts have been made by names of merit, known and unknown to fame, and not less in amount of ingenuity and perseverance have been the contributions of those unknown to fame or fortune, and now, at this late day, by far the larger majority practicing photography as a profession have little knowledge of its chemical or optical combinations or artistic requirements, nor are they disciplined in any principles of the fine arts, or in any mechanical employments whatever. Wisdom and prudence enter upon new and untried paths with cautious steps, eagerly observing every new sign and watchful of new developments, whilst youth, inexperience and ignorance push impetuously forward, reckless of consequences, accomplishing sometimes accidental success, oftener doomed to inglorious defeat. Into the practice of no other business or art was there ever such an absurd, blind, and pell-mell rush. From the accustomed labors of agriculture and the machine shop, from the factory and the counter, from the restaurant, the coach-box, and the forecastle, representatives have appeared to perform the work for which a life-apprenticeship could hardly be sufficient for a preparation for duties to be performed, or of a character to deserve honorable mention. [392]

The rustic life of the survey photographers is evidenced in this view of E. O. Beaman's encampment during his travels in the canyons on the Powell expedition.

PHOTOGRAPHY ON THE POWELL SURVEY

During the first seven months of the second survey of the Grand Canyon by Maj. John Wesley Powell, the official photographer, E. O. Beaman, made some four hundred negatives during the party's travels over a distance of 600 miles, two-thirds of it through canyon walls from 500 to 3,800 feet high and nearly three hundred rapids, fifteen of which required unloading of boats and carriage of supplies over treacherous rocks. Among his greatest "disadvantages," Beaman said, was the necessity of working with alkaline and mineral-impregnated water. In December 1871, he sent this report to the Anthony firm in New York:

We have found our finest scenery in the roughest cañons; and here, while making from ten to fifteen portages in a day and running as many rapids at a break-neck speed, I have made from ten to twenty negatives. The sand and dust are so thoroughly compounded with alkali, that it is hard to elude that great pest to the photographer, *pin-holes;* and some of my finest stereoscopic negatives are nearly spoiled. The upsetting of chemical boxes and blowing down of the dark tent is a common occurrence, while we often have to station a man at the tripod to keep the camera from going down the cañons on an exploring trip of its own, carried by the frequent whirlwinds which visit us during the calmest days. Often with two or three assistants I climb from one to three thousand feet, and with one or two quarts of muddy water develop eight or ten plates. About the 15th of July we arrived at the mouth of the Uintah, distant from our starting point about 300 miles. In company with Professor Thompson, I started for the Agency, dis-

tant forty-five miles, which we accomplished in one day. With my dark tent and chemical boxes packed on the back of a mule, and myself on top of these, I have managed to steer clear of rocks and shoals, not, however, with as much confidence as I should have done in one of our boats on the river. At the Agency we found about a dozen white men, employed by the Government in taking care of about 300 Uintah Utes. The Agency is situated in a beautiful and fertile valley on the head-waters of the Du Shine and Uintah rivers, and about 200 miles south-east from Salt Lake City. Photography is a new science among the Utes, and we had some difficulty in getting them to sit for pictures; they were, nevertheless, highly interested with my bottles, and I was often greeted with the short but significant interrogatory— "Whixee?" A few applications, however, of the ammonia bottle to the olfactories soon settled that point, and I was considered "koch weno" (no good) Medicine man. After some persuasion and a pro-

mise from Mr. Bassor, the trader, that no harm would come of it, we had an opportunity of shooting our gun, as they called it, at a group of these noble sons of the forest. We were warned, however, that should any of them get sick, or a pony die, our stay in that part of the country would be short; they then returned to their camp, and we awaited coming events with some anxiety. Early next morning a shabby-looking fellow, enjoying the high-sounding name of General Grant, and wearing an old cocked hat, came into the Agency—his face terribly swollen, probably from toothache—and said that I had looked so hard at him through my instrument that it had made his face "heap sick;" another soon followed with the cheering intelligence that "his pony was heap sick," also. The chief soon arrived, however, and being shown a print from the negative was highly pleased. As it did not make him nor his favorite squaw sick, we were looked upon with considerable favor. [393]

1871

One day in August 1871, the editor of the *British Journal of Photography* became ill and found himself at the same time short on material for his next weekly issue. He issued a call for help to several of his friends in the photographic community, among them Richard Leach Maddox, a physician and photochemist. Maddox dutifully responded with "a hurriedly written and fragmentary article," which described experiments he was then in the process of conducting with gelatine, hoping to come up with a more suitable article than collodion for making dry plates. Maddox had added bromide of silver to his gelatine, and had just had his attention drawn by the Philadelphian, Matthew Carey Lea, to a chemical mixture called aqua regia (nitric and hydrochloric acid). He added this to the gelatine, "fancying that its use would decompose some of the gelatine and furnish the extra silver a chance of forming an organic salt of silver, which might improve the image." Then he made some photographs from "sundry negatives" and sent them off to the *Journal* along with his article, which appeared on September 8. "As there will be no chance of my being able to continue these experiments," he said at the conclusion of the article, "they are placed in their crude state before the readers of the *Journal,* and may eventually receive correction and improvement under abler hands. So far as can be judged, the process seems quite worth more carefully conducted experiments."

With these modest remarks, Robert Maddox dismissed his pioneering steps—and did not thereafter participate in further steps taken by others during the 1870s—in perfecting the gelatine dry-plate glass negative universally adopted after 1880. Like Frederick Scott Archer before him (who died penniless after giving the collodion wet-plate process freely to the world in 1851), Maddox fell on hard times (principally from a prolonged illness which kept him from further experimentation), but became the beneficiary of a fund established by the Photographic Society of Great Britain, and the recipient of several major international awards. In 1891, the Franklin Institute awarded him its coveted Scott Legacy Medal and Premium, stating of his process first published in 1871:

They [subcommittee of the Committee on Sciences and the Arts] find that although gelatine had been employed photographically in a variety of ways, and although silver haloid salts had been emulsified successfully with collodion in photographic practice, prior to the publication by Dr. Maddox of his gelatino-bromide process, nevertheless the successful emulsification by him of silver haloids with gelatine and the perfecting of a working process founded upon it, involved such painstaking experimentation and investigation, and was such a departure from old methods that it merits recognition, on account of its marked influence on the progress of photography, on the enlargement of its practise and the multiplication of its applications in technical and purely scientific directions. The process, though affording negatives of good quality, was soon improved in regard to the quality and sensitiveness of the plates by different individuals, by the removal of the soluble salts, by heating to higher temperatures, by prolonged digestion, by the addition of ammonia, and by changes in minor details.[395]

THE RIGORS OF PHOTOGRAPHY IN THE YOSEMITE VALLEY

After the Civil War, Thomas C. Roche became for a time one of the principal field photographers for E. & H. T. Anthony & Co. On June 10, 1871, he sent in this report from the Yosemite Valley:

It is very difficult to work long with the same bottle of collodion, as it is so hot (110°) that it thickens up after you coat five or six plates, and flows like syrup. Collodion in this state becomes very tender. To avoid this, I have to pack three or four small bottles. Adding ether in the field, and shaking up, will not do quite so well. So far my work is all right, and plenty of it; but I could keep on and make very many valuable pictures here for the next six months, but I will have to stop. I have about one week's more work in the valley, and then, if I can get a good man and pack-mule, I will make a trip to Lake Tenaya and the highest range of the Sierras, fifteen thousand feet above the sea. This will take, out and back, nearly two weeks. I have had no less than six different men to help me. They will not work when it comes to starting at 3 A.M. and tramping all day long. They prefer to pick up jobs around the valley.

There is a Mr. Garrett, of Wilmington, Del., photographing here. He came out by steamer, and has an E. A. view tube. He got his traps and big photo tent in here; but the pack-train mule, in coming up at night, undertook to ford the river, and was carried down the stream, when he rolled over with all his photo traps, and was drowned. A man swam out and tied him to a tree until morning, when they went out in the river and cut the boxes off. All his things were soaking wet. His plates were all albumenized. This, of course, used him up for about two weeks; then he commenced, but could not move half a mile, his traps were so heavy. His plates were all fogging. He had a Philadelphia collodion which has a separate sensitizer. This he mixed as he wanted to use it; but the result has been nil. I gave him half a pound of your new negative collodion, when his plates came out all right. He has now sent to Mr. Taylor, in San Francisco, for two pounds of it. I hope Mr. Taylor has it on hand.

There is also a Mr. Pond, a photographer from Buffalo, N. Y., here. Mr. Pond has a pair of the Ross wide angle. They are not to be compared in any way alongside of the little Dally Rect. lens. Riley says the Rect. Stereo. beats anything he ever used. He is taking all his groups with it. The Ross wide angle stereo. will not cut the field sharp all over.[394]

"TWELVE TINTYPES FOR TWENTY-FIVE CENTS"

In his book, *Thirty-three Years under a Skylight* (Hartford, 1873), H. J. Rodgers describes a number of tintype galleries which he visited in 1871:

One day my attention was called to a sign conspicuously displayed over a doorway, (an entrance to a picture gallery,) where distortions and contortions were displayed in profusion, and after some considerable time deciphering the hieroglyphics which resembled the oriental characters on a tea box, "Twelve tin-types for twenty-five cents," I started as a matter of curiosity, for the artist's sanctum. I had not ascended more than six flights of stairs when I met great numbers and varieties of people coming down. One woman declared that she would not let John see hers; she'd burn them up just as soon as she got home. She knew her nose wasn't long, nor her mouth wide. Another, somewhat vehement in her manner, said hers were a "perfect fright." She hoped she would know enough next time to go where comfort, cleanliness and convenience were regarded. An old gentleman, turning to his wife, said, "Betsey, we've seen a good deal of this world; but we've got humbugged agin. Live and learn' Betsey. Ha! ha! ha!"

About three o'clock in the afternoon, I strolled into another cheap tin-type room, in which was a man, his wife and baby, with right-minded brothers, devoted sisters, fond grandpapas, child-spoiling grandmammas, maiden aunties, generous uncles, expectant neices, and hopeful nephews; all there together, to get a tin-type of that promising baby; and during the operation, I passed away an hour in conversation with the man down stairs, who concluded, sensibly, that in order to succeed with his baby, it didn't require his services, as there were already, twenty-seven in the operating room.

Said he, "This paying for a name, I don't believe in, you know. I can get a good picture here, you know, for five cents; and what's the use throwing away seven or eight dollars at some fashionable place, you know. I went into one before I came here, you know, and the artist said his goods were all imported, you know, and nobody had the kind he did, you know. Well, I spose a good many'll go into a nice place, and pay high for the name on't, you know. The picture taker here, wanted ten cents for the baby, you know, but we beat him down to five cents, and I guess that's reasonable, you know; that is, if he gets a good one. Babies are so hard to get, you know, and he's all life, and ain't still when he's asleep. I shouldn't wonder if they had a regular time on't, keeping the little shaver still."

At this point, Aunt Sophia came down stairs, rather impatiently. Said she:—

"Ezekiel, I jest wish you'd come right up;—we can't do nothing with Johnny, and the artist is crosser'n 'lection. We've tried many's a dozen times, and if 'taint good we shan't take it. He haint got a bit of patience. Come rite up, now!"

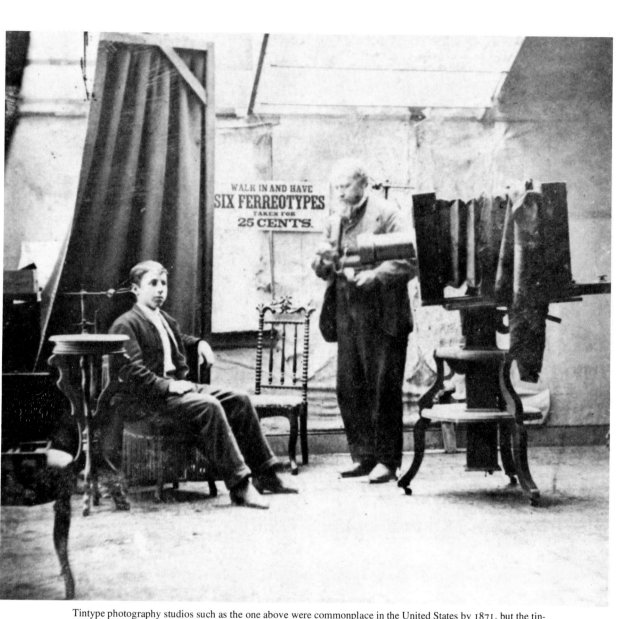

Tintype photography studios such as the one above were commonplace in the United States by 1871, but the tintype process itself remained an ''American novelty'' in England and on the continent where tintypes were made only by beach and street photographers. A ''gem'' tintype camera (top left) contained 36 tubes (with lenses) and could make thirty-six images at one sitting on a single negative plate. An example of a multi-image tintype plate is shown below left.

The improvements made "by different individuals" in the Maddox process came principally from English and Belgian experimenters, and by 1874 a number of British amateur photographers had begun exhibiting photographs made with homemade gelatine dry-plate negatives. But as we shall see, experimentation in the United States during the 1870s continued to center on collodion-bromide emulsions as a vehicle for making dry-plate negatives. As early as February 1870, for example, E. & H. T. Anthony & Co. announced that the "gratifying success" achieved with the collodion emulsions "impels us to offer them for sale to amateurs or the trade." The announcement stated that prospective purchasers need only "state distinctly, in inches, the sizes wanted."[396]

The summer of 1871, meanwhile, also represents a great turning point in American landscape photography, particularly in the West. The Philadelphian John C. Browne, in his report on the progress of photography at the N.P.A. convention, made a point of emphasizing that "this department of our art does not show the improvement that its importance justifies." Continuing on this theme, he told his audience:

Landscape photography in America does not occupy the position that it should, and we earnestly entreat photographers to pay more attention to this subject. In Europe, landscape photography is fully on a par with portrait work, and is very remunerative; both stereoscopic and large pictures are eagerly sought for at all places. There is undoubtedly a reason for this, insomuch that in Europe there are more really fine subjects for outdoor work than in America. We have fine scenery, embracing mountains, rivers, lakes, and waterfalls, but we lack the exquisite pictorial effect of the quaint old buildings, bridges and fine specimens of landscape gardening that are so constantly to be met with in Great Britain, Germany, France and Italy. Much of the scenery of America is unique, for example, the magnificent Yosemite Valley and Falls of Niagara; but, without wishing to underrate our fair country, we are deficient in the *bits* that go so far in making a charming landscape picture. While this may account in some measure for the exquisite beauty of outdoor foreign photographs, and add largely to their demand, yet there is more to be considered than the question of old buildings, picturesque bridges, etc. The simple truth of the matter is that at present we cannot successfully compete in execution with the best foreign landscape photographers. The quicker, then, those interested in this subject apply themselves attentively to outdoor manipulation and pictorial effect, the better it will be for the credit of photography in America.[397]

Browne may have been aware of but gave no recognition in his address to the works of the western landscape school represented by this time by such photographers as Watkins, Muybridge, O'Sullivan, Russell, Charles R. Savage, and a newcomer, William H. Jackson. Also, scarcely a week prior to Browne's speech, a San Francisco newspaper was taking note of the fact that the Yosemite Valley "abounds in photographers, and their signs hang upon the outer walls of their canvas houses, notifying men and women that their shadows may be secured with El Capitan, or any of the falls, in the background." The newspaper gave particular notice to the activities of Thomas C. Roche of E. & H. T. Anthony & Company:

Roche is interested in earnest in his business. He is ever on the hunt for new views and bits of mountain scenery in far-off and

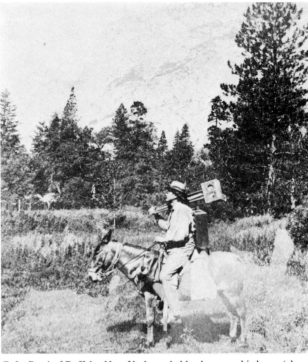

C. L. Pond of Buffalo, New York, probably shown on his horse (above), was among the many photographers arriving in the Yosemite Valley in 1871. Another new arrival, T. C. Roche of E. & H. T. Anthony & Co., contended that the Ross wide-angle lens used by Pond was inferior to the Dallmeyer Rectilinear used by himself and others.

almost inaccessible mountain localities, whither, with his apparatus, he betakes himself, regardless of time, trouble or expense. He essays also with infinite patience to catch the grand but momentary effects of certain of the mists and clouds, as slowly from the valleys they rise and partly veil the face of the cliffs, disclosing, in some jagged, rent pictures of pines and rock, pinnacles a thousand feet in the air over your head; and then everything is hidden for another five hundred feet, when another bit of sky territory is dimly disclosed.[398]

Roche's own report of his activities is contained in a letter addressed to *Anthony's Photographic Bulletin* just two days prior to Browne's N.P.A. address, and an example of his work will be found on page 364. The *Bulletin* had been started by the Anthony firm the previous February, and during most of the 1870s it served as the prime competition for the *Philadelphia Photographer*. Roche is not today included among the ranking photographers of the western school, but his photographs, like those made in the Yosemite Valley by A. S. Robbins of Cleveland, as well as others, were sold to the public along with those by photographers of now more noted fame in the landscape school. In November, the following announcement appeared, for example, in the *Bulletin*:

Anthony & Co. offers a series of foreign and U.S. large views as suggestions for Christmas presents. In Europe there exists a great and laudable competition among the celebrated amateurs and professionals in the production of artistic results. The ex-

cellence of some is truly astonishing, especially the works of Robinson and Cherrill, Col. Stuart Wortley, Capt. E. D. Lyons, Frith, England and Frank M. Good. We have, of our own publication, a series of Yosemite Valley, Pacific Railroad, Niagara, Central Park, and New York City, and also William Notman's extensive and lovely Canadian scenes; Stoddard's Lake George, Upton's Western and Minnehaha, and Beer's Catskills.[399]

The views "of our own publication" were presumably Roche's, and in the light of Browne's remarks the previous June, it is interesting to see that within six months the Anthony firm was giving active promotion of landscape views by such other photographers as Seneca R. Stoddard, of Glens Falls, New York; Beer and Company, of New York; and B. F. Upton, of Minneapolis.

Roche returned to New York after the summer of 1871 and gave many "valuable suggestions" to another photographer, E. O. Beaman, who purchased his supplies from the Anthonys before joining Maj. John Wesley Powell's second expedition to map the Colorado River's passage through the Grand Canyon. Beaman's reports of his exploits as the survey's first official photographer reveal the difficulties and hardships faced by photographers accompanying these early government surveys. After September 1872, Beaman left the Powell expedition to conduct a photographic venture of his own in the Adirondack Mountains in the east, but then disappeared entirely from the photographic scene.

Evidently there was a falling out between Powell and Beaman. After the latter's departure, an assistant, Clement Powell (a cousin of Powell's), was unable to get good pictures with the chemicals Beaman left behind, and payment was stopped on Beaman's final salary check on the supposition that he had deliberately ruined the solutions (an accusation which Beaman reportedly denied). James Fennemore, a photographer in C. R. Savage's Salt Lake City gallery, was first chosen to replace Beaman, but soon afterwards John K. Hillers became the official photographer for the remainder of the Powell surveys (which continued on for another six years).

In a letter to the Anthonys mailed from Utah just before Christmas 1871, Beaman said he had made some four hundred negatives of "some very fine scenery, several of them instantaneous." But today there are no large photographic views attributed to Beaman among the photographs in the Library of Congress taken on the Powell surveys. There are, however, a handful of card stereographs by Beaman in the Library's collection.[400]

About this time, Edward Anthony visited J. H. Dallmeyer while on a trip to Europe, and the latter insisted that E. & H. T. Anthony & Co. become his American agent for Dallmeyer lenses. This report from *Anthony's Photographic Bulletin* on the doings of the 1871 N.P.A. convention indicates that the firm was by then actively promoting the British lenses:

At the National Photographic Association convention in Philadelphia, naturally, great interest was manifested in the Dallmeyer lenses; for it was generally found that those pictures (portraits) which had special claim to favor were made by them, and the idea was expressed that much of the progress and interest of the exhibition was due to the very marked improvement manifest in portraiture generally, resulting from the use, even in less skillful hands, of the lenses of Mr. Dallmeyer.[401]

Col. V. M. Wilcox, a partner in the Anthony firm after 1880, recalled in later years how he was personally involved in selling the first of the Dallmeyer portrait lenses in New York, presumably about this time:

The first lens that was used in New York City, to my knowledge, was one I took up to Mr. J. Gurney. I asked him to take the 3B Dallmeyer lens and use it. He said he had enough lenses. I left it with him, however, and after about a month I went to Mr. Gurney's and asked him if he did not want the lens. He said he did not want it; he did not see but that his lenses were just as good. Mr. Frank Pearsall was his operator then. There was a well-hole in the center of the building, and he overheard the conversation between Mr. Gurney and myself, and he put his head over the well-hole and said, "If you let that lens go I will go." The lens stayed, and from that day to this it has been the favorite with first-class photographers throughout the country; not only this, but scientific men, men in the employ of the Government, have used the Dallmeyer lens more than any other.[402]

Prior to the N.P.A. June convention, a number of notices had appeared in the *Philadelphia Photographer* concerning the destruction of photographic galleries by fire. In one an-

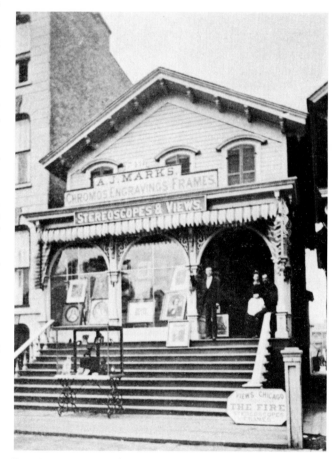

Few photographs exist of the fire which ravaged Chicago on October 8, 1871, but photographers in Chicago, and others who came from Cleveland, Toledo, St. Louis, and even New York, made numerous card stereograph views of the aftermath, which were sold widely. The A. J. Marks store (above) placed a sign in front of its building to advertise the availability of photographs taken in Chicago both before and after the fire.

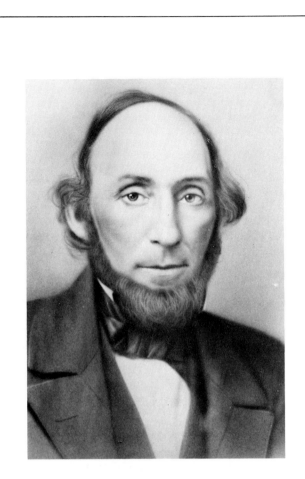

**IN MEMORIAM:
JOHN JOHNSON**

The minutes of the American Photographical Society, in its early years, occasionally record the comments or doings of its first treasurer, John Johnson, such as when he demonstrated a gas burner projection device in 1862, or when he presented a paper on the influence of light on the growth of plants (in 1863). But by 1866, the former partner of Alexander Wolcott had returned permanently to his native Saco, Maine, where in that year he helped found and became the first president of the York Institute, a repository of artifacts and records associated with natural history which survives to the present day as the Dyer-York Museum and Library. Records of this institute reveal that over a period of four years, Johnson donated a variety of minerals obtained locally and from other sites in New England, Georgia, and Canada. In his new capacity as president of the Institute, Johnson acquired the title "Professor," and a biographical sketch of his career prepared in the 1890s described him as not only a pioneer in photography but also as a "patron of learning." He died in Saco on May 3, 1871.[404]

nouncement of three fires in March 1870, for example, it was stated that S. W. Sawyer was burned out in Bangor, Maine, and thereafter moved to Chicago where he bought John Carbutt's gallery, which had been advertised for sale that same month. At the N.P.A. convention, a committee was established to determine the basis for action "at some future time" leading to the creation of a photographers' fire insurance company to be established under N.P.A. auspices. But no action had been taken, and Sawyer was presumably ensconced in his new quarters when, suddenly, on October 8, Chicago was struck by the great fire which raged through the city for two days, killing three hundred people and leaving ninety thousand homeless. Alexander Hesler lost his Lincoln negatives along with forty thousand other valuable negatives and prints. Charles W. Stevens watched his gallery burn, then calmly set about obtaining new quarters and new supplies from New York:

> He came upon a place where fresh meat was wont to be sold, and there began to ply his persuasive powers upon he of the knife and cleaver until success crowned his efforts, and the lease for the store was signed. The butcher's block and the rows of meat-hooks had to give way to shelves for the American Optical Company's apparatus and Union Goods, Sun Plates, &c. Leaving the rest in the hands of his assistant, he proceeded to arrange for an immediate trip to New York to lay in fresh supplies. But lo! on searching for funds, he found one dollar and a quarter was all he had. He was dismayed, for there was no use trying to borrow anything there while Chicago was still in flames. His faithful porter came to the rescue, loaned the money, and in fifteen hours after his store was burned our hero was on his way to New York. He was delayed twelve hours on the way, but arriving on Wednesday, dusty and smoky, his face still black with the embers of poor, saddened Chicago, he entered the store of Scovill Manufacturing Company just as they were closing on Wednesday evening. He was scarcely recognized by his friends there. After hand-shaking and words of sympathy, he said "I have a store. I am going to open again. I want some more goods. Will you help me lay them out to-night?" Of course his wishes were all granted. The alarm was sounded around the store that "all hands must work to-night," and in a few moments a brilliant scene followed. Our hero doffed his coat, put on his slippers, and went to work with the rest. Beginning at one end of our store, the whole was gone over by midnight, he laying out such goods as he desired, and our employees at once entering and packing them. At eleven A.M next day, Thursday, several cases were on the way in the freight train which left New York at that hour for Chicago. [403]

1872

The grand flowering of the western school of landscape photography was by this time in full swing. Although wheeled vehicles could not yet penetrate the Yosemite Valley floor, new trails were added to the flatland between Vernal and Nevada Falls, and from the base of Sentinel Rock to Glacier Point, affording new vantage points for photography. By this time, too, the first of a number of scenic wonders in the West had been named for a photographer of the new school. This was Jackson Canyon, a picturesque ravine a few miles south of what is now Casper, Wyoming, which was named for William H. Jackson.

Jackson left a position as a photographer's artist in Rutland, Vermont, in 1866 after quarreling with his fiancée, and headed west, where he settled in Omaha. In 1870 he was named official photographer for a decade-long series of topographical surveys of the Rocky Mountains conducted by Ferdinand V. Hayden, head of the U.S. Geological Survey. The noted landscape painters Thomas Moran and Sanford R. Gifford each joined the expedition for a year in the period 1870–71, and the presence of these men was particularly valuable in helping Jackson (then twenty-seven) evolve a style of his own in landscape photography.

Photographs and paintings made respectively by Jackson and Moran in the unchartered headwaters of the Yellowstone River in 1871 were notably influential in gaining passage of legislation through Congress in 1872 which established Yellowstone as the nation's—and the world's—first national park. A single photograph made by Jackson in 1873 of the Mount of the Holy Cross in the heart of the Rockies—the mountain's deep ravines displaying a vast cross of snow—chanced to fall into the hands of the poet Longfellow, who once again (as with the Hesler daguerreotype of Minnehaha Falls) based the lines of a poem on the thoughts which were brought to his mind from viewing a photograph.

Many notable landscape views were also made at this time by Timothy O'Sullivan and William Bell on Lieut. George M. Wheeler's surveys in Utah and Arizona, and by John K. Hillers on the remainder of the Powell surveys in the Grand Canyon. A Chicago photographer, T. J. Hines, made photographs on Capt. John W. Barlow's reconnaissance of Wyoming and Montana territories in 1871, but waited until his return to Chicago to make prints. His negatives were then destroyed in the great Chicago fire, but sixteen of his prints were reportedly saved.

Although Eadweard Muybridge and Carleton E. Watkins are now considered by many knowledgeable curators to be the foremost photographers of the western landscape school, Muybridge's attraction to this form of photography was only temporary, and his fame rests more fully on the photographic studies he later made of animal and human locomotion. After emigrating to America when he was about twenty, Muybridge is believed to have learned photography from Silas Selleck, an organizer of the Daguerrean Association in 1851 (see page 85). When Selleck later moved to San Francisco, Muybridge followed and

TIMOTHY O'SULLIVAN

During the Civil War, when he was twenty-three, Timothy O'Sullivan photographed the dead on the battlefield at Gettysburg, and the published engravings made from these photographs provided a major inspiration for Lincoln's Gettysburg Address. In 1867, O'Sullivan was named official photographer on the first of four major United States government surveys of the West, and while the photographs he and others made on these surveys were essentially documentary, many are today classed as among the most celebrated works of the western landscape photography school. From 1867 to 1870, O'Sullivan operated with Clarence King on a geological survey of the 40th Parallel, which took him to the lakes, mines, and wastelands of Nevada, and to Salt Lake City, Wyoming, and Colorado. In 1870, he served for seven months as official photographer on a survey of the best route for the Panama Canal. Back in the West in 1871, he worked for three years with Lt. George Wheeler on a survey of the 100th Meridian, which took him through the canyons of Colorado, and to Indian habitats in Arizona and New Mexico. Along the way, O'Sullivan contacted tuberculosis, and after serving briefly as photographer to the Treasury Department, he died in 1882 at age forty-two.[405]

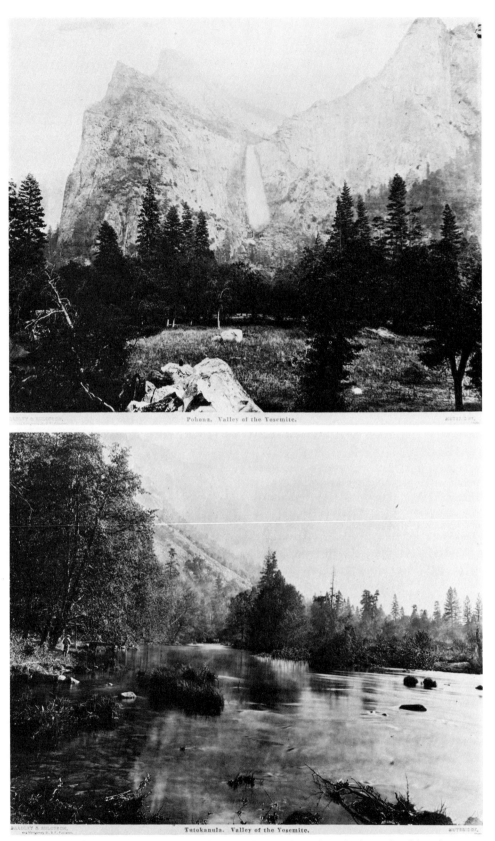

Pohona. Valley of the Yosemite.

Tutokanula. Valley of the Yosemite.

1872

218

The Yosemite Valley served as the focal point for many photographs made by the first cadre of American western landscape photographers. These 1872 views by Eadweard Muybridge were included in a portfolio of fifty-one of Muybridge's Yosemite photographs which won the International Gold Medal for Landscape Photography at the Vienna Exposition of 1873. The portfolios were sold publicly by the San Francisco dealers and photographers Bradley & Rulofson.

operated a bookstore there from 1855 until he adopted photography as his principal vocation. His first major landscape works were created in the Yosemite Valley in 1872, and the superiority of these photographs was acknowledged internationally with the award of a gold medal for landscape photography at the Vienna World's Fair of 1873. Lieut. Wheeler submitted photographs by O'Sullivan to the Vienna exhibition, but these apparently went unrecognized.

Muybridge was the fourth photographer to venture into Yosemite (in 1867), and the first to capture the presence of clouds in the skies above the mountains and ravines which he photographed there. This was accomplished with the aid of a homemade shutter which allowed for varying exposures on a single negative plate, either vertically or horizontally, to compensate for the difference in the sensitivity of the plate to different colors, and to the brightness or softness of the sky.

Muybridge made photographs in the Yosemite Valley throughout the spring and summer of 1872, and his activities drew considerable attention in the San Francisco press. The *Alta California*, for example, reported in April that

> he has waited several days in a neighborhood to get the proper conditions of atmosphere for some of his views; he has cut down trees by the score that interfered with the cameras from the best point of sight; he had himself lowered by ropes down precipices to establish his instruments in places where the full beauty of the object to be photographed could be transferred to the negative; he has gone to points where his packers refused to follow him, and he has carried the apparatus himself rather than to forego the picture on which he has set his mind.[406]

At precisely the same time that Muybridge returned to San Francisco to print his photographs for a deluxe edition, E. O. Beaman completed his travels with the Powell survey, and with a companion, two mules ("Tom" and "Jerry"), a supply of a hundred stereoscopic negatives, and some articles to trade with the Indians, he set out to photograph the Aztec cities in the Arizona desert. In a letter to *Anthony's Photographic Bulletin* dated September 15, he described his transportation system:

> For an outfit of one hundred 5 x 8 negatives I require three boxes of about the following dimensions: eight inches wide by fourteen deep and eighteen long. In one I carry my camera, instruments and about thirty plates for immediate use; in another my bath and chemicals for working with, and in the remaining one my stock of glass, etc. These boxes, with leather straps around them, make a very easy pack to fasten on an animal; by hanging them on the pack saddles, and covering over with dark tent, blankets, etc., and then throwing the diamond hitch around them in the packer's style, a mule will carry them all day without the least danger of breakage.[407]

Public interest in large photographs of the American West, meanwhile, was running high. In New York, the Anthonys began offering prints (presumably by Watkins, Weed, Hart, and Muybridge) which were supplied by the San Francisco dealer Thomas Houseworth & Co. James W. Hutchings, the proprietor of the principal Yosemite Valley hostelry (and the valley's official guardian), took to the lecture circuit, carrying large photographs of Yosemite supplied by the Anthonys. When he appeared in Boston in January 1872, he drew a large audience despite a storm.

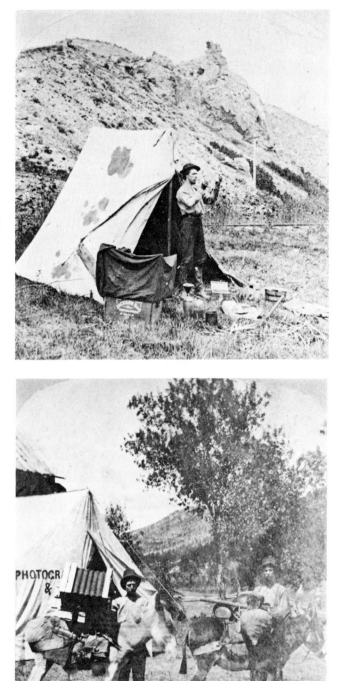

Expeditionary photographers such as William H. Jackson (top), E. O. Beaman, Timothy O'Sullivan, and others operated out of makeshift tents in the field, and transported their equipment, including mammoth-plate cameras, on mules, as did the unknown photographer (bottom). Photographs made by Jackson at Yellowstone in 1871, while traveling with the F. V. Hayden geological survey in Wyoming, helped Congress to decide to establish the Yellowstone National Park there in 1872. Jackson also was first to make photographs in what is now the Grand Teton National Park, and served for the longest period of time (until 1879) as an expeditionary photographer on the western government surveys.

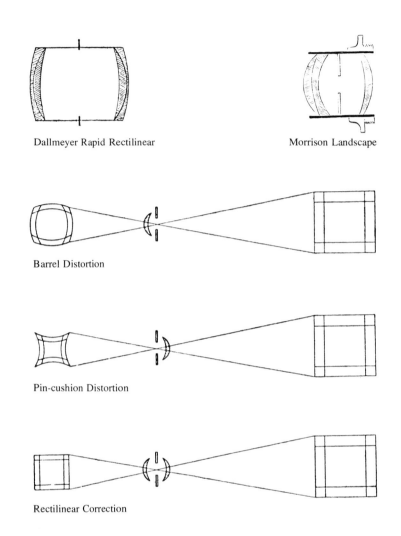

Dallmeyer Rapid Rectilinear

Morrison Landscape

Barrel Distortion

Pin-cushion Distortion

Rectilinear Correction

LANDSCAPE LENSES

Although photographers such as David Bachrach swore by the Harrison *Globe* lens throughout their careers, the "Rapid Rectilinear" (essentially a pair of aplanatic lenses mounted back to back at each end of a short tube) became the universal standard until perfection of the anastigmat lens (see page 336 for description) in 1890. Dallmeyer, Ross, and Swift were the principal manufacturers of the rapid rectilinear, which provided the modern equivalent of an f/8 aperture and overcame the distortion of straight lines, such as is evidenced in the "barrel" and "pincushion" line distortion shown in the two illustrations indicated above. Where barrel distortion is evident, the diaphragm opening, or lens "stop," is shown placed in front of the lens; pin-cushion distortion results from placement of the stop behind the lens, where a bending of lines occurs in a direction opposite to that evidenced in barrel distortion. In the corrected rectilinear (bottom illustration), the lens stop is placed between

two lens cells, which balances the opposing forces and creates an image with straight lines. Barrel distortion was acceptable in most landscape work, but was unacceptable for interior or architectural photography where straight lines would be found near the edges of the plate. E. & H. T. Anthony & Co. became agents for the Dallmeyer lenses.

Richard Morrison, an employee of C. C. Harrison, modified the *Globe* in 1872 by overcorrecting one lens, and providing a crown-glass meniscus in place of the other. William Bell used the Morrison on the Wheeler surveys, and S. N. Carvalho found them better than the Dallmeyer for use in Martinique. The Scovill Manufacturing Co. became agents for the Morrison, which was manufactured at a plant in Brooklyn. In 1883, the *Photographic Times* described the Morrison plant as offering a more varied selection of lenses than any other American supplier.[408]

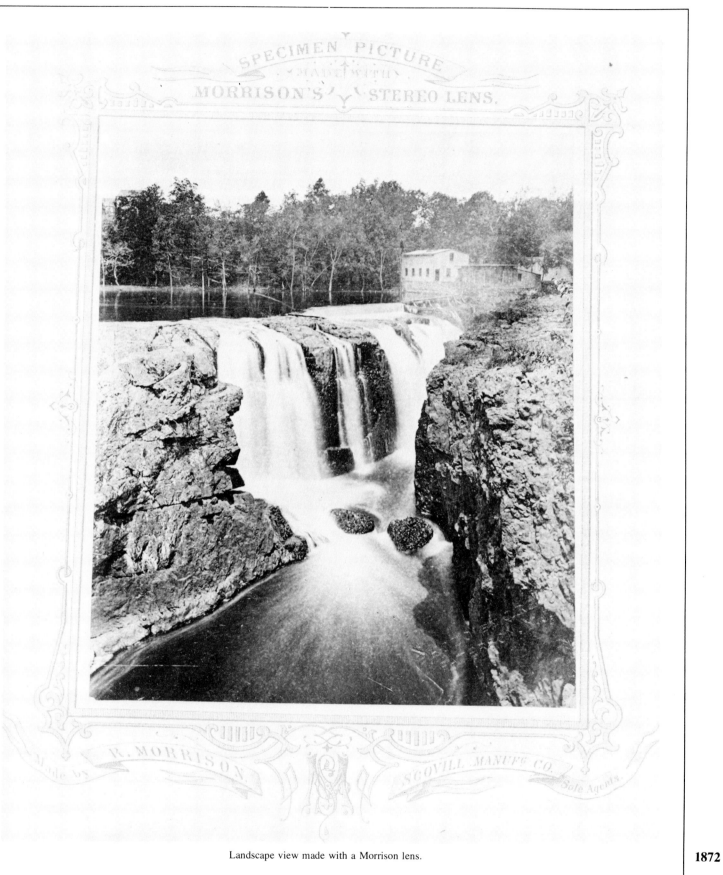

Landscape view made with a Morrison lens.

ALBERTYPES

Edward Bierstadt obtained the United States rights to the Albertype process, and by 1872 had several presses in full operation in New York. This prompted Prof. John Towler to state in a formal address that he "presumed" that Bierstadt would soon sell legal rights to practice the process, or to execute orders for book illustrations, government surveys, or the production of standard engravings. Towler described the Albertype process in these words:

> The Albertype is a print in *printers' ink, made by the lithographic press*, equal in every respect and similar to the silver print obtained from the same negative, and possessing advantages over the silver printed picture in the fact that neither washing, toning, fixing, nor mounting is required, that the print is perfect when it has passed through the press, that a graded border can be printed around the picture at the same impression, and that titles, descriptions, dates, &c., are in like manner all printed at the same time. Furthermore, I may add that any kind of paper can be used, and also that any of the colored inks of the typographer may be employed; consequently prints on albumen paper are most easily simulated, and engravings, lithographs, and maps reproduced so perfectly as not to be distinguished from the originals. Finally, by means of the ink-rollers, it is possible to grade the lights and shadows to suit the most fastidious artistic taste.
>
> Again, let us extend our investigations into the merits of this beautiful type. The negative can be stereotyped ad infinitum, that is, *one impression* can be prepared so as to keep *one press* in operation, or *twenty impressions* can be prepared so as to keep *twenty presses* at work simultaneously, or an indefinite number of presses may be maintained in operation upon the same picture at the same time. This is a very great advantage. One operator, attending to one press, can produce about two hundred prints in one day.

But although Bierstadt could achieve as many as 4,000 impressions from a single Albertype plate, the process—like all forms of collotype printing—remained about as costly for book illustration as the use of original photographs printed in volume and bound in separately from the text.[409]

But this aroused public interest was also being matched by a vast increase in the number of people who now had improved transportation means for visiting these western meccas themselves. By 1874, when wheeled vehicles gained access to the Yosemite Valley, the state of California deemed it advisable to purchase all private claims in the area. With the influx of travelers there came a change in the role of photographers making landscape photographs at Yosemite and elsewhere. Scenic views which had been made for aesthetic reasons (or on government surveys) became of less interest, generally, than photographs made of scenes with which the tourists could more readily identify. Such photographs, which from a critical standpoint would be considered inferior to the earlier works of Watkins or Muybridge, now came into greater supply, ending the short reign of the pioneer photographer-entrepreneurs.

After publishing his views taken in 1872 in Yosemite, Muybridge went on to other exploits. Watkins went to Oregon, where he made more of his aesthetically oriented photographs, but when the financial panic of 1873–74 spread across the land, he was declared bankrupt. Alfred A. Hart was already dead (his negatives had been acquired by Watkins in 1869), and Andrew J. Russell headed back to New York where he opened a Broadway gallery and became associated with *Leslie's Weekly*. After 1875, Timothy O'Sullivan, too, returned east. For a short time he served as chief photographer for the U.S. Treasury Department, but succumbed to tuberculosis in 1882.

Only William H. Jackson among the early "greats" of the western landscape school remained on the scene, continuing (until 1879) as official photographer on the Ferdinand V. Hayden geological surveys. In 1874, Jackson and Ernest Ingersoll of the New York *Tribune* discovered the ruins of cliff dwellings in what is now the Mesa Verde National Park, which Jackson photographed. In June 1876, the *Rocky Mountains Presbyterian* drew attention to a series of landscape negatives, 20 x 24 inches square, which Jackson had made of views around the Rockies, San Juan, and Uncompagre mountains in Colorado. "These are the largest plates ever used in field photography in this country. They convey an impression of the real grandeur, and the magnitude of mountain scenery that the smaller views cannot possibly impart." Jackson lived to experiment with Kodachrome color film in 1939, and died three years later at the age of ninety-nine.[410]

The proliferation of card stereographs, and of stereoscopic viewing equipment, also occurred at this time. Most of the western landscape photographers carried stereocameras as well as mammoth-plate cameras on their various expeditions, or on government surveys. Some, like John Soule of Boston and William G. Chamberlain of Denver, specialized in making stereoviews. The majority of the surviving photographs of Indians made at this time are in card stereograph form. These were made principally on government surveys by men such as Beaman, Hillers, and Jackson, but were also made independently by such photographers as C. R. Savage, operating out of Salt Lake City; S. J. Morrow, operating on the upper Missouri River and Yankton area; and H. H. Bennett, operating in New Mexico.

Beaman related his experience in trying to make photographs in the ancient Aztec cities in these words:

HELIOTYPES

The English photographer Ernest Edwards patented a modification of the Albertype process in England in 1870, which he designated the Heliotype. Then he obtained an American patent, and about 1872 came to the United States to reside permanently, and became associated with the Boston publishing house James R. Osgood & Co., which purchased the American rights. The Heliotype process made use of the same materials as the Albertype, but the gelatine was made thick enough to sustain itself when detached from the glass plate on which it was made for transfer to a metal printing plate. The process was evidently perfected as a result of what Edward Bierstadt contended were "magnified" fears of breakage of the glass plates used in Albertype printing. However, Bierstadt pointed out that the Heliotype method used only vertical pressure, while the Albertype used all modes of pressure known in printing. In the case of the Albertype, the glass plate was imbedded in plaster of paris on a printing stone, and, according to Bierstadt, became as solid as the stone itself. Because of its greater thickness, five times as much gelatine was required on an average for use with the Heliotype, as opposed to the Albertype process. As in lithography, it was necessary after every impression to dampen a Heliotype plate with water. A mask of paper was used to secure white margins for the prints, after which the impression could be pulled for issue. Two or more inks were sometimes used in producing one picture, because it was found that where the light acted deeply, a stiff ink was called for, whereas a thinner ink would be satisfactory where the light did not act so deeply (i.e., in the halftones). Thus, a stiff ink was first used for shadows, followed by a thinner ink for the areas of halftone. Three or four inks were sometimes used in printing a single impression. Because of this, the Heliotype offered a superb range of halftones. It was used by many first-class photographers, among them, Mathew Brady and William Notman.[411]

ENGLAND REMAINS SCENE FOR GELATINE DRY-PLATE STUDY

The publication by Dr. Richard L. Maddox of his gelatine dry-plate process stimulated further experimentation along similar lines, but principally in England. A London photographer, John Burgess, is credited with being the first (in July 1873) to offer a gelatine dry-plate emulsion, commercially, which could be poured on a glass negative plate and allowed to dry. Its sensitiveness in the dry state was held to be equal to the sensitiveness of a collodion emulsion in its wet state. But others in England were making, and possibly selling, dry plates at least as early as the fall of 1872. This was pointed out at that time by *Anthony's Photographic Bulletin* in this excerpt from an article on landscape photography:

> We are not one of those that expect to see the dry plate entirely supersede the wet, in ordinary landscape photography, but in the present knowledge upon the subject, it at least deserves serious consideration.
>
> The advocates of the various dry processes are untiring in their search after a quick and certain method for preparing plates, and from recent improvements, it would appear that there is much to be looked for in that direction.
>
> In England, the manufacture of dry plates is carried on extensively, and with such uniform success that they are largely used by photographers both at home and abroad.
>
> The results of a series of experiments recently made upon plates prepared in England, but exposed and developed in America, proved that an excellent article can be manufactured that will retain its sensitiveness for years, and will (when not tampered with by ignorant custom-house officials) yield uniformly good results.
>
> The manufacture of American dry plates of acknowledged merit, is a subject that is worthy of attention. Photographers could then procure a supply of plates at short notice, and not be obliged, as is now the case, either to experiment, and prepare dry plates themselves, or run the risk of accident and delay in importing them from England.[412]

This people, dwelling in houses three and four stories high, and peace-loving and intelligent beyond any other tribe that I have ever met with, are nevertheless very superstitous, so much so that I have found great difficulty in making negatives of them without getting myself into trouble.

They looked upon pictures that I made of their houses with wonder and amazement; and, when I presented them with some of my best efforts in the way of photographs of themselves, so soon as my back was turned they were immediately destroyed or thrown away. Had they been warlike, I presume that I should have come away minus a small lock of hair; as it was, I was politely request-ed to leave their towns. Nearly all the groups that I took of them are instantaneous views, or taken when they were not aware of what I was doing. They evidently look upon a picture as a sure passport to the happy hunting-grounds of another world.[413]

One historian estimates that only 2,000 to 2,500 stereo-views were ever made of Indian life and habitats prior to 1885, while the number of such card photographs made in California—principally of Yosemite and the Big Trees—has been estimated to total 12,000 to 15,000.

By Christmas, 1871, *Anthony's Photographic Bulletin* observed that the "demand for stereoscopic views is really surprising, chiefly of course for American scenery, but in-cluding every known and almost unknown foreign object of interest, whether in landscape, works of art, or portraiture." Among the principal topics of interest in stereoviews were the following: views of the world peace jubilees in Boston in 1869 and 1871; the completion of major new buildings and the paving of streets in the nation's capital; views of cemeteries, mausoleums and monuments; the building of landmark suspension bridges and viaducts; interior views and statuary of noted public buildings; and the scenic routes of all major railroad lines.

The *Bulletin* drew attention to an "immense collection of stereoscopic views on glass," imported from France. Few American photographers, evidently, made glass stereo-views.

With the onset of the 1873–74 financial panic, prices for card stereographs were cut, and the quality of items offered declined in many cases. Reportedly, the Anthonys curtailed production, but in New Hampshire, where the effects of the recession were possibly less severe, the Kilburn brothers' establishment added a new factory to their Littleton facility, which upped production of cards to two thousand a day. Benjamin Kilburn also set out at this time on a photographic tour of Europe and the Near East. This led to publication of hundreds of new titles of foreign tourist meccas, which sold very well during the 1870s and 1880s. At the time of the fi-nancial recession, E. L. Wilson reportedly was importing foreign stereoviews at the rate of three hundred thousand annually, jobbing them in gross lots.

1872 After the Civil War, the variety of stereoscopic viewing equipment offered commercially also became quite large.

224 E. L. Wilson, for example, maintained a stock of eighteen

Simpson, Robinson, Dallmeyer.
No. 54

AN ENGLISH CONNECTION

These Englishmen who posed together circa 1873 had a notable effect on the course of American photography. They are, from left to right: George Wharton Simpson, Henry Peach Robin-son, and John R. Dallmeyer. Simpson, editor of Britain's *Photographic News* from 1860 to 1880, critiqued American pho-tographic literature (see page 227) and invented a collodio-chloride formula used in the manufacture of *aristotype* paper. Robinson, the most influential pictorial photographer of his day, judged entries at one of the earliest American art pho-tography competitions (see page 355). Lenses made by Dallmeyer were used predominantly in American landscape photography, and were sold through E. & H. T. Anthony & Company (see page 215).[411]

different models which he sold wholesale at prices ranging from as little as 65 cents to $23. In many homes, finely made furniture, from simple floor racks to large cabinets, housed boxes or trays of stereoviews. The cards were also packaged in cases resembling finely made books for display on bookshelves.[414]

1873

"As an industry, photography has grown to proportions that surprise," the editors of a new book, *The Great Industries of the United States,* observed in 1873, a year of economic panic. Ready-sensitized albumen paper had become available the previous year, but how extensively it was used before albumen paper was gradually phased out in the 1890s does not appear to be recorded. In any event, *Great Industries* pointed to statistics covering the import of albumen paper from German and French mills, and concluded that 3,500 reams of the paper were being brought to the United States annually. From this the conclusion was made that American photographers were making 55,400,000 photographs a year. This was based on the calculation of 480 sheets of photographic paper to a ream, and the assumption that each photographer "makes probably thirty pictures" from each sheet, or a total of 14,400 photographs from a ream. Whatever the overall figures might be precisely, the book provided additional interesting data on the average metropolitan gallery operation which would be hard to find elsewhere:

> There are about 5,250 persons in the United States who follow photography as a business, and the leading house in this country in photographic materials estimates that each gallery or operator consumes two hundred dollars' worth of chemicals and paper annually. To obtain a cheap outfit for making cards of the usual size, one requires an outlay of some $200 to $250. The great galleries of the metropolis, where sometimes eighty or a hundred first-class pictures are made in a day, have expended at least $3,000 in their chemical and mechanical outfit, and, including the darkroom, the drapery, and the various devices for regulating the light, the outlay for equipping a first-class gallery is not less than $10,000.[415]

The foremost United States manufacturer of albumenized paper, John R. Clemons of Philadelphia, evidently was not included in the *Great Industries* survey, nor apparently were other American producers such as Daniel Hovey of Rochester. The Clemons factory appears to have escaped the camera's notice in the illustrated Philadelphia business directories of this period, but the facility is known to have been in operation at 915 Samson Street as early as December 1871. In that month, notice was given in the *Philadelphia Photographer* that a barrel of fifty dozen fresh eggs was delivered to Clemons on a particular day for albumenizing, but that while the proprietor was out to lunch all six hundred eggs were inadvertently hatched.

In February 1873, the editors of the *Photographic Times* paid Clemons a visit. After citing various problems and frustrations faced by photographers working with albumen paper, the *Times* gave this account of the visit:

> We were aware that his albumen paper was second to none in quality, but never fully understood the secret of his success. He first showed us his patent Churn, which cost him $300. To this he added an ingenious contrivance of his own, by means of which the cells containing the albumen were broken during the revolutions of the huge wheel, which is rapidly turned by the *"one man power"* applied to the crank outside. Into this huge

The scene above is at John McAllister's in Philadelphia, where a customer could probably buy as many different model stereoscopes in the 1870s as one could buy television sets today at a modern commercial establishment.

> Churn is placed many gallons of the whites of eggs. After the brisk turning of the crank for a few moments, the frothy substance is now in the right stage to add of milk and old Jamaica rum *quantum sufficit* to produce a glorious eggnog; but no, our good Methodist brother John won't hear of such a wicked thing, and despite our mouth waterings, inward yearnings and vain expostulations, away it goes into an immense strainer of Mr. Clemons' own peculiar construction, and soon percolates through, limpid and clear as crystal. Then is added a *secret* chemical compound which dissolves all the striated, or fibrous tissues, which, though almost invisible, produce in some makes of albumen paper the reticulations of surface which war against fine, soft, even tones in the finished print, notwithstanding the greatest care is observed by the painstaking photographer. To this secret agency is due the uniform smoothness of texture so peculiar to Mr. Clemons' paper.[416]

Citing Clemons' extensive albumenizing and drying rooms (facilities which, for example, would prevent the occurrence of diagonal streaks running through the paper because of improper drying), the article also observed that the Clemons paper was celebrated for its rich bluish-gray tints

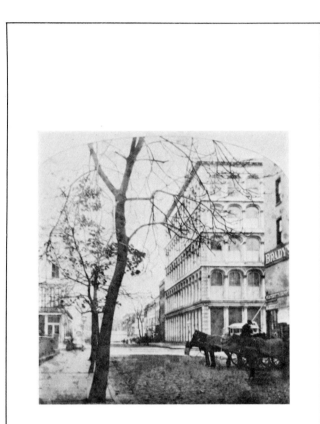

MATHEW BRADY FLEES NEW YORK

Mathew Brady's Broadway and Tenth Street gallery in New York was America's finest when it was opened in 1860. The Prince of Wales was among its first patrons, and *Leslie's* said of it: "If Brady lived in England his gallery would be called the Royal Gallery." The view (above) shows only one side of the building in which the gallery was housed. In the background, on the southeast corner of Broadway and Tenth, running all the way to Ninth Street, is A. T. Stewart's famed department store, which in the twentieth century became John Wanamaker's department store before its destruction by fire. But Brady had overextended his resources in opening the Tenth Street showplace, much as he had in even greater fashion by personally funding the principal photographic coverage of the Civil War. By January 1873, the demands of ninety-four creditors could no longer be staved off and Brady was declared bankrupt. But Brady had political connections with Boss Tweed's Tammany Hall, and he conspired with the Tweed-appointed Sheriff of the City of New York to spirit away nineteen cartloads of goods from the gallery before the U.S. Marshal's Office could obtain an injunction halting the action. Brady himself fled to Washington where for the first time he established his permanent residence.

"which vary from delicate pearl to deep blue, according to the taste of the photographer. These tints, unlike those produced by many albumenizers, *do not fade.* The deeper shades are particularly adapted for views, giving bluish skies so desirable in outdoor effects."

The financial crisis which struck the nation in 1873 was possibly the worst of the century. It began on September 18 with the failure of Jay Cooke & Co. in Philadelphia, the banking firm which had acted as the federal government's agent during the Civil War in floating bond issues to meet military requirements. The Federal Reserve System did not exist at this time, and a general suspension of banking was averted only by an agreement among the banks themselves to give dictatorial powers to the New York Clearing House Association, an organization headed by Frederick Dobbs Tappen (see illustration, page 259), which had been established merely to facilitate the exchange of checks. No solvent bank was allowed to fail because of depletion of cash reserves, and before the crisis eased, over $26 million in clearinghouse certificate loans were issued. But generally unfavorable economic conditions, including severe unemployment, persisted for another five years.

Many a photographer's business was brought to a standstill, and Carleton E. Watkins, as we have already seen, was forced into bankruptcy. John G. Vail, of Geneva, New York, waited the crisis out until as late as 1880, but finding that he still could not fulfill orders for a profit, he took all his negatives in a rowboat to the center of Geneva Lake and dumped them overboard (an action which he said he felt was necessary to prevent their falling into "unscrupulous hands").

Mathew Brady was another who was declared bankrupt in 1873. Brady's troubles began immediately after the Civil War when he failed in his efforts to have either the 40th or the 41st Congress appropriate funds for the purchase of his wartime photographs. Management problems in his Washington gallery and mounting debts at both his Washington and New York galleries came to a head in 1872, the same year that the Tammany Hall leader William Marcy ("Boss") Tweed went to jail. Brady had previously enjoyed a political helping hand from the Tweed forces against certain court judgments which had long been pending against him in New York, but with the demise of the Tweed machine, these court actions were prosecuted, resulting in the rendering of judgments against Brady by ninety-four creditors. But before the U.S. Marshal's Office could seize his property and goods, Brady prevailed upon his friend Matthew T. Brennan, Sheriff of the City of New York and a longtime Tammany sachem, to help him spirit away his goods to Washington.[417]

One who was untouched by the economic problems of the day was Edward L. Wilson. Wilson had struck up a close friendship with Dr. Hermann Vogel, and the pair decided to attend the 1873 World's Fair at Vienna. Wilson attended the opera in Berlin and was feted by the German Society for the Advancement of Photography. He and Vogel watched a parade led by Emperor William I, and visited the art studios of Loescher & Petsch, Meister, Tolbat, Obernetter and Schaarwachter. After the Vienna fair, the pair traveled together to Paris, Switzerland, and Italy.

Laurels were heaped on Wilson this year, too, by the

British photographic press, which cited his energy and enthusiasm as the principal motivating force behind a grand flowering of American photographic literature. "There was a time," wrote George Wharton Simpson, "when the photographic literature of America was of the most meagre and feeble description, its periodicals being chiefly filled with gleanings from English journals, whilst books of any pretension or completeness there were none. Now we look in vain in any other country for a photographic literature so copious and complete." Simpson cited American authors such as Matthew Carey Lea, whose *Manual of Photography* first published in 1868 became a world standard; Elbert Anderson, whose *The Skylight and the Dark-Room* Simpson felt "ought to grace every photographer's library"; and Wilson's own *Carbon Manual* and other books which had "teemed from the press" in America at this time. Publication of Simpson's article prompted H. H. Snelling, by now residing in upstate New York, to address a letter to the editor of the *Photographic Times* in which he also voiced praise for Wilson's efforts, but at the same time added this slight dash of cold water: "When Mr. Wilson established the *Philadelphia Photographer* he conceived nothing new, but simply continued the planned purpose of a predecessor, who failed in his enterprise because he was 'ahead of the times.' " The "predecessor," of course, was a reference to Snelling himself. In a separate editorial comment on Snelling's letter, the editors of the *Photographic Times* put a different perspective on the matter:

Entering upon his duties, nearly ten years ago, he [Wilson] seemed at once to sympathetically comprehend and understand the interests of the fraternity, and with cheerful persistence, saying *"come,* boys," rather than *"go,* boys," he has the pleasant consciousness which earnest labor always brings, of having been *useful* to those who look to him for their instruction and encouragement.[418]

Just as there was now a flowering of American photographic literature, so, too, the works of the western landscape school for the first time placed Americans in the "big league" of English and European fine-arts photographers. This was the league dominated in the 1850s and 1860s by such names as Dr. Thomas Keith (of Edinburgh), Robert MacPherson, Roger Fenton, Philip H. Delamotte, Charles Clifford, Gustave Le Gray, Edouard Baldus, Adolphe Braun, Maxime Du Camp, and Charles Negre. In the 1870s, the most prominent names were British: Francis Frith, Henry Peach Robinson, and John Thomson. Now Eadweard Muybridge and Carleton E. Watkins could be counted among the ranks of well-known photographers whose works won prizes at international exhibitions. To these should also be added the names of William H. Jackson and Timothy O'Sullivan, whose original prints today have a high value despite the lack of recognition given O'Sullivan, for example, at the 1873 Vienna fair.

For a number of years dealers and booksellers such as Wilson & Hood in Philadelphia, and E. & H. T. Anthony & Co., Charles Scribner's, Julius Bien, and C. F. McKim in New York, offered albums and portfolios of photographs published in England, or in Europe. Now, at last, there were some American counterparts, including Muybridge's *Views of the Valley of the Yosemite* (San Francisco, 1873),

PEERLESS LENS

The Scovill Manufacturing Company found itself without competition for the Dallmeyer portrait lenses imported by E. & H. T. Anthony & Co., and in July 1872, announced the commercial availability of the *Peerless* lens. In January 1873, the company followed up its announcement with this description in the Scovill-sponsored publication *Photographic Times:*

SINCE the death of Mr. C. C. Harrison there has been no one as yet in this country capable of making first-class *portrait lenses.*

And when we say that *this country* has produced no peer of Mr. Harrison, we need hardly state to the intelligent reader that no portrait instruments have been made since his death which have fully attained to his high standard of excellence.

This fact is so patent to the photographic fraternity as to require no extended remark at our hands.

Although we have still in stock a considerable number of lenses which were made by Mr. Harrison (all of which we guarantee as fully equal to any which he ever turned out, consequently unexcelled by any in the world), our stock of some sizes has been running low, thus compelling us to seek out the most accomplished talent to be found in the world. After many trials with opticians of the widest reputation and experience in this country and Europe, we have succeeded in finding a highly competent firm whose productions in the line of portrait lenses have met our most rigid requirements.

We have adopted the name *Peerless* for these lenses, and offer them for competition against any so-called first-class instruments in the market.

The intelligence of photographers has long been impugned by the endeavors of some parties to obtain exorbitant prices for imported lenses, when it is well known that the same instruments can be bought in Europe for at least fifty per cent less.

We would call attention to our very low prices (see advertisement on another page), which afford us only a reasonable profit, while they make it possible for photographers of limited means to procure all the instruments requisite to the prosecution of their business for a moderate outlay.[419]

1873

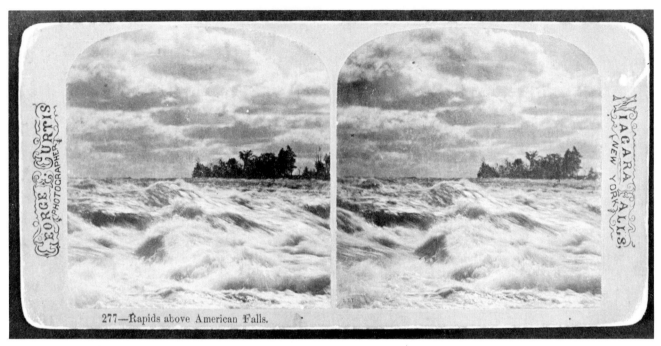

277—Rapids above American Falls.

Seascape photographs remained uncommon in the 1870s, and the view above at Niagara Falls was probably made after 1880. The subject was rarely discussed in photographic literature of the period, but in July 1873, *Anthony's Photographic Bulletin* published these remarks by F. R. Elwell at a meeting of the London Photographic Society: "Every aspirant of our art has eagerly longed for the means whereby he might *faithfully* depict the breaking waves, the sunlit landscapes sprinkled with its accompanying passing clouds, the fleeting and ever-changing expressions of children. All these are as yet satisfactorily possible only to a very limited extent; but with patience, and chemicals always kept in a high degree of sensitiveness, a great deal may be accomplished." Elwell said he had tried "various shutters," but concluded that a lens cap and "a small amount of hand practice" were still the best ingredients for rapid exposures.[420]

containing 51 large prints, 36 in size 5½ x 8½, and 379 card stereographs; W. H. Jackson's *Yellowstone's Scenic Wonders* (1871), and *Photographs of the Yellowstone National Park and Views in Montana and Wyoming Territories* (1873), both albums of photographs made on the F. V. Hayden surveys and published in editions of unknown size. Earlier (in 1870), Clarence King had prepared a small book of poetry, *The Three Lakes, Marian, Lall and Jan and How They Were Named*, which he illustrated with some of O'Sullivan's most picturesque photographs taken on King's surveys of what is now Wyoming and Colorado. Efforts were evidently also made at this time to publish folio-size books of landscape photographs taken by eastern photographers, but today such items are little heralded. One example is *Pictures of Edgewood*, published in 1869 by Scribner's, containing ten large mounted albumen photographs of the New Jersey town by George G. Rockwood, and text by Donald G. Mitchell. The book was issued in a limited edition of three hundred copies. There is no easy way of compiling a full listing of published works covering American landscape photography at this turning point of the medium's history, and the existence of works such as the Rockwood book frequently remain unknown until they appear at public auctions.

1873

1874

Except in isolated instances, photographers in the daguerrean era did not make what are now called "documentary" or "news" photographs. The daguerreotypes made by Robert Vance of San Francisco and environs during the gold rush years constitute the first such major undertaking, but unfortunately these photographs were lost. After the introduction of the card stereograph, however, these types of photographs gradually became more common. Photographers soon found that if card stereographs could be made of major public events or disasters, they could be profitably retailed locally, and sometimes nationally, depending upon the nature of the event or calamity. The thousands of card stereographs made during the Civil War, while they are classed as "wartime" photographs, are among the earliest documentary and news photographs produced on a large scale. But even in that day, only a small handful of the stereoviews (or larger views) taken were of actual battle scenes.

Card stereographs of the aftermaths of the disastrous fires in Portland, Maine (1866), Chicago (1871), and Boston (1872) were made by scores of photographers in each of these cities, and these were sold not only locally by the photographers themselves but nationally by E. & H. T. Anthony & Co. and other major commercial stereograph publishers. Most of the time these publishers would acquire negatives made locally, but occasionally they would dispatch photographers of their own to record an event or happening, and such ventures may truly be described as documentary or news photography in its earliest commercial form.

The first flash flood which caused loss of life and attracted public interest in locally produced photographs of the event was the flooding of the Allegheny Valley just north of Pittsburgh in 1873. But there was no first-rate stereophotographer in Pittsburgh at the time; hence, the photographs taken of the aftermath of the flood are extremely poor. In 1874, however, a number of photographers provided excellent coverage of the aftermath of the Mill River flood in western Massachusetts which ravaged the towns of Williamsburg, Skinnerville, Haydenville, Leeds, Florence, and a portion of Northampton, following the collapse of the Williamsburg Reservoir dam early on the morning of May 16. In many respects the photographic coverage of this tragedy is a classic in early American news photography, for not only did the photographers record the many scenes of damage but at the same time they also made photographs of the principal heros of the event. A. E. Alden, of Springfield, photographed the two "Paul Reveres" who rode through the towns warning residents to run for their lives minutes before the calamity struck. One of these was a young Civil War veteran, George Cheney, the gatekeeper of the dam at the 111-acre Williamsburg Reservoir. When the dam broke, he leaped on a horse and rode bareback three miles to Williamsburg to shout warnings of the impending disaster, which caused more than 130 deaths. Another was a milkman, Collins Graves, who, upon hearing Cheney's

NEWTON METHOD FREES PRINTS FROM HYPO CONTAMINATION

"Washing long and washing well is one of the fundamental laws of photography, the first learned and the longest remembered by every photographic printer," Henry J. Newton said in 1871. "This may be necessary," he added, "but I do not practice it for two reasons: first, I do not believe the necessity for it exists. Second, I am sure it injures the prints." Newton proposed measured use of acetate of lead in a series of washings to be sure that all hypo would be removed in print making, stating that "the whole process need not occupy more than fifteen minutes."

In July 1874, a committee was appointed by the Photographic Section of the American Institute (of which Newton was president) to test the Newton formula. The committee consisted of Henry T. Anthony, O. G. Mason (photographer-in-residence at Bellevue Hospital), James B. Gardner, and James Chisholm. On October 7, the group issued its report, from which the following has been excerpted:

The committee in their experiments have demonstrated in many ways the wonderful tenacity with which the hyposulphite clings to albumenized silver prints, and thus arrived at the conclusion that perhaps not one picture in a thousand was ever absolutely free from it. If, therefore, Mr. Newton's mode of removing it was true and practicable, it should be proven and made known to every photographer who takes even the smallest interest or pride in the permanency of his work.

At one of the meetings of the committee, it was determined by careful experiments that of all the known tests for detecting the presence of hypo, the starch and iodine was the most reliable when freshly and properly prepared. By this test, not even the 250th part of a grain in an ounce of water, or $\frac{1}{112000}$ part, escaped detection.

It was also demonstrated by experiments that the acetate or nitrate of lead was the best known means of decomposing the hypo. Prints that were washed after coming from the lead solution in simply four changes of water, showed no trace of hypo, while those washed in running water for twelve hours or more (without the lead solution) were still found contaminated with it.[421]

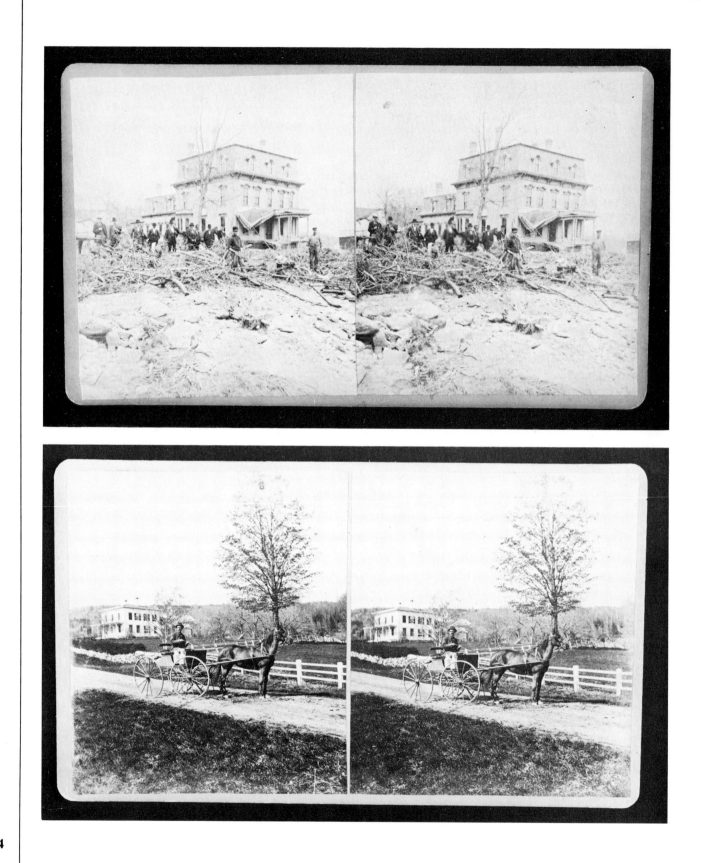

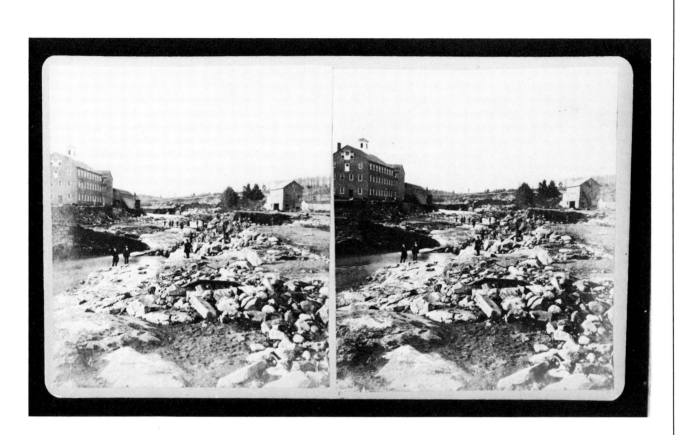

MILL RIVER FLOOD DISASTER

Photographic coverage of the disastrous flooding of the Mill River in western Massachusetts on May 16, 1874, stands as a classic in early American news photography. Card stereographs made after the tragedy provided lucrative returns for at least three photographers. These essentially news photographs were made and sold by A. E. Alden of Springfield, Massachusetts, depicting the damage to the Nonotauk Silk Works in Florence (top left), and to the Hayden, Gere & Company brass works in Haydenville (above). Bottom left stereoview is of milkman Collins Graves in front of his Williamsburg home, which was spared in the tragedy. After the Williamsburg dam burst, Graves rode Paul Revere-style to neighboring Skinnerville and Haydenville, shouting warning minutes before the flood ravaged these towns. Card stereographs not shown here were also made of the dam's gatekeeper who posed afterwards on the horse he had ridden bareback to Williamsburg to warn residents of impending disaster.

shouts, cut his horse loose from the milkwagon and set out at a gallop for Skinnerville and Haydenville. Collins arrived only five minutes ahead of the flood in Skinnerville and three minutes ahead of it in Haydenville. Alden afterwards photographed Cheney on his horse, and Graves in front of his home, and on his milkwagon (see pages 230–231). He also photographed George Roberts, a "little hero" who was rescued after being caught for an hour in the rampage. Alden printed and sold a series of forty-eight views of the flood, each card carrying the following advertisement on the back side:

> Having lived in the vicinity of the ruined villages, we have had superior facilities for securing views from the best points, and

DRAPER PROPHECY: PHOTOGRAPHIC OPERATION OF LIGHT AFFECTS PRODUCTION OF COLOR

In 1863, Prof. John W. Draper observed that certain vegetable tints were destroyed by light of a complementary color, and he suggested that the converse of this observed phenomena might have a bearing on photography:

> If you take a seed and make it sprout or germinate in a dark place, the young plant emerges of a pale and sickly yellow hue. If you persist in exposing it to such a trial, you soon find that it has no power of adding to its height, for with the exception of water it contains nothing more than was in the original seed. But set it where the sun can shine upon it, and soon its sickly yellowness is lost, its leaves turn green, it steadily increases in height. Its stem become firm, its branches put forth, in due season it bears its colored flowers, it reproduces its seeds, and so completes the cycle of life. Now, the accomplishment of all this turns on the chemical fact, that under proper circumstances the sun's rays can separate carbon from oxygen, and combine it with other elements into new and organized forms. Connected with this production of colors and forms by the influence of light, there is an interesting fact that well deserves the serious meditation of every photographer. I refer now to natural bleaching operations, or the destruction of colors by light. In vegetable tints of any kind, bleaching or destruction is accomplished by light of a complementary color; a green tint is destroyed by red light, a red tint by a green. Now those who have attempted the solution of that which must be universally considered as the grand problem of photography, the artificial representation of external objects in their natural colors, have perhaps come too hastily to their conclusion that there is no relation between the photographic operation of light, and the production of color. Obviously there is in the case of carbon compounds such a relation as regards their destruction, and therefore perhaps the converse of this is not so improbable as some have been led to suppose. But I have been alluding to carbon as the natural photographic material, for the purpose of illustrating my assertion that in photography we are at present only at the beginning of our work. We have used one material, Nature uses another. There are multitudes which neither we nor Nature have thus far resorted to. So there is a boundless field before us.[422]

IN MEMORIAM: WILLIAM LANGENHEIM

The death of William Langenheim on May 4 brought to a close the illustrious Philadelphia business of Frederick and William Langenheim, begun about 1842. Within six months, Frederick sold the business and himself died five years later. The Langenheims failed in their attempts, in the 1840s, to license American photographers for the early calotype paper photography practice, but they are the recognized pioneers in the development of photographic slides for audience viewing, and in establishing the American market for card stereographs. Through their brother-in-law, Friederich Voigtlander, they also introduced the first true camera lens (the Petzval lens, manufactured by Voigtlander) on the American market.

have taken time and pains to make our list the most complete and interesting that could possibly be obtained. We have secured a complete set from Williamsburg Reservoir to Northampton.[423]

Documentary photographs of the exterior, and in some instances the interior, of various New England mills and factories were made in the latter part of the 1860s and in the 1870s. T. Lewis, of Cambridgeport, Massachusetts, for example, made forty-four views covering the building and activities of the Waltham Watch Company in 1872. Other card stereographs were published in the period 1868–74 by Presscott & White, of Hartford, covering the Willimantic Linen Company; and by J. N. Webster, of Barten, Vermont, covering the Lydonville Machine Shop in Lydonville, Vermont.

The photograph of President Andrew Johnson on the front porch of a building with General Grant and Gideon Welles (see page 184) is a prime example of an instance in which a local photographer secured what is essentially a news photograph of a president on the campaign trail. But unfortunately, the name of the photographer as well as the location where the picture was taken remain unknown. While it was not uncommon for local photographers to make such photographs, there were no news photo services at the time, and occasions were few on which the large commercial publishers would put in a request for photographs taken locally for one reason or another. The Johnson card

Dr. Hermann Vogel, from a photograph circa 1872.

ORTHOCHROMATIC PHOTOGRAPHY

That there was a "relation between the photographic operation of light, and the production of color," as stated by Prof. John Draper in 1863 (see left), was observable in a vast number of photographs. Violet and blue colors were reproduced too light, while green, yellow, and red would appear too dark. In landscape photographs, much detail was lost in the foliage; blue skies would appear as light as the white clouds, often rendering the latter invisible. In portrait photography, auburn or red hair would come out too dark, and freckles much too prominent; blue eyes and blue or pink dresses would appear entirely too light.

The first action based on this observable phenomenon appears to have been taken in December 1873, when Dr. Hermann Vogel disclosed that certain aniline dyes could be used to increase the color-sensitiveness of the silver salts in a photographic negative to those rays of the spectrum which they absorb. "I fastened a dark-blue silk ribbon on a piece of yellow silk, and took a picture from it with an ordinary wet collodion plate," Vogel recalled later of his first experiments. "The result was a white ribbon on a dark piece of silk. It was obvious that I could not succeed much better with a corallin-dyed bromide of silver plate, because the action of the yellow in the spectrum on it was much stronger than that of the blue. Therefore, I interposed a yellow screen between the subject and the lens, depressing the intensity of the blue rays; and now I got indeed a negative which was a true positive print, wherein the dark ribbon was dark and the yellow silk was light." Vogel's discovery was a first step toward orthochromatic photography,

a way of using dyes to tender truer color values in a black and white photograph (the process was not one able to produce color prints).

D. C. Chapman, at a meeting of the Photographic Section of the American Institute in February 1874, called it the most important improvement since the invention of photography itself. "The process," he said, "appears to be adapted entirely to dry-plate photography, and is more particularly applicable to the bromide of silver alone." In photographing paintings, in which certain colors predominate, Chapman said it would now be possible to flow the dry plates with special ingredients so that "the predominating color of that picture may be made to give the predominating action on the plate; so that we may proportion the dry plates to the special purpose, and make those colors which appear the strongest show upon the photograph the strongest." In outdoor photography, he said it would be possible to "diminish the action of the clouds and the sky, and increase the action of the green."

Vogel's discovery led other investigators to experiment along similar lines, and better dyes were soon perfected. But despite these further advances, photographers were not given the means—even with the orthochromatic plates manufactured after 1884—to make their monochrome negative plates sensitive to all colors. The plates remained comparatively insensitive to red, and oversensitive to blue, unless a yellow filter was used to correct these drawbacks. After the appearance of the panchromatic plate in 1906, the photographers' monochrome plates were made sensitive to all colors, including red.[424]

1874

233

stereograph was probably sold locally, and only in a relatively small number. With the great loss, or destruction of photographs and negatives made in the nineteenth century, many, if not most of such locally made news photographs should be considered one of a kind, just as a daguerreotype or ambrotype is a one-of-a-kind photograph lacking a negative or duplicate prints.

The numerous government surveys begun after 1870, of course, provided another stimulus to documentary photography, and by 1874 *The Nation* made note of the fact that a photographer was "now considered indispensable to all Government expeditions of the first class." Citing the Hayden, Wheeler, Powell, King, Selfridge, and other surveys, the periodical observed that the number of negatives accumulated in Washington (stereoscopic views, and photographs in size 11 x 14) "has become really enormous," and that "the peculiarities of a country and of its human and other inhabitants can thus be exhibited in a very satisfactory manner." But why, the magazine asked, could not all of these photographs be made readily available to the general public?

> It is greatly to be regretted that no provision is made by Government for the publication of these pictures, so that they may be acquired by those who wish for them at a reasonable price. They are now to be had only by special favor of the heads of the departments, and a complete series cannot be obtained without great difficulty. A few sets might be distributed gratuitously to public institutions, others sold singly or collectively to individuals, at cost price. It is quite safe to say that the series of large plates amounts to over a thousand, while of stereoscopic pictures there are two or three times that number.[425]

The original negatives and prints made by the photographers themselves on these government surveys have, in many instances, found their way into the archives of libraries and historical societies, or into the hands of collectors. Those prints deposited with government agencies remain essentially where they were, or in the Library of Congress or Smithsonian Institution.

1875

"It is difficult to go into a bookstore now without seeing various works illustrated by means of one or more of the various photomechanical printing processes," the *Philadelphia Photographer* observed in February 1875. But in all of these methods used to incorporate photographic images with book text, it was still necessary to print the illustrations separately (i.e., on separate printing plates), then bind them together with the pages of separately printed type. The processes principally used included the Woodburytype, Albertype, and Heliotype. Publishers also continued to issue small editions of a few books containing mounted photographs printed in volume from original negatives, and likewise bound together with separately printed type pages. John Carbutt's 1868 *Biographical Sketches of the Leading Men of Chicago* was followed by volumes of a similar nature published in Baltimore, Cincinnati, Syracuse, and Nebraska. Where Carbutt had printed nearly 50,000 cabinet-size photographic portraits for his Chicago book, James Landy printed 65,000 cabinet-size prints for the Cincinnati book, issued in 1873.

Literary classics were published, principally in England or on the continent, in new limited editions with separately bound-in photographs, either made from original negatives or by the carbon, or a photomechanical process. One example of an American classic published in this manner was that of Washington Irving's *A Legend of Sleepy Hollow,* issued in 1870 with four carbon prints by Napoleon Sarony of actor Joseph Jefferson in the role of Rip van Winkle. In 1874, Edward Bierstadt's Photoplate Printing Company was given the job of making Albertype prints to illustrate a book on western scenery, using negatives made by W. H. Jackson in Yellowstone National Park, but all of the materials for the book were lost when the building in which Bierstadt's company was housed was destroyed by fire in January 1875.[426]

Two other photomechanical methods adopted by some publishers for line illustrations were photolithography, used principally for map illustrations, and photozincography, a process similar to photolithography, but one which made use of a zinc printing plate instead of a stone. But even to the present day a certain amount of confusion exists—even among so-called experts—as to whether various books published in the 1870s and 1880s contain woodcuts or line illustrations made by a photomechanical process.

Beginning in the early days of the daguerreotype, attempts were made—some successfully—to secure impressions from a photographic image on a metal printing plate. In 1842, for example, the U.S. Mint's chief engraver, Christian Gobrecht, made a daguerreotype view of the Mint building in Philadelphia, then made a bas-relief from this on a metal plate, from which he was able to make a facsimile, lead-backed printing surface by the then newly discovered art of electrotyping. With this printing plate, Gobrecht was able to make an engraving of the Mint which served as a line illustration in Eckfeldt and Du Bois's *A Manual of Gold and Silver Coins,* published that same year.[427] But the prin-

PHOTOENGRAVING

Of all the photomechanical printing modes, photoengraving made the least progress because it remained a slow and expensive process. R. W. Bowker gave this description of the art for the readers of *Harper's:*

The engraver has upon his table a smooth block of boxwood, upon whose surface appears, reversed, the drawing or a photograph from the picture which he is to reproduce. Modern photography has been able to coat the wood with a sensitive film which takes an exact photograph, reversed, of a picture to be copied, leaving the picture itself as a guide to the engraver. This is a double gain, and most artists now draw directly on paper in wash or body color, in preference to drawing backward on the wood itself, a design which the engraver's tool must destroy as he interprets it. The block is placed upon a cushion on the engraver's table, and between the block and his eye is a magnifying-glass supported from a frame, through which the eye directs and follows the hand. Thus equipped, the engraver uses otherwise only the simplest tools—gravers of well-tempered steel, sharpened occasionally on a whetstone near at hand, and sometimes the multiple graver or "tint tool," which has a cutting series like a comb, and cuts parallel furrows. This last is seldom used by the best men. Line by line, with exquisite patience, the engraver pursues his wonderful work, in whose highest reach there is no secret beyond the eye careful to see, the hand deft to cut, the artistic judgment which dictates the right kind, direction, and width of line to interpret the artist's feeling. The graver cuts away the furrows in the wood, leaving ridges which are to be the lines of the print, so that a magnified wood block is simply a carefully ploughed field.[428]

cipal reason these early attempts at photoengraving were not generally successful, commercially, was due probably to the softness of the metal at first used, which allowed only a limited number of good impressions. This situation was later remedied by the adoption of steel-faced plates, which made it possible to secure a greater number of engravings during a press run.

The earliest means of transferring a photographic image to an engraver's plate, while at the same time retaining some measure of the lights and shades of halftone, was accomplished in Europe. During the 1850s and 1860s, these processes included phototype printing, heliography, photogalvanography, and the aforementioned photozincography. By 1874, the New York photographer George G. Rockwood was advertising the capability (see page 236) of producing "thousands of pictures . . . with all the facility of the ordinary lithograph upon a press with ink." How successful, commercially, the several methods used by Rockwood were does not appear to be recorded.[429]

Two names which figure prominently in early American photoengraving activity were the brothers Louis and Max Levy, the sons of Bohemian parents, who grew up in Detroit. In 1866, at age twenty, Louis Levy took up pho-

ROCKWOOD PROCESS

In April 1874, George G. Rockwood offered to sell rights to a new photoengraving process, which he described in these words:

> Ten or twelve years ago, some progress was made in France in what was called "heliographic engraving," in which metal printing plates were obtained by the action of light; and more recently, in this country, some attention was bestowed upon the maturing of a process of this character, with varying success. Having devoted a long time and considerable means to the development and perfection of this process, it has steadily developed till now it is of the simplest and most reliable nature. Under ordinary photographic negatives, prepared plates of glass, zinc, and stone are exposed to the action of light, and from these plates thousands of pictures are printed with all the facility of the ordinary lithograph upon a press with ink. The effect of the light upon the sensitized plate is to transform it into a veritable lithographic plate—the parts exposed to the action of light having an affinity for fatty or printer's ink, and the portion protected from light rejecting the ink and absorbing water. So, first, a wet roller is passed over a plate ready for the press, followed by an ink-roller, and the paper then placed on the press, and run through the rollers at the rate of about sixty or seventy an hour. Specimens can be seen of this new process of very great variety—portraits, landscapes, and copies of mechanical drawings, music, and ordinary letter-press.

Rockwood's reference to previous French progress probably alludes to the "heliogravure" experiments conducted in the 1850s by Niépce de Saint-Victor, Edouard Baldus, and Charles Negre, all of whom used a bitumen coating on steel plates. Rockwood's use of glass suggests that he was following Paul Pretsch's 1854 patent for "Photogalvanography." Rockwood's other processes are probably more accurately described (with the benefit of hindsight) as photozincography (in the case of the zinc plates) and photolithography (in the case of the negatives prepared on stone). Several months later, Rockwood did, in fact, refer to his commercial activities in this area as photolithography.[430]

LEVYTYPE

This photoengraving process was patented in January 1875, by Louis E. Levy and David Bachrach, Jr. It was based on the "swelled gelatine" photogalvanography process invented in 1854 by Paul Pretsch of Vienna. In the Pretsch method, a gelatine mixture was coated on a glass plate, and the parts *not* acted on by light were swollen by water and made to serve as the basis of electrotyping. The Levytype process followed much the same procedure up to the time of exposure to light of a photographic negative in contact with the plate. The subsequent differing steps were described by Bachrach in these words:

> After exposure, the plate is immersed in cold water, and at once a curious phenomena occurs. Those parts of the plate not exposed to the light *swell* by the absorption of water, while those exposed remain unaffected. This, it will be seen, forms the relief. As soon as this action has begun all over the plate, we plunge it into a 20-grain silver solution until the relief is high enough, *but not a minute longer,* for if the action is carried too far the lines become rounded at the bottom, and sharpness is lost. This part of the process is very important, and is our original invention. We have patented this step particularly, as it is peculiar to our process alone. The advantage of this operation lies in the fact that it sharpens the lines, and allows greater relief being obtained without injury—very important for practical printing qualities—which advantage is recognized by printers using our cuts, which they prefer on this account over those made by other processes. The film, becoming full of bichromate of silver by this step, obtains greater consistency and solidity, and is capable of standing more handling in the subsequent steps.[431]

tography in order to record microscopic observations he was then making for the U.S. Meteorological Service. In 1873, he began experiments in photoengraving and became acquainted with David Bachrach in Baltimore, who allowed Levy the use of his gallery facilities for experimentation. Bachrach himself became interested in Levy's experiments, which concentrated on the photogalvanography process which had been invented in Vienna by Paul Pretsch in 1854.

By January 1875, Bachrach and Levy jointly obtained an American patent for an improvement of the Pretsch method

which involved a means of swelling gelatine to provide a

hardened surface for electrotyping. The process was at first given the name "Photo-Relief Printing," but has since come to be identified as the Levytype—principally because Levy alone continued to improve upon it. With his brothers Max and Joseph, he formed the Levy Photo-Engraving Company in Baltimore to market the process, then in 1877 moved to Philadelphia where he established the Levytype Company.

The process was evidently promoted successfully—presumably for book illustration—and in 1880 Max and Joseph Levy established the first photoengraving enterprise in Chicago, followed by a similar new venture in Cleveland. After 1880, new techniques introduced in photoengraving by others—most notably John Calvin Moss and Frederic E. Ives—made their appearance. Bachrach, reminiscing in later years, said the Levytype "became obsolete in about two years' time," but this observation is at variance with the recorded expansion of the Levy business to Chicago and Cleveland after 1880. One prominent photographer who used the Levytype process in the 1880s (and probably Ives's process later in the decade) was the Philadelphian Frederic Gutekunst. The latter also made use of the Woodburytype at this time, although after 1873 this process was not used as widely for book illustration as the photoengraving and various collotype photomechanical printing modes.

A principal advantage in collotype printing was the fact

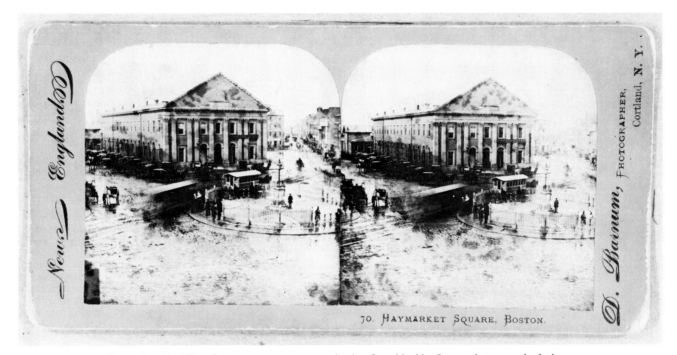

The continued inability of most cameras to arrest motion is reflected in this 1870s card stereograph of a horse-drawn trolley passing through Haymarket Square in Boston. Eadweard Muybridge's successful photographing of trotting horses at Leland Stanford's California racetrack remained during the 1870s just what the world thought of it: a wonderful scientific achievement. But there were several isolated achievements by photographers unknown to us today, which drew the attention of *Anthony's Photographic Bulletin* in June 1875. A photographer by the name of Maynard, of White Plains, New York, for example, made a photograph "in which the snow flakes are caught in the act of falling." Phillips and Crew, of Atlanta, produced stereoviews of "statuary contrasted with green foliage—very difficult subjects."

that illustrations produced by this method could be printed on a page with any desired margin, whereas in Woodbury-type printing the images had to be "bled" in printing, then mounted (like a photographic print from an original negative) on a page if a margin around the illustration was wanted. In one of his occasional communiqués to the photographic press from his position of retirement, H. H. Snelling drew attention to the drawback to book illustration caused by the necessity to mount the photographs used on cardboard:

. . . the objection is a serious one, not only on account of the thickness of the boards and the difficulty of binding them up with ordinary printing paper, but because of their giving too great weight to the volume. There are thousands of works published, scientific, medical, mechanics, poetry, biography, etc., of limited sale, many never rising above 1,000 copies, and the most popular of them barely reaching 5,000 copies. These, if none others, can be more cheaply illustrated by photography than by steel, copper, or wood engravings, or by lithographs, except in cases where the woodcut is printed with the letterpress in the body of the page. A thousand photographs of a given size can be furnished the publisher at less cost to him than the engraving of the steel or copper plate, or fine woodcut, if printed so as not to require mounting. I have no doubt if a suitable paper could be had, octavo photographs (i.e. printing of an octavo volume) could be furnished at $15–$20 a thousand, which would be a saving to the publisher in an edition of 5,000 copies.[432]

The year 1875 marked a turning point in another realm of photography, namely, that of viewing slides from the magic lantern. Up to 1874, the two major manufacturers of slides were the Langenheim brothers and Casper W. Briggs, of Norton, Massachusetts. Upon the death of William Langenheim, his brother sold the Langenheim business to Briggs, who consolidated all production thereafter in Philadelphia. By May 1875, *Anthony's Photographic Bulletin* observed editorially that "this instrument is now fast taking its deserved position as the medium pre-eminent for the diffusion of knowledge, and for the instruction and amusement of persons of all ages, and all classes of society. This has been brought about, in a great measure, by the important improvements which have taken place both in the lanterns and in the pictures used as illustrations, as well as by the growing desire for scientific knowledge which seems to characterize this generation."

The term *stereopticon* referred to a combination of two projectors which made it possible to dissolve views while showing them in sequence. This type of projector utilized limelight as opposed to oil for illumination and was the principal type used after 1870. Another version of the basic instrument was the artopticon, which was designed to use oil but could be adapted for the gases. In the stereopticon, oxygen and hydrogen gases were burned against a pellet of lime. By using large parabolic reflectors with a stereopticon, it was possible to spotlight the stage, which gave rise

AMUSEMENTS FOR THE HOLIDAYS. THE MAGIC-LANTERN.

By 1875, William Langenheim was dead and his brother, Frederick, decided to sell out to Casper Briggs, of Norton, Massachusetts, a competitor in lantern slide manufacture. But the center of activity remained in Philadelphia, where Briggs soon concentrated all production, dominating the slide-making field until after World War I. Briggs has been described as something of a forerunner of Hollywood, because of his introduction of a wide range of religious, literary, historical, scientific, and humerous slides (see above) used on the lecture circuit.

Rear view of a magic lantern slide projector with attachments for the supply of hydrogen and oxygen. Illumination was achieved by burning the gases against a pellet of lime.

1875

238

to the expression that a speaker or performing artist so spot-lighted was "in the limelight."

The lime or calcium light by now almost universally em-ployed for public lantern exhibitions, the *Bulletin* main-tained, "has by modern science been rendered perfectly safe to use, and can be easily and successfully operated." The *Bulletin* at the same time perceived a demand for "a better class of pictures" than those previously offered on the market, and said this was now being met by the in-troduction of "an entirely new class of photographic views, which are really works of art." The *Bulletin* also made this prophesy:

> We believe the time is not far distant when a good magic lantern and slides will be considered just as great a necessity in every school as is now the spelling book or reader. For instance, if the schools of any city were each supplied with a lantern, and, say thirty slides, no method of instruction would be more popular with the scholars themselves. The slides should be different, and could at stated times be exchanged one with the other, until they had gone the rounds of every school, and had been seen by all. It is not necessary in lantern exhi-bitions that the room should be entirely dark; it is only requisite that no light from any other source than the lantern should fall upon the screen. With the oxyhydro-gen light, good effects can be produced when other lights are burning low, at the back of the hall, and even with the oil light, if the screen is placed against a wall and has around it black cloth, made like a box, say three feet deep. Thus one of the objections to its application for school purposes, that of leaving the children entirely in the dark, can be avoided. Sunday schools and churches may also with profit own a lantern and views, with which entertainments can be frequently given to raise money for the school, or for charitable purposes.[433]

The Langenheims had used the albumen negative process to make their slides during the years 1850–1874, but Briggs used the collodion process, which his father before him had learned in 1853 from John A. Whipple in Boston. When the gelatine dry-plate process was introduced after 1880, Briggs experimented with this process, but returned again to the collodion method because he remained convinced that the best results were to be achieved only by this method.[434] In this he was joined by Thomas C. Roche, and by the British photographer Alfred Brothers (see page 380).

One thing remained lacking in the United States, despite its advancements after the Civil War in landscape photog-raphy, the flowering of a new photographic literature, and the various technical strides so far discussed. This was an artistic achievement in photographic portraiture which sim-ply never rose to a level in America recognizable in the works of a number of contemporary English and French masters of this period. Except possibly for Brady, there were no men or women of such stature in the United States as Mrs. Julia Margaret Cameron, or William Barraud in En-gland; or Nadar (Gaspard Félix Tournachon), Etienne Car-jat, or A. S. Adam-Salomon in France. Much of the reason for this has been attributed to a lack of the large number of

During the late 1870s, a number of new variations of the basic cabinet card form of photograph were introduced. A "new style" announced in 1875 was the "Promenade," measuring about 7 x 4 inches, an example of which is shown above. The scene is at Niagara Falls. For portraiture, the Prome-nade was intended for use in making three-quarter or full-length standing figures. "There isn't the appearance of squattiness that there is about the Cabinet size," the *Philadelphia Photographer* contended approvingly. The Promenade was said to have been first introduced in San Francisco by I. W. Taber.[435]

cultured amateurs of the professional, middle, and upper classes, which were to be found in Britain and France at this time. In addition, these now-recognized masters were artists to begin with, or were well schooled in art prior to taking up photography. Nadar and Carjet, for example, were formerly caricaturists, while Adam-Salomon was a sculptor (a voca-tion which was late in developing in the United States). Among American amateurs there was no counterpart to the self-taught Mrs. Cameron, a member of the English aristoc-racy who was in her sixties when she took up photography,

and whose photographic portraits are now recognized to be possibly the most outstanding of the entire Victorian era.

A leading American amateur of this period was Henry J. Newton, who had retired early from a business career. But while he headed the country's most prestigious photographic society for many years and was a prodigious experimenter, few, if any of his photographs will today be found among the archives of museums or libraries, or in the hands of collectors. But in men such as Napoleon Sarony in New York, an awakening to new forms and possibilities in portraiture was beginning to express itself. David Bachrach began following the Sarony style in lighting "as far as I could," as he expressed it in later years. Another Baltimorean, writing in *Photographic Rays of Light,* expressed the belief that Sarony was responsible for the beginnings of a new artistic movement in the United States. Speaking of a new style of head rest, and an "extra glossy surface" paper which Sarony offered, the writer, Nod Patterson, wrote:

Photographers like the paper—but the artistic effect of the studies, as they were called, set them wild. There was an ease, a grace, an artistic elegance about them that was refreshing and *new*. Outside of New York, the writer disposed of the first "rest" Mr. Sarony sold, and wherever he showed the "studies," operators *would* have them. Mr. Sarony being so earnestly solicited to open a gallery and produce "such results," he finally did so. What was the result? *Artistic photography* has placed him, with an immense business, in his palatial "Le Salon." . . . We are inclined to think the "Sarony studies" started the ball of artistic photography in motion in this country.[436]

Before the foreclosure of Brady's New York gallery, Brady's assistant, Alva A. Pearsal, perceived—evidently before anyone else at this time—that there was yet another dimension lacking in American photographic portraiture, namely, "instantaneous sittings." The "true artist," Pearsal contended in a letter to *Philadelphia Photographer,* could not carry out his conception of the picture he was about to make if, after all his efforts at posing and arranging the setting, etc., the picture was destroyed, either by movement or a want of harmonious expression:

With all the advancement in the art, the vexatious custom of making your subject a living mummy for the space of twenty-five seconds or more still remains with us, and my experience goes to show there is nothing more trying or more dreaded by the sitter, not excepting even the much-abused head-rest. I have long wished for the time when instantaneous sittings could be made, or sittings so nearly instantaneous as to be practically so, and I believe that the time will come. When it does, then good-bye to the horrid head-rest, and the unnatural expressions so often seen in the photographs of the present day. But as far as I can learn, there seems to be no one striving in this direction, and, in my opinion, the present time is the most auspicious for agitating the subject. Photography has advanced so wonderfully in all other directions, that it seems only instantaneous exposure is wanted to make the results perfect, and photo-portraiture a pleasure to the sitter, as well as to the artist.

If photographers would only realize the great importance of an apparent instantaneous exposure, and would go at it with a determination to master it, I think it would soon be an accomplished fact.[437]

1876

The American photographic community managed to raise sufficient funds ($20,000) to construct a separate building for photographic exhibits at the Philadelphia Centennial Exposition, which opened May 10, 1876. Technological progress was the chief theme of this first American international fair, and in photography as well as in numerous other fields, the world was truly at the threshold of a new era. Just around the corner was the telephone (demonstrated at the fair), electric light, the talking machine, and the gasoline automobile. Just around the corner, too, was photography's first universally accepted dry negative process, which would revolutionize the medium by the turn of the century.

Approximately seventy-five awards were given at the fair for photographs exhibited by photographers from England, eleven European countries, Canada, Mexico, Brazil, Japan, and New South Wales (Australia). Americans awarded premiums for photographs were the following: Centennial Photo Company, Carl Seiler, and John Carbutt, all of Philadelphia; Napoleon Sarony, William Kurtz, and the American Photo Lithographic Company, of New York City; Henry Rocher and C. D. Mosher of Chicago; James F. Ryder, of Cleveland; Carleton E. Watkins, Thomas Houseworth, and Bradley & Rulofson, of San Francisco; James H. Kent, of Rochester, New York; E. G. Bigelow, of Detroit; John Reid, of Paterson, New Jersey; Charles Bierstadt, of Niagara Falls; D. H. Anderson of Richmond, Virginia; and J. J. Woodward, of Washington, D.C. Other awards of particular interest were those given to John R. Clemons, for albumen and mat paper manufacture; David A. Woodward for his invention of the solar camera; and Alexander Beckers for his revolving stereoscopes. All of the principal English and European lens manufacturers were given awards, among them Dallmeyer, Voigtlander, Ross, Rathenow, and Darlot. No awards were forthcoming, however, for American lens manufacturers. John Carbutt felt that "quite a number of deserving exhibitors" in Photography Hall had failed to receive awards, and on behalf of twenty of these unnamed exhibitors (and unknown to them, too, Carbutt added), he submitted a formal complaint in November to the Committee on Contests and Appeals.[438]

The vast majority of photographs exhibited were made with collodion negatives, and among those attracting particular attention were a series of large transparencies (some as large as 28 x 36 inches) of scenic views of the American West made by W. H. Jackson. The U.S. Department of Interior, by this time, was offering copies of Jackson photographs at cost price in Washington, D.C. The collection numbered upward of 2,000 landscape negatives made on the F. V. Hayden surveys, plus another 1,000 negatives evidently made in part by Jackson under the sponsorship of a patron—William Blackmore, a wealthy Englishman, described at the time as "deeply interested in ethnography." The Blackmore collection also included other photographs, presumably of Indian culture, dating back over a period of twenty years.[439]

CENTENNIAL SNAFU

E. & H. T. Anthony & Co. contributed a gratuity of $500 toward construction of Photography Hall at the Philadelphia Centennial Exposition. But then a major snafu occurred, described as follows in *American Stationer:*

THE Centennial Exposition has proved, in some respects, a disappointment to many. It was hoped that business of all kinds would suddenly revive, and that every branch of mechanical industry would be stimulated under the high pressure of increased patronage and competition. So much labor in preparation, such vast expenditures, it was predicted, would assuredly restore activity.

With this conviction the firm of Messrs. E. & H. T. Anthony & Co., in common with others, contributed largely in means (a gratuity of $500), and through its influence with the class of professionals with whom it is associated by means of a monthly devoted exclusively to the practice of photography, towards the erection of a building at the Exposition in Philadelphia which should be specially adapted to the requirements of that industry.

At the appointed time, when arrangements had been completed for the transportation to Philadelphia of the splendid display, which had been manufactured by the Messrs. Anthony, on the very eve of their departure that firm received a notification that its exhibit could not be admitted, because the show cases which had been supplied for the protection of their goods exceeded four feet in height. No amount of persuasion, reasoning or argument would avail; the four-foot rule was made, and there was no breaking or bending it. But it was not alone the photographic fraternity which was thus ridiculously denied the opportunity of public inspection. The manufactures of that firm include a large variety of articles in which the stationery trade and the public generally are alike interested. Its display would have included, perhaps, the finest and richest assortment of photographic albums ever offered, together with a new and indestructible variety, lately patented, and known as the "Perfect Album." Novelties in richly gilt and velvet frames and passepartouts; one variety introduced, and already very popular, the "Continental," in banner form; the patented folding graphoscope in unapproachable richness and elegance of construction; the stereoscope in every conceivable style; stereoscopic views, the wonder of everybody; inimitable portraits of American and foreign celebrities; beautifully executed landscapes of every clime, on sea and land, colored in the most artistic manner, as well as uncolored. These and many other goods were all excluded, as well as the most elaborately finished and unapproachable variety of material required by the photographer ever exhibited in this or any other country.[440]

The meetings of the Photographic Section of the American Institute during this period (1875–76) concentrated heavily on experiments conducted by the society's president, Henry J. Newton, and others with dry plates made with collodion-bromide emulsions. No attempt appears to have been made, as indicated earlier, to experiment with, or to otherwise perfect, a dry negative process based on use of a gelatine-bromide emulsion. As early as November 1874, however, T. C. Roche exhibited negatives made with a collodion-bromide emulsion which he said required one-third less exposure than the ordinary collodion wet-plate process. Roche also contended that with the formula used, the plates would grow more sensitive with age rather than the reverse, which was normally the case with ordinary collodion used in making wet-plate negatives. But Newton observed that it was necessary to add silver to a collodion-bromide emulsion to bring it to its greatest point of sensitivity, and that this would then destroy its keeping power.

On his part, Newton found success with various experimental collodion-bromide formulae in which the emulsion was made with the silver in excess (enhancing sensitivity), after which the excess was neutralized with an alkaline or metallic chloride. The *British Journal of Photography* found this particularly noteworthy:

> The addition of a soluble haloid to an emulsion which has reached its full point of sensitiveness is well known to keep it in working order for a lengthened period; but we should scarcely have anticipated that the rejuvenating power of a simple chloride would have been so marked in the case of an emulsion which has become totally useless. This is, we believe, the first time the fact has been noticed.[442]

Matthew Carey Lea came up with a somewhat similar formula at this time with what Newton described as the "novel and important feature [of] adding a small percentage of the iodine ammonium to the collodion-bromide emulsion." But while this increased the plate's sensitiveness, it did not do so to the extent Lea claimed, Newton said, based on his own trials. The English photographer William J. Stillman tried Lea's method, but after running into trouble said that "on the whole, I suspect that Mr. Lea has been working with chemicals very much inferior to those we use here." He elaborated further:

> Mr. Lea speaks of tannin as always giving opalescent solution. Mine is as clear as pale sherry and filters like water, and it is only the ordinary commercial article of Messrs. Hopkin and Williams, being sold, I believe, at a shilling or two the pound. Mr. Lea's albumen does not coagulate with his tannin; mine does, take what precaution for mixing I will. The fault may be in the tannin, or it may be in me; but as my albumen is taken from fresh eggs, and that does not vary with the climate, I do not see that it can be in fault. My impression is that Mr. Lea does not use that exactitude in his experiments to which we have long been accustomed on this side of the Atlantic.[443]

Lea enjoyed an international reputation by this time, based upon the success of his *Manual of Photography* (first published in 1868, and now in its second edition), and he also served as American correspondent for the *British Journal of Photography*. Possibly because of this position of esteem (the British journal had only a month before published a glowing profile of Lea), Stillman bore down heavily on

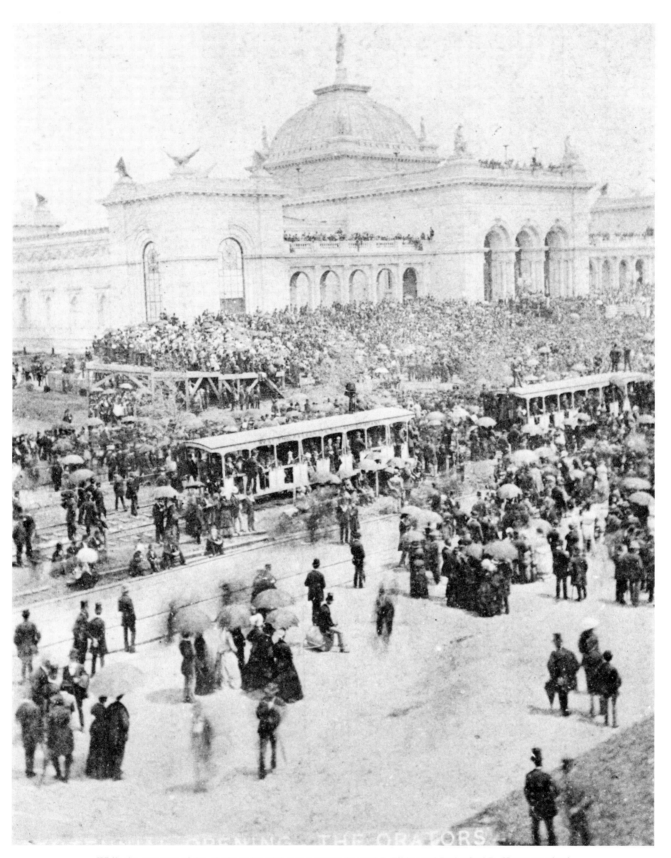

While the outcome of the 1876 presidential race between Samuel J. Tilden and Rutherford B. Hayes remained deadlocked in electoral votes (necessitating the appointment of an Electoral Commission by Congress), the American Centennial Exposition was opened (above) at Philadelphia. Fifty nations provided exhibits which were housed in 180 buildings, one of which was devoted to photography.

1876

A collection of photographs by the celebrated photographer of animals George Francis Schreiber (1803–1892) appears at the left of this interior view of the photography hall at the Philadelphia centennial fair. In the foreground in a wall cabinet is a collection of old daguerreotypes by Marcus A. Root. Portraits and scenic views by Frederic Gutekunst line the next divider wall. The effort to fund and manage construction of the hall was among the last undertakings accomplished by the National Photographic Association. Professional affiliation remained dormant until formation of the Photographers' Association of America in 1880.

Lea, asserting further that "if, with the experience I have had with emulsions, I cannot make it work, I venture to say that the public, and even the mass of amateurs, will find it of little use."

Immediately before, and after, the opening of the Centennial Exposition in Philadelphia, Newton exhibited emulsion plates and photographs in New York, and said he was working on an emulsion which he hoped could be adapted for portrait work in photography studios. Negatives he made of Edward Bierstadt in January, he said, were "thought to be so good that one of Mr. Bierstadt's friends had carried all the prints off with him." John Gurney (possibly a son of Jeremiah Gurney) exhibited portraits made with emulsion plates, and Andrew J. Russell (now photographer-in-chief for *Leslie's Weekly*), announced at a meeting of the Photographic Section of the American Institute in December 1875: "I have been converted today to Mr. Newton's emulsion process."

1876 Russell used an American Optical Company 4 x 5 pocket camera with tripod and dry-plate changing box. In February, he exhibited negatives taken in Philadelphia with New-

ton's emulsion which he said had given him as much satisfaction as with any wet-plates he had previously used. Russell said he had made 260 negatives, and had experienced only nine failures, prompting Newton to point out:

At this time of the year the exposure has to be at least two or three times what is required in May or June. In the negatives that I exhibited in June, the exposure was from 12 to 20 seconds. In the fall we should have to give about 90 seconds.[444]

Newton, like Maddox, considered his dry-plate experiments and specimens "more as a prophesy of the future of emulsion" than as a perfected process. Maddox's was the true process of the future, but Newton accurately prophesied the way this came about:

There has never been a photographic process perfected by one person. One individual, in following out the experiments and suggestions of another, will think of methods of improvement in one direction, another will make some important change for the better in a different branch of the process, and so on, gradually improving until the utmost capacity of the process is developed.[445]

Like Stillman, Newton exchanged verbal jibes with Carey Lea over their respective emulsion experiments, but few explosions rocked the American photographic community to such an extent as the arrival (from England) of the brothers Leon and T. S. Lambert in June 1876 to sell licenses to the Lambertype process. The Lamberts had purchased Swan's carbon process (including the American as well as English rights), and had thereafter "packaged" it under two separate operating modes, one, the Chromotype (for making prints of same size from an original negative) and the other, the Lambertype (enlarged prints from a smaller negative), both requiring use of "special" gelatine-coated paper "tissues." Leon Lambert made no bones about calling them Swan's process "in a new suit of clothes." He had endeavored to solicit E. L. Wilson's interest in acting as his American agent, but having been given the cold shoulder by the latter, he signed with E. & H. T. Anthony & Co. Although Wilson had authored the *American Carbon Manual* in 1868, and accepted Lambert's advertising in *Philadelphia Photographer,* he now said he "had no faith in any process based on carbon," and refrained from reporting editorially on the Lambertype.

Undaunted by what soon became open hostility, the Lamberts set out on an extended selling tour in September, which lasted until January 1877, and took them to the establishments of such dealers and photographers as Benjamin French in Boston; Richard Walzl in Baltimore; John Carbutt in Philadelphia; J. W. Morrison in Pittsburgh; and Napoleon Sarony in New York (who in November was quoted as saying: "Having tried Mr. Lambert's processes, I have found them to surpass my expectations, and in the hands of intelligent photographers will do all that he claims for them"). The Lamberts also held teaching sessions for groups of photographers at the Vanderbilt House in Syracuse, the Osborne Hotel in Rochester, Stanwix Hall in Albany, and the Exchange Hotel in Richmond. After selling the rights to the state of Virginia to D. H. Anderson in Richmond, the pair lost their luggage in a hotel fire on the way to Philadelphia, but were sent samples newly made by photographers previously visited, allowing them to keep the show on the road.

When Thomas H. McCollin, who had assisted Lambert in demonstrations at Gutekunst's Philadelphia gallery, bought the rights to the state of Pennsylvania, Wilson, in Lambert's words, "broke loose in a dozen-page article."

From this point, well into 1878, a bitter war of words was carried on between the two, with Lambert's responses appearing in *Anthony's Photographic Bulletin.* The *St. Louis Practical Photographer,* meanwhile, citing Swan's blessing for the Lambertype, and the "intense interest in it all over Europe," began referring to Wilson in several articles as "our oily-tongued friend," and joined Lambert in criticizing Wilson for his failure to report details of the process in *Philadelphia Photographer.* David Bachrach also joined the fray. He was skeptical of the process and unimpressed with Lambert:

> As soon as Lambert's arrival was announced, there was a general eagerness manifested, on account of the fine samples shown and flaming advertisements. After consultation with a brother photographer, I had a meeting called at Busey's gallery of all who were interested, so as to act together. A committee of four (Bendann, Busey, Perkins, and myself) were authorized to investigate and act for the *thirteen* who responded. One hundred and ten dollars was demanded as a license, which we informed Mr. Lambert was too much for any of us; he then (this was T. S. Lambert, the fugleman of the inventor) proposed to sell the city for six licenses to the committee, and they to license the others. We finally offered to pay the price of four licenses, and then only after the process had been fully demonstrated to the committee. At this he was highly indignant, fumed and expostulated, and told us we would all be *compelled* to buy it afterwards at a higher price, if we did not *accept the present offer,* etc., in his well-known arrogant style, which is a regular dodge with him since. We were, however, inexorable, especially as Messrs. Bendann and Perkins had been taken in by this same weather-eyed chap on the Sarony crayon process, and they were suspicious. (I had warned several of my friends against that process, but without avail.) Well, he found there was no other way of selling it here, and so our terms were accepted. The result was, it cost each of us about thirty-five dollars; about all it was worth. [446]

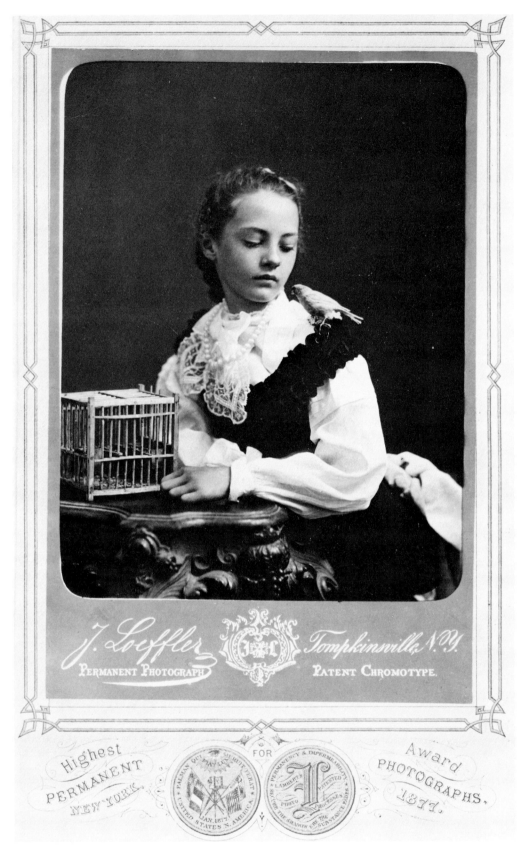

Winning chromotype by Staten Island photographer J. Loeffler, at competition held in June 1877 at the offices of E. & H. T. Anthony & Co. The name ''chromotype'' was given by Leon Lambert to pictures made from carbon or pigmented tissue according to his particular mode of operation.

1877

An upsurge in the so-called permanent printing processes took place this year at photographic galleries across the country. One of the most important of these modes—the printing of photographs in the salts of platinum, as opposed to the pigments of carbon—was yet to come, but the flurry of activity which centered around the Lambert brothers (who remained in the United States for several years) clearly rejuvenated the somewhat dormant practice of carbon printing, and at the same time led to widespread adoption of the Lambertype and Chromotype.

On January 11, 1877, the Anthonys staged an exhibition on their premises in New York, at which 355 photographs made by the patented Swan or Lambert processes were hung. A gold medal was awarded by Leon Lambert at the conclusion of the exhibition to a photographer from the town of Tomkinsville, on Staten Island. In December, a second exhibition (billed as "the second annual exhibit of permanent prints") was held in New York, at which 1,497 photographs in carbon were exhibited by photographers from almost every state in the Union, as well as from Canada. Twenty-four more exhibitors arrived on the scene too late for the judging. The first prize for a Chromotype was awarded to William H. Illingworth, of St. Paul, who in 1874 had taken a noted series of photographs while accompanying Gen. George Custer's ill-fated expedition to the Black Hills of North Dakota. The first prize for a carbon enlargement (i.e., a Lambertype) was awarded to a St. Johnsbury, Vermont, photographer by the name of Clifford. At the third such exhibition (on December 20, 1878), an American Carbon Society was formally established with George Gentile as president, and T. C. Roche as treasurer. Officers were also chosen to represent twenty-four states, Nova Scotia, British Columbia, Newfoundland, New Brunswick, and the Canadian provinces of Quebec and Ontario.[447]

Early in 1877, Lambert took note of a "certain Dr. Ott," who was endeavoring to sell licenses to a "certain process," which Lambert contended was akin to his own, and he cited Ott for acting in violation of his U.S. patent rights. Lambert notified American photographers, through the medium of *Anthony's Photographic Bulletin,* that if they used Ott's process commercially they would be prosecuted to the fullest extent of the law. He refuted those who said he would be unable to prosecute anyone placed in debt over such litigation:

I have received an anonymous letter stating it was impossible to stop infractions from irresponsible parties, as there is no imprisonment for debt in this country; and the infringers not having enough to pay the heavy damages allowed us can thus escape scot-free. This is in error, for if the first offense from penniless infringers remains unpunished, an injunction from a court to cease infringing would make a repetition of the offense contempt of court, which is punishable in the United States both by fine and imprisonment.[448]

Theodore Lilienthal, the noted New Orleans photographer, was among the first who "practically abandoned silver printing" to work the carbon process, and according

FIRST EXHIBITION HELD OF "PERMANENT" PRINTS

The demonstrations and promotion of the Lambertype at all major eastern and southern cities evidently sparked a new interest in the carbon practice, both in its original and new form. On January 11, 1877, the first "annual exhibition" of prints made by the carbon and Lambertype processes was held at E. & H. T. Anthony & Co. in New York:

There were fifty exhibitors from various parts of the United States and Canada, and some pictures made by European artists were also shown. Col. Stuart Wortley had sent some from England, but although they had arrived in this port, they could not be got through the Custom House in time to be placed on exhibition. M. Liébert, of Paris, had proposed to send his Centennial display, but in consequence of the high charge for U.S. duties they were returned to France. The whole number of productions by the various processes was 355, and it may be fairly said that there were none that were not equally as good as silver prints could have been made by the same persons, while the larger quantity were far superior, in our opinion, to any that could be made by silver from the same negatives.

We were quite pleased, if not surprised, by the large number of exhibitors and the prevailing excellence of the work. Besides the exhibits for which medals have been awarded, and several arrived too late for competition, were some very excellent productions by the Lambertype Processes from Messrs. Dimmers, of New York; Wykes, Quincy, Ill; Wallin, Fort Wayne, Ind; Milnes, Hamilton, Can.; Vail, Geneva, N. Y.; Poole, St. Catherines, Can.; Saunders, Alfred Center, N. Y.; Allen, Pottsville, Pa.; Potter, Warren, O.; Klauber, Louisville, Ky.; Brooks, Dundee, Can., Smith, St. Albans, Vt.; Roth, New Orleans, La.; Higgins, Bath, Me.; Sherman, Elgin, Ill.: Ross, Syracuse, N. Y.; Holton, of Boston, Mass., and others.[449]

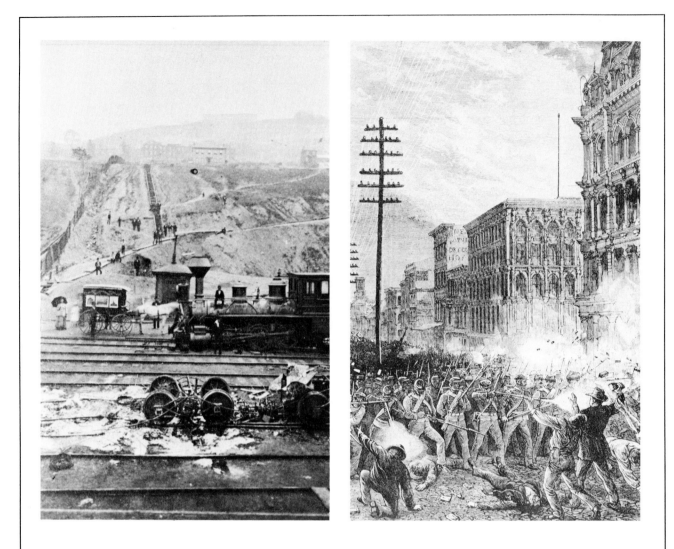

THE GREAT RAILROAD STRIKE OF 1877

The earliest surviving photographs of an American labor dispute appear to be those made in 1877 after a strike of Baltimore & Ohio Railroad workers in July spread spontaneously during the remaining days of that month to the Philadelphia & Reading, Pennsylvania, Erie, and New York Central lines. A virtually unknown photographer, S. V. Albee, published forty-two card stereographs of scenes which he made *during,* as well as after, pitched battles in Pittsburgh between the strikers and state militia. In the photograph above, left (from an Albee stereoview), Albee's photographic wagon is shown in the foreground with a stranded engine and burned railroad car at the bottom of a hillside opposite Twenty-eighth Street where, according to Albee, "citizens were shot" on July 21–22. Albee made views of Pittsburgh's upper and lower round houses (where he said "troops were besieged"), of burnt machine shops and burnt passenger cars in the Union Depot, and of troops in retreat from the rail line's carpenter shop. The scene depicted above, right, is a woodcut illustration from the August 11, 1877, issue of *Harper's Weekly,* and shows members of the Maryland 6th Regiment firing into a crowd of strikers in Baltimore, killing 10 persons and wounding many more. The illustration, which is reminiscent of the Boston Massacre of March

5, 1770 (or of the more recent killing of four students in a crowd of war protestors by National Guardsmen at Kent State University in Ohio on May 4, 1970), was made from a photograph—evidently now lost—by the Baltimore photographer David Bendann.

The depression of the 1870s had earlier caused strikes in the textile and coal mining industries, and in the case of railroading, the unrest began after the companies periodically lowered wages while in some cases doubling the number of cars on trains (without adding additional trainmen) to increase revenues. When the unled uprising of B. & O. strikers was begun in Baltimore, the Baltimore *Sun* contended that "in all their lawful acts" the strikers "have the fullest sympathy of the community." But public sympathy was reversed after rioting broke out in Pittsburgh, Chicago, and other midwestern cities, causing President Rutherford B. Hayes, for the second time in the nation's history, to call out federal troops to end warfare between private industry and its employees. The 1877 strike led to additional appropriations by states for expanded National Guard training and facilities, and to increased use of Pinkerton detectives in the private armies of railroads and other large corporations.[450]

to *Anthony's Photographic Bulletin* (March 1877), "he is making money and is enthusiastic." His success evidently continued, as in February 1880, Lilienthal brought suit against another New Orleans operator, William W. Washburn, for infringing on his rights to the process for the state of Louisiana. In his suit, Lilienthal was joined not only by the Lambert family but by the inventor, Joseph Swan.[451]

To David Bachrach's way of thinking, Lambert was merely the first of "a lot of 'secret' process men" who came along in the 1870s and "gradually robbed the mass of ignorant photographers." Lambert, Bachrach felt, was "particularly vicious and tricky," but he saved his furor for yet another battle over another new process, the Artotype, which appeared on the scene in 1879. Bachrach in the meantime allied himself with Wilson, who by this time had soured on carbon printing in general. "To make preparation for its practical use," Wilson said, in referring to all modes of carbon printing, "considerable expense is necessary, even to work it on a small scale, and its manipulations are so entirely different from any other photographic process that one not at all skilled in ordinary photographic printing can manipulate carbon better than an old silver printer. Moreover," he added, "gelatine, which is the basis of carbon tissue, is of such obstreperous nature as to be subject to the least climate change, and thence springs the principal difficulties which are met by the carbon worker."[452]

Alexander Hesler was another who exhibited no interest in carbon printing. "At the present price of material it costs more than silver prints," he said, "and, in a small way, a man cannot make as many card prints with the process as by silver printing. For strong negatives the results are better than silver," he admitted, but "for weak negatives, not so good. . . . It is at present too much trouble to make people appreciate the difference, and pay the advanced price over silver prints."[453]

Even the first American practitioner of Swan's process, E. L. Allen, of Boston, admitted that his firm (Allen & Rowell) could "make no money" on cabinet cards printed in carbon. Allen also noted that his customers had become more "fastidious" since the first days of carbon practice in 1867:

> Then one sitting as a general thing sufficed; now it is the exception when a sitter orders from the first set of pictures. The rule is to sit twice; and often three times, not because we have not made good pictures; they acknowledge they like them, but want to try again, just to see if they cannot get something better. Even babies are brought to sit over, on account of expression, so fastidious have our customers become. We use three glasses on a sitter, as a rule, making two impressions on a glass for cards, and the same size glass for cabinets, making one impression.[454]

The continuing economic depression was a major hindrance to carbon printing, the editors of the *St. Louis Practical Photographer* felt. "Let times brighten, and carbon will yet rise higher than ever among our better class artists." But the magazine also felt that the process had been falsely heralded as "easy and simple," and that the exclusivity in licensing also prevented its broader popularity:

> Look, for instance, at St. Louis: one man owned the exclusive right for the city and state; wanted a big price for rights; could

GALLERY FIRES

An insurance journal report in 1876 found that photographic galleries were more of a fire hazard than paper or woolen mills, steamboats or breweries. A fire in Abraham Bogardus' darkroom, and several other conflagrations, prompted this editorial comment from *Anthony's Photographic Bulletin* in January 1877:

> FOUR fires have recently occurred in photographic galleries in this City. As this is an exceptionally large number, even for a city containing as many of them as New York, it is a matter of interest to know, if possible, what were the causes. In one case the theory is that the fire was caused by a portion of a rocket falling through the skylight; another was caused by the carelessness of a person who was mixing collodion in a small dark room with a *lighted stove* in it. In the two other cases the cause is not known; but as they both occurred in places which for a very long time had been used, and where it is known that portions of the floor and shelving had become saturated with nitrate of silver, the reasonable supposition, from the known great inflammability of wood thus saturated when in a perfectly dry state, is that the nitrated wood was the cause of the fire. It is unnecessary to particularize instances that have occurred; it is sufficient to know that want of care in dealing with the silver solutions entails not only loss but ultimate danger, to induce photographers to be more careful both in regard to the waste and the possible danger lurking in places where the nitrate has been allowed to permeate the wood-work. The greatest care should be exercised to prevent fire in the shape of stumps of matches or of cigars being thrown upon such places, of which there are undoubtedly many throughout the land.
>
> In the fire which occurred in Mr. Bogardus's dark room it is a curious fact that two paper boxes containing soluble cotton, which stood on the shelf, were not destroyed. The shelf and all the wood-work of the room were burnt to a coal; the bottles containing collodion were burst and the collodion consumed, yet the article considered generally the most dangerous in a gallery, and of which insurance companies, steamship captains and old women have such great dread, *the soluble cotton, was not in the least affected.*[455]

not sell them. His next move was to open a gallery and try it himself; had all the other artists down on him and carbon. The result was he busted, and sold the right of the city and state to a gentleman who lives in New Orleans, and he, being independent, is in no hurry to sell or open up a gallery here himself. The result is that St. Louis, with a population of 500,000, has no carbon worker, or is likely to have any very soon.[456]

By January 1878, the vindictive warfare between Lambert and Wilson was again taking up the pages of *Anthony's Photographic Bulletin* and the *Philadelphia Photographer*. In one issue of the *Bulletin*, Lambert gave a detailed, comparative analysis of wording to support his assertion that Wilson had plagiarized George W. Simpson's *Carbon Instructor* (1867) in publishing his *American Carbon Manual* (1868). In this contention, Lambert was joined by the *St. Louis Practical Photographer*:

[Wilson] even went so far as to republish an English work on carbon and copyright it, having taken the precaution to alter the arrangement of the chapters, write a preface, and interpolate a few words here and there just sufficient to show his ignorance of the entire subject he was writing about.[457]

AN AMERICAN MAKES NIGHT PHOTOGRAPHY "FASHIONABLE" IN LONDON

Photographs had been made at night previously with the aid of artificial light, but those who experimented along these lines had never made a commercial success of such undertakings. It remained for the son of the editor of the American trade journal *Manufacturer and Builder* to make a commercial success of it in London in the spring of 1877:

Our clear smokeless American sky gives us no idea of the drawbacks connected with photographing in a smoky and foggy city like London, England, where the days in the business season are much shorter than here, and even the best parts in any season are usually obscured by smoke, mists, clouds, and fogs. It is not surprising that such a locality should be the first to develop the method of taking photographs by artificial light, which several years ago was attempted in the United States, but with very indifferent success. The simple reason of this was that those who attempted to apply the method, had not the least artistic idea of the kind of illumination required to produce a good and pleasing picture. These photographs had no middle tints, showed only white and black, and looked as if the sitter had been exposed to direct sun-light, with no reflection whatever in the shaded parts. The general judgment of the public was naturally that these photographs were "no good," and the method was abandoned, as it did not take, and therefore did not pay.

It was reserved for an accomplished artist to correct these defects and to arrange an artificial illumination which, by combining larger and smaller artificial lights and proper reflections, produced an illumination equal, if not superior, to that produced on the most favorable days by sun-light, and thus to obtain perfectly satisfactory results. This artist was Mr. Henry Van der Weyde, a son of the editor of this journal, who is now stirring up the city of London with his new method of taking photographs at night.

It appears to have become fashionable there at present to have one's picture taken after leaving the opera or a dinner late at night, and as the pictures are more satisfactory than those taken during the very inconvenient hours of the day, it promises to be a new era in this branch of business.

The New York *Times* contained recently a correspondence from London in which this was mentioned in a very awkward manner, which was not calculated to raise Mr. H. Van der Weyde in the estimation of those who possess information on the subject. Instead of stating what we have said above, it was asserted that he was attempting to bottle up sun-light, had made for this purpose a water lens, which broke and injured him, etc.; in short, he was represented as an ignoramus, who attempted absurd and impossible things, and ended by doing what had been done here several years ago—taking photographs at night, and perhaps poor ones at that.

The method followed by Mr. H. Van der Weyde, can of course be nothing but illumination by an artificial light of actinic power, such as that produced by burning magnesium, hydro-oxygen light, electric light, sulphur burning on melted niter, and other methods, which are available for the purpose, but to apply several of these lights simultaneously in such an artistic manner as to obtain results as satisfactory, if not more so, than can be obtained on the brightest days.

We need not say that this involves a revolution in the photographer's business; instead of waiting in the day-time for favorable periods, the photographer abandons the uncertainty of a London atmosphere and trusts to the results obtained by science and art to illuminate his sitters at midnight, independent of fogs or smoke, and he is sure of his results, and consequently (what is the main thing in all kinds of business) of his pay.

The success of such an enterprise in a city like London is undoubted, and the only reason why it will not be so soon generally introduced here is that our need for it is not so great. Still it was produced here several years ago. A few years ago we assisted in taking photographs at night by means of electric light and hydro-oxygen light, but, as above stated, they were so unsatisfactory that it offered no encouragement.[458]

Wilson must not have taken these charges seriously, for he never commented on them.

George Gentile, president of the newly formed American Carbon Association, recognized the problem, raised by Wilson, that climate had a direct bearing on the success or failure of working carbon, but he suggested that "the majority of photographers who have commenced to experiment in carbon printing have not given it a fair test. They ought to study the nature of bichromate gelatine, so that in their own particular locality it can be successfully worked." No operator in carbon could be successful, Gentile asserted, "unless he well understands the behavior of chromated gelatine with heat and moisture."[459]

As Gentile pointed out, there were photographers "who have and are making money by working the process," but perhaps when all was said and done the lesser extent to which the carbon or Lambertype processes were put to practice in the United States may have been due to the absence of a central processing establishment which could take the "somewhat complicated manipulation" out of the hands of the average worker and handle the processing much as film development was later to be handled for amateurs. In England, most photographers making carbon photographs availed themselves of a printing service provided by the Autotype Company in London. No such organization was ever established in the United States.[460]

If weather was a problem for carbon or Lambertype work, it posed a restraint as well on regular collodion practice. How many photographers, for example, made landscape or city views in cold weather? The reason was simple: the silver nitrate would freeze on the plate if used out-of-doors in winter weather. "The combination of photographic materials, to produce their best results," *Anthony's Photographic Bulletin* informed its readers, "take[s] place at temperatures the most pleasant and agreeable to the human system." The *Bulletin* gave this further advice for printing in cold weather:

It behooves operators, for the purpose of obtaining uniform results, to endeavor to keep their materials at as nearly as possible uniform temperatures. Never let your negative bath get much below the temperature at which you find it to work best; always in cold weather be provided with the means of readily warming your developer, and in hot weather of cooling it; never float your paper on a very cold silver solution and then print in a freezing temperature.[461]

The *Bulletin* repeated this advice again in a later issue "not only to save photographers time and expense but also to relieve ourselves of a great deal of unnecessary letter writing."

If it was a question of "to be, or not to be" a carbon worker, so, too, the dilemma for photographers was becoming more acute as to whether or not to begin using the new collodion-bromide emulsion plates. At this stage in photography, it was a question of "damned if I do, and damned if I don't." For some, the fact that you could know—right on the spot—if your pictures were successful overcame the objections of having to carry chemicals and luggage for making the standard collodion wet-plate negatives out-of-doors. In addition, the new emulsion plates required time to prepare before going out in the field, and just as much time, when all was said and done, to develop and fix them after returning to the darkroom. The *Photographic Times* contended that "the experience of dry-plate workers has been that the failures occur on the subjects they are most anxious to secure; such as some rugged nook, with strong contrasts of light and shade, or a shady glen where the sunlight only penetrates at a certain hour of the day, and where it is found to be almost impossible to get sufficient exposure on a dry plate while the light lasts." Just as Gentile could point to many prominent photographers working carbon, the *Times* could say that, "associated with this branch of photography [dry-plate work] are the names of many of the most intelligent, industrious, learned, and scientific men that have ever given attention to the heliographic art." But the *Times* also contended:

It would seem that invention and research had been exhausted in the multifarious processes which have been claimed as meritorious or superior. We have had dry collodion, albumen, gelatin, emulsions, with preservatives of tannin, tea, coffee, beer, albumen, tobacco, besides numerous mixtures of poisonous drugs; and developers, acid and alkali, hot and cold *ad infinitum*, till the beginner is bewildered in the mazes of the chemical nomenclature which present themselves to him as the A B C's of dry-plate photography.

It is doubtless this great variety of processes, and the uncertainty of their merits, that have deterred many from practicing dry-plate work, and especially is this true of professional photographers, who find it necessary that time and effort should count, and who are disposed to adopt that process which they can have most completely under control, and which will yield them the greatest amount of successful work.

We are not prepared to predict, nor do we anticipate that either the wet or dry will supersede the other, but rather that each will find its proper place, and be adopted by professionals, as well as amateurs, according to the work to be done, and the convenience and capabilities of each.

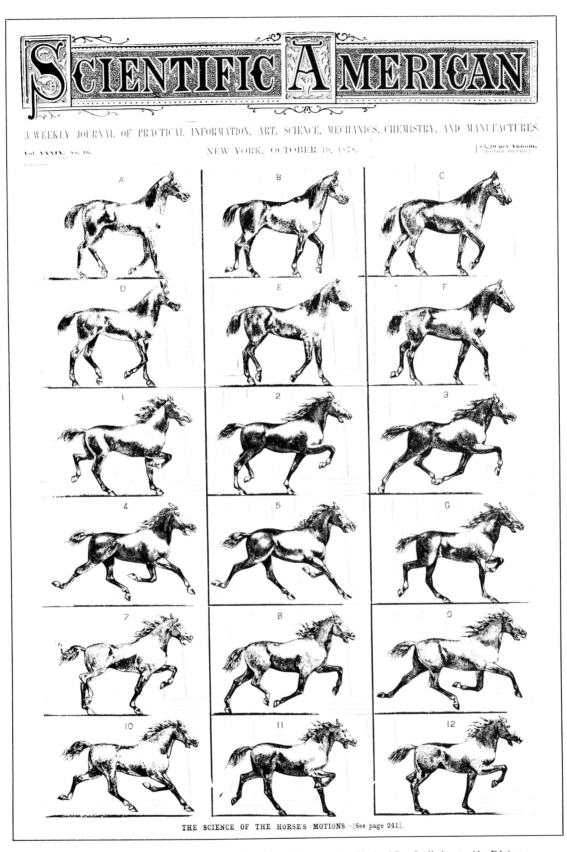

SCIENTIFIC AMERICAN

A WEEKLY JOURNAL OF PRACTICAL INFORMATION, ART, SCIENCE, MECHANICS, CHEMISTRY, AND MANUFACTURES.

NEW YORK, OCTOBER 19, 1878.

THE SCIENCE OF THE HORSE'S MOTIONS.—[See page 241].

1878

252

On June 15, 1878, Eadweard Muybridge made a series of photographs of Leland Stanford's horse, Abe Edgington, traveling at a gait of 40 feet a second. When the *Scientific American* got around to publishing a set of engravings made from Muybridge's photographs on its cover four months later, the world sat up and took notice. Soon, Muybridge became an international celebrity.

1878

When Eadweard Muybridge was making his most famous photographs of the Yosemite Valley in 1872, Leland Stanford, former governor of California and president of the Union Pacific Railroad, talked with him about making a series of instantaneous photographs of his trotter, Occident, on the run. Stanford contended, in a $25,000 wager, that the horse lifted all its feet off the ground at certain full-speed gaits, and he wanted photographs to prove it. Muybridge made several negatives of Occident that year, and again in April 1873, at the Sacramento Race Track. Stanford was satisfied that the ''photographic impressions'' which Muybridge obtained proved the correctness of his wager, but the photographs were subsequently lost and there remains no accurate description of them. During the years 1874–77, further efforts at racetrack photography were suspended after Muybridge shot and killed a lover of his young wife, and the sensational murder trial which followed (resulting in a judgment in Muybridge's favor) caused him to leave the country for several years.

While out of the country, Muybridge experimented with chemical means of accelerating camera plate action, and made further improvements on a shutter mechanism which he had developed in 1869, and had described in a photographic journal at that time. Back in the United States, he again made photographs of Occident in July 1877, at Sacramento, but this time with exposures which he claimed were less than one-thousandth part of a second. Several newspapers, after viewing one of these photographs, termed it a ''triumph'' of the photographic art.

In the spring of 1878, Muybridge began a series of large-scale experiments with elaborate equipment at Stanford's Palo Alto Stock Farm. These experiments officially launched a career in animal, and later human, locomotion studies for which he gained international fame. Special cameras were ordered from the Scovill Manufacturing Company, and a set of Dallmeyer lenses was procured for use with them (Muybridge contended that these lenses afforded ''extraordinary rapidity and wonderful depth of focus''). Special electrically operated timing mechanisms were designed and constructed at the Central Pacific car shops, and these were installed with twelve cameras in special housings along the southern side of Stanford's mile-long training track.

On June 15, all was in readiness for the press demonstration at which negatives were taken, and a dozen on-the-spot ''automatic electric-photographs'' made of Stanford's horse, Abe Edgington, traveling at a gait of forty feet a second. The photographs were made consecutively by each of the twelve cameras as the galloping horse tripped each camera shutter by striking threads strewn across the track like a series of finish lines. A white background, installed across the track opposite the bank of cameras, contained vertical black lines painted 21 inches apart, making scientific analysis possible of the motion ''captured'' in each successive photograph. The effect was not of motion as the eye sees it, but rather as the consecutive movements would be seen by a

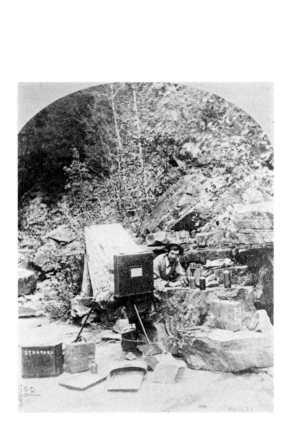

SENECA ROY STODDARD

No eastern or midwestern landscape photography schools emerged in the 1870s or 1880s to compete with the western school, but certain photographers such as Seneca Roy Stoddard of Glens Falls, New York (shown at work in the field, above), deserve greater recognition for their dedication to landscape photography in their immediate locales in this period. Stoddard, Albert Bierstadt, Benjamin Kilburn, and George E. Curtis, of Niagara Falls, were cited for their landscape works at the 1876 Philadelphia Centenial, for example. Stoddard also published a number of picture books containing his views made in the Adirondack Mountains, at Lake George, and elsewhere in the period 1873–1915. In 1880, he began donating copies of his photographs (most of them on imprinted mounts) to the Library of Congress, which is now a principal repository of his landscape views.

THE EXCLUSIVE BUSINESS OF COLLEGE PHOTOGRAPHY

The first recorded photograph of a college class was the daguerreotype made in 1840 by Prof. S. F. B. Morse of the Yale class of 1810, while attending its thirtieth reunion in New Haven (see page 28). Daguerreotypes of graduating classes were also made in 1843 at Princeton, in 1847 at Brown, and in 1848 at Yale and Bowdoin. George K. Warren, who operated out of various Boston-area cities, appears to have been first to make a specialty of graduating-class photography. He made all photographs for Dartmouth's first class photo album in 1858, and beginning in 1859, he kept a virtual monopoly on university photography for more than a dozen years. But by 1878, the scene had begun to change. "The photographer who bases his calculations on the likelihood of retaining the patronage of a given college for a long series of years," the New York *World* contended, "is tolerably certain, whatever the degree of his artistic success, to come to grief at the end." The *Harvard Crimson,* for example, viewed Warren's 1877 class photographs with "disappointment." In 1878, Harvard selected George W. Pach. In 1877, the Brown graduating class selected a local photographer, Henry Manchester, then in 1878 their successors chose Manchester's "hated rival," a Mr. Jones, also of Providence. Napoleon Sarony photographed Yale's 1869 graduating class, then in 1870 secured the votes of half a dozen or more colleges. The Montreal-based William Notman (who also operated out of Boston) gained his first popularity in 1872, and in the period 1872–77 "probably manufactured more college photographs than all his rivals combined," according to the *Photographic Times.* By 1878, the mantle appears to have passed to Pach, who secured contracts for the 1879 graduating classes at Yale, Harvard, Princeton, Dartmouth, Williams, Wesleyan, Vassar, and West Point. This patronage continued to the turn of the century, when Pach Brothers maintained "contributory" photographic galleries in most of the major college towns and cities.[463]

RECORDED CLASS PHOTOGRAPHS

A = Atkinson, Troy, New York
F = Foreshew, Hudson, New York
J = Jones, Providence, Rhode Island
L = Lovell, Amherst, Massachusetts
M = Manchester, Providence, Rhode Island
N = Notman & Campbell, Montreal
P = Pach Brothers, New York
R = Reed, Brunswick, Maine
S = Sarony, New York
W = Warren, Cambridgeport, Massachusetts
Boston, Massachusetts

	'59	'60	'61	'62	'63	'64	'65	'66	'67	'68	'69	'70	'71	'72	'73	'74	'75	'76	'77	'78
Harvard			W	W	W	W	W	W			W		W	W					W	P
Yale				W		W				W	S				W					P
Princeton	W	W	W		W	W			W				W						W	N
Dartmouth	W	W	W	W		W	W	W						W					N	N
Williams	W		W	W		W	W	W	W		W	W		W			W		L	A
Brown	W	W		W	W				W	W			W	W					M	J
Rutgers	W	W	W	W																
Wesleyan							W	W	W	W	W			W			W			F
Union		W				W	W			W	W	W								
Amherst															W					L
Bowdoin																W	W	R		R
Trinity																	W	N		N
Tufts														W			W			
Hamilton										W										
Michigan												W	W							
West Point						W		W		W			W	W		W	P	P	P	P
Cornell																			A	
Vassar																				P
Columbia																				P

series of eyes at different viewpoints. Because each photograph was an independent picture taken from a separate point of view, the result was not a *synthesis* of the movement such as is captured by the modern motion picture camera from a single point of view. This distinction is important in evaluating these experiments as the milestone they represented in the perfection, later, of motion picture photography.

One local newspaper reported after the press demonstration that the photographs showed the gait of Abe Edgington "in a manner before impossible," adding: "A long description even would be unintelligible, while the photographs show the whole stride at a glance." During the remainder of the summer, more of Stanford's horses were photographed at the Palo Alto track, and a series of card photographs was published by Muybridge, each illustrating a particular horse in either six, eight, or twelve positions. This series was the first of Muybridge's photographs to attract international attention, and on October 19 the *Scientific American* reproduced a full page of wood engravings on its cover made from the Abe Edgington series. The editors recognized that the engravers' work could not convey the convincing force of the actual photographs themselves; nevertheless, they conveyed what came as a shock to many artists around the world. The analysis of the horse's movements during various gaits had long been a matter of study and debate among artists, but now it was made apparent to all that a horse had, indeed, all four legs off the ground during one phase of its gallop. Stanford visited the noted French painter Jean Meissonier in 1879, and again in 1881, and the great master at first reacted in utter disbelief to the photographs shown him. But in November 1881, Meissonier gave Muybridge a spectacular reception at his Parisian residence, which was attended by many of Europe's artistic and scientific elite. As Muybridge recounted the affair later: "Many of the most eminent men in art and science and letters in Europe were present at the exhibition; and men like Dumas, Gerome and Millet requested the pleasure of an introduction to me. Happily I have strong nerves, or I should have blushed with the lavishness of their praises."[464]

But before his entrée into the councils of Europe's elite, Muybridge toured the lecture circuit in the United States, beginning just a month after the June 1878 press demonstration. At first he projected lantern slides of his photographs life-size in quick succession before enthusiastic audiences. The near-synthetic effect achieved from one slide quickly following the other is believed to have made him determine to devise a way to project them in quick enough succession as to correctly reconstitute the motion which his instantaneous photographs had stopped. Muybridge thus devised a projector based on the design of an earlier device, and to this he gave the formidable name *Zoopraxiscope*.

Drawings based on his photographs were first mounted around the periphery of a glass disc. Next, a second opaque disc of same size, but containing a series of slots equal in number to the drawings on the glass disc, was mounted in front of the glass disc on the lantern-style projecting apparatus. When the two discs were revolved in opposite directions in front of the lantern, images of the drawings were flashed onto the screen in rapid succession, presenting to the

PHOTOGRAPHING INTERIORS

This branch of photography remained in "a very crude state," according to David Bachrach. There were certain requirements for success, which he enumerated as highly sensitive collodion; a rapid lens (a large aperture, but not having a wide angle in this instance); and some means of keeping the negative plate moist for the longest possible time. With respect to lighting, he offered the following suggestions:

> It should be borne in mind that the weakest solar light is far preferable to any artificial method of producing it. But if artificial light must be used, unless a great deal of experience has been had with it, great difficulties will be encountered. With the exception of the electric light, which is not yet available, magnesium gives the most actinic of all artificial lights. But all the lamps made for this purpose, with clock-work or otherwise, that I have ever seen, are practically useless. The best method of using it is to buy the twisted tapers and station persons at various points on the sides between the instrument and the objects or space to be photographed, so that they do not come upon the plate, and light all of them simultaneously and burn as many as necessary to produce the effect desired upon the plate. The smoke and fumes caused by the fine powdered calcined magnesia, produced by its combustion, have not by any practical method been avoided as yet. It will not be found very practical to photograph a larger space than say 30 feet in area each way at one time by artificial light, on account of the loss of actinism as the light travels, unless a very large number of lights are used. I had occasion to photograph sections of a tunnel at one time, showing the junction of brick and timber work, and tried magnesium, but the smoke and fumes made it impracticable (with a clock-work lamp) in such a confined space. So I proceeded to procure six calcium lights, with oxy-hydrogen combustion, and threw the light with concave reflectors on the objects. Only three of them, however, were effective, as the other reflectors were in too poor condition and of too long focus. I succeeded in lighting a space of about 8 by 12 feet in width and height, and 20 feet in depth, and obtained a good image in twenty minutes. For small spaces this is the most reliable light, and though containing more yellow rays than magnesium, it is more easily controlled and steady. The reflectors should be in the best condition and of a focus so as to throw all the light, without loss, on the objects to be illuminated. This whole subject of artificial light, so far as its practical use by the regular photographers is concerned, is yet in a very crude state.[465]

Clarence Johns's 1873 oil painting of a western roundup (above) illustrates the mistaken way in which artists depicted galloping or trotting horses on their canvases prior to the widespread publicizing of Muybridge's photographic achievements. Among the first to recognize the art world's need to change was the French painter Jean Meissonier.

audience a much more realistic portrayal of a horse in motion. In later years (1899), Muybridge said of his *Zoopraxiscope* that it was "the first apparatus ever used, or constructed, for synthetically demonstrating movements analytically photographed from life, and in its resulting effects is the prototype of all the various instruments which, under a variety of names, are used for a similar purpose at the present day . . ."[466]

But was it? It has been said that when Henry Heyl saw the *Zoopraxiscope,* "he thought he recognized his *Phasmatrope.*" Heyl never contested Muybridge's claim, nor did he travel the lecture circuit demonstrating the *Phasmatrope.* It is quite possible, therefore, that Muybridge never was aware of the *Phasmatrope*'s existence. Presumably, Muybridge's and Heyl's paths did not cross during the years after 1884 when Muybridge was engaged in camera re-

search at the University of Pennsylvania, and certainly not after 1894 when Muybridge returned to his native Kingston-upon-Thames in England.

Perhaps, too, Heyl did not feel that he was entitled to a prior claim for having "synthetically demonstrated movements analytically photographed from life" with his *Phasmatrope.* As he himself stated in 1898, looking back to his 1870 demonstrations at the Philadelphia Academy of Music, and the Franklin Institute: "At that day flexible films were not known in photography, nor had the art of rapid succession picture-making been developed." With respect to the latter, this was possibly a reference to—and an appreciation of—Muybridge's world renowned feats at Palo Alto, which Heyl may have thought attached greater significance to the *Zoopraxiscope.* But the flexible films Heyl referred to, in either case, had yet to be developed.[467]

1878

256

1879

Up until this time, virtually all of the discussion and reports on dry-plate activity in American photographic literature had been concerned with collodion-bromide processes. Records are meager covering mention of gelatine dry-plate experimentation, yet John Carbutt, for one, tried making gelatine dry plates in Chicago as early as 1868. Foreign journals periodically gave reports on experimentation with, or the use of, Maddox's gelatine process, and in 1876 an amateur photographer in Philadelphia appeared before the Photographic Society of that city to report on his success with gelatine plates, which he said had been prepared on the basis of reports he had read in British photographic journals.

Things began to come to a head this year. Carbutt had abandoned his efforts to engage in large-scale photomechanical printing, and after perfecting a gelatine dry-plate process to his satisfaction, he placed a commercial article—the *Keystone* dry plate—on the market. Either this year, or as early as 1878, Albert Levy of New York (not known to be a kin of Louis, Max, or Joseph Levy) also began the commercial supply of gelatine dry plates. In England, a twenty-five-year-old American, George Eastman, of Rochester, New York, was awarded a patent on July 22 for an improved process of manufacturing gelatine dry plates.

Photographers such as Andrew J. Russell had already adopted use of Henry J. Newton's collodion-bromide emulsion process (a bottled formula ready to use in preparing a dry-plate negative), and as early as 1877 E. & H. T. Anthony & Co. had advertised the availability of packaged dry plates—presumably made with a collodion-bromide emulsion developed by T. C. Roche. In its advertising, the company said it considered the plates "quite equal to the wet plate in rendering of detail, and in vigor, while they are perfectly easy to develop either by the alkaline or pyrogallic methods." Prepared dry plates made with Newton's emulsion formula also now became a commercial article. In July, the *Photographic Times* announced:

> Mr. H. J. Newton, the pioneer emulsionist in America, has consented, in compliance with the many urgent requests from all parts of the country, to supply through Scovill Manufacturing Company dry plates made from an emulsion which he shall have tested and approved. . . . These plates will produce strong, brilliant negatives, in which the halftones are blended beautifully with the shadows and highlights, happily in contradistinction to the dull, chalky, black-and-white negatives produced by most emulsions.[468]

How early Levy's and Carbutt's gelatine dry plates became available does not appear to be recorded, but by April 1879, the *Photographic Rays of Light,* a new journal published in Baltimore, observed that dry-plate photography was becoming quite popular in England. The following remarks in the same article would seem to suggest that the summer of 1879 was the proverbial lull before the approaching storm:

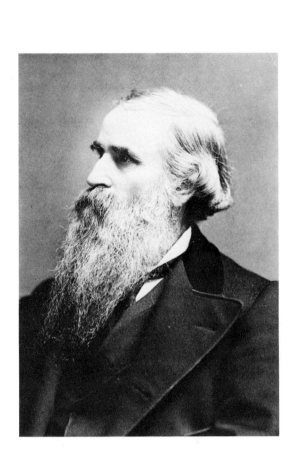

HENRY J. NEWTON

Revered in his time as America's "pioneer emulsionist," Henry J. Newton perfected a collodion dry-plate negative process which became a commercial article just at the time when the attention of the photographic world turned to the gelatine dry plate. As early as February 1876, he exhibited emulsion plates for studio portraiture, which were perfectly satisfactory for use even on cloudy days. All the photographer had to do was flow his glass negative with the bottled Newton emulsion and let it set. Within a minute, an alcoholic preservative could be applied and the plate was ready for an exposure. The Scovill Manufacturing Company began offering Newton's collodion plates commercially in January 1880, and it is possible that the *Defiance* dry plate put on the market that same year by E. & H. T. Anthony & Co. was also a collodion version. But we do not know how successful Newton's plates were—or might have become—because by December 1880, the gelatine plates eclipsed the collodion versions.[469]

Now that the numerous uncertainties which were such serious drawbacks to the dry-plate system, at its first or early stages, are overcome, and its practicability thoroughly recognized and established, it is astonishing so few photographers in this country have turned their attention to it. The plates, emulsion, etc., are manufactured now in the United States, and can readily be obtained. We trust many of our landscape artists will this season try their hand on dry plates, as long as the process is now so simplified that they need not apprehend any trouble.[470]

Emulsion plates, possibly of both the gelatine and collodion variety, were used for the first time by all of the members of the Photographic Society of Philadelphia during the society's fourth annual field trip in the summer of 1879. Two hundred and twelve plates of seven different varieties were used, and exposures ranged from 30 seconds to as long as 15 minutes in making photographs of differing subject matter. A considerable amount of difficulty, however, was encountered in developing the negatives.[471] Just before this excursion, some professional comment and advice from France had been published in the *Photographic Times* on the preparation and use of collodion dry plates, and this may have proven helpful to those making the trip. Among the most important points cited in the article was the necessity of insuring that the emulsion coating was made firmly secure to the glass negative plate. Several methods were given to accomplish this. With respect to developing the plates after an exposure, practitioners were warned that there was no "exact formula" to insure proper development, first, because different bottles of emulsions would give very different results, and secondly, because the carbonate of ammonia required for development was a product of unstable nature:

> All formulae are good, either by mixing together at the very start the bromide of potassium, pyrogallic acid, and the carbonate of ammonia, or, by first covering the plate with bromide and pyrogallic acid, or with bromide and carbonate, to which the third product is finally added; the only essential point to obtain a development free from fogs is to use from the start a sufficient quantity of bromide of potassium. It is at the commencement of the development that the plate has the greatest tendency to fog. When the appearance of the image is about complete, pyrogallic acid or carbonate of ammonia should be added until the required degree of intensity is obtained.[472]

About the time of the Philadelphia outing, Alexander Hesler reported the results of his own preliminary trials with dry plates, in which camera exposures evidently required 15 seconds, as opposed to 5 seconds for wet-plate negatives. "Every plate came out spotted," Hesler said of the Levy emulsion plates used. "Nearly all show crepe-like lines in the direction which the emulsion was drained from the plate."[473]

In its review of "twelve months of gelatine studio work," the *St. Louis Practical Photographer* was a little more bullish:

> Less assistance is required in taking pictures. Many more can be taken in the day; they save the time previously occupied in filtering baths, washing out, etc., and the waste in wear and tear of apparatus. All this means money; but, besides this, pictures cost less on dry plates than on wet collodion. One hundred half-plates can be developed with one ounce of pyro, one pound of ferrocyanide of potassium, and two ounces of ammonia. This

PLATINOTYPES

Metallic platinum in its blackened, powdered form, remains unaffected by air, moisture, or acids—as do the pigments of powdered carbon. A process of securing photographic prints in platinum was invented in 1873, and a series of American patents was awarded in 1876 and 1879 to William Willis, Jr., and Alfred Clements, both natives of England (Clements had been the first to emigrate to the United States in 1867 to work for E. & H. T. Anthony & Co.). Platinum printing depended not on the direct influence of light on the platinum salts, but on its influence on certain organic salts (ferric oxalate, oxalate potash, potassic chloro-platinite, etc.) also used in the process, which then convert the platinum salts to a metallic state during print development.

While the 1879 patent was a great advance over the original invention, none of the three principal organic salts mentioned above was commercially available, necessitating their costly manufacture. Added expense in working the process resulted from the loss of platinum when the platinum salt was mixed with the developer and heated. Another obstacle turned out to be the difficulty in obtaining a good plain paper for print making. "There was none on the market free from animal sizing," Clements said, "and as platinum salts have a great desire to remain in contact with such sizings, it was impossible to get a print having pure whites." As a solution to this problem, Clements went to Germany where he succeeded in making arrangements with the Steinbach factory to make a suitable paper.

During the period 1880–81, Willis and Clements developed improved means of heating during development (which reduced the amount of platinum lost in this operation), and experimented with printing by electric light, since sunlight proved to be yet another "uncertain factor" in working the process. But platinum printing remained troublesome and expensive, and did not become popular until the 1890s.[474]

can be done in two-thirds of the time required for wet plates, and with one-eighth of the exposure. . . . One of the most fertile causes of failure in dry plate work is over-exposure, and this is why the remark has been made that they work better in dull than in fine weather; but we must look at this from another standpoint: in the writer's experience it was found on beginning dry-plate work that the usual card lenses were too rapid, the exposure being so brief that it was not under control. This has been remedied by the double operation of using longer focus lenses (3A, instead of 2B) and interposing between the sitter and the light a much more opaque medium than usual.[475]

Another variation of the collotype family of photomechanical printing processes—the Artotype—made

ARTOTYPES

Close on the heels of the Lambertype came the Artotype, which even its promoters agreed was "similar in some respects to the Albertype." But most importantly, it was "different in patentable points." The *Buffalo Express* gave this account of the process in the spring of 1879:

> THE Artotype process seems destined to revolutionize the photographic business. In permanence, cheapness and artistic beauty the new process possesses extraordinary advantages over the old style of picture-taking, and we shall be greatly surprised if the Artotype does not in a few years bear the same relation to the photograph that the photograph now bears to the old-fashioned ambrotype. The Artotype process, let us say, is the obtaining of superior photographic prints by means of the regular hand press and printer's ink. The credit of inventing and discovering this particular process is due to Mr. J. B. Obernetter, a celebrated chemist of Munich, and the credit of applying the discovery in this country belongs to Messrs. T. S. Lambert, W. A. Cooper and A. Mueller, who comprise the Artotype Company of New York, to which belongs the entire right for the United States. The manner in which the Artotype is produced may be briefly described as follows: The impression of the person or object is first taken on the negative, the same as an ordinary photograph; then the negative is put with a plate of prepared glass and subjected to the action of the sunlight. A coating of gelatine is first put on the glass, and that rendered sensitive to light after having passed through a hardening process causes the film to adhere to the glass, so that an unlimited number of prints can be taken off. A perfect picture having been indelibly printed on the plate by the sun's rays, the hand-press and a little printers' ink are only required to produce any number of finely finished pictures. The plate is used the same as a lithographic stone, and photographs can be printed from it in all of the natural colors, by skillful manipulations. These photographs are different from the sun-printed pictures, inasmuch as they will never fade, never turn yellow or become blurred—the colors and tone being permanent. People can select their own colors or tones even after the negative has been printed, and impressions can be taken from the same negative of either soft or brilliant tints. Nothing but unprepared artists' paper is used, and prints can be made with either mat, brilliant or enamel surface, without losing any of their brilliancy.[476]

AN ARTOTYPE OF A "DICTATOR"

Edward Bierstadt became probably the foremost user of the Artotype process at his New York establishment after 1879. He used it primarily to make illustrations for business catalogs, and his orders would run to 120,000 sometimes on a single job. His use of the process to make photographic portraits for book illustration was considered "secondary." But Charles D. Fredericks evidently found it quite suitable for book illustration. In 1882, for example, Fredericks published a book, *The Bank Officers of the National and State Banks of the City of New York,* which contained nearly two hundred Artotype portraits, among them that of Frederick D. Tappen (above), the acknowledged "banking dictator" of America. Tappen was repeatedly given dictatorial powers by the financial community in all major economic panics prior to creation of the Federal Reserve System in 1913.[477]

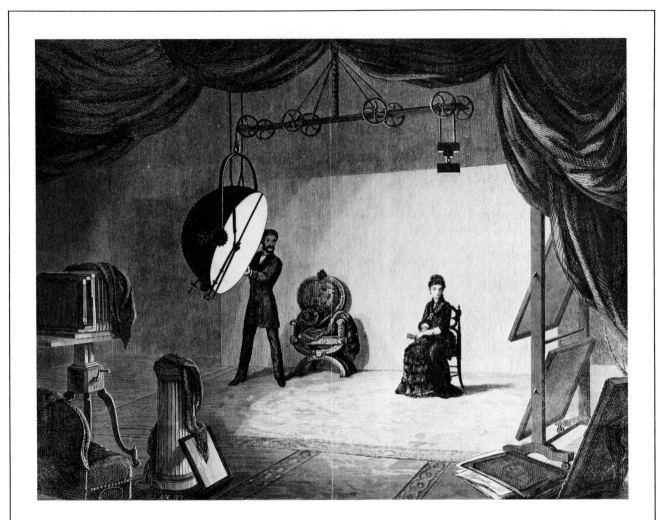

PHOTOGRAPHY BY ELECTRIC LIGHT

In April 1879, the *Philadelphia Photographer* marveled at an interior photograph of the Willimantic Linen Company taken by electric light, which the magazine received from Isaac White, of Hartford, Connecticut. The print depicted the room in which the thread was wound for linen manufacture. "This room is lighted by two electric lights, which take the place of sixty-two 5-foot gas burners," the magazine reported in an article describing the photograph. "Time: only twelve seconds. This is a wonderful achievement. We have seen many interiors taken by sunlight, with long exposures, that have not had so much detail as this one taken by electric light."

Isaac White's feat took place nearly half a year before Thomas Edison brought three thousand spectators to his New Jersey facility in special trains to witness a demonstration of hundreds of incandescent lamps. This marked the beginning of electricity's ability to compete with gas for home lighting. By this time, too, Henry Vanderweyde was specializing in electric light portraiture at the London studio where he first made portraiture by artificial light "fashionable" in 1877. In a report on Vanderweyde's activities, *Anthony's Photographic Bulletin* contended that "it is impossible, from an examination of the pictures produced, to arrive at a conclusion that they were produced by artificial light. Instead of the harsh, chalky lights and black shadows without gradation, which experience associates with the majority of examples of portraiture produced by artificial light, these are for the most part remarkable for their softness and their singular perfection of gradation and modelling. Not only is every highlight picked out crisply and precisely, but every gradation of halftone is accurately rendered. The highlights are surrounded by delicate pearly greys, which remove all baldness and crudeness of effect, and the shadows are made transparent by the plenitude of reflected lights carrying detail into the deepest shadows."[478]

its appearance this year, touching off yet another round of dissension between the houses of Wilson and Anthony (as well as among other prominent members of the photographic fraternity). In January, Wilson refused to accept advertising in the *Philadelphia Photographer* from the newly established Artotype Company of New York, whose owners included Wilson's former adversary, T. S. Lambert, W. A. Cooper and A. Mueller. The advertising, Wilson contended, was "extravagant, and could not be verified by facts." The only people opposed to the new process, *Anthony's Photographic Bulletin* shot back, were Wilson, David Bachrach, John Carbutt, and R. Benecke of St. Louis. The *Bulletin* even expressed the opinion that the attacks made by this group both on Lambert and on the process itself resulted from "a personal opposition on the one hand, and on the other, from the persistent desire to do everything possible to 'beat Anthony.' "[479]

But just the previous month (December 1878), the judges of the forty-seventh annual fair of the American Institute had awarded a "medal of superiority" to the Artotype Company for its exhibit of prints at that fair, noting in its report: "All distortion, which is so common in silver prints, is entirely overcome. The printing is likewise done in different tints, and some very nice pictures have been shown . . . done in three different colors, thus to a certain extent solving the art of photographing in color."[480]

Beginning in May, representatives of the Artotype Company, following the method used by Leon and T. S. Lambert several years earlier, began a schedule of free demonstrations of the process at hotels in Rochester, Buffalo, Cleveland, Chicago, St. Louis, Louisville,. and Cincinnati. But even before this schedule went into effect, the *Bulletin* ran a series of laudatory letters received (probably with no little solicitation) from William G. Chamberlain in Denver; J. A. Williams in Newport, Rhode Island; C. H. Muhrman in Cincinnati; W. J. Baker in Buffalo (who purchased the rights to the process for Erie, and six other New York State counties); and W. H. Illingworth, who wrote that he had discharged his silver printer and was "now turning out nothing but permanent work, carbon and artotypes. Is Minneapolis," he inquired, "still for sale?"

Two months before the Artotype Company demonstrations began, John Carbutt did an about-face, and signed up:

As there seems to be an increasing conviction that my mode of photomechanical printing is a direct infringement of some of the patents now legally held by the Artotype Company, some of which are undoubtedly valid, and not wishing to go into long and costly litigation, or endanger others who might learn of me, I have concluded to give no further instruction in photomechanical printing. I have secured the exclusive license of Artotype Company's patents for Philadelphia and vicinity, and will henceforth fill no orders from negatives originally taken in the localities for which the exclusive license of Artotype Company had been sold, wishing to be similarly protected in my own territory.[481]

David Bachrach, meanwhile, contended that Artotype printing should be confined to major photomechanical printing establishments, such as Carbutt's or Edward Bierstadt's in New York. Wilson called on Bachrach to join him in the fight, and as Bachrach recalled in later years: "I was young

CAUSES OF PRINT FADING

"Outside influences" were the most destructive causes of print fading, F. A. Wenderoth of Philadelphia contended. Prints surviving from the nineteenth century attest to the veracity of his remarks in a long article on the subject in *Philadelphia Photographer*:

Silver photographs made on different papers are influenced differently, and withstand the destroying elements differently. Albumen prints, with very few exceptions, fade and discolor simultaneously; prints on plain paper fade but do not discolor, at least the paper does not more so than ordinary paper under the same influences. Since the introduction of highly albumenized papers this discoloration has very much increased.

Another decided difference is in the tint of fading prints on these two kinds of paper. On the single and on plain paper the remaining tint of the image is blackish, whereas on the double paper the remaining tint of the image is mostly brown or reddish-brown always on a more or less discolored albumen film.

It will be asked what produces the difference in the amount of fading of silver prints made on the same paper under similar conditions. This, I think, in most cases, can be explained by the difference in the strength of the negatives, difference of albumen film, over- or under-printing, and consequently great difference in the changes produced by the gold toning bath.

I think it admits of no doubt that prints made from strong negatives, consequently stronger printing and gold toning, will resist fading influences better than those made from thin negatives and slight toning.

Prints on thinly albumenized paper permit of a deeper incorporation of the image in the body of the paper support, and having less organic matter to expose to atmospheric influences, will suffer less and keep an even surface even after the application of water. This is entirely different with double albumenized papers. Prints on these papers, when closely examined after being mounted, will be found to have cracked into millions of particles, but firmly adhered to the paper; after the application of water, these little pieces curl up, leaving open seams between them, giving free entrance to their great enemy, the sulphuretted hydrogen of the atmosphere, and the body of the albumen film being of considerable thickness, the absorption of moisture will be greater, consequently, the process of fading more energetic and quicker than with single albumenized paper. I think the sooner these highly albumenized papers are discontinued the better.[482]

1879

and full of fight . . . I thoroughly checkmated the fellow [Lambert] by issuing a pamphlet to every photographer I could reach, giving the entire absurdity of the scheme away. There were no more taken in then; in fact, but few had been. I received scores of letters acknowledging their obligations to me.'' Of the thirteen Baltimore studios that had bought the Lambertype process two years earlier, his was the only gallery using it with any regularity, Bachrach contended, ''and then only for porcelain negatives and the reproduction or enlargement of negatives.'' Bachrach lashed out equally sharply against efforts by ''the process mongers'' to license the Artotype:

> I wish to say a few words to you, fellow photographers. So long as you will be easily gulled by every foreign-named process-monger, so long as you will, in your eagerness to get ahead of your neighbor, try to cut each other's throats, so long as you will not act together against the common enemy of process- and patent-mongers, so long will you be open to just such conspiracies against your pockets.[483]

The causes of print fading provided yet another major topic on which disagreement—albeit, in milder form—was aired in the photographic press this year. F. A. Wenderoth of Philadelphia identified three principal causes: namely, the use of improper mounting material; failure to remove hypo during printing (not as bad a problem, Wenderoth felt, as Newton and others said it was); and the effect of outside influences. Alexander Hesler argued that improper al-

bumenizing of the paper was a major cause of print deterioration. The use of hard, very dry paper in coating provided an albumenized paper susceptible to blistering, he contended, whereas if the albumenizers would use paper previously dampened, and allow it to fully absorb the albumen into the paper's fibers, no blistering would result. The Philadelphia manufacturer of albumen paper, John R. Clemons, responded to this with a different theory:

> Now, my theory is that the sizing at the paper manufactory is not made as it used to be; perhaps made in such large quantities that it is lumpy, and these lumps are of various sizes, and they become the nucleus, turn sour, and then enter into the pulp, all passes through the rollers, when they are spread out, small and large. Then the poor albumenizer gets it; from him it passes to the printer, and the printer pours a big lot of cussedness upon the very spot where it don't belong. Now we will look at this in another light. If it was the fault of the albumen, why do not all the albumen prints leave the sheet, and not blow up in spots by the gases engendered in the sour sizing? I may be wrong, but I think I am as near right on *that* blister as anyone else who has guessed.[484]

Frank Thomas, in a letter to the *Philadelphia Photographer,* agreed with Clemons. But, Clemons excepted, ''the majority of albumenizers make one mistake,'' he said, ''and that is they do not tell us how strong they salt their paper; we would have less trouble in silvering correctly, did we possess that information.''[485]

1880

Newspaper illustrations made their appearance in the 1830s. Among the first in an American newspaper was a woodcut view of the ruins of the great New York fire of December 16–17, 1835. In an early journalism "extra," the New York *Sun* published a lithograph of the burning of the steamboat Lexington in Long Island Sound three days after the tragedy on January 13, 1840. Thousands of copies of the extra were sold on the streets throughout New York, establishing an overnight reputation for the young lithographer Nathaniel Currier. But after 1850, newspapers virtually ceased using illustrations, and the public obtained its visual accounts of people, places, and events through the pages of such illustrated weeklies as *Harper's* and *Leslie's*. As we have already seen, the woodcut illustrations in these weeklies were frequently copied directly from supplied photographs.

In 1873, the New York *Daily Graphic* made its appearance, using lithography for the printing of both type and illustrations (photolithographs). Stephen H. Horgan was hired as a photographer, but soon took over management of the paper's photomechanical printing operation. As he said later, the appearance of this newspaper "startled the whole printing world, for it demonstrated that photography was going to usurp the place of wood engraving." This it did for the first time on March 4, 1880. What F. W. von Egloffstein had endeavored to accomplish in the 1860s now appeared on the *Graphic*'s editorial page in the form of a halftone illustration printed on the same press with the columns of newsprint. The brief explanation of the illustration read as follows:

> On the lower left hand corner is an illustration entitled "A Scene in Shanty Town, New York." We have dealt heretofore with pictures made from drawings or engravings. Here we have one direct from nature. Our photographers made the plate from which this picture has been obtained in the immediate presence of the shanties which are shown in it. There has been no redrawing of the picture. The transfer print has been obtained direct from the original negative. As will be seen, certain of the effects are obtained by use of vertical lines. This process has not yet been fully developed.

On March 2, 1880, the New York *Daily Graphic* appeared with the illustration of Shanty Town dwellings (above) modestly placed on the editorial page. There was no public fanfare, and it was not labeled a "first." But it was. It was the first time that a newspaper converted a photograph by screening to a halftone block for printing with type without the aid of an engraver.

AN UNANNOUNCED PREVIEW

When the members of the Photographic Section of the American Institute attended the society's regular monthly meeting on March 2, 1880, O. G. Mason, secretary, greeted them with an advance copy of the world's first newspaper halftone illustration:

. I have here a print, which might be called an advance copy of a supplement of the New York *Daily Graphic,* which will be issued in two or three days hence. Knowing that I have taken a good deal of interest in the various printing processes which were founded on photography, the publishers, and Mr. Hogan, who has charge of the photographic work, took pains to send me this sheet. It is particularly interesting to *us* from the fact that it has in it a picture made and printed in the power press directly from a negative by our chairman. It is issued on this advance sheet and will be printed in the paper by the thousand, without the slightest touch of the hand on the photographic work. The method of producing it may be described as follows: A negative is made from a series of fine rulings slightly out of focus. The film of that negative, if transferred by the use of collodion—or rather taken off and placed between the negative from nature and the bichromated gelatine film—a print made and treated as the ordinary photo lithographic prints are treated, the effect is to produce detail in the shadow parts, and where there is a light portion the ruling shows very slightly. Another interesting picture is made upon a photographic base; that is, a photograph is made and a drawing in ink finished upon this, the outline and shade put in; then the photograph is bleached out by the use of chloride and alcohol, leaving only the drawing, from which the work is carried forward. Another interesting picture of the series shows the artistic corps preparing a picture for the next day's issue; the original picture from which that was made I have here. The drawing was made in about one hour, a hand drawing, upon a peculiar paper which they call grain paper, which admits the photographic process being worked without filling up the shadows. This sheet is a most admirable illustration of the utility of photography in the production of illustrations for the daily press.[486]

Stephen H. Horgan, circa 1890.

The original photograph of "Shanty Town" was an Albertype made by Henry J. Newton. To process it as a halftone illustration, Horgan prepared a screen of seventy lines per inch, by which the picture was broken up into lines and dots that could be secured on a printing block. The clarity of the "Shanty Town" illustration, as it appeared in the *Graphic,* is not up to today's standards, but was comparable to a halftone illustration of E. L. Wilson which was published in an 1881 issue of *Philadelphia Photographer* (see page 369). Detail in the shadows is evident, and intermediate tone (halftones) were secured without the hand of an engraver. The *Graphic* produced other halftone illustrations after this, but printing difficulties precluded use of the method with any regularity. In addition, the *Graphic* did not fulfill the role of a news publication, and in 1889 it was forced to close down.

Although honored (in 1930) for his pioneering work in halftone, Horgan's efforts were only the first which ultimately led to the perfection and subsequent universal use of halftone printing after 1890. Horgan became art director of the New York *Herald* in 1893 and the methods he developed on the *Graphic* were later adopted for high-speed press work by the New York *Tribune.*[489]

"HEADQUARTERS FOR EVERYTHING PHOTOGRAPHIC"

From the *New York Review*

"The pedestrian who travels down Broadway will, if he be of an observant disposition, notice about midway between the Post Office and Grace Church, a good many showcases containing photographs of celebrated actors, actresses, public men of this and other countries, and photographic pictures of nearly every imaginable description. Most people stop now and again to admire these pictures, and some, more thoughtful than the rest, wonder "where they all come from." To find out something precise and definite on this head a *Review* reporter made it his business the other day to pay a visit to the leading establishment in this line—that of E. & H. T. Anthony & Co., of 591 Broadway, opposite the Metropolitan Hotel. Knowing the widespread celebrity of this house, the reporter was prepared to find things upon a pretty large scale, though nothing like so extensive as the reality turned out to be had ever entered his head.

Messrs. Anthony & Co., carry on business as manufacturers and importers of photographic materials, stereoscopes, views, albums, frames and fancy goods, and make of photographs of celebrities a great specialty. The business was established originally in the year 1842, by Mr. E. Anthony and Mr. H. T. Anthony, brothers. They were both civil engineers by profession and had practiced as such before commencing their present business. They started in a very small way, but now do the largest business of any house in this line in the United States. At the above address they occupy four floors, each 100x30 feet, and also a rear building of four 100x30 floors. At the corner of Elm and Centre streets they have a factory, over the Hartford & New Haven R. R depot, and they have another very large one in the lower part of Broadway, and in New Jersey they have a third, where photographic chemicals are manufactured. They employ in all over 300 experienced hands, and the quantity of work turned out is simply enormous. Of frames alone they make fourteen gross per day, or nearly 700,000 per annum. Their goods go all over the world, being regularly sold in London, Paris, Spain, Germany, Australia, China, Japan, the West Indies, and in South America alone the firm have four regular agents. Their customers are jobbers and wholesale dealers, who in turn supply the retail trade.

The house is the chief source from which the United States Government draws its supplies of this character, and of general photographic materials. Amongst other foreign houses that are represented is that of J. H. Dallmeyer, whose telescopes and best photographic lenses are well and favorably known all over the world. For this house Messrs. Anthony & Co. are sole agents. The *Review* reporter was courteously conducted through the establishment by Mr. H. E. Pierce, who has general charge of the stereoscopic department. He was shown an amazing variety of choice and tempting goods, the entire stock being one that certainly could not be equalled in the United States and probably not in Europe. The display of velvet, satin, silk, gold, ebony and other styles of frames attracted particular attention. It includes all the newest and most beautiful designs, including many that are entirely original and could not be met with elsewhere. All grades are included so that all tastes can be suited. Of albums the stock is beyond description. They range from the tiniest pocket-book albums to the largest and most expensive ever made. There are imitations of English and French goods, of which it may be said that the copies are better than the originals, and there are amazingly tempting productions in calf and morocco, which only need to be seen to be admired.

In another department is a collection of stereoscopic views that seem to have no end, and the reporter is quite prepared to believe his guide when the latter says that it includes 50,000 different subjects. Included are views of nearly every pretty piece of scenery in the United States, together with tit-bits gathered up from every country under heaven. In the arrangement and classification of these goods a most comprehensive system is observed, so that no matter what a buyer may require it can be found in a moment. Elsewhere is seen a superb line of stereoscopes, and the reporter learns that the firm control a very fine patent folding stereoscope that is intended for the use of travelers. The collection of photographs of celebrities calls forth the statement that Messrs. Anthony & Co. are sole agents for Sarony's productions in this line. They color them themselves and sell them in immense quantities.

The house is, in short, headquarters for everything photographic, no matter of what nature, and in every department of their business they lead the trade. The firm publish a book called the "Silver Sunbeam," which refers to various matters of interest connected with the photographic art. "*Anthony's Photographic Bulletin*" is another well-known publication of the house, now in its tenth volume.

The concern is now in reality a joint-stock corporation, of which the Messrs. Anthony and Mr. V. M. Wilcox are the heads. 487

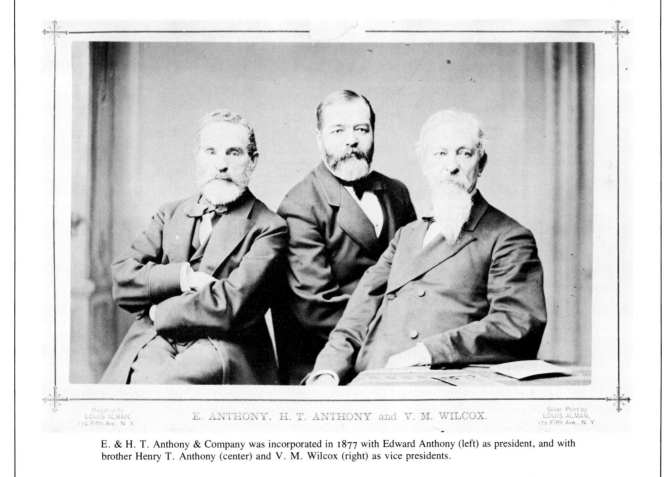

E. ANTHONY, H. T. ANTHONY and V. M. WILCOX.

E. & H. T. Anthony & Company was incorporated in 1877 with Edward Anthony (left) as president, and with brother Henry T. Anthony (center) and V. M. Wilcox (right) as vice presidents.

1880

MOSS PHOTOENGRAVING PROCESS

These appear to be the only surviving illustrations depicting the birth of American photoengraving, either at 67 Park Place, New York, where John Calvin Moss (1838–1892) operated his pioneering business in the late 1870s, or at 535 Pearl Street, where Moss moved in 1881, becoming, in the words of Stephen Horgan, "the best-known photoengraver in the world." To prepare book and magazine illustrations, Moss's draftsmen prepared line drawings on top of photographs in a special way (top), after which the drawings were photographed (middle), and the negatives made of the drawings were exposed on a sensitized gelatine surface. In this operation, the portion of the gelatine exposed to light (i.e., the lines of a drawing) was rendered insoluble, while the remainder of the gelatine (i.e., the white surfaces) could be dissolved chemically, creating hardened gelatine molds into which metal was poured (bottom). In this manner, photomechanically produced illustrations were created in stereotype plates which could be printed on a press with type.[488]

Despite the handwriting on the wall personified by "Shanty Town," the demise of the hand engraver did not immediately follow. During the lull in halftone development, which lasted up to about 1893, wood engraving continued unabated, while at the same time the new methodology of photoengraving began taking on sizeable proportions.

The first to introduce photography into successful commercial engraving was John Calvin Moss, a native of western Pennsylvania. But Moss's was an agonizing route to success, and one which he was fortunate in being able to share with an equally dedicated wife, Mary. Together, the couple experimented at nighttime during all of the 1860s on what must have seemed many times to be a fruitless endeavor. Originally, Moss's interest had been aroused by the failure of another to produce an engraved plate by etching out a daguerreotype image. Why not, he thought, etch through the thin coating of silver on a daguerreotype plate, then place the plate in another chemical solution which would act upon the copper base—but not the silver coating—and thus allow further etching to the required depth for plate printing? The first plate was produced in short order, but as *Anthony's Photographic Bulletin* observed later, Moss and his wife "did not realize that nearly ten years of constant experimenting under the most trying circumstances, often in great poverty and want, would roll away before they would be able to make the first plate that would be paid for and used." On their first large order, the couple found that their chemicals "would not work as they had worked before," but somehow the job was completed and capital was forthcoming after that to fit up a loft in New York where manufacturing operations could be carried on on a larger scale.

Business prospered at the loft, but Moss and his wife again embarked on a decade-long period of adversity which saw the establishment and dissolution of two companies in which interim financing had been provided by outsiders. Finally, in the spring of 1880, the Moss Engraving Company was formed with Moss as president, his wife as treasurer, and a son, Robert, as assistant superintendent. Two longtime employees were named, respectively, secretary, and assistant secretary of the company. During the 1880s, Moss became, in Horgan's words, "the best known photoengraver in the world."

Moss's success resulted from training an entirely new school of pen-and-ink draftsmen who took the place of wood engravers in preparing line illustrations that could be transferred photographically to a stereotype printing block. Among the most noted artists whose works were reproduced by the Moss process for magazine and book illustration was the author and illustrator Howard Pyle. The accuracy of the pen-and-ink draftsmanship was essential. As the *Philadelphia Photographer* noted some years later: "The Moss-type process can produce photographs and drawings and mezzotint engravings with photographic accuracy, but it is necessary, however, to have no defects in the original, as they will be reproduced in the plate."[490]

Records are lacking on the accomplishments of the Moss Engraving Company during the 1880s, but it appears that even among so-called experts the question cannot readily be answered as to whether a woodcut, or a photo-technology

PHOTOGRAPHY BY MOONLIGHT
From the *Photographic Times*

IF "seeing is believing," there was no mistake at all as to its being a genuine moonlight picture which was submitted for our inspection. In the first place, it was labeled as such; while, secondly, *there* was the full moon, high in the sombre midnight heavens, imparting a silvery lustre to the skirts of the adjacent clouds, and giving a beautiful reflection from the tips of the waves of the sea which formed the centre of the fine picture, and across which boats —some in full sail—were depicted with such fidelity to nature that every rope could be seen. The moon itself, too, courted examination through a magnifying-glass, by which the details of its selenographic features were clearly to be distinguished. An *instantaneous view by moonlight!*—that was the claim. And why should it not be received?

We shall speak of photography by moonlight, first, in a philosophical, and, secondly, in a practical spirit.

What is the difference between the luminous energy of the sun and that of the moon?

Some individuals, possessing an abnormal degree of the poetic or imaginative faculty, have been known to describe a fine moonlight night as being "almost as light as day." Pretty, but altogether untrue.

Computations to determine the comparative degree of luminousness of the sun and moon have been made by several *savants*, among others, by Leslie, Bouguer, and Wollaston. The first of these, Prof. Leslie, very strongly supported a theory to the effect that there is possessed by the moon a phosphorescent principle, brought into action by the influence of the sun, by which the latent light was thus emitted. He computed that the sun's light remitted from the moon to the earth was attenuated 105,000,000 times, and found the intensity of the moon's light to approach the $\frac{1}{110000}$ part of the direct light of the sun; so he reasoned that, as the utmost possible quantity of reflected light could not exceed the $\frac{1}{110000}$ part, the excess must be owing to the spontaneous light of the moon, which, consequently, is a phosphorescent body.

Bouguer's experiments led him to conclude that the moon's light is between the $\frac{1}{150000}$ and $\frac{1}{300000}$ part of the direct light of the sun, or about three hundred and fifty times greater than the computed amount of reflected light. The best astronomers, however, give the preference to the measures of the brightness of the sun and moon determined by Dr. Wollaston, and which give the former equal to $\frac{1}{801072}$ of the latter at full. This comes very near what one might deduce from the distance of the moon from the sun, the direct reflecting power of a rocky surface, and the angular subtension of the moon from the earth.

From the foregoing, the following deduction is made—that, as the light of the moon is 801,072 times less than that of the sun, if a photograph of any terrestrial object, while lighted by the sun, can be taken during an exposure of one second, a similar picture of the same subject, when lighted by the full light of a full moon, will require an exposure of two hundred and twenty-two and a half hours, or a space of time equal to nine and a quarter days.

This renders quite unnecessary any further argument against the idea of obtaining instantaneous moonlight pictures.

Now, it is not only quite legitimate to produce pictures possessing moonlight effects by the agency of the sun's light, but it is a fascinating department of photographic practice; and numerous exquisite pictures have been thus obtained. There are, however, only a limited class of subjects capable of being made subservient to the interests of the so-called moonlight photographer. Those containing water and trees are the most effective for this purpose, and the binocular camera is the instrument by which such scenic representations can be best made. The camera should be planted straight in the direction of the sun, the arrangement being such as to have the sun itself included in the picture. To secure this, the picture should be taken either in the morning or evening, when the great orb has not attained such a degree of altitude as to prevent it from being included.

In order that the full effect of the "moonlight on the waters" be obtained, the exposure should be extremely rapid, the arrangement of the shutter being such as to admit the minimum of light from the sky, and thus prevent the sun from being solarized. Among the expedients for insuring this is the placing the stop of the lens in such a position as not to form a right angle with the axis of the lens, as usual, but with a leaning downward toward the immediate foreground. This causes a very attenuated pencil of light to be admitted from the top of the picture, where the sun is situated, and a large volume of light from the more dimly-lighted foreground. To suit the exigencies of this case, cardboard stops should be provided. At any rate, the stops must be very small and the exposure very rapid.

It is essential to good effect that the negative be under-exposed, with well-marked high-lights, so as to imitate nature as seen in the moonlight, when the Goddess of Night is in front of the spectator.

The method indicated is that by which the finest French "moonlight views" are taken, the image of the sun, unless in exceptional instances, being made to do duty for that of the moon. The difference in apparent diameter of these two orbs is too slight to be capable of being detected in a photograph, that of the sun being 32′ 2″, while that of the moon is 31′ 26.5″.

It is when such a photograph is printed as a transparency that it shows to most advantage; and the enormously high prices asked and readily given by *connoisseurs* for such stereoscopic slides attest the estimation in which they are held. Consummate art is displayed in printing such transparencies. If they are printed upon albumenized paper, it will be well to impart a final bluish tint to the picture by one of the preparations of anilin, which can be locally discharged, where required, by means of acid. 491

ENTER GEORGE EASTMAN

In 1877, George Eastman, twenty-three, a junior bookkeeper at the Rochester Savings Bank in Rochester, New York, bought a camera and employed a local photographer, George H. Monroe, to teach him the wet-plate process. He also began reading photographic liturature, and was attracted by an improved gelatine dry-plate formula which first appeared in the March 28, 1878, issue of the *British Journal of Photography* (and was republished in American journals). This was the process of Charles Bennett, an English amateur, who improved Maddox's gelatine process by ripening the gelatine by heating. Eastman began making his own plates, and in the summer of 1879 Monroe began using them in his own photography. Eastman moved quickly; he went to England in 1879 to see how gelatine dry plates were produced there, and before returning to the United States applied for a British patent on a device for mechanically coating the gelatine emulsion on a glass plate (an American patent for the same device was applied for and awarded on April 13, 1880). Word of Monroe's and Eastman's successful use of gelatine emulsions reached the Photographic Society of Philadelphia in November 1879, and in a short report under the heading "Society Gossip," in Wilson's journal, a society member said he "thought that possibly plates would be sent out from there [Rochester] commercially." The thought was also expressed at the meeting that Rochester might be a particularly favorable location for dry-plate manufacture because of its location near a large body of water where less extremes in humidity were to be found. In January 1880, a correspondent, E. K. Hough, visited Rochester and sent word back to the *Philadelphia Photographer* that he had seen, and was particularly impressed with, Monroe's photographs:

> He intends to use the plates in gallery work, and said that a day or two before he had taken a portrait indoors in two or three seconds, full timed on a gelatin plate, which was under-timed under the same conditions with a good working regular bath and collodion, with twenty seconds, and that speaks volumes for its rapidity.
>
> He works the modified Bennett process, but modestly disclaims any credit of his own, giving all the honor, whatever there may be, to Mr. George Eastman, an amateur there, who worked it all out in his own way, and gave it to Mr. Monroe.
>
> I asked if he thought the lake had any influence. He laughed at the idea, and he does not believe that it makes a particle of difference. I asked if he found any difficulty in hot weather, as some have. He said, not any; some of his best negatives were prepared and made in the hottest part of the summer.
>
> The power of controlling it thus is what Mr. Eastman has discovered, if I rightly understood him, and is what will make it generally practical.

On a trip to the Thousand Islands in the summer of 1880, Monroe met Edward Anthony, who expressed interest in the Eastman dry plates. A correspondence was struck up between Eastman and Anthony, and in December 1880, E. & H. T. Anthony placed the Eastman plates on the market commercially.[492]

process was used in making line engravings in various magazines and books of this period. Only recently, for example, was Moss's role in Howard Pyle's work recognized.

Moss also prepared illustrations for direct sale to the public. We find in *Anthony's Photographic Bulletin,* for example, that an "art album" prepared by the Moss Engraving Company was offered at Christmas time in 1877. The album contained twelve "beautiful pictures" produced by the Moss process, and the announcement said that it was being offered "as a contribution to the effort to disseminate widely samples of the best pictures for the entertainment of the masses and the development and education of a popular taste."

Moss's establishment was described, in 1884, as "the largest establishment of its kind in the world." But subsequent developments in the photoengraving art soon outpaced Moss, and he was forced to adopt the newer modes because of their greater artistic quality for magazine and book illustration. According to Horgan, Moss died a "disappointed man," but in his obituary in 1892 the Moss Company was said to employ two hundred people who "do the work of 2,000 wood engravers."[493]

DAWN OF THE MODERN ERA

EMULSIONWARD

By Edward L. Wilson

UNDOUBTEDLY photographers are softening toward Emulsion. It has a long time been pounded into them, and, thanks to the persistency of its advocates, it is rapidly coming into favor. The way things look now it won't be *very* long before the bath and the dipper are laid away among the buff-wheels and mercury-boxes, and even the useful Bonanza Plate-Holder will stand aside with not a splash to bless it.

In a few years the now young scions of the art will exhibit their work at the grand conventions and think themselves veterans because they will be able to say, " I used to use collodion and a silver bath ; I made wet-plate negatives," just as the veteran of to-day swells up with pride, and preludes his say at the meetings with, " Mr. President, I made daguerreotypes ! "

Do not understand, however, that this happy day has yet come. Much, very much, has been accomplished by emulsion-workers and plate-makers, but we haven't *all* we need yet. There are drawbacks to overcome, improvements to make, and qualities yet to secure, before we are ready to take emulsion plates entirely to our hearts and depend wholly upon them for our best results. But it will soon come.

It can hardly be supposed that any one who has read the PHOTOGRAPHIC TIMES for the past year or two can be ignorant of what emulsion plates—dry and wet, collodion and bromo-gelatine—are, or fail to understand fully their advantages. For this magazine has been fraught with fervor on the subject, its live editor seeing with an intuition and an insight all his own what must surely become the popular method of negative-making.

It is not the purpose of this article, therefore, to do more than two things—namely : 1, to impress the live photographer with the necessity of making trials of the process, thus helping on a work that is sure to benefit him ; and, 2, to point out a few of the drawbacks and give a suggestion or two as to how they may be overcome.

First, then, the growing ones of our craft should no longer hesitate to make purchase of emulsion plates and carefully experiment with them ; study their natures and wherein they require treatment different from that needed in the wet process, and give an account of your successes, your failures, and your discoveries to the craft. This is the way to make the thing grow, and a sure means of heading off the swarm of secret processes which are sure to infest us in due season unless the utmost liberality is followed by the enlightened portion of our fraternity.

If you haven't a nice, clean, well made and handy camera box, be sure to get one, and give the process every chance. If you have, why, a new, clean holder (no silver saver needed) should be had, for nitrate of silver often fogs the sensitive emulsion plate.

Thus equipped, go ahead. Each maker of plates supplies you with full and faithful directions. Forget that you ever worked a wet plate. Drop all your old wrinkles, get out of the rut, follow directions faithfully, and your results will charm you.

Second, as to some of the drawbacks of the emulsion method. The plates are extremely sensitive, and work very rapidly as a rule. This is considered an advantage by some. It would be entirely so were it not that such a quality compels the utmost care in protecting the plates from any white light whatever from the moment they are taken from the manufacturer's package up to the time of the application of the developer. The trials which come from this are obvious ; but, when one is accustomed to them, they will be felt but little. The extreme care necessary in development and the entirely different operations thereof

may also be considered a drawback, but time will also modify, simplify, and improve this also, and we must not be discouraged yet.

As to the process of making the emulsion, it is complicated and troublesome, hence it seems wiser—at present, at least —to purchase the plates you need already emulsionified. The prices asked seem high, but they are not unfair, all things considered. Doubtless ere long the manufacturers will have more plates demanded than they can supply, and then they will furnish the sensitized emulsion in the form of a dried pellicle, which you can soften and coat upon the plates in your leisure hours. Thus the bugbear of price will be overcome.

Everything looks hopeful. The results both in outdoor work and portraiture which some of our leading artists are securing are most admirable ; the quality of the plates offered is so superior to those of a year ago, and the encouragements so great to adopt the new method, that it seems as though now only the ones content to stand still and lag behind will fail to look into emulsion and get the good out of it. 494

DRY PLATES, ROLL FILM, AND MOTION PICTURES
1881

Concurrently with the progress of the presidential campaign of 1880, in which James A. Garfield won election by a narrow margin, photographers across the land began switching to dry-plate practice. Albert Levy's gelatine dry plates and E. & H. T. Anthony & Co.'s *Defiance* plates were taken off the market by January 1881. But others were appearing on the scene. In St. Louis, Gustave Cramer teamed up with Herman Norden (who was "one of the first to introduce dry plates in this country," according to Cramer) to perfect a commercial plate that would be better than anything previously offered. Their activity was another of the proverbial "burning the midnight oil" variety, as Cramer recalled in later years:

> In the beginning we usually worked until late into the night, and once when we had finished working one emulsion we came to the conclusion to try an entirely different method, and to do so at once. Our stock of nitrate silver being exhausted, I had to go quite a distance to my gallery for a new supply. It was 2 o'clock in the morning when we started the new emulsion, which kept us at our work all night. Fortunately, the new way proved to be a success and gave us the first perfect plates, of which I took samples to the national photographers convention in Chicago.[495]

The convention referred to by Cramer was the first held by the newly established Photographers Association of America, successor to the National Photographers' Association of America, which had run out of steam several years earlier. The P.A.A. convention was held in Chicago in the summer of 1880, and Cramer and Norden were not alone in bringing dry plate samples for exhibit. Competitive items were also brought by John Carbutt (his *Keystone* plates) and by D. H. Cross of Indianapolis, who brought samples of his new *Indianola* dry plates. A committee was established at the convention to investigate and report on the merits of the three makes, but since the members of the committee were located in different sections of the country, it was decided that their individual reports would be submitted separately, rather than jointly. The first to respond in January 1881 were T. M. Schleier, of Nashville; Edward Bierstadt, of New York; and E. Klauber, of Louisville. Cramer and Norden's *St. Louis* brand, although thought to possess too much intensity by Schleier and Bierstadt, was adjudged superior from an overall standpoint, making this the first professionally certified dry plate in America. The *St. Louis* plates "work well, develop easily with either oxalate or pyro, and give soft and brilliant effects," Klauber said in his report. "They are equal in every particular to wet plates, and work—as do all of the different manufactured plates named—in about one-eighth of the time." (At a Franklin Institute lecture in the spring, Carbutt said exposures with his *Keystone* plates were made in 150th part of a second, which he calculated to be one 270,000th the amount of time required for an exposure in the days of the daguerreotype).[496]

Edward L. Wilson was not happy with the reports. "What the fraternity wants to know *now*," he said, "is not

whose plates are best (for as with paper, so with plates, the make of one party may work better than that of another in certain hands), but whether or not the time has now come for photographers to take up the emulsion process with reasonable hope of success." But in the same breath Wilson observed that "it seems photographers are not going to wait for any committee, but are already pretty deeply involved in emulsion."

Eastman's dry plates were placed on the market by the Anthonys in December 1880 and, hence, were not included in the P.A.A. competition. But by June, their use had become widespread. George Rockwood began using them at the rate of fifty a day, finding no problems in their use during a hot spell. He also considered them "a wonderful thing for babies at 5 o'clock in the afternoon." Edward Bierstadt was delighted with their "cleanliness," and "the absence of a thousand and one imperfections that beset the negative bath." George W. Pach said he was using the Eastman plates "with great success for interiors and all other occasions where long exposures were necessary." Hugh O'Neil, chief operator at the William Kurtz gallery, disclosed that "Mr. Kurtz will have nothing else." As for himself, O'Neil said, "I presume that I have made as many, if

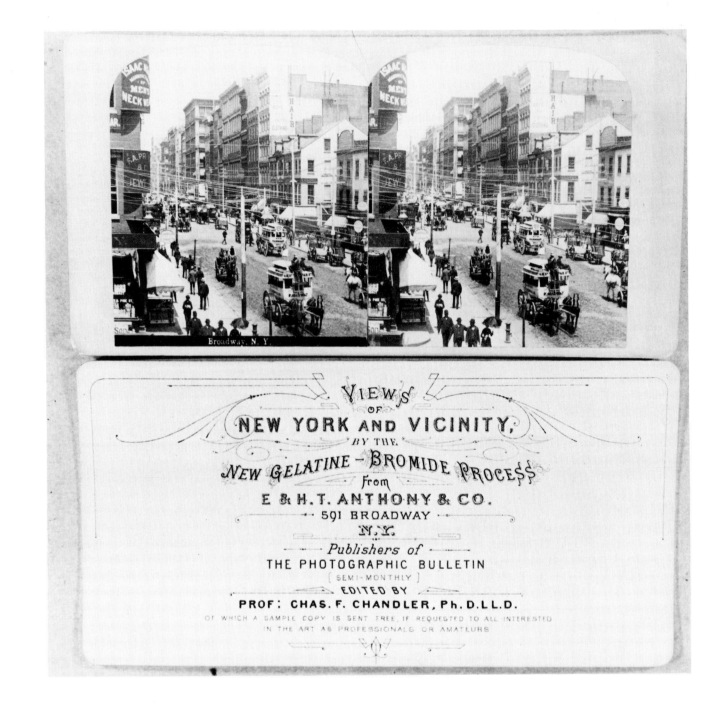

LAST ANTHONY STEREOVIEWS

As photographers everywhere began at last to adopt the new dry plates for camera work, E. & H. T. Anthony & Company issued a new series of card stereographs entitled "Views of New York and Vicinity by the New Gelatine-Bromide Process." The front and back of one of the cards in the series is shown above. But the prints were in no way superior to those in the many different series made previously by the company with the collodion process. In any event, the series proved to be the company's last, after having pioneered the "instantaneous" card stereograph in 1859 and having issued more than ten thousand titles thereafter.

1881

not more, wet plates than any man in this country . . . [and] for the first time in my experience I have been enabled to make, with dry plates, portraits as they appear on the ground glass.''

At a meeting of the Photographic Section of the American Institute held on February 1, T. C. Roche gave this report, which, as he was a principal of the Anthony firm, presumably pertained to the Eastman plates:

I made a trip to Niagara Falls the other day to put these dry plates into practical use; but the weather was not such as I desired. The light was so strong that I had to use a small stop, the diaphragm in the Dallmeyer lens being too large. I had to make smaller ones, one the thirty-second part of an inch and one the sixteenth part of an inch. I had to bring the plates back to New York to develop. I made up my mind that the ordinary developer would spoil all my negatives; I could only put a trace of iron in it and gradually coax the picture out. I developed more than forty, and I now have confidence in the plates and would take the risk of going anywhere with them.[498]

The word from Chicago was much the same. A correspondent for the *Photographic Times,* writing on May 7, observed that "about all you hear now, as you pass from studio to studio—from the most elegant to the obscure—is dry plates. The craze is upon the fraternity, and all are anxious to learn of them and to test their merits." An entire meeting of the Chicago Photographic Association was devoted to a discussion and exhibit of gelatine dry plates, and several suppliers in addition to Eastman, Carbutt, and Cramer and Norden were represented in these exhibits. Among them were the Eureka Dry Plate Company of St. Louis; the Des Moines Dry Plate Company; and a manufacturer by the name of Howe, whose plates were described as "now out of the market." Photographs from dry plates of individual make were exhibited by a number of photographers, including W. J. Baker of Buffalo; G. W. Taylor of Sycamore, Illinois; and Joshua Smith, of Chicago. The firm of Douglass, Thompson & Co. provided an exhibit which illustrated the requisites for making dry plates. These included Nelson Nos. 1, 2, and 3 gelatine; the Coignet brand gelatine; paper used by Carbutt and others; ruby glass; boxes for holding plates in a darkroom (or for holding negatives after exposure); lamps of various styles and pricing; and developing trays, one of a heavy Russian iron design, and another of a very light, japanned design. The Scovill Manufacturing Company provided what was described as a "splendid array of camera boxes." In great demand at the meeting were copies of the *British Journal Almanac and Yearbook* for 1881, which had been imported and bound by Scovill for distribution nationally. "It is rich in gelatine information," the *Times* correspondent noted, adding that after it was quoted from by a lecturer at the Chicago meeting, copies were sold to "a large number who had not thought to purchase before."[499]

T. M. Scheier, in his P.A.A. report in January, contended that the high cost of available dry plates resulted from high labor costs, rather than materials costs, and he suggested that "unless competition reduces the price of the plates, photographers . . . will make their own plates just as they make their own collodion, etc." Other professional studios besides those exhibiting at the Chicago event began making plates of their own, and to meet this competition

EXPLOSION DERAILS PLATINUM PROCESS DEVELOPMENT

To overcome one of the major drawbacks in platinum printing, Alfred Clements tested the sensitiveness of the platinum paper to a powerful light at the Technological Institute (now the Stevens Institute of Technology) in Hoboken, New Jersey, and decided that electric light would be preferable to ordinary sunlight for making enlargements by the platinum process. Clements and his partner, inventor William Willis, Jr., thereupon installed new equipment, including a steam boiler and engine to operate the lighting, at their New York establishment. Shortly before Christmas, 1880, an explosion took place which marked the first of a new series of setbacks to the process, and caused the firm to cease operations altogether in 1881 (Clements thereafter moved to Philadelphia where he began the manufacture of chemicals for the process, and to license those who wished to practice it). Following is a newspaper account of the New York explosion:

NEW YORK, December 18: The boiler in Willis & Clements' platino-zinc works, at 123 West 26th Street, was blown up shortly before midnight last night, and was thrown over the roof of several 5-story houses into the yard of No. 441 Sixth Avenue, 200 feet away. The house No. 123 is an ordinary dwelling house, in the basement of which is placed machinery. In a one-story brick house adjoining the rear wall of the main building stood an upright boiler of 5 horse power, and weighing about 2 tons. The fire under the boiler had been raked according to the statement of the engineer, and left to die out last evening, and workmen had gone away and closed up the house. At 11:30 P.M., neighbors were startled by a heavy crash and a loud rushing noise. Looking out they beheld the boiler house a heap of ruins. Doors and windows were broken and machinery upset or wrecked. The boiler was discovered in the yard in the rear of 441 Sixth Avenue, 200 feet from the place where it had stood. It had fallen into its proper position and had cut a passage for itself through the branches of a tree under which it stood in a manner that showed that it had come down almost perpendicularly, after passing over the roof of an intervening 5-story extension and a telegraph wire that ran diagonally across the block. It must have risen far above the adjoining houses, and from its position at the start and at the fall and the distance between these points, Mr. Willis, who is an engineer, thought that it must have ascended hundreds of feet. When the boiler was examined it was apparently uninjured. Only the walls of the furnace had been torn out. Two gauges that had been attached to the boiler were flung as far as 28th Street and Sixth Avenue, where they fell through the skylight of a house and into a bedroom on the upper floor in which a man was asleep. Where the boiler was found, it had done no damage except to the pavement in the yard. The damage to the machinery and the house by the explosion is estimated at $2,500. The boiler was new and had been twice examined. The inspectors will make an investigation.[500]

IVES PROCESS

Frederic E. Ives, twenty-five, who was born near Litchfield, Connecticut, but became a resident of Philadelphia, received two patents February 8 and August 9, 1881, for a "swelled gelatine" photoengraving process which he had perfected while working at the photographic laboratory of Cornell University. The process, which Ives considered superior to Moss's process, was described as follows by the *American Journal of Photography* in 1887:

> Ives' original method, invented in 1878, was to take an inked Woodbury relief and to press it against grained or embossed paper. The higher parts of the relief were forced most strongly against the paper, and consequently crushed down the grain upon it, producing a more or less solid black. The lowest part of the relief did not touch the paper at all, and consequently left no mark upon it. The intermediate parts touched the points of the paper lightly, and they received a little ink, or partly flattened them, so that they received a greater quantity, thereby producing a stipple that was perfectly graduated from solid black through a coarse grain, growing gradually finer up to pure white. The picture in this first process was copied in the camera, or transferred directly to stone or zinc for the production of an etched block by any of the known methods.
>
> The next improvement, patented in 1881, was to substitute a swelled gelatine relief for the Woodbury relief, and to take a cast from this in plaster. On this plaster cast the lines or stipple were impressed by means of an inked elastic stamp of V-shaped lines and dots, and this plan, Mr. Ives says, gives the operator considerable control over the effect. By flowing over the inked plaster with collodion, the ink picture was transferred to the resulting film, and after stripping this film off, a print was made on a dry plate. Other improvements followed, one of which was the transfer of the ink impression to a sheet of soft rubber, and thence to stone or zinc. Still more recent modifications and improvements have been made by Mr. Ives, but have not been published, because they do not concern the general public.[501]

Eastman introduced a dry-plate emulsion which could be dissolved in water then coated on glass plates by photographers themselves. But by the fall of 1881, prices of prepared dry plates were materially reduced, and the Eastman emulsion was discontinued thereafter.[502]

For the first time, David Bachrach was chosen to give the annual report on the progress of photography at the 1881 P.A.A. convention. After reporting that he could obtain dry-plate negatives equally as good as wet-plate negatives, using the *Keystone* plates (substituting ferrous oxalate for the alkaline pyro developer), he moved to the topic of photomechanical printing. He made no reference in his remarks to the controversy which had surrounded the Artotype practice, but did make the observation that "this branch of photography (photomechanical printing) is really not a part of our profession which has any practical value for the mass of photographers, being really of benefit only in connection with publishing on a large scale, as carried on by the Heliotype Company of Boston and similar establishments." The same remarks, he said, "will apply to the photo-relief processes for the typographic press." The largest amount of business in this branch of the art, he noted, was being done by the Moss Engraving Company, and the Levytype Company. Bachrach also drew attention to a new arrival on the photomechanical printing scene, namely Frederic E. Ives of Philadelphia, whose new photo-engraving process, just patented, provided a mode of obtaining typographic plates with halftone direct from photographic negatives. Bachrach indicated that Ives's results together with those achieved by others in France "give hope that this will also finally become a practical success, and when that is accomplished the application of photography to publishing purposes will be such as will astonish even the most sanguine of our art."[503]

Ives, unlike his competitor, Moss, perfected a "swelled gelatine" photoengraving method in which a photographic image was secured on sensitized gelatine. The gelatine was then made to swell, with the light parts of the picture standing out in hilly contour, and the dark parts remaining as valleys. By making a plaster cast from this, the dark parts would become the "hills" and the light parts the "valleys" (see right).

Ives's process differed from Moss's not only in the differing method of hardening the gelatine but also in the use of a type of gelatine which gave sharper relief cuts, and in the use of a different method of negative intensification. The process had essentially been perfected by Ives while he worked at the photographic laboratory of Cornell University. In 1879, he accepted a position with Crosscup & West, a Philadelphia wood engravers' firm which felt that the invention would have important commercial applications. Like Moss, Ives virtually wore himself out working around the clock during the years 1879–81, and at one point even his Philadelphia neighbors became suspicious:

> As soon as I was able to have a house of my own to live in, the third story front room was made into a workshop, study and private printing office, in which I carried on experiments and set the type for and printed two books, together with all the circulars and handbooks for the instruments I was developing. This workroom was considered a great curiosity shop by many who

DAVID BACHRACH, JR.

David Bachrach was born in Hesse-Cassel, Germany, and came to the United States as a boy, receiving his boyhood education in Hartford, Connecticut. He was chosen to report on the progress of American photography for the first time at the fraternity's annual convention held in 1881. This was just after he turned thirty-seven on July 16 and his wife, Fannie, gave birth, on the same day, to the couple's first son, Louis Fabian Bachrach. During the 1870s, David Bachrach made a specialty of making large photographs on canvas with a solar camera, after which the photographs were painted over in the manner envisioned by the camera's inventor, David Woodward, also of Baltimore. In 1875 the firm became known as Bachrach & Brother, but the name of the younger brother is not contained in present-day historical material on the famed family. Bachrach's sons, Louis and Walter Keyser Bachrach, operated separate chains of photographic studios in New England, the Midwest, and South prior to World War I, but united all of these operations to form Bachrach, Inc., in 1925. David Bachrach died in Batimore in December 1921, at the age of seventy-six. Many of his nineteenth-century negatives were lost in the great Baltimore fire of February 7, 1904.[504]

"SWELLED GELATINE" METHOD OF PHOTO-RELIEF PRINTING

To convert an untoned photograph on paper to an image which could be secured on a printing block by the so-called swelled gelatine process, the artist made an India ink drawing over the print to alter light, shade, composition, etc. The remainder of the print was then bleached away, and a new photographic negative made which was placed in contact with sensitized gelatine. After the latter was exposed to light, it was placed in a tray of water. The portions unhardened would then swell, and a cast was taken in a waxy composition, from which could be made a plaster of paris mold in which to cast the type-metal stereotype. The several stages of the photo-relief method can be depicted as follows:

negative film

sensitized gelatine

action of the light

gelatine when swelled

wax cast

plaster of paris mould

type metal stereotype

This process, as well as the electrotype and zinc etching modes of photoengraving served as the principal methods for creating magazine and book illustrations photographically until the perfection of halftone printing in the 1890s. In halftone printing, a screened photographic negative is made of the original photograph, breaking the image up into fine dots of varying size. No handiwork by an artist is required, and the dotted image can be transferred to a *metal* plate where it is etched into relief for printing on the same typographic press with textual material.[505]

THE SUPERIORITY OF CALIFORNIA PHOTOGRAPHY

After profiting handsomely from the moneymaking voyage of the *Hebe* in 1850, Isaiah W. Taber (1830–1916) became a gold miner then a rancher before returning a rich man to his native New Bedford, Massachusetts, in 1854. At first he became a dentist, but took up photography as a permanent vocation and was among the first to open a photographic gallery in Syracuse, New York. In 1864 he was invited to join the prestigious San Francisco gallery of Henry Bradley and William H. Rulofson, and in 1871 established his own gallery there. An illustrious career still lay ahead when Taber penned the article, below, to the *Philadelphia Photographer* in 1881. In 1888 he was named a commissioner of the Yosemite Valley area, which was formally established as a park in 1890. He photographed Queen Victoria's Jubilee in 1897, and later made portraits of King Edward VII. In the San Francisco earthquake and fire of 1906, he lost an estimated 80 tons of portrait negatives and another 20 tons of view negatives, an irreplaceable visual record of early California history.

In response to a query that has been put to me respecting the chief features of difference from the photographer's point of view between California and the Eastern Atlantic States, I will place myself on safer ground if I confine my localities of comparison to San Francisco on the one hand and the State of New York and north of it on the other.

As a photographer in San Francisco, I am very proud to find that public opinion has issued its pronunciamento that the quality of photographic portraiture in that city is somewhat higher than in any other city in the United States. This statement I do not make with any feeling of boasting, but merely to serve as a text, or rather a pretext for an inquiry into the reasons why the city within the Golden Gate should have this honorable position conferred upon it.

The great skill of photographers elsewhere—New York City, for example—being conceded, it is evident that it must be to something else than either artistic ability, chemical talent, or manipulative dexterity to which the Queen of the Pacific Coast owes its proud position.

One great cause lies in the equable temperature that prevails in San Francisco.

Owing to causes to be referred to presently, the heat is not so great there during the summer months as it is in New York, while during the very depths of winter it is so mild and genial that flowers and creeping plants upon the walls of the houses are in full bloom at the time when with you in the East the thermometer stands in the vicinity of zero, the water in pipes and tanks being all frozen, and the air so keen and sharp as to inflame one's face if exposed to a blast of it.

Is it to be wondered at if chemicals to be made use of in such a delicate operation as photography do their duty in an imperfect manner when furnaces or lamps have to be kept alight in the operating room to prevent the solutions from solidifying by the cold? The great wonder is, that under such circumstances they work so well as they do. It is a well known axiom that all chemical action is assisted by heat, and, if this be so, what kind of action can be expected when intense bitter cold is prevalent? The most favorable condition for working chemicals assuredly is not to be found when they are liable to become frozen out at night and have to be thawed down before getting into working condition in the morning.

Now, in San Francisco, we entirely escape this source of failure or difficulty, for, as I have said, a temperature of the nature indicated above is there quite unknown. The weather being invariably genial and mild, the chemicals always keep in good order so far as concerns the influence of temperature upon them.

Then, again, in summer, we are altogether unacquainted with that oppressive heat that prevails in the Eastern cities, and which necessitate lumps of ice being kept around the bath, collodion, and other chemicals. I have heard an Eastern photographer say that he has seen collodion frizzling on the plate when poured on, such was the heat of the latter. This is a kind of experience that is totally unknown in San Francisco. Even in the middle of summer there is a fine cool wind that blows in from the Pacific by which sultriness is altogether prevented. Our chemicals, therefore, are by comparison kept cool in the summer and warm in the winter by atmospheric agencies alone. In this, I think, is to be found the secret of the excellence of the photographic work here, coupled **doubtless, with an admirable and strong light.** [506]

Frederic E. Ives's patented ''swelled-gelatine'' photoengraving process was used to achieve improved halftones (in the printing plate) in reproducing this illustration by William Hamilton Gibson for E. P. Roe's book, *Nature's Serial Story*. Typographic plates with halftones could also be made directly from a photographic negative by Ives's new process (see page 369 for a pioneer halftone reproduction of a photograph of Edward L. Wilson, which was made by Ives's process and reproduced on soft paper in the June 1881 issue of *Philadelphia Photographer*).

visited me. . . . The fact that I spent so much time alone in this room made my next door neighbors suspicious about my occupation, and they reported to Government Secret Service agents that they thought I might be a counterfeiter. The agents visited me, but all the money I could get above living expenses at that period went promptly into new experiments and they could find no money of any kind in my place or upon my person.[507]

In Europe, meanwhile, photoengraving modes using a screening process, such as Baron von Egloffstein had used in 1865, were adopted by Joseph Swan in 1879, and by Georg Meisenbach, a Munich engraver, in 1882. These were single-line screens which were rotated or turned during exposure with a negative to achieve a cross-line effect in the image secured on the sensitized printing surface. A year later, Ives developed a ''cross-line'' screen (not introduced commercially until 1886) which consisted of two single-line screens cemented together face-to-face at right angles. Presumably, this materially enhanced his photoengraving process, however in later years he made the statement that at the time he made the change to the cross-line screen, none of his customers ''discovered any difference in the character

or quality of my work.'' But throughout the remainder of the 1880s, Ives's plates were still no match for a sturdy typographical press (used in type printing) because the screening was too fine for the printers, and the illustrations so prepared had to be printed separately, and usually on paper of a high-gloss character. Ernest Edwards, in one of his many reviews of the photomechanical printing art, agreed that the results were ''not satisfying to the photographic eye'' in mechanically produced photoengravings, but said there was no getting around the fact that ''in order to approximate the photographic effect, the lines or dots have to be so fine that the cuts cannot be satisfactorily printed with type.''[508]

Nevertheless, as the decade wore on—and particularly after the introduction of the cross-line screen—more book publishers utilized photographically produced halftone engravings, and an increasing number of such illustrations began to appear in such magazines as *Harper's* and *The Century*. In 1886 the *Philadelphia Photographer* ''noticed'' that Ives's process ''is preferred by many leading publishers,'' while similar work produced abroad, the magazine said, should be classed as ''miserably bad,'' and ''wretchedly printed.''[509]

Grand Illumination with Natural Gas, FINDLAY, O.
Photographed at night, by F. R. RAY

Prior to the 1890s, photographers rarely attempted to make outdoor nighttime photographs even with the aid of artificial light, because of the long exposures required. The top view (above) is from a cabinet card print which the photographer evidently secured by pointing his camera directly at a carnival scene illuminated by gaslight. In the bottom view, reproduced from a late 1880s card stereograph, the unknown photographer (or others) may have walked about on the street during the timed exposure carrying a lantern, which would account for the thin, wavy lines of light appearing on the sidewalk in front of the Palace Saloon (left) and crisscrossing the street to H. I. Brown's City Restaurant (right) and other buildings in the background. The town where the photograph was made is not known.

1882

278

1882

When electric light was used to illuminate an exhibition at Baltimore's Maryland Institute in January 1879, the *Photographic Rays of Light* found it "too unsteady or flickering for photographic purposes," but added: "We understand, however, that Mr. Edison has overcome this difficulty." And so he did; by September 1882, an Edison-built power generating station had been installed in lower Manhattan, for example, which was able to light up fifty-nine buildings. Although costly, this lighting was suitable for indoor photography. But exposures by electric light in photographers' studios remained about twice as long as for those made in daylight, depending on the power of the available electric light, through the 1890s.

Electric lighting installed on the exterior of buildings, or in parks, did not lend itself quite so readily, however, to outdoor night photography. Photographs were made of the Perry Monument in Cleveland by electric light in March 1882 (see next page), but the amount of time required for the exposures ranged from 3 to 4 *hours* each.

Although a few portrait galleries made a specialty of taking likenesses by the aid of electric light, it was not extensively employed for either indoor or outdoor photography during the remainder of the century. The chief problem was the high cost of its use, but it was still used to a greater extent in the United States than in Europe because of the more extensive lighting of buildings in American cities.

William Kurtz was the first to adopt it as a specialty in the fall of 1882. A year later he gave this brief description of the lighting system he used, comparing it to the system used in London by Henry Vanderweyde:

> I thought it would be best to build a chandelier, so that instead of being a slave to the light, the light becomes my slave, and this is brought about by arranging the six different lights so that each may be separately directed to the spot where the single subject or group is posed. The light falls at an angle of 45 degrees on the sitter. I have two lights near the ceiling, one about a foot from it, the other in the middle of the room. The lamps are the same as those used on the street, and the light is always available. This system of mine is much better than Mr. Vanderweyde's, because with his there is a single light only, while I have many lights, each of which diffuses with the others, thus neutralizing their individual shadows. I do not claim originality, but have simply adopted the plan universally employed by the artists all over the world, and applied it to photographic portraiture. There is no patent on it. All are welcome to it.[510]

Electric light brought a new brightness and bustle to cities at nighttime, and this tended to focus increasing public interest on theatrical personalities, adding further to an already popular "craze" of collecting cabinet card and carte de visite portraits of celebrities in all fields. A burgeoning of sales of card portraits began in the 1870s, principally motivated by photographers such as Sarony, Kurtz, José M. Mora, C. D. Fredericks, and Frederic Gutekunst—all of whom used photomechanical printing to some extent. These men set the style, using elaborate studio backgrounds, the "Rembrandt" effect in lighting (comparable to the effect

People's Picture Gallery,
LEE & STARNER,
PHOTOGRAPHERS,
COR. FOURTH & WALNUT STREETS,
WILLIAMSPORT, PA.
Photographs Taken by Electric Light.

The cabinet photograph (top) of three brothers, presumably triplets, was made with the aid of electric light, according to the photographer's printed statement on the reverse side of the card (bottom). But although it was considered an inducement for patrons in this instance, electric light was not widely used for making studio portraits in the nineteenth century.

CLEVELAND PARK.

CLEVELAND'S PERRY MONUMENT IS PHOTOGRAPHED
AT NIGHT BY ELECTRIC LIGHT

On the night of March 14, 1882, the Cleveland photographer Liebich made two photographs of the Perry Monument in Cleveland's public square with the aid of electric light. He used a stereoscopic camera with a Dallmeyer rapid rectilinear lens and gelatine dry plates. His exposures ranged from an incredible 3 hours for one stereoview to 4 hours for the other. Although he sent prints to *Anthony's Photographic Bulletin,* his views are not known to survive. The Cleveland *Leader,* in an article published two days after the feat, termed it "the first successful outdoor photograph by the electric light," but this was in error. John A. Whipple, of Boston, made two photographs by electric light of the Fountain in Boston Common on the evening of August 6, 1863. These prints are also not known to survive, although they were exhibited at a meeting of the American Photographical Society at the time. Whipple used a Voigtlander camera and made his exposures in only 90 seconds at full aperture. When Liebich made his phctographs in Cleveland Park, the Cleveland *Leader* reported that the light on top of the 260-foot mast was twice as strong as the full moon, and double that of the gas lamps which formerly illuminated the park. The newspaper gave this description of one of Liebich's photographs:

 The photograph has many peculiarities. Unlike moonlight photographing the sky is dark, and the foliage and surrounding objects remarkably clear and light. The small branches, and even the bark on the trunks of the trees, are distinctly visible. A miniature marten's house in the limbs of a tree far beyond the monument, at the corner of the park, is so perfectly photographed that the doors and windows are visible. The masts, anchor posts, and wire rope with its swivel, are portrayed clear and distinct, while even the shadow of the little railing that surrounds the drinking fountain is clear cut on the grass, the perfect detail of which is visible. In the distance the effect is alike remarkable. The buildings show as clearly as if photographed in the sunlight, and even the displays in dry goods windows across the street are seen while the sign "dry goods" on the side of the building can be read without the aid of a glass. Looking down Euclid Avenue one can easily read the signs, one of the most distinct of which is Brainard's, which is more than a block distant from the camera and nearly two blocks from the electric light. The white telegraph poles, with their outspread arms, stand out as distinctly as in daylight. But the monument itself, the central object of the photograph, is perhaps more remarkable than the surroundings. It would be difficult to get any picture with the corners and details cut sharper or more distinct. The shadows seem even more distinct than in sunlight photographs. Every detail of the sculpture is clear and the name of Oliver Hazard Perry can be read, while the inscription under the medallion itself, can be easily traced. All the weather stains on the front of the monument show up with a familiar distinctness.[511]

achieved in oil portraiture by the seventeenth-century Dutch master), or a dramatic and—for the first time—an artistic attitude toward posing. The interest in theatrical celebrities caused "runs" on orders for cabinet portraits of different actresses every year. In the early 1870s, this had been a highly profitable business for the innovators, but by 1880 the market had become glutted with cheaper-grade photographs sold by small shopkeepers and street peddlers. As one New York dealer told a *New York Times* reporter in November 1882: "People will scarcely pay fifty cents for a portrait when they can get the same thing, with a little less finish, for five cents."

The actress whose photographs were most in demand in 1882 was Mary Anderson. "She has sat for more pictures than any other woman who ever lived," according to the article in the *Times*. "It is no exaggeration to say that her photographs outsell those of any other actress two to one. She has been taken, it may be, a thousand times by every first-class photographer in the country in every possible attitude and character." Photographs of Lillian Russell ranked in popularity along with those of Mary Anderson, according to another account just three months later. Among the male attractions, the assassination of President Garfield had caused his portrait to be the heaviest in demand. As the New York dealer just quoted expressed it:

> Nothing has ever found so extraordinary a market as the Garfield pictures. The day after the President died the rush for those that had characterized his illness was trebled. One man came to me and said: "I want a million cheap photographs of Gen. Garfield and family in all the styles you have at 48 hours notice." I couldn't supply him, of course, but I kept 300 negatives running, got out ten thousand a day for three months, and couldn't begin to fill the orders.[512]

There were, just in New York City alone, half a dozen dealers at this time who handled nothing but photographs of noted people—actors, actresses, authors, lecturers, soldiers, preachers, statesmen, and politicians. The combined annual sales of these dealers was estimated by the *New York Times* to total "several hundreds of thousands" of dollars. Peddlers hawking cheap photographs on the streets multiplied tenfold after 1880, and their aggregate annual sales, according to the *Times,* totaled "a million dollars or more." American copyright laws protected American photographers from piracy of their negatives, but there was no international copyright law to prevent others (including American photographers) from copying photographs made abroad, either of foreign or American celebrities. In addition, all American-made photographs of a particularly popular celebrity were not copyrighted, because of the expense involved.

Just as the portrait of a particular actress would be "all the rage" for a while, only to be followed by that of another, so events, too, held sway on the market. In an analysis of the subject published on February 25, 1883, the *Times* observed:

> Each exciting political, social, or business event that brings into prominence certain persons is sure to be followed by a deluge of the photographs of the conspicuous individuals. The last election in this state, for instance, caused a widespread demand for the photographs of Grover Cleveland, the Democratic Governor. People are still buying his pictures out of curiosity to see

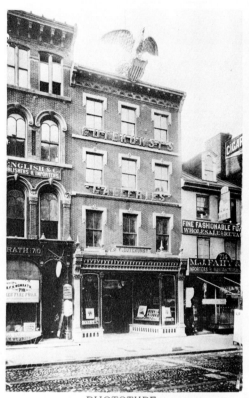

PHOTOTYPE.
(PHOTOGRAPH IN PRINTER'S INK.)
F. GUTEKUNST'S IMPERIAL GALLERIES,
712 Arch Street, Philadelphia.

Frederic Gutekunst, whose Philadelphia gallery is depicted in a circa 1870s photograph (top), and William Kurtz (bottom) adopted photochemical printing techniques to enlarge volume of sales in cabinet card and other photographs of people prominent in politics, the theater, business, and other walks of life. Gutekunst opened his gallery in 1856 and operated it until his death in 1917. Kurtz operated his at Madison Square, New York, until the turn of the century.

A EUROPEAN ESTIMATE OF AMERICAN PATRONS

Among the most noted photographers of celebrities was José M. Mora, a refugee from the Cuban revolution of 1868. Mora learned his trade from Napoleon Sarony, then established his own gallery in 1870 at 707 Broadway. In January 1881, he gave this view of what European photographers thought of their American customers:

AMERICAN people enjoy the reputation of being the most fastidious and troublesome in the world in regard to sitting for their photographs.

Of course it is only by intercourse with the photographers of other nationalities that we can arrive at any correct idea of the national peculiarities and idiosyncrasies of their sitters, and when I was in Europe two years ago, and visited many of the leading photographers in Paris and London, I was invariably made aware of the fact that when they were about to take portraits of Americans they entered upon the task in the full assurance of having to take them at least a second time, no matter how perfect might be the pose and the negative made by a first attempt. They insist upon their re-sit apparently for the excitement and pleasure it affords themselves and the desire to have a selection, quite oblivious of, or professing to ignore, the fact that such repeated sittings entail expense to the photographer, whose valuable time is also wasted upon efforts which he knows are unneeded, and ought not to be called for.

European sitters do not appear to be so unreasonable ; or then the artist there makes them feel that *he* is the master of the situation, and it is for *him* to decide upon the merits of the picture. Said an eminent French artist to me : "I invariably make the best possible pose the first sitting; and why then should I take a second, which is thus certain to be inferior to the first if I make any alteration?"

Alluding to the prevalent multi-pose fashion in the New World, my French friend inquires why this is so, and whether American photographers are not themselves to blame for thus educating the people by pandering to unreasonable and, in many instances, whimsical and silly demands.[513]

IN MEMORIAM: JOHN W. DRAPER, LL.D.

Prof. John W. Draper, one of the acknowledged "fathers" of American photography, died at his home at Hastings-on-Hudson, New York, on January 4, 1882. For most of his life he served as professor of chemistry, and later head of the New York University Medical College. Princeton gave him an LL.D. in 1860, and during the Civil War he served as one of the U.S. commissioners, inspecting hospitals after the battles of Antietam and Gettysburg. In 1875, the American Academy of Science and Arts awarded him its Rumford medal for his researches in radiant energy, and in 1876 he was elected the first president of the American Chemical Society. He was the author of numerous works, including a three-volume history of the Civil War, but his most celebrated book was the *History of the Conflict Between Religion and Science,* published in 1874. This book passed through twenty editions in the English language, and was translated into the French, Spanish, German, Dutch, Russian, Portuguese, Polish, Italian, and Serbian languages. Rome placed it on her "Index Expurgatorius," with the result that Prof. Draper jointed Galileo, Copernicus, Kepler, Locke, and Mill on the list of those under the ban of the Catholic Church.[514]

the man who received the largest majority ever given to any candidate in a single state. . . .

Since Chester A. Arthur's elevation to the Presidency his portraits have had a fair sale, which has increased notably during the last few weeks, probably owing to the prominent figure that he occupied during his recent very brilliant social season in Washington. Ex-Senator Roscoe Conkling and the Hon. James G. Blaine are about in equal demand among the photograph buyers. They both rank as "first class staple goods." Although there has been a great falling off in the demand for Gen. Grant's pictures during the last few years, the "hero of Appomattox" still has an excellent rating among the picture-dealers and he is credited with selling the best of any of the war Generals. Next to Grant comes Maj. Gen. Hancock, Gen. Sheridan, Gen. Sherman and Gen. McClellan. According to some of the sellers of photographs there is a steady and a considerable demand for photographs on the part of persons who are engaged in getting up classified sets for preservation. One buyer will want a set of military heroes; another buyer will want a complete set of the Presidents of the United States, a third will want a "set" of actors or actresses, and a fourth, perhaps, will want preachers or literary people. Of the Presidents there are three who outsell all of the others fifty to one. Those three are Washington, Lincoln and Garfield. Of the preachers, Henry Ward Beecher is, and has been for years, the most salable in a photographic sense. . . . Of the literary celebrities, Longfellow's pictures are in the greatest demand at present. There was a brisk sale of Disraeli's and George Eliot's photographs at the periods of their respective deaths, but the American people seem to care much more for the pictures of their own native born authors than for those of foreigners, no matter how popular and gifted the latter may be.[515]

LILLIAN RUSSELL
IN "THE PRINCESS NICOTINE"

Schloss — 54 West 23d St.
New York.

Nora 707 BROADWAY, N. Y.

PORTRAITS IN GREATEST DEMAND

Cabinet card portraits which sold the most in the early 1880s were those of actresses Lillian Russell (above), Mary Anderson (above, right), and James A. Garfield (right), whose assassination in 1881 caused his likenesses to become the heaviest in demand of any male portraits. Frederic Gutekunst of Philadelphia reportedly compiled the largest collection of celebrity cabinet card portraits.

PACH, PHOTO, N. Y.

SENATOR JAMES A. GARFIELD.

1882

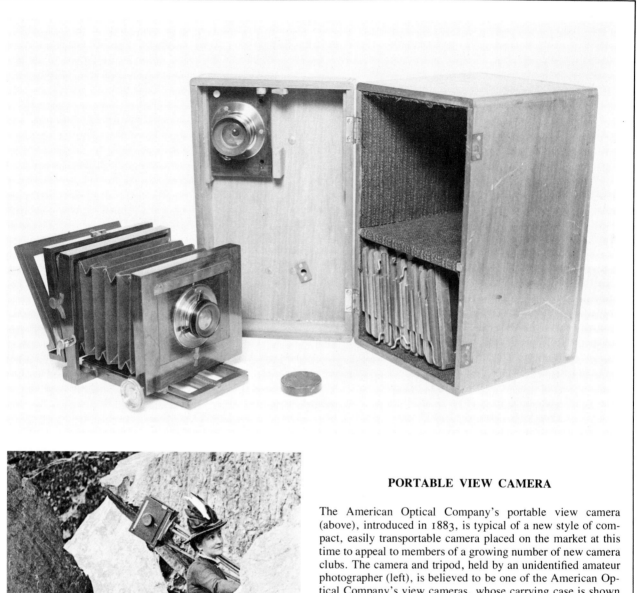

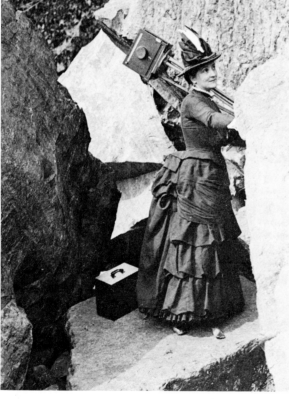

PORTABLE VIEW CAMERA

The American Optical Company's portable view camera (above), introduced in 1883, is typical of a new style of compact, easily transportable camera placed on the market at this time to appeal to members of a growing number of new camera clubs. The camera and tripod, held by an unidentified amateur photographer (left), is believed to be one of the American Optical Company's view cameras, whose carrying case is shown on the ground. Four years previous to this, a woman carrying and operating such a camera in the field would have been considered a curiosity. At that time, *Anthony's Photographic Bulletin* observed, "few towns indeed boasted the distinction of possessing such an individual, and the general public knew as little of such a personage as of amateur surgeons." But now, the magazine said, "thousands of pictures are being taken outside of the profession where one was taken before." The new amateurs "go into the highways and hedges, and secure negatives that no professional would have considered profitable to take. They become, as it were, omnivorous, and seize upon everything that comes in their way, which is capable of being photographed." Perhaps the new American Optical camera proved particularly attractive to photographers in Baltimore who, only four years earlier, were characterized by David Bachrach as being "far behind in outdoor photography." American Optical had a major outlet in that city in the Richard Walzl organization, which in 1883 functioned not only as a dealership for American Optical equipment but at the same time operated three photographic galleries in Baltimore.[516]

1883

1883

On two occasions in 1881, an English amateur photographer, Thomas Bolas, described in a British photographic journal the design of a hand-made box camera which he labeled a "Detective" camera because of its inconspicuous nature, and the minimum number of "suspicious looking features" used in making photographs with the device. As is frequently the case with a revolutionary new product, established manufacturers failed to see the immediate potential.

Two years later, on January 3, 1883, William Schmid, of Brooklyn, New York, was awarded an American patent for the first commercial version of the hand-held "Detective" style box camera. It weighed 3.3 pounds, and provided a rectangular viewing window which enabled the user to see the photograph he or she was about to take. The rear of the camera accepted one double plate holder, which could be used twice to make a 3¼ x 4¼ exposure on a glass negative. Schmid assigned his patent to E. & H. T. Anthony & Co., enabling that firm to be first on the market with this revolutionary style of camera.[517]

Other cameras came on the market at this time which also played significant roles in the coming boom in amateur photography. One was a small, square "pocket" camera developed by William H. Walker & Co., of Rochester, New York, which would make single exposures of 2¾ x 3¼ inches on a dry plate. The camera was designed for use on a tripod, but its most unique aspect (from the amateur's standpoint) was that it was manufactured of interchangeable parts, which allowed easy parts replacement. In addition, it was sold as part of a complete photographic outfit, consisting of chemicals, darkroom accessories, printing paper, cards for mounting finished prints, and an instruction booklet. To anyone who would form a photography club and send in an order for five cameras (which could be purchased separately), an additional camera was offered free. In another "first," Walker placed advertising for his camera in more popular magazines, such as *The Century,* as well as in the standard photographic journals.

The American Optical Company, noting the rapid growth in photography clubs and "outings," placed an attractive portable "American View Camera" on the market which provided compact space for a camera and carriage of up to a dozen dry plates (see opposite page).

Another "Detective" camera was introduced in 1855 by H. V. Parsell, and H. V. Parsell, Jr. (see next page). It was a rectangular box design patented by the father-and-son team. According to their promotional literature, the Parsells designed the camera "to resemble a lady's reticule, or a case such as a physician frequently carries." Following the placement of the Parsell camera on the market, E. & H. T. Anthony & Company's principal competitors, Scovill Manufacturing Company and the Blair Camera Company (of Boston), joined in the competition, and thus began photography's mass merchandising of hand cameras in a variety of forms which has characterized the camera market ever since.

William Schmid's "detective" camera, patented January 2, 1883, was the first of the hand-held, box style variety produced in the United States which could take "instantaneous" pictures in the manner in which candid pictures are taken today. Camera was marketed by E. & H. T. Anthony & Co.

The Schmid camera, a year after its introduction, was said by its manufacturer to have "practically revolutionized" the taking of instantaneous photographs:

Until very recently, the taking of an instantaneous picture was not a work to be undertaken without a great deal of preparation, and so much apparatus, that few except the most courageous amateurs dare face the inevitable crowd, which in all public places attended the artist, without at least one assistant. A picture in a crowded street, a workshop in any busy corner where interesting subjects were to be found, was as impossible as to set up an instrument in the centre of Broadway upon a week day.

The Detective Camera, however, has practically revolutionized the taking of instantaneous pictures. This small sized, complete, portable instrument, with the still more complete methods of controlling the exposure, is what its name denotes, a Detective Camera, capable of being used in almost any situation. It is so compact that it may be taken under the arm and a lady might without attracting any attention go upon Broadway, and take a series of photographs, feeling perfectly sure that she would attract no more attention than she would if she carried a work-box or work-basket. With such an instrument, all fields are open to the amateur. His apparatus can go with him wherever he can carry it, and whenever there is sufficient light for work he is enabled to seize his subjects at the very best moment and secure effects which are utterly beyond the reach of one who has to travel with a more elaborate apparatus.[518]

The Parsell camera (shown above) made dry-plate photographs of size 2.5 inches square. The camera could hold six double plate holders, one in position for taking pictures and five in a rear compartment. A shutter mechanism allowed taking of either timed or instantaneous exposures.

But with the mushrooming sales of new dry-plate cameras of great variety, there was now, as Anthony's *Bulletin* observed, "scarcely a limit to the size of prints of this character that can be produced." The magazine marveled at instantaneous photographs of size 12 x 15 inches which George Rockwood made in February 1883 of a yacht under full sail. Rockwood followed this in May by hiring a steam tug to go out into New York Bay at the time of the opening of the Brooklyn Bridge, where with some sixteen operators and assistants he made 160 exposures of moving objects in the bay on plates ranging in size from 5 × 8 inches to 14 × 17 inches. Rockwood wrote Edward L. Wilson with considerable pride that he had secured "over a hundred good negatives *of* these moving objects, taken *from* a moving object." Responded Wilson: "Who can beat it, and what other process [gelatine dry-plate process] makes such a feat possible as this?"[519]

Most of the new dry plates being offered commercially were about ten times as sensitive as the wet collodion plates previously in universal use. To some, this sensitivity was not recognized at first, and after overexposing their plates they complained of the results. Even George Eastman ran into trouble because of his (and presumably everyone else's) failure to understand, precisely, what it took to preserve the sensitivty of the gelatine in supplied dry plates. A sulphur-bearing compound was required, but this was not at first recognized. When complaints began to come in about the sensitivity of Eastman's plates (relayed through the Anthonys), Eastman closed down his Rochester plant and rushed to England to purchase the best plate formulae for comparison with his own. The problem was quickly recognized thereafter, and Eastman renewed his manufacture, refunding the purchase price on all spoiled plates.

1883 Problems or uncertainties lingered among professional photographers, as well as amateurs, in their use of dry
286 plates. "I would like to hear of the quickest way of fixing

gelatine negatives, with which I have had trouble," Benjamin J. Falk stated at a meeting of the Photographic Section of the American Institute on January 2. This led to a discussion on the pros and cons of using cyanide, after which the chairman, Henry J. Newton, asserted:

> In my experience in trying different makes of emulsion gelatine plates, I have found no two have worked just alike, especially in the fixing, and from my observation I have learned that the makers as a rule went upon the principle of getting on all the gelatine they could, depending on its quantity rather than bromide of silver to produce the picture. Now it may seem like economy, but I think it is very poor economy, because if I can coat two plates with an ounce of gelatine and the proper quantity of silver instead of one, by putting it on thin, I economize. Some commercial plates will fix as quick as collodion emulsion, so much depends on the quantity of gelatine used.[520]

Dr. Hermann Vogel, who once again visited the United States to attend the annual convention of photographers, indicated that similar problems were being encountered in his country. "There is much more difficulty to fix and to work out a gelatine plate than a collodion plate, especially if the first be reinforced by mercury salts, and many careless photographers who look after their gelatine negatives of the past year find them discolored and useless to make a print from." Elsewhere in his speech, Dr. Vogel alluded to the importance of amateurs throughout the history of photography's development, most recently in perfecting the gelatine dry plate. Then he made this rather profound analogy:

> We have a very interesting instance in Germany that amateurs elevate the art. Why is Germany the most musical land of the world? Why do you find music there more appreciated than in any other part of the world? Because we have so many musical amateurs. And in spite of the numerous amateurs, the position of the musician in Germany is an excellent one; they are esteemed there more than in any other country.[521]

The swelling of the ranks of amateur photographers, both in Europe and the United States, was just beginning to take place at this time. Soon, this phenomenon would be followed by various movements seeking to achieve "aesthetics," "naturalism," or "impressionism" in photography, and within a decade amateurs would organize the first major exhibitions of artistically rendered photographs at museums in Germany. But for the time being, there remained what one photo historian has characterized as a "dearth" of artistic expression in photography the world over.

A loosely organized revolt against the alleged "conservatism" of the National Academy of Design's leadership in the art world does appear, however, to have had an effect on photographic portraiture. The New York author and art critic Charlotte Adams pointed this out in a series of articles which appeared in the *Philadelphia Photographer* in the summer of 1883:

ACTORS PHOTOGRAPHED ON STAGE WITH THE AID OF ELECTRIC LIGHT

At midnight, May 2, 1883, Benjamin J. Falk made a celebrated photograph of the cast of ''A Russian Honeymoon'' on stage at the Madison Square Theater in New York, using thirty electric lights suspended from the ceiling around the theater. ''The result obtained,'' Falk said after the feat, ''seems to establish beyond a doubt the fact that the electric light in large quantity can be managed photographically to exactly imitate the effect of sunlight over an extended surface; also that it exerts almost identically the same actinic force on the sensitive plate.'' Although considered a ''first'' at the time, Falk's achievement was preceded by a similar undertaking accomplished three years earlier by William Notman, who photographed a group of Harvard students on stage in the Greek play ''Oedipus'' at the Saunders Theater in Cambridge, Massachusetts. ''The thing was with Mr. Notman more an experiment than a speculation,'' the *Photographic Times* noted later, ''and it cost him about $500 to put in the apparatus and accomplish the deed; but the pictures were so admirable that he unexpectedly *cleared* by the sale of them about $1,000.'' The stage scene depicted in the card stereograph above is undated, and unidentified as to location or performance, but appears to have been made in the 1880s.[522]

GEORGE G. ROCKWOOD

One of the little known sidelights of history is the fact that some of the earliest photographs ever taken of moving vessels from the deck of another moving vessel were those made by George G. Rockwood during the colorful ceremonies attendant to the opening of the Brooklyn Bridge in May 1883. Rockwood was managing editor of a Troy, New York, daily newspaper when he took up photography in 1853, and moved to St. Louis. He had established his first New York gallery when, reportedly, he made the first carte de visite photograph in America (in 1859), of Baron Rothschild. His first female patron was Mrs. August Belmont, of whom the first American vignetted carte de visite was also reportedly made. "Probably few photographers have personally made so many sittings," *Anthony's Photographic Bulletin* observed in 1881. The estimate then was 113,000. Rockwood experimented with photoengraving in the mid-1870s, but is not known to have been successful in this venture. He is credited with being among the first to adopt use of Eastman's dry plates. Rockwood's gallery was located at 17 Union Square in New York.[523]

The great art-movement which has been going on all over the country during the past few years, has naturally influenced all those branches of art, which, fundamentally considered, are also mechanical processes, and, proportionately, the claims of photography to rank as an art, have been increasing in strength and importance. A new school of photography is arising, notably in New York, the actual art center of the United States, which bears about the same relation to the old that the younger body of American artists does to the elder. This new school of photographic art is not satisfied with merely producing likenesses of literal representations of figures or objects. It accords to its subjects, and seeks to employ in its methods, approximately the same treatment that would be given to a picture in oil or watercolor. Pose, composition, both of ensemble and of detail, warmth or coldness of tone, breadth, force and delicacy of treatment, effects of light and shade, the various qualities of color produced by different handling of black and white, are all considered by the artistic photographer of today. The progress of American photography is keeping pace with that of American art, and the relation and reciprocal influence of these two forms of artistic production, hitherto considered widely distinct, are every day becoming closer and more powerful. The term "photographic" is losing its contemptuous significance as applied to the character of a picture, and on the other hand, the highest praise that can be accorded a photograph is to say of it that it is artistic or pictorial. It is to the younger American artists that photography owes much of its present impulse in the direction of artistic development. This has arisen partly from the general interest which has been awakened among artists at large, with regard to reproduction processes—the so-called "mechanical processes" of various kinds—and partly from the fact that photography is largely employed in engraving and kindred arts of illustration, forcing a sort of interpretive medium between artists and the public. Many New York artists are now directly interested in photography, some for the sake of the art itself, others for the advantage of being able to photograph their own works, others in order to catch a fleeting landscape effect, and others for convenience in painting accessories. . . .[524]

Despite such encouraging signs in photographic portraiture, David Bachrach was at the same time lamenting the loss of taste and quality in American stereophotography. In an article suggesting an improvement in stereoscopes, he lashed out at what he called the "decadence" of stereo pictures currently on the market:

> There is not a man in this country who has the backbone and grit to get up a reputation and command the prices of Mr. Wilson, of Aberdeen, whose views, in my opinion, have never yet been equaled, both for selection and execution. When we do as he does—keep only the best negatives; work for quality, not quantity; issue only the best prints and make a reputation gradually, and adhere at the same time to living prices—then, and not until then, will the better class of patrons again take hold of them. Is it not about time to learn the lesson taught by the "chromo?" To cheapen art in quality and price is to kill it. In this country we are short-sighted. Everything is done for present profit, leaving the future to itself. No sooner does anything pay than a horde rush into it and kill the goose that lays the golden eggs.

VOGEL COMPARES AMERICAN, EUROPEAN PHOTOGRAPHY

Attending a national American photography convention for the third time, Dr. Hermann Vogel made this analysis of the photography scene:

> Thirteen years ago only a few American pictures reached us in Europe ; to-day we find in every art shop window of Berlin American pictures, and they are sold by our photographers as masterpieces. We have introduced into Europe, American cameras and American backgrounds. If you have learned in the past from us, we now learn from you.
>
> Very often I am asked, What is the difference between American and European photography ? Is there any in general ? It is true you use the same lenses, the same apparatus, the same chemicals and papers as we do. The main field of photography is in America and Europe the same—the portrait, the likeness. You retouch the negative as we do, and, are anxious to improve the artificial qualities of a picture. But in America you have not so many portrait painters as we in Europe. Life size photographic pictures are an exception in Europe, because our painters make them, while in America the life size picture is an important branch of portrait photography, and, I must confess, in this branch American photography goes ahead.
>
> Still more difference I observe in landscape photography. The stereoscopic picture is much more esteemed in America than in Europe ; I think there is no parlor in America where there is not a stereoscope. The main difference is that photography in America is much more esteemed by the scientific men, by the men of industry, and the people in general, than in Europe. If any scientific expedition is sent to the far West or to any part of the world from America, certainly a photographer will join it. More than that : American photographers have been the pioneers and have told by true pictures to the world the wonders of the mammoth trees of the Yosemite Valley and the Columbia River before scientific men reached there. American photography has more merits for geographical knowledge than big hand books. In Europe, I am sorry to say, the scientific value of photography is only partially acknowledged.
>
> A great many scientific men who intended to travel in Asia and Africa have visited me a few days before their departure, to learn in a hurry something of photography in twenty-four hours ; and because photography is esteemed in America by everybody, its position is a better one, and the photographer is more honored than in Europe. [525]

WHAT CONSTITUTES ART IN PHOTOGRAPHY?

The veteran Civil War photographer J. F. Coonley gave these opinions on this subject at an 1884 meeting of the Photographic Section of the American Institute:

> In looking over the great number of photographs that we see in such profusion, if we examine them critically we are forced to the conclusion that far the greater part of them were made by persons who have very little taste or education in the direction of art, and if the same tests were applied to them that pictures in an art exhibition are subjected to, but few would pass the ordeal without being terribly scarified. The same defects are apparent whether they are portraits or out-door views from nature. The most of them will be found wanting in one or more particulars, and not what they might have been if made by some one with more taste or cultivation in securing picturesque effects. This talent, or whatever you may choose to call it, is a natural gift born with the individual possessing it, and is capable of being developed to an extent often arriving at a degree of excellence so that anything it comes in contact with of this nature not in harmony with its ideas or feelings causes as palpable a discord to the feelings of its possessor as does a false note in music to the ear of an accomplished musician.
>
> Pictures of all kinds, no matter how made or by whom produced, are a combination of effects, and the more harmonious and brilliant these effects can be produced, the nearer they approach nature and the ideal of the true artist. Without these characteristics they partake less of the artistic and more of the mechanical. Comparatively few of the great army of men engaged in photography ever attain a name or celebrity beyond a limited circle or local reputation. The great world beyond or outside never hears of them or knows that they have being. Those who do make their mark and become famous will be found in every instance to be men who have a natural talent in the direction of art, and in many instances have devoted years of their lives as professional artists in some of its various forms before they embarked in photography. The school they have thus passed through has admirably fitted them to assume and take position in its foremost ranks. They may be young in the business, but their natural gifts in art studies, and their former associations in this direction has enabled them to assume prominence by the superior quality of their works, and their names are household words in many lands. [526]

In 1883, the St. Louis dry-plate photography pioneer Gustave Cramer and his co-worker Herman Norden dissolved their partnership which had led to introduction (in 1881) of the first professionally certified dry-plate negatives in the United States (see page 271). Although Norden went into business for himself (first in St. Louis, then in the east), he returned to St. Louis in 1889 to take charge of a department in a much larger business operation which Cramer had by then established. Cramer continued to manufacture dry plates and other photographic supplies until the turn of the century.

The only way to check this tendency is to cultivate the public taste up to the appreciation of quality. 527

But ironically, just the sort of revival Bachrach wanted was getting underway at that very moment—but as a vast and profitable business undertaking, not simply a revival or renewal of taste as exercised by individual photographers or the established publishers. In Kansas, the brothers Elmer and Benjamin Underwood (neither of them yet twenty-one) were arranging for a new distribution network for card stereographs west of the Mississippi, and in 1884 established themselves as the sole agents throughout the United States for Charles Bierstadt of Niagara Falls; J. F. Jarvis of Washington, D.C.; and the Littleton View Company in New Hampshire. Thus was launched the famed Underwood & Underwood enterprise which quickly revitalized the trade, principally through sales of boxed sets of stereoviews and through the packaging of whole series of expertly made and professionally approved views for educational instruction. The company pioneered door-to-door sales of stereoviews, and by 1901 was manufacturing views at the rate of twenty-five thousand a day. In the 1890s, another major competitor, the Keystone View Company, entered the field, ultimately purchasing the negatives of vast numbers of publishers, including Kilburn and (in 1912) Underwood & Underwood as well.[528]

1884

By 1884, vast numbers of new recruits had joined the ranks of amateur photographers, attracted by the simplicity of the new "Detective" and other hand-held or easily transportable cameras using dry plates. In the spring, *Anthony's Photographic Bulletin* said the increase was so phenomenal as to have no parallel in the history of any other art. The *New York Times,* on August 20, observed editorially that the new "camera epidemic" could be likened to the cholera disease then spreading throughout Europe. The "worst ravages" of the "true lamina sicca type" of the camera variety, the *Times* said, were occurring in the summer resorts of northern New York, and in Long Branch, New Jersey, and Newport, Rhode Island.[529]

But William Metcalf, writing several years earlier in the *Photographic Times,* had put his finger on a problem which continued to plague photography as well as other art forms in America. This was "a well-developed love for art," which he contended was wanting among Americans:

> Their reputation for mechanical ability is known the world over. No nation equals them for inventive genius. Their artistic qualifications—"aye, there's the rub"—are still slumbering, and will only be awakened when the fathers and mothers of the nation come to a realizing sense that the æsthetic side of their children's nature needs care and culture quite as much as those others which, until quite recently, have received exclusive attention. The common-school education which the American boy receives is quite enough to start him well in life, enable him to make a comfortable living, and perhaps a fortune; but his dormant sense of form and color has received no impulse, and he jogs on through the world cheated out of much that helps to make life worth living.
>
> When every pupil in every public and private school in the land shall be carefully instructed in the elements of drawing and coloring, not as an accomplishment merely, but as a part of his education as important as arithmetic, then, and not until then, may we hope to see more amateurs in every branch of art; then shall we also find in our decorative workshops American designers, places now filled almost without exception by foreigners.[530]

David Bachrach's career may be taken as typical of what Metcalf was talking about. At age thirteen or fourteen he served as a tintype photographer's apprentice, and at sixteen he was launched on his illustrious photographic career. Then came the years of stereophotography around the American circuit, followed by the opening of a gallery of his own when he was twenty-four. After that, as Bachrach himself confessed towards the end of his life, he "had to acquire a little taste in posing and lighting, which took years to succeed with partially."[531]

But in the career of another famous American photographer, Alfred Stieglitz, we find a totally different story. Initially, Stieglitz's father took his son to Europe when Alfred was seventeen and entered him in the Berlin Polytechnic Institute, believing that the future belonged to engineers. But Stieglitz became attracted to photography after seeing an inexpensive camera outfit in a Berlin shop window, and when he learned from a co-student that Dr. Hermann Vogel was lecturing on aesthetic theory as applied to photography in another course at the Institute, he enrolled immediately in Vogel's class. "The other students," he said later, "had no inkling about the driving force within me." Stieglitz's sense of form and color was anything but "dormant," and now he was given that added "impulse" to embark on a career which not only helped to bring about but in the fullest sense *personified* a new dimension in American photography.

Stieglitz was less interested in Vogel's lectures on photochemistry and spent as much time as he could working in the Institute's laboratory. When he complained about restrictive hours of scheduling for their use, he was allowed to volunteer to be responsible for the rooms during hours of his own choosing. Dr. Vogel taught him the rudiments of focusing, curtain manipulation, and lighting control, and he soon began the practice of photographing an object—a brick wall, a plaster cast of the head of "Apollo Belvedere," etc.—in repeated exposures in an effort, as he expressed it, "to fathom the secrets of variations of light." In this early period of his studies, he also developed a preference for platinum paper over the standard albumen, using it almost exclusively until years later when it became difficult to buy. The blue-black appearance of the images printed on platinum paper he found much more to his liking, compared with what he characterized as the "hard, cold prints" on the albumen paper.

One day in 1884, Dr. Vogel asked to show some of Stieglitz's photographs to a group of distinguished painters. While Europe's awakening to the potential of artistic expression in photography was still several years away, it appears that this twenty-year-old American in Berlin was among the first to awaken this interest among some of Germany's leading artists. Of the group who were shown Stieglitz's prints, several expressed the desire to have copies; one, according to Stieglitz, remarked: "Isn't it too bad your photographs are not paintings. If they had been made by hand, they would be art."

Stieglitz at first worked the wet-plate process, but soon acquired dry-plate equipment. Speed in the taking, developing, and printing of his photographs became a mania with him, and when he was asked why this was so, he responded that newspapers would in future be reproducing photographs more frequently, and that speed would become of increasing importance in this type of activity.[532]

NEW YORK AMATEUR SOCIETY TAKES ITS FIRST FIELD TRIP

On June 20, 1884, shortly after the founding of the Society of Amateur Photographers of New York, a party from the society took a field trip on the Hudson River aboard a private yacht. Among those in the group was the society's founding president, Frederick C. Beach, an editor of the *Scientific American;* Beach's uncle, Moses S. Beach, a former owner of the New York *Sun;* and Henry J. Newton. The *Photographic Times* gave this description of the event:

The beautiful river and mountain scenery between Peekskill and West Point, on the Hudson River, was the objective locality selected, and afforded the party abundant opportunity to make picturesque photographs.

The party took the eight o'clock train from the Grand Central Depot, for Peekskill, and were met there by Dr. P. H. Mason, Moses S. Beach, and Mr. Atwood, formerly of New York. They were then conducted to the steam yacht "Zephyr," which lay at the wharf near the depot, by Dr. Mason and Mr. Beach. Cameras were now unpacked, mounted upon their tripods, and everything made ready for work.

Prior to their departure, photographs of the party were made by Mr Atwood, formerly of New York.

The light was excellent and the day very clear, the atmosphere having been purified the night before by thunder showers. Light clouds dotted the sky, casting their shadows upon the round and symmetrical mountain-tops, forming a superb background for the many landscape views which were secured. A light north-west wind made the sail up the river comfortable and agreeable. The following amateurs were with the party: Henry J. Newton, James B. Metcalf, P. Grant, P. Grant, Jr., Wm. Chamberlain, Gilbert A. Robertson, C.W. Dean, Dr. P. H. Mason, Jacque M. Rich, F. C. Beach, President, and Jos. S. Rich, Treasurer. Dr. Mason assumed command of the boat, and she was headed down stream for a short distance. Here Mr. Newton, Mr. Robertson, and Mr. Beach took a small boat ashore to obtain some views of the Raceway and Dunderberg mountain opposite. Continuing on up the river, the next excitement was the photographing of the "Chauncy Vibbard," as she passed by under the shadow of Dunderberg mountain, on her way to Albany. It was an interesting sight to see

some seven or eight men standing on the deck behind their cameras ready to let go the shutters as the steamer speeded by, and the successive click of each shutter as the "Vibbard" came opposite the center of each instrument reminded one of the firing of guns by infantry in succession. Some good pictures were obtained, and their effect was heightened by the beautiful clouds which appeared at that moment.

Passing on, several views were made from the boat of the fine rock scenery which jutted abruptly into the water, and in a short time the party were brought to Iona Island, a locality noted for the height of the surrounding mountains and the beautiful scenery. Here all hands disembarked, carrying their instruments ashore; several views were taken, the one which proved the most attractive being that of Anthony's Nose, on the east bank of the river opposite the island.

On boarding the yacht again, the party were conveyed up the river to Garrisons, and *en route* refreshed with lunch, which had been provided by Dr. Mason. A few drop-shutter exposures were made on passing vessels. At Garrisons, a belated member of the party was taken aboard, and the boat continued on to West Point, the authorities there having kindly given Dr. Mason the privilege of landing.

West Point foot-way was ascended, in a broiling sun, by six or seven of the party, who were repaid for their labor in securing some fine views of the river and surrounding mountains. Pictures of the cadets and their camp were taken, and of portions of the celebrated Flirtation Walk which winds through the woods from the hotel to the wharf. Those who remained on the yacht were successful in obtaining excellent drop-shutter photographs of the steamer "Albany" on her way down the river.

At three o'clock, the whistle was sounded for members to return, and in few minutes thereafter the yacht started up the river. Some views of the Storm King and bits of scenery along the river were taken from the boat. She then turned homeward, stopping occasionally by the way for a view.

Shortly after five o'clock the party landed at Peekskill and took the six o'clock train to this city.[533]

The Paterson, New Jersey, photographer, J. P. Doremus, fitted out this floating gallery at a cost of $4,000 to make scenic photographic views of the Mississippi River and its tributaries, extending from the Falls of St. Anthony to the Gulf of New Mexico. The circa 1884 card stereograph was made of the gallery at Oceola, Wisconsin.

Possibly Stieglitz was influenced by the increasing attention which various photographic journals were paying to what was now characterized as "process work" (see page 294). Stieglitz's sentiments were expressed concurrently by others. George Gentile, in reporting on the progress of photography in the spring of 1885, for example, said "I predict it will not be long before every newspaper of any importance will have a photographer attached to their staff." *Anthony's Photographic Bulletin* foresaw "a new branch of the photographic business" wherein amateurs would play a new role (much like the modern picture agency) in servicing artists as well as illustrators:

> With such an army of photographers seeking every view which by any possibility can be made into a picture, trying every possible experiment and working with a zeal and courage that is worthy of all commendation, it seems as though their labors should be made remunerative not only to the individual but to the public. The most feasible plan that we have been able to devise by which the work can be utilized seems to be one which practically introduces a new branch of photographic business, and which may not only make the la-

bor of the amateur profitable to the world but of pecuniary benefit to himself.

We must remember that this is an age of illustrations, and every year brings with it an increasing use of pictures of every description, for amusement, instruction and pleasure. Indeed it would not be surprising if history should call this the beginning of the age of art. To the artist a "study," as it is called, is absolutely essential. Without studies, pictures of a high class would become well nigh impossible. To produce studies, however, requires much time and labor, and many artists are buying photographic outfits in order to enable them to obtain a certain kind of studies, which they need for various classes of their work, with ease and speed. Until the advent of instantaneous photography certain subjects were rarely attempted, save by specially favored artists, or those who were unusually gifted by nature with quick and accurate perceptions.

Suppose now that at some central point an exchange or business agency be established where the army of amateurs can send

1884

FIRST WHO'S WHO OF
DRY-PLATE MAKERS

The list below, published in January 1884, grew to nearly thirty by 1889, when the annual output of plates was estimated to have reached 80 million:[534]

> John Carbutt, 628 Chestnut Street, Philadelphia, Pa.
>
> G. Cramer, Buena Vista and Shenandoah Avenues, St. Louis, Mo.
>
> Chicago Dry Plate and Mfg. Co., 2449 Cottage Grove Avenue, Chicago, Ill.
>
> C. F. Richardson, Leominster, Mass.
>
> M. A. Seed Dry Plate Co., 306 Walnut Street, St. Louis, Mo.
>
> Monroe Dry Plate Co., Rochester, N. Y.
>
> Neidhardt Dry Plate Co., 360 Milwaukee Avenue, Chicago, Ill.
>
> Rockford Dry Plate Co., Rockford, Ill.
>
> Allen & Rowell, Boston, Mass.
>
> David T. Weld, Freeport, Ill.
>
> H. Norden, 827 Chouteau Avenue, St. Louis, Mo.
>
> Dumble & Mawdsley, Rochester, N. Y.
>
> Inglis & Reid, Rochester, N. Y.
>
> W. L. Colclough, 1846 Fulton Street, Brooklyn, N. Y.
>
> Blair Tourograph and Dry Plate Co., 471 Tremont Street, Boston, Mass.
>
> C. & V. E. Forbes 22 Tremont Street, Rochester, N. Y.
>
> Hub Dry Plate Co., Mason and Aborn Streets, Providence, R. I.
>
> Johnston Dry Plate Co., 14 Arcade Building, Buffalo, N. Y.
>
> Crystal Dry Plate Co., 76 West New York Street, Indianapolis, Ind.
>
> Iowa City Dry Plate Co., Iowa City, Iowa.
>
> Challenge Dry Plate Co., 231 Centre Street, New York City.
>
> I. W. Taber, San Francisco, Cal.
>
> Dr. S. C. Passavant, San Francisco, Cal
>
> G. H. McDonald, 289 West Madison Street, Chicago, Ill.
>
> H. A. Hyatt, 411 North 4th Street, St. Louis, Mo.
>
> New York Gelatine Dry Plate Works, Ralph Avenue and Monroe Street, Brooklyn, N. Y.
>
> Eastman Dry Plate Co., Rochester, N.Y.
>
> Hazenstab Bros., St. Louis, Mo.
>
> Crowell Dry Plate Co., Rochester, Minn.
>
> Frank Norris, Suspension Bridge, N. Y.
>
> H. Schaefer, German Dry Plate Co., Coldwater, Mich.
>
> St. Paul Dry Plate Co., St. Paul, Minn.

PROCESS WORK

A new term, "process work," had crept into the photographic language by this time, and within another ten years it would become the subject of regular sections of news coverage in photographic journals. The term applied to the techniques used in utilizing photographic negatives in the printing press. By 1884, all portraits published in newspapers were being made from photographs, as were those landscape or other views where extreme accuracy in reproduction was wanted. Photographs were customarily altered before their final reproduction by a printing press. They were either photographed on wood and then passed on to engravers (who could make the changes or alterations before printing) or untoned photographic prints were made on plain paper, over which artists could trace the designs with pen and India ink (making such changes or alterations as were wanted). Prints made in this fashion were bleached away, after the pen-and-ink alterations, with a solution of bichloride of mercury in alcohol, leaving a drawing on perfectly white paper. Once again, photography was used to make the printing block by one of various "processes." These could be classed under three headings: the etching method; the photo-relief plate method (see page 275); and the photo-electrotype method. The etching method was performed usually on a plate of zinc, in which the whitest or hollow portions of the plate were dissolved by an acid. The photo-relief method, as we have already seen, would produce a printing plate in stereotype metal. The electrotype method involved sensitizing gelatine differently from the manner used in photo-relief, and provided an electrotype plate. This was considered the most serviceable plate for newspaper work, although zinc plates were considered better (particularly in Europe) because of the superior results achievable with highly skilled labor in plate making.[535]

prints from their negatives, and place them on sale. Here, classified, catalogued and ready for reference they would be accessible to the artist, the author, the illustrator, the designer, the teacher and in fact by all classes of people who desire studies. It would form a library of artistic information whose value it is difficult to form a conception of in advance of its establishment. Not only would the work of the amateur be made practically useful with such an or-

A TESTIMONIAL DINNER FOR THOMAS C. ROCHE

One of the most obscure but significant episodes in the annals of nineteenth-century American photography was a testimonial dinner for Thomas C. Roche held on the night of March 18, 1884, at Martinelli's Restaurant, 110 Fifth Avenue, New York. The idea was conceived by Henry N. Grenier by way of "reciprocity" for what he considered the "many good services" which Roche had performed for the photographic fraternity. It was meant to be a quiet affair, but the responses to the invitations sent out necessitated holding it at a large restaurant. "Never before in this city were seated together so many honored and shining members of the craft, to render homage to one of its humblest though worthiest of representatives," observed *Anthony's Photographic Bulletin* following the event. Although neither Anthony was present (Henry T. Anthony was ill), both Edward and his brother sent congratulatory messages to be read at the dinner. It was a night of many speeches, not only touching on Roche's career but covering progress in such fields as amateur photography and photomechanical printing. Among those who gave the speeches were: Col. V. M. Wilcox, Grenier, Abraham Bogardus, C. D. Fredericks, George Rockwood, Andrew J. Russell, J. F. Coonley, W. E. Partridge, James B. Gardner, Percy McGeorge, Theodore Gubeman, a Mr. Atwood, a Prof. Dudley, and a Dr. Gammage.

Roche's was a unique career in American photography. Beginning in the Civil War, he made several hundred large photographs (of size 10 x 12) for the United States government, and thousands of stereoscopic views of war scenes for E. & H. T. Anthony & Co. After the war, he traveled all over the United States making upwards of fifteen thousand negatives for the Anthony firm, including some of the earliest landscape views of Yosemite and other tourist meccas in the Far West. Views he made in New York's Central Park won high praise from James Gordon Bennett. Thereafter he proceeded to other exploits at the Anthony firm. Among the first was a patented method of collotype printing placed in commercial use by the Anthonys, and by Osgood & Co., of Boston. In 1880, he perfected a particular type of gelatine dry plate for use in tropical weather, which was patented and sold as the Eastman Tropical Dry Plate. At the same time he developed a gelatine-bromide photographic paper which, because of its rapidity in

Thomas C. Roche, from a photoengraving by the Moss Engraving Company, published in *Anthony's Photographic Bulletin*, April 1884.

printing, immediately revolutionized the making of direct photographic enlargements, using artificial light. After 1886, when Eastman Kodak took up the manufacture of the paper on a large scale, it gradually surpassed albumen paper in commercial and amateur use.

As testimonial dinners go, the Roche dinner was clearly convivial. When C. D. Fredericks rose to make his tribute, he looked at the menu card, then said:

> This is all very dry; the wet has not been much (*laughter and applause*). This bottle shows (*turning upside down*) that the wet is played out and it is very dry; and I suppose we all are (*laughter and applause*). I love certain things; I love everything that is good. I did at one time love this old wet thing; but it is played out. I now love the dry. I love old Roche, because he is a good fellow; and I love you all, and though it is dry enough, that is all I have to say (*laughter and applause*).[536]

ganized centre, but it would receive a new stimulus. Instead of taking subjects at random here and there, as caprice or fancy dictates, subjects would be opened to him from which he would select his work according to his tastes, opportunities and apparatus.[537]

If Alfred Stieglitz's thoughts were running to the mechanization of photography, one of Japan's earliest photographers—a man only four years older than Stieglitz—was at this time also considering the possibility of large-

scale book illustration with photography. This was K. Ogawa, the son of a deposed landowner of the Japanese feudal system (which had ended with the revolutionary wars of the 1860s). A love of photography had become a consuming passion with Ogawa to the same extent it had with Stieglitz. Ogawa learned the rudiments of the wet-plate collodion process and even took up the manufacture of collodion (using Japanese paper instead of cotton, which was normally mixed with the ether and alcohol), because of the short supply (which resulted from the fact that one Uchida held a virtual monopoly on photography in Japan at this

1884

295

time, charging the equivalent of $75.00 for a carte-de-visite size glass positive!).

Just about the time that Stieglitz signed up for Dr. Vogel's course in Berlin, Ogawa got himself hired as a sailor aboard the American Asiatic frigate *Swatara,* and set sail to seek his fortune in the United States. He disembarked in Washington, D.C., January 1883, and remained in the United States until June 1884. He went first to Boston, where he studied portraiture with the firm of Rizey & Hastings, and carbon printing with Allen & Rowell. He also studied collotype printing in its various forms before proceeding to Philadelphia, whre he spent considerable time with John Carbutt, learning the rudiments of dry-plate making as well as dry-plate photography. Ogawa evidently possessed a nature which, as a contemporary observer put it, "inclines all men to him." Not only was he given assistance by officers aboard the *Swatara* after landing in the United States but he soon thereafter made the acquaintance of Viscount N. Okabe, who was described as "a man of means who saw the talent there was in the young man," and who "put at his disposal what capital he needed."[538]
disposal what capital he needed."[538]

The parallel between Stieglitz's and Ogawa's careers did not end with their respective beginnings in foreign lands. Ogawa returned to Japan where, for a time, he operated a large studio in Tokyo. Soon he was photographing the heir-

K. Ogawa, from a photograph published in *Anthony's Photographic Bulletin* in March 1890.

**IN MEMORIAM:
HENRY T. ANTHONY**

On the night of October 8, 1884, while attempting to cross what is now Park Avenue South at Seventeenth Street in New York City, Henry T. Anthony was struck by a cab which "rolled rapidly away" after the accident. Anthony, who was seventy, suffered from vertigo, and according to the *Photographic Times,* "may have fallen in consequence of a sudden rush of blood to the head, occasioned by a sense of impending danger." He was taken to New York Hospital where he was revived and gave his name and address (108 Lexington Avenue). He was immediately removed to the residence of Edward Anthony at 715 Madison Avenue, where recovery at first seemed possible. But three days later he died, after having sat up in bed and heard his brother read a glowing tribute to him published in the then current issue of the *British Journal of Photography.* Among those who attended his funeral in New York were: Mathew Brady, Abraham Bogardus, Jeremiah Gurney, Alexander Beckers, C. D. Fredericks, Andrew Prosch, W. B. Holmes, James B. Gardner, John Barnett, George Barnett, Charles Cooper, Wilfred French (son of Benjamin French, of Boston), and W. Irving Adams (later a partner in the firm Scovill and Adams, a merger effected in 1889).[539]

apparent to the Japanese throne—a vastly greater honor in Japan than for a similar feat performed in any capital of the western world. He founded the *Shashin Shimpo,* Japan's only photographic periodical, and established a photomechanical printing factory in Tokyo. The first practical result from the latter undertaking was a collotype print used as a supplement to the *Shashin Shimpo.* Ogawa traveled with an expedition that unearthed and recorded art treasures hidden in many old temples in Japan, and by 1890 he was making large collotype reproductions of photographs made on this expedition to illustrate the *Art Journal of Japan.* Alfred Stieglitz, meanwhile, remained in Europe until 1890, after which he returned to the United States to become the protagonist of the American fine-arts photography movement, and founder of two of the country's most influential turn-of-the-century journals, *Camera Notes* and *Camera Work.*

1885

"Amateur photographers are now counted by the thousands, and in the different cities are organized into flourishing and growing societies,'' the *Photographic Times* stated in its year-end review of photographic activities. In 1885 the Pittsburgh Amateur Photographers' Society admitted women to membership, assuring them that "there are no difficulties in the way that cannot be surmounted by any young woman of intelligence and possessed of artistic tastes and instincts." By summer, the country boasted two weekly photographic periodicals, the *Photographic Eye* of Chicago and the *Photographic Times,* which had converted from monthly publication in the fall of 1884. *Anthony's Photographic Bulletin,* a monthly, now commenced to publish fortnightly.

"The most beautiful photographs taken in this city," observed the New York *Mail & Express* in April, "are by a young lady." Identifying her only as the daughter of a prominent banker, the newspaper said that her photographs "only circulate privately," but that they excited admiration wherever they were seen:

> She belongs to a knot of young women who are studying art, and for their own benefit they pose for one another, and for such a collection of artistic studies there is many an artist that would give a pretty penny. These are, however, carefully guarded from sacrilegious eyes. The peculiarity of these photographs is in the use made of shadows and the softness of lines. The professional photographer gets a glare of light and brings everything to a sharp focus. This young woman keeps her subjects in shadow and her instrument just a little out of focus.

The newspaper also drew attention to the works of the department store head, Frederick Constable:

> Last year he took 500 negatives in and about New York. This fact was formerly the despair of his wife, who could trace him by the blackness of nitrate of silver and the destruction of his shirts. Since the modern discoveries in photography, which render it, as they say in the advertisements, a light, clean and easy employment, his wife has become as much interested in photography as he is, and accompanies him in his photographic prowls.[540]

On October 17 and 18, the Society of Amateur Photographers of New York held their first annual exhibition in the Sloan Building at Broadway and Thirty-second Street. Judges at the event (at which some seven hundred prints were exhibited) were George W. Pach and the marine artist J. O. Davidson. The judges' awards were given to exhibitors whose names are today unknown, but the flavor of the exhibit was caught by *Anthony's Photographic Bulletin* in its summary of the judging. The society's president, F. C. Beach, exhibited photographs of yachts at sail. Mr. and Mrs. Robert DeForest exhibited prints from photographs made in the Middle East, including scenes of the olive trees of Mount Hymettus near Athens; views of Egypt and its temples; and "uncommonly fine" views of boats on the Nile. L. P. Atkinson exhibited stereoscopic views of New York street scenes, and of the elevated railroads. R. A.

F. A. P. Barnard, from a carte de visite, circa 1880.

THE "PROMINENT AMATEURS"

Among the prominent amateur photographers listed by the New York *Mail & Express* in April 1885 were: Frederick A. P. Barnard, president (since 1864) of Columbia College, who was in the throes of establishing an affiliated college for women (designated Barnard College six months after his death in 1889); one of the younger Harper brothers; J. Wells Champney, the artist; Louis Tiffany, the glass-maker and son of the founder of the jewelry firm; and "Ted" Hewitt, a fourteen-year-old grandson of Peter Cooper. The newspaper also listed Joseph Drexel, Arthur Doremus, and such "Wall Street men" as John A. Cisco; R. A. C. Smith, president of the Havana Gaslight Company; and Low, a partner in the firm Low, Harriman & Co. With obvious reference to amateurs of the "Wall Street" caliber, the newspaper observed that "with a bit of magnesium wire, the busy man through the day amuses himself in the evening with family photography—the wire furnishes him all the light he needs."[541]

C. Smith exhibited views and photographs of laborers in Cuba. Dr. P. H. Mason exhibited views made along the highlands of the Hudson (possibly some made on the excursion of his yacht, *Zephyr,* the previous July). C. W. Canfield exhibited still lifes of flowers (winning a top award in that class), and J. H. Maghee exhibited platinum prints of seascapes, which won a like award in marine prints.[542]

With the amateur market expanding in leaps and bounds, the young innovator George Eastman was looking about for ways to better serve the market. William H. Walker, the Rochester camera maker and dry-plate manufacturer, had joined forces with Eastman, and together the pair began experimenting with an entirely new mode of packaging and using camera film. By 1885, the announcement was made that the Eastman company was prepared to provide a box attachment for standard view cameras, in which a compact roll of negative film (the film being a gelatine emulsion coated on photographic paper) could be placed on, and then unwound from a roll holder to make as many as twelve or twenty-four exposures. All the user had to do was observe a

clicking device, which indicated the proper position of the film in making each exposure. Loading and unloading the film was to be accomplished in a darkroom. After unloading, the film was to be cut up into individual negatives, each of which could be made translucent by an oiling procedure. After this, developing and fixing of prints could be accomplished with customary darkroom chemicals and equipment. Eastman labeled his new product "Negative Paper," but it was not long before an old problem experienced by calotype workers forty years earlier became apparent: the grain of the film's paper base showed up frequently in the prints.

Eastman next resorted to making the negative film strippable from the paper base. Film stripping was not something new; for many years in photomechanical printing, for example, the exposed collodion negative film was stripped off its glass plate and supported by a thin transparent material, which allowed printing from the reverse side of the negative. In the Franco-Prussian War of 1870–71, strippable films were utilized to enable Paris to carry on a cor-

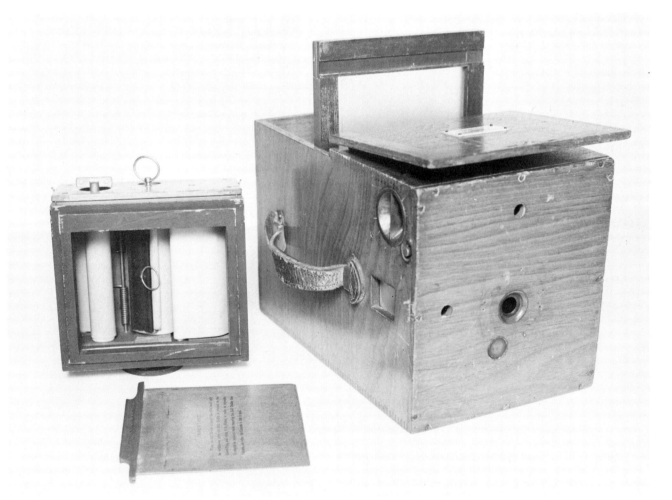

Roll holders were introduced by George Eastman in 1885 as standard attachments for the back of Eastman-produced and other cameras. These provided rolls of negative film (the film being a gelatine emulsion coated on photographic paper) which took the place of separately inserted dry plates, and could be simply unwound to make as many as twelve or twenty-four exposures. Roll holder (above left) could be used in rear of this "detective" camera, eliminating use of single plate holders such as the one shown in a raised position in camera.

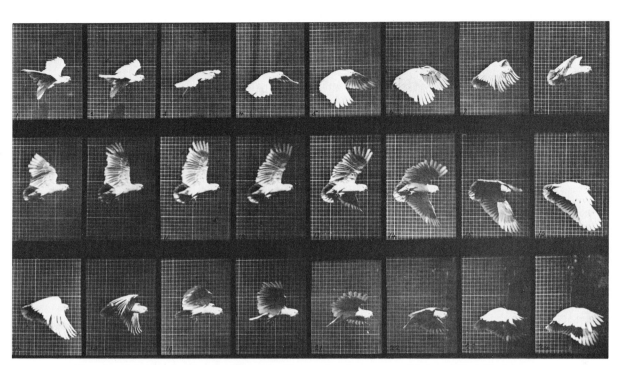

The series of photographs (above) are from *Animal Locomotion*, the summary of Eadweard Muybridge's instantaneous photographic studies published in 1887.

MUYBRIDGE PHOTOGRAPHS SHOW PIGEON
MAKES FIVE "ROUND" FLAPS IN A HALF-SECOND

In 1881, Eadweard Muybridge visited the French physiologist Étienne Marey, but the photographs he brought with him of birds in flight were unsatisfactory for the scientific studies which the Frenchman was then conducting along similar lines. After Muybridge returned to the United States, he began a new series of photographic experiments at the Philadelphia Zoo, and in the summer of 1885 the *Philadelphia Ledger* published this report on his findings:

Mr. Muybridge yesterday examined the plates taken from his cameras on the previous day when, by his "instantaneous" system, he and his assistants photographed half a dozen pigeons in motion. The apparatus was so adjusted as to be capable of making twenty-four successive exposures in half a second. Twenty-four distinct electric currents were connected with as many cameras. The largest number of exposures which Mr. Muybridge succeeded in obtaining from one flight of a pigeon on Wednesday was twelve in half a second. In that time the pigeon made five "round" flaps with its wings, the upward and downward movement together being counted one flap.

"I was surprised by this discovery," Mr. Muybridge said. "I had thought that a pigeon would not make more than about one and a half flaps in half a second. A well-known pigeon fancier, whose opinion on the subject I had asked, said he thought the number of flaps made in a minute would

be about fifty. The pigeon in question moved its wings at the rate of six hundred flaps a minute; but that was just after starting from the trap or box. I think the bird's wings do not long continue moving as fast as that.

"Those five flaps were divided into twelve exposures. We want to get at least twelve exposures of one flap, and, with that end in view will try pigeons again in a day or two. It is desirable to get twenty-four exposures of one flap. I think we will be able to demonstrate that a pigeon in soaring can operate every feather of the wing, while the wing, as a whole, is apparently not flapping. We propose to double our battery power and make a series of twenty-four exposures in, at most, one-fifth of a second. If we wish we can make several series like that simultaneously. If we can make and break the electric currents fast enough we will try to reduce the time of making such a series to one-eighth or one-tenth of a second."

Yesterday Mr. Muybridge experimented with a crow, a fish hawk, a red tail hawk, a black vulture and an owl. The plates taken of these will not be sufficiently developed for examination until some time to-day. All these birds were tied with a very light cord to prevent their escape. The pigeons had not been tied, as they fly around the "Zoo" at will. The hawk's flight was not entirely satisfactory and only four exposures of it were obtained. The owl's flight was also unsatisfactory, owing to its long confinement and nocturnal nature. Mr. Muybridge said he was well pleased with his experiments with the two hawks, and the vulture's flight gave almost equal satisfaction.

The pigeon photographing, Mr. Muybridge said, corroborated statements that have been made about the comparative slowness of the downward movements of the wing. In moving half way down from the top of the flap, he said, the wing consumed as much time as in making the remainder of the flap.[543]

respondence with the outside world by means of a "pigeon post." In this instance, stripped collodion positives—copies of dispatches, letters, or other important documents reduced to sizes of 1 x 2 inches—were enclosed in a quill (about the size of a toothpick) and attached to a pigeon's tail. After reaching their destination, these minute photographs were projected on a screen by a magic lantern, where the documents could be read with ease.

The strippable "American Film," which Eastman now introduced, produced negatives that were transparent and free from any graininess. But the process was not exactly easy, and extreme care had to be taken in order to prevent damaging the film during the stripping operation. As a result, Eastman introduced a developing service in which the customer could send the exposed film to Rochester where regular-size prints or enlargements would be made in sizes ranging from 10 x 12 inches to 30 x 40 inches.

In addition to weight savings (a film negative weighed only a twentieth the amount of a glass negative of same size), Eastman's more flexible film photography offered several immediate advantages for the beginner: a roll could be taken from a holder and another substituted in its place in no more than five minutes, whereas it would take half an hour or more to change a dozen standard dry plates; in addition, beginners were in the habit of exposing the same plate twice with a camera using glass negatives. This problem was virtually eliminated with use of only a single film holder.

But J. Murray Jordan, writing in the *American Journal of Photography* in the spring of 1886, found the public apathetic:

> The melancholy fact remains, however, that instead of trying the new invention, which could be done at a very small cost, the average amateur begins at once to pick it to pieces without knowing anything whatever about the process. He talks learnedly upon the subject, insists that the grain will show; that the paper will rot in time from the use of oil; that re-oiling is necessary every time the negative is printed, or that the odor of castor oil is disagreeable to his aristocratic nose. All these objections I have heard, and upon asking: "Have you given the negatives a fair trial?," the answer has generally been: "No; but so-and-so has, and he don't appear to think much of them"—or someting to that effect.

CYANOTYPES

Sir John Herschel discovered a method of "fixing" a photographic image with potassium ferricyanide in 1839. It gave prints with a blue color, and he found he could make photographic line impressions of algae in blue by this means, some of which survive to the present day. The process, which Herschel labeled "Cyanotype," was used sparingly (by photographers such as Henri Le Secq in Paris in the 1850s), but essentially remained dormant until 1881 when a London photographic publisher began selling the prepared paper both to amateurs and to government agencies and manufacturers for making cheap white-line "blueprint" reproductions of drawings, plans, etc. While the blueprint process was universally adopted by architects and engineers, amateur photographers also adopted its use because of its ease in making photographic prints. The steps involved: 1) A chemical solution (potassium ferricyanide and ferric ammonium citrate) was brushed on sized paper and allowed to dry; 2) the sensitized paper was exposed under a negative to sunlight or artificial light; 3) the paper was then washed in ordinary water (no hypo was required), after which an intense blue image would appear on the paper's surface. In 1888, George Rockwood began providing his patrons with a specially printed circular in blue, which provided full instructions on how to make "leaf prints" by the cyanotype method. The process was chiefly used by amateurs for instantaneous photographs made with hand cameras, but towards the end of the century it was used to some extent in landscape work.[544]

There are but few of my photographic acquaintances who have a roll holder, and not more than half a dozen who have tried the paper at all. "I want," they say, "to be absolutely sure the paper is a perfect success, and then perhaps I may try it.[545]

As late as the winter of 1888, Wilson's journal reported that the new film photography was "more popular abroad than here where it was perfected." But on a note of optimism, the journal concluded: "Another season will probably show a great change in this direction."

1886

In the spring or summer of 1886, George Eastman selected Paul Nadar, son of the just-retired Parisian photographer, as his agent in France for the new Eastman roll film system. By happenstance, the editors of *Le Journal Illustré* at about the same time asked Nadar to make photographs of the famous chemist Michel Chevreul in celebration of the latter's one hundredth birthday on August 31. The result was that the younger Nadar used a camera fitted with Eastman roll film to record the world's first photographic interview for a news publication. Nadar reportedly wanted to use a phonograph to record Chevreul's voice during the interview, but instead his father sat with the centenarian asking the questions while a stenographer recorded the conversation, and Nadar took over a hundred photographs, each exposure being made at a reported $1/133$ of a second (using a special instantaneous camera shutter). Thirteen of the photographs secured in the interview were reproduced by the "Krakow" halftone process and published in the journal's September 5 issue. Four showed Chevreul in the process of writing, while the remainder showed him in animated conversation, expressing interest, amusement, earnestness, etc. In the course of his discussion with the senior Nadar, Chevreul reminisced on his acquaintanceships with Joseph Nicephore Niépce and Daguerre, giving the most plaudits to the former rather than the latter. He also contrasted the 15-minute lens of the daguerreotype era with the instantaneous exposures achievable with the Nadar camera and dry film.

The appearance of the September 5 issue of *Le Journal Illustré* was evidently greeted with extraordinary interest by Parisians. By evening of the day in which the publication appeared on the newsstands, copies of the 15-centime paper were changing hands for five francs. But strangely, this first-of-a-kind feat—so common today—was not soon thereafter repeated. Two months later, the *Photographic Times* offered some suggestions along these lines, but evidently to no avail:

> There are many suggestions that occur to the mind, of further application of this principle of photographic interviewing. Why cannot celebrated actors and actresses be got to go through their principal roles before the camera?, giving thus a living meaning to the words. So with orators and statesmen. As it is a common complaint that photographic portraits give only one phase of a *mobile* countenance, why not take a series of the same person, engaged in conversation with the photographer or a friend? [546]

If the Chevreul interview was an event ahead of its time, so photographers for the most part—the new amateurs as well as the professionals—were not yet really oriented in their thinking as to the general "newsworthy" aspects of the medium. This was pointed out earlier by Stephen H. Horgan at a meeting of the Photographic Section of the American Institute in New York. Amateurs throughout the country, he said, were beginning to pile up valuable negatives, most of which were only being seen by their immediate friends. Once a photograph was taken, amateurs would customarily turn their attention to the next subject. While this "restless, unsatisfied spirit" was a good thing in its way, Horgan said, "they should not hide their accomplished work. Let the public see it." The best medium, of course, was the newspaper, which Horgan said was "gradually reaching a position to use the contribution of the camera." In fact Horgan characterized the new demand for photographs for newspapers as being "in the form of a revolution," which was "bound to succeed." A picture, he said, was the quickest and most agreeable method of conveying an idea or impression. "In this rapid age, people want to grasp a situation or get their impression of a public man at a glance. A picture tells the whole story at once, and in a better way sometimes than columns of type." While admitting that "current newspaper cuts" were not particularly "artistic" (because skilled draftsmen were scarce), nevertheless, the quality of newspaper illustration *was* gradually improving, he maintained, and this improvement would be further hastened if photographers would but give a helping hand:

> The way to proceed might be something like this: Find first if you have among your negatives or in your vicinity a subject that is likely to be of national, sectional, or local interest. This subject may be a portrait, residence, a recent event or accident.
>
> By way of illustration I might mention a few of the thousands of subjects around us in which the public of the whole country would be interested:
>
> There is John C. Fremont, the "Pathfinder," one of the great characters in our history, who has probably never been photographed since he was a candidate for the Presidency in 1856. He comes to his office on Broadway every day, yet no one thinks of securing a negative of him. The residences of such men as George William Curtis or Charles A. Dana, are of general interest, because even the exterior of a house reflects somewhat the character of its inmates. From the site of the proposed bridge across the Kills at Staten Island to the shattered Andre Monument. From the Croton Valley, where the largest dam in the world is about to be constructed, along the line of the new aqueduct to the Crematory at Fresh Pond, Long Island, plenty of subjects for the camera may be found which the people of the whole country would like to see, and the further away from New York, often the greater the interest in these scenes.
>
> How true it is that we do not appreciate that which is within our reach. On the death of the late General Robert Toombs, of Georgia, recently, a telegraphic application was made to the local photographer

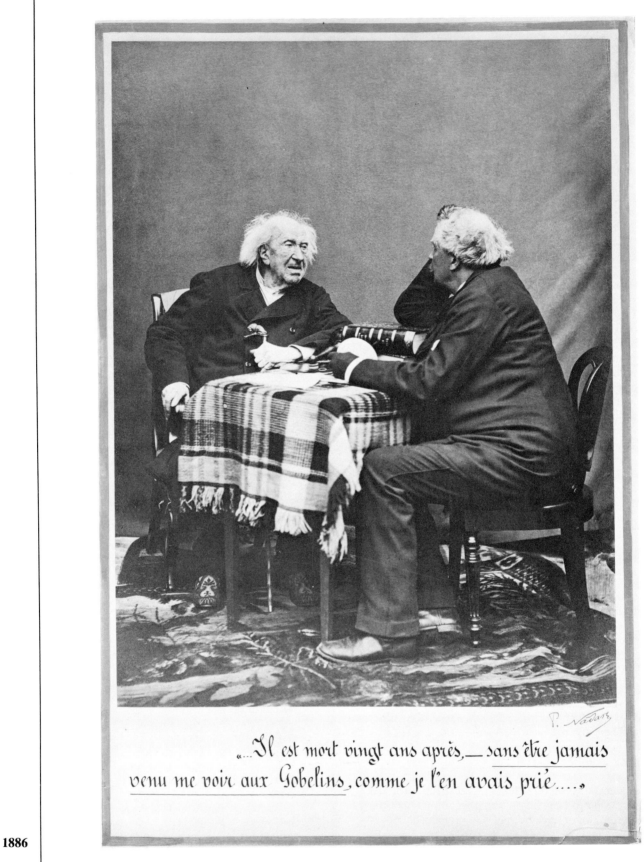

«...Il est mort vingt ans après, — sans être jamais
venu me voir aux Gobelins, comme je l'en avais prié.....»

ROLL-FILM CAMERA USED
FOR PHOTOGRAPHIC INTERVIEW

On his hundredth birthday, August 31, 1886, the French scientist Michel Chevreul granted history's first recorded photographic interview. During the interview, Chevreul engaged in animated conversation with the celebrated Parisian photographer Felix Nadar (Gaspard Félix Tournachon), shown with back to camera, while the latter's son, Paul Nadar, photographed the event with a camera fitted with George Eastman's new roll film. The three illustrations above have been copied from poster-size original photographic prints, suggesting that the Nadars may have placed large prints of the photographic interview on display at their gallery or elsewhere. Halftone reproductions of the Nadar photographs, together with a story on the interview, appeared in the September 5, 1886, issue of *Le Journal Illustre*. But despite the fact that newsstands immediately sold out all copies of the issue, other attempts at photographic interviews were not made for sometime either in Europe or the United States.

1886

BEFORE THE COLORS FADED

In an address to the Photographic Section of the American Institute in 1886, Stephen Horgan goaded photographers into making negatives of "the thousands of subjects around us in which the public of the whole country would be interested," citing John C. Frémont as one man who "probably never has been photographed since he was a candidate for the Presidency in 1856." The cabinet card provided a suitable medium for making and distributing likenesses of famous people of an earlier time, but such likenesses are uncommon among the vast numbers of surviving photographs of this style. Two examples above are those of the Civil War general Benjamin F. Butler (1818–1893) (left) and Lincoln's childhood companion, Dennis Hanks (1800–1893) (right). In Butler's case there was good reason for photographing him, in that he had served as a Massachusetts congressman for eleven years after the war, was governor of the state in 1880, and a candidate for president in 1884. But although Dennis Hanks may be familiar to all who have read of Lincoln's early years in a log cabin, his name will be found in few biographical dictionaries of illustrious Americans. Dennis was the adopted son of neighbors of Lincoln's parents. At age nine, he spent the night rolled up in a bearskin before the fireplace after Lincoln was born, and was Lincoln's constant companion before he married one of Lincoln's half-sisters. Much of the folklore which was grown up around the Great Emancipator's childhood came from the tales which Dennis told for twenty-eight years after Lincoln's assassination.[547]

for a photograph of the General's home. The answer received was that he had never thought of making a negative of it. How interesting to us, North, would be the pictures of the homes of these great war figures, Toombs and Jefferson Davis, yet it is not likely that even the latter has ever been photographed. In the town of Springfield, Ohio, is a rapidly decaying structure now used as a livery stable. It was once a church, and the one in which Henry Ward Beecher preached his first sermon. The local photographer would, no doubt, dislike to waste a plate on it. Still it is just the sort of picture the public would like to see. Innumerable similar examples might be mentioned of picturesque subjects of historical interest at which the camera is never aimed, while much good ammunition is wasted on landscapes or figures of no particular interest.[548]

Despite the slow awakening of interest and activity in photojournalism, numerous other innovations and advances were rapidly taking place in the photography arena. Just to touch on some of them, Dr. Arthur H. Elliott, associate editor of *Anthony's Photographic Bulletin,* gave what appears to be one of the most lengthy reports ever given at a national photographic convention, covering the recent progress of photography. The speech was delivered at the Photographers' Association of America's seventh annual convention, which was held in June at St. Louis.

First, Dr. Elliott covered various new innovations in cameras, which included three new "detective" devices. One, from G. B. Brainerd, offered improvements in focusing and plate exposure; another, developed by Richard Anthony, son of Edward Anthony, was designed to fit an alligator hand-satchel carried on a shoulder strap; a third, from the Eastman company, turned out to be a flop.

This camera was shown for the first time at the St. Louis convention, and one would have expected that it would eclipse all previous detective models, based on previous Eastman camera innovations. But in November, just before a patent for the camera was issued to Eastman and co-inventor Franklin M. Cossitt, Eastman announced that he had been unable to obtain a special brass fixture for securing the roll holder in the camera, and would not fulfill orders until he did. Although the camera was advertised for sale two months later, no orders were forthcoming. Only fifty were made, and in January 1888, Eastman unloaded forty of these with a Philadelphia dealer, stating: "We shall not make any more of them, owing to the expense, there being no probability of our being able to make anything on them in any quantity." But it is more likely that Eastman's attention was focused not on the detective device, but on an entirely new line of cameras which was to be announced later that year.[549]

Dr. Elliott also gave a report at the P.A.A. convention on the new "vest pocket" camera developed by the St. Louis photographer, Robert D. Gray (see description, page 306). Of numerous "concealed" cameras developed in the nineteenth century, this was among the most famous and successful. Suspended from the neck behind a vest, the camera

PHOTOJOURNALISM AT SCENE OF A BUILDING COLLAPSE

News events were still covered at this time by artists, as well as by reporters, but a correspondent sent E. L. Wilson this account of photography's role in a news story on which the writer accompanied two New York *World* artists (identified only as "McDougal" and "Folsom") to the scene of a building collapse on Bethune Street in lower Manhattan:

McDougall and his assistant, Folsom, sprang to their feet, and donning their rubber coats, for it was raining hard, and giving me an invitation to accompany them, started for the scene of the accident. It was then five o'clock, and the pictures were to be in the paper the next morning. I expressed some doubt in regard to their appearance, but McDougall's confident smile assured me that it was a certainty. Arriving at the entrance to the street, we passed the 'fire lines,' and saw the ruins of a large building, whose walls had fallen into the street, killing a woman and injuring several men. It was already dark, and the fitful light of a street lamp showed the dark outlines of the remaining walls looming up against a cloudy sky. The black figures of some firemen were seen on the roof of an adjoining house. Almost by feeling, McDougall sketched the scene with a blue pencil, while Folsom darted in another direction. Twice McDougall had to go to the street lamp to judge of the correctness of his sketch. It was finished in an amazingly quick time, and we hurried to the roof of the house where the firemen were removing a mass of bricks. Here he made a plan of the ruins, locating the scene of the fatality, and we went again to the street. Another sketch was made, this time by the light of a fireman's lantern, and after taking a few notes we hurried back to the *World* building, where we found Folsom already busy at work.

"With increasing interest I watched the pictures growing beneath their fingers. McDougall had taken in the entire scene, showing the street in perspective, with a great heap of bricks and timber lying across it. At 7:45 the first double column sketch was finished. The drawing was made about ten inches wide, and with an amount of detail and shading that surprised me. This was despatched to the photo-engraver, and he then made a sketch of a horse and its driver escaping from the falling walls, which was followed by the drawing of firemen searching for bodies in the debris. These were all drawn with India ink on Bristol board. Mr. Folsom had completed the sketch of the building before the fall, the plan of the buildings, and removing the bodies to the hospital. All but the first sketch were for single column cuts, and all were sent to the engravers by 9 o'clock.[550]

could be used to take up to six small circular negatives on a circular plate rotated before each exposure. The camera was styled the "Button Camera" in Germany, and was said to have been sold in a quantity of three hundred to Russian police.

In addition to the various new cameras, Dr. Elliott pointed to a number of improvements in shutter mechanisms:

In the matter of improvements in shutters, it is almost impossible to give an idea of the many devices that have been brought out for exposing the sensitive plate. All are modifications of the well known sliding plates either working horizontally or vertically, or else they are rapidly moving disks passing one another. Quite a variety of positions relative to the lens have been assigned to shutters—some work behind the lens, some in front; while others take the same position as the diaphragm.[551]

London, calling it the most suitable shutter mechanism for the fast-acting gelatine plates now in universal use.[552]

Cameras were being given "f/" numbers (designating the size of the lens diaphragm) at this time, and several Englishmen, in the period 1885–87, published tables which were a primitive form of guide to actinic light measurement under varying light conditions. But in 1887, when Edward L. Wilson published *A Quarter Century of Photography,* he could say nothing more about precision in determining a camera exposure than that it was "largely a matter of inspiration, of feeling." Earlier (1885), the *Photographic Times* published this rather incomprehensible but "popular" method which could be used to estimate exposure times:

> If a pendulum be formed by attaching a circular disc of blackened metal to a string 40 inches in length, and this be caused to swing in front of a white ground on which are placed marks to show the extent of the oscillations, such pendulum will perform its vibration in one second. By photographing it while in transit, and comparing the longer diameter of the more or less oval form of the pendulum ball in the negative with the shorter, which represents the diameter of the circle, and these with the whole distance which the pendulum travels during a second, an excellent idea may be had of the duration of the exposure.[553]

Because the first universally accepted dry plates were coated with a gelatine-bromide emulsion, the same emulsion (in a weaker state) as well as other emulsion formulae were coated on photographic papers and supplied ready to use. Eventually, these emulsion papers supplanted the albumen paper used by most professional and amateur photographers. Printing was much faster with the emulsion papers; where, for example, one firm could print only as many as six prints a day from a single negative on albumen paper (in 1886), Morgan & Kidd of London could report in 1887 its capability of producing a thousand prints a day from one negative on bromide paper. While Dr. Elliott credited T. C. Roche in his P.A.A. address with patenting an American bromide paper, David Cooper told those attending the St. Louis convention that the paper was proving ideally suited for use by photographers themselves in making enlargements (where previously such work was sent to establishments specializing in solar camera work):

> It is no exaggeration to state that never before in the history of photography has anything like the class of work which is accomplished by this process in enlargement been placed before the public. The results are as near perfection as the comparative infancy of the method will admit. . . . Nothing can exceed the softness and beauty of an enlarged print, say life-sized, from a well-retouched and otherwise perfect cabinet negative. It is a fact that prints far superior in softness and detail are to be obtained by enlargement by this process, than can be got by contact printing from the same negative on albumen paper. . . . It is rather early, perhaps, to urge the adoption of the permanent bromide paper for geneal work (in enlarging), as the public needs to be educated gradually to a change. Don't persuade yourselves that it is best for you to wait until Smith or Jones or Robinson makes a success of it before you will try, because either one or both of them will get your trade while you are waiting.[555]

But as is frequently the case among experts, not everyone was in agreement. The editor of the *American Journal of Photography,* for example, indicated three years later that

GRAY'S VEST CAMERA

"Outwardly it resembles a nickel-plate circular bon-bon case," the *Philadelphia Photographer* said of R. D. Gray's vest camera in October 1886. About six inches in diameter and an inch thick at the center, its lens was designed to protrude through the buttonhole of a vest. Inside was a circular sensitized plate and positioning mechanism, which rotated the plate for as many as six circular exposures of size 1¾ inches. But nothing could be photographed closer than six feet. The circular "instantaneous" plates were manufactured by John Carbutt, and a special developing and printing outfit was supplied by Scovill Manufacturing Co.[554]

Elliott did not identify them as such, but the new shutters which he said operated behind the camera lens immediately in front of the negative plate were soon given the designation "focal-plane shutter"—a new term in photographic lingo. The British photographer William England had used a shutter of this variety in the 1860s, and in 1879, B. J. Edwards had demonstrated the use of such a device in

he was inclined to think that a direct large negative would render halftones more beautifully than would be the case with an enlargement made from a small negative:

> In the enlargement, the relation of the patches of light and shade is not by any means so harmonious as in a direct negative. There is always an unavoidable break, a falling off in the halftones, so that up to a certain size it could be better to make direct negatives. But when larger sizes are demanded, the additional factors of increased expense of plate, camera, etc., enter into consideration, as well as the great increase in mechanical difficulties attending the production of large direct negatives.[556]

Some six years after Cooper's P.A.A. address, the English photo historian Alfred Brothers agreed that bromide print enlargements, "when carefully worked upon by a skillful artist, have qualities which are possessed by no other prints, with the exception of carbon," but suggested that bromide printing was still of "too recent date" for tests "to have been effectual" on the comparable permanency of bromide prints (with the known permanency of carbon prints) from exposure to atmospheric influences over long periods of time.[557]

Dr. Arthur H. Elliott, from a carte de visite, circa 1880.

Theodore Roosevelt poses with residents on the steps of a New York tenement.

CAUSE AND EFFECT

Following publication of *How the Other Half Lives,* Jacob Riis returned to his office one day after an absence of some hours and found on his desk a calling card from Theodore Roosevelt, then a civil service commissioner, on which was written: "I have read your book and I have come to help." The two quickly became warm friends, and in his autobiography written in 1913, Roosevelt said, "My whole life was influenced by my long association with Jacob Riis, whom I am tempted to call the best American I ever knew." During Roosevelt's years as Police Commissioner of New York (1895–97), Riis became "the man who was closest to me," Roosevelt said. Riis's influence soon led the commissioner to abolish police-lodging houses, which Roosevelt termed "tramp lodging-houses, and a fruitful encouragement to vagrancy." He made frequent visits to the tenement regions (usually in company with Riis) to check up on health and police department enforcement of laws and codes. "The midnight trips that Riis and I took," Roosevelt said, "enabled me to see what the Police Department was doing, and also gave me personal insight into some of the problems of city life." Later, when he became governor of New York, Roosevelt secured passage of laws to regulate and improve sweatshop labor, then, in the company of Riis, made sudden and unannounced visits to such shops picked at random. As a result of these inspections, he said, "we got not only an improvement in the law, but a still more marked improvement in its administration." [558]

1887

In 1870, when he was twenty-one, Jacob Riis emigrated from Denmark to New York and spent the next seven of those American depression years going from job to job, often hungry, and once walking all the way to Philadelphia to seek a job from a Danish family he knew. Several times he spent nights in a police lodging house in New York. As a youth in Denmark, he had helped his father prepare copy for a weekly newspaper, and this experience finally proved helpful in landing a job as a police reporter for the New York *Tribune* in 1877.

The plight of his fellow immigrants remained uppermost in his mind, and soon his daily stories of unsanitary and inhuman conditions on the Lower East Side helped to bring about the establishment of the city's first Tenement House Commission. But as he said later, "the wish kept cropping up in me that there was some way of putting before the people what I saw there. A drawing might have done it, but I cannot draw." So he merely continued to write, "but it seemed to make no impression."

Then, one morning in September or October 1887, while scanning his morning newspaper at the breakfast table, an article caught his eye. "I put the paper down with an outcry that startled my wife, sitting opposite. There it was, the thing I had been looking for all those years. A four-line dispatch from somewhere in Germany, if I remember right, had it all. A way had been discovered, it ran, to take pictures by flashlight. The darkest corner might be photographed that way." If Riis had been a practicing photographer, he might have read this fuller description of what took place in Germany, which appeared in the October issue of the *American Journal of Photography:*

Danish-born Jacob Riis (1849–1914), journalist, social reformer, and author of *How the Other Half Lives*, published in 1890. Riis was on the staff of the New York *Tribune* when this photograph was made. He joined the New York *Evening Sun* in 1888.

Instantaneous photography by artificial light is the latest novelty. Messrs. [Johannes] Gaedicke and [Adolf] Miethe, at one of the recent meetings of the Berlin Society for the Advancement of Photography, exhibited a process which excited much interest. They used magnesium, but instead of slowly burning the wire, employed the metal in the state of a powder, mixing it with salts evolving oxygen, such as chlorate and nitrate of potassium. The mixture produced an extremely brilliant white light, burning with such rapidity as to permit the photographing of moving objects. Instantaneous pictures were shown, produced by the process. The burning can be accomplished in one-fortieth of a second. The inventors have produced a very complete arrangement for avoiding the fumes. The powder is burned in a lantern, consisting of a strong case with a glass front; the case being impervious to the fumes, none escape. The lighting of the shadows is effected by tinfoil reflectors, and the light softened by interpositions of tissue screens.[559]

The magazine listed a number of advantages of the new process, among which was the statement that "portraits can be taken in ordinary dwelling rooms without skylight." The report which Riis had seen said much the same thing, and this was enough for him. "I went to the office full of the idea and lost no time in looking up Dr. John T. Nagle, at that time in charge of the Bureau of Vital Statistics in the Health Department, to tell him of it. Dr. Nagle was an ama-

teur photographer of merit and a good fellow besides, who entered my plans with great readiness. The news had already excited much interest among New York photographers, professional and otherwise, and no time was lost in communicating with the other side. Within a fortnight, a raiding party composed of Dr. Henry G. Piffard and Richard Hoe Lawrence, two distinguished amateurs, Dr. Nagle and myself, and sometimes a policeman or two, invaded the East Side by night, bent on letting in the light where it was so much needed."[560]

Riis soon realized that the camera was not a tool to be left in the hands of others in helping him further his cause; he would have to learn, himself, to master its use. In doing so, he became America's first celebrated photojournalist and its first social documentation photographer. He soon produced a visual record which clearly achieved the "impression" he had long sought to make on the New York community at large. With the publishing of his book, *How the Other Half Lives,* in 1890, he single-handedly altered American society's perception of the term Social Justice (even though the book was illustrated with drawings, instead of the actual photographs from which the drawings were made).

Jacob Riis flashlight photo of a ten-year-old boy pulling threads in a New York sweatshop, circa 1889.

THE MAKING OF TWO PHOTOJOURNALISTS

The illustrations on these pages are early examples of social documentation photographs made of slum life and child labor working conditions in nineteenth-century America. Those on two pages were made by Jacob Riis (1849–1914), the Danish-born New York newspaperman who was at heart a reformer, and who considered the camera simply as a tool for social reform. Jacob Riis concentrated his full attention on slum life in the tenements of New York's Lower East Side. First, he asked amateur photography friends to accompany him on his nighttime visits, but when these abandoned him "just when I needed help most," he engaged a professional photographer. Although he paid the man well, the photographer "repaid me by trying to sell my photographs behind my back," Riis said, so he resolved to master the use of a camera himself. Instead of firing a pistol to obtain his flash light, he substituted a frying pan for the revolver and flashed his light on that. "It seemed more home-like," he said. But he was by his own admission "clumsy." Twice he set fires in the buildings where he photographed, and once set fire to himself. "I blew the light into my eyes on that occasion," he recalled later, "and only my spectacles saved me from being blinded for life." On one mission when he set fire to a tenement room with five blind people in it, he barely managed to smother the flames he had ignited. Afterwards, when he met a policeman in the street, the latter joked about his concern: "Why, don't you know that house is the Dirty Spoon?" the officer laughed. "It caught fire six times last winter, but it wouldn't burn. The dirt was so thick on the walls it smothered the fire!"

The illustration of the "breaker boys" at work in a Pennsylvania coal mine (above right) might well have been made by Riis, but was in fact made by Frances B. Johnston (1864–1952), a celebrated photojournalist in the years leading

Frances B. Johnston's photo of a group of breaker boys at the Kohinoor mines near Shenandoah, Pennsylvania, 1891.

up to World War I. In the late 1880s, Miss Johnston reportedly asked George Eastman to recommend a camera for her when she abandoned an art career for photography, and he is said to have sent her a Kodak. In 1889 she made her first photographs of life in the White House, and as she repeated this in later administrations she became known as ''the photographer of the American court.'' Miss Johnston was a documentary, as opposed to a *social* documentary, photographer. Her visit to the Pennsylvania coal mines in 1891 was made not at her own volition, but at the suggestion of a publisher. Soon thereafter she photographed workers in a shoe factory in Lynn, Massachusetts, and life aboard Admiral George Dewey's flagship, *Olympia*. She also photographed Theodore Roosevelt and the ''Rough Riders,'' and her photographs of student life at Virginia's Hampton Institute, made at the turn of the century, today rank among the finest examples of American documentary photography.[561]

Jacob Riis photo of ''Bandits' Roost'' near what is now Columbus Park in the heart of New York's Chinatown.

Photogravure, by the International Art Publishing Co.

A PHOTOGRAVURE OR GELATINE PRINT?

In February 1887, Ernest Edwards said he had just looked over some new books said to be illustrated with photogravures, but found that they were illustrated, instead, with photo-gelatine prints. Several months earlier, the *Art Review* noted the confusion in the public mind over photomechanical terms, and said "the difference in appearance between a gelatine print and a genuine photogravure—that is, a print from the face of a copper plate—is easily detected on placing them beside each other; the former has a flatness and surface-effect that is exchanged in the photogravure for depth and richness of color. But there is just enough similarity between them to deceive the inexperienced, and perhaps it is for this reason that the photo-gelatine prints of a certain eastern firm are now masquerading in the market as so-called 'photogravures'." The illustration (above) is taken from *The Great Cathedrals of the World,* by Fred H. Allen, published by the Haskell & Post Company (Boston and New York, 1886), and said to contain 130 full-page, plus additional smaller-size, photogravure plates.[562]

With the benefit of hindsight, it is interesting to compare, now, how differently the invention of flashlight photography was viewed by others. Where Riis immediately saw its value for social documentation, the *American Journal of Photography* saw it as a boon to glamorizing social night life:

> The instantaneous flashlight is destined to be something more than a passing novelty. Judging from the excellent results so far obtained, it looks as if the day were not far distant when it would be called into active service by the professional, to secure pictures of people in evening costumes at their homes, and as a supplementary illuminator for full daylight exposures.[563]

As its first flashlight photograph illustration (an original bromide print bound in separately from the text in all copies of the December issue), the *American Journal of Photography* used an attractive young woman posed in evening dress with train.

No photographs taken at night were among those exhibited this year at the first joint exhibition of works by members of the New York, Boston, and Philadelphia amateur photographic societies, which was held at a Broadway gallery in New York between March 26 and April 2 under the auspices of the New York society. "But from the standpoint of the great public," *Anthony's Photographic Bulletin* observed, "the exhibition can hardly be called one of photographs." By this was meant the customary silver prints (photographs made on albumen paper). "Glossy albumenized silver prints occupy less space on the walls than the blacks and whites and blues," the magazine noted. Thus, for the first time at a major showing of amateur works, platinum prints, cyanotypes, and prints made on bromide paper were the mediums principally chosen for exhibition. In the case of the platinum and bromide prints shown, viewers evidently were unable to tell the difference between the results made by either process:

> The relative artistic merits of the platinum prints as compared with the bromide of silver has not been settled by the exhibition. Practically, one could not say which was which. One exhibitor, Mr. Cowee, of Troy, N.Y., showed a platinum landscape mounted on a sheet of bromide paper on which a border had been printed. Before they were hung, several gentlemen examined these pictures closely at the rooms of the society. No one who saw them discovered the slightest difference in the different parts of the work, and it was only when the blank for the catalogue was examined that the difference in the paper was discovered. Even then it had to be taken on faith.

The *Bulletin* waxed enthusiastic over the bromide prints:

> Every shade from a velvet black up is obtainable. Vigor or softness, or both, were successfully obtained, and the results were so frequent and so uniform as to show that the process is not overrated by its friends. Some of the skies printed on bromide paper were certainly the finest things of the kind that have yet been shown. They seemed more like delicate washes of Indian ink than anything producible by photography.[564]

But a year and a half later, the *American Journal of Photography* sounded somewhat less enthusiastic:

> It seems . . . desirable that a method may be found by which the tone of a bromide print should be brought under control. Since bromide printing first became popular, it seems that few, if any, attempts have been made to modify the cold blacks and

PHOTOGRAVURE

This process became one of the most artistically satisfying of all the photomechanical printing modes. A negative image of a retouched photograph was secured on the gelatine-coated surface of a steel-faced copper plate, then etched in varying depths proportionate to the tones of the original picture—the shadows being the deepest and thereby holding the greatest amount of ink. Etching was accomplished with a mezzotint tool able to cut more sharply and deeper than was possible with chemical means used in preparing plates by other photomechanical modes. This allowed doctoring by hand (usually the photographer's) to achieve artistic results, and also allowed use of transparent inks made of a soft color, such as bitumen, or Vandyke brown, in place of black or burnt umber inks. The deeper photogravure plate rendered a softer, more glowing print than could be achieved in printing from a chemically etched plate. But photogravure plates were weaker than ordinary copper engraved plates, and only the steel facing made it possible to use photogravure in book illustration. The art of making a really good, yet thin steel facing was also difficult, making it impossible to obtain more than about a thousand first-class prints off one facing before it would give away. Sized paper (which, when used, could add to the brilliancy of the darks of a print) or paper with a coarse fiber (of the type admired for etchings) could not be used for photogravure, as the hard, rough texture would not enter into the tiny pits of a photogravure process plate. One great advantage of photogravure was that prints produced by the process were always uniform.[565]

grays produced in the direction of rendering them warmer, and more like sepia or burnt sienna drawing.[566]

A study of the catalogue for the New York exhibition, meanwhile, revealed that exhibitors favored foreign-made lenses. A "hasty count of noses" by the *Bulletin* showed "103 Dallmeyer, 55 Ross, 51 Darlot, 41 Euryscope, 27 Beck, 15 Morrison and 6 or 8 single landscape lenses." The count also revealed a "prejudice against single lenses," which the *Bulletin* was at a loss to account for.

A preference for foreign-made lenses among professional photographers was also noted by Dr. John Nicol in an address to the annual meeting of the Photographers' Association of America. Among American-made lenses, he cited the "Universal Photographic Objectives" of Bausch & Lomb, and the Morrison *Leukoscope* lens for large portraiture as the newest candidates for public favor.

Nicol also eloquently summarized for the P.A.A. the advanced state to which the gelatine dry-plate process had by this time been brought:

> The conditions under which silver bromide and iodide suspended in a solution of gelatine can be made to assume particular qualities or properties are almost daily being better and better understood, so that makers of sensitive surfaces can now at will produce plates sufficiently varied in character to suit any particular requirement. The intelligent photographer is now able to select just the kind of plate that is best suited for any special purpose, and the time will soon come, if it has not already arrived, when we would as soon think of using one particular va-

riety of plate for all the various kinds of work, as driving tacks and tenpenny nails with the same hammer.[567]

Photography was in a better condition commercially, too, Nicol contended, because of improvements in "process work." The Austrian-developed photogravure process had by this time been introduced commercially in the United States, and Nicol felt that the Photo-gravure Company, as well as the other major process workers (Moss, Gutekunst, and "the company working Ives's process") were turning out work "superior to anything in the same line in any other part of the world."

The first book illustration produced by the photogravure process in the United States was a reproduction of an oil painting by Theobald Chartran in Edward Strahan's *Masterpieces of Centennial International Exhibition* (Philadelphia, 1877). But this was published at a time when the process was still under wraps, and before it was introduced anywhere commercially. Thus, when E. L. Wilson ran a photogravure frontispiece in the January 16, 1886, issue of *Philadelphia Photographer,* he could probably claim, justifiably, that it was "the first of its kind which has been given in any photographic magazine, we believe."

Among the first major publishing ventures in which the Photo-gravure Company became engaged was the eleven-volume work *Animal Locomotion,* by Eadweard Muybridge (Philadelphia, 1887), which contained a total of 781 folio-size prints. But Muybridge's publishing venture appears not to have been followed by similar publications of either book or portfolio variety which were comparable to those beginning to appear in England and on the continent. Peter H. Emerson, the son of American and English parents, led off with a "naturalistic" school of fine-art photography in London. His first work was a portfolio of platinum prints, *Life and Landscape of the Norfolk Broads,* which appeared in 1886. This was followed over a period of nine years by additional books and portfolios of artistically rendered photographs in photogravure. As soon as he adopted the latter process, Emerson continued to make use of it thereafter. He considered it more artistic, and able to render softer prints than could be obtained by any other photographic process. An "impressionist" school of photography followed close on the heels of the Emerson school, and many of the most noted works of this school were also rendered in photogravure.

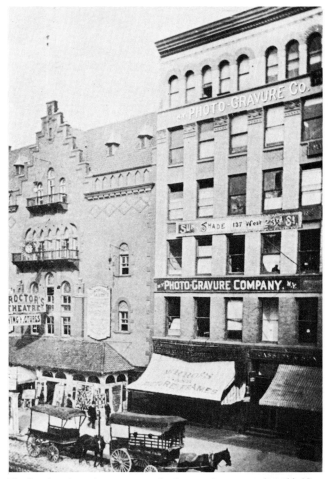

The first American photogravure style photographs were made at this New York establishment by Ernest Edwards, the English photographer and inventor of the heliotype who became a principal spokesman for the art of photomechanical printing. Edwards gave a major address on photogravure printing at the World Congress of Photographers in Chicago in 1893.

1887

1888

Eadweard Muybridge began a new series of lecture tours in the United States, Britain, France, Germany, Switzerland, and Italy following publication of his *Animal Locomotion* in 1887. In January 1888, the *Nation* expressed the thought that his *analysis* of human and animal motion could now be followed by a *synthesis* "with the aid of the zoetrope, and especially with the aid of the stereopticon." All that was needed, the magazine contended, was a large "battery" of cameras in large cities to record people and events in moving pictures. The *Nation* also suggested that Edison's phonograph might be used with such a battery of cameras to record, verbally, what people said or did in the act of speaking or walking. Muybridge did meet with Edison at this time, but his accomplishments left the latter "unsatisfied," according to one Edison biographer. In later years Muybridge contended that he had discussed with Edison the possibility of combining the zoopraxiscope and the phonograph, but Edison maintained, also in later years, that the subject had *not* been raised in their meeting.

The world of communications was such, in 1888, that the *Nation* was unaware that a Frenchman had received an American patent in January 1888 for a motion picture machine which could, in fact, provide a true synthesis in motion picture recording by making its record with a single camera from a single point of view. Muybridge's photographs showed moving bodies always before the camera with the background scenery moving backwards. The effect was not of motion as the eye sees it, but rather as the consecutive movements would be seen by a series of eyes from differing viewpoints.

The Frenchman was Louis A. Augustin Le Prince, forty-six, a man of considerable wealth who journeyed to the United States in 1881 and for a number of years constructed panoramas for exhibit in various United States cities. In 1885, he began serious experiments in obtaining photographs of movement in series. This was accomplished in the workshop of the Institute for the Deaf, then at One-hundred-sixty-third Street and what is now Fort Washington Avenue in New York. Because of his mysterious disappearance five years later, little can be actually documented as to Le Prince's experiments which led to the development and patenting of several cameras, and the making of several motion pictures which happily have also survived.

Le Prince's first machine (page 317) had sixteen lenses which recorded photographs alternately on two bands of film, made from sensitized gelatine, mounted on spools in a wooden compartment attached to the back of the camera. The camera could take sixteen pictures per second. But the sensitized gelatine could not be used when the camera was converted to a projector, because the heat of the arc lamp lighting attachment inside the device caused the material to swell and blister, throwing the pictures out of focus.

In 1887, Le Prince returned to Leeds, England, where he had founded the Leeds Technical School of Art following service in the French army during the Franco-Prussian War.

THE ILLUSTRATED LONDON NEWS.

No. 2614.—VOL. XCIV. SATURDAY, MAY 25, 1889.

After publication of his *Animal Locomotion* in 1887, Eadweard Muybridge became a world famous lecturer, visiting and speaking before groups of renowned artists and scientists in England and on the continent.

In Leeds, he completed a new single-lens camera in which animated pictures could be secured on a sensitized roll of paper (probably Eastman's "paper film"). But while paper recorded an excellent negative, it was not successful as a "positive" for projection purposes, being neither sufficiently strong nor sufficiently translucent. Nevertheless, Le Prince made a successful motion picture film with the camera (see page 316) which survives today in the Science Museum in London.

In 1889, Le Prince obtained a supply of sensitized, transparent celluloid film in sheets (see next chapter) which he cut and joined together for purposes of new film experimentation. But here the story ends. Le Prince had taken out American citizenship papers in 1886, and in September 1890, he journeyed to Dijon, France, to say good-bye to a brother before returning to the United States. On September 16, he boarded an express train at Dijon headed for Paris

A PRIMITIVE MOTION PICTURE

The frames above are from motion picture film made in 1888 of traffic on a bridge in Leeds, England. The images were secured (at the rate of twenty a second) on a roll of sensitized paper (probably George Eastman's "paper film") by Le Prince, who had perfected his first motion picture device in New York City in the period 1885 to May 1887. The single-lens camera which he used for filming in Leeds (where he had founded a Technical School for Art sixteen years earlier) was built several months after he had been awarded the patent for his 16-lens camera. The single-lens device was equipped with a shutter which reportedly operated fifteen times more rapidly than the shutters on the 16-lens camera.

Edward Anthony did not long survive his brother. It appears that among his last major accomplishments at the Anthony firm was the interest he took in George Eastman's dry plates, following the meeting Anthony had with Eastman's friend, George Monroe, at the Thousand Islands in the summer of 1880 (see page 268). Anthony was described in one obituary as having been in "feeble health" for some time prior to his death, but in *Anthony's Photographic Bulletin* it was said that he suffered a heart failure on December 7, 1888, and died seven days later. He was survived by his wife, a son, Richard Anthony, and two married daughters. In later years, the contents of Edward Anthony's desk were obtained from Richard Anthony's daughter, Mrs. Dudley Morriss, of Washingtonville, New York, by the noted collector Alden Scott Boyer (1887–1953), who donated his collection to the International Museum of Photography at George Eastman House in 1951.[568]

and was never seen or heard from again. In New York, his wife had only a year before moved into the Roger Morris mansion in what is now Morris Park at One-hundred-sixtieth Street and Edgecomb Avenue. The house had been redecorated, and its large drawing room was ready for the public showing of moving pictures which her husband had indicated he planned to schedule soon after his return to New York. A Le Prince panorama of the Civil War engagement of the gunboats *Monitor* and *Merrimac* was for many years a cultural attraction at Madison Avenue and Fifty-ninth Street in the 1880s, and it is likely that had Le Prince returned to the Morris mansion, this historic site would today be heralded as the birthplace of the motion picture industry.[569]

Eadweard Muybridge, meanwhile, adopted the position that photography's "more popular use is now entirely subordinated by its value to the astronomer and the anatomist, the pathologist and other investigators of the complex problems of nature." That was the framework within which he worked, and there is no evidence to suggest that he harbored thoughts of originating anything like a motion picture when, in 1893, he gave demonstrations of his zoopraxiscope in a Zoopraxographical Hall erected for this purpose at the Chicago World's Columbian Exposition.[570]

This (1888) was also the year in which people began taking indoor photographs at banquets and other social and

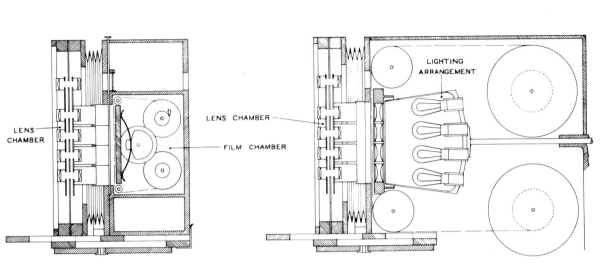

LENS CHAMBER

LENS CHAMBER

FILM CHAMBER

LIGHTING ARRANGEMENT

CAMERA

PROJECTOR

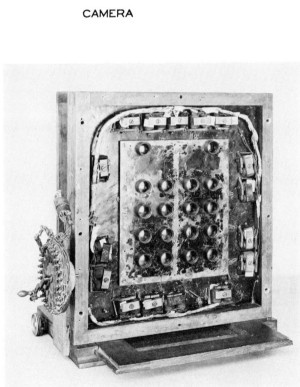

During the period May 1887 to February 1888, Louis A. A. Le Prince, the French-born photography experimenter, built the 16-lens motion picture camera (left) according to the provisions of an American patent awarded January 10, 1888. Le Prince built the camera in Paris and used it to make film there. In making exposures, eight lenses facing one film were set off in rapid succession (top), after which the eight other lenses facing another roll of film were discharged while the first roll of film was advanced for a succeeding set of eight pictures. Each set of eight lenses was thus used alternately, and the release of shutters was so arranged that there was a slight overlap in consecutive exposures. When the camera was used as a projector, this overlap meant that there was no period of darkness between successive pictures.[571]

1888

business gatherings. The first of these was taken at Delmonico's restaurant facing Madison Square. Characterized at the time as "an unprecedented feat," the photograph of feasting journalists at a press club dinner was taken by W. I. Lincoln Adams, editor, and Charles Ehrmann, associate editor, of the *Photographic Times*. The pair used a camera supplied by the Scovill Manufacturing Company, Gustave Cramer's dry plates, a Morrison wide-angle lens, and "an unusual quantity of Carbutt's magnesium 'flash light' compound." Just a week earlier, the New York *Sun* had published a major story on Jacob Riis's nighttime visits to the Lower East Side slum tenements, illustrating the article with wood-cut drawings made from the flashlight photographs. Within another two months, the *Philadelphia Photographer* would make special mention of the taking of instantaneous photographs by flashlight at a nighttime social gathering at the home of Mrs. Fitzgibbon Clark, 2334 Olive Street, Philadelphia.[574]

The danger of using magnesium flash powder was early recognized. Dr. Henry Piffard, an amateur photographer who accompanied Riis on the latter's first "raiding party," appeared before the New York amateur society to describe how he used the powder, and to warn of the danger of a premature explosion—"a danger that will be appreciated by all who are familiar with the behavior of mixtures containing chlorate of potash." Piffard said it was his understanding that the compound originally introduced in Germany by Gaedicke contained this substance, but this was denied several months later by R. Gaedike, of Brooklyn, New York (not known to be related to Johannes Gaedicke, the German inventor). Piffard recommended mixing gunpowder with the magnesium. "If one part of gunpowder be mixed with four parts of magnesium powder and ignited in an open space," he said, "an extremely actinic light is instantly developed. This mixture is absolutely safe, as it cannot be ignited except by the application of fire, and will not explode by concussion." Probably referring to his visits to the tenements, Piffard said, "I have made several negatives by the flash of a pistol, the weapon being loaded with a mixture of gunpowder and magnesium."[575]

Newspapers as well as the photographic press devoted considerable attention to deaths and injuries which resulted from improper use of flash powder. In one major incident, a Philadelphia factory worker, John E. Richardson, was killed shortly before Christmas (1887) while mixing magnesium, chloride of potash, bichloride of potash, and picric acid by chaser-wheels. This prompted the *Photographic Times* to assert that "the death not only of this man, but past accidents to all photographers who might be using the mixture, is due to the criminal negligence of those who allowed their workmen to use such dangerous agents without any knowledge of their danger. What a pretty substance, indeed, is picric acid to place in the hands of an ignorant workman?"[576]

REVIVAL SEEN IN PLAIN PAPER USE

"There seems to be a reaction in favor of plain paper; at least mat surface prints are beginning to dispute the monopoly hitherto enjoyed by albumen photographs," the *American Journal of Photography* observed in March 1888. "The effect obtained on bromide and platinum papers may have directed the attention of photographers to the old method, and some of our veterans may have recalled the fine artistic results in the days gone by. Albumen prints, with their glossy surface, do not generally receive the commendation of artists, but it must be confessed that better results may often be obtained with albumen, when a rather poor quality of negative is used, than with mat surface. A great many of the plain prints, by inexperienced amateurs, are characterized by a lack of vigor. The defects in the negative are not easily masked with plain paper as with albumen. But on the whole we are inclined to favor the revival." Dr. Charles Mitchell, in a paper read at this time to the Photographic Society of Philadelphia, noted the introduction of various mat surface papers (bromide, "alpha," and platinum papers in particular), and suggested that many of the desirable goals sought in using these newer papers could be achieved equally well by reviving the old salt print. Printing on plain paper, he contended, "gives results which, for softness, delicacy and perfection of tint, cannot be surpassed by any other method with which the writer is acquainted."[572]

HOTEL DARKROOMS

On May 5, 1888, the *Philadelphia Photographer* disclosed that the proprietor of several hotels in Madeira had established darkrooms in each of his hotels for use by amateur photographers visiting the island. The following year, Coleman Sellers provided this list of American hotels which he said provided darkrooms for guests:

WESTPORT INN, Westport on Lake Champlain, New York
THE MAPLEWOOD, Pittsfield, Massachusetts (A. W. Plumb, proprietor)
THE ARLINGTON, Washington, D.C. (T. E. Roessle, proprietor)
THE FOUR SEASONS, Harrogate, Tennessee
TAMPA BAY HOTEL, Tampa, Florida (J. H. King, proprietor)

"Many a batch of pictures have been spoiled from the want of the treat of first exposure at a new place, where the light may be different from what it is at home," Sellers maintained. "If others will help me scatter seeds of instruction among hotel keepers, the time will come when we will find a good darkroom in all hotels at watering places." On a visit to Atlantic City, Sellers encountered an Englishman "with some sort of a detective camera in his hand," who also complained that none of the hotels there provided a darkroom where he could change his plates. Sellers applied to a photographer's gallery on the boardwalk and was offered free use of the photographer's darkroom, which was not then being used. Two other darkrooms were loaned to Sellers while he was in Atlantic City, "the owners feeling pleased when not busy to chat with the tourist."[573]

HISTORIC GEORGIAN MANSION LOSES ROLE IN MOTION PICTURE HISTORY

Motion picture pioneer Louis A. Augustin Le Prince mysteriously disappeared from an express train in France two years before this photograph was made of his home, now a museum in Morris Park, New York City. Built in 1765 as a summer residence by Roger Morris, the mansion served as headquarters for both George Washington and British troops in the American Revolution, and was restored in 1810 by Stephen Jumel. While Le Prince was in Europe in 1889, his wife took possession of the house and completed redecorations for a planned showing of motion pictures that was to have taken place in a large drawing room, using a new camera perfected by Le Prince abroad.

The R. Gaedike mentioned above addressed a letter to the *Photographic Times* from Brooklyn on January 20, 1888, and in this letter he spelled the name of the German flash powder inventor (Gaedicke) the same way he spelled his own name (Gaedike), suggesting the possibility of a family connection. R. Gaedike contended in this letter that the Gaedike (sic) and Miethe flash compound did *not* contain chlorate of potassium, but did not further describe the mixture, stating only that it was "put up separately in tin boxes," neither of which was explosive.[577]

Two Rochester, New York, photographers reported favorably on a "Blitz-Pulver" flashlight compound, but the aftermath of smoke remained a problem. Piffard contended that the best results in flashlight photography were to be obtained by professional photographers skilled in the use of screens, reflectors, etc., but the *American Journal of Photography* contended that "there is so little variety in the character of the illumination employed by photographers, that the production of one gallery scarcely differ[s] from those of another, save in technical qualities." In a year-end report on the progress of photography given on August 10, 1889, W. I. Lincoln Adams said that although photographers had undoubtedly improved in their "management" of the light effect, it could scarcely be said that the use of flashlight photography had generally increased:

On the contrary, it is probably considerably less used now than it was a year ago, though those who do employ it are more skillful in its use. The tendency at present is to use magnesium powder in a pure state; and many ingenious lamps and devices for lighting and burning it have been invented.[578]

THE YOUNG PHOTOGRAPHY BARON

"The full import of George Eastman's discoveries in photography are not yet fully recognized by the world at large," the writer of an 1891 profile of Eastman observed. "Outside of the trade and scientific circles it is scarcely known that Eastman's dry plates were the first dry plates made in this country, or that they are so much superior to any ever made anywhere that Rochester goods are now the standard of Europe as well as America."

George Eastman was essentially a natural-born captain of industry who happened to have chosen photography as his field of interest. In the beginning, he secluded himself to experiment with and perfect a dry-plate process, but even at this stage his mind was concentrated on the enterprise that was to follow. His way was the opposite of John Calvin Moss, for example, who with his wife remained closeted for over two decades grappling day after day with the intricacies of photoengraving, finally establishing an enterprise of only momentary significance. Eastman agonized for only the briefest of moments when customers began to complain of a loss of sensitivity in his first dry plates; he simply shut down operations, went to England to buy the formula for the best plates, compared them with his own, and found the root of the problem immediately. Eastman's policy became one of buying the basic patents, as well as the talents of individuals and entire companies whose activities or operations posed a threat to, or would be beneficial to, his present or future plans. In 1884 (probably as early as January), he hired William H. Walker, another Rochester camera manufacturer, to help him perfect a roll-film system. Walker contributed a needed mechanical skill (to complement Eastman's previous experimentation with paper-based film), and he also offered valuable production and administrative talents (the Walker pocket camera introduced in 1881 having been among the first to be manufactured with interchangeable parts). This association led to the Eastman-Walker roll holder, the first of its kind. When Eastman decided that a transparent film should replace the paper-base roll film (which had to be stripped off its paper base during film development), he hired a young chemist, Henry M. Reichenbach, to perfect it for him. An Eastman biographer calls this "one of the first industrial research assignments" to be given in American industry, but in any event the film was ready by the end of 1889. But Reichenbach became one of few of Eastman's "inner circle" to pass quickly from the scene. In 1892, Reichenbach and two assistants were discharged for conspiring to form a rival company, and Eastman later brought suit against them.

In the 1890s, Eastman would emerge as an industrialist of

George Eastman, from a cabinet photo taken in Paris circa 1886.

the first order. His first company was organized with a capital of $1 million, then was recapitalized twice (despite a financial recession) at $5 million, then (in 1898) at $8 million. Eastman bought the process which allowed film loading in daylight, and he bought the company which invented the "little red window" for keeping track, by the number, of film movement inside the camera. After 1900, the road to a vast monopoly lay ahead, which would make Eastman one of America's five leading philanthropists.[579]

KODAK REVOLUTION
1889

The outset of photography's second half century coincided with the introduction of the Kodak camera and nitrocellulose film—both hallmarks of a new era for the medium. The new negative film process was an American development, resulting from independent research and development activities in Philadelphia, Newark, New Jersey, and Rochester. The Kodak camera was actually patented on September 4, 1888, and was on the market at the outset of 1889. It was small (6¾ x 3¾ inches) and lightweight (22 ounces), and was strictly a film camera. The roll holder was an integral part of the camera, and was inserted into or removed from the camera through a rear panel in the manner of all subsequent "box" cameras. The name "Kodak" was selected by the patentee, George Eastman, because he thought *K* was a "strong and incisive sort of letter," and by trying out various combinations of other letters to follow the *K*, he arrived finally at "Kodak."

As many as a hundred exposures could be secured on a single roll of film supplied with the first model Kodak. The images were circular (each 2½ inches in diameter) because the camera's image frame was circular. Eastman's "American" (stripping) film was used with the camera, and the company launched a full-scale promotional effort to have camera users mail their exposed film to Rochester for processing and printing. "You press the button, and we do the rest," the advertisements stated. By September 1889, Eastman had sold over 13,000 Kodaks, and a month later the company was reported to be processing between sixty and seventy-five rolls of exposed film daily (or the equivalent of 6,000 to 7,000 negatives a day). Great public events were soon found to have a measurable effect on the film processing. After the inauguration of the New York centennial celebration, for example, some 900 Kodaks were received in the mail within a single week for film processing.

E. L. Wilson's son, Fred Hart Wilson, visited the Eastman factory in October for his father's publication (the title was changed in January from *Philadelphia Photographer* to *Wilson's Photographic Magazine*), and observed that "in the short period of its astonishing existence, this little black box has persuaded thousands to the pursuit of photography, and its name has become a household word. It is the pioneer of a new type of camera, the creator of a new class of photographers, and has brought all the pleasures of the art-science within the reach of those who never thought they should enjoy them before it came upon their view; it has added largely to the ranks and considerably changed the methods of amateur photographers."[580]

Film processing called for printing by sections of twelve images in an "airy" printing room on the roof of the Eastman factory, looking out towards the Genesee Valley. According to Wilson, the foreman inspecting the prints would find "woful evidences of fog and double exposures, and other ills amateur work is heir to," but "very seldom" any faults due to defects in camera mechanisms or in the paper.

Such may have been the case in October 1889, with the paper-base "American" film, but Eastman's adoption of

"AMERICAN FILM" MANUFACTURE

The first Kodak cameras sold used Eastman's "American Film." After making exposures, people sent their rolls of film to the Eastman factory where the exposed film was stripped from its paper base and developed. *Wilson's Photographic Magazine* gave this description of the film's manufacture on October 19, 1889:

The making of the film that is carried in the Kodak is not only an interesting but an impressive process. The emulsion-making is carried out after the ordinary [methods, and presents no particular interest more than any other emulsions. It is the process of coating which is the imposing part to watch. You pass through the usual double door into the big, cool dark-room on one of the upper floors, and, clinging close in the obscurity to the hand of the foreman, who guides you, cross over to where, by the dim light of electric lamps shining through lanterns of red tissue-paper, you see the outlines of a great machine, which a few black forms hover about, and whence proceeds at intervals a sharp measured click of wood striking against wood. It suggests, with the dim crimson glow of the cylindrical lanterns, a lawn fête of demons, after most of the diabolical guests had departed and the lights were going out. Slowly travelling up the front of the machine and over its top, is a broad white band, that gleams wetly under the light of two of the red lanterns. It is the paper in process of coating; and, looking closer, one sees the trough full of emulsion, whose presence had been announced to the nose some time before by its rather pleasant, though eminently photographic, smell. The band of paper that passes through the trough is forty inches wide, and is being fed from an enormous spool. It travels at quite a fair speed, and gives one a very vigorous impression that a great deal of that paper must be coated in the day's work—not to speak of the trough that holds several gallons of the emulsion, and yet must be renewed constantly, and the yards of paper stretched drying on the racks. The paper passes over the top of the machine for some fifteen feet, and under again, by which time the emulsion is set; then it is taken up by long wooden arms and hung in loops of about the same length, to complete the drying. About six thousand feet is a day's work. It only takes between three and four hours to run it through the machine; the rest of the time is spent in drying. In the morning it is wound off upon a spool, and thence slit in rolls of two and three-quarter inches, to be wound off on the small spools. Often there will be a slight surplus of length, which the purchaser has the benefit of, so that some Kodaks carry ten or a dozen exposures over the hundred.[581]

the transparent celluoid film (under a patent awarded December 10 to Eastman's principal chemist, Henry M. Reichenbach) resulted in later problems, both real and imagined. After 1890, for example, it became apparent that celluloid film had a tendency to bulge up during development, and once developed and dried, it had a tendency to curl up into a tight roll. Ultimately, of course, a noncurling film was developed to eliminate this problem.

But the pioneering development work on celluloid was accomplished elsewhere. The material itself was developed in England in 1861, but appears not to have been exploited there. After 1869, it was manufactured commercially by the Celluloid Manufacturing Company of Newark, New Jersey. People had *suggested* its applicability to photography earlier in the 1880s, but it was considered at that time to be too thick to be practical as a negative base support for emulsion coating. But it was hard, durable, almost entirely unaffected by acids or alkalies, and unchangeable under ordinary atmospheric conditions. About 1884, John Carbutt persuaded the proprietor of the Celluloid Manufacturing Company, John Wesley Hyatt, to try manufacturing some of the material in thin sheets. By 1888, Hyatt provided a suitable article only 0.01 inches in thickness. For Carbutt, this constituted "the most complete and perfect substitute for glass yet discovered." In addition to being light, tough, and flexible, it could be treated during development in the same way that a glass negative was treated.

This was the ultimate, and presumably the most successful, undertaking of Carbutt's long career of attempted and achieved "firsts." He described the film's development in a

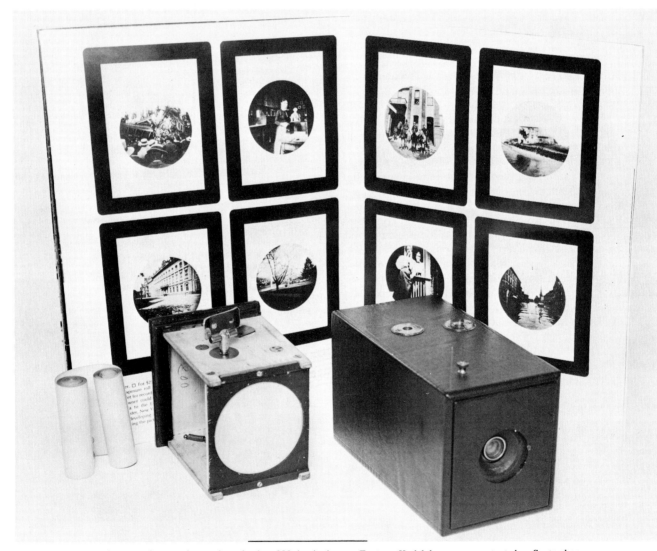

Amateur photography was booming by 1888, but in the new Eastman Kodak box camera patented on September 4, 1888, and placed on the market at the outset of 1889, photography was given its true "Model T" among cameras for all people. It was strictly a film camera, and the roll holder (left) was an integral part of the camera, inserted into or removed from the camera through a rear panel in the manner of all subsequent "box" cameras. Images were printed circular (see samples, rear) because the camera's image frame was circular. First Kodaks used a paper base "American" stripping film, which could accommodate one hundred exposures. Subsequent Kodaks, beginning in 1890, used celluloid film allowing twelve exposures.

This circular Kodak camera print shows the factory building at Rochester, New York, where George Eastman, with Henry A. Strong, founded his Eastman Dry Plate Company in 1879. Company was recapitalized in October 1888, as the Eastman Dry Plate & Film Company, to include manufacture of celluloid film.

lecture at the Franklin Institute in November 1888, and was first on the market with a commercial celluloid dry plate to be used in a plate holder in exactly the same manner as a glass plate. Carbutt's "Flexible Negative Films" joined his *Keystone* dry plates as popular commercial products for the remainder of the century. After 1900, the thickness of the film manufactured by the Celluloid Manufacturing Company for Carbutt, as well as for others, was further reduced.

Neither Carbutt nor Hyatt applied for a patent for the new celluloid photographic film, possibly because the retiring rector of the neighboring House of Prayer in Newark, the

JOHN CARBUTT

An Englishman who emigrated to America in 1853 at age twenty-one, John Carbutt became something of a "man for all seasons" in American photography, although he is today little known. He was among the first to follow and to photograph the building of the transcontinental railroad. After this he made photographic portraits of the leading citizens of Chicago, which were published in book form. In 1871 he moved to Philadelphia to establish the first American photomechanical printing establishment, utilizing the British-developed Woodbury-type process. At this time he also began experimenting with gelatine dry plates, and was first on the market with a commercial article in 1879. Next, he took up the manufacture and standardization of lantern slides. He pioneered the American manufacture of X-ray film, and became a supplier of magnesium powder for flashlight photography. About 1884, he commenced experimenting with celluloid as a substitute for the glass negative, and once again was first on the market with a commercial product. In 1880 he was named the first president of the Photographers' Association of America, successor to the National Photographers' Association formed in 1868.[582]

Rev. Hannibal Goodwin, had applied for a patent on May 2, 1887, for a method of making photographic film of nitrocellulose in a manner which was not described in very specific terms. Like David Woodward of Baltimore (who invented the solar camera as a means of improving his portrait painting), Goodwin had turned to experimenting with photography after trying in vain to find illustrative material which he considered suitable for use in lantern slide lectures for the young people of his parish. The experiments were evidently conducted over a long period of time (ten years), and were centered on trying to find a substitute for the glass negative. The proximity of the Celluloid Manufacturing Company may have had something to do with the direction of Goodwin's endeavors, and, conversely, his achievements may have discouraged Carbutt and Hyatt from seeking patents of their own.

Between May 2, 1887, and September 12, 1889, Goodwin's patent was revised seven times, and it was during this period that George Eastman determined that the future resided with a flexible negative film of some sort, and that he had better do something about it. Thus he hired a young chemist, Henry M. Reichenbach, to develop a new flexible film for the Kodak camera. The result was an application by Reichenbach for a patent, which initially ran afoul of the Goodwin patent in the U.S. Patent Office, but was ultimately granted on December 10, 1889.

Although records are now lost, it appears that T. C. Roche may have experimented with celluloid film as early as (or before) Goodwin. John Carbutt stated at the tenth annual convention of the Photographers' Association of America, held in August 1889, that "since I have become a manufacturer of the article, I have learned that I was antedated two or three years. . . . I was shown in New York, in the offices of Messrs. Anthony, a film said to have been made some five years ago on celluloid." The transcript of Carbutt's remarks reveal that a Dr. Eliot (presumably Dr. Arthur Elliott) responded with this statement:

> Mr. Carbutt has very generously credited Anthony & Co. with the making of the first films. I happen to know that it was the old veteran T. C. Roche who had the first idea. T. C. Roche, of New York, was the man who had the first idea of using celluloid and making films. But somehow or other it fell through.[583]

The Blair Camera Company of Boston also became a supplier of rollable celluloid film, principally for the popular Hawk-Eye detective camera (introduced about 1889 by the Boston Camera Company, which Blair acquired in January 1890), and the Kamaret (Kodak-style) box camera introduced in 1892. In 1902, T. H. Blair gave a description of his company's manufacturing process, which may be summarized briefly as follows: The film base (taking the place of negative glass) was formed by spreading the liquid nitrocellulose material on an endless moving surface, as for example a cylinder, where it was given sufficient time to harden to the point where it could be handled without injury by machinery. The film was then stripped from its supporting surface and placed in motion over rollers, allowing air to pass over both sides of the film until it was further "seasoned." The film was then transported to a coating machine in a nonactinic department where the sensitive emulsion was applied. Once again, the film was transported on de-

A TRIP THROUGH CHINATOWN
WITH A KODAK CAMERA

From the Los Angeles *Times*

A gentleman, the happy owner of a most fluent tongue, entered the *Times* local-room last night, and laying a small box, about six inches long by three high, on the city editor's desk, asked if he would like to go out "shooting" that evening. The mandarin of the blue pencil replied that he had no great hankering for the sport at that moment, being at peace with all mankind, except a few unesteemed contemporaries, and these he preferred should die a lingering death. The visitor hastened to state that he was not thinking at all of shooting to kill, only of shooting for views. He simply desired to exhibit, for the benefit of the local-room, a little dodge for taking instantaneous photographs by day or night. Turning to a companion who had entered with him he desired him to fire a "shot." That gentleman produced a kind of scoop shovel, painted white, and pulled the trigger, while the first visitor pointed the little box at an occupant of the room. Suddenly a snap was heard, a flash like lightning dazzled the eyes, a little puff of smoke rose to the ceiling and the "subject" was informed that his photograph had been taken. "That's all the 'shooting' I do," said the visitor. "My name is S. C. Jones, agent for the Kodak Instantaneous Camera, and if you will send a reporter with me this evening I'll show him a little night gunning."

A reporter was detailed to accompanying the head artilleryman, who proposed beating the Chinatown preserves by lamplight. The expedition numbered four; the head cannon-box carrier, the "flash" firer, an aide-de-camp and note-taker. Mr. Jones said he had reconnoitered the ground the previous night, and was prepared to lead the way. He marched the invaders into a little 6 x 10 cubby hole in a dark alley, down in Chinatown, used as an opium den by a fat, old, spectacled Chinaman named Yuen Kee, but whom Mr. Jones familiarly addressed as "papa." "Papa" was very glad indeed to see Mr. Jones, and showed the army the opium stalls where a few Chinese fiends were "hitting the pipe." Mr. Jones explained most eloquently to "papa" and his customers that he was the agent for a cheap electric light, without which no Chinese residence was complete, and offered to give an illustration of how it worked. Assent was freely given, and literally in a flash, the assistant artilleryman shot his apparatus, and a good picture of the opium fiends, puffing away, was taken. "Papa" seemed delighted, and never suspecting his picture was being stored up in the box, rubbed his eyes and asked for more. More flashes, and "papa" in various attitudes, his customers and his den, were transferred to the films. The flashes attracted a large number of Chinese, who peeked in through the windows in astonishment. Gen. Jones led the way next to a Chinese barber shop, where, though no electric lights were needed by the proprietor, no objection was made to an exhibition. With the diplomacy of a Bismarck, Gen. Jones "shot" a highbinder who

was getting his head shaved, another washing his face, and the boss barber and his assistants in various attitudes of astonishment.

Next a raid was made on a Chinese general store, where another "shot" was taken and a firstrate picture obtained. All this time it must be remembered not even a suspicion of the true object of the visit passed over the Chinese mind, Gen. Jones talking most evangelically about his electric light, and sighting his cannon camera so skilfully that no attention was paid to the deadly machine.

A Chinese fruit stall was next "shot," and then a blonde young woman with a red wrapper and a hoarse voice, who peeped through a latticed window and invited the army to pay her a fleeting visit, fell a victim. She, however, was the only one so far who objected. She anathematized the "shooters" forcibly and fluently. But then she was an American and not Chinese.

Another Chinese store was raided, where the proprietor and two of his wives were standing behind the counter putting up Chinese delicacies in packages. When the flash went up, the two Chinese girls squawked in terror, and, crouched behind the counter, jabbered something about white devils. Preparations were being made to carry the war into Africa and Mexico, when the assistant artilleryman made the alarming discovery that the ammunition was all expended. A council of war was accordingly held and a cessation of hostilities for the night ordered by Gen. Jones. The army then took a wet "shot" themselves and disbanded.

The instrument with which the cannonading was done is what is known as the Kodak camera for taking instantaneous photographs either by day or night. It is 7½ inches long by 3¼ deep and three inches wide, and weighs, when ready for action, just one pound and ten ounces. All that is necessary for good work is a little practice in pressing the button on the top of the camera which opens and closes the lens, and, perhaps the most important of all, holding it perfectly steady. For night work one must have an assistant to set off the flash. This is composed of *Blitz-Pulver*—a magnesium powder made in Philadelphia. It is spread on a small plate, shielded at the back by an upright piece of tin to protect the eye. A toy pistol cap is placed in the center of the powder and discharged by pulling the trigger of a small hammer. A flash as vivid as lightning occurs immediately, and the photograph is taken. It can be used in a lighted room or in a dark one, in the street or inside the house—in fact, anywhere. There is enough material in the camera to take 100 photographs, which can be taken consecutively as fast as the button can be pressed. The lens produces a photograph about three inches in diameter. These can be sent to any photographer to be developed, and printed either on blue, albumen or bromide papers. They can also be enlarged or reduced at wish.[584]

ELECTRIC LIGHT ENLARGER

"Very few who can get the electric light will use the old solar camera," G. Hanmer Croughton said in April 1889. Solar cameras were expensive to use, and the sun could not always be depended upon, he observed. Describing a much more economical electric light apparatus (left), he said the arc light should be placed in a closed box or cupboard (1), and a pair of condensers (2) should be utilized which would have sufficient diameter to cut to the corners of the size of the negative used. A ground glass placed between the two condensers (3) could be omitted to shorten exposures, but only at the expense of softness in the copy print. The camera and plate holder are shown respectively by 4 and 5, and the copying board on which the sensitized paper for the enlargement is to be pinned as labeled as 6.[586]

vices which allowed drying and exposure of air to both the newly coated surface and undersurface of the film. Blair emphasized that air was given constant access to both sides of the film during the entire series of operations (seasoning, coating, and drying). Seasoning, he also explained, could be prolonged to any extent of time desired by simply extending the area over which the film was transported.[585]

There are grounds for concluding that the Rev. Goodwin could have prevented issuance of a patent to Reichenbach for celluloid photographic film manufacture, but in any event, Goodwin's patent application went through a long series of rejects and revisions before it was finally granted in 1898. In 1900, Goodwin organized the Goodwin Film and Camera Company, and began construction of a new plant in Newark where the Goodwin film was to be manufactured in competition with Eastman and other film suppliers. But in the summer of 1900, Goodwin was injured in a streetcar accident, and he died the following December. Two years later, E. & H. T. Anthony & Co. acquired a controlling interest in the Goodwin Company, and F. A. Anthony, a nephew of Edward Anthony, became the company's president.

Troubles had already arisen between the Anthonys and Eastman in 1887, when Eastman sued the Anthonys for infringements of patents covering the machinery used in coating bromide paper, and the Anthonys countered by bringing suit against Eastman for infringement of the patent issued to Roche for the formula used in manufacturing the paper. These suits were ultimately settled out of court, but after the Anthonys gained control of the Goodwin operation, a suit was filed against Eastman's company claiming infringement of the Goodwin patent (on the grounds that Eastman had departed from the specifications of Reichenbach's patent, and had in effect adopted Goodwin's process).

This case turned into one of the most important legal controversies in the whole history of photography, but unlike the Cutting patent warfare nearly half a century earlier, it did not involve the fraternity. The case was not settled until March 1914, but in the process, the legal determination was made that Goodwin was, in fact, the rightful inventor of celluloid photographic film. The decision compelled Eastman to make restitution to Goodwin's heirs and to the Ansco Company (the surviving company which followed the merger of the Anthony firm with Scovill & Adams in 1902), and on March 27, 1914, George Eastman sat down and wrote out a check for $5 million.[587]

1889

326

1890

Although it was still not possible to make color photographs in the modern sense, photographers by this time had at their disposal an assortment of special plates and color screens (color filters, in modern terms), the use of which would enable them to render better "color values" in their black and white prints. The basis of the technology involved was the orthochromatic or isochromatic principle enunciated by Dr. Hermann Vogel in 1873. Both terms meant the same thing; when a photograph was taken, the use of negative plates containing a dye, or dyes, and the placement of a colored screen behind the lens would reproduce, in the uncolored print, a more correct brightness in the colors which the eye could see in making the photograph, but the photographic print would not otherwise adequately record. Stephen Horgan explained that "it is what wood engravers have aimed to do, that is, to render in black, or white, or monochrome what they term 'tone values' of a painting, portrait or landscape." For this very reason, he said, a magazine such as *The Century* kept a distinguished engraver (Timothy Cole) in Europe to make his engravings on wood before the paintings and frescoes of the celebrated masters, thus ensuring that he recorded on his blocks a "true orthochromatic reproduction" of the masterpieces copied.[588]

Among the first American-made "isochromatic" plates were those perfected by Frederic E. Ives. At first he used Newton's emulsion plates treated with an alcoholic solution of chlorophyll from blue myrtle or periwinkle leaves. But because these early plates were less sensitive to green than to blue or red, he added eosine to the chlorophyll and got what he considered more satisfactory plates. In 1886, Ives was awarded the Scott Legacy Medal by the committee on science and arts of the Franklin Institute for his isochromatic plates, which the committee (headed by Henry Heyl) held were the "first successful application" of the orthochromatic principle.

During the 1880s, numerous other dyes were introduced for orthochromatic plates, among them: erythrosine, cyanine, fuchsine, azaline, aurantia, rose Bengal, quinoline red, xanthophyll, gallocyanin (a blue dye), chrysanaline, corallin, and aldehyde green (most of them derived from coal-tar distillation). But "from all the evidence available," Alfred Brothers wrote in his *Manual of Photography* (London and Philadelphia, 1892), "it does not appear that any one of the substances hitherto used is, in itself, sufficient to render plates color-sensitive to all the rays, and that no single one is altogether satisfactory for the red." Such a complete color sensitivity would have to wait for the panchromatic plate introduced after the turn of the century.[589]

By June 1890, Dr. Vogel termed orthochromatic photography "an old thing," but said that there were a great many people who knew nothing about it, or didn't believe in it:

Only in Germany, where color-sensitive photography was invented, is it duly appreciated. In the establishments of Braun (Dornach), Albert & Naunfstängl, Obernetter, Bruckmann

(Munich), the Photographische Gesellschaft (Berlin), are many thousands of subjects reproduced by color-sensitive collodion, and in the British Museum such plates have been used. Color-sensitive gelatine plates are already made in at least six manufactories in Germany, one in England, and one in America. In using these plates, a yellow screen is required to diminish the action of the blue rays; but there is one kind of plate by which the right color effect is produced without the yellow screen in taking landscapes; this is the eoside of silver plate.[591]

The necessity to use the yellow screen was a bugaboo to many photographers. Not only did its use necessitate longer exposures, but in addition, its interposition behind the camera lens changed the focus, necessitating refocusing after the screen was in place. This was difficult because of the feeble light admitted through the screen. The St. Louis plate maker Gustave Cramer told photographers attending the 1890 Photographers' Association of America convention in Washington, D.C.:

It is now the aim of the experimentalists to prepare orthochromatic plates in which the sensitiveness to the violet and blue rays is reduced to a minimum, and the sensitiveness to the green, yellow, orange, and red increased to the highest degree, so that the use of yellow screens is rendered unnecessary, and I

ORTHOCHROMATIC PRINT DIFFERENCE

Probably only those who have made a study of nineteenth-century orthochromatic photography can discern from examining an old print whether or not an orthochromatic negative plate (or isochromatic plates, as they were also termed) was used in the camera to make the picture. But the difference can be clearly seen when one has two photographs of the same subject, as above, the one (left) made with an ordinary negative, and the other (right) with an orthochromatic (or isochromatic) negative. A dye or dyes used on the latter plates, together with placement of a colored screen behind the lens in the camera, reproduced in the uncolored print a more correct rendering of brightness in colors which the eye could see in making the photograph, but which the print could not otherwise adequately record.

HALATION

The blurring of light around the window in an interior photograph remained a virtually unsolvable problem for photographers throughout the nineteenth century. This "halation" was caused by the light passing through the film during the exposure and reflecting itself back on the film, a situation aggravated by use of glass negatives. Halation was alleviated to some extent by use of paper negatives, or (after 1889) celluloid film. But by 1895 "nonhalation" glass or film dry plates became available which contained an inert coloring matter which would arrest the actinic rays then dissolve itself in the photographer's developer.[592]

1890

329

STATUE OF LIBERTY IS PHOTOGRAPHED
AT NIGHT WITH AID OF FLASH LIGHT

The Glens Falls, New York, photographer S. R. Stoddard thought that to photograph the Statue of Liberty in daytime would be like "picturing a corpse." In justice to its generous donors, and to the sentiments it portrayed, he felt it must be photographed at night with a black sky and rayless surroundings in order to be, in fact, "Liberty Enlightening the World." Stoddard accomplished the feat with the aid of magnesium flash powder, and gave this description in an 1891 photographic annual:

In company with one of the soldiers stationed there, I climbed up into the shoulder of the statue, then, unlocking a grated trap intended to keep the inquisitive public back, we went up and up through the mighty arm (the coldest arm I ever had around me), and out on the platform surrounding the torch, from which point a strong wire was let down until it touched the base and was secured at top and bottom for use when needed. Experimenting, we found that neither a Le Clance battery nor the electric light plant of the island seemed to heat a fine platinum wire, A, sufficiently to ignite the flash powder or gun cotton, but finally, after much searching among powder dealers, I found an explosive cap used for blasting purposes, that could be exploded by passing a current through it from the electric light machine.

As night approached, I reared a battery of five cameras—a 16 x 20 with 23-inch Dallmeyer R. R. lens; an 8 x 10 with Morrison W. A. 13-inch focus; an 8 x 10 with a ten-inch Dallmeyer R. R.; a 5 x 8 with a five-inch W. A. Dallmeyer and a pair of Zentmayer stereo lenses of about four-inch focus—and then turned my attention to the proposed source of light.

To the wire that was suspended from the torch, at the point where it could be reached from the steps that led up to the door in the base of the pedestal, I attached a cardboard box, B, containing a pound and a half of flash powder with an ounce of pure powdered magnesium thrown in for good measure. In this I buried one of the cartridges secured for that purpose, to which was fastened two, fine, insulated copper wires, C, to complete the circuit and explode the cap when at the proper moment connection would be made with the electric light system of the island. The strong wire was then continued on over the ramparts to the water's edge and thence with plenty of slack, carried out on the water by men in a boat, until the box with its hanging wires was drawn out and as high up in air at the side as possible.

Then began a series of accidents. First the wire broke out toward the boat somewhere and the end had to be hunted up, spliced to another piece and carried out again. Then the wind was unfavorable and it was with much difficulty that the box, faintly seen in the air, could be brought to hang in the right position, then the copper wire that ran down to the hand of the electrician below, parted and came down and the distant boat must come in shore again until a new set of wires could be made fast and finally when all seemed right, the

lenses were all uncapped and the signal given, but no explosion came. The electric current or the wire, or the magnesium or something was wrong.

The lenses were capped and new plates put in the holders—for of course it would not do to uncover the same plates twice with the certainty of having two bright spots where the torch sent its light out and down to the sensitive plates where there should be but one, and the whole performance had to be gone through with again. More experimenting followed to demonstrate that the current properly applied, would explode one of the two remaining caps, and the last one then put in position. Then once more, the wires were carefully overhauled, the long wire hauled taut by the boatmen, the lenses uncapped and the signal given.

Away up on the ramparts the black silhouettes of men could be dimly seen. The marble pedestal shone white in the glory of the arc-lights. Above, the black form of the statue was reared with the shadowy arm uplifted, while above all the gleaming torch sent its lines of light straight out over the waters of the bay. A moment of suspense followed, then the night seemed rent apart and for a moment all was white as blazing day, then in the sudden return of darkness a few burning bits of paper fluttered down through the air and all was over.

On developing the various negatives, I found that the 16 x 20 and the 8 x 10 made with the 13-inch Morrison were under exposed. The 5 x 8 and the stereoscopic plates came up very satisfactorily but were spoiled in the fixing bath from particles of partially dissolved salt that in some manner had become mixed with the hypo, while the 8 x 10, taken with the Dallymeyer 10-inch lens, proved a success and is the excuse for this article.[593]

172. LIBERTY ENLIGHTENING THE WORLD.
Photographed by Magnesium Light.
Copyright 1890, by S. R. STODDARD, Glens Falls, N. Y.

William Gladstone, zinc engraving.　　　William Gladstone, chalk engraving.　　　William Gladstone from a photograph
circa 1890.

PHOTOZINCOGRAPHY VS. THE "CHALK" ENGRAVING PROCESS.[594]

Photozincography, or more simply "zinc etching" as it was commonly termed, was by this time the predominant mode of photoengraving used to make newspaper illustrations. But a rival method advertised extensively as being better than any photoengraving process was adopted by some newspapers in various sections of the United States. This was the "chalk process," wherein a thin coating of plaster of paris and chalk was applied to a steel plate, after which an artist could draw through the chalk coating to make an intaglio-style engraving. After the drawing was completed, the plate was placed in an iron box and molten metal was poured against it to make a relief cast of the engraving for subsequent printing on a press.

Stephen Horgan contended that the chalk process was unsuitable for making reproductions of photographic portraits, and that it was mechanically impossible by this method to obtain the character necessary to produce an acceptable likeness. To illustrate the point, he published two illustrations of British Prime Minister William Gladstone, one made by photozincography and the other by the chalk process. Above left is an illustration made by Horgan by photozincography. Center is an illustration made by an artist by the name of Wagstaff on the Atlanta *Evening Journal,* using the chalk method. Right is a

contemporary photograph of Gladstone reproduced here in halftone for comparative purposes. The Atlanta artist was evidently pleased with his results and sent the chalk process illustration to Horgan, asserting that the process was among other things much quicker than photozincography. With tongue evidently in cheek, Horgan responded: "I will not question the likeness in this case. Mr. Wagstaff says his portrait is that of Mr. Gladstone, and I will take his word for it." But he challenged Wagstaff's contention that the chalk process was quicker (Wagstaff said his illustration was completed in 1¾ hours). In the presence of several witnesses, Horgan arranged for artist Alexander Zenope to make a drawing from the same original used by Wagstaff, then processed the reproduction by photozincography. The total amount of time involved was an hour and eighteen minutes, which Horgan said was broken down as follows:

Drawing portrait	18	minutes
Photographing and reversing negative	15	"
Preparing the plate for etching	14	"
Etching	15	"
Blocking and routing	5¼	"
Engraving and proving	10¾	"

for myself can report progress in my experiments in this direction, so that I hope soon to be able to place on the market an orthochromatic plate of good sensitiveness which can be worked without a yellow screen.[595]

A year later, John Carbutt, another supplier of orthochromatic plates, contended that color screens were rarely needed in making landscape photographs, except in cases where photographs were being made in brightly lit mountainous regions, or where white clouds were to be found in relief against a blue sky. Then a pale yellow screen would be called for, which, with a longer exposure, would better render details in the foreground of the picture. Carbutt said photographers should also make greater use of the plates for studio work, and he gave this description of the way in which to revamp a studio for this purpose:

> The best light I find is that coming through an orange-red medium, and as the orthochromatic plate is more sensitive to yellow than to blue, I would suggest that the walls of the studio be tinted a pale yellow, the side screens also, and the curtains to the skylight of yellowish cheese-cloth. The results in your portraits would be blue eyes rendered darker, auburn hair lighter than it is usually rendered, freckles much less conspicuous, and colors in drapery rendered with a truer color value, together with a more harmonious result generally . . .[596]

After a while, the matter probably became academic. Julius F. Sachse, the newly named editor of a revitalized *American Journal of Photography,* pointed out that no one buying a box of dry plates knew just how the maker's particular emulsion was prepared (since all manufacturers kept their formulae carefully secret), hence, there was nothing to hinder a manufacturer from using on his *ordinary* plate an emulsion to which had been added an orthochromatizing solution.

Stephen Horgan found as much when he took a tour through eight New York photographic stock houses in 1897 to purchase orthochromatic plates for comparative analysis. Frequently, he said, he was told (always "in confidence") that all dry plates by the best makers were made orthochromatic. In the guise of a one-man "consumer's union," Horgan subsequently published his findings, and his review would, in today's terms, be called "mixed." He found that Cramer's *Banner* plates possessed the advantage of photographing the violet one shade darker than Eastman's "extra rapid" plate, but that this was offset by Eastman's plate recording orange one shade brighter than the Cramer plate. Horgan considered Cramer's "slow isochromatic" plate the best in orthochromatic properties of all makes, but said it would photograph green and red one shade too dark in each case. Plates made by Wuestner and Carbutt, he said, possessed like properties, namely that violet (the darkest color) would photograph lighter than yellow (the brightest color), "leaving these plates hardly deserving the title of orthochromatic." The French-made Lumière "series B" plate, Horgan said, was the only plate that would photograph red at its proper value, but was in every other respect no better than the American plates.[597]

VOL. XXIX.—No. 749. NEW YORK, JULY 15, 1891. PRICE, TEN CENTS.

Puck

KEPPLER & SCHWARZMANN, Publishers. COPYRIGHT, 1891, BY KEPPLER & SCHWARZMANN. PUCK BUILDING, Cor. Houston & Mulberry Sts

ENTERED AT THE POST OFFICE AT NEW YORK, AND ADMITTED FOR TRANSMISSION THROUGH THE MAILS AT SECOND-CLASS RATES.

THE PEEPING TOMS OF THE CAMERA.

1891

334

1891

The explosion in amateur photography came at a propitious moment in the cultural history of America. This was the start of the Gay Nineties, when whole cities were characterized as "restless," and there was a push and hurry not to be seen in any other land. In art, it was a time for idealizing women, and this expressed itself in photography as well. Throughout the country there developed a preoccupation with the enjoyment of one's time in leisure hours. For some, this period was "the springtime of life," but to Alfred Stieglitz, newly returned from nine years of living in Europe, he could see only a "spiritual emptiness of life" which he found "bewildering." Bicycling for the first time became a national vogue. New "safety" bicycles were introduced with equal-sized wheels and cushioned rubber tires; "drop-frame" bicycles also appeared, which allowed a lady's skirts to veil most of the legs down to the ankles. Wherever the new hordes of bicyclists went, their new hand cameras went with them.

Despite the boom in the camera market, the term "detective" continued to be applied to a variety of the hand cameras introduced before the turn of the century (signifying, no doubt, an appreciation for privacy little known today). At the same time, a whole new breed of novelty cameras appeared on the scene, including those concealed in watches, binocular cases, hats, cane handles, and even scarves; or packaged in such fashion as to resemble a revolver, a set of books, etc. Among the professional photographers, considerable discussion began to take place among those who advocated the use of small versus large cameras. Cameras able to accept large plates had traditionally been used to make many of the finest photographs of exhibition caliber, but enlargement had become a simpler matter from negatives made with the new hand cameras.

As there was more to discuss in the trade, as well as among amateurs, so there appeared a new group of periodicals, particularly aimed at what was presumed to be a permanent new market of amateur readers. The three prime new publications, all of which first appeared in 1889, were the *American Amateur Photographer,* published in Brunswick, Maine (home of the editor and publisher W. H. Burbank); the *Photo-American,* published in Stamford, Connecticut; and the *Photo-Beacon,* published in Chicago. All were discontinued in 1907—perhaps a telling indication of just how long their subscribers were interested in reading up on photography before accepting the camera as just another adjunct of everyday living.

The Kodak's first competition, the Kamaret, a product of the Boston factory of the Blair Camera Company, made its appearance in 1891. Dr. Arthur Elliott, reporting on the progress of photography at the annual P.A.A. convention in July, described it as "the most compact hand camera now in the market" (principally due to placement of the roll film between the cone of rays and the side of the box); but the camera was not a success; later, even a Blair officer referred to it as a "lemon."

Among other camera styles which became more popular

at this time were the reflex camera (which reflected the image to be photographed onto a viewing glass at the top of the camera) and the magazine camera, which stored a number of plates or cut films inside the camera (each plate being changed after an exposure by a mechanism of some sort). At the P.A.A. convention, Elliott lauded a new magazine camera just introduced by E. & H. T. Anthony & Co.:

> Coming to the use of plates in hand cameras, we must give the palm to the new magazine camera of Anthony. This embodies several new devices that are quite ingenious. First, the plates are made to come into focus automatically by means of a spring, and after exposure a single push on a button takes the exposed plate out of the way into a well, leaving another plate in place for further use. Second, after all the plates in the magazine of the camera have been exposed, the camera may be loaded up again by attaching a reservoir box to it containing a new lot of plates, which are readily transferred to the body of the camera by use of a couple of slides. The empty box can now be used to hold the exposed plates in the camera, and these are removed by attaching it to the bottom of the camera and with the movement of two slides the plates fall out to give place to those that are to be exposed afterward. When we remember that all these transfers are accomplished in open daylight, we must confess that this is a decided advance in the construction of hand cameras.[598]

JENA GLASS

In 1881, Ernest Abbe (of the Carl Zeiss lens manufactory) and Otto Schott established a glass factory in Jena to develop a new type of optical glass. By 1886, they were offering a variety of new glasses, including three versions of a new barium crown glass. This gave a new dimension to photographic optics, which had previously relied principally on flint glass. The new Jena glass enabled opticians to increase the angular aperture of their lenses, and to produce perfect flatness of field and freedom from astigmatism. The glass was applied to lens design in 1887, and as one British expert expressed it several years later, "it seemed as if mathematicians might play with the designing of lenses" for the first time. The first major application of the Jena glass was in the Zeiss Anastigmat, introduced commercially in 1890. In more technical terms, the Jena glass allowed a better compromise between roundness of field and astigmatism. Roundness of field was a lens defect wherein the definition at the margin of the plate is defective, while that at the center of field is good. By focusing, definition at the margin could be improved only by sacrificing definition at the center. Astigmatism was a lens defect also giving a want of marginal definition, but which could also be improved by sacrificing central definition.[599]

ANASTIGMATIC LENS COMBINATIONS

Astigmatism in a lens means that the lens does not have the ability to bring to a focus at a point all of the rays proceeding from a point in the subject or object being photographed. A point in the subject becomes something else in the image. The first anastigmats (corrected for astigmatism) were single lenses of two or as many as five pieces of glass. The single lens anastigmat, top left, has four glasses. Double anastigmats were introduced immediately after the single-lens versions. The example, top right, consists of two single lenses having a total of eight glasses in all.[600]

THE TELEPHOTO LENS

Photographers had long sought a lens that would, as one of them put it, "give enlargements direct in the camera." This was supplied in 1891 by two sources—T. R. Dallmeyer, in London, and Dr. Adolf Miethe in Berlin. While there was talk of priority, Dallmeyer had indicated privately that he was working on such a lens in 1890, at the behest of Peter H. Emerson. In the Dallmeyer lens, a diverging or achromatic concave lens was placed at the end of an internal extension tube which projected back into the camera from behind an ordinary portrait lens. By extending the camera, an image could be obtained of objects situated too far distant for adequate viewing by the naked eye. The optical principle was not new, but the ability to provide good definition and a flat field, together with plenty of light, was something of a technical breakthrough (not fully achieved at first, but evidently achieved by the time of the 1893 Chicago Exposition). W. K. Burton, a British photographer who was serving as secretary of the Photographic Society of Japan, discussed the powers of the Dallmeyer lens at the Chicago fair and said "it will be found that using the same back focus, that is to say, the same distance between the posterior lens and the ground glass, the telephotographic lens gives an image from about three to about five and a half times as large as is got by an ordinary form of lens, according to the extension of the camera, and the form of 'ordinary lens' used. This is linear enlargement, or 'diameters.' At first sight these figures may not seem very great. If, however, we consider a case or two it will be seen how enormous the advantage is. For example, 6 inches is a common enough focus for a quarter plate. Say, a single lens is used. We may, with the same back focus, get an image with the telephotographic lens as large as could be got by a single lens of 34 inches focus."[601]

Automatic photographing machines also were introduced this year. By putting a nickel in a slot you could have your picture taken and framed while you waited. But Elliott's reference to them was disparaging: "All we have seen are easily distanced by the poorest tintype artist that visits the smallest country town."

Photographers using magnesium flash powder found that by dividing the powder into a number of small charges (instead of lighting it in one large flash) they could overcome some of the hard shadows which characterized their early flashlight prints. They were finding, too, that they could easily modify the color of the magnesium light, and that this could be applied to particular advantage when using orthochromatic plates.

A proliferation of new lenses matched that of the many new camera styles. Oscar G. Mason, the resident photographer at New York's Bellevue Hospital, and one of the pillars of the Photographic Section of the American Institute, had observed several years previously that "the once prevalent idea that all kinds of photographic work might be done, and well done, by one or two combinations of lenses has passed. And it has been conceded that each maker's productions, if not each lens, is best adapted to a single kind, or quite limited field of work." One colleague, Mason noted, owned some forty lenses, yet "often wishes for a different combination for some of the strange cases which he is

constantly meeting in his varied and curious practice."[602]

Perhaps the greatest boon to lens development was the introduction of a new type of Jena glass in Austria (see page 335). In his P.A.A. speech, Elliott lauded the new Zeiss anastigmat lens (made with the new Jena glass), and said "there is no doubt that this Jena glass, which has done such wonders in the field of microscopy, is destined to teach us some new things in the world of photography." The anastigmat was the first lens to virtually eliminate astigmatism—an inability to obtain sharply defined images of vertical and horizontal lines, especially at the edges of the field of view, at one and the same time.

The success of the Zeiss anastigmat quickly stimulated other opticians to work along similar lines, and may be said to have led German manufacturers to a new predominance in the lens market. C. P. Goerz, of Berlin, soon followed with a double anastigmat, which further reduced astigmatism and supplied increased illumination and general definition. In the period 1894–96, Voigtlander came out with the Collinear lens, which was said to be twice as rapid as the double anastigmat. For portraiture, the Petzval lens first supplied by Voigtlander in 1841 continued to be the world standard. As late as 1897, when Friedrich Voigtlander (fourth owner of the firm) visited the Boston Camera Club, he noted that the Petzval had "found a home in nearly every well-regulated studio throughout the world," and that this

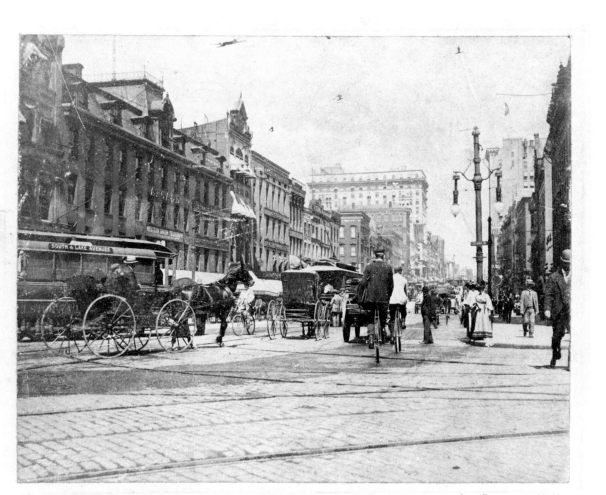

MADE WITH LONG FOCUS PREMO. Rochester Optical Co., Rochester, N. Y.

TELEPHOTOGRAPHY IN THE 1890S

The term "long focus" was applied to lenses with telephotographic capabilities, since the telephotographic lens could also be described as a long-focus lens (or battery of long-focus lenses) in a single instrument. Ten years after the introduction of this type of lens, the *Photo-Miniature* observed that "it cannot be said that photographers generally have an intelligent appreciation either of the significance or uses of telephotography." The magazine also observed that, "with the notable exceptions of Mr. Dallmeyer's comprehensive treatise, Dr. [Paul] Rudolph's monograph, and a few scattered papers by . . . others, there has been a stange lack of plain and practical information concerning the whole subject."

At the World Congress of Photography held at the Chicago 1893 fair, the British photographer and secretary of the Photographic Society of Japan W. K. Burton said he was sorry not to be able to mention any "recent radical improvement in photographic lenses by Americans," besides a new telephotographic lens just at that time introduced by Albert B. Parvin of Philadelphia. But Burton noted that "few American lenses ever reach this country [he was presumably referring to England], and the description of new lenses in American journals are generally vague, if not misleading." A full description of the Parvin telephotographic lens was published by Parvin in *American Amateur Photographer* in June 1893.

Talbot Archer, another British writer, informed *Anthony's Photographic Bulletin* at the time of the 1893 fair that telephotographic lenses were being used by the British War Department to obtain views of distant fortifications, and by such Alpine travelers as C. T. Dent, who made surveys of snow-clad regions in the Himalayas, the Caucasus, etc.

T. R. Dallmeyer, in a series of articles covering the evolution of lenses which was published in 1900, gave scant attention to telephotographic lenses, asserting that "the subject will require but very brief treatment." But he said he himself was working on a new telephotographic lens which could be used in hand cameras.[603]

lens, alone "was capable of producing the soft, round, plastic and delightful effect in portraiture, which is the artistic standard in this branch of photography for all time."[604]

Although heralded at the July P.A.A. convention, no anastigmats appear to have been used by those exhibiting prints at the joint exhibition of the New York, Boston, and Philadelphia amateur societies held at about the same time in New York. Of approximately 1,300 photographs (principally landscape views) exhibited by American and foreign photographers, roughly a quarter were taken with a Dallmeyer rapid rectilinear lens of one class or another. More than 150 of the photographs were made with a Ross doublet-style view lens, while another 94 were made with lenses manufactured by Ernest Grundlach, of Rochester, New York.

This may have been the first exhibition by an American photographic society to which the early followers of P. H. Emerson's "naturalistic" school of photography sent photographs, and it is likely that their participation was arranged by Alfred Stieglitz, who was himself an exhibitor and who four years earlier had been given first prize by Emerson at a London amateur photographic exhibition. There were three outstanding British photographers represented at the New York exhibit, all of whom were to become founding members, in 1892, of the Linked Ring Brotherhood. They included Frank M. Sutcliffe, Lyddell Sawyer, and Henry Peach Robinson, the noted "pictorial" photographer. The American landscape photography school was represented by William H. Jackson. Records of the exhibit reveal that the lenses used by the above photographers for the photographs they exhibited were as follows:

Alfred Stieglitz	Steinheil Rapid Rectilinear
William H. Jackson	Ross Rapid Symmetrical; Gray Periscope
Frank M. Sutcliffe	Dallmeyer and Ross lenses
Lyddell Sawyer	Ross Rapid Rectilinear; Darlot Portrait
Henry P. Robinson	(Not stated)

The Steinheil lens used by Stieglitz had an aperture of f/7, and was particularly suited to making outdoor portraits of individuals or groups, for which Stieglitz was noted at this time. Although the Dallmeyer Rapid Rectilinear was adopted for studio portrait work (Brady reported one stolen from his Washington gallery in January 1891), David Bachrach was of the opinion that portraits made with such "hard, wiry, sharp lenses" were "abominable." The use of

IN MEMORIAM:
JOHN A. WHIPPLE

Boston's illustrious pioneer photographer John A. Whipple died on April 11, 1891. After his partnership with J. W. Black was terminated in 1859, he operated alone until 1874, when he gave up his practice and engaged in publishing religious works. Whipple is remembered as the inventor (concurrently with Niépce de Saint-Victor) of the first (albumen) glass negative process, and of the "Crystalotype" paper prints made from these and the later collodion glass negatives. He was among the first to photograph the moon, and to make photographs through the microscope. His outdoor photographs taken by electric light in Boston Common in 1863 are the first of this type recorded in America.[605]

these lenses for portraiture required good lighting under any circumstances, and Bachrach felt their indoor use should be limited to group portraits. But whether because of the availability of the new Jena glass or due to other factors, opticians at this time improved on the manufacture of rapid rectilinear lenses, providing lenses with apertures that were actually f/8, whereas such lenses manufactured prior to 1890 more frequently than not contracted to less than f/8. Because of this, photographers attending the 1893 Chicago fair were warned that while secondhand rapid rectilinears might be excellent in every other respect, they were liable to be slower than newer lenses of the same make.[606]

1892

In many respects this was photography's most eclectic moment. Not only was there much that was new to choose from in equipment and apparatus but there were many choices to be made, as well, in processes. Still to come (but just around the corner) were entirely new dimensions, both in portraiture and in the means of printing "artistic" photographs for public exhibition and sale. Perhaps because of all the innovations—and in part, too, because of the onset of another severe financial recession—there was something of a lull in commercial business in 1892. David Bachrach blamed it on a rush to "cheapness and quantity," which he blamed for the fact that "among people of the class who in former years were liberal patrons and are able to pay good prices, *it is no longer fashionable to display photographs,* except as mere cheap souvenirs, and as a possible basis for future use in copying, etc." Bachrach had been a vocal opponent of various processes such as the Lambertype and Artotype, introduced in the 1870s, and he now began a series of analyses, pro and con, of the major photographic processes and papers, the series running off and on in *Wilson's Photographic Magazine* throughout the 1890s.[607]

S. H. Mora (possibly a kin of the New York photographer J. M. Mora) put the matter succinctly when he addressed the tenth annual convention of Canadian photographers: "At the present time, the question, 'What paper shall I use?' is one that is agitating the minds of a large percentage of the photographers throughout the world, especially in Canada and the United States." Among the so-called silver prints, there were now—in addition to the longtime standby, albumen paper—such choices as plain or mat surface papers (the modern versions of the original "salt prints" of the 1850s) and the carbon process; bromide paper; a series of collodio-chloride and gelatine-chloride papers; and the still little-used platinum paper.

Of the photomechanical printing modes, that which produced prints in photogravure had become the most popular, although principally, at this stage, only for book illustration. It was Bachrach's contention that albumen paper retained its popularity, and that the "liberal patrons" were not buying finely made photographs because even those made on plain or platinum paper were generally not up to the standards of taste exhibited in prints made from engraved plates:

> To read the articles written by the most artistic of our co-workers one would imagine that the first or plain-paper process, and the platinotype later on, should certainly have distanced all the rest by the engraving-like effects, and that only the persistent degraded taste of the people for "shine" and "polish" caused the meretricious and less permanent (albumen, gelatine, and collodion) processes to survive. I confess I have done my share in decrying the evil, but, after a careful reconsideration, I have come to the conclusion that the masses were, at least, partly right.
>
> Were it a fact that the plain-paper and platinotype prints are in every respect equal to prints from engraved plates, either line, mezzotint, or photogravure, then the condemnation

BROMIDE PAPER

Introduced in England in the 1870s, this paper, as patented in the United States by T. C. Roche (for E. & H. T. Anthony & Co.), was made with an emulsion holding in suspension the bromide haloid of silver. It was a developing-out rather than a printing-out paper, and being highly sensitive to light (giving it fast action in use), it could be developed under artificial light. This feature, alone, made it an attractive candidate for replacing albumen paper, which required printing-out in sunlight, usually on rooftops. But David Bachrach considered it only suitable for commercial work, or for enlargement of landscape or architectural photographs. "The process," he said, "is very useful for making enlargements quickly and very sharp from the densest negatives, which heretofore had to be done by very troublesome and roundabout methods." He also felt that its early adoption by "cheap Johns" and "charlatans of the profession" to make cheap enlargements of portraits at low cost had had a bad effect on the profession, and adversely affected business. In the spring of 1893, the *Photographic Times* reported that the paper "seems to be coming into more favor again," and that dealers were reporting large sales increases. In 1898, the Eastman company introduced a new variety which it labeled "Royal Bromide Paper." This was a creamy tinted paper of heavy weight, offered with a smooth or rough surface. But Charles Lovell, writing in Wilson's journal after the turn of the century, felt that one of the mysteries of the photographic business was the "contemptuous way" in which the paper was treated in the 1890s:

> It has been left altogether too much in the hands of that class of the young amateur who does not know what is a good print, or of the low-priced photographer who uses bromide paper as a substitute for platinum, and who often is as much at sea as the amateur as to what constitutes a good print.[608]

poured out on the artistic taste of the public would be justifiable. I contend that not one in fifty of such productions can compare in quality with plate prints of the kind mentioned; and, if they did equal them, I will again say that "the masses" would not so eagerly have preferred the glossy prints. A print from a steel or copper plate has its deepest shadows composed of such a depth of ink that the same shadows in a plain sil-

CHLORIDE PAPERS

S. H. Mora, in a speech to Canadian photographers in 1893, said albumen paper was "doomed," and "must step down and out." The claim that a gelatine emulsion was not as long lasting as albumen, he said, was a "false one." Just as many photographers had failed to produce permanent results with albumen or collodion papers, as with a gelatine paper:

My honest belief is that all of the papers made today are permanent in the way in which we understand the word, when properly handled in manipulation. An intelligent photographer can easily answer the question to his own satisfaction by referring back to the negatives which he has made. He will find that there may be some that have turned color, but if they have turned color in spots it would indicate insufficient fixing. If they have turned over the entire surface, he will notice a crystallization of hypo, indicating insufficient washing. But he will find a large majority of his negatives are as clear today as they were when made several years ago. The same thing will apply to gelatine paper, as the base, gelatine, is the same, and consequently should not turn any more than the negative; the chemical emulsion is practically the same as a collodion emulsion. There is, therefore, no good reason why one paper should not keep as well as the other. A large number of photographers have tested the permanency of gelatine emulsion as compared to albumen or collodion, and I have not yet heard of a single case in which it did not hold out as well as, or better than, albumen or collodion.[609]

ARISTOTYPES

Like albumen paper, aristotype paper was a printing-out paper requiring development with the aid of sunlight, as opposed to development in a darkroom with the aid of artificial light. The aristotype came in two versions, one made with a collodio-chloride emulsion (paper containing silver chloride in a layer of collodion), and the other made with a gelatine-chloride emulsion. Both versions were first introduced in Europe in the 1880s, after which their manufacture was begun about 1890 by the New York Aristotype Company in one small room in New York City. About 1892, the company was relocated to a larger factory in Bloomfield, New Jersey. The founders of the American concern were the brothers W. M. and F. M. Cossitt (the latter presumably being the Franklin M. Cossitt who had been co-inventor, with George Eastman, of the ill-fated Eastman detective camera in 1886). In June 1893, an editor of the *Photographic Times* visited the Cossitts and gave a brief account of the company's operation, from which the following is excerpted:

We were much struck by the size of the building and the enormous amount of paper prepared and sold. The coating room, containing the coating machine, and hanging and drying arrangement is no less than 220 feet long. Great rolls of the raw paper are fitted to the machine and made to pass around a roller dipped in the sensitive gelatine emulsion. After coating, it is carried right on to the other end of the room, looped up, so that in this space no less than two miles of paper is hung. This quantity, we are told, is usually prepared at one time. Two miles of photographic paper! What a number of pictures this quantity is likely to produce. In another part of the room stands the machine for coating the "kalona" or collodion paper. This is somewhat different to that used for the gelatine paper. After it is coated it runs through a trough about 120 feet long; this is heated and a current of air passed through to take away the ether and alcohol fumes. By the time the paper reaches the other end it is quite dry and is cut up into sheets and stored away.[611]

vered paper or platinotype print cannot hope to rival it in strength, and at the same time the picture is entirely on the surface, not sunk in as in the photograph, thus combining great delicacy in half-tone with great brilliance of light and shade. I deny that either of the processes mentioned ever give such a result except in very exceptional cases, and hence the preference of the public for the glossy albumen prints which give all that the engraving does in delicacy and depth, and at the same time a range of very pleasing tones. Let us be frank and acknowledge the truth that the people at large are not altogether to blame for their preference. I say this as the avowed friend and long practitioner of the platinotype process for large work.[610]

There was a direct analogy, Bachrach felt, too, between the "fate" of stereoscopic photographs and the current pursuit of cheapness and quantity about which he complained in professional work. Where stereocards were the attraction in every parlor twenty years ago, "quantity increased, quality decreased, prices kept pace with quality, the 'dollar stores' took hold of them, the parlors abolished them, and now who makes them?" Not one photographer in a hundred even *owned* a stereoscopic cmaera, he asserted.

Of all the emulsion processes, Bachrach was at first inclined to favor printing on bromide paper, although he changed his mind by 1896. But in the summer of 1893, he contended that:

. . . of these various methods of producing prints by the modern processes of emulsion printing, the gelatine bromide, devel-

oped with ferrous oxalate, is probably the most permanent, if the iron is promptly and thoroughly eliminated after the development, and if the fixation has been thorough, and if the washing has been the same. Otherwise, they are worse than the average albumen prints produced by good establishments.[612]

Bachrach's greatest antipathy towards the emulsion processes was directed at this time towards the aristotype, a trade name applicable to certain photographic papers produced with either a collodio-chloride, or gelatine-chloride emulsion (see above). The aristotype, Bachrach said, outshone the albumen print in polish, and in effect this was simply continuing a mistaken course which had been first taken in the 1870s when a higher gloss in albumen paper was achieved by doubling the albumen layer. In the case of the aristotype, it was impossible to add more than one ounce

Photographs of nighttime fires were uncommon in the nineteenth century; hence, this "instantaneous" photograph of the burning of a famous hotel in a Virginia resort town was considered a technical feat, and as such was reproduced in the *American Journal of Photography*.

1892

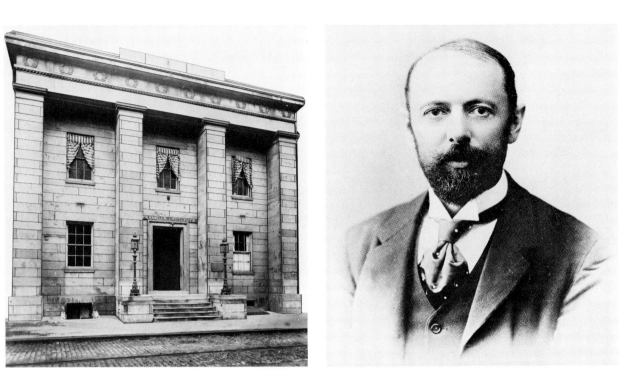

Like the Cooper Institute in New York, the Franklin Institute in Philadelphia (left) was the scene of many important activities and events in nineteenth-century American photography. Frederic E. Ives, shown (right) in an 1896 photograph, chose the Institute as the forum for reporting on his continuing improvements in color photography, and was twice awarded medals by the Institute for his discoveries.

IVES "HELIOCHROMY" SYSTEM ALLOWS VIEWING OF PHOTOGRAPHS IN COLOR

The perennial inventor Frederic E. Ives patented a "Trichromatic Camera" in 1892 which provided the basis of a system for viewing photographs in color, but not in securing them in color print form. Ives himself described the camera as "somewhat complicated in optical construction," but it was capable of securing three separate images simultaneously on one orthochromatic plate through three light filters (red, green, and blue-violet, respectively). From this triple monochrome negative, a triple positive was made on glass, which Ives called a "chromogram." Using red, green, and blue-violet lights, the triple images of the chromogram could be projected in register for viewing as one full-color photograph (using a magic lantern with three optical systems), or the images could be seen in color and in register through a viewing instrument (which Ives called a Heliochromoscope). This device allowed monocular viewing through a single eyepiece, but in 1894 Ives patented a stereoscopic viewing instrument, which he called the Photochromoscope, or "Kromskop," as the commercial version came to be known. Because the trichromatic camera required as much as two minutes to make an exposure, it was not used to make photographic portraits for color viewing. From 1892–94, Ives lectured on his "heliochromy" process in England (before the Royal Photographic Society and the Royal Institution), France, and Switzerland. In 1894 he made photographs with the trichromatic camera in Yellowstone Park, and in 1895 he was awarded the Elliott Cresson Medal for his invention by the Franklin Institute. But as the *Pall Mall Gazette* pointed out at the time of Ives's lectures in London, color photography still remained elusive:

> The invention in the sense of pure science does not claim to be color photography. In the strict meaning, a color photograph would be a picture taken directly by lens and camera with the colors and the light of nature. Such a thing has never been done, and there is nothing in the present state of science to justify the supposition that this result may ever be accomplished. It certainly has been possible to obtain upon a film of quicksilver some impression more or less fleeting of a few of the colors of the spectrum. It would, moreover, be practicable, with prolonged exposure, to obtain some kind of colored image from a powerfully illuminated object of, say, a red color. But the impression would be a mere silhouette of color without light and shade of gradation. Such successful experiments have frequently been made and chronicled from time to time in the newspaper press as the early promises of a great discovery. The last occasion may be fresh in the memory of many. This was the result of some researches by Prof. Lippman of Paris. But his discovery admittedly fails to render even the simplest combinations of color. It would appear that no clue exists to the secret of color photography. The dream may fascinate, and the hope may stimulate, but the search has hitherto been as fruitless as for the philosopher's stone.[613]

THE HAND CAMERA AND ITS ABUSE

From *Anthony's Photographic Bulletin,* November 12, 1892

The press-the-button photographer has considerable food for reflection this month. The summer has seen him, camera in hand, recklessly snapping the shutter in all sorts of inaccessible places, and the confidence he has had in his results is more than painfully amusing. The many rolls of film have been sent to the dealer for development and finishing off, the end being that a very disgusted individual finds himself the recipient of a very small percentage of poor prints, with a large bill to pay for the production thereof. The camera, or more often the film, is blamed, the operator rarely realizing that while photography is a wonderful art-science, it cannot be expected to supply brains and common sense to its votaries.

Large batches of such developed films have reached us, accompanied in most instances by long letters of complaint, and often by the camera itself, for examination. In ninety-nine out of every hundred such cases, the fault has not been that of camera or film. The blame must, therefore, lie with the user of the instrument. Taking one such batch, we find, in some of the films, just a faint glimpse of a shelf and a clock; on another, a black patch representing a window; on another, a ghostly outline of trees; on the majority, nothing distinctly visible. All that has been written on photography has availed nothing with the producer of these results, and why? Because all that which has been written has never been read. The camera and films have been purchased, the instruction imparted by the vendor, carelessly listened to, forgotten, and all commonsense principles as to the lighting of the subject violated. And this disregard of the first principles of snap-shot photography is on the increase, judging by the quantity of useless matter produced.

The remedy for this is, obviously, education, obtained by careful perusal of photographic literature. Such education becoming general, the mechanical photographer will cease to exist, for the impossibility of an outsider to do justice to the work will be realized. And, more important still, the truly remarkable efforts put forth by these very-much amateurs will be gently restrained; no more instantaneous shots at picnic parties in shady glens, or lovers in cosy nooks under piazzas, will be attempted. The implicit trust that the mechanical photographer has in his instrument is really pitiful. It is to him the only factor in the work. But it is a factor concerning the properties of which he is, like his subjects, entirely in the dark.

There can be no doubt that the number of users of the hand camera is increasing at an enormous rate. The portability, compactness and general simplicity of action of the instrument commend it to all. But of all photographic instruments, it is the one calling for the exercise of judicious self-restraint and careful handling. The user must remember that an instantaneous picture is usually an under-exposed one, and that it is practically useless to attempt to photograph a poorly lighted object unless an exposure of one-half to one second can be given. The users of tripod cameras seldom expose with the shutter unless forced to do so, and the percentage of results ranks considerably higher than that of those of the hand camera. The users of the latter instrument rarely, indeed, use the time attachment, and, therefore, must depend on the extreme rapidity of their plates or films and on the choosing of well-lighted subjects. In most of the cheaper hand cameras the lenses are perforce diaphragmed down so as to give good depth of focus, for the focusing is done chiefly by a graduated scale. The lens will work usually about right if the light is really good. Under any other circumstances the negative will be poor and weak.

Now, the number of cheap hand cameras sold is very largely in excess of the expensive ones. With these cheap cameras good instantaneous pictures can only be obtained when working under the best possible conditions. This must be borne in mind in purchasing and in using them. Though it cost a pang to lose a good subject, it should be allowed to go; for it is simply throwing away material and labor to expend a plate upon it.

To users of films we would remark that very careful manipulation is required. Many, not well acquainted with the intricacies of their roll holders, partially fog the film by prolonged exposure to the red lamp. No lamp is perfect, and the less the film is exposed to any light the better. Then, the same cause of fogging must be avoided when cutting up the film for development. A glance at the back of the film, this being held so as to reflect the light, will reveal at once the position of the punctures. A long pair of scissors does the rest. Frilling round the edge from handling is a source of great annoyance; but care in handling and the confining of the attention to one film at a time will obviate this. All films should be soaked in water containing alcohol and glycerine before being allowed to dry, and should be stored face to face between cardboard. A film once cracked is like a plate broken.

The cut films do not receive the share of patronage they deserve. They are rigid, and have all the qualities of the best plates, and are easier to handle than the roll film. But the greater portability of this latter and its easy exchange will ever entitle it to favor, though these are the qualities rendering its employment dangerous because of its facility. In the abundance of material, recklessness and abuse arise, and the percentage of good results lowers.[614]

BICYCLE CAMERAS

Bicycling and photography came into vogue at the same time as new pastimes for leisure hours. W. I. Lincoln Adams described for the readers of *Week's Sport* which cameras were best suited for bicycling:

THERE are a number of cameras especially designed for bicyclists; the pocket photographic outfit, consisting as it does of a 3¼ x 4¼ inch camera, with a double dry-plate holder, hinged ground glass, and weighing only twelve ounces, being about the best. This little outfit contains an excellent lens, with diaphragms for increasing or diminishing the amount of light, and is sold complete for $10. A nickel-plated bicycle adjustable support costs only $2 extra. This outfit has no loose pieces, and is so accurately made that there is no side plate whatever. As its name implies, it may be carried in the pocket when not in use, and is a very convenient little camera. In photographing it may be adjusted to the handles of the machine by the adjustable support, and it makes excellent pictures.

Larger instruments are carried packed, attached to the wheel by a spring carrier, which is a kind of skeleton framework on springs mounted in front of the handle bar. Twelve or fifteen pounds may thus be carried easily without danger of breakage, or without adding extra work on the pedals. The larger cameras may also be used on handles of the machine a steel support being furnished for holding the wheel rigid while the exposure is being made, or if a tripod is carried, as some wheelmen prefer to do, the camera is set up on its legs, and the photograph is made in the usual manner.

Most cyclists prefer, on the whole, the hand camera in some form, such as the Waterbury, the Knack, or the Scovill, for it may be carried before the handles by means of the spring carrier already described and snapped from the wheel, even while in motion, if desired. It is usually supplied with an excellent instantaneous lens, so that "snap" pictures may be made at the right hand or the left during a run in the country. The hand camera may also be used on a tripod for making landscapes or other accurate pictures when desired.[615]

of hyposulphite of soda in 18 or 20 ounces of water in the fixing bath without bleaching the print out of sight. "I have seen more bleached, faded, yellow gelatino-chloride and collodio-chloride yclepted 'Aristo' prints in one year than I have of albumen prints in the last three years," he said.[616]

No other spokesman for the finest that could be achieved in photography wrote consistently for one of the country's foremost photographic journals during the 1890s, and it must be presumed that Bachrach's influence on the profession was considerable. It is amusing to read, therefore, in a short memoir which he published just before World War I, that his influence on one major customer in Baltimore was anything but formidable. The customer was William T. Walters, a railroad tycoon who had previously made a large fortune in the wholesale liquor business and was the possessor of a vast art collection which is today housed in the Walters Art Gallery in Baltimore. As Bachrach relates it, the story (circa 1890) went as follows:

I had made some groups for him and, as a compliment, printed him one copy of platinotype and handed it to him, and asked his opinion. He looked it over carefully and said: "Bachrach, I made money by selling people the kind of whiskey they wanted, not the kind I thought they ought to have." Well, I followed his lead and it was five years before I made the serious attempt to do away with glossy paper.[617]

There is no indication in Bachrach's memoir, or in his writings in Wilson's journal during the 1890s, that he participated in any way in the amateur movement towards fine-art photography, which began at this time on both sides of the Atlantic. If Bachrach and men such as Alfred Stieglitz and P. H. Emerson were treading separate paths, their endeavors were headed toward a similar goal. Bachrach may have had trouble getting his customers to appreciate the platinotype, but there would shortly be many works in platinotype exhibited in some of the finest art galleries, as well as museums in the United States, England, and Germany.

About 1890, William Willis, Jr., and his partner, Alfred Clements, visited a London photographic exhibition and counted sixteen prints made on platinum paper—three or four of which were landscapes by Emerson. This prompted Willis to redouble his efforts to further improve on the manufacture of platinum paper (which at this time had a notably poor keeping quality), and, according to Clements, this was accomplished at some point prior to 1895. "Amateurs," Clements said, "began to force the professionals into adopting it for much of their work, though they resisted as long as possible."[618]

As the 1890s wore on, there was a strong revival, too, in the popularity of card stereographs. The "dollar stores," to which Bachrach disparagingly referred, may have included Underwood & Underwood, which moved its main office from Kansas to New York City in 1891, but more likely referred to the competition which Underwood & Underwood (followed by the Keystone View Company after 1892) soon displaced. Underwood & Underwood had opened branch offices in Baltimore in 1887, and in England (Liverpool) in 1889, and in the 1890s the company began producing high-quality stereoviews from negatives made by their own staff photographers, or purchased from photographers in localized areas.

In Newport, Rhode Island, the modest opulence of the handful of remaining downtown wooden mansions of colonial times had become eclipsed by marble palaces (dubbed "cottages") on fashionable Bellevue Avenue. The country was in the throes of another financial recession (almost 600 banks and 15,000 businesses failed in 1893 alone), but the losers were predominantly wage earners and farmers, while the number of millionaires surpassed 4,000 (the vast majority of them in New York City, including more than 150 in Brooklyn). The Gay Nineties not only produced a row of new mansions in Newport but along New York's upper Fifth Avenue, on the shores of Long Island, and in Chicago (which boasted nearly 300 millionaires), San Francisco (about 150 millionaires), and other major cities. Along with all of this new splendor—as might well be imagined—there came a new opulence among a select group of "fashionable" photographers, whose photographic galleries eclipsed the earlier showplaces of Brady, or C. D. Frederieks. If the photographic periodicals of the decade are to be taken as a measure of what took place, no galleries exceeded in splendor those of Benjamin J. Falk in New York, or J. C. Strauss in St. Louis. Falk is perhaps most representative of this group, but while he was widely known in his day, his name is hardly a household word now.

Falk was a native New Yorker who took up a career in law after graduating from the City College of New York. But then the world of art suddenly beckoned more assiduously. He completed studies at the New York Academy of Design, then decided to take a job with photographer George G. Rockwood. In 1877, at age twenty-four, he opened his own gallery on East Fourteenth Street.

During the 1880s he moved several times to larger quarters and gained an international reputation as an "artist-photographer." When the new wave of mansions began appearing on the New York scene, Falk decided the time had come to make his own big move. In 1892, the same year in which William K. Vanderbilt completed "Marble House" in Newport (he had already completed a new mansion in New York), Falk constructed an entire building which became known as the Falk Building at Nos. 13 and 15 West Twenty-fourth Street, near Madison Square. Perhaps Falk's fame would be even greater today had he engaged Vanderbilt's architect, the celebrated Richard Morris Hunt, to design the building, rather than doing it himself.

But Falk's reputation was sufficient to bring a St. Louis reporter running to his hotel room in St. Louis one day in January 1893, when Falk was there for a short stay. The reporter started off his story after the interview by stating that "what a man who is famous in two continents, whose copyrighted pictures are seen in every shop has to say on the subject of this popular form of art [i.e., photography], should have the widest interest." The interview continued:

"What do you think of the work of the photographers as compared with that of a great portrait painter?" Mr. Falk was asked.

"I will answer with what may sound like a paradox,

NEW EAGLE DRY PLATE WORKS

While the rising cadre of amateur photographers were in the market principally for roll film, the professional photographer continued to use glass negatives until a suitable flat film became commercially available in 1912. One major supplier of glass dry plates was the New Eagle Dry Plate Works, which had been founded by Edward Wuestner in St. Louis about 1885, then relocated to New Jersey about 1893. The plant was built south of Jersey City on the peninsula between Newark and the upper New York bays. The setting was described as one where "the air is always fresh and clear, and free from dust." The factory consisted of a main building, 50 x 150 feet, and a series of "out-houses" for boilers, a machine shop, and glass storage. Glass plates were cleaned and made ready for emulsion coating at the rate of 12,000 size 8 x 10 plates every four hours. Special machinery was used to coat and chill from thirty-six to forty of these plates a minute. Coating could be accomplished on plates ranging in size from 6½ x 8½ inches to 26 x 42 inches. One of the company's specialties was to supply plates to the trade in packages without separators, each plate placed film-to-film in its respective package. Thus, the drying of the emulsion films before packaging was a critical matter, and the operation was described as the only one of its kind among all plate manufacturers. The New Eagle company maintained three separate temperature-controlled drying rooms, and after they passed through these drying rooms, the plates had to be certified *bone dry* before packaging. Among its products, New Eagle was most noted for its orthochromatic and "Imperial" nonhalation dry plates.[619]

The camera is at once the best and most truthful medium for art work, as well as the one with the most limitations. There is a great class of work open to the painter which is entirely outside of the photographer's field, and such work should never be attempted by the latter. When it is the results are ludicrous, as is shown where positions of the human figure are attempted which the lens cannot reproduce without distortion or exaggeration. But this is technical. As far as portraiture pure and simple is concerned, the general impression seems to be that the realistic school is the only one for the camera. This is not true; if it were, one would get a map of the human face, but not a portrait. Everybody knows there is the same difference visible between good artistic photographic pictures and poor ones, although technically they may be equal as between good and poor portraits produced by pencil or brush. All of which shows what has come to be recognized pretty generally during the past ten years that the camera, like the brush or pencil, is simply a tool, and may be handled well or ill. Formerly the overcoming of technical difficulties was enough to give any photographer a prestige, but now that these have been swept away, the photographer has been placed on the same plane as any other artist, and he must be judged by the same standards."[620]

STRAUSS GALLERY

The new opulence in the 1890s also became reflected in several of the more posh photographic studios across the land. J. C. Strauss, who began working in a tintype gallery at age twelve, had come a long way by the time he opened this showplace in a French chateau-style building in St. Louis. Studio included an exhibition gallery (top), grand reception room (middle), and palatial stairway to the balcony and operating rooms (bottom). Gallery's Turkish waiting room was equipped with varicolored jeweled lamps. Of a display of autographed photographic portraits, Wilson's magazine commented: "Everybody who is anybody is there." [621]

1893

346

Many of the great and famous in photography are known for their colorful antics in photographing the great and famous among their contemporaries. Alexander Hesler, for example, ran his hands through Lincoln's hair just before taking his likeness in 1857. In 1903 Edward Steichen would thrust a knife into a startled J. P. Morgan's hands to get the drama of the financier's personality. Still more recently (in 1941), Jousuf Karsh would snatch a cigar from Winston Churchill's mouth to catch the striking portrait which typifies Churchill's dogged spirit as no other likeness of the World War II prime minister does. B. J. Falk evidently had similar albeit more gentlemanly thoughts in mind when he decided on a course of action to obtain a dramatic likeness of President Grover Cleveland, newly elected to his second term in office (in 1892), having previously served one term from 1885 to 1889. The St. Louis reporter elicited this description from Falk of the Cleveland sitting:

> By the way, Mr. Falk, what kind of a sitter was President Cleveland?
>
> He came to the gallery all worn out with the excitement of notification week, entirely unlike the descriptions I have read of him, mild and gentile, and with a more worried expression than I had ever seen on any man's face. I was disappointed and looked about for something to say or do to drive this careworn look away. At the last moment I said: "Mr. Cleveland, there are six good democrats in our family." "Yes?," said he, and his face lighted up. That was the expression I wanted and it was caught and fixed by the camera. The result was the portrait you have seen. [622]

Like the celebrated London photographer of earlier years Oscar Rejlander, who made notable anecdotal pictures with allegorical compositions, Falk became a master of photographic compositions, as well as studies from life. Examples of these works included titles such as "The Fisher Maiden," "Judith," and "The Curfew Shall Not Ring Tonight." Falk also was among the first to photograph actors and actresses on stage in their roles. Like Sarony and Mora, he also became noted for his portraits of the stage celebrities, whom he would usually ask to perform the lines of a role in his studio until they got into the spirit of the part. "Then," as he said later, "it takes but a moment to seize upon a favorite attitude and expression and transfer it to the camera." An estimated 50,000 to 100,000 of Falk's professional portraits were sold annually throughout the world.

This was also the heyday period for the Pach brothers' firm, which occupied several floors of a building at 935 Broadway in New York, running from Broadway all the way through to Fifth Avenue. Here, too, were spacious reception rooms and galleries adorned with the finest in furniture and paintings, as well as photographs. Like Falk, the Pach firm made a specialty of printing cabinet cards, as well as larger prints, in platinum. Carbon printing, in which the Pachs also specialized, was handled by "a young worker of considerable promise" (a sign, possibly, of the new awakening to carbon printing which was taking place at this time). Pach Brothers engaged most heavily in college and school photography, operating through "contributory" studios in collegiate cities and towns throughout New England, New York, and New Jersey. All printing and finishing of these orders was accomplished at the New York headquarters, where the printing room handled as many as two thou-

Third floor reception room of the Pach Brothers' establishment in New York, running between Fifth Avenue and Broadway on the south side of Twenty-second Street, was approximately 50 x 20 feet. Its walls were covered with a maroon cloth and framed photographs of celebrities, interiors, still lifes, etc.

1893

347

EDISON'S KINETOSCOPE

Although Louis A. Augustin Le Prince was already at work constructing a motion picture camera and projector, Thomas A. Edison concluded in 1887 that it should be possible "to devise an instrument which should do for the eye what the phonograph does for the ear, and that by a combination of the two, all motion and sound could be recorded and reproduced simultaneously." Edison's first move was to order some of John Carbutt's celluloid film coated with a photographic emulsion. With this he secured a primitive form of motion picture film by wrapping a 15-inch-long section of the coated celluloid around the cylinder of one of his phonographs. Edison's chief assistant at this time was William K. L. Dickson, and while Edison and his wife traveled to Europe to attend the World's Fair in Paris in October 1889, Dickson perfected a camera-projector on the basis of Edison's design specifications. Although both Le Prince and Edison were acquainted with the pioneer French experimenter Dr. Jules Marey, there is no evidence that Le Prince ever met, or corresponded with Edison. In any event, Le Prince had perfected his first camera by the time of the 1889 Paris exposition, and Marey exhibited a film sequence on celluloid film (of a man riding a bicycle on the Champs Élysées) at the Paris exposition. Marey briefed Edison on the camera he used to photograph moving objects in series, and showed him the "viewing box" which he used with the camera. But like Muybridge, Marey was interested primarily in the scientific aspects of motion picture photography, and took no steps to commercialize his inventions. When Edison returned to the United States following the Paris exposition, Dickson had already perfected a camera-projector and a film sequence which showed Dickson bowing and welcoming Edison home audibly, his words and lip movement on the film all perfectly synchronized. Edison quickly prodded George Eastman into supplying celluloid film in lengths up to fifty feet, and thinner than Carbutt's, and by 1890, Edison and Dickson had perfected and patented the kinetograph (opposite page), a camera which could start, move, and stop a strip of sensitized film, securing forty-six photographic images a second. The width of the film used on this primitive machine was 35 mm, which remains a standard in film projection to the present day. A total of nine hundred impressions could be made on a 50-foot film strip, which was carefully perforated with a series of holes along one edge. This made it possible to rerun the developed film over the same spools in accurate registration with a phonographic cylinder, the words or sounds precisely coinciding with the position, expression, lip movement, etc., of an actor or singer recorded on the film. The duration of each image during a film rerun was as little as one-ninety-second of a second. A lantern furnished with a light interrupter was used to eclipse the light between the movement of each of the nine hundred frames, and an entire film showing took no more than half a minute to complete. The idea for the kinetograph's light-interruption mechanism is said to have come from Edison's reading of a report published in 1889 by Ottomar Anschütz, an Austrian who described experiments then in progress in which he said he could view photographs on the rotating wheel of a zoopraxiscope with the aid of successive flashes of light from an electric discharge.

In 1891, Edison patented the kinetoscope (right), a peep-show cabinet which would allow one person to view the images of a kinetograph through an eyepiece. Immediately after the patenting of the kinetoscope, the *Scientific American* reported that "the daily papers have been filled with reports of interviews with Edison, from which the reading public would obtain the idea that Edison had lately invented something of paramount importance, whereas these inventions, as curious and wonderful as they appear, are, in reality, scarcely more than the pastime of the hour with Mr. Edison." In 1893, Edison built a tar paper hut (known as the "Black Maria") on his New Jersey estate, which could be revolved on a pivot base and was covered by a roof that could be opened entirely, or in sections, to sunlight. Here he recorded films of circus and music hall artists (Annie Oakley and Buffalo Bill among them) for the kinetoscope peep-show parlors which were opened on Broadway in April 1894. The films shown in these parlors remained at the 50-foot length, because longer lengths of film could not be drawn through the camera without jerking the film and causing it to break. Edison continued to view the kinetoscope as "a scientific toy," and under the press of other business, he failed to patent the invention in either England or France. The result was that the kinetoscope was first copied then improved upon in those countries, and a solution to the film breakage problem (use of an extra feed sprocket to provide a loop for slack film) was developed by others.[623]

Side view of kinetoscope cabinet shows film looping arrangement beneath a coin-operated kinetograph machine, which sequenced a 50-foot length of film continuously for viewing through eyepiece.

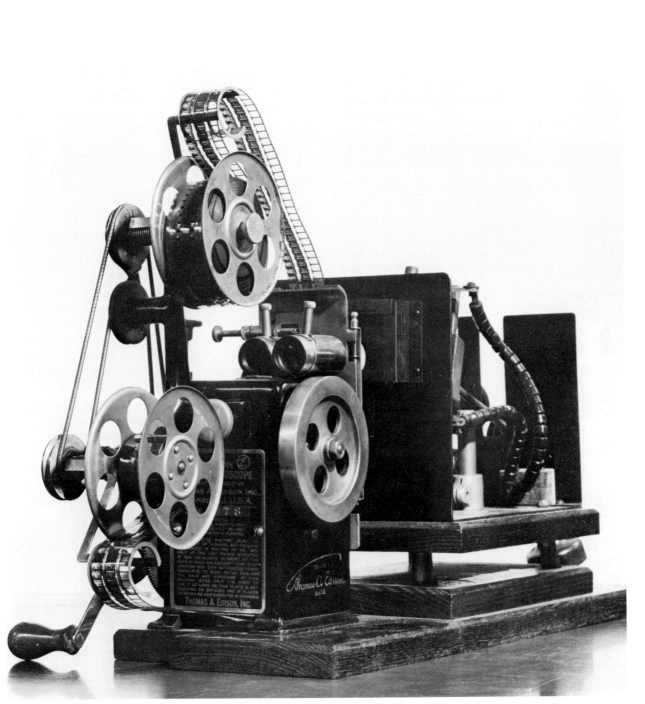

Thomas A. Edison's first kinetograph (above) is today housed in the archives of the Franklin Institute.

EXPOSURE METERS AND EXPOSURE TABLES

Beginning in the 1890s, a number of instruments were placed on the market having as their objective the correct timing of a camera exposure. These instruments included photometers, actinometers, actinographs, and exposure meters. Wynne's "Infallible Exposure Meter," introduced about 1893 by E. & H. T. Anthony & Co., was described by the company as "so very simple and exact that the spoiling of a plate because of error in exposure should hereafter be a rarity." The instrument was the size of a small watch, and was supplied with the actinometer numbers of various manufacturers' plates, together with a supply of sensitized paper. All the user was required to do was record the time it took to darken a piece of the sensitized paper (in sunlight) to a standard tint. But the Denver photographer W. H. Jackson remained unenamored of all such devices:

I do not think it possible for the out-of-doors or general all-around photographer, as distinguished from the portrait photographer, to always be able to make a correct exposure. It is all a matter of guess-work, and, other things being equal, the best is one who comes nearest guessing right. In this, more than in any other branch of work, experience is of the greatest use—an experience gained from long practice, that so educates the judgment as to enable the photographer to estimate at once, without reasoning, an approximately correct exposure.

In nearly all other operations connected with photography you can take your time and figure out carefully what you want to do and how you propose doing it; but in exposure, conditions change so rapidly that between focussing and putting your plate in the camera you may have cause to change your mind. Even with the exposure under way, one will increase or cut short in the time two or three times as much as first intended.

Many schemes have been devised to aid the photographer in the correct estimation of the intensity of the light, of the color, of the atmosphere, and of other factors entering into the question of exposure, aside from the apertures of his lenses and the speed of his plates. Exposure meters, exposure tables and the like are calculated with the greatest precision, and one would think that such a thing as failure could not occur—the whole business seemingly being reduced to fixed laws, which, being fully committed to memory, would enable you always to arrive at the correct result. As to the exposure meters, I confess myself in ignorance of the method of their application except in a very general way, but it has always seemed to me that in order to use them intelligently it would tax the understanding as much as is required to make an off-hand judgment.

Exposure tables, giving the difference in the quality of the light at different times of the day and year, and under the different circumstances of being on sea or on land, in the woods or on the plains, are mostly a delusion and a snare—they only approximate, in a very general way, the differences. The exposure tables, however, in which are given the differences in the apertures of lenses as regards their focal lengths, and the proportionate exposure required for such differences, are of some use, for in this we have the only approach to fixed laws to work from.[624]

sand individual frames, and three hundred sheets of albumen paper daily. In the case of all albumen prints, printing was done on the building rooftop in sunlight, where dozens of permanently situated tables could accommodate long rows of printing frames. The tanks in the toning and washing rooms below were so vast as to resemble a public bath.[625]

The scale of such elite and posh metropolitan galleries lasted only as long as there were wealthy patrons to support them, and it is unlikely that we shall ever see anything like them again. In one sense, Falk left a legacy which has survived to modern times. He was influential in helping David Bachrach ''acquire a little taste in posing and lighting,'' as Bachrach later expressed it, and this has remained the hallmark of the Bachrach organization through successive generations of growth and prosperity.

The awakening of renewed interest in carbon printing, just mentioned, was sparked by the introduction by the Autotype Company in London (successors to the rights to Swan's carbon process) of a better carbon ''tissue'' (special paper coated with gelatine, colored in one of approximately fifteen available colors or shades). This occurred in 1893, but before its wide acceptance, W. A. Cooper gave an address at the 1893 Chicago fair in which he contended that photographers had been misled over the years by the cry for glossy-finished carbon prints, just as the same want of high glossiness had, in the opinion of many experts, plagued albumen paper printing. In technical jargon this meant that photographers using carbon printing had been giving preference to a double-transfer (higher gloss) rather than the original single-transfer (matt finish) process patented by Swan in 1864. But the chief attribute of the new carbon tissue was that print drying could now be accomplished in daylight rather than in a darkroom.

Another stimulus to carbon printing proved to be the aristotype process, which produced prints with a matt finish. Not only was this a benefit to carbon users but, as Cooper said in Chicago, ''now the desire is for matt surface in all gelatine printing papers.'' By May, the *Photographic Times* announced that a Brooklyn company (the Stillwell Manufacturing Company) had reorganized itself, and had been renamed the Photo Supply Manufacturing Company for the sole purpose of manufacturing carbon tissues on a large scale. The *Times* also gave this brief description of the change it had noted over the past four years in printing methods among the ''better class of the trade'':

As is well known, the style of photographic printing has changed to a considerable extent with the better class of the trade since the Aristotype papers were first introduced four years ago. We now see in the high class galleries plain paper printing, platinotype and other matt surface papers under different names put upon them by each gallery. We hardly think there is any of them that rivals this old-time friend [the carbon process], and doubt whether any of them equal it in permanency. We have lately noticed in some of the showcases of a few of the New York galleries some exceptionally fine carbon prints, especially in the upper part of the city, designated as photogravures. There has been a small quantity of carbon tissue manufactured in this country within the last year, but the main part has been exported from France. Whether the prices charged were too high for it to be generally adopted, or on account of its merits not being generally known, we do not know, but from the conversation which we have had we know that this will be overcome in the new photographic firm which has been organized for its production in large quantities.[626]

AN EAKINS PHOTOGRAPHIC PORTRAIT

The photograph of Walt Whitman (above) is from a platinotype made shortly before Whitman's death in 1892 by the Philadelphia artist Thomas Eakins (1844–1916). Eakins had been a leader of the revolt by young artists against the "conservatism" of the National Academy of Design in the late 1870s and, after 1880, added photography as another dimension to the celebrated "realism" of the works he executed in oil. But never in his own time was Eakins described as he has been by one modern authority as "probably the greatest American painter, and certainly one of the greatest 19th-century painters on any acceptable list." Nor has he, until recently, been accorded proper recognition for his role (together with others in Philadelphia's amateur photography school of the late 1880s and 1890s) in demonstrating photography's capabilities as a fine-art medium. Eakins also painted Whitman (in 1888) before making a series of photographic portraits from which this profile has been selected.[627]

"NEW SCHOOLS" AND BUSINESS TRUSTS
1894

When Alfred Stieglitz returned to the United States in 1890, he soon realized, he said, "that 'photography,' as I understood the concept, hardly existed in America." [628] Because of his first-prize award at an 1887 London amateur photography competition, and the favorable recognition accorded him by European artists as well as photographers, Stieglitz became the sole American to actually participate (though not formally) in the movements begun at that time in England, France, Germany, and Austria to elevate photography to its rightful position as a fine art. The "pictorial" school begun earlier by H. P. Robinson was followed by the "naturalist" school headed by Peter H. Emerson, which narrowed its sights on capturing in photographs a "painterly" effect of what was seen in nature, and an "impressionist" school credited to the London photographer George Davison in which photographers sought to doctor their negatives to secure "controlled" images (otherwise known as "manipulated" prints) on various pigmented matt-surface papers or canvas. By 1892, many of the photographers in these schools had banded together in a Linked Ring Brotherhood.

Stieglitz was generally correct in his 1890 appraisal of the dearth of fine-art photography in America, but there was one encouraging note which had occurred prior to this at the 1887 joint exhibition of photographs in New York by the amateur societies of New York, Boston, and Philadelphia. Landscape photographs in bromide and platinum at this exhibition "completely outranked" other prints on albumen paper and toned in a conventional way, according to one reviewer.

In the period 1890–94, there were other isolated events which indicated that the movements across the Atlantic were having an effect on American photographers. In December 1890, for example, "impressionism" in photography was chosen as a topic of discussion at the Pacific Coast Amateur Photographers' Association; and in July 1891, forty American photographers attempted to exhibit 350 photographs at an art photography exhibit in Vienna.

This exhibition was among the first to put into effect the principle—adopted later by all photographic "salons"—that the members of the committees organizing such events would judge all contributions *prior* to a given exhibition, weeding out those items not considered to be up to the committee's standards. Thus, at the 1891 Vienna exhibition, thirty of the Americans submitting photographs were literally "thrown out with their works" before the event, leaving only twenty-five American entries supplied by ten photographers. Five of the entries were from Stieglitz; others were provided by photographers from Rochester, Buffalo, Chicago, and Lowell, Massachusetts. But of these, only the names of James L. Breese of New York and John G. Bullock of Philadelphia gained prominence at later exhibitions. [629]

More than any other single individual, Alfred Stieglitz provided a motivating force for an American art photography movement. This was further aided by his assump-

tion of co-editorship with F. C. Beach of the *American Amateur Photographer* in July 1893. At the time this occurred, Stieglitz and several partners were operating a photoengraving company (the Photochrome Engraving Company) which, after 1893, supplied a number of halftone reproductions as illustrations for the *American Amateur Photographer* (many of them being reproductions of Stieglitz's work). But business was poor and in 1893 Stieglitz took to wandering the streets of New York with a hand camera. His first photograph was made on Fifth Avenue during a blizzard on Washington's birthday. At first his colleagues at the Camera Club scoffed at the blurriness of the small photograph, but were later astounded when it was blown up in slide form (see next page). Nothing quite like it had ever been seen before, and within a short time the feat was imitated by others.

Shortly after Stieglitz became an editor of the *American Amateur Photographer*, George Davison became its British correspondent. In his first article, which appeared in January 1894, under the title "To American Photographers," Davison indicated that, from his own standpoint (and presumably that of others in the Linked Ring), American fine-

THE LINKED RING

When the "artists" of the Royal Photographic Society in London "began to find they were being tolerated only," H. P. Robinson said, "Some of them left the society; others followed, and [in 1892] a little club was formed to promote the cause of art in photography." This was the Linked Ring Brotherhood, a loose organization without a president or council, whose members were elected on the basis of their evident artistic ability. With the possible exception of a calotype club which operated in London from 1847 to 1851, no organization of photographers had ever before been established for this purpose. Before the Brotherhood was organized, eight of the so-called "artists" had gotten together and published a series of folio-size monographs, each of which contained biographical material and samples of work (in photogravure) by a particular photographer among the group. The series was appropriately entitled *Sun Artists,* and the monographs were issued consecutively during the period October 1889 to July 1891. Although said to be the first publication to represent the "artistic" position of photography, it was not continued after 1891. But in 1893, the Linked Ring sponsored its first photographic "salon" in London, which was a decided success. For the next fifteen years, this became the most important annual event of this kind in the photographic world. In 1894, the first Americans were elected to membership. These were Alfred Stieglitz and Rudolf Eickemeyer, who was co-operator (with James L. Breese) of a New York studio specializing in carbon printing. [630]

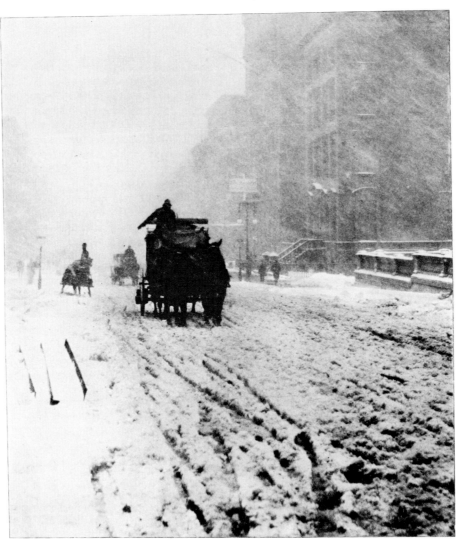

"Winter—Fifth Avenue," by Alfred Stieglitz, taken on Washington's birthday, 1893, with a hand camera.

STIEGLITZ PHOTOGRAPH HERALDS
"THE BEGINNING OF A NEW ERA"

About 1892, Alfred Stieglitz saw some prints of size 4 x 5 inches made with a hand camera which he found extraordinarily beautiful. Thereupon he decided to buy a hand camera and "master its use." On Washington's birthday in 1893, a great blizzard raged in the city. Stieglitz stood at the corner of Fifth Avenue and Thirty-fifth street watching the lumbering stage-coaches moving slowly northward, and thought to himself: "Could what I was experiencing, seeing, be put down with the slow plates and lenses available?" F. W. Crane, writing in *Godey's* magazine two years later, said Stieglitz spent six hours at the corner getting the snap-shot he wanted. A short time later, even before the negative was dry, Steiglitz showed it to other members of the New York amateur photographers' society. "For God's sake, Stieglitz," one of the members said, "throw that damned thing away. It is all blurred and not sharp." But Stieglitz was entirely happy with his negative, and by his own account replied: "This is the beginning of a new era. Call it a new vision, if you wish." The next day, when he showed a lantern slide from the negative, the members all applauded. "No one would believe it had been made from the negative considered worthless." Stieglitz called his photograph "Winter—Fifth Avenue," and years later Edward Steichen said it was Stieglitz's "most exhibited, reproduced, and prize-awarded print." [631]

arts photography still lagged behind what was taking place across the Atlantic. American pictures, Davison wrote,

> appear to be concerned with trivial details and circumstances rather than with the broader effects; with complicated, made-up subjects rather than with simple natural beauties of light in landscape or expression in portraiture. Are there no varieties of weather in America, no mists, no rain, no atmosphere, no clouds, no wind, and no character in its landscape either simple or sublime? Do all photographers there go out religiously when the sun is vertical, and only then? Are all of them under bondage to their tools instead of masters of them?[632]

Despite Davison's criticism, there were a number of American photographers besides Stieglitz who were producing excellent pictorial works, although nothing of the pioneering nature of Stieglitz's wintery view of a stagecoach on Fifth Avenue, which he labeled "Winter—Fifth Avenue." Catherine Weed Barnes of Albany, for example, began photographing on her travels to Europe with her parents, and took up the study of chemistry in order to improve her darkroom work. She was an active member of the New York and Brooklyn amateur societies, and the only woman honorary member of the Chicago Camera Club. She was also an editor on *Outing,* and the editor whom Stieglitz replaced on *American Amateur Photographer* when she left for London to marry the British photographic editor Snowden Ward. There were, too, such acclaimed photographers as W. B. Post and James L. Breese of New York, and Breese's partner, Rudolph Eickemeyer, the second American to be elected to membership of the Linked Ring in 1894.[633]

The greatest center of activity in pictorial work at this time was Philadelphia, home of the Platinotype Company (the American counterpart to a similar company in London). Probably due to the close proximity of this supplier, a large number of the members of the Philadelphia Photographic Society, John G. Bullock among them, worked almost exclusively in platinum. In Stieglitz's view, this posed a real threat to New York amateurs, and as early as 1892 he published an article in which he cited the lack of progress in the use of the platinotype in New York:

> Probably not one in five hundred uses it in this city, while in Philadelphia it is in general use for all fine work. For exhibition work it is indispensable, and the sooner the New York amateur makes up his mind that, in order to compete successfully with the Englishman, or even with the Philadelphian, in the large exhibitions, he will have to discard all albumen paper, glazed aristotype (that *bete noir* for every fine-feeling eye), etc. . . .[634]

One member of the Philadelphia school, in particular, deserves recognition as an unheralded pioneer in American fine-arts photography. This was Alfred Clements, the proprietor of the Platinotype Company, who evidently worked quietly out of the limelight, and as early as 1887 took an award at the joint exhibition that year of the New York, Boston, and Philadelphia amateur societies. His first notoriety came in an unusual way. In the summer of 1894, the *American Amateur Photographer* announced a special competition in which contributors were asked to send eight photographs under an assumed name to England for judging by Henry P. Robinson and George Davison. In December,

ALFRED STIEGLITZ

After "Winter—Fifth Avenue," Alfred Stieglitz made a series of other photographs of snowy street scenes which, as Paul Rosenfeld later said, provided photography and art "with a new motive." After this, city snow scenes made their appearance "in numbers" at exhibitions, as did night street scenes after Steiglitz made such photographs in 1896. In the course of his career, Stieglitz said of himself: "Photography is my passion. The search for Truth is my obsession." And for a man gifted with his insight and talents, it was inevitable that a touch of the contemptuous would reveal itself over the years towards others less committed in their lives and works. By 1894, he recognized that "Eastman's mass-production methods" were causing "enthusiasts" to lose interest in photography. Within the several New York photographic societies he identified what he termed the "dress suits" and the "democrats," who were figuratively pitted against one another. As far as he was concerned, "all factions were in a state of dry rot," nevertheless, he played a major role first in the amalgamation of the New York societies (in 1896), and ultimately in the founding (in 1902) of Photo-Secesssion, the American counterpart to the Linked Ring. Twelve years before his death in 1946, the Literary Guild published a "collective portrait" of Stieglitz in which Jennings Tofel summed up the man in these words: "Alfred Stieglitz must know, as well as most of us do, that there is no one else as venturesome and right, as unselfish and just, and as complex a personality as himself, in all the art life of this land at this time, and hitherto."[635]

A STRUGGLE FOR EXISTENCE.

ALFRED CLEMENTS.

"A Struggle for Existence," Alfred Clements' prize-winning photograph in an 1894 competition among American photographers judged in England by Henry P. Robinson, founder of photography's "pictorial" school, and George Davison, originator of the "impressionistic" school. Entries in the competition were submitted under assumed names. Second prize was awarded to Alfred Stieglitz.

1894

356

when the judges' decision was announced, the first prize was found to have been won by "Dr. Malaria," who turned out to be Clements. The second and third prizes were awarded respectively to "Progressive" (who turned out to be Stieglitz) and "Iquitos" (who turned out to be Clarence B. Moore). Clements' prize-winning photograph was a platinotype of a sandy beach on which was a cluster of small trees in a sanded mound. The picture was entitled "A Struggle for Existence." In a critical analysis of the Clements photograph, Davison said it showed considerable taste in selection and treatment, adding:

> . . . it is made out of simple materials; the author has been quick to see the slightly fantastic character of the trees. There is unity and simplicity with strength, combined with distinct feeling and sentiment.[636]

No greater testimonial to Davison's credentials as a critic is to be found than in this comment made later by the third place winner, Clarence Moore:

> I wish to say that in each point where Mr. Davison criticizes my work unfavorably he hits the nail full on the head; and if we had over here such a worker as Mr. Davison, and such a just, fearless and competent critic, combined with workers who would give heed to his counsels, the cause of amateur photography on this side would be materially advanced.[637]

Although Clements' works are today unknown, he brought a definite style to the views he made in forests, fields, and along shorefronts. His own thoughts on the subject were expressed in an interview with the *Photographic Times* in 1895:

> It has always seemed to me as though temperament affected preference for subjects. Some may like figures while others prefer landscapes. As for myself I care little for the former because it is difficult to take away the conscious expression of the models, and this to me robs such pictures of all value as works of art. My preference is landscapes, or landscapes with figures where faces scarcely show. The weird things where the imagination can play suit me best.[638]

His fondness for pictures of this kind, the *Times* was quick to point out, was not due to any morbid tendency; on the contrary, for those who knew him best his pictures tell only of his "quiet, generous nature, and keen delight and admiration for those occupations and sports which take one into the sunlit woods and fields, and of his liking for the homely things in nature, and the desire to interpret her in all her varying moods, be they grave or gay." The *Times* was quite forthright in its evaluation of Clements' influence: "To Mr. Clements' efforts its [platinotype] success in this country has been due, and an artistic school of photography in America made possible."

There are distinct parallels in the motivation behind Clements' and Stieglitz's photography, and in making the comparison, the word "isolation" comes most quickly to mind. As Harold Clurman pointed out in later years:

> What was the New York that Stieglitz returned to at the end of the century? It was a world in which fragments of Old World grace were lost amid the rising emblems of New World power. But the skyscrapers that were being built and the whole life of which they were the most conspicuous symbols were also fragmentary, lacking the human and social integration that could be read clearly in every detail of European existence. The world

ALFRED CLEMENTS

A native of Kent County in England, Clements grew up as a farm boy, but at an early age went to work for William Willis, inventor of the aniline process used in engineering and architectural reproduction work. In 1867, when Edward Anthony bought the American rights to the aniline process, Clements was brought to New York to take charge of the activity. But the American climate was found to be too hot and dry for successful operation, and within a few months the undertaking was abandoned. Clements was thereupon reassigned by E. & H. T. Anthony & Co. to the Anthony photolithography business, represented by the American Photo Lithographic Company in Brooklyn, New York. After several years, Clements left the Anthony firm to become head of the New York *Daily Graphic*, which, as we have already seen, was printed by photolithography. During all of his years in New York, Clements maintained a correspondence with William Willis, whose son, William, Jr., invented the platinotype process in 1873 (receiving British and American patents in 1876). When Willis, Jr., came to the United States in 1877, Clements decided to go into partnership with him. Although the Willis & Clements manufactory became a successful one, improvements were attempted which were not equally successful in furthering wider use of the platinotype. Perfection of platinum printing in its final form was not achieved until after 1890.[639]

IN MEMORIAM:
CHARLES D. FREDERICKS

After an illness of six months, death came to Charles D. Fredericks, seventy-one, on May 26, 1894. A native New Yorker, Fredericks was sent as a youth to Havana to acquire a knowledge of Spanish, then returned to New York for collegiate studies. But the panic of 1837 wiped out his father's fortune, and Fredericks was required to take up a gainful occupation. After working on Wall Street, he embarked for Venezuela to join his brother in a business venture, taking along a daguerreotype camera. But photography became his vocation, and he traveled widely in South America. In 1853, he established a gallery in Paris, but soon returned to New York, first in partnership with Jeremiah Gurney but after 1857 as operator of his own gallery. By 1861, John Werge was saying that "London and Parisian galleries do not compare with the Fredericks New York gallery." When he was burned out in 1886, his new quarters at 585 Broadway were viewed as the largest photographic enterprise in the country.[640]

that Stieglitz returned to was a lonely world: active, ambitious, pushing its way frantically and fantastically to a goal it did not know. Man was somehow shut out of this world, even while he was helping to make it.[641]

Where Stieglitz had earlier captured the charm and simplicity of children, and of older people in their European country and urban habitats, he developed, in New York, a new affinity for deserted streets. Clements, on the other hand, photographed *nature* in isolation. Stieglitz loved snow, mist, fog, and rain, and was attracted to scenes of man's endurance against these elements, as well as to other surmountables of everyday living. Clements also photographed misty mornings, but in remote settings; and his "Struggle for Existence" was typical of other photographs he made at this time, depicting *nature's* dogged endurance in isolation.

But where Clements' motivation was singular—nature in isolation—Stieglitz's was many-sided. There was more illumination, now, to city nightlife, and this, too, held its attraction for Stieglitz. Independently—but simultaneously, as it turned out, with the English photographer Paul Martin who was photographing London streets at night—Stieglitz made a photograph of a nighttime street scene in New York, which he exhibited in 1895 at the second annual Salon of the Linked Ring. In the same year, Martin exhibited a set of lantern slides, "London by Night," at a meeting of the Royal Photographic Society. Soon, other photographers were following their lead, and as the decade wore on, photography of outdoor scenes at night became commonplace.

1894

358

1895

The best that could be achieved with color photography in the nineteenth century was perfected experimentally, or brought to a viable commercial status in the period 1893 to 1895. Although prints in color could not be obtained from color negatives or color film in an ordinary camera, several methods were perfected which allowed people to view photographs in color on a screen, and, after 1893, good halftone illustrations could be produced in color on a photoengraver's letterpress.

The first to perfect a color halftone printing process was William Kurtz of New York. In 1892, he employed Dr. Herman Vogel's son, Ernst Vogel, to help him in these endeavors, and by the summer of that year he obtained what he considered to be satisfactory results. Among the first of these was a negative of some fruit on a table which he used to secure the image, in relief, on three separate printing plates, each screened to receive ink of a different color.

The three plates were used to print a large quantity of colored halftone reproductions of the image (showing the fruit in their natural colors), which Kurtz sent to Dr. Vogel in Germany. Presumably the publishing "first" which shortly followed was worked out in advance between Kurtz and the elder Vogel, but in any event the prints were bound in as color illustrations in all copies of the January 1, 1893, issue of *Photographische Mittheilungen*. The publication caught the photographic world by surprise, and left the *Photographic Times* wondering "why Mr. Kurtz, of New York, should have felt called upon to announce his results first in a foreign publication."

Kurtz soon thereafter made additional color prints from the same negative, and these prints were used as the frontispiece of the March 1893 issue of *Engraver & Printer*, published in Boston. Possibly because of the world's fair which took place in Chicago that year, photoengraving firms in that city became the first to gear themselves to this new mode of color printing, and their first results began to appear in the *Inland Printer* and other publications in 1894.

In addition to the Kurtz method, which Kurtz never attempted to patent, color printing took a variety of forms. Alfred Stieglitz, for example, applied color to one of his photographs made on platinum paper, then made photomechanical reproductions of the colored platinotype at his photoengraving company. These were used as the frontispiece illustration of the January 1894 issue of *American Amateur Photographer*.[642]

But just as it had not been possible to trap the images seen on the ground glass of a camera obscura prior to 1839, so it remained impossible, in the nineteenth century, to trap *in their natural colors* what the photographer and the camera could see and photograph in black and white. In retrospect, the best color photographs obtainable in the nineteenth century were those which could only be viewed momentarily on a screen. In 1892, as we have already seen, F. E. Ives perfected a means of viewing photographs in color, either when a superimposed image from three separately filtered glass positives were viewed through the eyepiece of a table-model "Heliochromoscope," or when the image was projected in superimposition on a screen, using a magic lantern with three optical systems. In December 1894, Ives patented a table-model Kromskop (see next page) as a replacement for the Heliochromoscope. The Kromskop allowed one-person viewing of stereoscopic glass positives in color. This instrument was exploited commercially in England, France, and Germany, beginning in 1895, but was not manufactured commercially in the United States until 1899.

Independently of Ives, Robert D. Gray, a New York lens maker, perfected another means of projecting superimposed images in color on a screen, using a modified lantern (see above). Ives had not yet applied for a patent for the Kromskop, and was in London when Gray's process was first demonstrated at Chickering Hall in New York City on January 10, 1894. Presumably alluding to his 1892 patent (for the trichromatic camera), Ives sent this brief but angry letter to the *American Amateur Photographer:*

> It is not true that there is one single new idea or improvement shown in Gray's demonstration. His claims are fraudulent, and he appears to be infringing my patent rights while trying to discredit my work by misrepresentation.

POST OFFICE RULING ENDS USE OF TIPPED-IN JOURNAL PHOTOS

The practice of binding-in original photographic prints with the text of a photographic journal began with Snelling's journal in 1851, and was continued after the war by Wilson's journal and the principal other journals in the field. On May 1, 1895, *Anthony's Photographic Bulletin* announced that it would abandon the practice as a result of having received, "with considerable surprise," the following communication from the U.S. Post Office:

> In accordance with instructions from the Post-Office Department, I have to inform you that it has been decided that photographs and other matter pasted to printed paper sheets, otherwise eligible to admission to the mails as second-class matter, subject them to a higher (third-class) rate of postage, for the reason that the law prescribes that second-class publications must be formed of printed paper sheets, and shall contain no writing, print or sign thereon or therein in addition to the original print, except as provided by Section 308, Postal Regulations (which relates only to certain permissible writing and printing on second-class publications and their wrappers). If it has been your practice heretofore to affix photographs or other matter to your publication, mailed at second-class rate, please discontinue it in future.

"Our readers will note," the *Bulletin* remarked editorially, "that we have not this month presented them, in accordance with our usual custom, with an actual photograph. . . . We regret exceedingly that the Post Office takes this stand, especially as for some thirty years publications containing photographs have gone as second-class matter unchallenged."[643]

Gray's response was contained in a letter to the same publication some three weeks later:

> I have gone over the Ives matter. The only reply I could make would be an accurate description, with stereoscopic measurements of the absorptions, of the light filters used, properties of the plates used with each screen, and the results of the combinations. This I am unwilling to do, but will say they are very different from the formula published by Mr. Ives. We all know the superimposing idea to be old, and the means of getting the slides in register and of keeping them there are mechanical details not worth quarrelling about.[644]

Ives appears not to have indulged in any further criticism of Gray, or to have instituted any legal proceedings later on. Gray's invention may also have gone into production, as it was stated at the time that Gray gave a demonstration of his process at the New York Camera Club in July 1896, and that the machine used was "a Natural Color Triple Stereopticon" manufactured by J. B. Colt & Co., of New York. But Ives's Kromskop was by far the better recognized of the two systems in its own time. To the editors of the *Photographic Times,* the process was "a veritable realization of color photography to the extent of bringing before the eyes, by a simple and practical process, a photographic image in the natural colors which is far more perfect and realistic than any colored picture on paper could possibly be." The *Times* also drew this analogy:

The Kromskop photograph is therefore, although not a color photograph, a *color record,* just as the cylinder of the phonograph, although not a cylinder of sound, contains a record of sounds, and the kinetoscope ribbon, although not an animated photograph, contains a record of motion.[645]

Austin Leeds, who became publisher of the *American Journal of Photography* for a year before its merger (in 1900) with another new periodical, *Photo Era,* described the Kromskop's color photographs as "so intensely realistic" that they "can almost be handled." He labeled the Kromskop as "perfectly practical commercially as a means of advertising, as an instrument in educational and lecture courses, and as an adjunct to the study of art, medicine and natural history."

In 1900, Ives developed a "Junior" Kromskop, and a "Miniature" Kromskop, but at the same time candidly admitted that the tricolor cameras used to make the slides for color viewing in any of the Kromskop models were "complicated, costly, and delicate of adjustment, which puts them out of court for the amateur who wishes to go in for color photography with a moderate investment." In his autobiography (1928), Ives said that, despite all the "medals and other honors of scientific societies" which were conferred him, "the general public demanded prints on paper and refused to take sufficient interest to justify commercial exploitation."[646]

1895

360

Although color photographs could not be obtained from color negatives or color film in an ordinary camera prior to the twentieth century, color photographs could be produced artificially for viewing through a table model device such as the Kromskop (left) or on a screen projected by a triple stereopticon of the type shown at right. But inventor Frederic E. Ives admitted that the Kromskop was too complicated, costly, and delicate of adjustment for the ordinary amateur photographer, and the triple lantern device, developed by R. D. Gray, is not known to have been widely used.

PHOTOMECHANICAL PRINTS EXHIBITED IN COLOR

Although he gave up his photoengraving business in 1895, Alfred Stieglitz's Photochrome Engraving Company was one of nearly a dozen American and foreign firms to exhibit photomechanical prints in color at the New York Society of Amateur Photographers in December 1894. Prizes were evidently not awarded, but the "place of honor," according to *Anthony's Photographic Bulletin,* "undoubtedly" belonged to Edward Bierstadt, who exhibited four portraits from life, printed in collotype from three color separation negatives. "The total time required for the sitter to pose before the camera while the three negatives were exposed," the *Bulletin* said, "was at least seven minutes, and, judging from the excess of blue in the prints, it would appear as if the negatives for the red and yellow were undertimed. Though the results were not entirely satisfactory, they record progress, and it was only a man with the frankness of Mr. Bierstadt who would have exposed them to the criticism of those unaware of the difficulties attending their production." Bierstadt's were the only color portraits exhibited. Other exhibits were of watercolors, advertisements of rugs, still lifes, etc. The exhibition also featured showings of photogravures by American, French, and German firms, and halftone reproductions supplied by William Kurtz, Frederic Gutekunst, the National Chemigraph Company, and Stieglitz's Photochrome Company. In October 1895 (or just about the time Stieglitz withdrew from business), the *Bulletin* published a report on three-color process work which lauded Stieglitz's work, and said that his company was "too modest" about its productions. "A bit of still life which they show," the *Bulletin* contended, "is equal to anything that has been done, and yet Mr. Alfred Stieglitz, the artist of the firm, is seeking effects still higher before permitting them to bear the imprint of his company." [647]

THE ADULTERATION OF PAPER STOCK

In July 1895, *Anthony's Photographic Bulletin* told its readers: "Now it is known that much of the modern book and magazine paper pulp will go to destruction within a generation. The coated papers, those used for halftone printing, will disintegrate the quickest and the illustrations be lost. It would appear as if, of all the flood of pictures we are now making, only platinotypes and pictures printed on cotton or linen papers would be preserved a century hence. The greed of the paper manufacturers and publishers causes them to close their eyes to the fact that most of the paper now used will in short time crumble to dust." The problem lay in the adoption of wood fiber in place of rags for paper making. But as far as one paper industry spokesman was concerned (in 1892), resistance to the use of wood fiber (mixed with sulphite and other chemicals) was comparable to the "Spanish grandee who fought against the windmills." With a mixture of good cellulose, soda, or sulphite, he contended, you could make pulp paper just as good as if it were made with rags. But the editors of the *Bulletin* were joined by Julius F. Sachse in identifying the problem with which modern libraries can only contend by microfilming bits and pieces of the pages of many publications of the 1890s which literally are crumbling to dust. In 1893, Sachse pointed out that things were going from bad to worse as mechanical methods of paper making gave way to cheaper chemical methods, followed by a further adulteration of the sulphite wood pulps with ground soapstone and talc, both mineral substances of a similar nature. "Few persons have the slightest idea of how great proportions this industry for the supply of adulterants for paper has assumed," Sachse said. "There are different mills throughout Pennsylvania exclusively for grinding soapstone into flour." When such mineral and chemical adulterations of the paper are brought into contact with fermenting animal or vegetable mountants, he said, "they certainly cannot be conducive to the permanency of the photographic product." [648]

There were two other methods perfected at this time for making color transparencies which could be projected by lanterns for screen viewing. One was developed by a Dublin physicist, Charles Joly, and the other was developed independently by James W. McDonough of Chicago. Taking their cue from the glass screen processes perfected for photoengraving halftone work, Joly and McDonough each prepared a glass screen ruled with fine lines alternating in the three primary colors. These screens were then placed in front of an orthochromatic plate and exposed in the camera. After the exposure, a positive black and white glass transparency was prepared. The same screen was used again and bound together with the black and white plate (the colored lines of the screen in register with the uncolored lines from the same screen on the black and white plate), and the combined plate and screen were placed in the plate holder of a magic lantern. What was projected was a photograph in full color—the equivalent, in every respect, to the results achieved differently by the Ives and Gray methods.

With respect to colored photographic prints which, according to Ives, the public "demanded," such pictures produced in the nineteenth century were not faithful records of the colors or objects photographed. Certain names do stand out, however, for the pioneering work which they undertook in the 1890s to secure colored prints of one kind or another. The first was Gabriel Lippman, professor of phys-

As electric lighting became commonplace, and photographers universally adopted use of the highly sensitive (i.e., quick acting) bromide paper, automatic printing of photographs became practical. The scene above is of the electric light exposing apparatus of the Automatic Photograph Company in New York, where 147,000 cabinet-size photographs could be produced daily.

PHOTOGRAPHY AND THE PRINTING PRESS

Automatic printing of a large volume of photographs from a single negative was attempted as early as 1861, when Charles Fontayne of Cincinnati appeared before the American Photographical Society in New York to demonstrate a hand-operated device which passed a roll of sensitized paper under a horizontally placed negative (the negative being pressed in contact with the paper during exposure). But although Charles Seely and others waxed enthusiastic over the machine, John Johnson remained skeptical, and nothing was heard of the project thereafter. By 1891, a French-designed "Autocopiste" (autocopy) machine was developed for studio use in printing collotypes on a relatively small scale, and men such as William Kurtz in New York and Frederic Gutekunst in Philadelphia maintained presses for a variety of photographic printing operations. These included printing of halftone reproductions and three-color photomechanical prints (done in competition with numerous photoengraving houses), and large-scale production of cabinet, or carte de visite photographs. Several periodicals devoted regular sections to the new "process work," and in February 1895, *Anthony's Photographic Bulletin* told its readers: "The money is to be made now in large editions only, and there is no

reason why the photographer should not control the complete output of prints from his original negatives, whether these prints are made by photography, or through the medium of the printing press."

In 1895, the Automatic Photograph Company, of 25 West Twenty-fourth Street, New York, installed a rapid printing machine which had been demonstrated at the previous year's P.A.A. convention (and which operated on much the same principle as Fontayne's earlier invention). The machine reportedly could make between 200 and 300 prints an hour on bromide paper, all perfectly uniform, and it was put to work publishing the numerous illustrations required for each issue of the magazine *Celebrities Monthly*. According to Wilson's journal, one man and one boy could produce from 50,000 to 80,000 cabinet-size photographs, finished and ready for mounting, in the same time it would normally take to produce an estimated 300 cabinet cards by hand. In an ordinary day's work (10 hours in 1895), output could total as much as 147,000 prints. The high sensitivity of the bromide paper made it adaptable for such rapid printing. Exposure by electric light of a number of negatives could be accomplished simultaneously, thus increasing

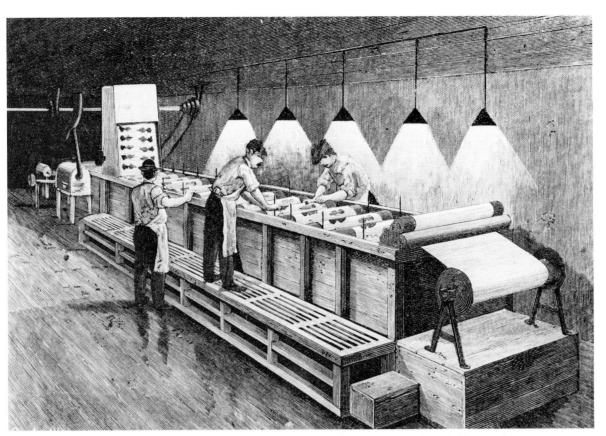

The Automatic Photograph Company's developing apparatus is shown above. Tanks held as much as 500 gallons of the developing solution in some instances. The company reportedly used 75 miles of bromide paper to make roughly 7½ million photographs in 1895. Exposed paper passed through different stages of development at the rate of 100 feet a minute.

output. During 1895, Automatic reportedly used 75 miles of the bromide paper (supplied in enameled form by the Nepera Chemical Company of Yonkers, New York), which worked out to roughly 7.5 million pictures. The paper was fed to the machines in rolls 1,000 yards long by a yard wide. Printing, developing, fixing, and rinsing were accomplished in essentially the same manner as they are done at large establishments today. But at Automatic, tanks were lined up along the sides of the developing room, each holding up to 500 gallons of the developer solution. A barrel of hypo was used at one time, and the exposed paper would pass through the different stages of development at the rate of a hundred feet a minute.

Other publishers and printers at this time began producing postcards and albums in booklet form with halftone illustrations. In February 1895, the *Bulletin* quoted a British source which stated that "a large view publisher, recognizing that his occupation must soon be gone, converted part of his factory into process work, and is successfully pushing for zinc-block business, in line and halftone. As we write, printers in London and Edinburgh are running night and day on magnificent halftone albums of celebrities." [649]

Detail of exposure apparatus (top) and of developer tank (bottom).

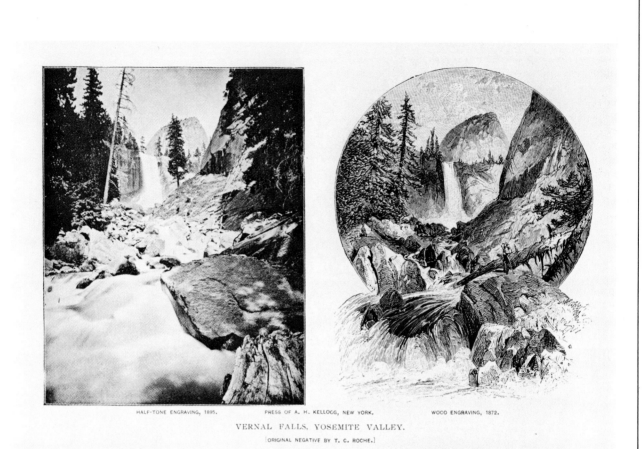

HALF-TONE ENGRAVING, 1895.　　　PRESS OF A. H. KELLOGG, NEW YORK.　　　WOOD ENGRAVING, 1872.

VERNAL FALLS, YOSEMITE VALLEY.

[ORIGINAL NEGATIVE BY T. C. ROCHE.]

FOR THE WOOD ENGRAVER, THE END OF THE ROAD

The two illustrations above, which appeared on the same page of an 1895 issue of *Anthony's Photographic Bulletin,* were produced from the same negative made in 1872 by Thomas C. Roche. To make the wood engraving, right, an ordinary photographic print was made from the Roche negative, and this was used by a wood engraver to make a sketch (in reverse) on a wood block. As can be seen in the example above, much depended upon the engraver's skill as to whether the details of the photographic negative were fully and accurately reproduced, or altered. To make the halftone engraving, left, Roche's negative was screened with a glass plate of finely-ruled cross lines, breaking up the image into dots which could be transferred to, and etched into relief on a printing plate. At first (in the early 1880s), a single-line screen was used in photoengraving, the screen being turned crosswise during its exposure with the negative, but in 1886 Frederic E. Ives introduced a sealed crossline screen to accomplish the same purpose more readily. Still, the halftones produced by Ives's or other photoengraving methods were used only sparingly for magazine or book illustration, principally because of the coarseness of the screens at first used. But by May 1894, the *Photographic Times* observed that "the work of the wood-cutter, except the very finest, and also for special kinds of work, is apparently dying out forever." By January 1895, the *Bulletin* could point to a revolution not only in illustration, but in the materials and appliances used in halftone printing:

Paper-making has been changed almost completely; coated paper, that is, paper in which the fibre has been covered up entirely with a hard and smooth enamel coating, has become a necessity, and develops a new industry. The superfine ink required has brought out new pigments, and more exacting care in their manufacture into ink. The printing presses that were considered wonderful examples of mechanical skill are being rapidly superseded by machines with cylinders turned true to the thickness of a hair, and journal bearings as carefully made as the works of a clock.[650]

ics at the Sorbonne. He tried applying the principle of light interference (as seen in a soap bubble, or a patch of oil on a wet road) to negative making, using a negative emulsion backed with a mirror layer of mercury. The mercury was supposed to reflect light rays back upon themselves in the emulsion during a prolonged camera exposure, which would then make it possible to trap the rays in the positive print made from the negative. But although Lippman reportedly secured images of "vivid coloring," they had to be viewed—like a daguerreotype—at an angle in order to observe the coloring. The process was also too uncertain to achieve commercial status.[651]

For a short time in 1897, too, E. & H. T. Anthony & Co. touted the prospects of a French-developed "radiotint" color photography process, but this quickly proved to be a dud. The process was another mode of working with chemical dyes (using them to perform a self-toning operation during print development), but the inventor, M. Chassagne of Paris, evidently could not produce colored prints with repeated certainty. Richard Anthony, son of Edward Anthony, went to Paris where he reportedly worked the Chassagne method successfully himself, but after the Anthony firm promised thereafter to demonstrate the process at the August 1897 P.A.A. convention, it was compelled to announce at the convention that chemicals sent to the United States from Paris had not worked in New York, and that a Chassagne representative subsequently dispatched to New York had been "unable so far to produce satisfactory results." After that, the radiotint process was heard from no more.[652]

IN MEMORIAM: HENRY J. NEWTON

In the early evening of December 23, 1895, the former long-time president of the Photographic Section of the American Institute was struck by a cable car at Broadway and Twenty-third Street (the site of the Flatiron Building constructed there a decade later). "This estimable man-citizen and friend of progress," the *Photographic Times* said in a eulogy, "was almost instantly removed from human activity, leaving a void in the hearts of his many friends, and an unfilled place in the ranks of those who lead humanity to a higher and nobler plane of existence." Newton was seventy-two.[653]

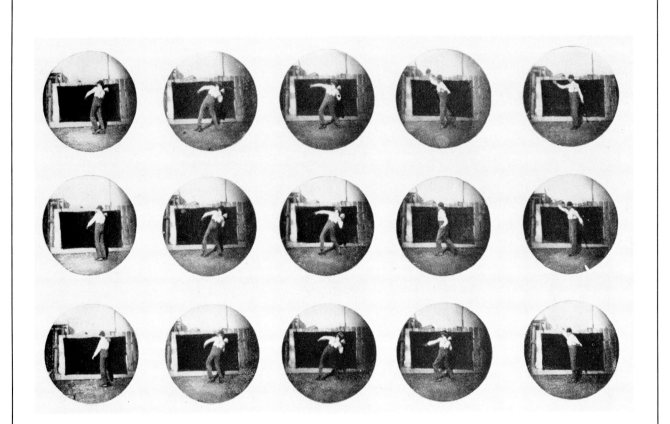

PHANTOSCOPE

Forerunner of Thomas Edison's Vitascope motion picture projector was the Phantoscope, invented by Charles Francis Jenkins. The prototype model, lacking many of its essential operating elements, is shown right at its repository, the archives of the Franklin Institute. Fifteen frames are also shown (above) which were made by Jenkins with the Phantoscope, illustrating the successive motions of shot-putting. The sequence is from one of the earliest motion picture films made in the United States.

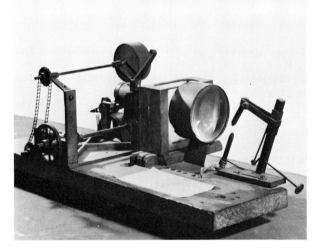

1895

1896

The beginning of the motion picture industry in the United States is generally attributed to the showing of a film of vaudeville acts on the night of April 23, 1896, at the Koster & Bial Music Hall, which was situated where Macy's department store now stands on Thirty-fourth Street in New York City. The event was another which brought accolades to Thomas Edison for his role as a pioneer in the new industry, but the Edison Vitascope projector used on this occasion was an acquired rather than an Edison-invented machine. Developments had moved rapidly in the period 1894–95, and not only had counterfeit kinetoscope machines appeared on the market in England and France but also entirely new inventions began to make their appearance. By January 1896, for example, Parisians were queuing up daily to watch 20-minute showings of a motion picture film in a basement salon of the Grand Café, where the world premiere of the Cinematographe (invented by the Lumière brothers) had taken place the previous December 28.

The story behind the development of the Vitascope is one that is little known. The invention can be rightfully attributed to Charles Francis Jenkins, who in 1890 at age twenty-three left his family's farm in Indiana to become secretary to a United States Treasury Department bureau head in Washington, D.C. Basically an inventor, Jenkins took up photography as a hobby in 1890, and began concentrating on what he termed at the time as "devices for recording and reproducing motion." But the mechanical, optical, and photographic problems which he encountered "did not yield readily." Film posed a problem, so he bought some film intended for use in a Kodak camera, split it into strips in the dark, and spliced the strips together into "considerable lengths." Then, as he recalled later:

> Cameras for exposing this strip evenly and in rapid succession were made, as well as devices for developing this long length, and others for printing a positive therefrom for lantern projection. It was fascinating work, although the results were strange and awesome to the athletic friends who willingly enough tumbled, jumped, or otherwise performed in front of the strange camera without clearly understanding until days later what the resultant pictures were to look like.[654]

At first, Jenkins used an oil lantern as a source of illumination in filming, but in 1893, at the suggestion of a friend, Dwight G. Washburn, he fitted an arc lamp to his machine. By 1894, accounts of his successful motion picture exploits appeared in his hometown newspaper in Indiana, and in the *Photographic Times*. "As the plaything developed," he later said, "it attracted to itself more and more attention, as better and better screen pictures were attained, until in the summer and fall of 1894, demonstrations were rather regularly made."

Jenkins gave the name Phantoscope to his invention, and made application for two patents covering differing versions of the basic machine in the period 1893–94. These were U.S. Patent No. 536,569, awarded March 26, 1896, and

U.S. Patent No. 560,800, actually submitted first but not awarded until May 26, 1896. The machine's first use was in an attempt to photograph the flight of a projectile from the great gun "Peacemaker," at the U.S. Navy Indian Head test site on the Maryland shore of the Potomac, south of Washington. "But the concussion of the very first discharge," Jenkins mused later, "split the camera into kindling. The tug brought back a wiser boy than it took down the Potomac River that morning."

In the winter of 1894–95, Jenkins was introduced to Thomas Armat, whom he described as "the junior member of a real estate firm in Washington, a man possessed of that great lubricant for inventions, money." One day prior to the award of U.S. Patent No. 536,569, Jenkins and Armat entered into an agreement to build a machine of the type described in this patent. By the terms of this agreement, Armat was given a half interest in whatever commercial applications might follow in return for his financial support of the undertaking. But the machine described in the 536,569 patent proved unsuccessful, whereupon Jenkins began construction of another device along the lines of an earlier experimental model not covered by either Jenkins patent. On August 25, 1895, Jenkins allowed Armat to cosign a joint patent application for this device, and in September the pair took three of the newer machines ("refined copies of that old 1894 projector," as Jenkins expressed it later) to Atlanta, Georgia, for demonstrations at the Cotton Sales Exposition. But at this fair, two of the machines were lost in a fire which destroyed the special buiding which had been erected for the film showings. One machine was saved, because it had been left in a trunk at a downtown hotel in Atlanta.

Both in his memoirs and in a letter addressed on August 27, 1897, to Henry Heyl at the Franklin Institute, Jenkins asserts that Armat, or a hired thief, stole the third machine from Jenkins' home and took it to New York where it was demonstrated to Edison's representatives in a vacant room in the Postal Telegraph Building on lower Broadway. Just when this occurred is not clear; but on November 25, 1895, when Armat was "out of town," Jenkins filed a new patent application on the improved machine, citing himself as the sole inventor. Both patent applications were subsequently declared to be in interference—one listing Jenkins and Armat as co-inventors, the other, Jenkins as sole inventor (the language of both applications being otherwise similar). For reasons not explained, Armat and several brothers prevailed upon Jenkins to sell out, whereupon the joint patent application (submitted August 25, 1895) was allowed to stand, and was approved July 20, 1897, and the November 25, 1895, application submitted by Jenkins alone was forfeited. Jenkins, evidently in financial straits, went back to secretarial work.[655]

But not for long. On December 18, 1895, Jenkins appeared before an audience of more than one hundred people at the Franklin Institute to demonstrate the Phantoscope, and was declared the sole inventor of the machine by a Dis-

CHARLES FRANCIS JENKINS

Few men are born inventors, and fewer still make a success of the inventive way of life. Charles Francis Jenkins (1867–1934) fitted both categories. At the beginning, there were "grueling" years in developing the Phantoscope, but even George Eastman recognized the value of some of Jenkins' early inventions, and, for example, acquired Jenkins' film perforator mechanism as the demand for long-length film began to mushroom. But Eastman had to cash his own check to Jenkins so that the latter would have enough money to buy his rail fare from Rochester back to Washington, D.C. In the latter part of the 1890s, the Phantoscope served as one of the less heralded machines sold in competition with such more famous projectors as the Vitascope and biograph; but it was the first motion picture projector carried to the Klondike gold rush, and was used to film "The Battle of Shiloh," an epic in its day produced at the Sigmund Lubin pioneer motion picture studio in Philadelphia. While continuing to merchandise the Phantoscope, Jenkins applied his talents to other fields of endeavor. For example, he built the first horseless carriage seen on the streets of Washington, D.C., and in 1908 he developed the Graphoscope, a motion picture projector intended for educational use. This became a successful commercial product, and Jenkins established his own company to handle its manufacture and sales. Shortly before World War I, Jenkins took up flying and thereafter engaged in motion picture camera development for the United States Navy. At the same time he organized and was named the founding president of the Society of Motion Picture Engineers. In the 1920s and 1930s, Jenkins became a pioneer developer of radiovision and television equipment. Before his death, he had acquired over four hundred American and foreign patents covering numerous inventions.[656]

Inventor C. Francis Jenkins perfected a number of early devices and accessories for motion picture filming, among them a developing tray (left) and a film perforator (right), which according to Jenkins was built for the Eastman Dry Plate & Film Company to enable that company to handle the manufacture of increasingly longer lengths of camera film. Jenkins delivered the perforator personally to George Eastman in Rochester, where immediate payment was requested and provided, enabling Jenkins to pay his return train fare.

1896

368

PERFECTION OF HALFTONE PROCESS

The importance of screening for successful halftone reproduction can be seen by comparing the primitive halftone engraving of Edward L. Wilson, top, which appeared in an 1881 issue of *Philadelphia Photographer,* and the true photographic effect achieved in the halftone illustration of Max Levy of Philadelphia, bottom, which was reproduced in the January 1896 issue of *Anthony's Photographic Bulletin.* The former was made with Ives's first photoengraving mode, described earlier. The latter was achieved with a screen of new design co-invented by Max Levy and his brother, Louis. The Levy screen was made by etching cross lines on a glass plate and blackening the depressions with an opaque pigment. This type of screen made halftone printing both technically and commercially attractive, and by 1897 halftone illustrations (made with Levy screens) began appearing regularly in American newspapers. The *Bulletin's* halftone of Max Levy was made with a screen having about 152 lines ruled within an inch. Previously, Ives had complained that printers would not accept a screen more finely ruled than 120 lines to the inch. But then, as now, there was no "best" grade of screen ruling applicable for all purposes, and Max Levy gave these reasons why:

> Manifestly, if we have only 100 given units of black in a square inch of white space, the effect will be much lighter than if there are 1,000 similar units of black on the same space, and the same is true inversely of the white dots in the shadow, so that it necessarily follows that the greatest difference in color between the deepest shadow which is not absolutely black, and the highest light not perfectly white will decrease as the the number of lines in a given area increases, and *vice versa,* and it follows that the strength of the resulting picture, and richness and variety of tones, will increase, as the ruling on the screen is coarser.
>
> On the other hand, in cross-line work, as the *direction* of the lines never follows the contour of the details, but always cuts them more or less, the ruling will require to be finer as the details become smaller. Another point involved is the size of the picture under consideration. If this is quite small it will generally be viewed at short range, so that the lines of the screen will become more apparent than is likely to be the case in a larger picture, which will usually be viewed at a greater distance in order to take in the whole subject. From these considerations the following conclusions are drawn:
>
> Very large pictures are best made with coarser rulings—very small pictures with finer rulings—very bold subjects yield bolder reproduction with coarser than with finer rulings, while the coarser ruling is fatal to fine detail. [657]

Edward L. Wilson, from an Ives process halftone engraving, 1881.

Max Levy, from an improved Levy process halftone engraving, 1895.

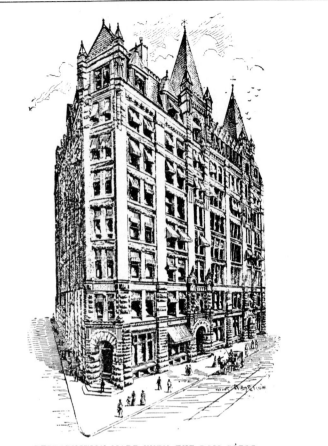

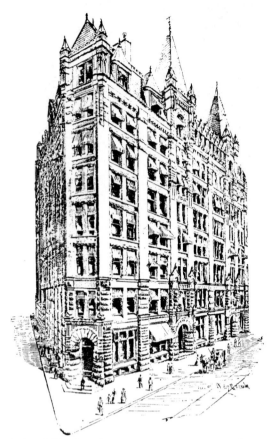

REPRODUCTION MADE WITH THE ROSS-GOERZ
ANASTIGMAT.

REPRODUCTION MADE WITH RAPID RECTILINEAR
LENS.

ANASTIGMAT LENS GIVES BETTER
PHOTOENGRAVING LINE REPRODUCTION

In June 1896, Edward L. Wilson took the position, editorially, that anastigmat lenses of the Ross-Goerz variety were proving superior to the standard rapid rectilinear ''for all photographic work where extremely fine definition, great covering power, and rapidity of action are required.'' At the same time, a New York operator, William Weston, decided to make a comparative test, using an anastigmat and a rapid rectilinear to make separate negatives of a building drawing, from which two photoengraving plates were made to produce the two illustrations shown above. For both negatives, a lens of 19 inches focus was used, since this size was considered the most suitable for all-around purposes in photoengraving. In using the anastigmat, the drawing was positioned at the end of a camera stand (the camera used was a 14 x 14 process camera), the stop f/32 was inserted, and an exposure of one minute was made by electric light (using a mirror to brighten up the side of the image furthest away from the electric lamp). The illustration made from this negative is shown above, left. When the rapid rectilinear lens was used, it was found necessary to insert the diaphragm f/22 to insure definition, and the stop f/64 was selected for an exposure which required four minutes. The illustration made from this negative is shown above, right. An examination of the two illustrations reveals that although the vertical lines in the reproduction made with the rapid rectilinear lens are well rendered, the horizontal lines are less defined than the same lines in the illustration produced with the anastigmat. ''In the negative taken with the rapid rectilinear,'' Weston said, ''certain delicate parts of the original line-drawing were entirely lost, as they were so covered that in the printing preceding the etching, they were hardly visible, and disappeared entirely in the etching.''[658]

trict of Columbia court after Armat endeavored to restrain his use and promotion of it commercially. The Edison "representatives" before whom Armat demonstrated a Phantoscope were Norman Raff and Frank Gammon, proprietors of Edison's Kinetoscope Company, which in 1895 was suffering from declining business. Reportedly, Raff and Gammon "prevailed" upon Edison to acquire the machine for which Armat now held full patent rights, after which Edison himself is said to have given it the name Vitascope.

The Phantoscope embodied two essential developments that were lacking in previously invented projectors. The first was the incorporation of a loop of slack film, the absence of which precluded drawing long lengths of film through the projector without jerking it and causing it to break. The other was the provision for a longer period of rest and illumination for each picture, coupled with a mechanism allowing quick movement from one picture to the next. In later years, these innovations would become important factors in prolonged litigation involving Edison and other inventors (but not Jenkins) over the origins of motion picture camera development, and in the end they would provide grounds for the ultimate legal opinion rendered in which no one individual was cited as the "father" of the motion picture camera.[659]

On December 1, 1897, the Science and Arts Committee of the Franklin Institute, chaired by Henry Heyl, published a notice in the Institute's *Journal* that Jenkins would be given the Institute's coveted Elliott Cresson Medal for the Phantoscope invention. Although a protest was lodged by Armat, Heyl and the only other member of the committee, John Carbutt, decided to dismiss the protest after further evaluation nearly a year later. Jenkins was thus awarded the Cresson Medal as the sole inventor of the Phantoscope.

In 1916, the Institute also awarded Jenkins its John Scott Medal for the Phantoscope invention. In light of the litigation involving Edison and others in the interim (1897–1916), the Institute's citation to Jenkins bears repeating:

Eighteen years ago the applicant exhibited a commercial motion picture projecting machine which he termed the "Phantoscope." This was recognized by the Institute and subsequently proved to be the first successful form of projecting machine for the production of life-size motion pictures from a narrow strip of film containing successive phases of motion.[660]

Just as Henry Heyl proved to be an important factor in having credit given where it was due in Jenkins' case, so, too, we learn from the Heyl papers in the Franklin Institute that another prolific inventor, Rudolph Melville Hunter, of Philadelphia, engaged in motion picture camera development independently, but at the same time as Jenkins. Hunter was the holder of many patents in electrical engineering. His pioneering invention of a motion picture camera was described by Heyl in these words:

After returning from the World's Fair Exposition in Chicago, in 1893, he [Hunter] devised improvements in photography and motion machines designed to project images from pictures arranged in consecutive order in film form, the film to be intermittently fed forward by mechanical devices, the light to be projected through the pictures upon a screen and the images to be intermittently shut out from view during the feeding of the film of pictures.[661]

SMALL AIR BUBBLES FOUND IN LENSES MADE OF JENA GLASS

Charles P. Goerz, the German lens maker, disclosed in 1895 that American photographers sometimes complained about air bubbles in the Goerz Double Anastigmat, and other high-quality lenses. This prompted the glass maker, Schott & Gen, to issue the following circular from their Austrian manufactory at Jena:

"The efforts of opticians in the improvement of objectives in the higher characteristics of optical results have, in later years, particularly in photographic objectives, resulted in an increasing demand for such kinds of glass which, in their optical properties and chemical composition, differ very considerably from the crown and flint formerly used, and the production of which presents far greater technical difficulties to the producer than the former optical glass. Particularly does the majority of the kinds of glasses requisite in the construction of the improved photographic objectives, which have been recently introduced, offer unusual difficulties in the accomplishment of complete purity, that is, freedom from small air bubbles. The definite demands, which are made for these special glasses, varying from the ordinary materials in their conditions between refractive index and dispersive power, subject the chemical composition of the glass flux to such narrow limits, that the technique of melting leaves no choice in bringing about favorable conditions for the greatest possible purity. The result is that in such kinds of glass it becomes practically impossible to regularly produce pieces free from *small air bubbles*.

" We must point out that the existence of such small air bubbles even in the most unfavorable cases, hardly reaches a loss of light amounting to ¼th per cent. and therefore is entirely without influence on the optical result of a lens system.

" It is therefore apparently *unreasonable* to demand of the producer of optical glass that, to meet the increased demand of the optician in reference to all the *really* important properties necessary for the function of the objectives, he should reject ¾ths of the produced glass merely because it shows a defect which, in application, is absolutely insignificant.

" If the purchaser, especially of photographic objectives should, as has hitherto been customary, declare lenses with a few small air bubbles as " faulty," the optician will be constrained to explain that objectives of improved quality in *optical* results cannot be produced out of any crown and flint which may be selected at will, but only from such kinds of glass, in the selection of which higher considerations than the presence of a few small air bubbles must be decisive." [662]

SCIENTIFIC AMERICAN

A WEEKLY JOURNAL OF PRACTICAL INFORMATION, ART, SCIENCE, MECHANICS, CHEMISTRY, AND MANUFACTURES.

(Entered at the Post Office of New York, N. Y., as Second Class matter.)

Vol. LXXVI.—No. 16.
Established 1845.

NEW YORK, APRIL 17, 1897.

[$3.00 A YEAR.
Weekly.

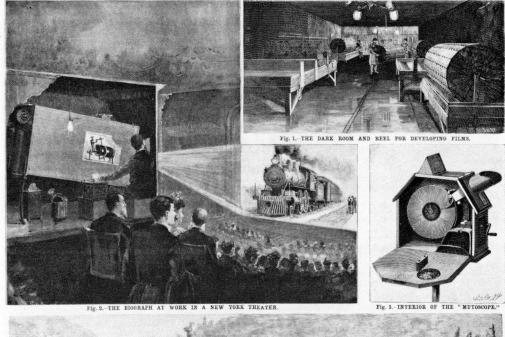

Fig. 1.—THE DARK ROOM AND REEL FOR DEVELOPING FILMS.

Fig. 2.—THE BIOGRAPH AT WORK IN A NEW YORK THEATER.

Fig. 3.—INTERIOR OF THE "MUTOSCOPE."

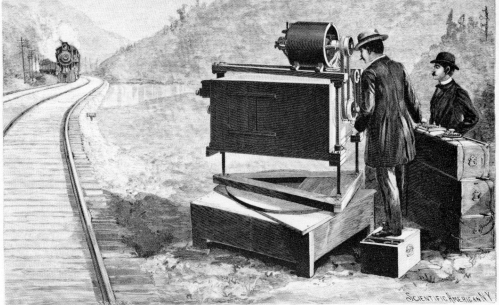

Fig. 4. THE "MUTOGRAPH" PHOTOGRAPHING THE PENNSYLVANIA LIMITED WHEN RUNNING AT THE RATE OF SIXTY MILES AN HOUR.

PHOTOGRAPHY AS AN ADJUNCT TO THEATRICAL REPRESENTATION.—[See page 248.]

MUTOSCOPE AND BIOGRAPH

1896

372

In April 1895, W. K. L. Dickson left Thomas Edison to join the American Mutoscope Company, where he helped perfect a peep-show mutoscope device (Fig. 3) and biograph film projector (Fig. 2). A mutograph (Fig. 4) took pictures on location for viewing either in the mutoscope (competition for Edison's kinetoscope), or for projection on a screen by the biograph, which quickly became more popular than Edison's Vitascope. Figure 1 in this series (which appeared on the cover of the April 17, 1897, issue of the *Scientific American*) shows the darkroom for mutograph film developing.

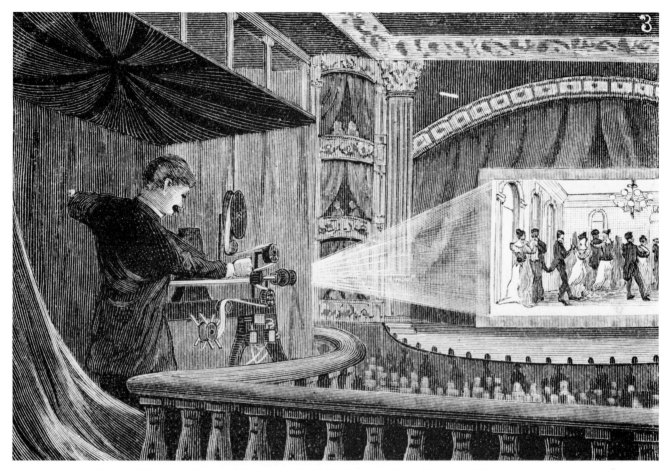

Thomas Edison gave the name Vitascope to the motion picture machine which he and his associates demonstrated at a showing of a film of vaudeville acts at the Koster & Bial Music Hall in New York on April 23, 1896. But the Vitascope was manufactured on the basis of the design for C. Francis Jenkins' Phantoscope, after Jenkins' partner, Thomas Armat, who had cosigned a patent application for the Phantoscope with Jenkins, took a model to Edison's associates, Norman Raff and Frank Gammon (proprietors of Edison's Kinetoscope Company). Armat bought out Jenkins' rights to the Phantoscope patent in 1896, or early 1897.

1896

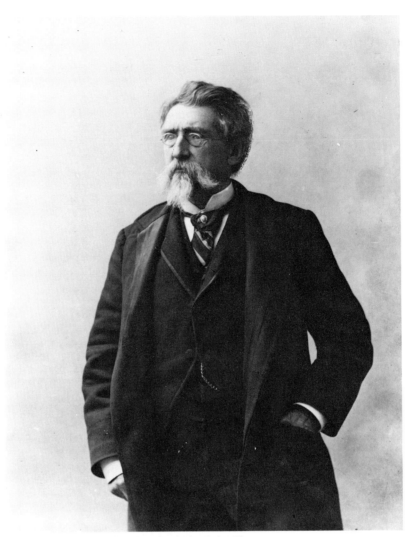

Last known photograph of Mathew Brady, made in 1889.

IN MEMORIAM:
MATHEW B. BRADY

Like his New York gallery, Brady's Washington gallery was shut down (in 1881) after foreclosure of outstanding mortgages. Brady was then left with several hundred daguerreotypes, about three thousand photographs, his desk, clock, some personal memorabilia and the chair given him by Abraham Lincoln (in which so many of the nation's celebrities had posed for his camera). From 1882 to 1894, he worked for, or in partnership with, others as a photographer. In 1887, his wife died, and he was forced to live with a nephew, Levin C. Handy, who had worked for Brady as a youth and succeeded to his business. Still trying to interest Congress in his Civil War pictures, he became "the sad little man" who haunted the desk of a public stenographer at the Riggs Hotel, who worked primarily for congressmen. Brady's final years were described by Handy in a letter which he sent E. L. Wilson shortly after Brady's death on January 15, 1896:

> A change of administration and many other things discouraged him, and he finally mortgaged the remainder of his material, instruments,

etc. This seemed to break his heart. In his eagerness to keep afloat he ventured out on the night of Emancipation Day, April 16, 1894, and in crossing the street in front of the Riggs Hotel, was run over by a carelessly driven carriage; his leg was broken, and he was removed at once to my house, where the limb was set. Mr. Brady was forced to remain indoors for nearly a year. While he lay on his back the parties holding the mortgage closed in on him and left him penniless. As soon as he was able to get out, he went to New York, where arrangements were being made that he should give an exhibition by the stereopticon of some of his celebrated pictures. All things seemed to favor this plan; the exhibition was to have taken place on the 30th day of January. Mr. Brady, while in New York on this last visit, was largely assisted by the Veterans of the 7th Regiment, of which he was a member, and the Artist Club, of which he was a founder, stopping for some time with William M. Riley, of 119 East Fifteenth Street. Mr. Brady, however, never fully recovered from the injury received in Washington. It caused a complication of troubles, and he was finally removed to the Presbyterian Hospital, where everything possible was done for him. An operation was performed, under which he gradually sank until he died.[663]

Hunter purchased and renovated a building in Atantic City for purposes of showing films in 1894, but for reasons unknown, the undertaking was aborted. Because of a misunderstanding over the dates of filing on the Edison and other motion-picture camera patents (and the press of other patent litigation), Hunter failed to prosecute his patent application, according to Heyl, with the result that it was later abandoned.

Another early inventor was Woodville Latham, who first sought Edison's help in perfecting a projector based on the kinetoscope design, but after being rebuffed, developed a machine of his own design which he labeled the Pantoptikon. Latham demonstrated the Pantoptikon in New York on February 22, 1895 (and thereafter became involved in the subsequent patent litigation), but his device (which he renamed the Eidoloscope) was not long lasting.

Edison's principal competition in the Vitascope came from his former assistant, W. K. L. Dickson, who left Edison before the latter's acquisition of the Vitascope to help found the American Mutoscope Company (initally to manufacture a peep-show device of different design from the kinetoscope). The company shortly changed its name to the American Mutoscope and Biograph Company, reflecting the name of its second important invention, the biograph.

The biograph was first publicly demonstrated at the Alvin Theater in Pittsburgh in September 1896. It was able to project larger pictures than the Vitascope, and these the Pittsburgh *Post* found to be more "clear-cut and distinct" than any previously seen. After an extended showing at the Koster and Bial Hall in New York from October 1896 to January 18, 1897, the biograph became the only one of the major projectors to remain in use at the major New York theaters. Over three hundred films for biograph shows were screened in the period 1896–1901, including scenes from the Spanish-American and Boer wars, and the Boxer Rebellion. In 1897, Edison began legal action against the American Mutoscope and Biograph Company, and this and other court battles over the various patented machines continued on into the twentieth century.[664]

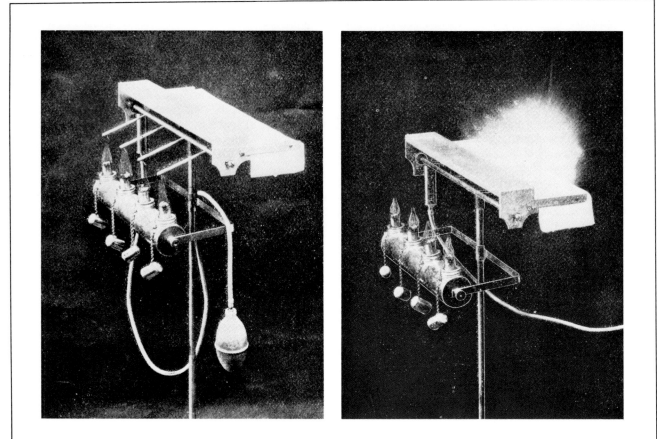

A SAFE, CLEAN, AND RAPID FLASH MACHINE

There were five deaths in Philadelphia alone during the first two years in which magnesium flash powder came into vogue, and in 1891 several tin cans of the powder carried by W. H. Jackson in his luggage exploded during a change of trains in Chicago, causing serious injury to the baggage handler. On January 6, 1898, the New York *Sun* published a letter from a former first lieutenant in the Second U.S. Artillery, pointing to the "many accidents" caused by using dangerous flashlight compositions. "I have heard of flash powder being advertised as safe because it can be eaten," the lieutenant said. "It contains chlorate of potash, which is sometimes a remedy for sore throats, but this same chlorate of potash in any kind of powder is extremely dangerous." The fumes from powder containing the substance were also very corrosive, he added, and likely to injure draperies or other furnishings. In 1896, A. E. Johnstone, manager of the Automatic Printing Company, paid a visit to E. L. Wilson, inquiring where he could get a quick-acting flash apparatus for portraiture, which would at the same time be clean and safe. Johnstone found drawbacks to every suggestion put forward by Wilson, so the latter recommended that Johnstone design his own machine. In June 1897, Johnstone appeared again in Wilson's office "bearing under his arm the proverbial mysterious package." This proved to contain the apparatus shown above. The device consisted of a powder tray, "air engine," and a cylindrical spirit-lamp equipped with four gas jets, which was positioned to the rear of and beneath the powder tray. Traversing horizontally along the back of the tray was a spring-actuated rod bearing four platinum-tipped arms, each extending to a position just above the flame of a gas jet. Placement of the magnesium powder was not in the tray itself, but on a sheet of fireproof paper affixed to the tray with clips. Ignition of the powder was accomplished by actuating the horizontal rod, which propelled the red-hot points to a position beneath the tray where four equidistant perforations in the bottom of the tray allowed the heated points to penetrate through the paper to the powder. Because of the ease with which the paper could be removed after use and replaced with a new sheet, Wilson declared Johnstone's machine just as clean after a hundred exposures as after the first.[665]

1897

The choice of which paper to use in making photographic prints—whether for professional studio work or for exhibition purposes—remained more of a problem in the last decade of the nineteenth century than is perhaps generally recognized. Frequently, it is simply stated that the old reliable albumen paper was replaced by the gelatine-bromide papers "about 1890." But a close examination of photographic literature of the period suggests otherwise. In 1895, for example, *Anthony's Photographic Bulletin* pointed to evidence of a lack of permanency in its own printing with the gelatine papers, adding:

> However, we do not desire our readers to accept our own evidence unsupported, and would call their attention to the fact that the majority of the prominent professional photographers in this country are not using gelatine printing-out papers.[666]

E. W. Foxlee, writing in the *British Journal Almanac* in 1895, reported similar problems with the gelatine papers:

> I venture to say that, although gelatine-chloride has only been in vogue for two or three years, there are, in that short time, more gelatine prints in existence with brimstone-colored lights and bilious halftones than there are albumen ones made in any similar period, and kept for so brief a time.[667]

David Bachrach, as might be expected, was among the most forthright in his unfavorable evaluation of emulsion papers in general. To begin with, the poorest kind of negatives could be used to make passable prints on such papers, he contended, and "the most ignorant" of people could make them easily if they used a combined toning and fixing bath. But what was going to be the effect on the profession in general, he wondered, when one considered "the wholesale fading out, peeling off, and what not of the mass of the prints made on these papers." This was not a matter open to dispute, he said: "I boldly say that there are now in existence more badly faded prints, made in the last five years, than there ever has been from the twenty-five previous years of albumen printing." For him, it was time to "look backward." Except for carbon and platinum prints, well-manipulated single-albumenized paper prints would make the most permanent products of the photographic art. If other photographers, like himself, felt that they were "wandering after false gods and false ideals" to their ultimate financial destruction, "why not turn about now?" he asked. In his own case, he explained how this came about:

> From some time in 1893 to the summer of 1895 we used emulsion paper for our small work. The latter summer was hot and sultry, and we were using gelatine paper. I had long considered we were on the wrong track, and suspected that the prints were fading *en masse*, but had the common, foolish fear of being considered not up to date or a back number by doing what I thought was right. One memorably

A PHOTOGRAPHER'S APPEAL: RETURN TO ALBUMEN PAPER

In 1893, Walter E. Woodbury published a series of articles in the *Photographic Times* giving high praise to the then new gelatine chloride papers, and at the same time condemning the continued use of albumen paper. Peter C. Andrews responded in the same publication with these remarks, saying that he had given the new papers a try, but that he was returning to the use of "my old, tried and trusted friend," albumen paper:

> In the first place I do not find, and I am sure others will bear me out in this, that same evenness and regularity with these new kinds of paper. If I silver my own, as I sometimes do, I can vary my proportions to suit my negatives. This I cannot do if I use these new-fashioned papers, but am bound to put up with whatever the manufacturers like to give me. Printing may be a little quicker, perhaps, but the time thus saved is lost in the toning, for I have found it impossible to tone any large number of gelatine prints at one time. Others I believe have found the same fault with it. Whereas with a batch of albumen prints I can lay them in the toning solution fifty or a hundred at a time, and be certain of my results, with the gelatine or collodion paper I am obliged to tone but a few at a time, four or five only, and then if care be not taken uneven toning will result. As soon as we get the hot summer weather with us I am thinking that there will be not a few who will return to albumen paper.
>
> The want of toughness in the gelatine prints is another serious drawback. The films are far too tender for the ordinary professional work. The amount of handling that albumen prints will stand is surprising. They are far more easily mounted and burnished, and with a good brand of paper and a good burnisher I can get all the surface I want. I do not by any means admire the fearful glaze given to these gelatine prints. It is inartistic, gives false reflections, and only fit to please little children who delight in bright and pretty things.
>
> With regard to the collodion papers, whatever advantages it may have, are certainly set aside by its fault of curling up and becoming unmanageable. Whatever the makers may say I have never found it to lie flat. For uniformity and reliability give me albumen paper, and I hope what I have said will cause others to ponder before they rashly desert a process that has been a friend to them so long for an untried, and in my opinion, much overlauded rival.

Roving photographer Frances B. Johnston, her Kodak on the floor beside her, confers with Admiral George Dewey aboard the *Olympia* during 1899 visit in which she made 107 photographs of activities aboard the flagship vessel.

Above is a Sigmund Krausz photograph of a youthful Chicago street peddler of flypaper and matches.

These two boys, photographed on a bright, sunny day in Pennsylvania, convey the innocence of a rural way of life which has long since succumbed to more sophisticated ways of urban living. The photograph is from the collection of the early twentieth-century Photo-Secessionist John G. Bullock.

PURPOSEFUL AMATEURS

In many museums, libraries, and historical societies there will be found photographs dating from the 1890s of urban street scenes, unusual social gatherings or public events, and other views of an essentially documentary nature which have captured in a tasteful and sometimes candid fashion an element or moment in time having a lasting visual appeal. George Bernard Shaw complained that "the photographer is like the cod, which produces a million eggs in order that one may reach maturity." But along with the hand camera there came a new generation of photographers like Frances B. Johnston (above left) who took their Kodaks, Graflexes, etc., seriously. Enduring photographs were made for example by Miss Johnston and Moses Y. Beach, scion of a family of inventors and journalists, of President Benjamin Harrison's participation in the centennial observance of George Washington's first inauguration, which took place in New York City in 1891. About this time, the father-and-son team of Joseph and Percy Byron began making a record of life in New York which prompted Edward Steichen to say in later years: "They were among the earliest to realize that the camera

An unknown photographer made this early photograph of a world heavyweight championship fight, which took place at Carson City, Nevada, on March 17, 1897. A "brainy, modest and nimble-footed" San Francisco bank clerk, James J. Corbett, met and was defeated by the English-born knock-kneed Robert Fitzsimmons in the fourteenth round.

used for visual reporting opened up an endless field in photography. It became a good business because of their enthusiastic and tireless energy, their uncanny instinct for finding timely, newsworthy aspects in almost everything, whether photographed on the basis of a commission or on shrewd speculation of what would be saleable. Their only specialty was making photographs, photographs without opinion, comment, slant or emotion. . . . Their photographs are objective because the places, the things and the people photographed have a chance to speak for themselves without interference.'' In Chicago, Sigmund Krausz created a veritable "Street Life of Chicago" comparable to what John Thomson and Adolphe Smith had accomplished with their *Street Life in London,* published nearly two decades earlier. Between 1880 and 1900, S. R. Stoddard traveled throughout upstate New York and New England, making a vast record of the mountains and resort towns. Similarly, H. G. Peabody of the Boston Peabody clan concentrated on yachting and naval vessels. In San Francisco, a Berlin physician, Dr. Arnold Genthe, who settled there in 1895, made a

vast photographic record of the city's Chinese quarter, and of the great earthquake and fire in 1906. Afterwards, Genthe moved to New York where he became a celebrated photographer of the socially prominent. While the approach in the photographs made by the photographers just mentioned was purposeful, it may also be characterized as intellectual, and frequently artistic. This was true, too, of many of the photographs made at this time by members of the Photographic Society of Philadelphia (an example by John G. Bullock is shown left). Across the Atlantic, photographers such as Eugene Atget in Paris and Paul Martin in London made unparalleled records of the life and architecture of their respective cities around the turn of the century. Martin is particularly noted for his views of ordinary people, places, and events, not only in London but among English seaside resorts. In these endeavors, Martin was among the first to use a hand camera which had a concealed lens. When he pointed the camera in one direction, the lens could be focused, and a picture secured of a scene or of people located to his left or right.[669]

hot day the prints were more sticky than usual, and almost a whole batch of over three hundred spoiled while in the wash-water. I am one of those who, on rare occasions, under great provocation, not only act quickly, but use language more emphatic than elegant. Both things happened. The whole batch was thrown out, and I swore that not another print should be made on those papers. Two or three dozen sheets of albumen paper were sent to the printer to sensitize at once, to replace the prints spoiled, and from that day to this we have never used the glossy emulsion papers for our work.[670]

"LANTERN SLIDE YEAR"

"The past twelve months of the Camera Club of New York will, without question, be known in the pages of its annuals as the 'Lantern Slide Year,' Alfred Stieglitz declared in October 1897. Never before, he said, was there so much work done, or so much interest shown in this most peculiarly fascinating branch of photography. Slide making remained one of the few outlets for the wet-plate collodion practice. T. C. Roche favored the collodion process because it gave greater detail, and cleanness in highlights. In London, Alfred Brothers contended that those amateurs who took the trouble to learn the collodion process "would probably give it the preference over all others for making lantern slides." Although slide-making was viewed with disdain by some fine-art photographers, it was practiced by some of the best. Paul Martin, for example, made the first photographs of London by night on lantern slides, as did William Frazer, one of the first to specialize in making night photographs in New York. Alfred Stieglitz analyzed the subject in these words:

Many of our best amateurs devote themselves exclusively to this branch of work, our Mr. Frazer being a notable example, notwithstanding the fact that most of the leading pictorial photographers of Great Britain and the continent look down upon slide-making as outside the "art limits," and therefore beneath their artistic dignity. It has become an accepted fact among them that the process is purely mechanical, and that at best the tonality of slides was incorrect. As for the declaration that slide-making is purely mechanical, permit me to say that, after a conscientious writer's work in this line of photography, I have come to a different conclusion and claim that the technique of slide-making may be quite as interesting as that of the known printing processes. . . . As for incorrect tonality, in most cases that is due to the lack of knowledge and skill on the part of the slide-maker, who has not given the matter enough study or, who, perhaps, does not quite grasp the material with which he is working."[671]

The following year (1896), Bachrach began giving out this circular to his patrons:

"NOTICE TO OUR PATRONS.

"It will be observed that these pictures are the strong, well brought-out albumen paper prints, with a medium polish, similar to those we made up to three years ago, and which a twenty-five year test demonstrated to be permanent when made by reliable photographers, and are not the extreme high gloss aristo prints with a hard marble-like appearance, so much used of late.

"We have returned to this more expensive and troublesome process because the last three years' experience has shown not only the great liability to fade and defacement by rubbing and scratching of prints made on the high gloss papers, but it has also demonstrated the better artistic quality and truer resemblance to human flesh of the albumen prints. We have, therefore, considered it the interest of our patrons, and incidentally our own, by the greater value attached to such productions, to discard what we consider an inferior process, and return to that which years of experience has taught us to be the best.

"Anyone having high gloss prints made by us in the last two years showing signs of fading can have the same replaced with albumen prints without charge."[672]

If the gelatine papers posed such a problem, the question naturally arises, what other alternatives were there besides "looking backward," as Bachrach expressed it? The evidence points on the one hand to a marked increase in the use of the platinum and carbon printing methods, particularly by the more fashionable galleries, and by fine-art photographers; but it also suggests that there was a widespread adoption of the matt collodion papers, particularly those toned in platinum (papers known in the trade as "aristo-platino"). Foxlee noted that the price of collodion paper had become competitive with the gelatine or albumen papers, and he indicated that this should give an added boost to the collodion paper use:

Collodion paper possesses many advantages over gelatine. Like albumen, it does not require a special type of negative. It may be toned in almost any bath. Any color, from a red brown to a deep rich purple black, or even a cold black, can be obtained at will. It does not yield double tone, and vignettes with pure whites can as easily be obtained as with albumen paper. The prints can be blotted off and dried before the fire without risk of injury. Collodion, unlike gelatine and albumen, does not form a compound with the silver, therefore the results are more permanent than can be claimed for any other silver process, as time has proved.[673]

One of the best indications of a rank-and-file interest in aristo-platino paper is to be found in the annual report on the progress of photography given by a Dayton, Ohio, photographer, A. L. Bowersox, at the 1896 P.A.A. convention:

The paper that has found favor among the greatest number of photographers is the aristo-platino. The seeming simplicity with which this paper is worked is the cause of the increased demand for it. The final results are similar to carbon and more easily obtained.[674]

Bachrach, meanwhile, admitted that albumen paper was "by no means my ideal printing-out paper." The aristo-pla-

tino, he said, "is far nearer the ideal in results, platinum and carbon being my ideals for perfection to date." When the matt collodion paper was strongly printed and toned with platinum to the black stage, he felt that such prints would prove to be as permanent as the best-made albumen prints. But if they were rubbed against one another, or if they were used roughly, aristo-platino prints were subject to fatal injury, he contended.[675]

Bachrach was joined by many others in his preference for the platinotype. B. J. Falk made a specialty of it at his New York gallery, as did the new Midwest master of portrait photography, Isaac Benjamin, of Cincinnati. As Bowersox noted in his P.A.A. address, the better grade of platinum paper which had become available commercially from Willis & Clements in Philadelphia, had much to do with the new preference for it:

> With platinum, beautiful results can be obtained, and we are pleased to note that the manufacturers, Messrs. Willis & Clem-

ents, have succeeded in the past year in securing a much finer deposit than heretofore, giving still greater value to this already celebrated paper. The greatest obstacle to the more extensive use of this kind of paper is the obligation of the photographer using it to purchase the developer and chemicals from the manufacturers, not knowing what they are composed of.[676]

As far as Bachrach was concerned, nothing ever surpassed the platinotype during his entire career, and after his retirement he asserted that "we must take off our hats to Mr. Willis, and his years of splendid technical ability and work, as the savior of modern photography."[677]

Other suppliers of platinum paper appeared on the scene as its use increased in the 1890s. These included the American Aristo Company, the di Nunsio Company in New York, and John Bradley of Philadelphia. Possibly because of the close proximity of the Willis & Clements firm, Bradley maintained great secrecy concerning his business, and according to one source, he maintained this secrecy by employing only one person—a Chinaman.[678]

1898

382

America's Alfred Stieglitz and England's Paul Martin pioneered in making photographs of city streets and parks at nighttime (in 1895), but to the New York photographer William Frazer must go the laurels for superior work of this character in the 1890s and early 1900s. The scene above, made by Frazer circa 1898, was entitled "Wet Night, Columbus Circle."

<u>1898</u>

The flowering of American fine-art photography, which had begun in a small way after 1890, came to its first fruition with the staging of a European-style photographic salon at the Philadelphia Academy of Fine Arts, October 24 to November 19, 1898. Previous to this, according to Joseph T. Keiley, the Wall Street lawyer turned photographer (and soon to become the fourth American elected to membership in the Linked Ring), the joint exhibitions of the various American amateur societies were for the most part run by "committees," which he described as "totally devoid of any artistic feeling or training." Artists were usually appointed to make the awards at these events, "but these gentlemen," Keiley contended, "rarely took their responsibilities any too seriously." As a result, the exhibitions were "rarely of any real international importance, and seldom even nationally representative."

In these sentiments, Keiley was joined by A. L. Bowersox, who, in his report on the progress of photography at the 1896 P.A.A. convention, asserted that "the only thing most needful of progress in the coming year is to try to realize our extreme art-poverty, and we shall feel the need of instruction in this line more real and urgent." Another who expressed similar sentiments was E. Lee Ferguson, of Washington, D.C., who made these remarks in an early issue of *Camera Notes:*

> While three of our largest and most cultured cities could not maintain a good exhibition once in three years, many provincial towns in Great Britain have the advantage of a view of some of the best work every year. The work of some of our best pictorial photographers is much better known abroad than at home. . . . We now have little but our petty local shows—usually a dreary collection of mediocrity—and a dream of what might have been had our great cities kept up the work.[679]

But there *were* several salons—albeit less heralded—which were held before the Philadelphia event, and these suggest that the American fine-art photography movement had actually gotten off to an earlier start. The first was a salon held in Washington, D.C., in the spring of 1896. This event was staged at the National Museum of the Smithsonian Institution, and was sufficiently successful to cause the Museum to purchase fifty of the prints exhibited. When a "National Photographic Salon" was scheduled to be held at the museum the following year, G. Brown Goode, the assistant secretary of the Smithsonian in charge of the National Museum, dispatched this letter to the designated chairman of the planned event:

> I am very much gratified to learn that it has been decided to hold a second exhibition of art photography in this city, under the name of the National Photographic Salon of 1897. The exhibition of 1896 must be regarded as the most impressive exhibition ever held in this country. It has demonstrated the right of photography to a place among the fine arts, and was suggestive of possibilities in the future which are by no means generally appreciated. Such exhibitions are useful not only to the photographers themselves, but to all those who have occasion to avail themselves of the possibilities of photography in the deco-

rative and graphic arts, in illustration of books and in the sciences. I am desirous of utilizing the coming exhibition for the purpose of extending the photographic collection in the National Museum, and therefore authorize you to announce that a number of the best photographs there exhibited will be purchased.[680]

Whether the 1897 event took place does not appear to be recorded in the photographic literature of the period; however, in March 1898, the Pittsburgh Amateur Photographers' Society staged an international salon at the Carnegie Art Galleries, which was considered one of the great American art centers at this time. Attendance at this salon was so great that the exhibition had to be extended.[681]

The Philadelphia salon followed closely on the heels of the Pittsburgh event. Many well-known European names were missing from the Philadelphia show, but those whose works were hung included A. Horsley Hinton, the principal spokesman for the Linked Ring and a noted British photographer of landscapes; and Frederick H. Evans, a London bookseller who, at forty-five, was just beginning an illustrious career as a photographer of literary giants, and of cathedrals in Britain and France (all of his work being accomplished in platinotype). Some 1,500 photographs were submitted, but of these, only 259 were hung. These were the works of a hundred photographers, seventy-six of whom were American. From Keiley's standpoint, the Philadelphia salon was a distinct American milestone:

> Individuality and correct tonality, with all that these two things imply, were evidently the essential qualities looked for by the majority of the judges in the prints submitted. The result was a surprise to all except the advanced workers, whose claims for photography it more than confirmed. For the first time it was realized that a Stieglitz, a Hinton or a Day [F. Holland Day, of Boston, the third American elected, in 1896, to membership in the Linked Ring] was as distinctive in style as a Breton, a Corot or a Verestchagin; that photography is open to broad as well as sharp treatment; that it had its impressionists and its realists.[682]

Without question, the salons held in the major European capitals, and the formation of the Linked Ring Brotherhood, had had a profound and stimulating effect on American fine-arts photography; another important contributing factor was Alfred Stieglitz. This is reflected in this tribute to him penned by the critic Sadakichi Hartmann:

> . . . not only during my first visit to the Camera Club but often since, it has seemed to me that artistic photography, the Camera Club, and Alfred Stieglitz were only three different names for one and the same thing. . . . I am not given much to eulogies of one man, but I am a hero worshipper in the truest sense. Any man who asserts himself in a certain vocation of life has my fullest admiration. There may be hundreds of amateur photographers in New York who do their very best to advance the art of Daguerre, but it would be absolutely foolish to deny that artistic photography in America would not have reached its present standard of perfection without Mr. Stieglitz. He has, perhaps, been prominent at exhibitions for a larger period than any other living American photographer, and a persistent ad-

View of a mountain scene made by John G. Bullock, an officer of the Philadelphia Photographic Society.

AMERICAN ART PHOTOGRAPHY

A desire on the part of members of photographic societies and camera clubs to record scenic outdoor views in artistic fashion began to flourish after a European-style photographic salon was held in Philadelphia in 1898. The Boston artist Darius Cobb expressed the belief that exhibits of some photographs by various camera clubs "give sufficient evidence to the unprejudiced mind that photography is a fine art." Members of the Philadelphia Photographic Society worked almost exclusively with the platinum process, a situation which Alfred Stieglitz considered a threat to the artistic achievements of New York amateurs (see page 355). Frequently, camera clubs held outings with large groups of members (see right), but few individual photographers went to the extent to which Stieglitz did to capture what for the time was unusual in the extreme. One snowy night in sub-zero weather in the winter of 1898, for example, he put on three layers of underwear, two pairs of trousers, two vests, a winter coat and Tyrolean cape, and armed with tripod and camera, stole out of his apartment on East Sixty-fifth Street near Central Park in New York to photograph some glistening trees coated with ice adjacent to a snow-covered walk. No one had previously attempted to make a nighttime photograph of this nature under comparable conditions, although a group of photographers from a camera club in Orange, New Jersey, made a similar but unfruitful attempt several nights later when the weather was apparently much the same.

Maine seascape view made by Dr. Charles H. Mitchell, also a member of the Philadelphia Photographic Society.

Members of the Newark, New Jersey, camera club on an outing, circa 1900.

The photograph above has been reproduced from a gum print by Charles Job, an early practitioner of the process popularized in 1896 by the Parisian photographer and painter Robert Demachy.

GUM BICHROMATE PROCESS ("GUM PRINTS")

With the appearance of the "impressionist" photography school, this process, first used in 1855, became popular among avant-garde, fine-art photographers. The process involved sensitizing sized paper with potassium, or ammonia bichromate, coating the paper with a water-color paint mixed with gum arabic, exposure of the prepared paper (in contact with a thin negative), and development of the print in cold water (where the parts of the pigmented gum not hardened by light were washed out). Throughout all the stages of the process, it was possible to alter, or in numerous ways to modify, the procedures. To begin with, different papers would produce different results. Thus, a heavy-sized paper would yield excessive contrasts, which a lighter paper would not. Sensitizing and coating could be done separately, or at the same time. If sensitizing was done first and the paint and gum put on the paper afterwards, this called for a shorter exposure, or about the same amount of time as would be required for an exposure in working the platinum process. If sensitizing and coating were accomplished at the same time, the exposure required would be longer, or about the same time required in working with albumen paper. In print development, the amount of the pigmented gum washed out could be influenced by the warmth of the water, by spraying, sponging or brushing, depending upon the photographer's intentions. In the paper coating operation, it was desirable to lay as thin a coat of paint as possible with a brush, preferably with a badger hair brush (which precluded streakiness, and made for greater softness in the finished print). During development, portions of the image could be removed, while after development the finished print could be touched up with water color of painters' size to achieve desired artistic effects.[683]

The side effects from working with photographic chemicals was not a new thing, but the gum process brought with it a new danger, described in this warning which appeared in *Wilson's Photographic Magazine:*

> About fifteen years ago a physician introduced to notice a new disease which he named the "bichromate disease." Very many people have scoffed at the thought of any danger in working with bichromate of potash, and it is only occasionally that a bad case crops up, but a number of workers have suffered from it and have found it very troublesome. The disease is most probably contracted during development, and not in sensitizing, the steady dabbling in the hot water, even with the necessarily very slight amount of bichromate present, being more dangerous than the dipping into a stronger but cold solution. The symptoms commence with a very violent itching between the fingers, and this itching spreads to the back of the fingers, and if the work is kept up the backs of the hands and wrists become affected. In extreme cases the system seems to become permeated with the poison, and the man in such a condition cannot continue his work. There seems to be no class or type of person more liable to attack than others, and some of the worst cases have been strong, robust men. But heavy or rich living and alcohol seem to foster the disease. As soon as any itching symptom is felt, precautions should be taken, for it is a disease that cannot be eradicated, except by discontinuing the work. The parts must not be rubbed or scratched. At night, rub well into the itching parts a little nitrate of mercury ointment, which a druggist will supply if told what it is for. . . . The only safe way to work after having contracted the disease, is by using rubber gloves.[684]

"INSTANTANEOUS PHOTOGRAPHY" BECOMES DEPARTMENTALIZED

Photo Era was founded in Boston in May 1898, and remained a prominent voice in photography for thirty-four years. This announcement appeared in December 1898:

> It has been deemed advisable by the board of editors of the *Photo Era* to establish a department to encourage and deal exclusively with instantaneous photography. This decision has been arrived at after considering the small amount of attention paid to this class of work by other photographic magazines. The time was—and it is not so very long since—when such a thing as really good, rapid instantaneous work was unknown, the pictures either being blurred by the movement of the subject during exposure, or so considerably underexposed as to be practically worthless. Even lenses which possessed sufficient aperture to give the illumination necessary for very short exposures were not capable of giving anything like accurate definition, except on a small area on the center of the plate. Now, everything has changed. With the advent of much more rapid plates have appeared anastigmatic lenses, which have developed more and more speed until they have culminated in the Zeiss Planar, Series I.a, with a speed of f/3.4, and perfect definition over the whole plate. In shutters, the changes have been not less marked, until, among the most rapid, we find the Prosch Manufacturing Company's "Athlete," Newman and Guardia's "Celeritas," and the Thornton-Pickard Company's and C. P. Goerz's focal plane instruments. With these changes in facilities should come a remarkable change in results—much more marked than is so far apparent—and it is this improvement which we wish to encourage and demonstrate.[687]

vocate upon the higher claims which have been made for photography. More than that, he has been a teacher to whom a great many owe whatever position they may hold today.[685]

Interestingly, the veteran daguerrean era photographer Albert S. Southworth pointed to the concurrent revolution in mechanical reproduction of photographs, and suggested that this was having an equally profound effect on the acceptance of photography as a fine art:

> Confining ourselves to this side of the Atlantic, American painters and sculptors, until a very recent date, were wont to sneer at and actually deride photography as an important adjunct of their professional work in the formative processes in their studios. This applied to the most distinguished members of our native art. The late George Inney [Inness] or A. H. Wyant at the head of the landscapists would show their teeth in the wildest kind of wrath should one suggest there were artistic expression, tone, perspective or power in the finest examples produced by the camera. The same was true of our leading portrait painters and sculptors, and it was not until the very highest class of magazines and art journals in the United States and Europe put aside wood and other engraving for halftones after the camera that the true art value of the latest development of the invention of Daguerre began to dawn upon and influence their professional workmanship.[686]

The 1890s remained a period of transition, both in the evolvement of new forms, tastes, and styles in pictorial photography and photographic portraiture and in the acceptance of the best of this work as a new medium in art. In

May 1898, for example, *Scribner's* magazine published an article in which the contention was made that photography's influence on art had been more evil than good. On the one hand, the reasoning went, it was causing some painters to try to rival the photograph in its "accuracy of statement" (which would cause people, in the long run, to "resent being fobbed off with mere nature when they ask for art"). On the other hand, while it was true that nature sometimes "fortuitously arranges itself into a semblance of pictorial harmonies" (which enabled a photograph to "seize and perpetuate one of these accidental arrangements"), nevertheless, the *Scribner's* article contended, "the more consciously the photographer attempts to be an artist the worse, in general, are his results, because the complicated harmonies which the painter arranges on his canvas are impossible of achievement anywhere else."[688]

The Boston artist Darius Cobb took a different view, however:

> The exhibitions of some of the camera clubs give sufficient evidence, to the unprejudiced mind, that photography is a fine art. I am aware that adjusting the lenses is not a fine art, nor is the closing of the shutter, nor any distinctly mechanical operation in the making of a picture; neither is the process of etching a fine art, nor the mere act of painting with the brush; yet we say etching is a fine art, when etching itself is but a mechanical process, and we say painting is a fine art, although it is itself of so mechanical a character that the term is applied to painting a house as well as to painting a picture. The fact is, we term etch-

In July 1897, Alfred Stieglitz launched *Camera Notes,* a new quarterly journal of the New York Camera Club designed to stimulate members to greater artistic efforts in photography. In his own words, Stieglitz said the publication had Europeans talking about it "in one country after another" within three months. By 1898, he said, individual issues "sold for high prices at auction." Nevertheless, the journal received this mixed review from the critic Sadakichi Hartmann (an admirer of Stieglitz's), after the appearance of a dozen issues:

> *Camera Notes* has helped to make the N.Y. Camera Club known in photographic circles all over the world. Dignified in appearance as it is, it cannot help but to attract attention to its publishers. It is the most ambitious club publication in existence; there is no art magazine in this country which could compete with *Camera Notes* in its distinctive and peculiar make-up. The pictures are reproduced in a manner that leaves but little room for fault-finding. The letterpress, although not free of small imperfections, is on the whole satisfactory. The material, however, within the covers is very frugal and consequently open to criticism. The articles of a strictly technical and scientific character, of course, are in place, but as far as I can see the trend of the magazine, it is to initiate its readers in the artistic possibilities of their art. In this, it fails. The aesthetic laws which rule photography have not yet been determined; what we need most, therefore, are decided opinions which endeavor to solve this problem. It would be by far more profitable than the everlasting commenting upon half a dozen men and women, and their more or less doubtful artistic qualifications.[689]

1898

388

ing an art and painting an art because by these words we understand the object of the etching and the painting. So, in speaking of photography as a fine art, we mean the mental process combined with the mechanical.[691]

Among the new processes adopted by a select group of photographers on both sides of the Atlantic at this time were those involving manipulation of finished prints. By the use of the gum bichromate process in particular, photographs could be altered to such an extent in printing that they could no longer be viewed as a merely mechanical reproduction by the photographer's apparatus. "One could proudly say these photographers have broken the tradition of the artificial reproduction of nature," one German authority, Dr. Karl Voll, said. "They have freed themselves from photography. They have sought the ideal in the works of artists. They have done away with photographic sharpness, the clear and disturbing representation of details, so that they can achieve simple broad effects."[692]

Whether or not photography qualified as a fine art, pictures hung at the various salons and camera club exhibitions were being bought, for the first time, by collectors. As we have already seen, the National Museum purchased fifty photographs at the 1896 Washington, D.C., salon, and expressed the intention of purchasing additional photographs at the projected 1897 salon. In Syracuse, a leading businessman and amateur photographer, George Timmins, began buying photographs at exhibitions, and on May 25, 1896, he opened a private display of his collection at the Hendrick Art Gallery in that city. Seventy-seven photographers from twelve countries were represented in the Timmins exhibition, all of whom were considered "artists" with the camera. Alfred Clements' 1894 prize-winning photograph, "A Struggle for Existence," was among the total of 278 photographs shown. The range of selection encompassed all of the current photography styles and movements.[693]

1899

Talk of a "new school" of photographers, and of "the new portraiture," was now prevalent in photographic circles. Exhibits sent to the National Academy of Design for its first exhibition of photographs in the fall of 1898 "were chiefly from men who are classified as belonging to the 'new school,'" E. L. Wilson observed in his review of the event. Among those he cited were: Isaac Benjamin and W. N. Brenner, of Cincinnati; J. E. Mock, of Rochester; G. E. Tinley, of Mystic, Connecticut; J. M. Appleton, of Dayton; H. H. Pierce, of Providence; C. P. Marshall, of Cazenovia, New York; E. Lee Ferguson, of Washington, D.C.; G. K. Kimball, of Concord, New Hampshire; Elias Goldensky, of Philadelphia; W. F. Schreiber, of West Bend, Wisconsin; and F. Holland Day, of Boston. "The prominent position taken by amateurs in portraiture, as well as in general work, was, we believe, a surprise to many professionals who visited the exhibition," Wilson said.

Among the new school was a small group of women, most of whom were just beginning illustrious careers. Foremost among these were Mathilde Weil, of Philadelphia, who said she was charging the highest prices paid for photographic portraits in the City of Brotherly Love; Zaida Ben Yusuf, of New York, a native Londoner who was encouraged to take up photography as a career by George Davison, and who subsequently emigrated with her family to New York, where she opened a gallery on Fifth Avenue; Eva Watson (later Eva Watson Schutze), also of New York, a close friend of Alfred Stieglitz and a specialist in the gum bichromate process; and Gertrude Kasebier, who studied painting at Brooklyn's Pratt Institute, and in Paris, before opening (in 1897) what was to become one of New York's most fashionable photographic studios.

Conspicuous for their absence from those exhibiting photographs at the National Academy of Design were "the great lights of the profession," as Wilson labeled them, although he noted the presence of photographs sent in by J. C. Strauss of St. Louis, and the C. D. Fredericks studio in New York. In his review of the works shown, Wilson made this distinction between those provided by professionals as opposed to amateurs:

Almost invariably, the professional had striven for a brilliant print with a good range of tones from black to white; the amateur, on the other hand, apparently gave more thought to the effect desired in his picture than in its range of gradation or colors. The portraits by the amateurs, for instance, were generally what the professional would describe as dirty, or muddy in tone, grays, sepias, and "off-colors" being the rule, whereas the professional portraits were, as a rule, rather too positive in color.[694]

As Wilson later expressed it, photographers all across the land (beginning about 1895) had become "awakened" to the idea that the old methods of portraiture did not satisfy new requirements. "A change of some kind was evidently necessary, he said, "as a means of relieving the stagnation

A SCULPTOR'S THOUGHTS ON THE "NEW PORTRAITURE"

After finding himself "startled" at some of the sentiments about "modern photography" expressed at the annual P.A.A. convention at Lake Chautauqua, New York, Prof. Lorado Taft expressed some of his own thoughts on "the art question" in an unscheduled address to the convention:

I have found that there is an entirely different standard erected by some of you for the photographer and the painter. I don't believe in that. You have not won me over yet; in fact, the more opposition I hear, the stronger I feel in my view, and I suppose the stronger you feel on your side—some of you. This is what I am worrying about: the fact that some of you consider detail everything in art. A certain amount of detail is good; a certain amount of detail is necessary in every art; even in sculpture I like to see some, even the veins and the arteries throbbing, as was suggested here the other day; but I don't like to see a marble bust that you can comb with a fine-tooth comb—I don't want to see every hair. ↓

So let me say, the modern painter's effort is to discover that treatment which will best give the general effect as it may be gathered at a glance, seeking to give most closely the illusion of nature. And in your work I think you will have a number of faults to correct—many of you. To begin with, avoid those black shadows, which many of you think belong to the work of the old masters. That is a great mistake; their black shadows were not black, which to me make a portrait very unpleasant.

To go on to other things with which I have been quite strongly impressed, I feel that in general exaggerated lighting of the head is a detriment; I feel that, as far as possible, a softer treatment of the head is a little better than those extremely round heads. I like strong lighting for strong, rugged faces; but ordinarily you will get nearer to the illusion of life, the effect of nature as you see it in the streets, where you meet people in public places, if you have a softer and more diffused light.

Another thing which strikes me very unpleasantly is the cutting off of a figure within a frame. The frame should do the cutting off. We all have to be cut off—in our prime, sooner or later it may be—but to vignette the figure and leave the head and shoulders floating in blackness seems a very sad fate, to me very unpleasant. I think you should always represent the figure as far as you go, throwing it a little out of the focus, a little out of intensity, concentrating on the face; but let there be some legitimate means of stopping the figure, such as stopping it with the frame—not that cutting off with a black veil, or "vignette," as you term it.

I could go on indefinitely, because our arts are closely related. Very many of these things which I see among your exhibits here appeal to me strongly, as a sculptor.

I feel the essential thing is the face; everything should be subordinated to it. I think we are at a disadvantage in photographs, because the details, for instance, of a lady's hat are so inflexible, so insistent, in the photograph. In nature the head is generally bobbing; she will toss the head around and smile. You are looking at the lady and her face, studying her, not the head. In a picture among the exhibits the technical effects shown in the lady's hat are fine from that standpoint. The shadow under the hat is fine; that was evidently the object sought in the representation. It is a beautiful piece of modeling; but, after all, it is the hat that cries out for attention. I get a little tired of the punctures around the hat, the embroidery, etc. It is the hat, not the face. How to avoid the difficulty I cannot see. But the man who took that portrait is broad and big enough to avoid the fault if he tries. The impression on me is not that of a portrait of a lady, but of a lady's hat.[695]

1899

389

Photography in platinum was not restricted to exhibitors at eastern photographic salons, and was used by an Omaha establishment, for example, to make over 1,200 dramatic likenesses of warriors from about forty North American Indian tribes. But prints from these sittings, like the one above, are now quite rare.

of business which followed the 'panicky' business years of 1890–95.'' Here and there, men attempted to solve the problem by putting more individuality into their work, with the result that gradually a few ''progressives'' founded what was to become the ''new school.''

This then divided the fraternity, Wilson said, into two camps. First, there were those who continued to favor the ''old methods'' of ''plain, straight-forward portraiture,'' making portraits which, whether they exhibited any ''pictorial value'' or not were technically and photographically good. In this school were such photographers as B. J. Falk, Frederic Gutekunst, Isaiah W. Taber, and a number of lesser-known names. All were men whose work had won them high reputations, ''and an apparent prosperity.''

1899 The so-called new school, Wilson said, was distinguished less for a rigid adherence to photographic or technical quality than for a striving for a ''pictorial,'' or

390

''painter-like,'' effect in its works. Sometimes the portraits made by members of the new school would be thoroughly good, photographically, while in other instances they could be viewed as technically very poor examples of photography. But in the case of any portrait made by the hands of an intelligent and skillful worker, Wilson contended, ''it almost always exhibits the qualities of character, individuality, feeling, etc. (in other words, picture qualities) in a measure which makes it decidedly interesting.'' [696]

Prof. Lorado Taft, the noted sculptor and instructor at the Art Institute of Chicago, observed this division in the fraternity when he addressed those attending the P.A.A. convention at Lake Chautauqua, New York, in the summer of 1899:

I was surprised when I reached here a few days ago to find that there are two decided elements, two decided camps, among photographers. That is, the artists in their line, and the imitators of the old. To some of us the old masters are the foundation of our

Foremost among a "new school" of photographers to emerge in 1898 was Isaac Benjamin of Cincinnati, whose portrait in platinum made in 1908 of President-elect William H. Taft (above) is among the most noteworthy of his surviving photographs. Prior to 1889, Benjamin and others in his family made musical instruments.

faith; they are like the Bible to the Christian. We take it for granted of the old masters, as of the old prophets, that what they said was true, and we found our belief upon that. So when I find here that some of you consider that a mere species of rot—as it was so retailed to me—that the old masters had nothing to do with the modern masters, modern photography, I was a little startled. 697

Prof. Taft contested the idea that there was a different standard for the photographer, as opposed to the painter, in portraiture, but at the same time he cautioned his listeners against using too much "exaggerated lighting" in their studio work. In this respect he seemed to be somewhat at odds with one of the longtime "great lights" of the fraternity, namely George Rockwood.

Rockwood was an early proponent of the new school, and even went so far as to dub what he called "the new ultra-artistic phase of photography" as the "Vandyke style." To Rockwood, this meant not only subordinating everything to the portrait in photography (deemphasizing or entirely eliminating accessories) but going one step further and "subordinating everything in a portrait to the head or likeness alone." Rockwood drew this analogy to the work of another of the sixteenth-century Dutch masters:

> Rembrandt, when he painted a portrait, used a skylight less than two feet square. In this beam of light he placed his sitters, and, as may well be understood, nothing could be seen but the head in this manner illuminated. There was nothing to divide the interest or distract attention from the portrait. The work of no other master has ever equalled his portraits. In this line I have for many years worked for artists and connoisseurs, until now there is a positive demand and appreciation of this new-old-style of portraiture. By this manner is developed the strong personality, character, and beauty of the human head, and in but a few cases have I failed to find it complimentary. 698

No more outstanding examples of the strong personality

1899

391

By 1899, professional as well as amateur photographers had adopted the varied forms of velox paper, and a smooth matt surface version was used by Rudolf Eickemeyer to make the portrait of the unidentified black man (above left). By 1899, too, judges for American photographic salons were being selected entirely from the photography world, where previously awards had been determined principally by artists. The photograph at right is of the judges for the 1899 salon of the Philadelphia Photographic Society, and includes Henry Proth, center; Frances B. Johnston, seated left; Gertrude Kasebier, seated right; F. Holland Day, standing left rear; and Clarence H. White, standing right rear.

and character of the American Indian are to be found than the series of .photographic portraits in platinum made at this time in Omaha, Nebraska, of the warriors of about forty North American tribes (see illustration on page 390). This undertaking was begun by the Omaha photographer F. A. Reinhart, at the United States Indian Congress of the Trans-Mississippi and International Exposition, which was held in that city in 1898 under the auspices of Capt. W. A. Mercer, of the United States Army. Credit for all, or many of the more than 1,200 platinotype portraits made of the braves, should probably go to Reinhart's assistant, A. F. Muhr, who identifies himself as the photographer in a catalog of the portraits made available commercially in 1899.[699]

Just as there was increased preference for platinum paper and carbon tissues among the new school, so the photographers welcomed a new competitor on the scene, which renewed interest in gelatine chloride papers. This was the new velox paper introduced as early as 1893 by the Nepera Chemical Company of Yonkers, New York. It was basically a gelatine chloride paper, but was sensitive enough to be printed by gaslight (or more quickly, if necessary, in weak daylight). By the late 1890s, the paper (offered in a

number of varieties) had become popular with professional as well as amateur photographers, and was adopted at such fashionable studios as those of Falk and Eickemeyer. After the 1898 P.A.A. convention, at which the largest exhibit was that held by the Nepera company, *Photo Era* expressed its complete enthusiasm for the velox paper:

> The nature of this exhibit showed conclusively to anyone who might still think otherwise, that prints made on velox are fully the equal of, if not superior to, platinum prints, that special rough velox, in particular, seems to be eminently adapted for large works, while for smaller work, where detail is of more importance, portrait velox seems to be preferred. Some of the smaller prints exhibited by the company were made on portrait velox from negatives by Mr. Furman, of San Diego, Cal., and were strikingly similar to prints made on carbon tissue transferred to celluloid, and if it had not been for the label on these prints, anyone would have mistaken them for the latter.[700]

But there remained one major holdout—David Bachrach. "The fact stares us in the face," he said, "that less silver is produced in the operation of printing with emulsion papers, and, in consequence, less gold is formed in the final image. As to the relative stability and liability to chemical change

This portrait in carbon of an unknown young lady, by James Lawrence Breese, is typical of the more vivid and interesting "picture qualities" which Edward L. Wilson attributed to photography's "new school." Little known today like so many of his contemporaries, Breese operated the Carbon Studio in New York in partnership, for a time, with Rudolf Eickemeyer, Jr. In 1894, Breese authored an article for *Cosmopolitan* on the relationship of photography to art, and was evidently successful enough in his business to maintain a mansion in East Hampton, New York.

of the mediums employed in holding the salts of silver, coagulated albumen or hardened gelatine, the weight of evidence is certainly not on the side of gelatine.''

To this line of reasoning, Dr. Leo H. Baekeland, the president of the Nepera Chemical Company, responded:

> I will be glad to show by direct tests to Mr. Bachrach, and to anybody, that I can make prints on Nepera paper which has a hardened gelatine film rich in silver, toned in separate baths, and fixed in plain hypo, which will stand the test and outlast any albumen prints made by the leading photographers of the United States.[701]

Bachrach's adversary, in this instance, was probably one of the most formidable of his career. As a young Belgian chemistry professor, Baekeland attended a meeting of the New York Camera Club in 1889, where he was introduced to Richard Anthony. This led to his being asked to join the Anthony firm. But he had worked in Belgium on the chemical formula for a type of photographic paper sensitive enough to be printed by artificial light, and in 1893 he formed the Nepera firm in partnership with Leonard Jacobi to manufacture the paper. George Eastman was among those who thought well of the velox papers—so well, in fact, that he decided that Eastman Kodak should acquire Nepera. In 1899, Eastman contacted Dr. Baekeland. "If you are interested in selling, come up to Rochester," he wrote. "We can talk it over and, I am sure, come to terms." Baekeland made the trip and was reportedly paid $1 million for the Nepera operation. After that, Dr. Baekeland went on to yet another famous invention: oxybenzyl-methylenglycolanhydride, or, as it is now commonly known, Bakelite.[702]

Eastman's acquisition of the Nepera Chemical Company was but one step in a much grander design. Earlier, the principal French and German paper manufacturers had formed a coalition and had doubled the price of their respective Rives and Saxe papers. This had naturally caused considerable reverberations in the photographic world, and on August 10, 1899, Eastman took the bold step of forming a large American combine with the twofold purpose of controlling *all* of the major American photographic paper business, and, at the same time, controlling—for North America—*all* of the sales of paper products by the aforementioned French and German manufacturers. The new combine was given the name General Aristo Company, and involved the purchase of, or a controlling interest in, the following companies: Eastman Kodak Company, of Rochester (photographic printing paper business, only); the American Aristotype Company, of Jamestown, New York; the Nepera Chemical Company; the New Jersey Aristotype Company, of Bloomfield, New Jersey; the Photo Materials Company, of Rochester, New York; and Kirkland's Lithium Paper Company, of Denver, Colorado.

E. L. Wilson hastened to assure his readers that the new combine was in no way a detriment to the American photographic community:

<div style="border:1px solid">

VELOX PAPERS

The introduction of a variety of velox papers by the Nepera Chemical Company brought a renewed interest in gelatine chloride emulsion papers, and after the turn of the century, papers made on the velox principle became the standard in contact printing. Wilson's journal gave this description of the papers in 1900:

> Taking the different kinds of velox, we see how completely the paper can be adapted to any kind of negative or subject. All velox papers may be divided into two classes, known as "Special Velox" and "Regular Velox." These terms have reference to the time of exposure and development. Regular velox is designed for soft negatives and for those which need their contrast increased. It requires a much longer exposure than Special velox, but the image develops in half the time or less. Special velox is adapted to soften hard or contrasty negatives, and to give the most delicate gradations of tone of which the negative is capable.

VARIETIES OF VELOX

Regular

CARBON VELOX—Smooth matt surface
ROUGH VELOX—Rougher surface
GLOSSY VELOX—Prints can be produced with high polish

Special

SPECIAL CARBON—Surface similar to regular carbon
SPECIAL PORTRAIT—½ matt surface
SPECIAL ROUGH—Very artistic paper; gives broad effects; less detail
SPECIAL GLOSSY—Similar to regular glossy; quicker printing; longer developing
SPECIAL ROUGH (double weight)—Requires no mounting
VELOX POSTAL CARDS—Smooth matt surface like carbon[703]

</div>

It is not a combination of the interests of several individual concerns handled by promoters who do not understand the business and have no interest at stake except the profit of stock manipulation, but a company which has as much at stake in the proper care of its consumers and in the reputation of its goods as anyone of the individual concerns had previous to the consolidation. . . . We learn that there will be no increase in price, and that the company will not permit any competition to undersell them, quality considered.[704]

But the San Francisco *Call* dubbed the move "imperialism," and foresaw "the greatest rate war in photographic supplies that has ever been inaugurated in this country." Not so, said George Eastman. "The *Call* reporter," he said, "may not be able to grasp the idea, but for the future growth of our business and profit we do not look for a 'forcing up of prices,' but rather for such a reduction as shall enable us to make Kodakers of every school boy and girl, and every wage-earning man and woman the world over."[705]

1899

394

1900

Photography, like the horse and buggy, was poised for a coming age of mechanization, as the world passed into its twentieth century. At the outset, the former was clearly in the lead; there were, by this time, 100,000 Kodak cameras alone in the hands of amateurs, whereas only some 8,000 horseless carriages were registered as of 1900. Eastman Kodak was also ready with a new "Brownie" dollar box camera, which would shortly vitalize the camera market much as the Ford Model T would stimulate auto sales several decades later. The name "Brownie" was chosen principally because of the popularity of a children's book of cartoons of the same name, and partly, no doubt, because the camera was manufactured initially for Eastman by Frank Brownell, also of Rochester, New York. Just down the road, too, was the first of Eastman's famous line of folding, bellows-style pocket cameras, which would produce pictures of 3¼ × 5½ inches (postcard size, as they were popularly called at the time) from the camera's roll film.

Until 1900, the manufacture of emulsion-coated dry plates, as well as the supply of various types of photographic paper, was handled by small factories, principally firms in which the business was carried on under the direct personal supervision of the founder. But the new era of the business trust, and the dawn of chain-store retail merchandising, changed all this. The formation by Eastman of the General Aristo paper trust in 1899 led to the establishment, two years later, of the Eastman Kodak Company of New Jersey, the country's first holding company in the photography field. The New Jersey company absorbed the business of General Aristo, as well as British, German, and French Kodak operations, and beginning in 1900 George Eastman made other acquisitions which, by 1902, made his company the predominant supplier not only of paper but also of cameras and dry plates. At the same time, the company acquired the principal photography retail outlets in Boston, Chicago, and other midwestern cities.

The motion picture "industry," meanwhile, was dragging its feet, not only because pioneers like Edison and David W. Griffith failed to appreciate the medium's potential but also because the entire business was in a rut, with most of the early equipment developers battling one another in the courts over patent infringements, and all of them making unimaginative, action-oriented films of 5 to 10 minutes' length in secrecy at "factories" in New York, Philadelphia, and Chicago.

But changes were in the wind in this field as well. In 1903, the "story" film was inaugurated by an Edison cameraman, Edwin S. Porter. Porter was influenced by earlier British films in which a judicious cutting and splicing of film taken of different subjects or actions in a particular news event made the event seem more like a story, since the audience was given several points of view concurrently. Porter's "Life of an American Fireman," produced by Thomas A. Edison, Inc., in June 1903, became the first American motion picture drama to be photographed free from the perspective of a single stage, and to evoke a sus-

A "Brownie" with his new dollar box camera.

tained audience interest and suspense through similar film editing. By 1907, the motion picture "factories" likewise came under the control of a business trust, and films produced thereafter by the survivors of the various patent litigations were "packaged" and distributed by a single corporation to movie theaters across the land (see page 398).[706]

The adoption by newspapers of halftone illustrations made directly from photographs sparked the creation of the type of photographic news services envisioned earlier by Stephen Horgan (see page 301). These services managed to grow competitively, however, escaping management by a single trust.

The "father" of this type of business was a former St. Louis newspaperman, George G. Bain. Bain became Washington manager for the United Press in the 1890s, and adopted the practice of carrying a hand camera with him on special stories and interviews. He became a friend of Ohio Congressman William McKinley, and when the latter was elected to the presidency in 1897, Bain was allowed to make the first informal shots of a President and members of his cabinet on White House grounds.

At this time, newspapers did not pay for photographs provided by reporters or free-lance writers, and Bain decided that this tradition should be ended. About 1898, he formed the Bain News Service in the newspaper district of New York, an organization which remained in business until Bain's death in 1944. By 1905, he had accumulated a

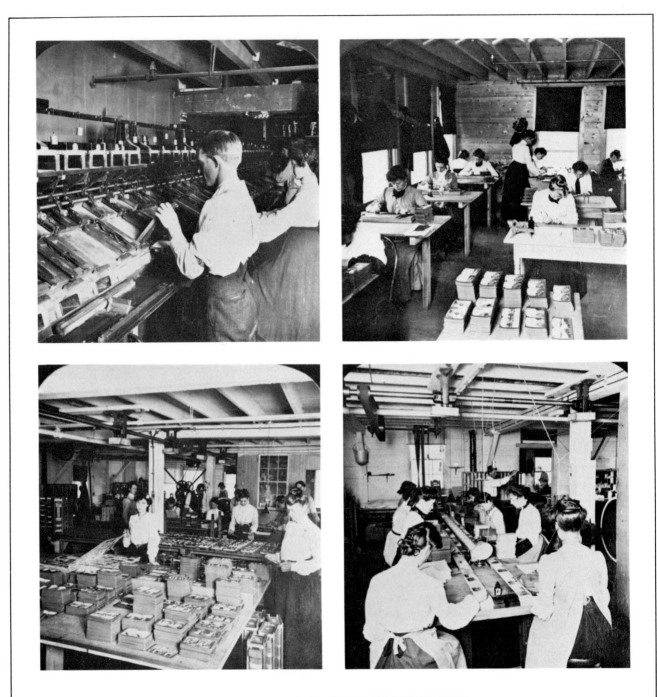

MASS RETAILING OF CARD STEREOGRAPHS

The popularity of card stereographs reached a new high by the turn of the century, sparked principally by new merchandising techniques, widespread interest in views of the Spanish-American and Boer wars, and the introduction of boxed series of cards covering geographical points of interest in foreign lands, and the workings of business and industry at home. Vast numbers of cards were also produced and endorsed by college and university heads as visual aids in educational instruction. The principal publishers at the turn of the century, all with sales outlets at major world capitals, were: Underwood & Underwood, Keystone View Company, Griffith & Griffith, and, from 1901 to 1914, the H. C. White Company, where the photographs above were made of the company's manufacturing operations. These views illustrate (top left) an automatic printing machine, (top right) mechanism for mounting the paired photographs on cards, (bottom left) sorting and trimming of inventory, and (bottom right) retouching department.

million photographs, all of them catalogued and cross-indexed, and most of them purchased or acquired from correspondents around the world. Among these prints, Bain had many "firsts," including the first photographs taken in a federal courtroom; Octave Chanute's experiments with aircraft before the advent of the Wright brothers; the first photographs of the U.S. Senate and House of Representatives in session; and the first automobile races at Newport, Rhode Island.

But all of Bain's photographs were lost when the Parker Building, in which his news service was housed, was destroyed by fire in 1905. Today, only the published illustrations from some of these photographs, which lie unrecorded in the pages of yellowed and crumbling newspapers in public libraries, are all that remain of Bain's pre-1905 inventory.[707]

Even fine-art photography was headed for the big time with an international photographic salon scheduled for 1900 at New York's Madison Square Garden. But after much talk of preparations in 1899, the event appears not to have taken place. As for the critic Sadakichi Hartmann, he felt it was "a great pity" that fine-art photography exhibitions were held on such an exclusive basis, whereas if they were made more accessible to the public they could do much to instruct people about the aims and accomplishments of photography as an art form. "Ninety-nine persons out of one hundred are not yet even familiar with the term 'artistic photography,'" he contended, "much less with its aspirations and aims." Hartmann argued that the artistic enterprises of the New York Camera Club, for example, "were managed on a too exclusive scale; their publications [i.e., *Camera Notes*] as well as their exhibitions only reach the profession, not the public at large."[708]

And what of the professionals, whose predecessors had started it all in the first place? Along with the "new school" in portraiture had come an even greater elegance among the most fashionable studios. "There is a glamour over Fifth Avenue, New York, such as is over no other photographic center in America," Wilson observed in November 1900. He cited several newcomers, among them Hollinger, D. H. Anderson, and Jeanette Appleton. Other "showcases" were the studios of Gertrude Kasebier, Zaida Ben Yusuf, Rudolph Eickemeyer, and the successors to Napoleon Sarony.

The one studio which Wilson found "difficult to describe without seeming to give way to unreasonable superlatives" was that of B. J. Falk, who had abandoned his Falk Building near Madison Square for the former quarters of a winter garden atop the Waldorf-Astoria Hotel on Fifth Avenue between Thirty-third and Thirty-fourth streets (site of the present Empire State Building). Opened in 1897, the hotel was comprised of two buildings of similar architecture, but built separately (and then joined together) by feuding members of the Astor family. Falk's studio occupied most of the top (fifteenth) floor, and when one considers that the industrialist John W. Gates paid a reported $20,000 annually for just a suite of rooms on a lower floor, one can only imagine the size of Falk's rental. But here, Falk could mingle with the new business elite, among them such regular patrons of the Men's Cafe as J. P. Morgan, Henry Clay Frick, and Charles Schwab.[711]

The increasing simplicity of hand cameras made it possible by the turn of the century to place new emphasis in promotional efforts on young people. At top, is the cover of an 1899 book described in the introduction as "a boy's adventures in the company of his camera." Above, a little girl poses with a No. 4 folding Kodak camera which was popular in the 1890s. The camera was the first of the bellows-style folding variety to feature roll film.

George Eastman (left) and Thomas Edison (right) had become old friends by the time this 1930 photograph was taken with Charles A. Lindbergh.

THE MAKING OF THE "KODAK KING"

After the U.S. Supreme Court virtually repealed the Sherman Anti-Trust Law by sanctioning the formation of a monopoly (in the sugar industry) through the device of a holding company (in 1895), the way was paved for organization of the General Aristo Company in 1899 by George Eastman. But while this was a trust in the same sense that the sugar combine was, it differed in that control remained in the hands of one man—George Eastman—rather than in Wall Street. When New Jersey amended its incorporation statute to permit one corporation to own the stock of another, Eastman took the same step other "tycoons" were taking in other industries: he "wound up" General Aristo and the Eastman Kodak Company of Rochester, New York, and established a new holding company, the Eastman Kodak Company of New Jersey. This company was established on October 24, 1901, and became the direct owner of the previous General Aristo business operations in the United States, plus the owner of all of the capital stock of Kodak, Ltd. (Great Britain), and German and French Kodak operations headquartered in Paris and Berlin.

Already in the process of establishing a trust in the supply of photographic paper, Eastman made his next move in cameras. In 1900, he purchased the Blair Camera Company, of Boston, and the American Camera Company, of Northboro, Massachusetts. The same year he introduced a new dollar box camera, the "Brownie," supported by a vast advertising campaign. E. & H. T. Anthony & Co. offered, at this time, to sell out to Eastman, too, but the offer was rejected (after which the Anthony firm merged with the Scovill & Adams Company in 1901, forming Anthony and Scovill—a name ultimately shortened to Ansco). But despite the competition from Anthony and Scovill,

and a dozen other smaller firms, Eastman Kodak became the dominant manufacturer of cameras at the start of the twentieth century.

In 1902, Eastman acquired the principal competition in dry-plate manufacture. This included the M. A. Seed Dry Plate Company, of St. Louis (which had a corner on nearly half the market for American-made dry plates) and the Standard Dry Plate Company, of Lewiston, Maine. At the same time, he purchased the card-mount business of Taprell, Loomis & Company, of Chicago, and acquired control of the principal photographic retail outlets in Boston, Chicago, Minneapolis, St. Paul, Milwaukee, and Sioux City. The Boston acquisition was of the old-line firm, Benjamin French & Company.

As the motion picture industry began to mature after the turn of the century, and the prolonged litigation came to a head over the rights to basic patents in film projection equipment, yet another trust appeared on the scene. This was the Motion Pictures Patent Corporation, which operated through the General Film Corporation in distributing packaged reel films to movie theaters. While it was a boon (until 1912) to all participating companies, this trust was a particular bonanza for Thomas Edison, whose film company derived profits of up to $1 million annually in royalties and allotments in film productions. At the same time, through a special agreement with the trust, Eastman Kodak secured a monopoly on the supply of celluloid film. Eastman, in 1908, endeavored to establish an international cartel for photographic supplies, but in this he was countered by French and German concerns, which provided vigorous competition until Eastman's acquisition of the Pathé film plant in 1927.[709]

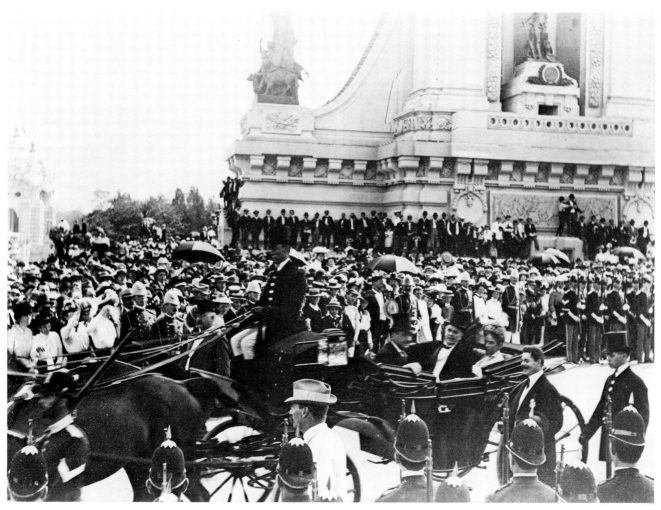

Frances B. Johnston worked occasionally on assignment for George G. Bain's pioneering photographic news agency (opened about 1898), and her photographs of President William McKinley made at the Pan-American Exposition in Buffalo, on September 4, 1901, provided an unexpected boon to the news service when McKinley was assassinated there two days later. In Miss Johnston's photograph (above) the President and Mrs. McKinley are shown touring the fair grounds with the fair's head, J. G. Milburn.

DETAIL OF STAIRWAY. STATUE BY MORETTI. AN ALCOVE.

RECEPTION-ROOM.

"GLAMOUR OVER FIFTH AVENUE"

The most palatial of the photographic galleries on New York's Fifth Avenue was B. J. Falk's establishment (above), which occupied most of the top (fifteenth) floor of the Waldorf-Astoria Hotel between Thirty-third and Thirty-fourth streets (site of the present Empire State Building). A portion of the gallery included what had originally been intended as a winter garden. "Irresistibly," E. L. Wilson observed after examining the gallery's oak-paneled walls and Pompeiian tapestries and waiting rooms, "the mind recalls pictures of the Palace of Versailles as it was in the time of Louis XIV." [710]

Pirie MacDonald, one of the first to become a photographer of men only, and proprietor of another of New York's most fashionable studios, looked forward to new vistas, now that the chemistry of the art no longer demanded the largest part of a photographer's attention:

The new order of things has given an opportunity to men who are constituted differently. Now that the bonds are loosened and the mechanical part of the work is a secondary consideration, some rather curious changes have taken place. Men with sympathies in certain lines are able to gratify their notions. Men with certain artistical proclivities can spend their energies toward the fulfillment of their dreams without the distraction of mechanical problems. How much time and labor would be lost and how many of the better moments would be wasted and opportunities thrown away if a painter had to discover and grind his own colors. How the chemical problems chilled the artistic enthusiasm of photographers, only those who have had to go through the mill know.[712]

But for a member of the old school, James F. Ryder, who made his first photographs in 1848, the passing of the nineteenth century was a moment of nostalgia. The dry-plate process and the amateur's ability to make instantaneous photographs at random was to him something of a "left-handed blessing":

It has made the whole world photographers and people are not content now with snapshots which they and their friends make, and all there is for the photographer to do is finish the plates for the amateur. If the amateur snap-shotter gets a picture that is funny or cute, he is satisfied, and photographic art is left out of the question. How different it all is from the old times, when people went to the photographer and had a daguerreotype taken and finished so that they could take it away with them. If they wanted more than one they sat for each picture they wanted and paid $5 or $10 for each one. With a boy to help me, I used to make as much money as the big galleries with a dozen employees do now.[713]

BIBLIOGRAPHY AND KEY TO ABBREVIATIONS
USED IN THE NOTES TO THE TEXT

Books

ACKERMAN—*George Eastman,* by Carl W. Ackerman, Boston & New York, Houghton Mifflin, 1930.

ANDREWS—*Picture Gallery Pioneers,* by Ralph G. Andrews, N.Y., Bonanza Books, 1964.

APPLETON'S—*Appleton's Cyclopedia of American Biography,* N.Y., D. Appleton & Co., 1888.

BEAR—*Life & Travels of John W. Bear, The Buckeye Blacksmith, Written by Himself,* Baltimore, D. Binswanger & Co., 1873.

BROTHERS—*Photography: Its History, Processes, Apparatus & Materials,* by A. Brothers, F.R.A.S., London and Philadelphia, 1899.

BURGESS—*The Photograph Manual,* by N. G. Burgess, N.Y., 1862 (Revised 1865 edition).

COALE—*Manual of Photography,* by George B. Coale, Philadelphia, J. B. Lippincott & Co., 1858.

DAB—*Dictionary of American Biography* (15 vols.), N.Y., Charles Scribner's Sons, 1935.

DAGUERRE—*L. J. M. Daguerre, The History of the Diorama and the Daguerreotype,* by Helmut and Alison Gernsheim, N.Y., Dover Publications, 1968.

DARRAH—*Stereo Views, A History of Stereographs in America and Their Collection,* by William Culp Darrah, Gettysburg, 1964.

EDER—*The History of Photography,* by Josef Maria Eder, translated from the German by Edward Epstean, N.Y., Columbia University Press, 1945.

GERNSHEIM—*The History of Photography,* from the camera obscura to the beginning of the modern era, by Helmut Gernsheim in collaboration with Alison Gernsheim, London, Thames & Hudson, 1969.

G.I.U.S.—*Great Industries of the United States,* by various authors, J. B. Barr & Hyde, Hartford & Chicago, 1873.

HARRISON—*A History of Photography,* by W. Jerome Harrison, London and N.Y., 1887 (available in reprint from the Arno Press, N.Y.).

HEATH—*Photography,* by A. S. Heath and A. H. Heath, N.Y., 1855.

HORAN—*Mathew Brady, Historian with a Camera,* by James D. Horan, N.Y., Bonanza Books, 1955.

HULFISH—*Motion Picture Work,* by David Hulfish, Chicago, 1913. Made available courtesy of the University Club of New York Library.

HUNT I—*Researches on Light,* by Robert Hunt, London, 1844.

HUNT II—*Photography,* by Robert Hunt, London and New York, 1852.

IVES—*The Autobiography of an Amateur Inventor,* by Frederic E. Ives, Philadelphia, 1928 (privately printed).

JAMMES—*William H. Fox Talbot, Inventor of the Negative-Positive Process,* by André Jammes, N.Y., Macmillan, 1973.

JENKINS—*The Boyhood of an Inventor,* by C. Francis Jenkins, Washington, D.C., 1931.

LOTHROP—*A Century of Cameras,* by Eaton S. Lothrop, Jr., Dobbs Ferry, N.Y., Morgan & Morgan, 1973.

LUBSCHEZ—*The Story of the Motion Picture,* by Ben J. Lubschez, N.Y., 1920.

MORRIS—*Incredible New York,* by Lloyd Morris, N.Y., Random House, 1951.

MUYBRIDGE—*Eadweard Muybridge, The Stanford Years, 1872–1882,* a catalog prepared by the Stanford University Museum of Art to accompany an exhibition held at Stanford University, the E. B. Crocker Art Gallery in Sacramento, and the University Galleries at the University of Southern California from October 1972 to March 1973.

NAEF—*Era of Exploration, The Rise of Landscape Photography in the American West, 1860–1885,* by Weston Naef in collaboration with James N. Wood, Metropolitan Museum of Art and the Albright-Knox Art Gallery, 1975.

NEWHALL—*The Daguerreotype in America,* by Beaumont Newhall, N.Y., Graphic Society, 1961.

NORMAN—*Alfred Stieglitz, an American Seer,* by Dorothy Norman, N.Y., Random House, 1960 (1973 revised edition).

PAGEANT—*The Pageant of America, A Pictorial History of the United States,* Ralph Henry Gabriel, editor, New Haven, Yale University Press, 1925 (15 vols.).

PRIME—*Life of Samuel F. B. Morse,* by S. I. Prime, N.Y., D. Appleton & Co., 1875.

RINHART I—*American Daguerreian Art,* by Floyd and Marion Rinhart, N.Y., Clarkson N. Potter, Inc., 1967.

RINHART II—*American Miniature Case Art,* by Floyd and Marion Rinhart, N.Y., A. S. Barnes & Co., 1969.

ROLLE—*California, a History,* by Andrew F. Rolle, N.Y., Thomas Y. Crowell Co., Inc., 1969.

ROOT—*The Camera and the Pencil,* by M. A. Root, Philadelphia, 1864. Reprinted by Helios Press, Putney, Vt., 1971.

RYDER—*Voigtlander and I,* by James F. Ryder, Cleveland, 1902 (available in reprint from Arno Press, N.Y.).

RUSSELL—*One Hundred Years in Yosemite,* by Carl Parcher Russell, University of California Press, 1947.

SANDBURG—*Abraham Lincoln, the Prairie Years and the War Years,* by Carl Sandburg, Reader's Digest Illustrated Edition, 1954.

SIPLEY—*A Half Century of Color,* by Louis Walton Sipley, N.Y., Macmillan, 1951.

SNELLING—*The History and Practice of the Art of Photography,* by Henry H. Snelling, N.Y., G. P. Putnam, 1849 (available in reprint from Morgan & Morgan, Dobbs Ferry, N.Y.).

STEPHENS I—*Incidents of Travel in Yucatan,* by John Lloyd Stephens, N.Y., 1843.

STEPHENS II—*Incidents of Travel in Central America, Chiapas & Yucatan,* by John Lloyd Stephens, N.Y., 1845.

STIEGLITZ—*America & Alfred Stieglitz, a Collective Portrait,* Waldo Frank, Lewis Mumford, Dorothy Norman, Paul Rosenfeld and Harold Rugg, editors, N.Y., The Literary Guild, 1934.

TAFT—*Photography and the American Scene,* by Robert Taft, N.Y., Macmillan, 1938 (available in reprint from Dover Publications, N.Y.).

TAYLOR—*Optics of Photography and Photographic Lenses,* by J. Trail Taylor, London, 1892.

THOMAS—*The Origins of the Motion Picture,* by D. B. Thomas, A Science Museum Booklet, London, 1964.

TISSANDIER—*History and Handbook of Photography,* by Gaston Tissandier, translated from the French and edited by John Thomson, London, 1876.

TOWLER—*The Silver Sunbeam,* by John Towler, N.Y., J. H. Ladd, 1864 (available in reprint from Morgan & Morgan, Dobbs Ferry, N.Y.).

WALDACK—*Treatise of Photography on Collodion,* by Charles Waldack and P. Neff, Cincinnati, 1857.

WERGE—*The Evolution of Photography,* by John Werge, London, 1890 (available in reprint from the Arno Press, N.Y.).

Articles

BACHRACH—"Over Fifty Years of Photography," by David Bachrach, Jr., *Photographic Journal of America,* Vol. 52, Dec. 1915, pp. 578–579; Vol. 53, Jan. 1916, pp. 18–20; Vol. 53, Feb. 1916, pp. 71–73; Vol. 53, Mar. 1916, pp. 117–119.

COBB—"Mathew Brady's Photographic Gallery in Washington," by Josephine Cobb, Archivist-in-Charge, Still Pictures Branch, The National Archives, a paper delivered at a meeting of the Columbia Historical Society, Feb. 18, 1953.

COULSON—"Philadelphia and the Development of the Motion Picture," *Journal of the Franklin Institute,* Vol. 262, July 1956, pp. 1–16.

MCCOSKER—"Philadelphia and the Genesis of the Motion Picture," *The Pennsylvania Magazine of History and Biography,* October 1941.

Periodicals

AAP—*American Amateur Photographer,* New York, 1889–1907.

AAOP—*American Annual of Photography,* N.Y., 1887–1953.

AH—*American Heritage,* New York, 1954–present.

AJP—*American Journal of Photography,* New York, 1858–1867 (n.s.); Philadelphia, 1879–1900 (n.s.).

AJS—*American Journal of Science,* New Haven, Conn., 1820–1879.

APB—*Anthony's Photographic Bulletin,* New York, 1870–1902.

ARASM—*American Repertory of Arts, Sciences & Manufacture*, New York, 1840–42.

BJP—*British Journal of Photography*, begun as *Liverpool Photographic Journal* (1854–56), then issued as *Liverpool & Manchester Photographic Journal* (1857–58), *The Photographic Journal*, Liverpool (1859), and BJP, London, 1864–present.

CN—*Camera Notes*, New York, 1897–1903.

CW—*Camera Work*, New York, 1903–1917.

DJ—*Daguerreian Journal*, New York, Nov. 1850–Dec. 15, 1851.

GA—*Graphic Antiquarian*, Indianapolis and Wilmington, N.C., 1971–present.

HJ—*Humphrey's Journal*, New York, April 1852–April 1862; June 15, 1862–April 15, 1863; May 1, 1863–April 15, 1868.

IAAPB—*International Annual of Anthony's Photographic Bulletin*, N.Y., 1888–1902.

JFI—*Journal of the Franklin Institute*, Philadelphia, 1823–present.

PA—*Photo-American*, Stamford, Conn., 1889–1907.

PAJ—*Photographic Art Journal*, New York, 1851–1853.

PAPS—*Proceedings of the American Philosophical Society*, Philadelphia, 1838–present.

PAS—*Pennsylvania Arts & Sciences*, Philadelphia, Pennsylvania Arts and Sciences Society, Philadelphia, 1935–1941.

PFAJ—*Photographic and Fine Arts Journal*, New York, 1854–1860.

PE—*Photo Era*, Boston, May 1898–March 1932.

PJ—*The Photographic Journal*, begun as *The Journal of the Photographic Society of London* (March 3, 1853–Dec. 1858); issued as PJ, London, 1859–present.

PJA—*Photographic Journal of America*, New York, 1915–1923 (New title for *Wilson's Photographic Magazine*).

PM—*Photo Miniature*, New York, 1899–1932.

PP—*Philadelphia Photographer*, Philadelphia, Pa., 1864–1888.

PRL—*Photographic Rays of Light*, Baltimore, Md., 1878–1881.

PT—*Photographic Times*, New York, 1871–1915.

PW—*Photographic World*, Philadelphia, 1871–72.

SLCPP—*St. Louis and Canadian Practical Photographer*, begun as *The St. Louis Practical Photographer*, St. Louis (1878–1882); issued as *The St. Louis Photographer*, St. Louis (1886–87); and as SLCPP, St. Louis, 1888–1905.

WPM—*Wilson's Photographic Magazine*, New York, 1889–1914. (New title for *Philadelphia Photographer*).

Bibliography
and Key

404

NOTES TO THE TEXT

1. *Journal of the Royal Institution,* Vol. 1, 1802, p. 160.
2. References: DAGUERRE, pp. 51–53: GERNSHEIM, 55–64.
3. References: DAGUERRE, pp. 69–84, 198–204; GERNSHEIM, pp. 65–74.
4. References: GERNSHEIM, pp. 75–85; JAMMES, pp. 6–9; PJ, Jan. 1941, "Sidelight on Fox Talbot," by J. Dudley Johnston, Hon. F.R.P.S., pp. 24–26; *Latent Image,* by Beaumont Newhall, N.Y., 1967, Anchor Books, pp. 55–56.
5. *Latent Image,* pp. 57–60.
6. DAGUERRE. pp. 87–88. APB, Vol. 26, Feb. 1, 1895, pp. 60–61.
7. APB, Vol. 26, Feb. 1, 1895, pp. 60–61.
8. References: *American Science and Invention,* by Mitchell Wilson, N.Y., Simon & Schuster, 1954, pp. 24–31 (Benjamin Thompson); PAGEANT, Vol. 10, pp. 301, 316; *Dictionary of American History,* Vol. 5, N.Y., Charles Scribner's Sons, 1940, p. 44; *Encyclopedia of American History,* Robert Morris, editor, N.Y., Harper & Bros., 1953, pp. 530–531; *The Harvard Graduates Magazine,* Vol. 3, Dec. 1894, pp. 195–197 (re: Josiah Parsons Cooke, Jr.).
9. *Dictionary of Scientific Biography,* N.Y., Charles Scribner's Sons, 1970, Vol. 6, pp. 114–115.
10. AJP, Vol. 1, n.s., June 1, 1858, pp. 2–6.
11. SNELLING, pp. 11–12.
12. *New York Observer,* May 18, 1839.
13. *The Corsair,* Vol. 1, Apr. 13, 1839, pp. 70–72; JFI, Vol. 23, Apr. 1839, pp. 263–265.
14. *McClure's,* Vol. 8, Nov. 1896, p. 10.
15. *New York Observer,* May 18, 1839.
16. *The Corsair,* Vol. 1, Apr. 13, 1839, pp. 70–72. Thomas Cole quotation is from *American Album,* N.Y., American Heritage, 1970 abridged edition, p. 16.
17. PRIME, p. 407.
18. *New York Times,* Feb. 19, 1883.
19. HJ, Vol. 6, July 15, 1855, p. 97.
20. PRIME, pp. 402–404. In 1868 the perennial inventor Joseph Dixon claimed that he had daguerreotyped his wife with powdered face in a 15-minute exposure in bright sunshine in September 1839 (PP, Vol. 5, Feb. 1868, pp. 53–54).
21. APB, Vol. 14, 1882, p. 76.
22. *Eureka,* Vol. 1, Sept. 1846, pp. 7–8.
23. References for Draper statements: AJP, Vol. 1, n.s., June 1, 1858, pp. 2–6; ARASM, Vol. 1, July 1840, pp. 401–404. The former is a letter addressed by Draper on May 3, 1858, to a committee of the Mechanics' Club in New York, which had been charged with trying to ascertain who made the first photographic (daguerreotype) portrait, an undertaking which appears never to have been resolved. In this letter, Draper concludes: "How any doubt can be now entertained as to who took the first portrait [meaning himself], passes my comprehension." But Draper either ignored or was unaware of the tiny daguerreotype likeness made of John Johnson in October 1839, or of Robert Cornelius' self-portrait, or of Dr. Paul Goddard's likeness of Aaron D. Chaloner, both made prior to or during December 1839. The plaque affixed to the outside of the New York University building at Washington Square East and Waverly Place, which cites Draper as having made "the first photographic portrait of a human face" at this location, must be considered in error.
24. APB, Vol. 5, Sept. 1874, p. 399.
25. AJP, Vol. 2, n.s., 1859, p. 355; ROOT, p. 351.
26. AJP, Vol. 13, third series, July 1892, p. 310.
27. The series of photographs on this page were made of Goddard's equipment at the Franklin Institute in Philadelphia. Reference for text comes from AJP, Vol. 13, third series, Dec. 1892, pp. 546–548, "Early Daguerreotype Days," by Julius F. Sachse, AJP editor.
28. PAPS, Vol. 1, 1840, p. 155.
29. AJP, Vol. 13, third series, Aug. 1892, pp. 355–356. The Chaloner portrait was exhibited later at the American Philosophical Society in 1843, at the Franklin Institute in 1893, and at the Smithsonian Institution in 1939 ("Early Photography and the University of Pennsylvania," by Mrs. Joseph Carson, *The General Magazine and Historical Chronicle,* University of Pennsylvania, January 1941, p. 6).
30. PAPS, Vol. 3, 1843, p. 180; AJP, Vol. 14, third series, Aug. 1893, pp. 375–376.
31. References for Wolcott, Johnson, and Fitz activities: *Eureka,* Vol. 1, Oct. 1846, p. 24; minutes of forty-second meeting of the American Photographical Society, recorded in AJP, Vol. 5, n.s., Nov. 15, 1862, p. 238; *United States National Museum Bulletin 228,* p. 168.
32. PT, Vol. 15, Sept. 11, 1885, p. 521.
33. ROOT, p. 354.
34. References on Hale, Gouraud, and Bemis activities: *McClure's,* Vol. 8, Nov. 1896, p. 10; *Image,* Vol. 9, Mar. 1960, p. 18; *Image,* Vol. 5, June 1956, p. 140.
35. Reminiscence in an address to the National Photographic Association, June 1970, recorded over a year later in PP, Vol. 8, Oct. 1871, pp. 315–323.
36. Table is from ARASM, Vol. 1, Mar. 1840, p. 132; commentary also based on "Instruments for Measuring Exposure," by Eugene P. Wightman and Beaumont Newhall, *Image,* Vol. 6, Jan. 1957, pp. 13–17.
37. *Eureka,* Vol. 1, Oct. 1846, p. 24.
38. *Photographic News,* London, Vol. 7, Dec. 11, 1863; PP, Vol. 5, 1868, pp. 175–177.
39. *Eureka,* Vol. 1, Oct. 1846, pp. 24–25.
40. PP, Vol. 8, Oct. 1871, pp. 315–323.
41. Ibid.
42. *Eureka,* Vol. 1, Feb. 1847, p. 92.
43. *Eureka,* Vol. 1, Oct. 1846, p. 25.
44. ROOT, p. 354.
45. APB, Vol. 14, Oct. 1883, pp. 334–335.
46. *Eureka,* Vol. 1, Dec. 1846, p. 60.
47. Draper letter in AJP, Vol. 1, n.s., June 1, 1858, pp. 2–6; Johnson report in *Eureka,* Vol. 1, Dec. 1846, p. 60.
48. PP, Vol. 8, Oct. 1871, pp. 315–323.
49. AJP, Vol. 3, Oct. 1, 1860, p. 142; also see TAFT, p. 40.
50. *Journal of the Royal Society of Arts,* Vol. 30, Aug. 18, 1882, p. 932; copied from an earlier article by Dudley Armytage in *Field Naturalist.*
51. *New York Observer,* Aug. 25, 1840.
52. PAPS, Vol. 1, 1840, p. 171.
53. AJP, Vol. 4, n.s., Mar. 1, 1862, p. 434.
54. AJP, Vol. 1, n.s., June 15, 1861, p. 41.
55. AJS, Vol. XL, 1841, pp. 137–144.
56. *Eureka,* Vol. 1, 1846, p. 92.
57. *Literary Gazette,* London, Dec. 12, 1840, p. 803. Exhibit of Goddard daguerreotype portraits to the Royal Society is described in the *Photographic News,* London, Vol. 8, May 13, 1864, pp. 232–233.
58. *Eureka,* Vol. 1, Dec. 1846, p. 61.
59. *Eureka,* Vol. 1, Feb. 1847, p. 92.
60. AJP, Vol. 14, Aug. 1893, pp. 375–377.
61. PAS, Vol. 4, July 21, 1937, p. 23.
62. References: GERNSHEIM, pp. 131–154; PP, Vol. 5, 1868, pp. 175–177; *Polytechnic Journal,* London, Vol. 4, 1841, pp. 248–250.
63. *New York Tribune,* Oct. 5, 1841.
64. PT, Vol. 14, Mar. 1884, pp. 122–125.
65. APB, Vol. 5, Sept. 1874, p. 309.
66. References: AJP, Vol. 13, Aug. 1892, p. 357; *New York Tribune,* Oct. 12, 1841; APB, Vol. 16, Feb. 14, 1885, pp. 90–92.
67. PT, Vol. 14, Mar. 1884, pp. 122–123.
68. HJ, Vol. 4, May 1, 1852, pp. 28–29.
69. Undated clippings from nineteenth-century Canandaigua, New York, newspapers in possession of Timothy Beard of New York, a Finley heir.
70. References: *New York Tribune,* Aug. 9, 1841; SNELLING, pp. 82–84.
71. *American Annual of Photography,* Vol. 63, 1949, p. 43.
72. "Silver Plates on a Swampy Shore, the Daguerreian Artist in Chicago," by R. Bruce Duncan, GA, Vol. 3, July 1972, pp. 10–18.
73. RINEHART I, pp. 57–62.
74. References: AJS, Vol. 43, Apr.–June, 1843, pp. 73–74; DAB (Channing); HUNT I, pp. 66–67; *Harvard Graduates Magazine,* Vol. 3, Dec.

1894, pp. 195–197; Vol. 32, June 1924, pp. 589–597; *Popular Science Monthly,* Feb. 1877, p. 385.

75. STEPHENS I, introduction; STEPHENS II, p. 175.

76. STEPHENS II, p. 32.

77. *International Annual,* APB, Vol. 1, 1888, pp. 490–492. In HORAN, p. 9, the author states: "The years 1841–43 of [Mathew] Brady's life are shadowy."

78. AH, Vol. 12, June 1961, p. 103.

79. *Exploring with Fremont,* Private Diaries of Charles Preuss, etc., translated and edited by Edwin G. and Elizabeth K. Gudde, Norman, Okla., 1958.

80. PFAJ, Vol. 10, Nov. 1857, p. 376.

81. APB, Vol. 14, Oct. 1883, pp. 334–335.

82. References: PFAJ, Vol. 10, Nov. 1857, p. 376; SLCPP, Vol. 2–4, Feb. 1880, p. 44; WPM, Vol. 26, Jan. 5, 1889, pp. 26–28.

83. *Daily National Intelligencer,* Washington, D.C., Mar. 11, 1844.

84. References: GERNSHEIM, pp. 131–154; *Photographic News,* London, Aug. 8, 1879; *Manchester Guardian,* June 29, 1850, p. 1; *London Times,* Dec. 22, 1961; *Biographical Review, Biographical Sketches of Leading Citizens of York County, Me.,* Boston, 1896, pp. 78–79.

85. GERNSHEIM, pp. 131–154; obituary on Alexander Wolcott, AJP, Vol. 4, Apr. 15, 1862, pp. 525–526.

86. AJP, Vol. 3, Sept. 15, 1860, p. 122.

87. AJP, Vol. 4, Nov. 15, 1861, p. 286.

88. AJP, Vol. 4, Mar. 1, 1862, p. 437.

89. HULFISH, pp. 5–7.

90. "The Development of Optics During the Present Century," by George Lindsay Johnson, originally published in England and reprinted in APB, Vol. 29, July 1899, p. 214.

91. References: "Photographs in One Second," by Arthur T. Gill, FRPS, PJ, Nov. 1973, pp. 556–557; WM, Vol. 35, June 1898, p. 288; GERNSHEIM, p. 157.

92. References: BN, p. 50; APB, Vol. 20, Mar. 9, 1899, pp. 144–146.

93. APB, Vol. 5, Sept. 1874, pp. 309–310.

94. *Daily National Intelligencer,* June 23, 1843, p. 3.

95. All information on case manufacture is from "Preservation of Daguerreotypes," by Frank Fraprie, *American Annual of Photography,* Vol. 63, 1949, p. 197.

96. *Daily National Intelligencer,* Feb. 28, 1843.

97. *Documents of American History,* edited by Henry Steele Commager, N.Y., 1948, p. 302.

98. References: APB, Vol. 19, Sept. 22, 1888, p. 558; BN, p. 148; PAJ, Vol. 6, Sept. 1853, p. 148.

99. References: JAMMES, pp. 11–12; *Latent Image,* by Beaumont Newhall, pp. 120–122; *Living Age,* Vol. 2, 1844, p. 337.

100. References: HORAN, p. 9; WPM, p. 9; WPM, Vol. 30, May 1893, p. 235.

101. APB, Vol. 20, Mar. 9, 1889, pp. 144–146.

102. *United States Magazine and Democratic Review,* July–August 1845, editorial.

103. References: Interview with Brady in the New York *World,* Apr. 12, 1891, p. 23; HORAN, p. 10; WPM, Vol. 30, May 1893, p. 235.

104. References: *Philadelphia Public Ledger,* June 4, 1846, p. 2; GERNSHEIM, p. 119.

105. *McClure's,* Vol. 9, July 1897, p. 802; TAFT, p. 464; HJ, Vol. 1–4, April 15, 1852, pp. 12–13; Brady interview in New York *World,* April 12, 1891, p. 23.

106. References: ROOT, pp. 359 and 390; AJP, Vol. 13, Oct. 1892, pp. 410 and 451.

107. BEAR, pp. 138–140.

108. "Progress and Present State of the Daguerreotype Art," by Antoine Claudet, JFI, Vol. 10, third series, July 1845, pp. 45–51, and Aug. 1845, pp. 114–118.

109. Newspaper quotations are from the *United States Journal,* Washington, D.C., Jan. 29, 1846, p. 2; and the Washington *Daily Times,* Feb. 20, 1846, p. 2.

110. "John Plumbe, Jr., and the First Architectural Photographs of the Nation's Capitol," by Allan Fern and Milton Kaplan, *Quarterly Journal,* Library of Congress, Vol. 31, Jan. 1974, p. 4.

111. *Daily National Intelligencer,* Mar. 11, 1846.

112. BEAR, pp. 140–142.

113. References: *The Making of the Nation,* pp. 247–248; *The History of Surgical Anesthesia,* by Thomas E. Keys, N.Y., 1941; *The Centennial of Surgical Anesthesia,* by John F. Fulton and M. E. Stanton,

N.Y., 1946; handwriting on original backing of framed daguerreotype image from which the copy photograph used here was made.

114. References: *Correspondence of Thomas Carlyle and Ralph Waldo Emerson,* C. E. Norton, editor, Boston, J. R. Osgood & Co., 1883, pp. 103–109; PAGEANT, Vol. 11, p. 138.

115. *Quarterly Journal* (see ref. 110), p. 16.

116. References: GERNSHEIM, pp. 147–148; BN, p. 149; Carson (see note 29), p. 12.

117. References: "Early Photographers: Their Parlors and Galleries," by Jacob C. Vetter, *Chemung County Historical Journal,* June 1961; BN, p. 70.

118. *Living Age,* Vol. 9, June 20, 1846, pp. 551–552.

119. APB, Vol. 15, 1884, p. 62.

120. APB, Vol. 19, Sept. 22, 1888, p. 563.

121. *Early Ohio Taverns,* by Rhea Mansfield Knittle, privately printed, 1937, p. 42.

122. References: ROOT, p. 360; *Daily Enquirer,* Cincinnati, Oct. 6, 1852, p. 3.

123. GERNSHEIM, p. 200.

124. References: *Handbook of Inorganic Chemistry,* by William Gregory, N.Y., A. S. Barnes & Co., 1857, p. 59; *History of the Eclectic Medical Institute,* by Harvey Wicks Felter, M.D., Cincinnati, 1902, pp. 103–104.

125. DJ, Vol. 2, Sept. 1, 1851, p. 242.

126. References: ROOT, p. 404; BN, p. 52; APB, Vol. 20, Mar. 9, 1889, pp. 144–146.

127. All correspondence from AJP, Vol. 1, n.s., Sept. 1, 1858, pp. 99–100.

128. References: APB, Vol. 19, July 28, 1888, pp. 434–435; LOTHROP, p. 7; RINHART II, p. 197.

129. APB, Vol. 19, July 28, 1888, p. 434. The profile of the Anthony firm in chapter 1880 indicates that the business partnership between Edward Anthony and his brother, Henry, began "in a small way" as early as 1842, the same year Edward Anthony, J. M. Edwards, and Victor Piard began making daguerreotypes in a committee room of the United States Congress in Washington, D.C. (see page 35). Further corroboration of the 1842 date will be found in PFAJ, Vol. 10, Nov. 1857, p. 382, in which H. H. Snelling announces termination of his "arrangement" with Edward Anthony "with whom we have passed fifteen years of pleasantness and peace." Snelling served both as general manager of the Anthony supplies business and as founder and publisher of his own photographic magazine.

130. BN, p. 118.

131. APB, Vol. 15, 1884, p. 62.

132. PT, Vol. 29, Oct. 1897, p. 468.

133. RYDER, pp. 14–20.

134. *Henry Clay,* by Carl Shurz, American Statesmen Series, Boston & N.Y., Houghton, Mifflin & Co., 1899, Vol. II, p. 298.

135. ROOT, p. 154.

136. BN, p. 81. The last daguerreotype likeness of Clay reportedly taken from life by N. S. Bennett, of Washington, D.C., was lost with sixteen other daguerreotypes of American senators in the sinking of the steamer *Empire,* according to a news item in HJ, Vol. 5, Sept. 15, 1853, p. 175.

137. *The Legacy of Josiah Johnson Hawes, 19th Century Photographs of Boston,* edited by Rachel Johnston Homer, Barre, Mass., 1972, pp. 9–19.

138. *American Annual of Photography,* 1887, pp. 144–146.

139. BEAR, pp. 150–152.

140. References: PAJ, Vol. 2, Aug. 1851, pp. 94–95; *Philadelphia in the Romantic Age of Lithography,* by Nicholas Wainwright, Historical Society of Pennsylvania, Philadelphia, 1958, p. 73.

141. PAJ, Vol. 16, Sept. 1853, pp. 148–149.

142. GERNSHEIM, pp. 194–196.

143. "Memories of the Past," by S. L. Platt, PP, Vol. 17, Jan. 1880, pp. 23–24.

144. PT, Vol. 25, Nov. 2, 1894, p. 218; APB, Vol. 16, Apr. 11, 1885, pp. 247–249.

145. References: APB, Vol. 15, 1884, p. 64; ROLLE, p. 218.

146. APB, Vol. 19, July 28, 1888, p. 435.

147. SNELLING, p. 44–45.

148. SNELLING, p. 45.

149. ROLLE, p. 219.

150. SNELLING, p. 184.

151. TAFT, p. 80.
152. H. H. Snelling reminiscence in APB, Vol. 19, July 28, 1888, p. 435.
153. *The Cholera Years,* by Charles E. Rosenberg, Chicago, 1960, pp. 144–145; *Appleton's Encyclopedia of Biography* (Worth); DAB (Worth).
154. BN, p. 52.
155. "Cincinnati Panorama," by Cliff Krainik, GA, Vol. 3, Apr. 1974, pp. 7 and 12.
156. PAJ, Vol. 5, Feb. 1853, pp. 126–129.
157. *American Biography and Genealogy* (Taber biography, pp. 756–761).
158. PAJ, Vol. 5, Feb. 1853, pp. 126–129.
159. For a description of 131 of the photographs in Vance's 1851 catalog, see *Collectors' Guide to Nineteenth-Century Photographs,* by William Welling, N.Y., Macmillan, 1976, pp. 177–179.
160. TAFT, p. 489, Note 275.
161. References: BN, p. 162; HJ, Vol. 2, July 1, 1852, p. 115; ANDREWS, p. 59.
162. DJ, Vol. 1, Nov. 1, 1850, p. 54.
163. *The Art-Journal,* London, Apr. 1851, p. 106.
164. *Manchester Guardian,* June 29, 1850, p. 1.
165. WERGE, pp. 48–49.
166. GERNSHEIM, p. 263.
167. WERGE, pp. 45, 54, 58, 71 and 74.
168. References: *The Flowering of New England, 1815–1865,* by Van Wyck Brooks, N.Y., E. P. Dutton, 1st Mod. Lib. ed., 1941, p. 170; PAGEANT, Vol. 11, p. 160; APB, Vol. 26, Aug. 1895, p. 259.
169. References: APB, Vol. 20, Mar. 9, 1889, pp. 144–146; ROOT, p. 369; PT, Vol. 19, Mar. 15, 1889, pp. 130–131.
170. APB, Vol. 16, Feb. 14, 1885, pp. 90–92; AJP, Vol. 2, n.s., June 1, 1858, p. 10.
171. References: PAJ, Vol. 1, Dec. 1851, pp. 362–365; Vol. 2, Apr. 1851, pp. 122–123; Sept. 1851, pp. 169–171; Oct. 1851, pp. 245–249.
172. PAJ, Vol. 2, Sept. 1851, pp. 169–171.
173. PAJ, Vol. 2, Aug. 1851, pp. 122–123.
174. References: PAJ, Vol. 2. Nov. 1851, pp. 313–315; HJ, Vol. 3–4, Nov. 1, 1852, pp. 217–234; RINHART I, pp. 108–110. In HJ, Vol. 16, 1865, pp. 315–316, editor John Towler noted at the time of Hill's death that Hill "always affirmed to this writer that he *did* take pictures in their natural colors, but it was done by an *accidental* combination of chemicals which he could not, for the life of him, again produce!"
175. *Secrets of the Dark Chamber,* by D. D. T. Davie, N.Y., 1870.
176. References: DJ, Vol. 2, 1851, p. 19; TAFT, pp. 69–70; *Illustrated London News,* Vol. 18, 1851, p. 425.
177. References: DJ, Vol. 3–4, Dec. 1, 1851, p. 61; PAJ, Vol. 1, Feb. 1851, p. 95; "Phrenology's Golden Years," by Elizabeth Shafer, *American History Illustrated,* Vol. 8, Feb. 1974, pp. 36–43.
178. PAJ, Vol. 2, Oct. 1851, pp. 250–251.
179. PAJ, Vol. 4, Sept. 1852, p. 151.
180. HJ, Vol. 4, 1852, p. 73.
181. PAJ, Vol. 4, July 1852, p. 62; Nov. 1852, p. 317.
182. GERNSHEIM, p. 182.
183. References: HJ, Vol. 6, July 1, 1854, pp. 90–95; TOWLER, p. 171.
184. References: Lecture on Victor Prevost to the twenty-first annual convention of the Photographer's Association of America, Detroit, Aug. 6, 1901, delivered by W. I. Scandlin; GERNSHEIM, p. 179; HJ, Vol. 3, Dec. 15, 1851, pp. 84–85; Vol. 1, Mar. 1, 1851, p. 243; profile on Brinckerhoff, APB, Vol. 12, July 1881, p. 224; "A Special Privilege," by R. Bruce Duncan, GA, Vol. 2, April 1972, p. 5.
185. TAFT, p. 263.
186. References: ROOT, p. 372; PP, Vol. 5, Aug. 1868, pp. 288–289.
187. WERGE, pp. 52–53.
188. References pertaining to Hawkins: *Daily Enquirer,* Cincinnati, Oct. 6, 1852, p. 3; HJ, Vol. 4, Jan. 1, 1853, p. 282; PFAJ, Vol. 7, Mar. 1854, p. 105; Vol. 10, Nov. 1857, p. 377.
189. HJ, Vol. 4, May 15, 1852, p. 44. Also see *Lights and Shadows of New York Life,* by James D. McCabe, Jr., N.Y., Farrar, Straus and Giroux, 1970 facsimile edition of the National Publishing Company 1872 edition, p. 700, for drawing of Chatham Square in which a building with a sign, "I. Lewis, Daguerreotypes, Ambrotypes," appears in roughly the same position as the daguerreotype establishment pictured in the Chatham Square illustration on page 62 of this book.
190. PAJ, Vol. 5, Feb. 1853, pp. 112–113; DAB (Dewey).
191. HJ, Vol. 3–4, Dec. 1, 1852, p. 255.
192. PFAJ, Vol. 8, Oct. 1855, p. 319.
193. Scandlin lecture on Prevost (referenced in note 184).
194. APB, Vol. 12, July 1881, p. 224.
195. HJ, Vol. 4, May 1, 1852, p. 28.
196. PAJ, Vol. 5, Mar. 1853, pp. 182–183.
197. "Silver Plates on a Swampy Shore," by R. Bruce Duncan, GA, Vol. 3, July 1972, p. 15.
198. HUNT II, p. 257.
199. HJ, Vol. 3, Dec. 1, 1852, p. 151.
200. HJ, Vol. 3–4, Apr. 15, 1852, pp. 12–13.
201. PAJ, Vol. 3, Apr. 1852, pp. 253–255.
202. References: HJ, Vol. 5, Apr. 15, 1853, pp. 9–10; Oct. 1, 1853, p. 90.
203. PAJ, Vol. 5, Apr. 1853, pp. 254–255.
204. Ehrmann lecture on Whipple process delivered at a meeting of the Photographic Section of the American Institute on April 7, 1885, and recorded in APB, Vol. 16, Apr. 11, 1885, pp. 247–249.
205. References: HJ, Vol. 4, May 15, 1852, p. 47; Vol. 5, Oct. 15, 1853, pp. 202 and 206; PAJ, Vol. 6, July 1853, p. 67.
206. HJ, Vol. 6, Apr. 15, 1854, p. 15; APB, Vol. 16, Apr. 11, 1885, pp. 247–249.
207. PT, Vol. 25, Nov. 2, 1894, pp. 281–283.
208. PAJ, Vol. 6, Dec. 1853, pp. 381–382.
209. WERGE, pp. 52–53.
210. New York *Tribune,* quoted in PAJ, Vol. 5, June 1853, pp. 334–341.
211. *Philadelphia Public Ledger,* May 28, 1855.
212. APB, Vol. 15, 1884, pp. 63–64. Other references: PAJ, Vol. 6, Aug. 1853, p. 127; Nov. 1853, p. 260; and Dec. 1853, pp. 381–382.
213. PAJ, Vol. 5, Mar. 1853, pp. 183–184.
214. PAJ, Vol. 6, July 1853, p. 63.
215. References: PAJ, Vol. 4, Oct. 1852, p. 254; AJP, Vol. 3, Feb. 15, 1861, p. 288.
216. PAJ, Vol. 5, Jan. 1853, p. 63.
217. PFAJ, Vol. 7, 1854, p. 320.
218. APB, Vol. 20, Mar. 9, 1889, pp. 144–146.
219. GERNSHEIM, pp. 254–255.
220. GERNSHEIM, pp. 255–256 and 260.
221. References: HJ, Vol. 6, Aug. 15, 1854, p. 137; Sept. 1, 1854, pp. 163–164; PFAJ, Vol. 8, Feb. 1855, p. 63.
222. References: HJ, Vol. 7, June 1, 1855, pp. 44–45; PAJ, Vol. 4, Aug. 1852, pp. 106–113.
223. HJ, Vol. 5, Feb. 15, 1854, p. 322.
224. "C.E.F." in London Notes and Queries column, HJ, Vol. 6, April 15, 1854, p. 1.
225. HJ, Vol. 7, June 1, 1855, pp. 44–45.
226. PP, Vol. 8, Oct. 1871, p. 337.
227. References: HARRISON, pp. 82–83; BROTHERS, p. 173; WERGE, p. 203.
228. PAJ, Vol. 6, Dec. 1853, pp. 377–378.
229. HJ, Vol. 6, Dec. 1, 1854, p. 249; PFAJ, Vol. 8, Feb. 1855, p. 48.
230. HJ, Vol. 6, Sept. 15, 1854, pp. 169–170.
231. HJ, Vol. 7, May 1, 1855, pp. 9–11.
232. ROOT, p. 373.
233. PFAJ, Vol. 8, Aug. 1855, p. 255.
234. PFAJ, Vol. 8, Dec. 1855, p. 384.
235. PFAJ, Vol. 8, Aug. 1855, p. 246.
236. PT, Vol. 25, Nov. 2, 1892, pp. 281–283.
237. The nineteenth-century photographs and information on this page have been provided courtesy of Mrs. Roy Douglass, a descendant of Simon van Duyne and present owner of the van Duyne homestead.
238. In 1860, Southworth assigned the rights to his invention to Simon Wing, of Waterville, Me. (see page 149), and another photographer. During the 1860s, Wing brought suit against photographers using the moveable plate idea in their own cameras without paying him a fee. One suit against E. & H. T. Anthony & Co. was carried all the way to the U.S. Supreme Court, and in this case. *Wing* v. *Anthony* (106 U.S. 142, October, 1882), Justice William Woods ruled in favor of the fraternity, declaring that moveable plates had been used prior to the Southworth "invention." Southworth's description of his invention, quoted here, is from the court decision, p. 143. Tabulation of daguerreotypes taken in Massachusetts in 1854 is from BN, p. 34.

239. References: PFAJ, Vol. 8, Dec. 1855, p. 384; HJ, Vol. 6, Feb. 1, 1855, p. 326.

240. References: PFAJ, Vol. 9, June 1856, p. 192; *Public Ledger*, Phila., Mar. 7, 1856, p. 1; PFAJ, Vol. 7, Apr. 1854, p. 127; *Ballou's*, Vol. 1, Mar. 1855, p. 293.

241. MORRIS, pp. 74–75.

242. HJ, Vol. 8, 1856, pp. 41–44, 52, 120.

243. "The Invention of the Tintype," by Thomas B. Greenslade, Jr., Kenyon College *Alumni Bulletin*, July–September, 1971, pp. 22–23.

244. HEATH, pp. 103–105.

245. HJ, Vol. 7, Feb. 15, 1856, p. 325.

246. "Gold Rush Photography," by R. Bruce Duncan, GA, Vol. 2, Oct. 1971, pp. 14–19.

247. References: *Daily Pennsylvanian*, Phila., April 11 and 12, 1856; *Memoirs of John C. Frémont*, Chicago and New York, 1887, pp. xv–xviii.

248. References: "Ambrotype, A Short and Unsuccessful Career," *Image*, Vol. 7, Oct. 1958, p. 177; PFAJ, Vol. 10, Feb. 1857, p. 56.

249. References: AJP, Vol. 3, Feb. 15, 1861, p. 284; HJ, Vol. 10, Feb. 15, 1859, p. 308.

250. HARRISON, p. 41.

251. Quoted in PAJ, Vol. 6, July 1853, p. 30.

252. HJ, Vol. 7, Jan. 1, 1856, pp. 274–276.

253. HJ, Vol. 8, Dec. 1, 1856, pp. 225–226.

254. References: *Photographic News*, Vol. 3–4, Feb. 10, 1860, pp. 269–270; speech by Antoine Claudet before the British Association, recorded in AJP, Vol. 3, Aug. 15, 1860, pp. 81–83; HJ, Vol. 17, Oct. 1, 1865, p. 176; TISSIANDIER, pp. 148–151; GERNSHEIM, pp. 312–313.

255. Letter from Charles Meade to H. H. Snelling, PFAJ, Vol. 8, 1855, p. 253.

256. AJP, Vol. 1, Aug. 15, 1858, pp. 85–87; Sept. 1, 1858, pp. 107–108.

257. PFAJ, Vol. 12, June 1859, p. 30. Also see *Photographic Notes*, Vol. 4, Nov. 1, 1859, p. 261.

258. Report of Royal Society committee is recorded in AJP, Vol. 2, Apr. 1, 1860, pp. 322–330.

259. WALDACK, Introduction.

260. PT, Vol. 14, Mar. 1884, pp. 122–125. Also see APB, Vol. 6, Apr. 1875, pp. 97–100 (re: Frith "dexterity"); WPM, Vol. 29, Dec. 3, 1892, pp. 690–692 (re: Landy large photographs); PFAJ, Vol. 10, 1857, p. viii (re: Snelling offer).

261. References: PFAJ, Vol. 10, Apr. 1857, p. 121; Nov. 1857, p. 351.

262. AJP, Vol. 1, Aug. 1, 1858, p. 82.

263. *London Times*, Jan. 1, 1858.

264. AJP, Vol. 1, Sept. 15, 1858, p. 130.

265. References: BURGESS, pp. 76–79; PFAJ, Vol. 11, Dec. 1858, pp. 383–384.

266. COALE, pp. 12–14; 52.

267. PFAJ, Vol. 10, Jan. 1857, pp. 27–28.

268. WERGE, p. 203; Musgrave statement is from AJP, Vol. 8, Jan. 1, 1866, pp. 304–309.

269. AJP, Vol. 1, Dec. 15, 1858, pp. 223–225.

270. HJ, Vol. 10, Dec. 15, 1859, p. 241.

271. *Baltimore, A Picture History 1858–1958*, The Maryland Historical Society, 1957, pp. 26–30.

272. PFAJ, Vol. 11, Mar. 1858, p. 93.

273. *New York Times*, Jan. 21, 1859.

274. AJP, Vol. 1, July 1, 1859, p. 35.

275. WAINRIGHT, p. 73; DAB (Cutting).

276. AJP, Vol. 2, June 1, 1858, pp. 10–13.

277. AJP, Vol. 1, Mar. 1, 1859, pp. 301–303; PFAJ, Vol. 12, June 1859, pp. 19–21.

278. AJP, Vol. 2, Oct. 15, 1859, pp. 148–149.

279. References: GERNSHEIM, p. 344; ROOT, pp. 303–305; Wenderoth letter in PFAJ, Vol. 12, June 1859, p. 6; "Grecian" mode is from AJP, Vol. 7, Apr. 15, 1865, pp. 476–477.

280. HJ, Vol. 11, Aug. 15, 1859, p. 113.

281. PFAJ, Vol. 12, June 1859, pp. 20–21.

282. References: *Kansas Historical Quarterly*, Vol. 24, Spring 1958, pp. 1–3; *Lives of the Painters*, by John Canaday, N.Y., W. W. Norton, 1969, Vol. 3, pp. 1059–1062; *The Crayon*, Sept. 1859, p. 337. Also see a series of four articles on Bierstadt's western photography by Howard E. Bendix in *Photographica*, Oct., Nov., Dec. 1974, and Jan. 1975.

283. *Photographic Notes*, London, Oct. 1859, pp. 239–240.

284. BURGESS, p. 19.

285. TAFT, p. 141.

286. References: AJP, Vol. 1, Mar. 1, 1859, pp. 298–301; PFAJ, Vol. 12, June 1859, p. 31; AJP, Vol. 2, Mar. 1, 1860, pp. 289–292; PP, Vol. 5, Aug. 1868, p. 290.

287. Burgess statement quoted in PFAJ, Vol. 10, Sept. 1857, p. 282; historical data derived from *The History of Baltimore City and County*, by J. T. Sharf, Philadelphia, 1881, pp. 662–664; *Baltimore, A Picture History 1858–1958*, p. 7.

288. "Brady Didn't Take Them All," *Post-Standard Sunday Magazine*, Syracuse, June 2, 1963, pp. 3–7.

289. AJP, Vol. 8, Jan. 1, 1866, pp. 304–309; discussion at Oct. 11, 1860, American Photographical Society meeting is from PFAJ, Vol. 1, May 1860, pp. 144–145, and AJP, Vol. 2, Dec. 1, 1859, pp. 207–208.

290. AJP, Vol. 4, July 1, 1861, pp. 85–86.

291. HJ, Vol. 14, Aug. 15, 1862, pp. 78–79.

292. HJ, Vol. 19, Mar. 15, 1868, p. 346.

293. References: HJ, Vol. 18, Feb. 1, 1867, p. 302; AJP, Vol. 3, Feb. 1, 1861, p. 272; Vol. 4, Jan. 1, 1862, p. 360.

294. HJ, Vol. 12, Mar. 1, 1861, p. 9; "Alexander Gardner," by Josephine Cobb, *Image*, Vol. 7, June 1958, p. 130.

295. AJP, Vol. 4, July 1, 1861, p. 67.

296. References: LUBSCHEZ, pp. 24–29; "Coleman Sellers," by Charles Coleman Sellers, *Image*, Vol. 7, Dec. 1958, pp. 233–235.

297. APB, Vol. 19, May 26, 1888, pp. 302–303; June 9, 1888, pp. 338–341.

298. AJP, Vol. 3, Feb. 1, 1861, pp. 268–269.

299. See NAEF, p. 95, plate 5.

300. References: DAB (Snelling); AJP, Vol. 3, Dec. 1, 1860, pp. 207–208; PFAJ, Vol. 1, n.s., June 1860, pp. 179–180; "Plagiarism in the 'First' American Book about Photography," by R. S. Kahan and L. J. Schaaf, with R. L. Flukinger, *Papers of the Bibliographical Society of America*, Vol. 67, 1973, pp. 283–304.

301. Discussion at Jan. 14, 1861, meeting of the American Photographical Society, recorded in AJP, Vol. 3, Feb. 1, 1861, pp. 268–269; also Seely remarks in AJP, Vol. 4, Sept. 1, 1861, pp. 165–167.

302. AJP, Vol. 4, Sept. 15, 1861, pp. 181–184.

303. HJ, Vol. 12, May 1, 1860, p. 1; May 15, p. 19; Nov. 15, p. 212.

304. HJ, Vol. 15, June 1, 1863, p. 47.

305. AJP, Vol. 4, Feb. 15, 1862, pp. 421–422.

306. HJ, Vol. 15, July 15, 1863, p. 96.

307. Brady interview in New York *World*, Apr. 12, 1891; HORAN, pp. 35–59; *Civil War Photographs 1861–1865*, a catalog of numbered Brady photographs available from the Library of Congress, compiled by Hirst D. Milhollen and Donald H. Mugridge, Washington, 1961, introduction, pp. v–x.

308. References: *Atlantic Monthly*, Vol. 12, 1863, p. 1; TAFT, pp. 144–147.

309. AJP, Vol. 4, Jan. 15, 1862, pp. 379–380.

310. APB, Vol. 20, Mar. 9, 1889, pp. 147–149.

311. AJP, Vol. 5, Dec. 15, 1862, p. 285.

312. AJP, Vol. 3, Apr. 15, 1861, pp. 337–338.

313. References: Newton profile in APB, Vol. 16, Feb. 14, 1885, pp. 65–68; obituary in PT, Vol. 28, Feb. 1896, pp. 104–105; *Great Industries of the United States*, J. B. Burr & Hyde, Hartford, Chicago, and Cincinnati, 1873, pp. 317–331.

314. HJ, Vol. 15, Aug. 15, 1862, p. 80. Other accounts recorded in AJP, Vol. 4, July 1, 1861, pp. 60–61; Vol. 5, July 1, 1862, p. 23.

315. *American Heritage History of the Civil War*, R. M. Ketchum, editor-in-charge, N.Y., 1960, pp. 418–423.

316. PJA, Vol. 53, Jan. 1916, pp. 19–20.

317. *Eye to Eye*, Dec. 1953, pp. 9–12. Bachrach family records were provided courtesy of Bradford Bachrach, grandson of David Bachrach, Jr.

318. References: HJ, Vol. 15, June 15, 1863, p. 49; Sept. 1, 1863, pp. 129–130.

319. HJ, Vol. 15, Sept. 1, 1863, p. 129.

320. HJ, Vol. 14, Oct. 15, 1862, p. 141 (reprinted from *Macmillan's Magazine*). Other references on tannin plate users: AJP, Vol. 5, Nov. 1, 1862, p. 199; APB, Vol. 17, Oct. 23, 1886, p. 619.

321. AJS, Vol. 35, 2nd Series, May 1863, p. 324.

322. PJA, Vol. 53, Jan. 1916, p. 18. Records pertaining to Robert Vinton Lansdale provided courtesy of Robert Lansdale of Baltimore, Md., a grandson.

323. References pertaining to Harrison and his *Globe* lens: AJP, Vol. 5, Apr. 15, 1863, pp. 453–459; WERGE, p. 78; ROOT, p. 375; APB, Vol. 19, 1888, p. 435; HJ, Vol. 16, Dec. 15, 1864, p. 256.

324. GERNSHEIM, pp. 323–327.

325. PP, Vol. 2, June 1865, pp. 97–99.

326. AJP, Vol. 5, Apr. 1, 1863, pp. 451–452. Remarks by Seely are recorded in AJP, Vol. 5, Jan. 1, 1863, pp. 329–330.

327. HJ, Vol. 16, July 15, 1864, p. 95; EDER, p. 144; AJP, Vol. 4, June 15, 1861.

328. AJP, Vol. 6, Sept. 15, 1863, p. 143.

329. HJ, Vol. 16, July 15, 1864, pp. 93–94.

330. AJP, Vol. 6, Oct. 15, 1863, pp. 190–191.

331. *American Artisan,* Vol. 1, Nov. 9, 1864, p. 215. Description of Whipple, Black, and other Boston operations is from AJP, Vol. 6, June 15, 1864, pp. 321–323.

332. PP, Vol. 3, Mar. 1867, pp. 82–83; TAFT, p. 342; MORRIS, p. 167.

333. HJ, Vol. 16, Dec. 1, 1864, pp. 225–229.

334. BACHRACH, Memoirs. Reference to Brady and Gardner use of the solar camera will be found in COBB, p. 13.

335. References: Minutes of the American Photographical Society recorded in AJP, Vol. 6, Feb. 15, 1864, p. 379; Vol. 7, July 1, 1864, pp. 14–15; Newton reminiscence published in APB, Vol. 16, Apr. 11, 1885, pp. 250–257.

336. ROOT, introductions by the author, pp. xiii–xviii, and by Beaumont Newhall in 1971 edition, pp. 5–9; Muckle letter provided courtesy of Mrs. Joseph Carson of Philadelphia.

337. HJ, Vol. 17, May 15, 1865, pp. 29–30.

338. SANDBURG, p. 602.

339. GERNSHEIM, pp. 427–428; minutes of the Nov. 14, 1864, meeting of the American Photographical Society, recorded in AJP, Vol. 7, Dec. 15, 1864, p. 277.

340. PP, Vol. 2, Dec. 1865, pp. 189–190.

341. References: APB, Vol. 26, April 1, 1895, pp. 136–138; WPM, Vol. 32, March 1895, pp. 132–133; International Annual of APB, Vol. 9, 1897, pp. 201–204.

342. AJP, Vol. 6, Jan. 1, 1864, pp. 304–305.

343. "Alexander Gardner," by Josephine Cobb, *Image,* Vol. 7, June 1958, pp. 124–136.

344. *American Artisan,* Vol. 1, Feb. 1, 1865, p. 308.

345. HJ, Vol. 17, Dec. 15, 1865, pp. 246–248.

346. References: HJ, Vol. 17, Nov. 15, 1865, pp. 218–219; Dec. 1, 1865, pp. 235–237; Dec. 15, 1865, pp. 248–253; Jan. 1, 1866, pp. 265–266.

347. HJ, Vol. 18, May 15, 1866; DARRAH, pp. 41–42.

348. *Charles Sumner,* by Moorfield Storey, American Statesmen Series, Boston, Houghton, Mifflin & Co., 1900, p. 322.

349. *Alta California,* Feb. 17, 1868. Other references for previous pages: TAFT, pp. 277–283; *Education of Henry Adams,* by Henry Adams, N.Y., Modern Library Edition, 1931, p. 312.

350. PJA, Vol. 53, Feb. 1916, p. 71.

351. PP, Vol. 3, 1866, pp. 311–313; 357.

352. Ibid.

353. PP, Vol. 3, Jan. 1866, p. 32.

354. PP, Vol. 3, Feb. 1866.

355. HJ, Vol. 14, Sept. 15, 1863, p. 111; Vol. 15, Sept. 1, 1863, p. 129.

356. PP, Vol. 3, July 1866, pp. 217–218; HARRISON, pp. 94–95.

357. References: PP, Vol. 2, Dec. 1865; Vol. 3, May 1866.

358. References: HJ, Vol. 17, Mar. 1, 1866, p. 324; Vol. 18, June 15, 1866, pp. 58–59.

359. HARRISON, p. 100.

360. GERNSHEIM, p. 340.

361. PP, Vol. 3, Mar. 1867, pp. 81–82; report of an American correspondent in the *Photographic News,* London, Vol. 21, Dec. 7, 1877, pp. 579–580.

362. AJP, Vol. 7, Apr. 1, 1866, pp. 436–438.

363. PT, Vol. 28, Mar. 1896, pp. 125–126; also records of early meetings of the American Photographical Society and other articles referenced, or quoted in previous pages of this book.

364. PP, Vol. 5, Apr. 1866.

365. New York *World* article quoted in HJ, Vol. 17, Jan. 1, 1868, pp. 259–260.

366. HJ, Vol. 19, Aug. 15, 1867, pp. 113–117.

367. Paper by F. A. Wenderoth delivered at a meeting of the Philadelphia Photographic Society, June 5, 1867, and reprinted in PP, Vol. 4, July

1867. Seely's remarks are from AJP, Vol. 6, June 1, 1864, p. 542.

368. AJP, Vol. 4, May 1883, pp. 1–2.

369. *Lights and Shadows of New York Life,* op. cit., pp. 193 and 674.

370. HJ, Vol. 19, Apr. 1, 1868, pp. 358–361.

371. PP, Vol. 5, 1868, p. 281.

372. PP, Vol. 5, 1868, pp. 300–301.

373. All descriptions of the proceedings of the photographers' convention, depositions, etc., which are contained on pages 195–198 of the text are from PP, Vol. 5, 1868, pp. 135–150; 281–293; 300–301; 308–312.

374. References: "Color Photography," by R. James Walker, PM, Vol. 4, Apr. 1902, pp. 57–87; *Colour Photography,* by Eric de Maré, Penguin Books, 1973, pp. 41–42; *Color Photography,* by Robert M. Fanstone, London, 1935, p. 7.

375. WPM, Vol. 38, Apr. 1901, pp. 134–136; TAFT, pp. 324–331; PP, Vol. 5, 1868, p. 388.

376. BACHRACH, Memoirs.

377. NAEF, pp. 38, 70, 73.

378. A copy of the McClees and Beck book was displayed at an exhibition of photographically illustrated books held at the Grolier Club, New York, December 1974 through February 1975.

379. References on photomechanical printing: GERNSHEIM, pp. 547–549; meetings of the Philadelphia Photographic Society recorded in PP, Vol. 6, Dec. 1869, p. 444, and Vol. 7, Jan. 1870, p. 18; "Photomechanical Printing," by Edward Bierstadt, APB, Vol. 6, May 1875, pp. 129–136; paper on the Albertype by Prof. John Towler, PP, Vol. 9, June 1872, pp. 204–205.

380. PP, Vol. 16, Mar. 1879, p. 70.

381. COULSON, pp. 7–9.

382. JFI, Vol. 145, Apr. 1898, pp. 310–311. Also see MCCOSKER, pp. 406–408. Heyl statement indicating that the image wheel of *Phasmatrope* contained 18 picture spaces probably results from an error in memory, since the device at the Franklin Institute contains only 16 such spaces.

383. References: "The Woodburytype," by J. S. Mertle, *Image,* Vol. 6, Sept. 1957, pp. 165–170; PP Vol. 8, 1871, and Vol. 10, July 1873, pp. 241–244; TAFT, 431–432.

384. Heyl papers in the Franklin Institute Library.

385. Ibid. (undated newspaper clipping, "Current Topics of Town")

386. PP, Vol. 7, July 1870, pp. 225–235.

387. WPM, Vol. 29, Sept. 3, 1892, pp. 513–516.

388. PP, Vol. 7, Aug. 1870, pp. 299–300.

389. APB, Vol. 1, June 1870, pp. 77–78.

390. PP, Vol. 7, Sept. 1870, pp. 325–326.

391. PP, Vol. 7, Mar. 1870, p. 95.

392. PP, Vol. 8, Oct. 1871, p. 320.

393. APB, Vol. 3, Feb. 1872, pp. 462–465.

394. APB, Vol. 2, 1871, pp. 268–269.

395. PT, Vol. 21, Dec. 11, 1891, pp. 615–617. Also BJP, Sept. 8, 1871, quoted in GERNSHEIM, p. 238; and Maddox letter to W. Jerome Harrison, quoted in PT, Vol. 21, Dec. 4, 1891, pp. 603–604.

396. APB, Vol. 1, Feb. 1870, p. 15.

397. PP, Vol. 8, report on N.P.A. meeting June 8, 1871.

398. San Francisco *Daily Call,* May 28, 1871.

399. APB, Vol. 2, Nov. 1871, p. 370.

400. TAFT, p. 288.

401. APB, Vol. 2, June 1871, pp. 185–186.

402. APB, Vol. 23, Mar. 26, 1892, pp. 187–189.

403. PT, Vol. 1, Nov. 1871, pp. 160–161.

404. *Biographical Review,* containing sketches of leading citizens of York County, Maine, Boston, 1896, pp. 78–79.

405. NAEF, pp. 125–136.

406. MUYBRIDGE, pp. 39–45.

407. APB, Vol. 3, Nov. 1872, pp. 746–747.

408. References: HULFISH, pp. 8–9; TAYLOR, pp. 67–68; PT, Vol. 2, May 1872, p. 67, and Vol. 3, Mar. 1873, p. 35; PP, Vol. 2, Sept. 1872, p. 136.

409. References: PP, Vol. 9, June 1872, pp. 204–205, and Vol. 10, May 1873, p. 158.

410. *Presbyterian* article quoted in APB, Vol. 7, June 1876, pp. 186–187. See also NAEF, pp. 219–226.

411. References: Description of heliotype process in PP, Vol. 10, Aug. 1873, pp. 253–254; "Photomechanical Printing," by Edward Bierstadt, APB, Vol. 6, May 1875, pp. 129–136.

412. APB, Vol. 3, Sept. 1872, pp. 654–655.
413. Op. cit. (Note 407)
414. DARRAH, pp. 10, 51, 91–95, and 151.
415. G.I.U.S., pp. 880–881.
416. PT, Vol. 3, Feb. 1873, pp. 23–24. See also PP, Vol. 8, Aug. 1871, p. 275.
417. COBB, pp. 36–38; HORAN, p. 83.
418. PT, Vol. 3, Apr. 1873, pp. 52–54. See also Vol. 3, June 1873, p. 84, and WPM, Vol. 36, Mar. 1899, pp. 97–100.
419. PT, Vol. 3, Jan. 1873, pp. 4–5.
420. APB, Vol. 4, July 1873, p. 207.
421. PT, Vol. 4, Nov. 1874, pp. 171–172.
422. AJP, Vol. 5, Feb. 15, 1863, pp. 379–380.
423. Advertisement on back of an A. E. Alden card stereograph. See also *Holyoke Daily Transcript & Telegram,* July 17, 1937; "The Day Water Thundered Down Mill River," by Alice H. Manning (copy provided for this history, courtesy of Ms. Manning).
424. References: "Orthochromatic Photography," by George Cramer, APB, Vol. 21, Oct. 11, 1890, pp. 590–591; BROTHERS, pp. 126–133 (includes Vogel remarks); APB, Vol. 5, Feb. 1874, pp. 91–92 (includes Chapman remarks).
425. Quotation from *The Nation* in PT, Vol. 4, July 1874, p. 101.
426. PP, Vol. 12, 1875, p. 54. Also see Vol. 6, 1869, p. 133, and Vol. 10, 1873, p. 63.
427. *Smithsonian Studies in History & Technology,* No. 32, Smithsonian Institution, 1975, p. 13.
428. "Great American Industries, VI—A Printed Book," by R. W. Bowker, *Harper's,* Vol. 75, July 1887, pp. 165–188.
429. For a discussion of photomechanical printing see PP, Vol. 10, July 1873, pp. 241–244; APB, Vol. 6, May 1875, pp. 130–136.
430. APB, Vol. 5, Apr. 1874, p. 134; June 1874, p. 216.
431. PRL, Vol. 1, July 1878, p. 69.
432. PP, Vol. 9, Jan. 1872, pp. 11–12. Also see DAB (Louis Levy and Max Levy); BACHRACH, Memoirs; APB, Vol. 6, Apr. 1875, pp. 117–118.
433. APB, Vol. 6, May 1875, pp. 150–152.
434. "The Magic Lantern," by Louis Walton Sipley, PAS, Vol. 4, No. 1, 1939, pp. 39–43, 88–90.
435. PP, Vol. 12, 1875, p. 2.
436. PRL, Vol. 1, Jan. 1878, pp. 13–14.
437. PP, Vol. 8, Dec. 1871, pp. 385–386.
438. APB, Vol. 7, Nov. 1876, pp. 351–352.
439. APB, Vol. 7, June 1876, pp. 186–187.
440. APB, Vol. 7, July 1876, p. 246.
441. APB, Vol. 7, June 1876, p. 189.
442. BJP article quoted in APB, Vol. 6, July 1875, p. 213. Ref. to Roche exhibit will be found in APB, Vol. 5, Dec. 1874, p. 411.
443. APB, Vol. 6, Aug. 1875, p. 234.
444. APB, Vol. 7, Feb. 1876, p. 57. Russell remarks will be found in APB, Vol. 6, Dec. 1875, p. 370. Also see APB, Vol. 7, Apr. 1876, pp. 125–126; PT, Vol. 6, July 1876, pp. 145–148.
445. PT, Vol. 6, July 1876, p. 146.
446. PP, Vol. 16, Mar. 1879, p. 69. Other references on Lambertype will be found in APB, Vol. 7, 1876, pp. 282, 307, 348, and 369–373; SLCPP, Vol. 2, Nov. 1878, pp. 367–369.
447. APB, Vol. 9, Jan. 1878, pp. 28–29; Feb. 1878, pp. 60–61.
448. APB, Vol. 8, Jan. 1877, pp. 20–21.
449. Ibid.
450. References: Information on back side of S. L. Albee series of card stereographs covering the railroad labor strike (these card stereographs are today extremely rare); *Harper's Weekly,* Aug. 11, 1877; *The American Republic,* by Richard Hofstadter, William Miller, and David Aaron, Prentice-Hall, 1959, Vol. 2, pp. 207–210.
451. SLCPP, Vol. 4, Feb. 1880, p. 67; APB, Vol. 8, Mar. 1877, p. 96.
452. PP, Vol. 14, Mar. 1877, pp. 65–66.
453. *Photographic News* (British weekly), Vol. 21, Mar. 9, 1877, p. 116.
454. *Photographic News,* Vol. 21, Dec. 7, 1877, pp. 579–580.
455. APB, Vol. 8, Jan. 1877, p. 60.
456. SLCPP, Vol. 2, Nov. 1878, p. 362.
457. Op. cit. (Note 454)
458. *Man & Builder,* June 1877, p. 124.
459. PP, Vol. 16, Jan. 1879, pp. 24–25.
460. GERNSHEIM, p. 340.
461. APB, Vol. 4, Jan. 1873, p. 2.

462. PT, Vol. 7, Mar. 1877, pp. 50–51.
463. References: correspondence between Mrs. Joseph Carson of Philadelphia and various university officials in 1939 and 1943. Author is indebted to Mrs. Carson for making this correspondence available. See also PT, Vol. 8, Feb. 1878, pp. 34–35; and Vol. 9, Apr. 1879, p. 91.
464. MUYBRIDGE, p. 124; see also p. 69.
465. PRL, Vol. 1, Oct. 1878, pp. 100–101.
466. MUYBRIDGE, p. 25; see also p. 71.
467. Heyl remarks will be found in JFI, Vol. 145, Apr. 1898; see also COULSON, p. 11.
468. PT, Vol. 9, July 1879, p. 165. Earlier Anthony advertising will be found in APB, Vol. 8, Oct. 1877, p. 316.
469. Report on Newton's emulsion will be found in APB, Vol. 7, Apr. 1876, p. 124; *Defiance* dry plates were advertised in APB, Vol. 11, 1880, p. 150.
470. PRL, Vol. 2, Apr. 1879, pp. 38–39.
471. PP, Vol. 16, 1879, p. 216.
472. PT, Vol. 9, Apr. 1879, pp. 88–90.
473. PP, Vol. 16, 1879, p. 177.
474. References: "Alfred Clements and His Work," PT, Vol. 27, Oct. 1895, pp. 216–220; AJP, Vol. 13, Mar. 1892, pp. 97–98.
475. SLCPP, Vol. 3, Nov. 1879, pp. 833–835.
476. APB, Vol. 10, June 1879, p. 181.
477. "Bierstadt's Artotype Atelier," PT, Vol. 13, May 1883, pp. 195–198; DAB (Tappen).
478. APB, Vol. 9, Feb. 1878, pp. 40–41; PP, Vol. 16, Apr. 1879, p. 126.
479. APB, Vol. 10, Mar. 1879, p. 85; PP, Vol. 16, Jan. 1879, pp. 17–18.
480. APB, Vol. 9, Dec. 1878, p. 379.
481. APB, Vol. 10, Mar. 1879, pp. 90–93.
482. PP, Vol. 16, 1879, pp. 130–133.
483. PP, Vol. 16, Mar. 1879, p. 69; BACHRACH, Memoirs.
484. PP, Vol. 16, Jan. 1879, p. 8.
485. PP, Vol. 16, 1879, pp. 42–43.
486. APB, Vol. 11, Apr. 1880, p. 125.
487. SLCPP, Vol. 2–4, Feb. 1880, pp. 44–45.
488. References: Illustrations together with descriptive material provided courtesy of the Pennsylvania Historical and Museums Commission. See also DAB (Moss).
489. For a review of Stephen Horgan's career and work, see *Inland Printer,* March and April, 1924.
490. Article on Moss Engraving Company, APB, Vol. 15, 1884, pp. 192–195; PP, Vol. 24, Apr. 16, 1887, p. 254; obituary on Moss in WPM, Vol. 29, May 7, 1892.
491. PT, Vol. 10, Nov. 1880, pp. 248–249.
492. TAFT, pp. 378–382; PP, Vol. 16, Nov. 1879, p. 336; Vol. 17, Jan. 1880, pp. 8–9.
493. WPM, Vol. 29, May 7, 1892; APB, Vol. 8, Jan. 1877, p. 21.
494. PT, Vol. 11, Jan. 1881, pp. 12–13.
495. WPM, Vol. 37, Nov. 1900, pp. 506–507.
496. Dry plate committee report will be found in APB, Vol. 12, Jan. 1881, pp. 20–22; and in March 1881, pp. 78–79. Carbutt remarks will be found in PT, Vol. 11, July 1881, pp. 251–252.
497. APB, Vol. 24, Jan. 14, 1893, p. 1.
498. APB, Vol. 12, Mar. 1881, p. 87. Comments by other photographers mentioned will be found in APB, Vol. 12, June 1881, pp. 182–184.
499. "From the West," by Pyro, a letter to the editor of the PT, Vol. 11, May 1881, pp. 202–204.
500. SLCPP, Vol. 5, Jan. 1881, p. 32.
501. AJP, Vol. 8, July 1887, pp. 112–113.
502. TAFT, p. 382.
503. PT, Vol. 11, Aug. 1881, pp. 302–305.
504. References: BACHRACH, Memoirs; obituary in *The Sun,* Baltimore, Dec. 11, 1921.
505. Reference: "Photography and the Newspapers," by S. H. Horgan, PT, Vol. 14, May 1884, pp. 225–228.
506. PT, Vol. 11, July 1881, pp. 250–251.
507. IVES, p. 29.
508. AAOP, 1887, p. 135. Also see GERNSHEIM, pp. 549–551, and discussion in IVES, pp. 30–31; 48–55.
509. PP, Vol. 23, Dec. 18, 1886, p. 742.
510. APB, Vol. 14, Nov. 1883, pp. 371–372. Also see WPM, Vol. 29, Feb. 6, 1892, pp. 73–74.
511. APB, Vol. 13, Apr. 1882, pp. 130–131. Whipple feat recorded in AJP, Vol. 6, Jan. 1, 1864, pp. 304–305.

512. *New York Times,* Nov. 5, 1882.
513. PT, Vol. 11, Jan. 1881, pp. 10–11.
514. APPLETON'S, Vol. 2 (Draper).
515. *New York Times,* Feb. 25, 1883.
516. References: Walzl profile in PT, Vol. 13, Mar. 1883, pp. 102–104; APB, Vol. 15, Apr. 1884, pp. 164–166.
517. References: LOTHROP, p. 26; also "Collector's Notes," by Eaton S. Lothrop, Jr., in *Photographica,* Vol. 5, Mar. 1973, p. 9; May 1973, pp. 11–12.
518. APB, Vol. 15, Apr. 1884, pp. 164–166; also "Collector's Notes" (LOTHROP), *Photographica,* Vol. 6, Aug.–Sept. 1974, pp. 8–9.
519. PP, Vol. 20, July 1883, p. 224.
520. PT, Vol. 13, Feb. 1883, pp. 82–85.
521. Ibid.
522. References: APB, Vol. 14, June 1883, p. 190; PT, Vol. 14, May 1884, p. 230.
523. References: APB, Vol. 12, May 1881, p. 159; WPM, Vol. 26, July 6, 1889, pp. 401–402.
524. PP, Vol. 20, June 1883, pp. 179–183.
525. PT, Vol. 13, Aug. 1883, pp. 403–404.
526. APB, Vol. 15, Apr. 1884, pp. 167–168.
527. PT, Vol. 13, Mar. 1883, pp. 112–113.
528. DARRAH, p. 109.
529. *New York Times,* Aug. 20, 1884; APB, Vol. 15, Apr. 1884, p. 164.
530. PT, Vol. 11, Mar. 1881, pp. 93–94.
531. BACHRACH, *Memoirs.*
532. For a discussion of Alfred Stieglitz's studies and activities in Europe, see NORMAN, pp. 24–35.
533. PT, Vol. 14, July 1884, pp. 386–387.
534. PT, Vol. 14, Jan. 1884, pp. 48–49.
535. Op. cit. (Note 505).
536. For the text of speeches given at the dinner in honor of Roche, see APB, Vol. 15, Apr. 1884, pp. 136–153. An obituary on Roche appears in APB, Vol. 26, Nov. 1895, p. 367.
537. APB, Vol. 15, Apr. 1884, pp. 164–166.
538. For a profile in Ogawa, see APB, Vol. 21, Mar. 22, 1890, pp. 181–185.
539. PT, Vol. 14, Oct. 1884, pp. 537–539.
540. From the *New York Mail & Express,* as recorded in APB, Vol. 16, Apr. 11, 1885, pp. 222–223.
541. Op. cit. (Note 540).
542. For a report on the exhibition, see APB, Vol. 16, Nov. 28, 1885, pp. 683–687.
543. AJP, Vol. 6, Aug. 1885, p. 6.
544. References: PP, Vol. 22, Oct. 1885, p. 366; *Latent Image,* p. 62; *Scientific American,* Vol. 70, Jan. 6, 1894, p. 6.
545. AJP, Vol. 7, May 1886, pp. 1–3. For a discussion of Eastman film development, see TAFT, pp. 384–388; "Time Exposure," by Eaton S. Lothrop, Jr., *Popular Photography,* Mar. 1972, pp. 36 and 38.
546. PP, Vol. 16, Oct. 1, 1886, p. 520. Also see GERNSHEIM, p. 453.
547. Ibid (Horgan remarks).
548. PP, Vol. 23, Mar. 6, 1886, pp. 140–142.
549. Paper by Donald C. Ryon, curator of the Kodak Patent Museum, given at a symposium of the Photographic Historical Society, Rochester, Sept. 18–20, 1970.
550. PP, Vol. 23, Feb. 6, 1886, p. 74.
551. APB, Vol. 17, June 26, 1886, pp. 353–358.
552. GERSHEIM, p. 420.
553. PT, Vol. 15, Jan. 23, 1885, p. 38.
554. PP, Vol. 23, Oct. 16, 1886, pp. 638–639.
555. AJP, Vol. 7, Oct. 1886, pp. 4–8. Also see GERNSHEIM, p. 400.
556. AJP, Vol. 10, Jan. 1889, p. 9.
557. BROTHERS, p. 74.
558. *Theodore Roosevelt, an Autobiography,* N.Y., Macmillan, 1913, pp. 70, 185, 187, 218–219, 313.
559. AJP, Vol. 8, Oct. 1887, pp. 169–170.
560. *The Making of An American,* pp. 266–273.
561. References: *A Talent for Detail, The Photographs of Frances Benjamin Johnston,* by Pete Daniel and Raymond Smock, N.Y., Harmony Books, 1974, pp. 5, 27, 43, 57–59; *The Making of an American,* by Jacob Riis, N.Y., Macmillan, 1901, pp. 266–273; *How the Other Half Lives,* by Jacob Riis, N.Y. Dover Pub., p. 30.
562. Remarks by Edwards will be found in PP, Vol. 24, 1887, pp. 101–102.
563. AJP, Vol. 8, Dec. 1887, p. 224.
564. APB, Vol. 18, Apr. 23, 1887, pp. 242–245.
565. References: "The Limits of Photogravure," by A. Dawson, AJP, Vol. 10, May 1889, pp. 175–182; "Progress and Methods of Photomechanical Printing," by Ernest Edwards, AAOP, 1887, pp. 134–137.
566. AJP, Vol. 10, Jan. 1889, pp. 25–27.
567. PT, Vol. 17, Aug. 19, 1887, pp. 419–420.
568. References: APB, Vol. 19, Dec. 22, 1888, 737–739; WPM, Vol. 26, Jan. 5, 1889, pp. 26–28.
569. "Men in the Movie Vanguard," No. VI, Louis Aimé Augustin Le Prince, by Merritt Crawford, *Cinema,* Dec. 1930, pp. 28–31.
570. COULSON, p. 10.
571. THOMAS, pp. 26–27.
572. "Neglected Method of Silver Printing," by Charles D. Mitchell, AJP, Vol. 9, Feb. 1888, pp. 30–33; see also Mar. 1888 issue.
573. IAAPB, Vol. 2, 1889, pp. 209–210.
574. PP., Vol. 25, Mar. 3, 1888, p. 157; Apr. 7, 1888, p. 223.
575. AJP, Vol. 8, Nov. 1887, pp. 198–200.
576. PT, Vol. 18, Feb. 3, 1888, pp. 50–51.
577. PT, Vol. 18, Feb. 3, 1888, pp. 55–56.
578. AJP, Vol. 10, Aug. 1889, pp. 268–270; also Vol. 9, Jan. 1888, pp. 2–3.
579. The Eastman 1891 profile will be found in *Art in Advertising,* Vol. 5, Dec. 1891, pp. 120–121. Also see DAB (Eastman).
580. WPM, Vol. 26, Oct. 19, 1889, pp. 609–610.
581. Ibid.
582. References: Records compiled from recorded activities of Carbutt in nineteenth-century photographic journals, and DAB (Carbutt).
583. AJP, Vol. 10, Aug. 1889, pp. 277–279. For more on film photography development, see PM, Vol. 4, Apr. 1902; TAFT, pp. 391–403; GERNSHEIM, p. 408.
584. AJP, Vol. 10, Feb. 1889, pp. 73–75.
585. PM, Vol. 4, Apr. 1902.
586. WPM, Vol. 26, Apr. 20, 1889, pp. 247–248.
587. Op. cit. (items in Note 581); *Goodwin Film & Camera Co. v. Eastman Kodak Co., Federal Reporter,* Vol. 207, 1914, pp. 351–362; Vol. 213, pp. 231–240.
588. WPM, Vol. 33, Oct. 1896, pp. 462–465.
589. BROTHERS, p. 133. A report on Ives's process and the Franklin Institute award will be found in PP, Vol. 23, Dec. 4, 1886, pp. 699–700.
590. WPM, Vol. 27, Nov. 1, 1890, pp. 667–668.
591. BROTHERS, p. 127.
592. IAAPB, Vol. 1, 1888, pp. 306–307; 515–516; APB, Vol. 26, Jan. 1, 1895, pp. 4–6.
593. IAAPB, Vol. 4, 1891, pp. 190–194.
594. PT, Vol. 20, May 16, 1890, pp. 232–233.
595. APB, Vol. 21, Oct. 11, 1890, pp. 590–591.
596. WPM, Vol. 28, Aug. 15, 1891, pp. 505–506.
597. Op. cit. (Note 588). Sasche position recorded in AJP, Vol. 17, Apr. 1896, pp. 146–147.
598. WPM, Vol. 28, Aug. 1, 1891, p. 473. For a description of the Kamerat, see LOTHROP, p. 64.
599. "Recent Improvements in Photographic Lenses," by W. K. Burton, APB, Vol. 24, Oct. 28, 1893, pp. 650–656; "The Evolution of the Modern Lens," by T. R. Dallmeyer, a paper given at a meeting of the Royal Photographic Society on Oct. 9, 1900, and reprinted in APB, Vol. 31, Dec. 1900, pp. 384–387; Vol. 32, Jan. 1901, pp. 26–30.
600. HULFISH, pp. 12–13.
601. Op. cit. (Note 598)
602. IAAPB, Vol. 1, 1888, pp. 375–377.
603. References: Op. cit. (Note 598); PM, Vol. 3, May 1901, pp. 49–84; APB, Vol. 24, Apr. 8, 1893, p. 204.
604. WPM, Vol. 34, Dec. 1897, pp. 566–567.
605. An obituary on Whipple will be found in WPM, Vol. 28, Apr. 18, 1891, p. 256.
606. Op. cit. (Note 598). A report on lenses used at the New York amateur societies' exhibition will be found in WPM, Vol. 28, July 18, 1891, pp. 428–429. Remarks by David Bachrach will be found in his memoirs.
607. Bachrach quotation is from WPM, Vol. 29, Apr. 16, 1892, p. 233.
608. Lovell article will be found in WPM, Vol. 38, Aug. 1901, p. 322. Bachrach's remarks will be found in WPM, Vol. 29, Apr. 16, 1892,

pp. 231–234. Other references include PT, Vol. 23, Apr. 7, 1893, p. 184; and WPM, Vol. 35, Jan. 1898, p. 47 (contains ref. to Eastman paper).

609. AJP, Vol. 14, Dec. 1893, p. 567.
610. WPM, Vol. 29, Apr. 2, 1892, p. 197.
611. PT, Vol. 23, June 2, 1893, pp. 293–294.
612. WPM, Vol. 30, Aug. 1893, p. 368.
613. References: *Gazette* article quoted in AJP, Vol. 13, June 1892, p. 282; AJP, Vol. 12, Jan. 1891, pp. 27–28; July 1891, pp. 320–321; Vol. 13, Nov. 1892, pp. 515–517; APB, Vol. 23, June 25, 1892, pp. 374–375; WPM, Vol. 28, Oct. 17, 1891, p. 616; PT, Vol. 23, July 21, 1893, pp. 390–392.
614. APB, Vol. 23, Nov. 12, 1892, pp. 641–643.
615. PT, Vol. 21, Aug. 7, 1891, p. 397.
616. Ibid, p. 367.
617. BACHRACH, Memoirs.
618. Op. cit. (Note 474)
619. PT, Vol. 23, July 14, 1893, p. 376.
620. PT, Vol. 23, Jan. 20, 1893, pp. 33–34. For a profile of B. J. Falk, see WPM, Vol. 32, Nov. 1895, pp. 500–503.
621. WPM, Vol. 34, Aug. 1897, pp. 353–360.
622. Ibid.
623. References: PT, Vol. 21, July 17, 1891, p. 363; APB, Vol. 24, May 27, 1893, p. 293; Vol. 25, Apr. 16, 1894, pp. 208–212; PA, Vol. 5, June 1894, pp. 244–246; COULSON, p. 12; THOMAS, pp. 29–30.
624. WPM, Vol. 30, May 1893, pp. 219–220. Wynne device is described in APB, Vol. 25, Oct. 1, 1894, pp. 313–315.
625. For a review of the Pach brothers' operation, see WPM, Vol. 24, July 1897, pp. 305–310.
626. PT, Vol. 23, May 5, 1893, pp. 241–242. Cooper address at the Chicago Exposition will be found in APB, Vol. 24, Sept. 9, 1893, p. 552. Also see "Pigment Printing in Suitable Colors," by Henry Russell, AAP, Vol. 10, Dec. 1898, pp. 539–546.
627. *The Lives of the Painters,* by John Canaday, N.Y., W. W. Norton, 1969. Vol. 3, pp. 1096–1110.
628. NORMAN, p. 35.
629. AAP, Vol. 3, July 1891, pp. 268–269.
630. References: CN, Vol. 3, Apr. 1900, p. 196; "The New Movement in England," by Henry P. Robinson, APB, Vol. 25, Jan. 1, 1894, pp. 8–11.
631. *Vogue,* Aug. 15, 1948, p. 186. Also see "Recent Amateur Photography," by F. W. Crane, AJP, Vol. 16, Oct. 1895, pp. 457–464 (reprinted from *Godey's,* Sept. 1895); NORMAN, p. 36.
632. AAP, Vol. 6, Jan. 1894, pp. 1–7.
633. For a profile of Catherine Weed Barnes, see PT, Vol. 22, Mar. 4, 1892, pp. 153–155.
634. AAP, Vol. 4, Apr. 1892, pp. 153–155.
635. STIEGLITZ, p. 251. Also p. 116; NORMAN, p. 42.
636. PT, Vol. 27, Oct. 1895, p. 220.
637. AAP, Vol. 7, July 1895, p. 321.
638. Op. cit. (Note 635)
639. Op. cit. (Note 474)
640. For an obituary on C. D. Fredericks, see PT, Vol. 24, June 8, 1894, pp. 355–356.
641. STIEGLITZ, p. 269.
642. For more on Kurz's pioneering work, aided by Ernest Vogel, see SIPLEY, p. 16; PT, Vol. 23, Feb. 17, 1893, p. 82.
643. APB, Vol. 26, May 1, 1895, p. 172.
644. Both letters will be found in AAP, Vol. 6, Apr. 1894, pp. 188–189.
645. PT, Vol. 31, Apr. 1899, pp. 164–167.
646. IVES, p. 38. See also AAP, Vol. 12, May 1900, pp. 221–224.
647. APB, Vol. 26, Oct. 1895, p. 334. A report on the exhibition will be found in APB, Vol. 26, Jan. 1, 1895, pp. 20–23.
648. "The Adulteration of Paper Stock," by Julius F. Sasche, AJP, Vol. 14, Feb. 1893, pp. 65–66. See also APB, Vol. 26, July 1895, p. 241.
649. APB, Vol. 26, Feb. 1, 1895, pp. 63–64 (quotation is from an earlier undated article in the British journal *The Photogram*). See also WPM, Vol. 32, Dec. 1895, pp. 549–554; PT, Vol. 27, Nov. 1, 1895, pp. 289–292.
650. APB, Vol. 26, Jan. 1, 1895, p. 21.
651. GERNSHEIM, p. 525. Joly and McDonough processes are described in GERNSHEIM, p. 253, and *Color Photography,* by Robert M. Fastone, London, 1935, pp. 7–8.
652. WPM, Vol. 34, Aug. 1897, p. 371. See also May 1897, pp. 237–238.

653. PT, Vol. 28, Feb. 1896, pp. 104–105.
654. JENKINS, p. 70.
655. References: JENKINS, pp. 77–79; and the following, which are among the archives of the Franklin Institute: Aug. 27, 1897, letter from Jenkins to Henry Heyl; Aug. 18, 1898, report of the Heyl committee approving award of the Elliott Cresson medal to Jenkins.
656. Ibid. (from the full text of the book)
657. PT. Vol. 24, May 23, 1894, pp. 325–326. Also see APB, Vol. 27, Jan. 1896, p. 26.
658. WPM, Vol. 13, June 1896, pp. 271–273.
659. In three separate articles, Jenkins claimed that his Phantoscope would make each fragmentary moment of film illumination exceed the period of time required for sequencing to a new film image. See PT, Vol. 28, May 1896, pp. 222–226; Vol. 30, Apr. 1898, p. 152; July 1898, pp. 296–297.
660. JENKINS, p. 73.
661. MCCOSKER, p. 413.
662. PT, Vol. 27, Aug. 1895, p. 121.
663. Handy's letter will be found in WPM, Vol. 33, Mar. 1896, p. 123. Also see COBB, pp. 42–43.
664. For a review of the early years of the biograph, see *Beginnings of the Biograph,* by Gordon Hendricks, N.Y., 1964, and a review of the first ten years of motion picture photography in Rochester, N.Y. by George Pratt in *Image,* Vol. 8, Dec. 1959, pp. 192–211.
665. WPM, Vol. 34, June 1897, pp. 266–267.
666. APB, Vol. 26, Mar. 1, 1895, pp. 76–78.
667. Ibid.
668. PT, Vol. 23, June 2, 1893, p. 289.
669. References: *Creative Photography,* by Helmut Gernsheim, Boston, 1962, pp. 115–118; introduction by Edward Steichen to *Once Upon A City,* by Grace M. Mayer, N.Y., Macmillan, 1958, pp. ix–x; "Amateur Photography and Journalism," by M. Y. Beach, AAP, Vol. 3, Dec. 1891, pp. 486–487.
670. WPM. Vol. 34, Oct. 1897, pp. 459–463.
671. APB, Vol. 28, Oct. 1897, pp. 314–319.
672. WPM, Vol. 33, July 1896, p. 292.
673. Op. cit. (Note 665)
674. WPM, Vol. 33, Aug. 1896, pp. 365–366.
675. Op. cit. (Note 669)
676. Op. cit. (Note 672)
677. BACHRACH, Memoirs.
678. PAS, Vol. 4, No. 1, 1939, p. 59.
679. CN, Vol. 1, Oct. 1897, pp. 28–29. Also see "Philadelphia Salon—Origin and Influence," by Joseph T. Keiley, CN, Vol. 2, Jan. 1899, pp. 113–132.
680. Goode letter is reproduced in AAP, Vol. 8, June 1896, p. 243.
681. AAP, Vol. 10, Mar. 1898, pp. 99–104; 119.
682. Op. cit. (Note 679, Keiley article)
683. "The Gum Bichromate Process," by J. W. Warren, WPM, Vol. 36, Apr. 1899, pp. 147–149.
684. WPM, Vol. 37, Apr. 1900, p. 152.
685. From "The New York Camera Club," by Sadakichi Hartmann, PT, Vol. 32, Feb. 1900, pp. 59–61.
686. PT, Vol. 29, Nov. 1897, pp. 510–511.
687. PE, Vol. 2, Dec. 1898, p. 172.
688. "The Lesson of the Photograph," by K. C., *Scribner's,* Vol. 23, May 1898, pp. 637–639.
689. Op. cit. (Note 684)
690. WPM, Vol. 36, Mar. 1899, pp. 97–100.
691. PE, Vol. 2, May 1899, p. 306.
692. Dr. Voll's remarks are quoted in *Creative Photography,* p. 126.
693. AAP, Vol. 8, July 1896, pp. 297–303.
694. WPM, Vol. 35, Nov. 1898, pp. 497–502.
695. Op. cit. (Note 696)
696. WPM, Vol. 37, Feb. 1900, p. 49.
697. WPM, Vol. 36, Aug. 1899, pp. 348–350.
698. "The Vandyke Style in Portraiture," by George G. Rockwood, WPM, Vol. 34, Aug. 1897, pp. 340–341.
699. From *Rinehart's Platinum Prints of American Indians,* F. A. Rinehart, Photographers, 1520 Douglas St., Omaha, Neb., 1899, a sales brochure in the collection of George R. Rinhart, and kindly made available for this history.
700. PE, Vol. 1, July 1898, p. 68.
701. WPM, Vol. 33, Feb. 1896, pp. 107–108. David Bachrach's remarks

are from an address to the annual convention of the Photographers' Association of America, printed in WPM, Vol. 34, Oct. 1897, pp. 459–463.

702. *American Science and Invention,* by Mitchell Wilson, N.Y., Bonanza, MCMLIV, p. 380. In GERNSHEIM, p. 400, author contends that "contrary to the claims made at the time [1893], this paper [velox paper] was not the invention of Nepera's founder and technical manager, the Belgian chemist, Dr. Leo Baekland."

703. WPM, Vol. 37, Sept. 1900, pp. 411–416.

704. WPM, Vol. 36, Sept. 1899, p. 431.

705. ACKERMAN, pp. 169–170.

706. References: "The Moving Image," by Robert Gessner, AH, Vol. 11, Apr. 1960, pp. 30–35, 100–104; *The History of World Cinema,* by David Robinson, N.Y., Stein & Day, First Paper Book Edition, 1974, pp. 21–31.

707. "The Father of News Photography: George Grantham Bain," by Emma H. Little, *Picturescope,* Vol. 20, Autumn, 1972, pp. 125–132.

708. Op. cit. (Note 684)

709. References: ACKERMAN, pp. 170–183; DAB (George Eastman, by Blake M. McKelvey); *Edison, A Biography,* by Matthew Josephson, N.Y., Toronto & London, McGraw-Hill, 1959, pp. 400–403.

710. WPM, Vol. 37, Apr. 1900, pp. 161–166.

711. For a description of the life and times of the Waldorf-Astoria Hotel opened in 1897, see MORRIS, pp. 234–246.

712. WPM, Vol. 37, Feb. 1900, pp. 68–69.

713. WPM, Vol. 37, Mar. 1900, pp. 103–104.

PRINCIPAL HOLDINGS OF NINETEENTH-CENTURY
AMERICAN PHOTOGRAPHIC JOURNALS

Source	HJ 20 Vol.	PFAJ 13 Vol.	AJP 29 Vol.	PJA 60 Vol.	APB 33 Vol.	PT 47 Vol.	SLCPP 34 Vol.	AAP 19 Vol.	PB 19 Vol.	PA 19 Vol.	CN 6 Vol.
American Academy of Arts and Sciences, Boston			11	C							
American Antiquarian Society, Worcester, Mass.					15			NC			
Boston Public Library	15		10	C	C	C	22	14	12		C
Bowdoin College								17			
Brooklyn (N.Y.) Public Library					11						C
Buffalo and Erie County Public Library, Buffalo				58				5	2		
Bureau of Standards, Washington, D.C.					C						
California State Library, Sutro Branch, San Francisco							27				
Carnegie Library, Pittsburgh			11			NC	13	14			
Case Western Reserve, Cleveland							5	11			
Chicago Natural History Museum				28							
Chicago Public Library								15			
Cincinnati and Hamilton County Public Library, Cincinnati		2									
Cleveland Public Library				31	NC						
Columbia University	19	7	2	30					7		
Detroit Public Library		3		21		33					
Eastman Kodak Company, Rochester, N.Y.	12	2	10		25	45	19	18			
Enoch Pratt Library, Baltimore								15			
Franklin Institute, Philadelphia			14		18	NC					
Gettysburg College			C								
Harvard University				27	30	C	4	NC			
*Helios Press, Pawlett, Vt.	C	12		25							
Iowa State University of Science and Technology, Ames, Iowa				25		19					
John Crerar Library, Chicago	12	6		58	C	46	21	NC			
Kansas City Public Library								13			
Library of Congress	11	8	12	57	NC	45	17	C			C
Los Angeles Public Library						15					
Metropolitan Museum of Art, New York											C

Source	HJ 20 Vol.	PFAJ 13 Vol.	AJP 29 Vol.	PJA 60 Vol.	APB 33 Vol.	PT 47 Vol.	SLCPP 34 Vol.	AAP 19 Vol.	PB 19 Vol.	PA 19 Vol.	CN 6 Vol.
Mississippi State University					C						
Missouri Botanical Garden, St. Louis			7					9			
Newberry Library, Chicago									4		
New York Public Library	NC	12	19	NC	33	46	19	NC	14		C
New York State Library, Albany					27						
Ohio State University							C				
Oklahoma State University								5			
Philadelphia Free Library			13		7	NC					
Philadelphia Museum of Art											C
Queens Borough Public Library, New York				15							
Rinhart Library, George R. Rinhart, New York, N.Y.	4	1	8	21	16	32	7	11	6	5	C
Rochester Public Library					5						
Rose Polytechnic Institute, Terre Haute, Indiana						17					
Rutgers University			6					9			
Rutherford B. Hayes Library, Fremont, Ohio				15							
San Francisco Public Library				17							
St. Louis Public Library							1		9		
Smithsonian Institution, National Museum of History & Technology			7	58	25	34					
Spokane Public Library									5		
Union College			4								
United States National Library of Medicine					30		2				
University of Chicago					26	41					
University of Illinois, Urbana					28	20					
University of Maryland (College Park, Md.)			4								
University of Michigan				29	17			C			
University of Notre Dame									11		
University of Pennsylvania	8	1	6	19	6	41					
Yale University				27		44	1	12			

* = Holdings available in microfilm C = Complete run NC = Near complete run

Principal
Holdings

415

SOURCES OF ILLUSTRATIONS

Private Collections

Bachrach	Bradford Bachrach, President, Bachrach, Inc., Watertown, Mass.
Beard	Timothy Beard, of New York City
Bendix	Howard Bendix, of Montclair, N.J.
Bokelberg	M. Bokelberg, Hamburg
Carson	Mrs. Joseph Carson, of Philadelphia
Collerd	Gene Collerd, of Caldwell, N.J.
Crane	Arnold Crane, of Chicago
Douglass	Mrs. Roy Douglass, of Pine Brook, N.J.
Duncan	R. Bruce Duncan, of Northfield, Illinois
Kaland	William Kaland, of New York City
Korn	Pearl Korn, of the Bronx, N.Y.
Lansdale	Robert Lansdale, of Baltimore
Lehr	Janet Lehr, of Janet Lehr, Inc., New York City
Lightfoot	Frederick S. Lightfoot, of Greenport, N.Y.
Marcus	Lou Marcus, of West Hempstead, N.Y.
Ostendorf	Lloyd Ostendorf, of Dayton, Ohio
Plummer/ Miller	J. Randall Plummer and Harvey S. Miller, of Philadelphia
Rinhart	George R. Rinhart, of New York City
Russack	Richard Russack, of Freemont, N.H.
Sprung	Jerome Sprung, of Teaneck, N.J.
Steinmann	Mr. & Mrs. David Steinmann, of New York City
Wagstaff	Samuel Wagstaff, Jr., of New York City
Walter	Paul F. Walter, of New York City
Weiner	Allen and Hilary Weiner, of New York City
Zucker	Harvey S. Zucker, of Staten Island, N.Y.

Key to Abbreviations, Institutional Collections

BL	Bancroft Library, University of California Library at Berkeley
CHS	Cincinnati Historical Society
DCL	Dartmouth College Library
DYLM	Dyer-York Library and Museum, Saco, Maine
FI	Archives of the Franklin Institute of Philadelphia
GEH	International Museum of Photography at George Eastman House, Rochester
HL	Houghton Library, Harvard University
ISHL	Illinois State Historical Library, Springfield
KC	Archives of Kenyon College, Gambier, Ohio
LC	The Library of Congress
LCPPD	The Library of Congress, Prints and Photographs Division
LLM	Lloyd Library and Museum, Cincinnati
MCNY	Museum of the City of New York
MFA	Museum of Fine Arts, Boston
MHS	Maryland Historical Society, Baltimore
NA	The National Archives
NYHS	New York Historical Society
OHA	Onondaga Historical Association, Syracuse
OSU	Floyd & Marion Rinhart Collection, Ohio State University, Department of Photography & Cinema
PHMC	Pennsylvania Historical & Museum Commission, Division of Archives & Manuscripts, Group 214, Warren J. Harder Collection, Harrisburg, Pa.
PM	The Peale Museum, Baltimore
RHS	Rochester Historical Society
SI	The Smithsonian Institution
SM	The Science Museum, London
UC	The University Club of New York City
UCL	University of Cincinnati Libraries, Special Collections Department
UM	McKeldin Library, University of Maryland, College Park
UMBC	Edward L. Bafford Photography Collection, University of Maryland, Baltimore County, Baltimore
UT	Gernsheim Collection, University of Texas at Austin

Frontispiece	Collerd
1	Rinhart
2	SI
3	Zucker
6	Carson
7	UCL
10	Carson (unpublished)
11	Both: Rinhart (unpublished)
12	FI (unpublished)
13	*B*. LC (from AJP, Vol. 14, 1893)
	T. SI
14	Carson
16	*T*. FI (unpublished)
	B. Carson (unpublished)
18	LC (from ARASM, Vol. 1, 1840)
19	*B*. SI
	T. LC (from *Eureka*, Vol. 1, 1846)
20	*T*. Duncan (from PAJ, Vol. 2, 1851)
	B. Author
21	*B*. Duncan
	T. Carson (unpublished)
22	FI (unpublished)
23	*T*. Carson (unpublished)
	B. Rinhart (from *Evolution of Photography,* by John Werge)
25	Collerd
26	Zucker
27	Beard (unpublished)
28	Carson (unpublished)
30	HL
32	Rinhart
33	LCPPD
34	*T*. Author
	B. LC (from PFAJ, Vol. 10, 1857)
35	Carson (unpublished)
36	Bokelberg
38	UC (from *Motion Picture Work,* by David Hulfish)
39	*L*. UT
	R. Author
40	GEH
42	Author
43	Collerd
44	Carson (unpublished)
45	*T*. LC (from *Goggett Directory,* New York, 1843–44)
	B. Bendix
46	*L*. Collerd
	C. Rinhart
	R. Author
47	Author
48	*L*. GEH
	R. Carson (unpublished)
49	*L*. LC (from *McClure's*, Vol. 9, 1897)
	R. NA
50	Both: SI
51	UT
52	LCPPD
54	Crane

55　*L.* Author
　　R. LCPPD
56　*L.* Carson
　　R. Carson (unpublished)
57　Both: Korn
60　LLM (from *History of the Eclectic Medical Institute,* Cincinnati, 1902)
62　Both: MCNY
63　LC (from PT, Vol. 29, 1897)
65　MFA
66　Duncan
67　Zucker
69　Rinhart (from *The Art of Photography,* by H. H. Snelling, 1849)
70　*T.* Rinhart (unpublished)
　　B. Collerd (unpublished)
71　Rinhart (from *The Art of Photography*)
72　Rinhart (unpublished)
74　SI
75　*T.* SI
　　B. BL
76　DCL
77　Duncan
78　Carson (unpublished)
79　SI
80　Weiner
81　Rinhart (from *Evolution of Photography*)
82　Duncan
83　*T.* Duncan
　　B. LC (from *Pageant of America* Vol. II, 1925)
86　Duncan
87　*T.* Author
　　B. All LC (from PAJ, Vol. 1–2, 1851)
88　LC (from *American Phrenology Journal,* 1854)
90　*L.* Author
　　R. LC (from *Works of James Buchanan,* by James Moore, Vol. 1, 1908).
92　*T.* SI
　　B. LC (from APB, Vol. 12, 1881)
93　*L.* UCL
　　R. Both: Collerd
94　RHS
98　LC (from PT, Vol. 25, 1894)
99　Carson
100　Author (from *Leslie's Zeitung,* Oct. 9, 1858.
101　Author (Ibid., Oct. 23, 1858)
102　Sprung
104　*L.* Rinhart (from Manual of *Photography,* by A. Brothers, 1899)
　　R. Zucker (from *History & Handbook of Photography,* Gaston Tissandier, 1876)
105　*T.* Collerd
　　B. Rinhart
106　Plummer/Miller
108　*T.* LC (from *Dictionary of the Photographic Art,* H H. Snelling, 1854)
　　B. Author (unpublished)
110　Author
112　Author
113　All: Collerd
114　*T.* Both: Douglass
　　C. Douglass
　　B. Collerd
115　OSU
116　LC (from HJ, Vol. 8, 1856)
117　Author
118　Both: KC
119　Both: Duncan
120　LC (from *Narrative of Expedition of American Squadron to China Seas and Japan,* Francis L. Hawk, 1856)
122　*T.* Rinhart
　　B. Zucker
124–125　Carson (unpublished)
127　Author
128　Both: Rinhart
129　Weiner
130　Carson
131　LC (from *Leslie's Weekly,* 1859)
132　PM
133　Author (unpublished)
134　Carson
136　Plummer/Miller
138　All: Richard Russack
139　Author
140　*T.* Steinmann
　　B. Zucker
142　Carson
143　LCPPD
144　Lincoln photos: Ostendorf
　　Camera: GEH
145　Both: RHS
146　Author (unpublished)
147　MHS
148　OHA
149　UM (from AJP, Vol. 4, 1861)
150　Weiner
151　All: FI
152　LC (from *Optics of Photography,* by J. Trail Taylor, 1892)
153　Author
154　LC (from PFAJ, Vol. 8, 1855)
155　FI
156　Author (unpublished)
157　LC (from PFAJ, Vol. 2, 1851)
158　Rinhart
159　Both: Rinhart
161　Author
162　All: Rinhart
164　NA (provided courtesy GAF Corp.)
165　Lansdale (unpublished)
166　LC (from PFAJ, Vol. 8, 1855)
168　Author
169　Both: Rinhart
171　Carson
172　Carson
173　Both: Rinhart (unpublished)
174　Carson
176　ISHS
177　LC (from APB, Vol. 26, 1895)
178　Rinhart
179　*T.* Weiner (unpublished)
　　B. Author (unpublished)
181　Carson
182　LCPPD
183　Both: Author
184　Collerd (unpublished)
185　Author
187　All: Author
189　Author
190　LC (from PT, Vol. 28, 1896)
191　Weiner
192　Weiner
194　Author
195　LC (from PP, Vol. 5, 1868)
196　LC (from WPM, Vol. 37, 1900)
199　*T.* Carson
　　B. Rinhart
200　Rinhart (from PM, Vol. 4, 1902)
201　Weiner
202　Author
203　FI
205　Weiner
207　Rinhart
208　Carson
209　Lehr
210　LCPPD
212　Rinhart
213　All: GEH
214　Weiner
215　Rinhart
216　DYLM

Sources of
Illustrations

Sources of
Illustrations

INDEX

TO TEXT

Index

420

C

Cabinet card: invention of, 185; "Promenade" version, 239; vogue for celebrity portraits, 279, 281–283; automatic printing of, 362–363
Cabot, Dr. Samuel, 31
Cady, James, 84, 135
California Art Union, 201
Calotype paper negative process (British), 30; patented by Talbot, 31; 59; U.S. rights to, 79; used for Lincoln portrait, 91; 95, 100; extension of patent to collodion photography denied, 104
Calotype paper negative process (French): description of, 91; rejected for Fremont 1853 expedition, 92; advantages of, 131; 163
Camera Club of New York, 353, 360, 380, 383, 388, 394, 397
Cameras:
Camera obscura, vii, 1
Daguerrean era:
Daguerre style, 12, 17, 18; use of blue glass in, 31, 69
Cigar box style, 10, 11
Reflector style ("mirror" camera), 8, 13, 18; first U.S. patented, 19; 26, 69, 95
Voigtlander box, 46, 69, 88, 280
Voigtlander "spyglass," 39, 40
American (post 1847) W. & W. H. Lewis, 61; suppliers of regular, "quick-working" and mammoth-plate, 69; E. Anthony line, 88
Bellows, 93; proposed "Bellows Box," 121
"Wet-plate" era:
First binocular (British and French), 103–104
American "double" style, 104, 115
American (circa 1850s): C. C. Harrison and Holmes, Booth and Hayden, 108; E. Anthony portable field, 130
Foreign makes (1856), 116; mention of, 121
Solar, 122–123, 173; rooftop operation of, 192; 326
"Megascopic," 123
Multilens,143-144;Semmendinger,150
Ormsbee and Wing "multiplying," 149–150
Mammoth-plate, 153, 158, 199
Stereoscopic: single lens, 116, 130; twin lens, 191
Tintype, 213
Modern era:
American (circa 1880s) Scovill, 272, 318; American optical view, 284–285; Walker pocket, 285; export to Germany, 289
"Detective": Schmid, Parsell, Scovill, Blair, 285, 291; Brainerd, Anthony, Eastman, 305; Eastman, 340

Cameras: modern era (cont'd)
Vest pocket, 305; called "Button" in Germany, 306
Kodak, 311, 321, 325, 335, 342, 378, 395, 397
Kamaret, 324, 335
Enlarging, 326
Reflex, 335
Magazine, 335
Bicycle, 349
Bellows-style pocket, 395
Brownie, 395
Motion picture: Le Prince, 315–317; Kinetograph, 348–349, 367, 371, 372; Phantoscope, 366–368, 371; Cinematographe, Vitascope, Mutoscope, Biograph, Pantopikon, Eidoloscope, 367–368, 371–373, 375; Graphoscope, 368
Trichromatic, 342
Cameron, Julia Margaret (1815–1879), 239–240.
Campbell, John, 135
Campbell, William, 154
Canfield, C. W., 299
Carbon process: origins of, 189; Swan process, 189; American process, 189, 191, 193, 248; Queen Victoria requests use of, 242; lambertype, 242, 245–247, 250–251, 339; chromotype, 245, 246, 247; improved process, 351
Carbon Studio, 393
Carbutt, John (1832–1905), 172, 182, 183, 185, 186; submits to bromide patent, 188; 195; U.S. rights to Woodburytype, 204; 235, 241, 245; develops Keystone dry plate, 257; opposes artotype, 261; 271; develops flashlight compound 318; manufactures celluloid film, 322, 324; profile of, 324; 333, 370
Cardboard (for mounting photographs), 208
Carjat, Étienne (1828–1906), 239
Carlyle, Thomas (1795–1881), 55
Carnegie Art Galleries, 383
Carte de visite, 111, 143, 150, 169–170
Carvalho, Solomon N. (1815–1899), 92, 120, 220
Case (partner of J. W. Black), 170, 183
Cases (for daguerreotypes and ambrotypes): moroccan leather, 40; wooden, covered with embossed paper, 41; papier-mâché, 41; mother-of-pearl, 41; plastic, 41; ambrotype, 111; 113
Catherwood, Frederick (1799–1854), 31, 32, 33
Celluloid Manufacturing Company, 322, 324
Centennial Photo Company, 241
Central Pacific Railroad Company, 183, 253
Chaloner, Aaron D., 13
Chamberlain, William G., 222, 261
Champney, James Wells (1843–1903), 297
Channing, William F., 30, 31

Chanute, Octave (1832–1910), 397
Chapman, D. C., 233
Charlie Pfaff Restaurant, 115
Chase, Lorenzo P., 20
Chase, William, 165, 183, 185, 201
Chatham Square, New York, 62
Cheney, George, 229–232
Chevreul, Michel Eugène (1786–1889), 47, 301–303
Chicago Camera Club, 355
Chicago Photographic Association, 273
Childs, George, 120
Chilton, Howard, 46
Chilton, James R. (1810–1863), 9, 18, 19, 33, 88, 135
Chisholm, James, 229
Chromotype, see Carbon process
Cinematograph, 367–368
Cisco, John A., 297
Clare, Ada, 115
Clark, Mrs. Fitzgerald, 318
Clark, J. M., 72, 86; named president of the American Photographic Institute, 89
Clark, J. R. (probably J. M. Clark), 95
Claudet, Antoine Francois Jean (1797–1867), 8, 25, 51, 56, 94–95; lauds Woodward solar camera, 123
Clay, Henry (1777–1852), 34, 65
Clements, Alfred, viii; co-patents platinotype in U.S., 258; 273, 344, 355; prize photo, 356; profile of, 357; 358, 388
Clemons, John R., 193, 225, 241, 262
Clerk-Maxwell, Sir James (1831–1879), 200
Cleveland, Stephen Grover (1837–1908), 281, 346
Clifford, Charles (d. 1863), 227
Clurman, Harold, 357
Coale, George B., viii, 121; publishes manual for amateurs, 130–131; 137, 152
Cobb, Darius, 384, 387
Cohen, Mendes (1831–1915), 135, 137
Cole, Thomas (1801–1848), 8, 201
Cole, Timothy, 327
College graduating class photographs, 254
Collins, A. M. Son & Company, 208
Collodion dry-plate glass negative process: Tannin mode, 163; 165; listing of all modes, 166; Newton process, 242, 244, 257
Collodion positive (ambrotype), 60, 111
Collodion wet-plate glass negative process, 37, 92; used to make crystalotypes, 93–94; 111, 113; technical description of, 126; photo society discussion of, 160; use of bromine in, 92, 196–198; 239, 241; use in slide making, 380
Collotype, see Photomechanical printing
Color photographs, see Photography
Colt, J. B. & Company, 360
Conkling, Roscoe (1829–1888), 282
Constable, Frederick, 297
Constable, William (1783–1861), 36

TO ILLUSTRATIONS OF PRINCIPALS